THE PELICAN HISTORY OF ART

EDITOR: NIKOLAUS PEVSNER

ASSISTANT EDITOR: JUDY NAIRN

PAINTING IN EUROPE: 800–1200

C. R. DODWELL

Rome, San Clemente, apse, Crucifixion. Mosaic. Before 1128.

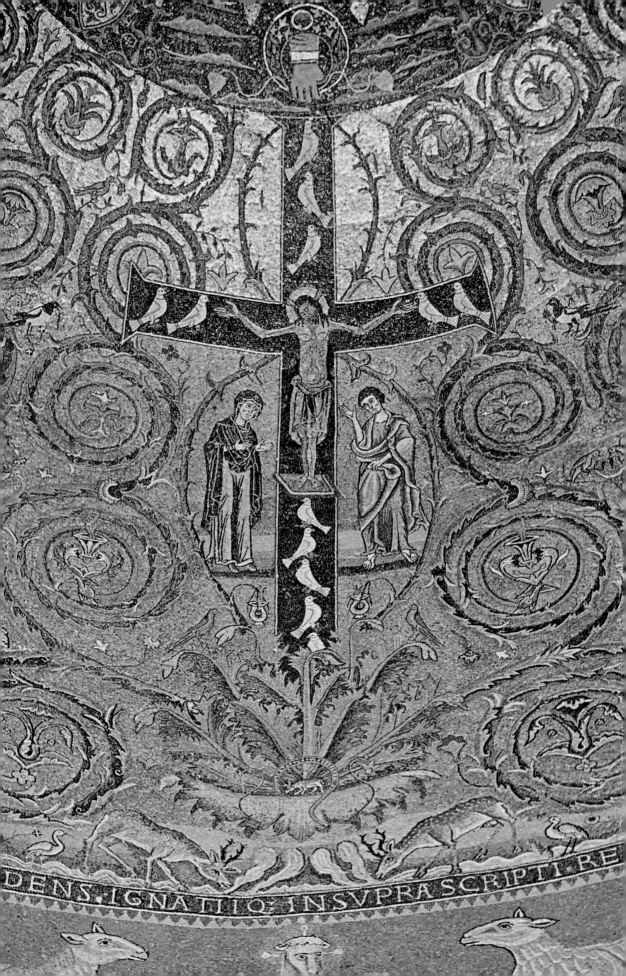

C. R. DODWELL

PAINTING IN EUROPE
800 TO 1200

PUBLISHED BY PENGUIN BOOKS

Penguin Books Ltd, Harmondsworth, Middlesex
Penguin Books Inc., 7110 Ambassador Road, Baltimore, Md 21207, U.S.A.
Penguin Books Australia Ltd, Ringwood, Victoria, Australia

★

Text printed by Richard Clay (The Chaucer Press), Ltd, Bungay, Suffolk
Plates printed by Balding & Mansell Ltd, London
Made and printed in Great Britain

★

SBN 14 056034 3

★

First published 1971
Copyright © 1971 C. R. Dodwell

TO SHEILA

CONTENTS

CONTENTS

CONTENTS

LIST OF PLATES

*Where not otherwise indicated, copyright in photographs belongs to the museum
in which objects are located, by whose courtesy they are reproduced*

Frontispiece: Rome, San Clemente, apse, Crucifixion. Mosaic. Before 1128 (Snark International)

1 Rome, SS. Cosma e Damiano, mosaic of apse. Early sixth century (Anderson, Mansell Collection)
2 Rome, Santa Prassede, mosaic of apse. 827/44 (Anderson, Mansell Collection)
3 Rome, Santa Cecilia in Trastevere, mosaic of apse. 817/24 (Anderson, Mansell Collection)
4 Rome, San Marco, mosaic of apse. 827/44 (Anderson, Mansell Collection)
5 Rome, Santa Prassede, chapel of San Zeno, mosaic of vault. 817/24 (Josephine Powell)
6 Germigny-des-Prés, Ark and Cherubim. Mosaic. 799/818 (Archives Photographiques, Paris)
7 Auxerre, Saint-Germain, west crypt, St Stephen preaching to the Jews. Wall-painting. Ninth century, second half (Paris, Archives Photographiques)
8 Mals (Malles), San Benedetto, secular portrait. Wall-painting. Mid ninth century(?) (James Austin)
9 Procession of martyrs, from St Maximin. Wall-painting. Ninth century, second half(?). *Trier, Landesmuseum*
10 Actors wearing classical masks, from a copy of a late classical *Terence*. Carolingian. MS. Vat. lat. 3868 folio 63. *Rome, Biblioteca Apostolica Vaticana*
11 Illustration from a later copy of a Carolingian illustrated calendar. MS. 7524/55, folio 210. *Brussels, Bibliothèque Royale*
12 Eridanus, from a copy of Cicero's *Aratea*. Carolingian. MS. Harley 647 folio 10 verso. *London, British Museum*
13 Andromeda, from a copy of Cicero's *Aratea*. Carolingian. MS. Voss. lat. Q79. *Leiden, University Library*
14 Odbert of Saint-Bertin: Andromeda, from a copy of Cicero's *Aratea*. 990/1012. MS. 188 folio 24. *Boulogne-sur-Mer, Bibliothèque Municipale* (Bibliothèque Nationale, Paris)

15 Charlemagne's Court 'Ada' School: Christ, from the Godescalc Gospel Lectionary. Completed in 783. MS. nouv. acq. lat. 1203 folio 3 recto. *Paris, Bibliothèque Nationale*
16 Charlemagne's Court 'Ada' School: Frontispiece, from a Gospel Book from Saint-Martin-des-Champs. Late eighth century. MS. 599 folio 16 recto. *Paris, Bibliothèque de l'Arsenal* (Bibliothèque Nationale, Paris)
17 Charlemagne's Court 'Ada' School: Evangelist, from the Ada Gospels. Late eighth century. MS. 22 folio 59 verso. *Trier, Stadtbibliothek*
18 Charlemagne's Court 'Ada' School: Initial with the Annunciation to Zacharias, from the Harley Gospels. c. 790–800. MS. Harley 2788 folio 109 recto. *London, British Museum*
19 Charlemagne's Court 'Ada' School: Evangelist, from the Harley Gospels. c. 790–800. MS. Harley 2788 folio 13 verso. *London, British Museum*
20 Charlemagne's Court 'Ada' School: Canon table, from the Soissons Gospels. Late eighth century. MS. lat. 8850 folio 10 verso. *Paris, Bibliothèque Nationale*
21 Charlemagne's Court 'Ada' School: The Twenty-four Elders and the Lamb, from the Soissons Gospels. Late eighth century. MS. lat. 8850 folio 1 verso. *Paris, Bibliothèque Nationale*
22 Charlemagne's Court 'Ada' School: Fountain of Life, from the Soissons Gospels. Late eighth century. MS. lat. 8850 folio 6 verso. *Paris, Bibliothèque Nationale*
23 Charlemagne's Court 'Ada' School: St John, from the Lorsch Gospels. Late eighth century. MS. Pal. lat. 50 folio 67 verso. *Rome, Biblioteca Apostolica Vaticana*
24 Lorsch School: St John, from the Gero Codex. 950/70. MS. 1948 folio 4 verso. *Darmstadt, Hessische Landesbibliothek* (Foto Marburg, courtesy the Warburg Institute)
25 Charlemagne's Court 'Palace' School: Evangelist, from the Coronation Gospels. 795/810. Folio 15 recto. *Vienna, Weltliche Schatzkammer der Hofburg* (Kunsthistorisches Museum, Vienna)

xi

ACKNOWLEDGEMENTS

ONE of the pleasures of writing a book of this sort is the kindness that one encounters from friends, and I should like to thank them all most warmly. For reading through all or part of the text and giving me the benefit of their criticism and corrections I am grateful to Professor D. H. Green, Dr Florentine Mütherich, Professor N. Pevsner, Dr Hanns Swarzenski, Dr C. H. Talbot, and Mr Derek Turner. I am also indebted to Dr Cecelia Meredith and Mr Piers Tyrrell for checking some references, and to Mrs Judy Nairn for seeing the book through the press. Not the least help has come from my secretary, Mrs Pauline Lownsborough, who has typed this book with her usual cheerful efficiency.

C. R. DODWELL

MAPS

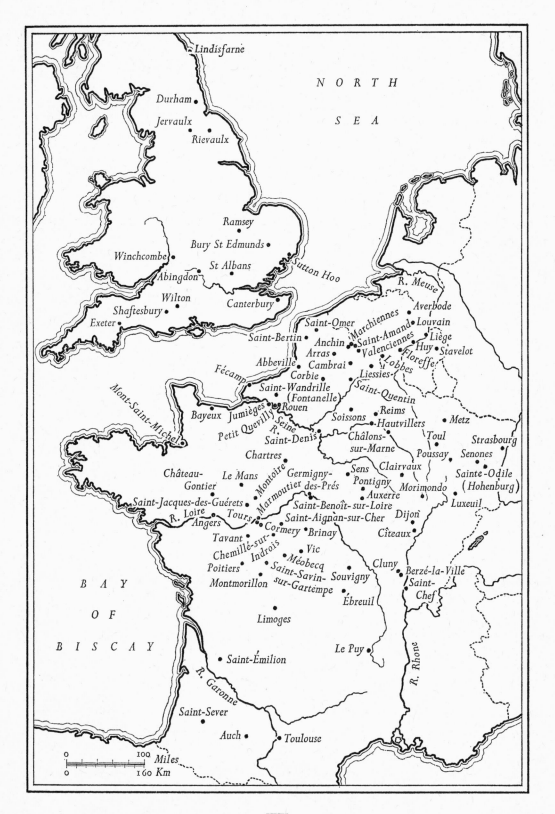

NORTH

SEA

Lindisfarne

Durham
Jervaulx
Rievaulx

Ramsey
Bury St Edmunds
Winchcombe
St Albans
Abingdon
Sutton Hoo
Wilton
Canterbury
Shaftesbury
Exeter

R. Meuse
Averbode
Saint-Omer
Marchiennes
Louvain
Saint-Bertin
Anchin
Saint-Amand
Liège
Arras
Valenciennes
Huy
Stavelot
Abbeville
Cambrai
Floreffe
Fécamp
Corbie
Lobbes
Saint-Wandrille
Liessies
(Fontanelle)
Saint-Quentin
Bayeux
Jumièges
Rouen
Mont-Saint-Michel
Petit Quevilly
Reims
Soissons
Metz
Seine
Hautvillers
Saint-Denis
Châlons-
Toul
Strasbourg
Chartres
sur-Marne
Poussay
Senones
Sens
Clairvaux
Château-
Le Mans
Germigny-
Pontigny
Morimondo
Sainte-Odile
Gontier
Montoire
des-Prés
Auxerre
(Hohenburg)
Marmoutier
Morimondo
Luxeuil
Saint-Jacques-des-Guérets
Saint-Benoît-sur-Loire
R. Loire
Tours
Saint-Aignan-sur-Cher
Dijon
Angers
Cormery
Brinay
Cîteaux
Tavant
Chemillé-sur-
Vic
Indrois
Méobecq
Cluny
Berzé-la-Ville
Poitiers
Saint-Savin-
Souvigny
Saint-
Montmorillon
sur-Gartempe
Chef
Ébreuil
B A Y
Limoges

O F
Le Puy
R. Rhone
B I S C A Y
Saint-Émilion

R. Garonne
Saint-Sever
Auch
Toulouse

0 100
Miles
0 160 Km

XXV

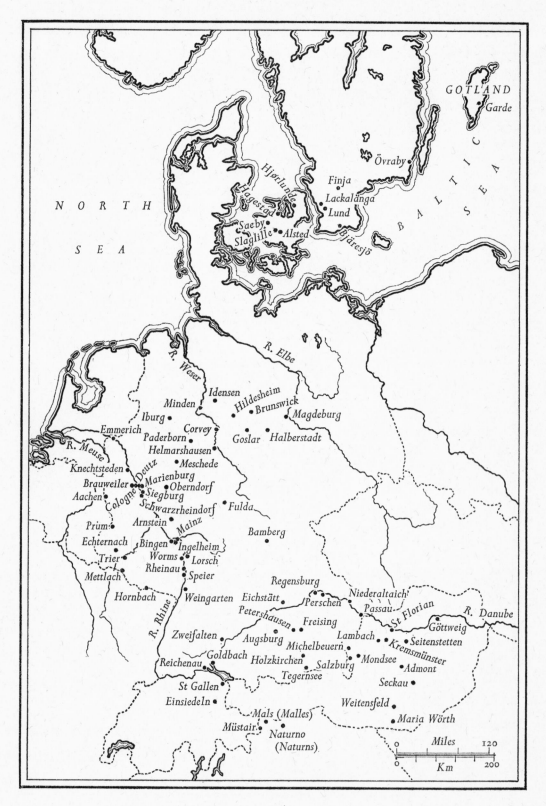

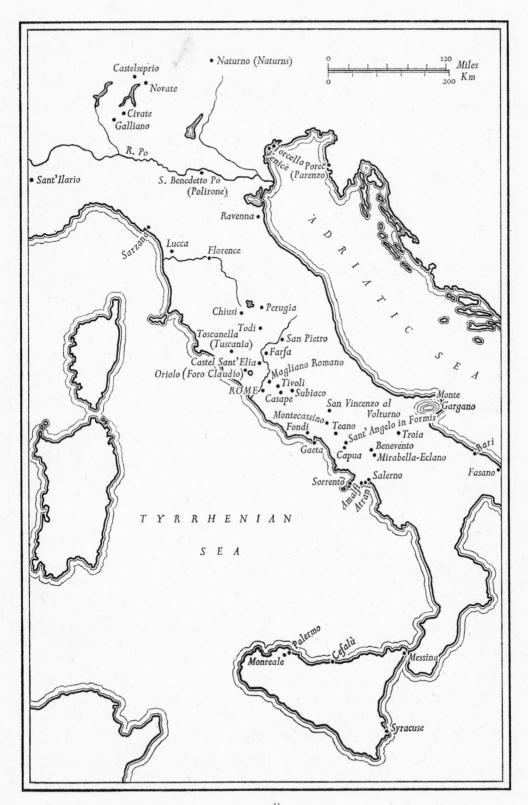

Castelseprio
Novate
Civate
Galliano
Naturno (Naturns)

R. Po
Sant'Ilario
S. Benedetto Po
(Polirone)

Torcello Poreč
Venice (Parenzo)

Ravenna

ADRIATIC

SEA

Sarzana
Lucca
Florence

Chiusi Perugia
Todi
Toscanella
(Tuscania)
Castel Sant'Elia
Oriolo (Foro Claudio)
San Pietro
Farfa
Magliano Romano
ROME
Tivoli
Casape Subiaco
San Vincenzo al
Volturno
Montecassino
Fondi Teano
Gaeta Sant'Angelo in Formis
Capua
Sorrento Salerno
Amalfi
Atrani

Monte
Gargano

Bari
Troia
Benevento
Mirabella-Eclano
Fasano

TYRRHENIAN

SEA

Palermo Cefalù
Monreale Messina

Syracuse

Miles
Km

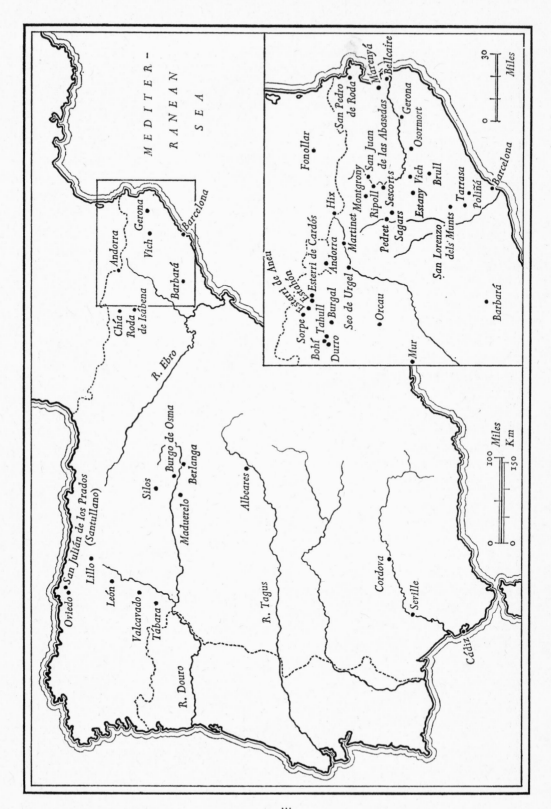

CHAPTER I

INTRODUCTION

THE Roman empire of the West was revived at the outset of the eighth century; the
Roman empire of the East was overwhelmed at the beginning of the thirteenth. The
period between, with which this volume is concerned, sees the gradual development of
the Europe of the future. It begins in weakness but continues into power.

The collapse of the original Roman empire in the fifth century had left the West
recumbent and defenceless – open to any and every predator. In theory, of course, the
empire had not collapsed. After the death in 480 of the last emperor of its Western half
centred in Rome, full authority over the whole was supposed to have reverted to the
Eastern half which was based on Constantinople. However, this Eastern or Byzantine
half was strong enough to exploit but not powerful enough to succour. It could take
advantage of the position to continue to occupy parts of Italy until the end of the
eleventh century, but it could not protect the West from forces which were an actual
threat to itself. So Germanic barbarian tribes from the north continued to occupy almost
every part of what was to become Europe – the Visigoths in Spain, the Franks and
Burgundians in Gaul, and the Lombards in Italy. From Africa to the south, the Arabs
crossed the straits of Gibraltar and poured into Spain, which they conquered and
occupied almost completely, before attempting to pass the Pyrenees into Gaul. And
even when our period had already begun, the dreaded Norsemen flooded down from
the Scandinavian countries in the north to terrorize most of the coastal areas of Europe
and to carve out for themselves areas of occupation in northern France and the British
Isles.

In the eighth century, however, the West began to bestir itself, to flex its muscles and
feel its powers. Already in 732, the Frankish leader, Charles Martel, routed near Poitiers
an Arab army that had crossed the Pyrenees, intent on adding other parts of the West
to their Spanish conquests. This defeat checked their advance in 'Europe' and, though
the Mohammedans continued to harass southern Gaul and the valley of the Rhône for
many years, there was no longer any question of adding Gaul and other parts of Europe
to the vast Arab empire. Martel was the chief minister of the effete dynasty of Merovin-
gians who then ruled the Franks in Gaul. From these Merovingians, his son, Pippin,
seized power. Pippin made himself king of the Franks in 751 and began a new dynasty
which took its Carolingian name from his famous grandson Charlemagne, who
succeeded as king in 768. Charlemagne followed up Martel's military check to the Arabs
with a political check to the Byzantines. By allowing himself to be made the first Holy
Roman Emperor in Rome on Christmas day 800, he resurrected the idea of empire in
the West and challenged the claim of the Eastern empire to suzerainty over the whole
of the former Roman empire. However theoretical such a claim might be, it was one
that Byzantium had itself taken seriously. Even in the tenth century a Byzantine emperor

was to cast into prison papal envoys who had addressed him merely as 'Emperor of the Greeks' and not also as 'Emperor of the Romans'.

In a sense history had come full circle, for the barbarians who had helped destroy the Roman empire were now trying to resuscitate it. But Charlemagne did not see the new empire simply as a revival of the old. His was an empire sanctified by Christianity and he looked back for its vindication not simply to the days of empire but also to the more remote days of the Old Testament. The Franks, indeed, visualized themselves not simply as the successors of the Romans but as surpassing them since they were also the heirs of the Israelites. All this (as we shall see) is clear in contemporary art and contemporary writings.

This new Holy Roman Empire of the West, embracing most of present-day France, Germany, and northern Italy, was the nucleus of medieval and modern Europe. There were, to be sure, bitter setbacks ahead and the West was not to be free for some time from attacks and invasions. But, from now on, Europe gradually passed from the defensive to the offensive, from a state of lethargy to one of dynamism. Whereas in the eighth century the Arabs were in occupation of most of Spain, all of Sicily, and part of southern Italy, by the thirteenth century not only had the Arabs been expelled from every part of Europe except the southern tip of Spain but the West had also carried the assault into the Arabic empire in Palestine and Syria and there conquered for itself small kingdoms in the form of Crusading principalities. Again, when our period commences about 800 the West felt some trepidation at the power and prestige of the empire of the East which it was beginning to challenge. By 1204, however, such was its own strength that it could successfully attack and defeat Constantinople in an expedition which can only be described as incidental. The period covered by this volume is one in which the West begins to feel and to develop its own strength and its own identity.

Nowhere is this more true than in the field of the arts. It begins in the Carolingian period with a sequence of trials and experiments based on styles from other areas and periods, but it concludes with an art of its own which is unmistakably and indigenously Western.

When the Franks were consolidating their power in the eighth century, there was no significant living tradition of art in their hands. Apart from the pockets of comparatively sophisticated art left on the Continent by recent missionaries from the British Isles, their main painting was largely confined to the rude initials of Merovingian manuscripts,[1] and the painful attempts, under Pippin, to copy figurative Italian painting[2] only emphasize by their gaucheness the primitive nature of the native artistic talents. The three main streams of art flowed outside the Carolingian heartland. To the north was the Anglo-Irish, to the east was the Byzantine, and to the south was the Italian.

Art in the British Isles[3] represented the finest expression of an aesthetic which may be described as barbarian in a sense that is historic and in no way pejorative. We have already seen that barbarian tribes descended on Europe in the fifth and sixth centuries. Their destruction of the art of the Roman empire was immense, but the art they brought with them was not to be despised. Indeed, for decorative vigour and sheer quality of technical achievement, some of the barbarian metalwork is difficult to surpass. But this

barbarian art was an art with severe limitations. Its primary task was to decorate portable objects such as swords and shields and belts. It was an art of ornamentation and display. We might, indeed, call it a craft rather than an art in the sense that it showed technical skills of the highest order but remained formally decorative and ornamental rather than imaginative and creative. Particularly fine examples of it have been found in England in the burial hoard of Sutton Hoo.[4] This art of display, originally intended for metalwork, was adopted by painters in Northumbria and brought to an extraordinarily high level of refinement and skill. Probably the finest achievement of it, before Charlemagne, was the Lindisfarne Gospels,[5] which were made in Northumbria, and which combine, to a remarkable degree, tasteful colours and sheer decorative dexterity.

At the opposite aesthetic pole was the art of Byzantium.[6] This eastern part of the old Roman empire, centred at Constantinople, had been threatened, but never succumbed to barbarian and Arab pressures. It therefore retained a cultural continuity with Antiquity which had been lost north of the Alps. This is reflected in its art which, despite all the hiatuses of the iconoclastic periods, showed a consciousness of the classical tradition which was deliberately renewed during periods of renaissance. It was a classical tradition, it is true, that had been given a Christian and Eastern cast during the Early Christian period so that Byzantine art can be hieratic and symbolic. But it still retained a sympathetic understanding of the human organism, and the classical ingredients of Byzantine art should not be underestimated.

Even closer at hand, in Italy,[7] we find a great reservoir of past traditions. Always (as in her great classical period) open to influences from Greece which even threatened at times to engulf her, she nevertheless also held on to her Western past. Not the least extraordinary feature of Italian art in this earlier phase was its sheer stamina, which through times of barbarism and savagery, neglect and indifference still enabled it to continue and maintain for the West its own links with the past.

As we shall see, all these traditions were drawn on by Carolingian and later artists and their particular impact will be duly recorded. But, in a broader sense, they were to influence the general development of art in the West. The barbarian tradition infused into it a strong feeling for vigorous decoration and a splendid sense of colour and design. The Byzantine tradition offered standards of quality and sumptuousness which awakened the West to emulation as well as to envy. Italian art gave a feeling of continuity and kinship with the late classical and Early Christian past. From all these elements developed the art with which we are concerned in this volume – an art that was European, medieval, and Christian.

This medieval European art was, of course, much more than the sum of a number of influences, and it quickly revealed its own inherent spirit and direction. This – until the transition to Gothic at the very end of our period – was always towards the abstract and the transcendental.

At the beginning of our period in the Carolingian era, it cannot be too strongly emphasized that artists could command an inheritance which included many of the realistic elements of Late Antique art. Already at the outset, therefore, early Carolingian painters could represent weight and mass, register recession in space and perspective in

architecture, convey a feeling of atmosphere, and recapture some of the classical figural styles.[8] But these particular classical elements of realism were discarded rather than developed. The feeling for weight and space was repudiated, the subtlety of atmosphere was changed to the rhythm of pattern, naturalism was schematized and classicism disclaimed.

There is some evidence that when required, artists were always capable of some realistic representation. We know from literary sources that artists could catch a likeness sufficiently well for convincing portraits to be made: one was even used during the twelfth century as a source of identification for the apprehension of a particularly important traveller who was expected to cross the Alps from distant England in disguise.[9] Such likenesses were not intended for posterity, but even among the more formalized pictures that survive, we find portraits which register character as well as representing physical appearance.[10] Such is the eleventh-century portrait of the aristocratic abbot, Desiderius, at Sant'Angelo (Plate 146).

All this, however, is peripheral and even irrelevant to the developments of art between 800 and 1200, for artists then were normally uninterested in realism in the sense of accidental externals. They lived in a world which taught that the real was not the obvious. So, no scholar would take a biblical text at its face value, but would start with the basic assumption that the deeper and really important meanings were to be extracted from below the surface level: the external was only a husk, masking the kernel of the true reality within. In like manner, the artist saw outward appearances as something superficial, if not actually misleading, and so he was unconcerned with mere verisimilitude. His interest was rather to express what he knew lay behind the appearance. The resultant art is an abstract art in the sense that the artist's interest was not physical reality but his conceptions of the spirital and emotional forces behind reality. It is also abstract in a more physical sense, for the figure itself is more and more seen in terms of abstract shapes and forms. Though painting between 800 and about 1150 usually progressed by fits and starts, this basic development was always clear. It was consummated in a European style of great originality and great power known as Romanesque. First formulated in Germany in the late tenth and eleventh centuries, this style became general throughout the West in the twelfth. As an opera composer will treat a libretto simply as an excuse for the melodic rhythms and texture of his musical invention, so the Romanesque artist treated the natural configuration of the human figure simply as an opportunity for embarking on his own abstract melodies in paint. He saw the human form not as a point of arrival but as a point of departure for the exploration of all kinds of abstract shapes and forms. In this regard his art has analogies with the sculpture of, say, Henry Moore today.

At this point we must distinguish between the two main types of painting that will occupy this volume. The first is the frescoes, or wall-paintings, of churches. The second is the paintings or drawings used to decorate or illustrate vellum manuscripts.

Of the monumental paintings that originally filled churches in Europe, comparatively few survive, and even these are often faded or fragmentary or restored. Many were lost during the Middle Ages themselves, when changes of pictorial taste could lead to the

original frescoes being overpainted and when changes of architectural fashion could result in the sacrifice to rebuilding of whole walls with their pictures. Considerably more perished after the Middle Ages. Then artistic indifference to medieval styles led generally to their persistent neglect, religious intolerance in certain countries to their deliberate destruction, and, in the nineteenth century, misinformed restoration to their unhappy mutilation. As against this, immense numbers of manuscripts with drawings and paintings have survived and, since these have normally been shielded from the harmful effects of light, they remain in an unfaded and pristine condition. Many of these vellum-paintings played only a minor and humdrum rôle in the illustration and decoration of texts, but many also were splendid works of art on a scale as large as easel-pictures, and may, quite properly, be used as a basic source for investigating stylistic developments.

The two genres shared the same styles. They did not, however, serve the same purpose. The one was the public art of the masses and the other the private art of the educated. In some ways, the wall-paintings in the churches were the religious equivalent of the poster-art of today, concerned to convey a message. Their primary function was always to instruct and edify. The finest painted manuscripts, however, were also intended to be savoured by the connoisseur for their quality and richness. Among other purposes, they were objects of prestige. From the chronicles of the period we know how highly prized were these *manuscrits de luxe* and how the finest artistic craftsmanship of the time was lavished on them. The medieval observer was quite conscious of the distinct rôles of wall-painting and manuscript-painting. For him what was forbidden to the art of the unlettered masses might be quite acceptable in the art of the literate minority. So we shall see that, in the ninth century, the Carolingians opposed any classical symbolism in the public art of the churches, but permitted such symbolism in the private art of the manuscript page.[11] Again, in the twelfth century the Cistercians virulently attacked decorative and unmeaningful representations in church art but (in practice at least) acquiesced in such whimsies in the more private art of the manuscript.

The patrons of the finest manuscripts of our period were the princes of Church and State: the abbots and bishops, the kings and emperors, who might commission works not simply for themselves but to offer as gifts. And, though there is occasional evidence (as under Charlemagne) of an independent court scriptorium,[12] these patrons, whether lay or ecclesiastical, would normally turn to the monasteries to supply their needs. Until the rise of the universities in the twelfth century, the culture of the West was conserved in the monasteries, and it was here that most of the manuscripts were made. This does not exclude participation by those who were not monks. In the late eighth century, for example, Charlemagne's own court atelier[13] was presumably secular: and there is very occasional evidence of scribes and artists, who were not monks, working in monastic ateliers. So in the eleventh century a picture portrays a secular scribe at work inside the monastic scriptorium of Echternach,[14] and, in the twelfth, one of the most powerful monastic houses of Great Britain had its finest vellum-paintings made by a secular professional.[15] Despite all this, we may safely presume that the vast majority of manuscripts before the mid twelfth century was written and decorated and illustrated by monks in monastic scriptoria.

During all this time, little interest was shown in the actual identity of the artist. The patron – the person who commissioned and paid for the book – was often named and so, too, was the scribe (who was probably the 'compositor' responsible for laying out the manuscript as well as writing it). But (outside Spain)[16] the artist was hardly ever mentioned unless (as with Odbert of Saint-Bertin)[17] he happened also to be the patron.

We cannot apply the same generalizations to wall-paintings as to vellum-paintings. To begin with, there is evidence that, unlike the normal monastic illuminator but like the medieval architect and mason, the most accomplished of the wall-painters might travel quite widely. In the early ninth century we learn of the abbot of Fontanelle sending to the church of Cambrai for a wall-painter named Madulfus.[18] In the tenth century we know that a Trier artist was producing wall-paintings in southern England,[19] and that Tutilo, the celebrated painter of St Gallen, was thought by a later chronicler of his house to have been 'a much travelled man with extensive knowledge of places and cities'.[20] In the early eleventh century Otto III specifically summoned from Italy a painter to execute wall-paintings at Aachen[21] who later passed on to Flanders[22] and, in the same period, another Italian artist was brought to France to make wall-paintings at Saint-Benoît-sur-Loire.[23] From the twelfth century we have paintings of the highest quality which show that some of the most talented English artists of the period were then working in Spain.[24] In this same century a writer was complaining that even monastic wall-painters were always wandering from place to place: though they paint Christian scenes on the wall, he said, they do not apply monastic principles to their lives and adhere to the monastic principle of stability.[25]

It is clear from this comment of Hugh of St Victor as well as from other literary references that some wall-painters were monks. We should, however, resist the idea that all were, and that the monastic manuscript-painter was *ipso facto* a wall-painter. A twelfth-century artist, who called himself Theophilus,[26] has left us a very detailed account of the arts of our period, and from this it is clear that the techniques of manuscript- and wall-painting were quite different. They were two separate crafts, normally practised by two different types of artist. Of course, an occasional monastic artist might be so talented that he could follow both crafts just as other exceptional artists might be both goldsmiths and illuminators. And, as we have seen, some monasteries might have wall-painters of their own. But, despite this, I believe that most wall-painters were non-monastic. Even within the monasteries themselves, we know that the German artist who made the frescoes in the nunnery of Wilton in the tenth century was not a monk but a lay priest. The contexts of the chronicles suggest that Madulfus, who painted the abbey of Fontanelle in the ninth century, and Nivardus, who painted the monastery of Saint-Benoît-sur-Loire in the eleventh, were both outside the Benedictine rule. We can certainly infer that the wall-paintings made at Petershausen in the tenth century were executed by non-monastic painters.[27] We know, too, that an artist named Fulk, who was the wall-painter at the abbey of Saint-Aubin at Angers about 1090, was a layman. He was rewarded with a house and an acre of vineyard for use in his lifetime, and both house and land were to revert to the abbey at his death 'unless he have a son skilled in his father's art and willing to use it in St Aubin's service'.[28] Furthermore, when, in the

twelfth century, one of the greatest monastic centres of illumination in England chose to portray a monumental painter, it represented him as a lay artist.[29]

But, apart from frescoes in the monasteries themselves, there was a whole wide area of wall-paintings in lay cathedrals and lay churches which were completely outside the context of the cloistered monk, whatever his talents as an artist. Our evidence here, it is true, is of the slightest, since wall-painters are so rarely identified in chronicles. However, we do know that the painter used by Otto III at his palace at Aachen in the tenth century had the rank of bishop and was, therefore, presumably a lay-priest. And, when we come to the twelfth century, the signatures on the wall-paintings of Castel Sant'Elia near Nepi[30] would suggest that in Italy wall-painting was already being organized in secular family groupings. The fact that these latter paintings express a style which had probably been formulated in the atelier of a monastery will, however, warn us against the dangers of reading too much into the monastic or non-monastic classification of artists. Whether the actual executants were monks or not, they were expressing an art which had been developed and dominated by monastic tastes and talents. Our period carries the impress of Benedictinism.

This, paradoxically, is true even of the secular art of the times to the extent that it seems to adopt Benedictine styles, even if its message is hardly monastic. At least, the extremely rare secular work of art reflects the styles of religious art. This is evident, for example, in the twelfth-century *coffret de mariage* at Vannes[31] which is decorated with lay scenes of falconing and knighthood and of a youth serenading a lady.

But, here, we are speaking of an area of art which has practically disappeared. If church paintings have suffered much, secular paintings have fared infinitely worse and or obvious reasons. Private art is more subject to changes of fortune than art of an institutional kind. Families die out, or fall into disgrace or debt. Palaces and their fitments change hands. In private, compared to corporate life, the dictates of fashions are more imperative. However, we should at least not forget that in art, as in literature, there existed a whole secular world interested in themes different from those of church or cloister.

That the rooms and chambers of palaces and castles were adorned with paintings and mosaics is clear from occasional comments in secular literature. In the *chanson* of *Girart de Roussillon*, for example, there are references to paintings on the walls of palaces, which also had splendid mosaic representations of stags and bulls and peacocks.[32] The descriptions here remind us of the twelfth-century secular, but Byzantine, mosaics of the Norman palaces of Ziza and Stanza in Sicily, which have similar decorative motifs.[33] Other rooms described in the *chanson* were hung with tapestries or silken wall-coverings so that 'you could see neither wall nor stone nor wood nor lath' behind.[34]

It was because they gave warmth to rooms that figured hangings were often preferred to wall-paintings in secular palaces. As such, they must have been used throughout the Middle Ages, and as early as the eighth-century poem *Beowulf* there is reference to them:

> The wall tapestries shone
> Embroidered with gold and many a sight of wonder
> For those that delight to gaze on them.[35]

One singularly fortunate survival of these secular hangings remains to us from our period. It is the famous Bayeux Tapestry. In pictorial form, this has been shown to be a secular *chanson de geste* following the conceptions and conventions of the French secular epic.[36] Basically, like many *chansons*, it is the story of betrayal and treachery. Harold is cast as the traitor and his treachery is seen at various levels – to Edward the Confessor his own king, to William as his feudal suzerain, and to William as his personal deliverer from danger. The full account of this is unrolled in the main narrative and underlined, as it were, by marginal comments on treachery in the form of carefully selected scenes from fables. The iconography is completely original, the style has pungency and vigour. There is a fluent, almost cinematic treatment of narrative, yet the episode is surprisingly rich in detail. If this, the only secular work of narrative pictorial art to survive from the Romanesque period, does no more, it should at least remind us that not all Romanesque art was religious.

One reason for the survival of the Bayeux Tapestry was that it was deposited before the end of the Middle Ages in Bayeux Cathedral, and such religious protection or association does account at times for occasional survivals of medieval secular art. So the magnificent figured cloaks of two royal figures of our period – the emperor Henry II and his wife Kunigund[37] – survived because their owners became saints and their garments were retained as relics. Because another splendid example of secular figured embroidery was converted into a chasuble and used by St Thomas Becket, it also remains to us today.[38]

This book is concerned with painting, but we should never lose sight of the importance of such embroideries and silks and hangings. Literary sources give them much emphasis, and they were used not only in secular palaces but also in churches and monasteries.

Some of the purely decorative materials have come down to us but we have been rather less fortunate in the survival of the figured hangings which in wealthier churches might take the place of frescoes on the walls and, like them, might represent whole narrative episodes. We hear, for example, of how, in southern Italy, Bishop Athanasius gave to the church of St Januarius great hangings on which the Gospel story was represented;[39] we know of hangings at Liège with allegories of the Old and New Testaments and their concordance;[40] we read of hangings with Old Testament figures at Marienburg;[41] we are told that there were more than enough hangings at Mainz (though here probably decorative rather than figural) to clothe the whole of the monastery on feast days,[42] and the twelfth-century monastery of St Afra and St Ulrich at Augsburg had a number of wall-hangings embroidered with representations of the Christian story and all kinds of theological allegories.[43] The Cistercian complaint against 'pulchra tapetia variis coloribus depicta'[44] indicates how general was this use of rich decorative and figural hangings, and a celebrated Spanish tapestry of the late eleventh or early twelfth century, depicting the Creation of the World, still survives at Gerona[45] to remind us of our losses.

Fabrics, other than wall-coverings, might be used not only decoratively but also to illustrate the Christian message. Altar covers, like the one described at Bamberg, might

be embroidered with the Crucifixion[46] or, like the one mentioned at Zweifalten, with the Majesty and twelve apostles.[47] Further to this, ecclesiastical vestments might themselves be embroidered with religious scenes, such as those originally at Minden on which were represented the passions of St Peter and St Gorgonius.[48] Comparatively few of these figured altar covers and vestments have survived from our period, though the altar covering at Cologne with its representations of the year and its constellations remains.[49] A particularly fine altar cloth of linen of late-twelfth-century German workmanship and displaying scenes from the Life of the Virgin survived at Berlin until the Second World War, when it was destroyed by fire.[50] A more sumptuous altar cloth from Rupertsberg, near Bingen, on the Rhine, which happily remains to us, is worked in silver and gold.[51] It probably belongs to the early thirteenth century but is still Romanesque in style and is of particular interest in its portrayal around the central Majesty of the human figures connected with the church and convent. Some figured vestments also survive. These include a particularly rich eleventh-century chasuble at Bamberg which has scenes of the nativity and related incidents as well as episodes from the lives of the patron saints of Bamberg, St Peter and St Paul.[52] Another magnificent chasuble[53] survived as the coronation mantle of the kings of Hungary. It was commissioned in 1031 by King Stephen and Queen Gisela of Hungary for the church of Székesfehérvár, and its gold embroidery represents Christ surrounded by prophets, martyrs, and apostles.

Before embarking on our investigation of Western paintings of the period 800 to 1200 let us not forget that they had to compete with such figured silks and textiles, which being more sumptuous and costly might well be more highly esteemed, and which might also occasionally influence the styles of the paintings themselves.

CHAPTER 2

ROMAN MOSAICS OF THE NINTH CENTURY

A T the outset of our period Italy was the one area of the West that personified tradition. Politically, it is true, it lacked cohesion and remained, in fact, not a country but a conglomeration of areas of influence or occupation: in the south it was occupied in turn by the Byzantines, the Arabs, and the Normans; in the north it was largely controlled by the new Holy Roman Empire of the West, led first by the Carolingians and then by the Ottonians. It was, however, just because Rome represented continuity, and particularly continuity with the ancient and imperial power in the West, that she was coveted by the new emperors. Rome became a goal because she represented a tradition.

In the artistic field Italy had a tradition which no other country could rival. Indeed, in wall-paintings and mosaics she could boast an almost uninterrupted continuity of pictorial art from the apogee of imperial Rome in the first century to the zenith of papal power in the thirteenth. The sequence of illustrated manuscripts is less continuous, but there still survives in books like the Vatican Virgil[1] testimony to late classical manuscript illustration in Italy, and in books like the St Augustine Gospels[2] early witness to the continuation of this art in the missionary era of Christianity in the West.

This consciousness of her own tradition became particularly articulate in Italian writings of the twelfth century. At this time, as we know, a whole literature was developed in Italy to extol her artistic past and, in particular, we find the emergence of guides for visitors to the various antiquities of Rome. No action during this century of faith expressed the consciousness of tradition so succinctly as the decision of the Roman senate to preserve the pagan column of Trajan and invoke dire penalties for its mutilation. In this context, the comments of a German and an Italian, both writing on the techniques of art in the twelfth century, make an interesting contrast. When the German Theophilus speaks of the remote past, he sees it as a time when art was dormant, for, in his eyes, art could only be fruitful when it was Christian.[3] On the other hand, the Italian writer Eraclius reverses the assessment. For him it is the artistic past of Italy that is significant and the present that is moribund: 'The greatness of intellect for which the Roman people was once so eminent has faded and the care of the wise senate has perished. Who is now able to show us what these craftsmen, powerful in their immense intellect, discovered by themselves?'[4]

Eraclius's reference to the past in his work on the techniques of painting carries with it clear political undertones, for the twelfth century was a period in which Rome tried to assert its ancient independence and actually did set up a new Republic with its own senate and consuls. This was fundamentally a movement against papal temporal power in the city. But, where painting is concerned, it was the popes themselves who had been primarily responsible for maintaining the tradition which led, at the time of Charlemagne's coronation in 800, to Rome being the only city of eastern or western

Christendom with wall-paintings extending back almost continuously to the time of Constantine (306–37) and beyond.

This period between the era of Constantine and that of Charlemagne had not been a happy one for Rome or Italy.

The emperor who had first recognized Christianity as a state religion in the fourth century was also the one who moved the imperial capital from Rome to Constantinople, so that the triumph of Christianity coincided with a shift in the focus of power from West to East. Thereafter Italy, though still under the titular authority of the Eastern empire, was invaded by the Goths in the fifth century and by the Lombards in the sixth, and Rome ceased even to be the effective capital of Italy, being overshadowed by Milan or Ravenna. The Lombards occupied most of northern Italy, though the intervention of the Byzantines in 535 did leave the Eastern empire in control of coastal areas and their hinterlands. However, in the eighth century the papacy had to turn to the Frankish kings north of the Alps for support against the Lombards, and the Frankish intervention which began in the middle of the century successfully culminated in Charlemagne's annexation of the Lombard kingdom. This association of the papacy with the Germanic north now found its famous expression in the creation of the Holy Roman Empire of the West, and (as we have seen) Charlemagne was crowned emperor in Rome on Christmas day, in the year 800.

During all these troubled times the tradition of painting had continued in Rome, and it had continued under the auspices of the papacy.

When the Eastern Christian empire was first seized by the spirit of iconoclasm that was to destroy and forbid Christian paintings for continuous periods between 726 and 842, it was Pope Gregory II who sent to the Byzantine emperor a letter of protest and rebuke,[5] and his successors not only refused to accept the imperial decrees against religious paintings but continued to commission paintings in Rome. Again, when the whole question of figurative art was in the balance in the West and was under consideration by Charlemagne and his advisers, it was Pope Hadrian I who wrote to Charlemagne in 794 in its support.[6] He could point to mosaics and wall-paintings still extant in Rome which had been commissioned by nine of his predecessors between the fourth and sixth centuries.

North of the Alps before the thirteenth century, art gushed forth in sporadic outbursts which are conveniently if inaccurately referred to as renaissances – the Northumbrian renaissance of the seventh century, the Carolingian of the ninth, and the Ottonian and Anglo-Saxon of the tenth and eleventh. In Italy, on the other hand, art continued to flow tenaciously from the time of Antiquity onwards. The stream might at some times be reduced to a thin trickle or to a degraded quality, and at other times be overwhelmed by powerful influences from the East, but at least some tradition of painting was maintained, and maintained largely by an institution whose whole strength lay in tradition – the papacy at Rome.

The inauguration of a new empire in the West by the coronation of Charlemagne brought to the artistic tradition of Rome a quickening of the pulse, an enrichment of the blood. Perhaps the installation of an emperor in Rome for the first time for over three

centuries gave her a consciousness of a new dignity which demanded some extra artistic expression. Perhaps the final repudiation of political dependence on Constantinople by this coronation of Charlemagne brought with it a desire to express more fulsomely the rejection of the artistic policy of iconoclasm which Rome had particularly resented. Be that as it may, we find in the first half of the ninth century a conscious effort to renew in mosaics the magnificence of the great period of Early Christian art in Italy of the fifth and sixth centuries and a conscious resumption of the early compositions. The same spirit inspired even the accompanying inscriptions which followed the self-confident, even self-laudatory style of earlier ones and further added their own classical undertones. The inscription in the apse mosaic of Santa Maria in Domnica on the Coelian, for example, announced that the glory of this work 'shines like that of Phoebus in the universe when he frees himself from the dark veils of obscure night'.[7] Fortunately, since the earlier practice was continued of identifying the pope who commissioned the mosaic or wall-painting by the use of inscriptions and of donor-portraits, this mosaic can be dated within narrow limits – it belongs to the pontificate of Pascal I (817–24).

The pope who crowned Charlemagne emperor, Leo III (795–816), was responsible for considerable artistic activity at Rome. Many churches were restored or embellished by him, and many were adorned with mosaics or frescoes. But, in this context, he is now chiefly remembered for a historical curiosity rather than a work of art. This is a representation of both himself and Charlemagne at the feet of St Peter.[8] From St Peter he receives the pallium and Charlemagne the banner of Rome. Made in 799, when Charlemagne was still king of the Franks and not yet emperor, it originally decorated the Triclinium of Leo III but is now, after a varied career, on the arch of the piazza of the Lateran. Despite restoration in the seventeenth century and the complete removal and remaking of the mosaic in the eighteenth, it is clear that there were rudimentary attempts here at portraiture, for there is a consonance between the portrayal of Charlemagne and his representations elsewhere. The balancing group on the other side of the arch, which represents Christ giving the keys to St Peter and the banner to Constantine, is an eighteenth-century copy of a seventeenth-century addition. Two original heads (now in the Lateran Museum) which survive from the reconstructed apse composition[9] show the original mosaics to have been of first-class quality. Both Leo III and Charlemagne, we may add, were represented in another mosaic in the apse of Santa Susanna, which is only known to us by copies. Here they were shown with Christ, the Virgin, and various saints.[10]

Despite the historical interest of Leo III's mosaics, it is to the activity of Pascal I (817–24) that we are really indebted for our knowledge of the artistic efflorescence in Rome. His work is marked not by a commemoration of the present but by a deliberate return to the past. This is expressed both by the use of mosaics – an art form which had achieved its most splendid expression in the fifth and sixth centuries – and by the deliberate revival in them of Early Christian compositions.

A significant theme for Roman apse mosaics in the fifth and sixth centuries had been that of Christ, who was represented as the God of power surrounded with mystic symbols of the future life and of immortality. The finest example in Rome is in the

early-sixth-century apse of SS. Cosma e Damiano (Plate 1).[11] Here the standing figure of Christ dominates the apse. He holds a scroll in one hand and raises the other hand aloft. The Roman apostles St Peter and St Paul approach from each side to present to Him the saints Cosmas and Damian who bear, as tributes, their martyrs' crowns. Another martyr, on the right, proffers his crown and the patron of the basilica, Felix IV (526–30), holds out a model of the building itself as his papal tribute. Palm trees on either side symbolize Paradise or the victory of martyrdom, and the phoenix over one signifies immortality. The paschal lamb below is approached on each side by six sheep which represent the apostles and which emerge from the two symbolic cities of Jerusalem and Bethlehem (the first signifying those converted from the Jews and the second those converted from the Gentiles). On the arch was represented apocalyptic symbolism – the twenty-four elders proffering their crowns, the Lamb of God on the throne, the book with the seven seals, the seven candlesticks, and the apocalyptic symbols of the evangelists. The whole made up a message of celestial power and celestial promise.

This Early Christian composition is one which influenced two apses made under Pascal and another made under his successor.

His apse composition of Santa Prassede (Plate 2)[12] follows the earlier one almost exactly. The identities of the saints and the pope have, of course, been changed to relate them to a different dedication and a different donor, and here St Praxedis and St Pudenziana are presented to Christ and the donor holding the model of the church is Pascal I. But there is the same grouping of figures, dominated by Christ in the centre set against a background of clouds. There is the same mystic symbolism of the palm trees, the sheep, and the allegorical cities, and even the apocalyptic symbolism on the apsidal arch closely adheres to the composition of SS. Cosma e Damiano. The same apse composition with its accompanying symbolism is repeated in Pascal's apse mosaic of Santa Cecilia (Plate 3) (which originally included apocalyptic symbolism)[13] and again in the apse mosaic of San Marco (Plate 4) by his successor Gregory IV (827–44).

We find this reaching back into the past in other mosaic work of the period. For example, in the chapel of San Zeno (also at Santa Prassede) which Pascal erected as a tomb to his own mother, the mosaic bust of Christ in a medallion supported by four diagonally placed angels (Plate 5) exactly repeats the sixth-century composition of the archiepiscopal palace at Ravenna.[14] On the exterior wall, the sequence of medallions, set in two semicircular compositions and containing busts of Christ, the Virgin and Child, apostles and martyrs,[15] also finds a very close parallel in the fifth-century mosaics of Santa Sabina, now only known to us by copies.[16] Yet another of Pascal's productions was the apse mosaic of Santa Maria in Domnica on the Coelian hill[17] which was inserted when he reconstructed the ancient basilica. And here the shimmering files of apostles approaching each side of Christ above the apse and the Virgin and Child surrounded by a choir of angels in the apse itself are elaborations of themes already stated in the sixth-century mosaics of Poreč (Parenzo).[18]

It cannot be pretended that in this minor efflorescence of the first half of the ninth century there was a renewal of early styles as well as of compositions. They make no attempt to recapture the spaciousness and breadth and sculptural qualities of, say, the

mosaics of SS. Cosma e Damiano. Some of them – like those of Santa Cecilia and San Marco – have a certain frigidity. Others – like those of Santa Maria in Domnica – have a looser, more linear quality. This may derive from Lombard art, for, though little is known of the painting of the Lombard kingdom, its sculpture does show a strong schematism and affection for linear proliferation.[19] Yet, it also follows a historic trend, for the whole history of painting and mosaics in Italy had shown a steady linearization of Early Christian styles and a deflation of the structure of the body in the interests of the abstract, the ethereal, or the purely decorative. This is already very clear in the sixth-century mosaics of San Vitale at Ravenna and in the seventh-century mosaics of the Roman Oratory of St Venantius. It is this tradition that is continued and even consummated by the mosaics of Santa Prassede,[20] which are of the greatest importance not only because they are the second largest cycle of mosaics extant in Rome, but also because they compare in quality with the Roman mosaics of any period. Here the drapery styles are clearly Early Christian in inspiration and relate in many ways to the sixth-century mosaics of the archiepiscopal palace of Ravenna. The figures themselves still have all the pose, dignity, and tranquillity of the earlier period. However, the process (already clear at Ravenna) by which the physical bulk of the figures has been slowly emptied away reaches a new level, and no attempt at all is made to register sculptural qualities below the draperies. The resultant incorporeal tone is one that is spiritual, tender, and almost elegiac. Sensitively drawn against their backgrounds of gold and deep colours, these figures are like a gentle threnody on a departed age.

Such mosaics are not completely devoid of originality: the depiction of the New Jerusalem on the triumphal arch of Santa Prassede, for example, seems quite new. Yet, when all reservations have been made, we can detect in these papal mosaics of the first half of the ninth century an absorption in the past which (though in a minor key) is almost as self-conscious as Charlemagne's political restoration of empire.

THE CAROLINGIAN RENAISSANCE

Its Significance

A CONTEMPORARY of Charlemagne said of him that 'he made his kingdom, which was dark and almost blind when God committed it to him . . . radiant with the blaze of fresh learning hitherto unknown to our barbarism'.[1] The historian may be inclined to read such a passage with caution if not scepticism. But where the visual arts are concerned, this would be unjustified. If we apply this remark to the arts on the Continent north of the Alps, then it is an apt enough description of the Carolingian Renaissance. From the aesthetic point of view, the preceding centuries in the Frankish dominions had been almost sterile. Quite unexpectedly a 'blaze' appeared which lasted more than a century – from the accession of Charlemagne as King of the Franks in 768 to the death of the emperor Charles the Bald in 877.

There had of course been earlier renaissances. Rome had had its renaissances (as, for example, under Augustus and Hadrian), when Roman art had turned for inspiration to Greece as later ages were to turn to Rome. Then in England, during the so-called Dark Ages, there was the Northumbrian Renaissance of the seventh century which was itself a significant factor in kindling the literary culture of the Carolingian Renaissance and which also had some influence on its art. What is remarkable about the Carolingian Renaissance is that the Franks, a people virtually without an artistic tradition, suddenly produced art of high quality in various media and sustained it over a number of decades. Under the earlier Merovingians,[2] it is true, missionaries from the British Isles had installed pockets of art on the Continent[3] at centres like Echternach and Fulda, but the native art had remained primitive, and, despite occasional exceptions, such as the Luxeuil manuscripts, surviving evidence suggests that Merovingian painting consisted primarily of gaudy and laborious drawings and initials, sparse in quantity, coarse in quality, and of little aesthetic merit. Now, under Charlemagne and his successors – as we know from literary sources[4] – the churches and palaces were filled with monumental paintings of a very elaborate kind. We find metalwork of a high quality and splendid painted manuscripts and carved ivories in abundance. When, in fact, we see the number of ivory carvings and painted manuscripts that survive and bear in mind the ravages of time and the destruction wrought by the Norman and other invasions, then the sheer artistic output of the Carolingians must itself surprise us. All this was to provide the basic traditions of medieval art in Northern Europe. But to Charlemagne and the Franks we owe even more. To them we owe the very possibilities of any European art at all.

This may seem a large claim but there can be little doubt that, if the Arabs had not been checked by the Frankish leader, Charles Martel, at Poitiers in 732 and had gone on to occupy large areas of the West, then 'Europe' would have been denied artistic expression as we now understand it; for the Arabs forbade figural art, since it was the

view of their Moslem theologians that the creation of figures in terms of art was a blasphemy on the supreme Creator. Then again, when Charlemagne was still only king of the Franks and not yet Holy Roman Emperor, he was confronted with an attack on artistic expression, possibly itself influenced by Arab feeling but coming from a different direction – from Byzantium, which was periodically swept by waves of iconoclasm. This iconoclasm was an attack on all forms of religious representation and was based on the fear that the people who venerated the pictorial representation might be guilty of idolatry, since they might confuse the picture with what it portrayed. One such period was during the eighth century, when religious pictures were officially condemned in Byzantium between 726 and 787. The whole question of whether the Western Church should allow religious representation or not was explicitly raised with Charlemagne after 787, and it is a crucial landmark for art in the West that the barbarian Frankish king, who then dominated Latin Christendom, should have decided to support religious painting. Had he not done so, then Europe might have become another civilization, like that of the Arabs and the Jews, devoid of figural art. After all allowances have been made for the pressures in its favour from the Roman Church and the Roman past, the decision was still remarkable when we remember that there was virtually no tradition of figural art in Charlemagne's homeland.

This Western policy was enunciated in a long treatise, known as the *Libri Carolini*,[5] and imbued with a spirit of moderation which was itself to give permanence to Charlemagne's decision. In the Eastern Church it was the association of religious painting with image worship that caused the fluctuations of policy which led to figural religious painting being now suppressed and now allowed. By rejecting all notions of the veneration of religious pictures Charlemagne insulated art from these emotional overtones and so saved Europe from the reversals of policy in Byzantium which could always lead to the rejection and destruction of paintings even after a period of acquiescence. To adore pictures, he said, is to confuse the material picture with the immaterial thing it represents. To destroy them is to show an insensitiveness to beauty and a lack of appreciation of their educative powers.

The *Libri Carolini*, or Caroline books, are of further importance since they provide us with the most comprehensive statement of medieval attitudes to monumental painting and one which will dominate the future. Briefly, the functions of painting (and, here, wall-painting is always meant) were said to be decorative, dogmatic, and didactic. Painting will create a beauty that may raise the soul to the divine beauty of Christ. But, more immediately and more importantly, it will illustrate the dogmas of the Christian faith, and by representing episodes from the Bible and the lives of the saints will give the spectator an opportunity to learn, recall, and contemplate the Christian message. Such a viewpoint had, it is true, already been anticipated by the early Fathers of the Latin Church, who saw painting as a general support of the faith,[6] but it was the authority of Charlemagne that gave new currency to this conception and made it acceptable throughout the Middle Ages. The viewpoint of the *Libri Carolini* became the traditional one of the Middle Ages.

In the light of the semi-missionary function attributed to painting by the *Libri Carolini*

we should do well to remember how recent was the Christianization of some parts of the Frankish kingdoms which were later to merge into the Carolingian empire. In particular, we should recall that the Christianization of central and northern Germany had only been begun by the Anglo-Saxon missionaries a hundred years before, in the seventh century, and had continued well into the eighth: in fact, the greatest of these missionaries – St Boniface – had been martyred in 754, only twelve years before Charlemagne's own accession. In view also of the Frankish attitude that painting was to instruct and illuminate faith as well as to awaken it, we should bear in mind another of St Boniface's activities. Apart from his missionary work St Boniface had been a great reformer of the Frankish Church, and, in one sense, painting should be seen as a concomitant of the ecclesiastical reforms inaugurated by him which reached their apogee under Charlemagne himself.

Wall-Paintings

We know from contemporary sources of Charlemagne's concern with wall-paintings in churches and of how his agents – the *missi dominici* – who were sent throughout the empire were instructed to report on their condition.[7] We also know something of their subject-matter, despite the fact that so few survive. This we owe to the current practice of identifying the subject-matter of paintings by inscriptions – a point on which the *Libri Carolini* had insisted for fear that there should be any confusion of interpretation.[8] Many of these inscriptions or *tituli* were recorded and have come down to us even where the paintings have not. From these, it is clear that church paintings followed the conventional precepts of the *Libri Carolini* and represented scenes from the Bible and portrayals of saints or episodes from their passions.

So, we learn that Charlemagne had the church of St Mary the Virgin at Aachen decorated with scenes from the Old and New Testaments[9] and that his successor, Louis the Pious, also had incidents from the two Testaments illustrated at Ingelheim.[10] Normally episodes from the New Testament by itself were preferred, as at Dijon[11] and St Gallen.[12] Pictures of Christ either by Himself or with evangelists or apostles were also not infrequent. Representations of saints and episodes from their lives were popular, too, and these included at Holzkirchen a painting of the martyrdom of the Anglo-Saxon missionary St Boniface.[13]

The numerous surviving descriptions and *tituli* are almost all religious; even the few secular ones may have had religious overtones. So, when we read a description of a picture of the seven liberal arts which decorated Charlemagne's palace at Aachen,[14] we should remember that the seven liberal arts were normally considered the basis of the study of theology itself. At first sight, the paintings of the great heroes of the past which decorated Louis the Pious's palace at Ingelheim[15] appear to be simply secular themes but, in fact, they reflected the Christian view of history proposed by St Augustine and elaborated by Orosius: on the one hand the pagan leaders who had brought so much pointless bloodshed into the world, men such as Romulus and Remus and Hannibal and Alexander: on the other, the Christian leaders whose wars were to bring pagan peoples

into the Christian fold – Constantine and Theodosius, Charles Martel, Pippin, and Charlemagne.[16]

The literary sources suggest that Carolingian wall-paintings were widely dispersed, though, in view of all the later vicissitudes of Europe, it is understandable that only a handful has survived. Even these are either fragmentary or restored. They do, however, confirm what we should expect, namely that there was a considerable dependence on the traditions and expertise of the one country of the West that had always cultivated wall-paintings or mosaics – Italy.

As it happens, the earliest surviving example of Carolingian monumental art is a mosaic. We know from contemporary accounts of other, more famous, Carolingian mosaics, such as the representation of the twenty-four elders of the Apocalypse around the enthroned Christ in the dome of Charlemagne's private chapel at Aachen,[17] but this is the only Carolingian mosaic that has come down to us. Even this has suffered mutilation under the guise of restoration during the course of the nineteenth century. The mosaic is at Germigny-des-Prés (Plate 6),[18] where it originally decorated the private chapel of the country residence of Theodulf, Bishop of Orléans (799–818). In terms of style, it has been influenced by Roman mosaics similar, for example, to those of the Oratory of Pope John VII of the eighth century. (Stylistic comparisons have, it is true, been made with figures of Charlemagne's Court School of illumination[19] and, in particular, with those of the Harley Gospels, but the apparent similarities here are due to the Italian ingredients in each style.) In terms of subject-matter, it represents the Ark of the Covenant, on which are set two golden cherubim with God's hand above (Exodus 25) and with an angel in adoration on either side (1 Kings 6). Now, this theme was much discussed in the *Libri Carolini* in relationship to the Byzantine proposition made at the second Council of Nicaea of 787 that the Old Testament account of the ark and the cherubim signified biblical approval for the veneration of images. This the Carolingian theologians opposed, for they argued that these works of art were unique, being inspired by God and the Holy Ghost, and that what was permissible here could never be extended to works of art that were simply man-made. The representation of this theme in the apse of a chapel which might normally be expected to contain a Majesty or biblical scenes may, therefore, carry deliberate undertones of attack on the whole Byzantine position. And this would not be entirely surprising in the context, for Theodulf was a Visigoth from Spain who may well himself have been influenced by the sentiments of his homeland, which was still dominated by Arabs who were opposed to 'images' of every kind.[20] We know that he eschewed the representation of divinity or figurative art of any kind in his illuminated manuscripts.[21] Furthermore, the other works of art that literary sources[22] tell us he commissioned were either decorative, such as his mosaic pavements, or allegorical, such as his murals depicting the four seasons and the seven liberal arts. There may, however, be yet other undertones to his portrayal of this particular theme.

Originally the ark and the cherubim were the focal points of the temple projected by David and built by Solomon: 'He made also in the house of the Holy of Holies two cherubims of image work: and he overlaid them with gold. . . . And they stood upright

on their feet, and their faces were turned toward the house without. He made also a veil of violet, purple, scarlet, and silk: and wrought in it cherubims. . . . And the priests brought in the ark of the covenant of the Lord into its place: that is to the oracle of the temple, into the Holy of Holies under the wings of the cherubims; so that the cherubims spread their wings over the place, in which the ark was set and covered the ark itself and its staves' (II *Paral.* 3, 12–14 and 5, 6–8). The selection of this very theme for Germigny-des-Prés may then carry with it the suggestion that this private oratory of Theodulf was to be seen as a new temple of David or Solomon.[23] All this would be in accordance with what we know of the attitudes adopted by the Carolingians towards the Israelites which saw Charlemagne as a new David and which we shall discuss more fully later. In this context, it cannot be too strongly emphasized that the chapel at Germigny-des-Prés was the personal and private chapel of one of the eminent members of Charlemagne's own court and might therefore permissibly reflect personal and aristocratic attitudes. Elsewhere, in churches intended for public use, we find a close adherence to the themes suggested in the *Libri Carolini*, that is illustrations from the Bible or from the lives of saints. This is true, for example, of Saint-Germain at Auxerre[24] where, in the west crypt, we find the only Carolingian wall-paintings to survive from the western part of the empire that was later to become France.

They belong to the second half of the ninth century and probably to the third quarter. The main sequence of paintings shows three episodes from the martyrdom of St Stephen. He is first seen brought to trial, then preaching to the Jews (Plate 7), and then stoned to death as he turns with outstretched arms towards the hand of God. The four nimbed bishops also depicted probably represent saints buried at Saint-Germain. The style has freshness and vigour and is related to the manuscript-paintings of the Court School of Charles the Bald (formerly known as the School of Saint-Denis) which we shall discuss later. Charles the Bald, who was lay abbot of Saint-Denis, in fact had close ties with Saint-Germain. He often resided there, took a prominent part in the translation of the body of St Germain, gave many donations to the abbey, and even sent his son Lothar to be educated at its school.[25]

Passing farther east to the area which is now Switzerland, we go from fairly securely dated wall-paintings to murals difficult to date because of the lack of comparative material. They are in the Johanneskirche at Müstair in the canton of the Grisons.[26]

No wall-paintings of the Carolingian period contain such profusion of illustration. The whole interior of the church is painted. The chancel arch is decorated with a picture of the Ascension, with the sun and moon in medallions, and with groups of standing angels and kneeling apostles. Each of the vaults of the three apses contains representations of Christ – Christ investing Peter and Paul in the northern one, Christ with angels in the centre, and Christ with saints and evangelist symbols in the southern one. The apses are also decorated with episodes from the lives of St John the Baptist, St Peter, St Paul, and St Stephen. The walls of the nave have a cycle of scenes from the lives of David and Absalom and some sixty-two episodes from the New Testament. (The David cycle, being above the Late Gothic vaults, was not overpainted like the rest in the later twelfth century and was transferred before the First World War to the Landesmuseum at

Zürich, where it still is.) The scenes are set within decorative borders, some filled with perspectival meander patterns and some with mask-heads at the corners. The more delicate colours are much faded, so that today the heavy browns and muddy greens predominate and it is difficult to make aesthetic assessments of the paintings as they originally were. It is quite clear, however, from the heavy modelling of the faces in green and from the occasional pearling of borders and draperies, that these pictures are closely related to Italian painting of the period, if not actually made by an Italian artist.

There are other paintings in a chapel dedicated to St Benedict at Mals (or Malles) in the Italian Tyrol,[27] which was once a dependency of the monastery of Müstair. The north wall has two zones of paintings of which the lower has almost entirely perished. The upper contains scenes from the life of St Paul and a representation of the martyrdom of St Stephen with four tonsured figures, of which one can be identified as St Gregory. The east wall contains pictures of Christ, of Gregory the Great, and of St Stephen. It also has a picture of a robustly represented secular figure in contemporary dress with both hands held on its sword in front (Plate 8). Presumably this is the donor. If so, this is a particularly impressive example of a donor portrait. The stylistic elements of the painting suggest a date about the mid ninth century and indicate that Frankish artistic influences were themselves now reaching northern Italy to mingle with the indigenous traditions.

The more primitive paintings of Naturno (or Naturns),[28] also in the Italian Tyrol, reflect northern influences still more strongly. More like outline drawings in red, blue, and black than paintings, they find their most natural relationship with the early manuscript-paintings of Salzburg, which were strongly influenced by the missionary art from the British Isles, and which we shall discuss later. The main surviving scene is that of St Paul making his escape from Damascus by being lowered over the wall in a basket. Though not without a certain childlike vigour, it is a peasant art without pretensions. Stylistically, it seems to belong to the end of the eighth or the early ninth century, though there is no knowing how long rustic art of this kind may have survived in isolated villages.

Farther north, on the soil of present-day Germany two buildings attract attention. The first is the Torhalle or Solarium of Lorsch.[29] This has, in the upper floor, restored *trompe l'œil* architectural wall decoration with painted columns, bases, Ionic capitals, and moulded architraves. During excavations a few fragments of heads comparable to the eighth-century parts of Santa Maria Antiqua in Rome were found in the crypt, but they may not belong to this particular building. The second is the crypt of St Maximin at Trier.[30] Here, on the wall facing the altar (over which a large Crucifixion is depicted), two columns of nimbed male and female figures carry palms under a colonnade (Plate 9), and painted figures in the vault include a standing prophet and two seated evangelists. Iconographically, they derive from an Italian tradition of monumental paintings or mosaics. Stylistically, however, their linear quality relates them to Carolingian illuminated manuscripts.

It is indeed to these manuscripts rather than to the frescoes that we must look for any assessment of styles in Carolingian painting. The wall-paintings are certainly of interest,

but their condition is too poor or restored to enable us to savour them, and their survival too haphazard and fragmentary for us to be able to treat them as reliable stylistic evidence.

Differences between Manuscript-Painting and Wall-Painting

We have earlier seen that manuscript-paintings survive in far greater numbers and better condition than the frescoes of our period and therefore provide a sounder basis for an understanding of the various styles. Complete reliance on them is quite permissible, since the two arts shared the same developments though they did not share the same rôles.

In the Carolingian period, the private and privileged art of the manuscript served a very different function from that of the public art of the wall-painting. Its subject-matter was naturally more varied, since it was related to so many differing texts, but, even within the same range of interest – within the compass of biblical illustration – it reversed the propensities of the frescoes and gave just that emphasis to the Old Testament that the frescoes gave to the New. There are, it is true, New Testament narrative scenes in Carolingian manuscripts, but these are few in number and usually small in scale; they are abbreviated in presentation and, indeed, more concerned with New Testament commentary than the New Testament text. Where Old Testament illustrations are concerned, attitudes are different. The pictures are large, expansive, and extensive, and show a lively interest in the portrayal of Israelite times. It might be argued that these manuscripts were made for the lay and ecclesiastical princes who had no need of the simple truths of the Gospel story that were conveyed to the unlettered populace in church paintings. But some explanation is still needed for this bias away from the New Testament towards the Old. It can hardly be explained by a residual fear of image worship, since pictures of Christ in Majesty and of the Evangelists were, in fact, made. One conceivable reason was that German Christianity remained essentially a religion of power long after the missionary period when particular stress was laid on this element of the Christian religion, and that this emphasis was sustained by an awareness of the forces of Islam in the West and of paganism in the East. There was certainly a preoccupation with the strength and power of God rather than with His humanity. He was referred to as 'the omnipotent ruler' before whom the powers will tremble,[31] and was clearly envisaged more in terms of the divinity of the Old Testament than of that of the New. Even this, however, hardly explains the different attitudes taken up in the public art of the frescoes and the private art of the illumination.

The real answer must lie in the association that the educated Franks saw between themselves and the Israelites. After their conversion, the Franks considered themselves to be replacing the former tribes of Israel in God's special care and protection. This attitude was already implied in their own *Lex Salica*,[32] and it was a viewpoint flattered by the Church and celebrated in literature and art. So, at their consecration, the sacring of the Frankish kings was related to that of Samuel and David[33] and, in the Gellone Sacramentary, their deeds were compared with those of David.[34] Popes and churchmen likened the Frankish rulers to the rulers of the Israelites. Charlemagne was often referred

to as David and given by Alcuin the *nomen* of David (i.e. not simply his name but his honour and dignity).[35] 'Blessed be our God who has allowed my eyes to see a second King David,' wrote Pope Stephen V to Louis the Pious,[36] whose family was carefully related to other Old Testament figures by Walafrid Strabo.[37] Another pope spoke of Charles the Bald as Solomon,[38] and elsewhere he was also referred to as David.[39] In literature, to take but one example, Otfrid in his *Ad Ludovicum* expatiated on the relationship between the Frankish king, Louis, and David.[40] In art, we know that the imperial throne at Aachen was made according to the description of Solomon's throne,[41] that Aachen Cathedral was compared to the temple of Solomon by Alcuin and Notger,[42] and that (as we have seen) a more oblique but comparable association may have been attempted at Germigny-des-Prés by Theodulf. In both the paintings and the dedication verses of imperial manuscripts the association between the rulers of the Franks and the rulers of the Israelites was given emphasis and point.[43] All this expressed in various ways a deep emotional identification derived from the times when the religious needs of the Franks were largely tribal, but it also had a political convenience for the Carolingians, since their own seizure of power from the legitimate dynasty might seem to be condoned by David's similar action in Old Testament days.

Just as pronounced as the differing attitudes of wall-painting and manuscript-painting to the biblical Testaments was their attitude to classical influences. The art of the educated minority was not to be subjected to the same restraints as that of the unlettered majority.

The *Libri Carolini* explicitly and fulsomely condemned the use of classical representations in wall-paintings. Such pagan imagery as river gods, earth gods, personifications of the sun and moon, monsters like centaurs, and naked or semi-naked figures were vigorously attacked because they were pagan and contrary to the scriptures.[44] In the field of vellum-painting, however, these were all happily accepted, and Carolingian illumination contains a wealth of classical symbolism. The Utrecht Psalter,[45] for example, is replete with classical allusions – personifications of the sun and moon, of river gods, the earth, the winds, night and day, classical atlantes, classical statues, classical aqueducts, and a representation of the machine used for casting lots in the original classical games. A Carolingian illustrated encyclopedia (which is only now known by a later copy)[46] even includes a detailed representation of the whole Pantheon of classical gods. Manuscript-painters went still further and made direct copies of classical pictures. An illustrated manuscript of the plays of Terence[47] is obviously made from a late classical prototype, and its numerous pictures (see Plate 10) in which the actors wear the original classical dramatic mask as in the paintings of Pompeii quite clearly derive from an authentic tradition of Antiquity. An illustrated calendar (now known to us only by copies; Plate 11)[48] has drawings of Roman consuls, of planetary deities, and of Antique representations of the months, all in an unmistakably classical and pagan style. As we know from the internal evidence of the text, it was copied from a late classical prototype which can be dated to A.D. 354. Pictures of the pagan personifications of the constellations in another Carolingian manuscript[49] must derive from another fourth-century source, but transmit with remarkable fidelity the earlier illusionistic style of Pompeii as we see from the painting

of Eridanus (folio 10 verso; Plate 12). The classical pictures which illustrate yet another Carolingian astronomical manuscript[50] seem more in keeping with a society that venerated Jupiter than with one which worshipped Christ and they give surprisingly authentic representations of the heroic gods and nubile goddesses (here represented by Andromeda, Plate 13) of Antiquity.

It is important to notice in the private field of manuscript-painting this tolerance towards those classically inspired pictures which were frowned on in church frescoes. Still, we should not overestimate the artistic significance of such overtly 'classical' paintings, for they tended to be particularized in their application. They usually occurred, in fact, in those manuscripts where the illustrations were clearly an extension of the text: for example, where an astronomical text was illustrated by pictures of the constellations. Here, the original illustrations were retained for educational and scientific purposes, and the classical pictures were copied with the same scrupulousness as the classical text. But, despite all this, their classical styles were really alien to the Carolingians. These pictures in fact were simple 'facsimiles', and there was no development from them. It was not as harbingers of the medieval future that they are important but as reflections of the vanished past.

The vanished past from which this 'facsimile' art derived was that of Late Antiquity (which may here be generally taken to be the fourth or fifth centuries). The more allusive classical symbolism often derives from an art of an even later period, for many classical ingredients had been early absorbed into Christian traditions which themselves transmitted classical symbolism to the Carolingians.

There were, in fact, both emotional and historical reasons why it was the very Late Antique and subsequent periods that provided the Carolingians with their classical material. To begin with, however much a small coterie of intellectuals might indulge in symbolic reference, the general body of Carolingians – like the writers of the *Libri Carolini* – could never quite forget that classical art was pagan and, in a Europe which still had areas that were pagan and idolatrous, this had overtones which only disappeared at a later stage of history. Then, like most styles and symbolism, those of the classical world were chiefly transmitted by illuminated manuscripts. The parchment manuscript was, in fact, introduced into the classical world in the second century,[51] but it only gradually superseded the roll or scroll and was not securely established before the fourth century – certainly no illuminated manuscripts survive from before this period. As it happens, this fourth century was also the century in which the Roman empire became Christian and its art could find ready Christian acceptance. So art of the fourth century and after was both more available and more eligible than that of any earlier period.

Charlemagne's Rôle

Manuscript-painting in the Carolingian period was mostly cultivated in the monasteries, which remained the fortresses of culture for most of our period. Here were developed schools of painting which might influence each other, but which would yet develop at a different pace and in a different direction, according to the enthusiasm and interest of a

particular abbot and the artistic models and talent available in his community. Carolingian art was essentially a federal art in the sense that it was uncentralized and nourished at various independent centres. Yet, despite all this, Carolingian painting owed its origin and being to the central personality of Charlemagne, and the earliest and most splendid school of manuscript-painting was at his own court.

Charlemagne's encouragement of painting was, no doubt, due to a number of reasons – a belief in its educative power, a consciousness of the prestige it would bring his court and empire, a feeling, perhaps, of association with the days of early Christianity. But, whatever the reasons, he was the first mover. And, as in the Middle East today, the potentate of a newly rich state who is ambitious to stimulate scholarship must necessarily turn abroad for his sources of scholarship, so Charlemagne also had to draw both his scholarship and artistic resources from elsewhere. In this he was so successful that he was able to divert to the heartland of his empire streams of art from abroad, which both fertilized the arid soil of his own period and formed a sufficient reservoir for the future. But one inevitable result of all this was that Carolingian art, particularly in its early stages, exhibited a mixture of disparate influences from different areas and periods.

As we have already seen, there were three traditions of painting available to Charlemagne and the Carolingians – the Anglo-Irish, the Byzantine, and the Italian.

There were natural associations between the Carolingians and the Anglo-Saxons, for from this latter race the Franks received not only the missionaries who converted their lands north of the Main but also the saint who was to reform their church and the scholar who was to become Charlemagne's chief adviser. Moreover, pockets of Anglo-Irish art were already to be found on Frankish soil, whither they had been brought by English and Irish missionaries. In a general sense, one cannot overestimate the importance of the Anglo-Saxons in transmitting to the Carolingian territories their own firm conviction of the necessity for manuscripts and the desirability of handsome and beautiful ones. But, in a more limited sense, the Anglo-Saxon art of the Northumbrian Renaissance was ill-suited to Carolingian needs, since it was primarily an art of decoration, little interested in the figural painting which was necessary for the narrative or pictorial scenes of church and manuscript. It did play some part in the Carolingian Renaissance, but its influence was almost completely confined to decoration. This is seen in many areas of the empire, but is found at its most concentrated in the area which is now North-East France, where the Franco-Saxon School (as it is known) was developed. This cultivated the Northumbrian style of decorative interweave and interlace and its original centre was Saint-Amand.[52]

In Byzantium, on the other hand, a figural art had been developed of considerable sophistication. Despite the interruptions of iconoclasm, it had for centuries been perfecting the means of expressing the Christian message which it renewed by continual recourse to its own Hellenistic traditions. Its court art, moreover, had a sumptuousness and prestige which the West always envied, and there can be little surprise if we find Byzantine influences strongly represented in the West.

Italy, as we have already seen, had also conserved a tradition of figurative art, and the papacy had felt so passionately about this that it had broken with the Eastern empire

rather than accept the consequences of iconoclasm. Here, in north and central Italy, was an area under Carolingian patronage and protection: an area enriched by the art of the East but supporting the new empire of the West; an area whose great cities of Rome, Ravenna, and Milan recalled the glories of Early Christianity; an area which, in exchange for present protection, could offer access to past traditions. In his own personal court art, Charlemagne made use of the three traditions available to him, but this was the area to which he primarily turned.

The Court School of Illumination[53]

While Charlemagne was still only king of the Franks and long before he was made emperor in 800, art at his court had already reached a high level of achievement. It was represented by two distinct groups. Because of a reference in one manuscript to a certain 'Ada ancilla Dei',[54] the first is traditionally known as the Ada School;[55] the second is usually referred to as the Palace School. The two styles are not only separate but divergent, yet they both owe their presence at Aachen to Charlemagne's personal interest and they both expired with Charlemagne's own death.

Of the Ada group, nine manuscripts – a Psalter, a Gospel Lectionary, and seven Gospel Books – have survived,[56] together with a fragment of a Gospel Lectionary. The earliest is the Godescalc Gospel Lectionary begun in 781 and completed in 783 (Bibliothèque Nationale nouv. acq. lat. 1203; Plate 15), to which is stylistically related a Gospel Book from Saint-Martin-des-Champs now in the Arsenal Library, Paris (MS. 599; Plate 16). The finest are the Ada Gospels at Trier, whose illumination is not all of the same date, for the portraits of the evangelists are later than the rest (Trier, Stadtbibliothek cod. 22; Plate 17),[57] the Harley Gospels belonging to the last decade of the eighth century (British Museum MS. Harley 2788; Plates 18 and 19), the Soissons Gospels (Bibliothèque Nationale lat. 8850; Plates 20–2),[58] and the Lorsch Gospels now divided between the Biblioteca Documentara Batthayneum, Alba Julia, Romania (Plate 54), and the Vatican Library (cod. Pal. lat. 50; Plate 23).[59] As befits a royal court, these manuscripts are all costly and luxurious. They are lavishly written in gold and silver (a practice already known to Early Christian, Byzantine, and Anglo-Saxon art), and they have gorgeous decorative pages and sumptuous full-page pictures in which the rich golds are set off by deep, warm colours. Compared to the poverty and crudity of Merovingian painting of the past, this new resplendence is like a sudden beacon. It seems at first an art without a past and without a parentage. And as far as the Frankish homelands are concerned, this is true; for it is to Great Britain and Italy that we must turn for an understanding of its pedigree.

The decoration consists primarily of frontispiece pages to the individual Gospels (Plate 16) and of elaborate canon tables at the beginning of the manuscript itself (Plate 20). The focal point of the frontispiece page is the intricate and elegant initial to the text, which is followed by the introductory words in a clear and beautiful script, the whole being enclosed in a decorative frame. Much use is made of gold, which is often set off by rich purples, and this combines with the clarity and precision of outline to give a frequent effect of cloisonné enamel rather than of painting.

It is from Anglo-Saxon sources that much of the actual decoration derives,[60] not least in the presentation of the great introductory initial with its segmented forms, its bold contours, and its fine, decorative infillings of intricate and delicate interlace. Very occasionally, these initials contain tiny scenes such as the Annunciation to Zacharias (Plate 18) or to Mary, or the Christ in Majesty found in the Harley Gospels. Yet even these historiated initials (as they are technically called) have Anglo-Saxon precedents. We find them, for example, in the Vespasian Psalter, made at Canterbury in the early eighth century.[61]

There is more, however, to this sumptuous decoration than the transference of British art to the Continent, for this art itself was modified by influences from Late Antiquity.[62] These Late Antique influences are evident in the intrusion of certain decorative forms from the classical period. Such, for example, is the architectural framework, composed of classical marbled columns supporting classical capitals of acanthus leaf, in the Soissons Gospels (Plate 20). But they express themselves more fundamentally in the fact that these decorative pages are now interpreted in terms of classical perspective which completely transforms the British styles. The painting of the British Isles had shown all the qualities of fine metalwork – precision, delicacy, fastidiousness, and elegance. However, it also had the limitations of metalwork – it was an art of surface decoration. Now where these Carolingian manuscripts are concerned the third dimension enters in, and the eye not only explores the initial and its surface space (as in British art) but also looks into and through it. In manuscripts like the Soissons Gospels there is a sense of space between the initial and its background of greens and blues, and also a feeling of depth and dimension in the background itself. These techniques for registering depth are also used in the finest of the canon tables where the columns of text are disposed inside a stage-setting of architecture which is represented with considerable conviction and accomplishment (Plate 20). There can be little doubt that these methods of representing weight and dimension were derived from Late Antique sources in Italy. Yet, though the decorative pages of the Ada School are, in a sense, the progeny of both British and Italian art, they do emerge with a distinctive and unmistakable Carolingian personality of their own.

Unlike the decoration which derives from two countries, the illustrations of these manuscripts derive primarily from one – from Italy. However, the fact that the Italian sources were themselves of different periods means that even here there is a combination of styles and influences. There are two types of illustration – the marginal and the full-page.

Something has already been said of the occasional tiny illustrations inside the initial. There are also occasional illustrations in the decorative borders, and these probably derive from a sixth-century Italian sequence.[63] It is curious that these, the only narrative scenes in a whole group of Gospel Books or Gospel Book readings (as all these texts are), should be so abbreviated in form and so tiny in scale. When compared to the main full-page paintings, which are author pictures of evangelists, they seem almost apologetic. The position becomes still more complicated when we come to examine the actual vignettes, for – with the exception of a single stray fragment of a Gospel Lectionary – we find that they are not direct pictorial exemplars of the New Testament but illustrations

of recondite commentaries on it.[64] So the shorthand scenes – for example, of the Annunciation, Visitation, Temptation, and Last Supper – which are lightly brushed into the margins or spandrels of the decorative and portrait pages of the Soissons Gospels are illustrations of the prefaces of the fourth-century Spaniard, Priscillian, which were originally written to accompany the pre-Jerome text of the Bible. And the single, comparatively large, narrative illustration in this group which depicts the twenty-four elders and the Lamb over a sea of glass (Plate 21) illustrates, not the New Testament text, but St Jerome's preface. It is almost as though the Carolingian manuscript-painter was apprehensive of the actual text of the Gospels, and felt it necessary to insulate himself from it by an apparatus of scholarly commentary.

The full-page pictures offer a considerable contrast. They are primarily of the evangelists, with an occasional Christ in Majesty. Among the rare additions to this basic repertory is a symbolic picture[65] which underlines the personal relationship of this group to Charlemagne himself. It appears in the very earliest of these manuscripts, the Godescalc Gospel Lectionary, which was commissioned by Charlemagne and his queen, Hildegard, on 9 October 781 and was written by a certain Godescalc. The dedication verses not only tell us all this but also add that this manuscript celebrated a double commemoration: the first was the fourteenth year of Charlemagne's reign as king of the Franks, and the second was the baptism of his son, Pippin, by Pope Hadrian in Rome. This baptism is given a literary reference in the dedicatory verses and a pictorial one in the illustrations, for the artist has painted a full-page picture of the baptistery of the Lateran in Rome in which Pippin was baptized. An erroneous tradition claimed that Constantine himself had been baptized in this baptistery and, as a result, it came to symbolize the Fountani of Life. Its popularity in this rôle is indicated by the fact that it appears no less than three times in manuscripts of the Court School with all kinds of allegorical elaborations and allusions,[66] the most pleasing example being that of the Soissons Gospels (Plate 22). It is generally to be understood in a symbolic as well as a literal sense.

Although, over the three decades covered by this school, there are naturally variations in development, in accomplishment, and even in particular sources of influence, the portraits of evangelists do form a coherent group and perhaps represent the art of the Ada School at its best.

The first tentative statement of the style of these portraits is made in the Godescalc Gospel Lectionary (Plate 15),[67] which was completed on 30 April 783. The paintings here have not yet the feeling of depth or the sophistication of the later works; indeed, one feels oneself in the presence of uninspired, if ambitious, copying. Even this, however, has some advantage, for it has enabled scholars to trace the source of these portraits to Early Christian art in Italy comparable to the mosaics of San Vitale at Ravenna.[68] In a slightly later manuscript, the Abbeville Gospels,[69] which was made between 790 and 814, the architectural framework is introduced that will become traditional, and we also begin to find something of the assurance that will characterize the greatest paintings of the school. The influences on this manuscript are also from Italy, but this time from eighth-century Rome.[70] From here have been traced some of the idiosyncrasies of this particular manuscript, especially the combination of an ample, almost pneumatic, figure

structure with a surface decoration of minute patterning.[71] The figures of the so-called Ada Gospels at Trier (Plate 17),[72] which are later than the main illumination of the manuscript and later, too, than the Harley and Soissons Gospels that we shall come to next, represent a much further development. The evangelists are now statuesque with a positive structural solidity; the draperies fall heavily with their own weight, and are no longer dissolved by gold lines into ornamental patterns. The deep folds which are here formed into 'hooks' call to mind Byzantine art particularly of the seventh century, and, since at this time Rome was under very strong Greek influence, it has been thought that the prototype was a manuscript from the Eternal City.[73]

In the other great masterpieces of the school – the Harley Gospels (Plates 18 and 19),[74] the Soissons Gospels (Plates 20–2),[75] and the Lorsch Gospels (Plates 23 and 54)[76] – artists utilize all the experience of the past for creative painting in a style peculiarly appropriate to the art of a court: a style which combines a wealth of colour with a contrived sense of grandeur.

The colours which flood the paintings are rich and almost sensual; golds are much in evidence, often set off by purples, ochres, or vivid blues. The evangelists are in varying formal positions assumed for the writing of their Gospels. They sit on thrones within a heavy architectural framework with their symbols in lunettes just above them. As we might expect, the picture space is completely dominated by the particular portrait, but the scene is always carefully balanced, and there is usually a feeling of space around the central figure and of depth behind it. To this sense of dimension in space the actual presentation of the figure adds a feeling of weight and solidity. Yet, opposed to the general breadth of conception is an overloading of detail everywhere, from the decoration of the columns and thrones to the pointing of every line and fold of the draperies. It is this combination of sumptuous colours, broad conception, and ornate detail that produces the characteristic Ada effect of occasion and ceremony. If, of all Carolingian styles, this is the first in time, it is also the foremost in splendour.

It is understandable that an art of this quality and richness should make an impact on the future, especially when there was need for a royal or aristocratic art of occasion, and we find its effect in the court art of succeeding Carolingian emperors such as Charles the Bald.[77] But it was to project its influence even beyond the period of the Carolingian empire and inspire the early art of the succeeding Ottonian empire when (as we shall see) manuscripts of the Ada group were used as a source of inspiration for sumptuous manuscripts made for princes of the Church.[78]

Very different from the Ada group was the second style of art at Charlemagne's court, that of the Palace group.[79] The first is measured, ornate, and compilatory, the second has ease and breadth and apparent spontaneity; the one was inspired by influences from Britain and Italy, but the other was probably entirely Byzantine in origin.

Four complete manuscripts survive of the Palace group; all are Gospel Books and all probably belong to the period between 795 and 810. The first, the Vienna Coronation Gospels, is in Vienna (Weltliche Schatzkammer der Hofburg; Plates 25 and 26); the second, the Aachen Gospels, is in the Schatzkammer of the cathedral (Plate 27); the third, which has had a splendid but unfinished portrait of an evangelist bound in at

folio 17 verso, is in Brussels (Bibliothèque Royale cod. 18723; Plate 28); and the fourth is in Brescia (Biblioteca Civica Queriniana cod. E. II. 9). Apart from these religious manuscripts, there is evidence of the former existence of a secular one. This was an illustrated astrological manuscript made about 810 in connexion with Charlemagne's astrological and calendar reforms, and it is known to us through a fine copy made about 840 for Charlemagne's son, Drogo, archbishop of Metz (Madrid, Biblioteca Nacional cod. 3307).

To an even greater degree than the Ada manuscripts, the Palace Gospel Books show an indifference to narrative painting. They contain initials and canon tables, and the only illustrations are the author portraits of the evangelists. Despite a slight admixture of Ada influence in one manuscript,[80] what impresses so much about all these elements is the prevalence of the classical tradition. Unlike the complex and elegant structures of the Ada manuscripts, the initials here, for example, are plain and simple like those of Late Antiquity. Again, unlike the overladen canon tables of most of the Ada manuscripts with their symbolic insertions and ornate decoration, these are now usually severe classical structures. The beauty and economy of the single title-page (that of the Aachen Gospels) also owe their inspiration to pre-medieval traditions. But nowhere is this classical feeling more apparent than in the portraits of the evangelists (Plates 25–8), which are pure expressions of the Hellenistic stream of the classical tradition. There is no reaching for effect, and everything seems easy and spontaneous. Clad in white, the evangelists bend over their manuscripts like authors of Antiquity, and the illusionistic style in which they are painted, the breadth of conception, the coherence of modelling and lighting, all relate them to the classical past. This is just as evident in the landscape against which they are usually set and of which the finest example is in the Aachen Gospels (Plate 27), where – exceptionally – the evangelists are grouped together. Here, though the landscape is sketchily portrayed, one is almost conscious of the air drifting through it, and the painters have even captured some of the atmospheric effect of the light receding in the distance or breaking in cool bluish-greens on the impressionistically painted hills.

The sudden appearance at Charlemagne's court of this easy, assured style of Antiquity presents many problems, not all of which have been resolved. It seems, however, that unlike the Ada painters, who were court artists making a synthesis at Aachen of outside influences, these were outside painters importing into the Frankish homeland an art with its own unadulterated tradition.[81] It is unknown whether the name 'Demetrius presbyter' inscribed in a margin of the earliest manuscript of the group, the Vienna Gospels, refers to the scribe or to the painter, and it may not even be a strictly contemporary entry, but it does suggest that the ambience in which this style survived was a Greek one. This does not necessarily mean that the artists had recently come from Byzantium, for we know that Greek painters were already at home in Italy. Indeed, there are 'Byzantine' wall-paintings at Castelseprio,[82] near Milan, which, if not in the same style, have points of comparison in breadth and illusionistic treatment and which, to my mind, belong to the same period. But there is much disagreement among scholars about the date of these latter paintings, and attributions range from the seventh to the tenth century.

This Palace style disappeared from the court at Charlemagne's death, and its classical qualities of breadth, atmosphere, and perspective almost completely vanished too. Yet the Hellenistic tradition from which it sprang was to exert a potent influence on the art of the empire. This was not, however, before it had experienced a fundamental change. It was as though it had to undergo a process of fermentation before producing the more heady and exhilarating style which was to become characteristic of the West. The full effect of this fermentation was found not at the Court School of Aachen but in the monastic school of Reims.

The School of Reims

If the School of the Court was the earliest of the Carolingian ateliers, the School of Reims was probably the most influential. And it was influential because it so completely captured the spirit of the period. It represents the quintessential expression of Carolingian art.

Though not initiated by him, the Reims School owed its real development to Ebbo, who had had close associations with Charlemagne's manuscripts, for he had formerly been imperial librarian. He was archbishop of Reims from 816 to 835. To the even narrower period between 816 and 823 [83] we can probably date the key-work of art of Reims and, indeed, the most significant work of art of the whole Carolingian period – the Utrecht Psalter (Utrecht, University Library Script. eccl. 484; Plates 29–30).[84] The Psalter has a considerable number of large pictures, each of them composed of numerous small scenes which are assiduous in their literal illustration of the Psalms and Canticles. 'Bow down thine ear to me; . . . Pull me out of the net,' says one verse of the Psalms, and we are duly shown God reaching forth to direct an angel to succour the psalmist, who is standing above a net (Plate 29).[85] 'I am tossed up and down like the locust,' says another, and a locust is represented in front of the psalmist, here looking up to God on the right (Plate 30).[86] There are several hundred such scenes within some 166 of the larger pictures.

These are not paintings but drawings in bistre in a style of tremendous exhilaration. The illustrations seem as if agitated by gusts of wind. The landscapes themselves are imbued with an inner excitement; the trees reach impetuously to the heavens, the hillocks whirl restlessly along and are more like clouds sweeping across the sky than clods of earth on the ground. The figures rush from one side of the page to the other, their turbulent draperies awhirl with dynamic movement. Their heads jut out vigor-ously, their hands gesticulate impatiently, their fingers are widely splayed. Everything is intoxicated with animation. Everything flutters with excitement. The whole world is galvanized by an inner ecstasy. It is a measure of the accomplishment of the artist that, despite all this volatile energy, the different and independent scenic episodes which make up each picture as a whole do not fly apart but cohere in a balanced and symmetrical harmony, often converging dramatically towards one centre of focus which is usually in the centre of the page. Nor are the artists content to use their skimming line to render something that is flat and two-dimensional. The gradation of line gives tonal values to

the figures and objects, endowing them with a cubic content and even giving an impression of recession in space.

There has been much controversy about these drawings, but everyone would agree that they ultimately derive from the illusionistic style of Late Antiquity which found one expression in the Palace group, and that this style is here galvanized by a new dynamic power. And though in one sense they represent a continuation of this older style, in another they mark a reaction against it, for the point and purpose of the illusionism of Antiquity was to suggest the ambience of reality; here the same illusionism is keyed up into a style which transcends it. The artist is anxious to capture the inner dynamism and not the outward show.

Though the influence from Late Antique art is quite clear, this influence was neither oppressive nor direct. There is nothing here of the 'facsimile' relationship that we find in other Carolingian manuscripts. This (if proof were necessary) is shown by the fact that one part of the text which is illustrated did not exist before the Carolingian period and that another was not until then incorporated into the Psalter manuscript.[87]

There is clear evidence that the Late Antique influences have been channelled through a Byzantine culture, for there is a wealth of analogy between details of the drawings and Byzantine art.[88] This need not surprise us since, in art as in literature, the Byzantines were sedulous in their cultivation of Antiquity, and the empire of the East was one of the major conservers of the art of the past. We know that Pope Paul I sent a collection of Greek books to the Frankish king, Pippin the Short, in 757,[89] and it is possible that the Hellenistically inspired, Byzantine art on which the artists of Reims drew was already at the heart of the Holy Roman Empire. But it is much more probable that it was brought from an Italy which had always been a willing recipient of Byzantine art and (during times of iconoclastic troubles) a ready home for its refugee artists. In the two centuries before Charlemagne's coronation as Holy Roman Emperor there were Greek schools and monasteries at Rome, and indeed no less than thirteen of the popes themselves were from the Eastern empire. Milan also was suffused with Greek influences, and we have already drawn attention to the remarkable wall-paintings at near-by Castelseprio which are Byzantine in inspiration and which in many ways bridge the gap between the illusionism of Late Antiquity and the style of the Utrecht Psalter, even though (as we have seen) there is so much controversy about their actual dating.

But, even if it could be argued that the Castelseprio and cognate Byzantine paintings are the antecedents of the Utrecht style, there are still fundamental divergences between the two. In the self-contained rhythm of their compositions and in their feeling for the structure of the human figure, the Castelseprio paintings are closer to the Late Antique than to the medieval and have not yet been electrified into the dynamic ecstasy of the Reims School. Indeed, however much we may plot its ancestry and relationships, we can never deny the Reims style its own intense and creative genius. If it draws on the past, it transcends its influence in one of the most important creative works of art of the medieval West.

There are other illustrated manuscripts of the Reims School which, though eclipsed by the packed intensity of the Utrecht illustrations, are still of great interest.

One of the most important is a Gospel Book at Épernay (Bibliothèque Municipale MS. 1)[90] from which most of our information about the provenance and date of the Utrecht Psalter is deduced. Though its pictures (Plates 31 and 32) are full-page paintings and not drawings, they are paintings which register the exact style of the Psalter illustrations. Here (though less concentrated) is all the galvanized activity of this Reims style, and closer comparison reveals an extraordinary consonance of detail. Everything from trees and landscapes to figures and buildings is, as it were, mirrored from the Psalter scenes.[91] The close affinity between the art of the two manuscripts makes it clear that they both came from the same scriptorium at the same period, and fortunately dedicatory verses in the Gospel Book identify each. They state that the Gospel Book was made, under the direction of Peter, abbot of the monastery of Hautvillers (near Reims), for Ebbo, archbishop of Reims. We have already noted that Ebbo was archbishop between 816 and 835, and the fact that there is no mention in the laudatory verses of Ebbo's missionary activities, which began in 823, suggests that the manuscript was produced before this date, that is between 816 and 823. Despite the reference to Hautvillers, our knowledge of the bibliophile interests of the archbishops of Reims and of the activities of the Reims scriptorium suggests that the real centre of artistic inspiration as well as of artistic patronage was Reims itself.

Two 'stray' drawings are close in style to the Utrecht Psalter but probably later. They are detached from their original manuscript and bound up in a tenth-century *Hrabanus Maurus* at Düsseldorf (MS. B. 113 folios 5 and 5 verso). Both illustrate miracle scenes from the Gospels: the first the healing of the withered hand (Luke VI, 10), and the second the healing of the leper (Luke V, 12–13).[92]

Related also to the Utrecht Psalter in style and iconography are two other Psalters. The first is the Douce Psalter (Bodleian Douce MS. 59), which has illustrations to Psalms 51 and 101.[93] The second is the Troyes Psalter (Treasury of Saint-Étienne-de-Troyes),[94] which, after some damage during the French Revolution, retains a single illustration to Psalm 51. The illustrations of these manuscripts are paintings, not drawings, and they have nothing like the quality of the Utrecht scenes (the Douce illustration is particularly maladroit). They are, however, of historic if not aesthetic interest, for, though the three independent illustrations to Psalm 51 are very similar, they were not copied from each other and must all, therefore, have been taken from the same archetype, which, it has been suggested, belonged to the fourth or fifth century.

That there were Late Antique sources at Reims seems quite certain. An important *Terence* from there (Bibliothèque Nationale lat. 7899)[95] is lavishly illustrated with pictures which could only have been copied from Late Antique prototypes of the West. An illustrated *Physiologus*[96] also apparently derives from a Late Antique model. There is, further, a conscious antiquarianism in some of the Reims manuscripts which may owe something to the fact that Archbishop Ebbo had originally been imperial librarian. The fact that this antiquarianism led to 'facsimiles' such as the *Terence* is of the utmost importance for the student of the classical tradition, but the historian of art will see such works as documents of the past with none of the intense creativity of the Utrecht Psalter style.

This Utrecht style was to find further expression in a number of manuscripts from Reims and related centres – the Hincmar Gospels,[97] the Loisel Gospels,[98] the Blois Gospels,[99] and so on.[100]

It was one influence on a small but highly distinguished group of manuscripts from Metz,[101] which was given particular stimulus by the patronage of Charlemagne's illegitimate son, Drogo, who was bishop of Metz from 826 to 855. Of the two Gospel Books made for Drogo, one (Paris, Bibliothèque Nationale lat. 9383)[102] is written entirely in rustic capitals of gold, and the other (Paris, Bibliothèque Nationale lat. 9388)[103] is of interest for its canon tables, its two historiated initials, and the magnificent initials to each Gospel actually formed by the symbol of the relevant evangelist. Indisputably the greatest masterpiece of the group is the Drogo Sacramentary (Paris, Bibliothèque Nationale lat. 9428; Plate 33),[104] whose numerous exquisite historiated initials, illustrating liturgical scenes or episodes from the life of Christ, are in a delicately windswept style influenced from Reims.

The Reims style influenced these and many other manuscripts of France, but it was of much more than local or regional importance: it was to play a primary rôle in the whole future of Western art. It had a significant influence on the art of northern 'France' and 'Germany', and in England was one inspiration for the Anglo-Saxon Renaissance.

The School of Tours[105]

If the Court School was the earliest and the School of Reims the most influential, the School of Tours was almost certainly the most prolific.

There were, in fact, four religious foundations in or near Tours: the cathedral of Saint-Gatien and the Benedictine houses of Cormery, Marmoutier, and Saint-Martin. Of these, the monastery of Saint-Martin, which was situated within the town of Tours, was by far the most important. Its original presiding spirit was Alcuin of York, an Anglo-Saxon scholar whom Charlemagne had met in Italy and who was to play a dominant part in the development of the scholarly and cultural side of the Carolingian Renaissance. In particular, he was responsible for revising the biblical text. He also promoted the reform of the Carolingian script, which was extricated from the barbarities of the past and developed into such a model of clarity and elegance that – except for the Gothic intermission – it was to inspire all the Western scripts of the future. During Alcuin's abbacy, from 796 to 804, Tours became something of an Anglo-Saxon centre. Indeed, the monks complained that the Anglo-Saxons swarmed around Alcuin like bees round the queen.[106] Despite this, Alcuin's successor was yet another Anglo-Saxon. He was Fridugisus, who was abbot from 804 to 834. In fact, the monks drew many advantages from the links forged with the court by Alcuin and Fridugisus, thought he benefits could be made reciprocal, as they found when, after the death of Fridugisus, emperors treated the headship of the abbey as a sinecure for their important state officials. So the emperor, Louis the Pious, made his seneschal, Adalhard, lay abbot of Saint-Martin in 834, and Charles the Bald appointed another court official, Vivian, to succeed him in 851.[107]

Connexions with the court – particularly under the lay abbots – gave the scriptorium the opportunity, or excuse, for many spectacular productions in the form of royal presentation manuscripts. However, it was the associations with scholarship that made it exceptionally productive and account for the large numbers of manuscripts it put forth. It was, in fact, because of the vigorous demand for Alcuin's revised biblical text that it became such a significant centre of supply for other libraries; this is important, since its own library was destroyed as early as the second half of the ninth century by the Norsemen, and our only knowledge of its development comes from what survives of its 'exported' books. When, indeed,we recall that the manuscripts originally owned by Saint-Martin no longer exist, and that the only manuscripts of Tours that survive are those made for other foundations, yet that two hundred of these still remain of which some sixty are illuminated, we can get some idea of what must have been the fecundity of its scriptorium.

From the time of Alcuin's abbacy, eleven decorated manuscripts survive.[108] Since we know that he had manuscripts sent to him from York,[109] and that Tours, under him, was something of a focal point for Anglo-Saxons, it is not surprising to discover that this early decoration was strongly influenced from England. This is particularly apparent in the St Gallen Bible (St Gallen, Stiftsbibliothek cod. 75).[110] At this time the decoration was quite modest, though under his successor Fridugisus there was a rapid development in its function. Initials, hitherto largely an extension of the text, became bolder and more independent, and both in them and in the canon tables we find a rich use of gold, silver, and colours. To this period must be attributed the earliest surviving illustrations which are found in the Stuttgart and London Gospels (Stuttgart, Landesbibliothek HB. II. 40; Plate 34; and British Museum MS. Add. 11848).[111] It was under the lay abbots who followed, however, that manuscript art flowered into its full magnificence. From the period of Abbot Adalhard ten decorated or illustrated manuscripts survive,[112] which include the Grandval Bible (British Museum MS. Add. 10546; Plates 35 and 36)[113] with its four full-page pictures and fifty-six richly decorated initials, and from the time of Abbot Vivian yet more sumptuously illuminated works have come down.[114]

The early Anglo-Saxon influences on the decoration are understandable in view of Alcuin's presence at Tours. The influences which initiated the figural painting were, however, probably quite fortuitous, though also no doubt due to the same Anglo-Saxon scholar. For his work on the revision of the Bible, Alcuin would have assembled at Tours biblical manuscripts of various regions and periods. He required them for their texts, but a few would contain illustrations. It was these paintings, collected together not for themselves but as appendages to the texts, that served as the earliest pictorial exemplars for the artists of Tours. At first these artists were content simply to copy their models, and indeed they did this with such assiduity and care that they have left to posterity faithful duplicates of the original exemplars they had in front of them. Clearly, these were from Italy. One was probably an illustrated Roman Bible of the mid fifth century[115] and another an illuminated Roman Gospel Book from the second half of the seventh or first half of the eighth century.[116] (A manuscript from Ravenna[117] will come to our attention later.)

Of the two Roman manuscripts, the later made its impact first. Its influence shines through the illustrations of the earliest surviving Gospel Book of Tours (Stuttgart, Landesbibliothek HB. II. 40).[118] These Stuttgart Gospels were made under Fridugisus and contain a full-page Majesty surrounded by symbols of the evangelists (Plate 34) and four full-page evangelist portraits, all placed in atmospheric settings. Here, the stylistic features – the interest in problems of lighting expressed, for example, in the heavy shadowing of the necks, the preoccupation with modelling by colour which is evinced in the deep grooving of the folds, and the thrusting of all figures to the front plane of the picture – are characteristic of Roman art between 650 and 750.[119] The illustrations must therefore reflect prototypes of this period. They do capture something of the atmospheric feeling of space of the original, but there is also something painstaking and deliberative about these ninth-century copies.

The impact of the second Roman manuscript is seen in the Grandval Bible (British Museum MS. Add. 10546),[120] which was made under Adalhard, probably soon after his succession in 834. This Bible has four full-page pictures. One prefaces the Book of Genesis with appropriate scenes of the Creation and Expulsion, another precedes the Book of Exodus and has scenes of Moses receiving and dispensing the Law (Plate 35), a third introduces the New Testament with a Christ in Majesty surrounded by symbols of the evangelists and full-length figures of four prophets (Plate 36), and the fourth follows the Book of the Apocalypse with a representation of the apocalyptic vision of the enthroned Christ and an elaborated portrayal of His altar. They all seem to be straightforward illustrations: in fact, however, they are full of symbolism and historical overtones for which the writings of St Augustine offer the explanation.[121]

Having himself been a Manichee for nine years, St Augustine had an intimate knowledge of this heresy and, after his conversion, an emphatic desire to suppress it. The Manichees rejected the whole of the Old Testament and, in particular, attacked the biblical history of the Creation and the account of Moses' reception of the Law. For them, the God who gave this Law was one of the Princes of Darkness; the true God, being incorporeal, could not create man in His own image or intervene in a corporeal sense in man's destiny. The human nature of Christ was also denied and all accounts of His death and resurrection firmly rejected. In his attacks on this heresy St Augustine emphasized the unity of the two Testaments on every possible occasion. One God, the Creator of all, was also the author of both Testaments. The Old Testament prefigures the New, just as the New brings to consummation the Old. What was dark and in shadow for the Children of Israel was simply brought to light and clarity by those who had profited from the birth of Christ. The Law of Moses is the Law of Christ, though but dimly comprehended before the coming of Christ. In his *Commonitorium*, he emphasized just those points that the Manichees rejected – the divine creation of man in God's own image; the divine origin of the Law of Moses; the true human nature of Christ, who died and arose from the dead, and the unity of the two Testaments. St Augustine himself died in North Africa in 430 just before the Vandals captured his episcopal city of Hippo. It was from these very Vandals that the Manichaeans fled to Italy, where they were to infect this area with their heresy, and it is not surprising that, to oppose it,

Pope Leo the Great (440–61) should make the fullest use of the arguments that St Augustine had prepared. It is, in fact, precisely these arguments, propounded by St Augustine and reiterated by Leo the Great, that are represented in pictorial form in the Grandval Bible.

The first picture shows the creation of man, God's order to Adam, the Temptation, the Fall and the Expulsion from Paradise: in other words, that initial disobedience which brought God's intervention in the history of mankind which is depicted in the remaining illustrations. The second picture represents Moses receiving the Law from God and announcing it to the Children of Israel. This is the revelation by God to His chosen people of that Law which will find complete fulfilment in the New Testament. The third picture is of Christ in Majesty. The open book on His knee represents the two Testaments of the Bible, which are further related to each other by the depiction of evangelist symbols and of prophets around. The final Apocalypse picture also links together the two Testaments, and by drawing on the commentary of Victorinus of Pettau demonstrates symbolically that what was declared in parables in the Old Testament is now made clear in the New.

In effect, we have here a pictorial statement of the Catholic orthodox faith as it was formulated against the Manichaeans. It is of interest in indicating the depths of meaning which paintings might be expected to convey; but it is important also in throwing light on the sources used by Carolingian artists.

One thing is clear: however profound may be the symbolism, it is an anachronism in the Carolingian historic situation. Its message is quite appropriate to the fifth century, but has no relevance to the ninth. It seems as though the Carolingian artists have taken over a fifth-century Italian source quite uncritically, and this, indeed, is exactly what the style of the paintings confirms. The feeling for recession in space, which is a survival from Late Antiquity and which can give to the coffered ceilings a convincing architectural perspective: the evidence of an illusionistic style, which also derives from the late classical period and which is here powerfully expressed in the draperies of the Majesty and heads of Adam and Eve: the thick, squat proportions and heavy staring eyes of the figures: all these reflect the Early Christian art of the fifth century. The Carolingians must have had an illustrated Bible of Leo the Great before them and, despite an occasional solecism, their paintings are almost exact copies of the fifth-century originals.[122] They are 'facsimiles' like the 'classical' illustrations we have referred to earlier. There is, however, a difference. Unlike the secular and 'classical' illustrations, these religious ones were not artistic blind alleys. There were developments from them.

Whether prompted by a consciousness of their own inexperience of figural painting or by an exaggerated veneration for pictures of some antiquity, the early artists of Tours were content simply to copy their prototypes. As, however, their skill and confidence increased, so did their freedom and independence. They took control of their sources instead of being controlled by them, and used them as influences to suggest rather than as authorities to follow. Where iconography is concerned, they still accepted useful compositions, but now they were ready to use them flexibly and to take an idea from one source and mingle it with ideas from others.[123] And they treated styles with a similar

freedom. Indeed, they did not hesitate to dilute or reject completely those of the past which were inappropriate to their needs and to replace them by styles more in accordance with their tastes. These tastes were not towards the world but away from it. The original models, available to the painters of Tours, had still retained from Late Antiquity many elements of realism: a feeling of weight and substance in the draperies, a sense of atmosphere in representing space and of perspective in depicting architecture. None of these elements, however, was taken up and developed by them. Their interest was rather in physical energy and spiritual power.

In the field of Bible illustrations, this is seen in the Vivian Bible (Bibliothèque Nationale lat. 1; Plates 37, 38, and 60).[124] Made under Abbot Vivian for Charles the Bald, it can be closely dated, for it was probably presented to the king during his actual sojourn at Tours at the end of 845 and beginning of 846. Apart from canon tables and some seventy-eight initials remarkable for their nobility and stylistic purity, this Bible has eight full-page pictures, four of which derive from the Bible of Leo the Great.

They follow the originals, however, in no servile or compliant sense. The whole style has been lightened and invigorated. This involves the sacrifice of the sense of spatial recession in the backgrounds and the feeling of weight in the figures, but it means also that some of the ponderousness is dispelled and the self-consciousness evaporated. The rather heavy treatment of the original figures has, in fact, been replaced by a new freshness and freedom in which the primary interest is linear animation. In the narrow sense this represents cross-fertilization from the style of Reims, but in the broader sense it represents the natural proclivities of the Carolingian artists.

The transfiguration of the original style is seen at its best in the paintings of the most accomplished of the three artists[125] who worked on the Vivian Bible. In his Majesty picture, for example (Plate 60), he lengthens the whole proportions of the figures and rejects the spatial recession in two planes in favour of an animated rhythm on the front surface of the page. The original feeling of weight and the spelt-out recession are exchanged for an excitement of linear movement. He shows an equal freedom with the iconography. Instead of Christ flexing His finger and thumb in benediction, He now holds there a gold sphere to symbolize the Host of the Sacrament; the full-length prophets are reduced to busts inside medallions and their places taken by evangelists at work on their Scriptures. (We shall find this iconography undergo yet a further change in the Ottonian future.)[126]

The remaining four pictures of the Bible owe nothing to the Roman prototype. Two, which contain scenes from the lives of St Jerome and St Paul, suggest influences from more than one source, and one draws largely from Late Antiquity. The other two, though deriving some inspiration from Late Antique representations, have all the hallmarks of genuine originality. One is a painting of David with his bodyguard and musicians (Plate 37). This probably carries eulogizing overtones of the relationship between the House of David and the House of Charlemagne; for not only is David encompassed by personifications of the four medieval royal virtues but his actual appearance approximates to that of the emperor. The other depicts the actual presentation of the manuscript and will be referred to later.

E

The spirit of emancipation that we here see emerging in the development of biblical illustration is also evident in the tradition of Gospel illustration. In the early Stuttgart Gospels[127] there is (as in the Grandval Bible) a close, almost servile, adherence to an Italian model.[128] Later, however, artists increasingly find their own self-expression. They treat the iconography of their prototype with flexibility and its style with freedom. So, in a Gospel Book made between 844 and 851 (Berlin, Staatsbibliothek theol. lat. fol. 733)[129] we find the artist modifying the iconography of the original Italian Gospel Book with elements taken from the original Italian Bible.[130] The Majesty, for example (Plate 39), is a very free adaptation of the Stuttgart one. Christ now holds a sphere instead of a sceptre. He has been given a rainbow as a footstool, and so dominates the picture space that the symbols of the evangelists have to be excluded from the space in which He sits. In style, there is still a certain compliance in the portraits of the evangelists, but that of the Majesty picture has been completely changed. Clearly influenced by the impression-istic rendering of the Majesty of the Vivian Bible, it has a new buoyancy and vivacity.

The new spirit finds more general and delightful expression in the masterly pictures of the Dufay Gospels (Bibliothèque Nationale lat. 9385),[131] where in pictures like the Majesty (Plate 40) the artist combines a fine sense of linear rhythm with a nice feeling for balanced composition. In the portrayals of evangelists he contrives to give yet further cohesion by psychological means. So, the physical sense of balance between each evange-list and his symbol is both strengthened and invigorated by the glances exchanged between the two.

It is, however, in the illustrations of the rich and splendid Gospel Book made on the orders of the Emperor Lothar between 849 and 851 (Bibliothèque Nationale lat. 266)[132] that this tradition of illustration finds its supreme expression (Plates 41 and 42). The painter was the chief artist of the Vivian Bible,[133] who probably directed the work of the Dufay Gospels. Here, however, he excelled himself. The organic feeling of the figures, the balance of the compositions, the general sense of vitality, the refinement of taste, all combine to make these rank among the most accomplished paintings of their period.

Though much more three-dimensional than the drawings of Reims, the figures are caught up by a similar dynamic fire. The divinity of Christ (Plate 42) is expressed, as it were, by a linear incandescence: galvanized by their inner inspiration, the evange-lists are like coiled-up balls of energy. The artist was certainly influenced by the style of Reims, but his primary source of inspiration was the impressionistic style of the Majesty of the Vivian Bible. However, he transcended what he used. There is about the Vivian Bible illustration a certain 'stage' effect which is due to the fact that the elements of the picture are compilatory. The draperies of the Majesty certainly have vitality, but it is a vitality contradicted by the heavy, staring eyes of the face, by the intrusive frame which divides up the picture space geometrically, and by the weighty ponderousness of one or two of the symbols and figures around. Our artist does not simply refine this style and charge it with a new dynamism: he gives it a new integrity and wholeheartedness. So the general linear excitement snatches up not only the draperies but also all elements of the picture, and the animation of the draperies is matched by the psychological intensity of the figures.

This artist who, in the Vivian Bible and the Lothar Gospels, has left us the finest Bible and Gospel Book illustrations of Tours, has also left us in these two manuscripts two secular pictures of no little interest. The first, in fact, is one of the earliest paintings we have from Northern Europe of a contemporary historical episode. It is the scene of the presentation of the Vivian Bible to Charles the Bald (Plate 38). Blessed by the hand of God above, seated on a throne and wearing a gold crown and full ceremonials, Charles the Bald is the physical centre of the group. On one side of him is his ostarius, whose function was the arrangement of audiences. On the other side is the sacellarius, who administered the royal treasury. Flanking these, and representing the emperor's military power, is a bodyguard. Below the right-hand soldier is the Abbot Vivian, who is making the presentation and who, being a lay abbot, wears secular clothes. Next to him are four of the dignitaries of Saint-Martin, three of whom are named in the dedicatory poem as Amandus, Sigualdus, and Aregarius. These all point to the Bible which is carried by the three persons who produced it, one of whom is a deacon. In the left foreground are other representatives of Saint-Martin, who carry white or violet-blue maniples with gold borders and red fringes, and wear white albs and golden stoles. It is noteworthy that the picture is given two focal points of interest, the one by physical, the other by psychological means. The physical centre is the emperor, who, by his size and central position, dominates all the other figures; the psychological one is the book being presented to him, for it is to this sumptuous manuscript that the surrounding figures turn their eyes or direct their gestures. In a very subtle fashion, therefore, the artist leads the gaze of the spectator from the emperor to the gift he is receiving.

There is a possibility here of direct or indirect Late Antique influence, for a very abbreviated form of this composition can be traced to consular diptychs.[134] But these could only have been used to suggest and not to dictate. The clothes that are worn are contemporary ones, and it is obvious that a scene as personal as this could not have been lying to hand in some fourth- or fifth-century source.

The second of the two paintings is of Charles the Bald's eldest brother, Lothar, in the Lothar Gospel Book (Plate 41). Wearing a gold crown and a red mantle threaded with gold, the emperor here sits on a throne flanked by two soldiers. With one hand he grasps his sceptre and with the other points to the dedication poem written in gold on the adjacent leaf. We can detect here some late classical influences both in the *gravitas* of the emperor and in the pose of his bodyguard. But the rhythmic balance of composition is Carolingian. So also is the focusing of attention both by psychological and physical means; for the head of the emperor is established as the centre of interest not only by the upsurging rhythm of the draperies but also by the glances of the soldiers towards him. Most characteristically Carolingian of all is the feeling of surgent and dynamic power achieved in the lush vitality of the curving, flowing lines of the draperies. This linear excitement of texture combines with the lively but majestic mien of the emperor to make this the most animated, as it is the most accomplished, of all Carolingian portraits.

Curiously enough, at Tours there runs parallel to this development towards the organic and dynamic a flat-silhouette style[135] (which may derive from a Late Antique or Early Christian prototype from Ravenna)[136] in which gold, silver, and colours are

used. In manuscripts such as the Vivian Bible and the Berlin and Lothar Gospels, this style is associated with the initials, but it is then extended to full-scale illustrations in manuscripts such as the Arnaldus Gospels (Nancy, Cathedral Treasury),[137] which was produced between 807 and 834, the Bamberg Bible from Marmoutier (Bamberg, Staatsbibliothek Msc. Bibl. 1)[138] of the same period, and the Sacramentary of Autun (Bibliothèque Municipale 19 bis)[139] made between 844 and 845. This subordination of the illustration to the decoration runs in many ways counter to the developments we have already seen, though, within its limitations, these silhouetted figures are actually influenced by the coloured paintings. For example, the Genesis cycle from the Bamberg Bible has to a limited extent been influenced iconographically and stylistically by the Vivian Bible. The figures in gold and silver with touches of green, brown, and violet make a strange compromise between the animated and three-dimensional style of the normal illustrations and the refulgent quality of the initials.

Both painted and silhouette styles reached their zenith about the middle of the century but, after this, historical conditions made impossible any further progress in either. In the second half of the century, the invasions of the Norsemen reduced the house and library to ashes and forced the monks to a life of sporadic exile in which they fled with the body of their patron saint from the brutalities of the dreaded pagans.

The Court School of Charles the Bald

If the School of Tours is the longest lived of Carolingian centres, the Court School of Charles the Bald, or the School of Saint-Denis, as it used often to be called,[140] must certainly be the most eclectic. This owed its existence to the patronage of Charles the Bald, who had a special relationship with Saint-Denis and not only retained the monastery in his own hands on the death of the abbot Louis in 867 but also left to the house a number of his own manuscripts.

One or two of the attributions within the group are controversial, but it has been generally thought to include the Prayer Book of Charles in the Schatzkammer at Munich, written before 869 and assigned to Saint-Denis on liturgical grounds; his Psalter in the Bibliothèque Nationale (lat. 1152)[141] written before 869 by a certain Liuthard and stylistically related to the Prayer Book; a Gospel Book decorated by a certain Liuthard ('Liuthardus ornavit') and now Darmstadt, Landesbibliothek MS. 746;[142] his Gospels, known as the *Codex Aureus* of St Emmeram in the State Library at Munich (lat. 14000), which is dated 870 by inscription; and his Bible (Plate 43) now in San Paolo fuori le Mura in Rome which, sumptuous though it is, was probably hastily compiled to commemorate his marriage to Richildis on 22 January 870. Added to this is his Coronation Sacramentary (Bibliothèque Nationale lat. 1141) containing (folio 2 verso) (Plate 44) a picture of a Frankish prince who may be Charles the Bald himself.

The general influences on the illumination are from the Franco-Saxon School on the one hand, and the Schools of Reims and of Tours on the other. We can perhaps explain the association with Reims by the fact that Hincmar, archbishop of Reims, had been brought up at Saint-Denis and was a trusted adviser of Charles. The connexion with

Tours is accounted for by the fact that the royal library which Charles the Bald inherited contained manuscripts made at Tours.

All these influences converge in the San Paolo Bible,[143] where the large initials are Franco-Saxon in style. There are powerful influences from Tours on the illustrations, which include a dedication picture representing Charles and Richildis, fourteen illustrations of the Old Testament text and four of the New, and four evangelist portraits as well. Thirteen of these pictures actually derive from the Tours School. These include the four pictures of the evangelists, which are typically Turonian and which should be compared with the Dufay Gospels except that the pictures of Matthew and Mark have been interchanged. The remaining seven pictures have been taken from the Vivian Bible, though, even here, something of the Reims style has been added in the vivid figure style and billowing landscapes, and something of the Reims iconography in the illustration of Moses blessing the children of Israel which might be compared with folio 45 of the Utrecht Psalter. This manuscript contains one of the finest sequences of Old Testament illustration of the period. And, since attention has already been drawn to the relationship between the Carolingians and the Old Testament, it is worth remarking that the throne image of Charles the Bald here is paralleled by a throne image of Solomon, and that the picture of the anointing of Solomon has been assimilated to a portrayal of the crowning of a Frankish king illustrated on Plate 44.[144] In the *Codex Aureus* of St Emmeram, the association of the rulers of the Carolingians and the rulers of the Israelites is made yet more explicit, for inscriptions under a throne image of Charles specifically associate him with David and Solomon.[145]

Northern 'France'

In the northern coastal areas of 'France' there was no great centre to compare with that of Tours, Reims, or even Saint-Denis, but, though often provincial in execution, art here had its own interest. Retardatory influences from the Merovingian past led to a continuing interest in zoomorphic initials, but these were less important than the influences from Britain and the Mediterranean.

We have already seen that the Anglo-Saxon (particularly the Northumbrian) style of initial had some influence on Carolingian art in general, but that its most concentrated influence was in the north of France. Here was developed the so-called Franco-Saxon School which was, in effect, a continuation on the French side of the Channel of the Northumbrian initials with their trellised structure filled with a delicate interweave of pattern. Thanks to the high technical accomplishment of the formative Anglo-Saxon art this always remained the most accomplished style of the area, and it survived well beyond the time of the Carolingian Renaissance.

The chief centre for this distillation of British influences was Saint-Amand,[146] and a noteworthy example of the style is found in the second Bible of Charles the Bald (Paris, Bibliothèque Nationale lat. 2; Plate 45),[147] which was made between 871 and 877, probably at Saint-Amand, and which introduces each Book with a great interlaced initial. Another fine example is the so-called Gospel Book of Francis II (Paris,

Bibliothèque Nationale lat. 257),[148] which, exceptionally for manuscripts of this school, contains figural illustrations as well as the normal geometric decoration. We should also mention in this context another Gospel Book probably given by Ermentrude, wife of Charles the Bald, to Saint-Vaast (Arras, Bibliothèque Municipale MS. 233).[149] To indicate the tenacity of this style, we can point to tenth-century manuscripts such as the Cambrai[150] and Gannat Gospels[151] (Cambrai, Bibliothèque Municipale MS. 327 and Gannat, église Sainte-Croix), and even eleventh-century ones such as the Arsenal Gospels (Paris, Bibliothèque de l'Arsenal MS. 592).[152]

In the other notable centre of northern France, Corbie, influences were rather different. To this area historical conditions at the end of the eighth century had brought a Byzantine bishop and a Lombard king.[153] The first was George, bishop of Amiens from 769 to 798, who came direct from Italy but is thought to have originated in Byzantium. The second was Didier, the last king of the Lombards, who was taken prisoner in 774 and was sent to Corbie. With this conjunction of circumstances it is not surprising to find that manuscript-painting here reflected influences from Byzantium and (more putatively) from Lombardy.

A Gospel Book (Poitiers, Bibliothèque Municipale MS. 17), probably produced at Amiens about 800 under the successor of Bishop George, Bishop Jesse (799–836),[154] has a frontispiece picture of Christ in Majesty which, though rustic in execution, is clearly based on a Byzantine prototype; indeed, this Byzantine influence is confirmed by a Greek inscription. Of more importance is the so-called Corbie Psalter (Amiens MS. 18)[155] of the same period which has a number of delicately coloured and competently drawn outline initials (Plate 46). Some of these are zoomorphic, but one or two are historiated, and it has been suggested that the figures here, with their diadems and starkly frontal positions, owe something to Lombard influence. A slightly later manuscript (c. 820–30) known as the Stuttgart Psalter (Stuttgart, Landesbibliothek, bibl. fol. 23) has been claimed for this area but attributed with more probability to Saint-Germaindes-Prés. However, if the first suggestion is correct, then this Psalter represents its most ambitious work.[156] It has a considerable number of coloured pictures (Plate 48), some of which suggest influences from Italo-Byzantine art of the fifth or sixth century. Their style is not particularly sophisticated but their application is, for these illustrate not the literal text of the Psalter but recondite commentaries on it, in a way so involved that the full relationship of the pictures to the text has not so far been unravelled. There are also in this area manuscripts of the Apocalypse[157] with important cycles of illustrations. These are in a tinted drawing style which seems to derive directly from lost Italian cycles of the fifth or sixth century and their interpretation of the powerful text is still the benevolent one of Early Christianity and not the more intimidating one of later periods. However, these manuscripts did not originate here but in the Eastern part of the Carolingian empire.[158] It was at one time thought that they came from the Salzburg area, but more recent opinion favours a centre on the Middle Rhine such as Mainz, for example.

South-East 'Germany'

In the Salzburg diocese itself manuscripts of no little interest were being produced even as early as the last twenty or thirty years of the eighth century. They show a mixture of influences from fifth-century Italian art and the missionary art of the Anglo-Saxons. One of them, in fact, is known after the name of its Anglo-Saxon scribe as the Cutbercht Gospels (Vienna, Nationalbibliothek cod. 1224).[159] Apart from initials and canon tables evincing strong influences from the British Isles, it has some large-scale pictures of the evangelists. The earliest of this particular group is probably the Montpellier Psalter (Bibliothèque de l'Université MS. 409),[160] which was made at Mondsee before 778, and the richest is the Codex Millenarius (Kremsmünster Cim. 1),[161] which was produced at Kremsmünster or Mondsee about 800. This latter manuscript gives full-page treatment not only to the pictures of the evangelists but also to their symbols on the adjacent folios, and it also originally contained decorative canon tables. We have already seen that the wall-paintings from Naturno in the Italian Tyrol (though cruder) show stylistic associations with this group. We should also draw attention to a slightly later manuscript from Salzburg belonging to the first quarter of the ninth century (Vienna, Nationalbibliothek cod. 387).[162] This is a collection of chronological and astronomical material which contains, among other illustrations, the earliest personifications of the months to survive from the Middle Ages.

St Gallen

In this Eastern part of the Carolingian empire, or 'Germany' as it was to become, the chief centre outside Aachen was unquestionably St Gallen.[163] This house showed a remarkable tenacity in artistic matters.

Founded by the Irish about 613, it is well known as a pre-Carolingian centre of Irish influence and is famed for its collection of Irish manuscripts. From about 720, Merovingian influences intervened in the styles of the initials, continuing until about 840,[164] for during the first decades of the Carolingian Renaissance St Gallen remained in provincial isolation. In the 840s a regeneration took place. Both Louis the Pious (814–40) and Louis the German (843–76) showed favours to the house, making it a royal monastery free of all lay jurisdiction, and from about 840 onwards there was a steady development in the field of art, as of scholarship. The new feeling was expressed under Grimald,[165] who was abbot from 841 to 872 and who had been educated by Alcuin at Tours. Under him the first catalogue of the library was drawn up, and this included some four hundred manuscripts, of which fifty-three had been presented by Grimald himself. In this mid-Carolingian period the style of the initials achieved a mature personality of its own which was most finely expressed in the Folchard Psalter (St Gallen, Stiftsbibliothek cod. 23)[166] of the sixties. This has no less than one hundred and fifty illuminated initials which are characterized by clarity and size, linear rhythm and animation, and an ample use of gold and silver. The Psalter also contains interesting illustrations. Arcades (rather like those of canon tables) enclose the Litany, and in the upper part of them are illustrations of the

life of Christ and representations of the dedication of the Psalter to Christ by Folchard and Hartmut. The influences here are from Charlemagne's Court School and from Reims and Tours.

In the late Carolingian period, which we may date from the abbacy of Hartmut to the end of Salomo's reign (890–920),[167] the initials become more complex and the decoration proliferates in a baroque manner, so that the form of initial is almost buried beneath the wealth of ornament. Under Salomo the St Gallen School reached the climax of its fame and produced the Carolingian masterpiece of this centre – the Golden Psalter (St Gallen, Stiftsbibliothek cod. 22). Written in gold letters, it contains over sixty initials, of which three are full-page. It also has a series of illustrations, including thirteen scenes from the life of David, which are drawn in coloured outline with a certain panache and vigour (Plate 47). Salomo was a trusted supporter and powerful ally of the last kings of Charlemagne's line. Under him the abbey became a centre of great wealth – both financial and intellectual – and at this time the abbey produced the famous teacher and musician Notker Balbulus and the poet, carver, and architect, Tuotilo, whose ivories cover the *Evangelium Longum*.[168] This was the golden age of the abbey, but it was followed by the age of iron which descended over most of the West. The attacks of the Hungarians and the raids of the Saracens in the first half of the tenth century saw the eclipse of the house, and when it re-emerged as an intellectual and artistic force, its connexions were with the Ottonian, not the Carolingian Renaissance.

The fact that art at St Gallen survived into the eleventh and twelfth centuries[169] shows the sheer artistic stamina of this particular monastery. Other and greater Carolingian centres, however, were less fortunate. As, under the pressures of internal dissensions and external attacks, the Carolingian empire itself disintegrated in the latter half of the ninth century and the first part of the tenth, so almost all major centres of art succumbed too. Even St Gallen itself, as we have seen, went into a temporary eclipse during the raids of Hungarians and Saracens. And when we read that Tours, for example, was attacked by Norsemen five times between 853 and 903, that five times the occupants of Saint-Martin evacuated their house, which was three times burned down and three times rebuilt, then clearly art under such circumstances was not simply a luxury but an irrelevance.

If, however, the fires of the Carolingian Renaissance were thus damped down almost to extinction, they were never entirely extinguished. They still retained sufficient heat to fire two later renaissances – the one in Germany and the other in England.

THE OTTONIAN RENAISSANCE

General Observations

THE heirs to the Carolingians were the Ottonians, who in the tenth century revived the disintegrated Holy Roman Empire. The new empire was not as extensive as the old, for it excluded 'France' and was largely confined to Germany and part of north Italy. The leadership passed from the Franks to the Saxons, and, as Charlemagne, the first Frankish emperor, had given his name to the Carolingian dynasty, so Otto the Great, who was crowned as first Saxon emperor in 962, gave his name to the Ottonian one. During the tenth and eleventh centuries, the new Ottonian empire saw a renaissance of art which, like the contemporary renaissance in England,[1] owed much in the early phases to Carolingian influences. These two contemporary renaissances in Germany and England have points both of comparison and contrast.

Apart from the Carolingian inspiration common to both, one clear parallel is that art in each country was stimulated by religious and, particularly, by monastic reform. The reasons for this are understandable. The reorganization of existing ecclesiastical foundations and the establishment of new ones involved the provision of liturgical books and vessels,[2] and artistic skills were lavished on them not only to invoke a feeling of self-pride in the community but also as a simple act of dedication. That the work of the artist and its encouragement by the patron were both seen during this period as acts of piety emerges time and again in the records. So, inscriptions in Ottonian illuminated manuscripts emphasize that the scribe saw his work as an expression of devotion,[3] and chronicles for their part will often assess the virtues of a bishop or abbot by his solicitude for the beauty of the house of God.[4]

The differences between the two renaissances are reasonably clear. Germany was far more wealthy and powerful than England, and therefore its works of art were often more sumptuous and lavish. The Ottonian princes of State or Church, who were the patrons of art in Germany, tended to favour cathedrals rather than the monasteries which the Anglo-Saxon patrons supported. So, though the works of art in each country were often made in monastic scriptoria and workshops, in Germany they tended to find their way into cathedral settings and in England to remain inside the monasteries. Then, though painting in England and Germany owed much of its early inspiration to the Carolingian tradition, the styles of the two countries were quite different. Anglo-Saxon painting was light, vivacious, and spontaneous; German art, though ecstatic at times, was more often heavy and incisive. English illumination had the delicacy and finesse of Chinese drawings, but it was insular in the sense that after the first impetus from Carolingian and Byzantine sources, it tended to develop independently of other influences. Ottonian painting lacked this refinement and consistency of quality, but it was cosmopolitan, showing an awareness of art forms from different times and places.

Consequently, while Anglo-Saxon art has a certain unity of style, Ottonian art has a considerable diversity.

If art was an expression of piety in Germany, it was also a symbol of prestige. To a degree that was quite unknown in Anglo-Saxon England, there was a consciousness in Germany of the power of art to impress and to condition men's thoughts in questions relating to this life as well as the life to come. We find, therefore, in Ottonian illuminated manuscripts a considerable emphasis on the authority of the princes of the Church which takes the form of sumptuous dedication pictures.[5] And nowhere is art used to greater purpose than in stressing the power and authority of the emperors. This may have specific relationship to a given historical situation. For example, as we shall see, the illustrations of a Gospel Book given by Henry II to Montecassino were intended to remind this venerable house after its recent defection to the Byzantine cause of the relentlessness of imperial justice.[6] But more often art extols the power of the ruling dynasty in quite general terms and in a manner quite unprecedented in the West, though not without parallels in the East.[7] So, manuscripts show Otto II or III regally enthroned and receiving tributes from the provinces of the far-flung empire (Plates 49, 50, and 62),[8] or depict Henry II enthroned in oriental splendour and accompanied by personifications of his territorial power.[9] This latter, it is true, has a Carolingian precedent in a portrayal of Charles the Bald.[10] However, the artist does not, as in the earlier picture, simply portray the emperor's secular might; he now underlines his divine authority also. So, Henry's crown is laid on his head by Christ, while saints support his arms and angels bring his sword and sceptre from heaven. The theocratic overtones of this scene are further heightened by the posture adopted by the emperor, which is like that of a bishop celebrating mass. Another manuscript of the same scriptorium depicts Henry wearing the stole of the priesthood, similar to the one worn by Christ on the Cross, and furthermore the Holy Spirit bears down on him rather like the dove descending on Christ at his baptism.[11] Pictures represent Henry III and his queen being crowned by Christ (Plate 76), but the most compelling commentary on the authority of the emperor is a painting of Otto III.[12] The emperor is here represented as being crowned, or blessed, by God; he is seated in the mandorla normally reserved in medieval art for Christ and surrounded by symbols of the four evangelists; he is venerated by princes and supported by a personification of the earth. This is one of the most remarkable expressions of imperial authority expressed in visual terms.

In this one can perhaps see some influence from Byzantium, which had already mobilized art to the service of its own imperial power. Otto II had, in fact, married a Byzantine princess, and his son, Otto III, preferred to stress the Byzantine side of himself, contrasting the refinement of his Greek inheritance with the rusticity of his Saxon one. Though it can be exaggerated, Byzantium certainly had some influence on Ottonian art, and there can be no doubt of the interchange of ideas between the Ottonian and Byzantine empires.

In terms of visual imagery, however, the claims of the Ottonians went further than those of the Byzantine empire and completely outstripped those of the Carolingian empire, though their real power was less than either. Charlemagne had been content,

politically, to be emperor of *Europa*, remaining on terms of friendship and equality with Byzantium. But the Ottonian emperors had greater ambitions. They saw their empire as the heir to the Rome of Augustus and entertained ideas of universal domination over East as well as West.[13] The depiction of their power certainly owes as much to representations of the authority of the pagan Roman empire as it does to Byzantine sources. For example, the illustrations of Otto II and Otto III receiving tributes from the provinces of empire were clearly inspired by illustrations in the Late Roman manual of imperial authority, the *Notitia Dignitatum*,[14] and, in view of the later importance we shall attach to Trier as a centre of Ottonian illumination, it is worth remembering that a copy of the *Notitia Dignitatum* was probably made at Trier in the tenth century. We shall have a fuller understanding of the importance of the *Notitia Dignitatum* both in this connexion and as a stylistic source for Ottonian art when present researches are published. Meanwhile, we can say that the Ottonian monarch saw himself as greater than either Byzantine or Carolingian. He was *rex et sacerdos*, king and priest, the universal emperor holding sway over all the territories of the classical Roman empire. This emerged in arts other than painting, for the cloak of Henry II was decorated with symbols of imperial domination,[15] and the seal of Conrad II was inscribed with the legend declaring that Rome held the bridle of the earth.[16] In the formulation of Ottonian concepts of imperial power, art was well ahead of other forms of expression, and it was not for some decades that the views already clearly expressed in the painting of the Aachen Gospels found comparable literary expression.

Though Ottonian art was employed in this way to propagate ideas of imperial power that were more far-reaching than those of the Carolingians, Ottonian art itself seems to have been more independent of direct imperial control than it had been under the Frankish emperors. No Ottonian emperor dominated or stimulated art as Charlemagne had. There were no *missi dominici* sent round to encourage wall-paintings in churches, and no court school of vellum-painting. When the Ottonians needed manuscripts, they called on the services of monastic scriptoria. These scriptoria might be Trier, Echternach, Regensburg, or even lesser houses: in 1048, for example, we learn that the entire resources of the Tegernsee scriptorium were commandeered to meet the emperor's needs.[17] Imperial patronage was clearly of importance in stimulating the production of some splendidly illuminated manuscripts, but Ottonian art owed its existence and growth not to the emperors but to the bishops and abbots.

Those of upper and lower Lorraine had a particular part to play, for in this area of north-west Germany, where Charlemagne's own school of painting had flourished and which was now the centre of the reform movement in Germany, beat the real heart of the Ottonian Renaissance. And, as we shall see later, even in this area, none of the centres of painting could compare in creativeness, eminence, and influence with Trier.

The subject-matter of paintings of Ottonian manuscripts had a different emphasis from those of the Carolingian period. The Carolingian interest in Old Testament illustrations was almost completely relinquished, and it was now New Testament illustrations that monopolized the interest of the artist. The Saxons did not feel that sense of emotional kinship with the Old Testament Israelites that had inspired the Franks.

Moreover, under papal influence, the basis of their own power was much more seen in New Testament terms. However, there were also very practical reasons for the change of emphasis. The Carolingian reforms were largely concerned with scholarship, with obtaining correct, definitive texts, particularly of the whole Bible. Religious reform under the Ottos was more interested in the maintenance of divine service by the provision of liturgical books. Ottonian illuminated manuscripts were, therefore, destined mainly for use in church services and took the form of Sacramentaries and Gospel Lectionaries. All these texts were based on the Gospels, and consequently their illustrations referred to the New Testament rather than the Old.

WALL-PAINTINGS

The new interest in Gospel themes in manuscript illumination meant that there was a greater consonance between the subject-matter of vellum-paintings and wall-paintings under the Ottonians than under the Carolingians; the primary attention of both arts was now focused on illustrations of the New Testament.

Unhappily almost all the Ottonian wall-paintings have now disappeared. Scattered references in the chronicles show that in the tenth and eleventh centuries there were wall-paintings at centres like St Gallen and Petershausen,[18] Reichenau,[19] Hildesheim,[20] Toul,[21] Brauweiler,[22] Deutz,[23] Halberstadt,[24] Iburg,[25] Cologne,[26] Mainz,[27] Zwiefalten,[28] Aachen,[29] Tegernsee,[30] Passau,[31] Eichstätt,[32] and Echternach.[33] The references are often in general terms. They simply say, for example, that Ralph, abbot of Deutz, adorned his monastery with pictures,[34] that Bernward, bishop of Hildesheim, decorated his cathedral with 'bright and exquisite paintings',[35] or that Gebhard, bishop of Eichstätt, had the chapel of St Gertrude painted with 'wonderful and almost living pictures'.[36]

Nevertheless, a few detailed descriptions do survive. One of these is a verse account which tells us that eleventh-century paintings in Mainz Cathedral illustrated the major incidents of the Old Testament and the Gospels.[37] Another informs us that at the abbey of Petershausen, which was built by Gebehard, bishop of Constance, between 983 and 992, the walls were covered with paintings depicting Christ's life and its prefigurations from the Old Testament, and that the ceilings were decorated with gilt bosses giving the impression of the starry vault of heaven.[38] We know something of painting at St Gallen, including the names of tenth-century painters there such as Kunibert, Ekkehard II, and Notker the Physician.[39] One of these probably made the wall-paintings of the life of St Gallus,[40] which were apparently planned by Immo IV, abbot from 975 to 984. Immo's successor, Ulric, had paintings made of the Assumption of the Virgin and the Dormition of St John.[41] In the neighbouring house of Reichenau, its 'golden abbot' Witigowo (985–97) had paintings made of the Virgin and Child and St Mark and St Januarius, together with the early abbots of Reichenau and the lives of the early Fathers.[42] Though not made on German soil the contemporary wall-paintings at the nunnery of Wilton in southern England can also be brought within the Ottonian context, since they were made by a painter from Trier.[43] These, executed just before

984, depicted the Passion of Christ and also the figure of St Denis, to whom the church was dedicated.

Detailed descriptions are too sparse to make generalization profitable, but they do suggest that the main themes of the wall-paintings followed those of the Carolingian period – incidents from the life of Christ with Old Testament episodes which prefigured it, representations of the Virgin, of the evangelists, and of those saints who were locally venerated.[44]

The two main centres at which Ottonian wall-paintings actually survive are Fulda and Reichenau. (As we shall see later in this chapter, paintings also survive at Lambach in Austria (see Plate 86). But, though these are of outstanding quality, they typify less the spirit of Ottonian art than the transition from it towards the Italo-Byzantine styles that were to become so popular in Germany in the twelfth century.)

The paintings at Fulda[45] do not belong to the celebrated abbey, but to two small suburban churches, one on the Petersberg, the other at St Andrew's. The crypt of the Petersberg chapel contains fragments featuring Christ's Baptism in the Jordan, the Lamb of God in a medallion, and representations of angels and saints. The crypt of St Andrew's at Neuenberg is decorated with tinted drawings in ochre, brown, and yellow, of Christ in Majesty, of Abraham, Melchisedech, and Abel as prefigurations of the Mass, and of three-quarter-length angels and busts in medallions. These are executed in a lively manner, giving an impression of lightness which is more easily paralleled in Anglo-Saxon than in Ottonian art. There were Anglo-Saxon literary influences on Fulda in the Carolingian period, and here we apparently have Anglo-Saxon artistic influences during the Ottonian. The date of these modest but buoyant paintings is usually associated with the consecration of the church, which took place in 1023.

At Reichenau,[46] the paintings are more ambitious but less well preserved. Here again, they do not survive in the main monastery but in two small chapels – St Sylvester at Goldbach near Überlingen and St Georg at Oberzell. They are normally ascribed to the late tenth or early eleventh century.

Though the paintings of St Sylvester (Plates 51 and 53) are more fragmentary than those at Oberzell, they have been less harmed by later restoration, and therefore offer clearer stylistic criteria for dating purposes. Originally the paintings on the east wall portrayed the donor Winidhere and his wife on either side of Christ, each sponsored by a saint, and with Winidhere proffering his church.[47] The pictures on the side walls depicted the healing of the demoniac, the stilling of the storm (Plate 51), and other miracles which survive but fragmentarily.[48] In better condition and by a different artist are the pairs of apostles (Plate 53), originally assembled around the enthroned Christ, which was itself removed when a Gothic window was inserted into the apse.

At Oberzell[49] the narrative paintings in the nave command attention. They are contemporary with the figures of prophets above and medallion busts below, and also with the ecclesiastic portrayed on either side of the apse.[50] These are earlier, however, than the Last Judgement on the west wall.[51] Their colours are restrained, and they have a feeling for space and a balance of composition which are very pleasing. Four paintings on each wall run between horizontal borders of meander pattern, divided vertically by

narrower borders containing formalized patterns.[52] Long and rectangular in format, they portray the miracles of Christ. The north wall contains the miracles of the Gadarene swine, the healing of the man with dropsy (Plate 52), the calming of the storm at sea, and the healing of the blind man. On the south wall Christ is shown healing the leper, raising the son of the widow of Nain from the dead, healing the woman with the issue of blood and Jairus's daughter (the latter two in one panel), and finally raising Lazarus from the dead. This is the most extensive cycle of wall-paintings that has been left to us by the Ottonian period.

The condition of these paintings makes any discussion of their style somewhat hazardous. They have not only been damaged by time but also distorted by the restorer. It seems probable, none the less, that they reflect Italo-Byzantine influences coming from Italy. The iconography of the scenes is ultimately Byzantine in inspiration.[53] The symbolic architecture which provides a background for each scene is paralleled in Byzantine art and has its closest links with Byzantine illuminated manuscripts of the tenth century such as the Menologion of Basil II[54] and the Bible of Leo the Patrician.[55] The background of horizontal broken bands in graduated colours (often green, blue, and ochre) can also be traced to Byzantine illumination, which borrowed it from the tradition of classical painting where it was intended to represent the atmosphere of the earth.[56]

As the most complete cycle that has survived from this period, these paintings naturally merit attention. One should, however, be cautious in using them as evidence of Reichenau's artistic importance, for there is no evidence that they were made by Reichenau painters. It is true that Reichenau had her own wall-painters in the ninth century, for we know that she then provided artists to decorate St Gallen;[57] but one cannot apply this evidence to a century later, when the position of the two houses might well have been reversed. This is certainly true where contemporary literature is concerned, for earlier Reichenau was more important but later St Gallen.[58] In the tenth century there is, in fact, the fullest evidence for the existence of monastic wall-painters at St Gallen but none for monastic wall-painters at Reichenau. Furthermore, when Reichenau's diocesan bishop, Gebehard of Constance, had wall-paintings made at his foundation of Petershausen, which was built on land acquired from Reichenau, he used non-monastic artists,[59] and this is difficult to understand if Reichenau then had wall-painters of her own. The Goldbach and Oberzell paintings could well have been made by itinerant artists. We have already seen that wall-painters journeyed far and wide[60] and that at about this time there was an Italian wall-painter working in Germany[61] and also a German in England.[62] Surviving paintings, such as those at Reichenau, may, therefore, simply indicate a single fortuitous point on a long itinerary of travelling artists.

All this needs to be said because the iconographic relationships of these paintings have been used as one basic argument for building up the image of Reichenau as a great centre of art and, in particular, of illumination at this period. That iconographic relationships exist between these paintings and Ottonian manuscripts is certain[63] – though in some cases the similarities have been exaggerated. However, one cannot infer from these similarities a Reichenau provenance for the manuscripts without evidence that the wall-painters themselves were from Reichenau, and without also making the completely

unhistorical assumption that the iconography of the paintings was the invention and sole property of Reichenau. In fact, the iconographic similarities between the frescoes and the illuminated manuscripts are easily explained by the Byzantine influences common to both.

ILLUMINATED MANUSCRIPTS

The Claims of Reichenau

This is perhaps a convenient point at which to draw attention to the traditional view of Ottonian illumination: which is that all the illuminated manuscripts that I shall ascribe to Lorsch and Trier were made at Reichenau. Though this is a viewpoint sanctioned by general scholarly opinion,[64] my own view is that Reichenau was a small artistic outpost rather than a central headquarters. The reasons for this attitude have been expressed very fully elsewhere,[65] but the following brief comments may be made on the large claims made for Reichenau.

With only one exception (and this a manuscript not made at Reichenau), none of the many masterpieces of the so-called 'Reichenau' school was ever in use at Reichenau: they do not carry the press-marks of the Reichenau library nor any inscriptions to indicate that they were made for use there. When, in fact, we look at the actual manuscripts which were at Reichenau at this period we find only one illustration.[66] The subject-matter of this is impressive enough, representing as it does the community of Reichenau in the presence of the Virgin and Child and of its patron saint, St Pirmin. But the quality of the style is derisory. Ironically, the illustration precedes an account of the activities of Abbot Witigowo, who is claimed as the great art patron of the house. It is difficult to reconcile the poor quality of this picture with the masterly quality of the illuminations usually attributed to Reichenau. Then, again, the claim that Reichenau was a great art centre whose illumination dominated the tastes of the empire finds support in no contemporary chronicle or document. Nor is the claim that Reichenau was commissioned to export illuminated manuscripts to other parts of Germany borne out by the dedication verses which some of them contain. These show that the books concerned were given and not sold, and given, moreover, to persons who, to the best of our knowledge, had no connexions with Reichenau. Equally unacceptable are the views which account for the imperial ownership of 'Reichenau' manuscripts by saying that Reichenau was the centre of the imperial chancellery, or that it was the favourite halting point of emperors on journeys to Italy. The imperial chancery was not confined to one place, and the evidence from *diplomata* indicates that emperors stopped at Reichenau only twice in one hundred and twenty years. Whatever its claims to fame in other spheres and times, Reichenau's art during the Ottonian period was of purely local importance.

The School of Lorsch

It has been said that Ottonian painting derived from the Carolingian tradition. This is very clear in the earliest illuminated manuscripts, usually referred to collectively as the

Eburnant group from the name of one of the scribes.[67] These include three of particular importance, which may have been made at Lorsch south of Darmstadt.

The first both in time and splendour is the Gero Codex, now at Darmstadt (Darmstadt, Landesbibliothek cod. 1948). It is a Gospel Lectionary and was probably written between 950 and 970.[68] Dedication verses tell us that a certain sacristan called Gero had persuaded the scribe, Anno, to write it for presentation to his foundation, whose patron was St Peter. The exact identity of this foundation is still rather uncertain, though it is possible that it was either Cologne or Worms, for both were dedicated to St Peter and each had a Gero attached as priest during the relevant period.[69] Whatever its destination, the Gero Codex was certainly made in a monastery, for its scribe, Anno, is represented as a monk.[70] We know that its paintings were inspired by those of a Carolingian manuscript which had already found its way to Lorsch (the so-called Lorsch Gospels[71] of Charlemagne's Court School that have been referred to on p. 28), and there seems every reason to suppose that it was made at the monastery there. Lorsch was a house which had some interest in manuscript production, for it included among its monks a certain Salemannus who later, as abbot from 970 to 997, had manuscripts 'splendidly bound in silver and ivory'.[72] It was not far from Worms and had close religious ties with Cologne.

Despite a slight tendency to schematization, some reduction in detail, and changes in the general balance, the full-page pictures in the Gero Codex of the Majesty and the four evangelists are clearly copied from those of the Lorsch Gospel Book (see Plates 23 and 24, 54 and 55 for the Majesty and St John in each).[73] Apart from these pictures, the Gero Codex contains two dedication pictures – the second showing Gero receiving the manuscript from Anno and the first showing him offering it to St Peter.[74] The first of the two dedication paintings is actually modelled on Carolingian dedication pictures such as that of Hrabanus Maurus presenting his *De Laude Crucis* to Pope Gregory.[75] There is, however, a shift of emphasis. In the Carolingian painting, it is the author who presents his work; in the Ottonian one, it is the scribe. This reflects an interesting contrast between the dedication pictures of the two periods.

As in Carolingian art, the differences of hierarchical importance are indicated by variations of size: a form of differentiation which later is taken to such extremes that the monks represented in the later Egbert Codex barely reach the archbishop's knees![76] Here, Gero is somewhat larger than Anno but considerably smaller than St Peter. Of all the figure paintings, the portrayal of St Peter in the second dedication picture, combining as it does a largeness of style with a delicate harmony of colour, is the most impressive.

Two manuscripts are closely related to the Gero Codex – the one stylistically, the other textually. Their pictures mark the beginning of the transition from the Carolingian to the Ottonian idiom.

The first, roughly contemporary with the Gero manuscript, is the Petershausen Sacramentary, now in the Heidelberg University Library (MS. Sal. IX b).[77] Here, the Majesty (Plate 56)[78] is derived from the Gero Codex, but the elimination of details such as the rectangular border and the evangelist symbols, and the limitation of the palette by the omission of green, for example, produce a new effect of austerity. The full-page

personification of the Church [79] – though not derived entirely from the Gero manuscript – is, like that of Christ, placed inside an ornamental circlet. Both these Petershausen figures have something of the quality of a brooch, for though the draperies and faces still remain soft and tractable, the figures themselves are given a sharp, precise outline which separates them completely from their backgrounds. This crisp definition was to become characteristic of Ottonian painting and to distinguish it clearly from Carolingian. The initials of the Petershausen Sacramentary are coloured in gold, blue, vermilion, and green, and, like those of the Gero Codex, have affinities with the manuscripts of St Gallen.

The exact provenance of this manuscript remains a problem, for there is no evidence that it was at Petershausen before the twelfth century. Its similarity to the Gero Codex makes Lorsch a possible source, and it may have been made at Lorsch before the Gero Codex actually left the scriptorium. The calendar, it is true, contains Reichenau elements, but it is not in the script of the original manuscript and was probably added at Reichenau, which received the manuscript before it went to Petershausen. [80]

The second manuscript associated with the Gero Codex is the Hornbach Sacramentary (Solothurn, Küsterei des Kollegiatstiftes) [81] belonging to the last quarter of the tenth century. Its writer was a secular deacon named Eburnant, who has given his name to this present small group of manuscripts. It was written for Adalbert, abbot of Hornbach in Upper Lotharingia, during the last quarter of the century, though in what scriptorium is again uncertain. However, its dedication verses are so close to those of the Gero Codex as to suggest that it was written in the same place. The initials, two of which are full-page, are executed with liveliness and verve and, like others of this group, show influences from St Gallen. The pictures consist of four dedication paintings: Eburnant, the scribe, presenting a book to Abbot Adalbert; Adalbert presenting it to the patron saint of his abbey, St Pirmin; St Pirmin giving it to St Peter; and St Peter finally offering it to Christ. [82]

These paintings again reflect the transition from a Carolingian to an Ottonian idiom. The first two pictures are still Carolingian in feeling, particularly in the breadth and ampleness of the painting, but the treatment of the second two pictures is harder, crisper, and more incisive. In style, they are closely related to the work of one of the greatest of the Ottonian painters, the Gregory Master, an artist who had associations with Lorsch, but whose work was centred at Trier. And, interesting as the Eburnant group is in showing how Carolingian art was first copied, then adapted, then transformed, it is to Trier that we must turn for our fullest knowledge of Ottonian painting.

The School of Trier

Ottonian manuscripts usually give us more information about patronage than about provenance. But the two need not be separated, for, in the absence of conflicting evidence, it is reasonable to presume that a patron would commission illuminated manuscripts in his own locality. This was almost certainly true of one of the greatest of all Ottonian patrons – Egbert of Trier. Son of a count of Holland and trained as a monk in

the abbey of Egmond, he later became in turn imperial chancellor (976–7) and arch-bishop of Trier (977–93).

Trier at that time was a powerful centre of reform and scholarship.[83] Its focal point was the abbey of St Maximin, whose influence was widespread. From the 940s on-wards, at the request of emperors and archbishops, it sent out monks far and wide to reform houses such as St Moritz at Magdeburg, St Pantaleon of Cologne, Gladbach, Echternach, St Emmeram of Regensburg, and Tegernsee.[84] The neighbouring house of Mettlach was also famous particularly for its scholarship, and, by the end of the century, monks and clerics were coming from all over France to study there. Since some of these men eventually became bishops and abbots, the chronicler could justifiably boast that they 'imbued the whole of France with the light of Mettlach'.[85] Of all European centres Trier was one of the most cosmopolitan. In the second half of the tenth century we find there monks and clerics from England and France, from Flanders and Holland, and (within Germany) from Fulda, Aachen, Reichenau, and Cologne.[86] In their turn monks and clerics from Trier visited France and England, Italy and Flanders, and (within Germany itself) Cologne, Regensburg, Tegernsee, St Gallen, Worms, and Hildes-heim.[87] At such a hub of culture we should expect to find a mingling of influences, both received and given. And this is, indeed, the picture we form of the art of Trier at this time.

Of Trier's artistic importance at Egbert's accession we know nothing. Trier, it is true, had an artistic tradition going back to the classical period, but this tradition was not continuous, and it is probable that it died out at the end of the Carolingian period. But under Egbert Trier developed into a dynamic centre of art of all kinds. We know that it was to Egbert of Trier that the archbishop of Reims sent to have a gold cross made;[88] we know of the gold and silver crosses Egbert himself gave to his cathedral[89] and of the gold cross and silver reliquary he sent to Egmond.[90] Such an interest in metalwork was not unrelated to painting. To begin with, we know of metalworkers who were also painters (such was the Trier artist, Benna, who was working in England), but we should also remember that illuminated manuscripts of the period were often bound in carefully worked gold and silver, so that the crafts of goldsmithery and manuscript-painting might be intimately related. It was certainly in the field of vellum-painting that Trier reached its greatest eminence, and here Egbert displayed to the full the generosity of his patronage and the fastidiousness of his taste.

One of his manuscripts is the lavishly illuminated Egbert Psalter (Cividale, Museo Archeologico cod. sacr. N. CXXXVI), which was made for Trier Cathedral.[91] It contains four dedication pictures. The first two show Ruodpreht (who is probably the scribe) offering the book to Egbert, and the second two represent Egbert proffering it to St Peter. This repeats the dedication sequence of the Gero Codex, where the scribe hands the book to the cathedral dignitary, who then presents it to the patron saint of the cathedral. The Benedictine habit worn by Ruodpreht indicates that he was a monk, but the attempts made to identify him on the simple basis of a fairly common Christian name are illusory, for we cannot raise the coincidence of such a name to the dignity of historical evidence. Probably he came from one of the local Trier houses on which Egbert had

lavished his generosity. The manuscript gives considerable prominence to Trier not only by the large number of Trier saints in the liturgy but also by its many pictures of Trier archbishops – it is worth noting that the reliquary for the staff of St Peter from the Trier workshop of Egbert also has a series of portraits of Trier archbishops.[92] We should also add in support of the Trier provenance of the Egbert Psalter that it has stylistic similarities with a Trier manuscript from St Maria ad Martyres (Koblenz, Staatsarchiv cod. 701).

The sources for the style of the figures in the Egbert Psalter have never been satisfactorily explained. Carolingian influences are clearly evident in the dedication pictures and portrayal of King David (Plate 57). The latter figure has been influenced by the Tours School, yet has its own power and compactness and swinging sense of rhythm which makes it more than a paraphrase of an earlier style. The standing figures of archbishops such as St Paulinus (Plate 58), however, are very different. Here the primary influence comes from Italy, and the modelling of the heads, the *orans* posture of prayer, the proportions of the figure, and the poised balance of the body are all paralleled in Italian wall-paintings that survive. In this connexion, we may recall that Egbert visited Italy in search of relics,[93] and he may also have accepted the invitation extended to him by the famous Gerbert to send Trier monks to study there.[94] But the figures of the Psalter are not simply essays in an Italian style. The tranquil expression of the faces and balanced poise of the figures come from Italy, but they are contradicted in spirit by the turbulence of the draperies, which probably derives from England, for we find the closest parallels in Anglo-Saxon manuscripts like the Benedictional of St Aethelwold (British Museum Add. MS. 49598). The south and the north have not found their happiest meeting place in these figures, for there is an unmistakable feeling of unease, of two discordant influences not completely integrated.

Written partly in gold and lavishly illuminated in gold, silver, and sumptuous colours, the Egbert Psalter is a manuscript of particular splendour. But its special interest is that it shows us the Ottonian artists turning to sources other than the Carolingian past and experimenting with different styles in their search for their own individuality.

Apart from the pictures (and we must ignore in our present context the Byzantine illumination added later)[95] there is a number of initials, fifteen of which are full-page. The initials have an Anglo-Saxon feeling of unrepressed vigour, but their pedigree points unmistakably to St Gallen even if they also offer some comparisons with a Sacramentary now at Florence which perhaps originated at Reichenau or Rheinau.[96]

The influence of St Gallen in the Ottonian period is not difficult to account for, since it was a flourishing centre of painting in the second half of the tenth century and its artists travelled to distant parts, one of them, Notker the Courtier, being appointed chaplain to the emperor himself.[97] Further to this, Otto I's anxiety to reform the house led to it being visited by prelates from all over Germany.[98] These included an archbishop of Trier, an abbot from Lorsch, an archbishop from Cologne, and a Cologne abbot who had been brought up as a monk at Trier. They all took an interest in the St Gallen library.[99] So did Otto I's son, Otto II, who was present at one visitation and who, after asking to be shown the finest manuscripts, exercised his royal prerogative by taking

many of them away.[100] At a critical period for the development of Ottonian art, then, St Gallen manuscripts were not only well known but in circulation outside the house of their origin. It is quite conceivable, therefore, that they may have served as models or sources of inspiration for artists at other centres.

Stylistically related to the Egbert Psalter is the Poussay Gospel Lectionary (Bibliothèque Nationale lat. 10514).[101] Its exact origins are unknown, though its earliest associations are with the diocese of Toul. It belonged to the nunnery of Poussay, a gift, according to an eighteenth-century tradition,[102] from Pope Leo IX, a former priest and bishop of Toul who (if the tradition is correct) may have found it at Toul. Just as Egbert had given a Sacramentary to the archbishop of Reims and sent manuscripts to his former monastery of Egmond, so he may have sent this Gospel Lectionary to Toul, which was a suffragan bishopric.

The dedication pictures in the manuscript[103] do not help to identify the original Toul owner, for they are something of an enigma. In the left-hand one (Plate 59), the donor stands between two archangels and offers the manuscript to Christ, who, enthroned in the right-hand picture, reaches out to accept it. The donor is unnamed and does not even wear the vestments of a Western bishop but (like the angels on either side) is dressed in the *sticharion*. Despite the fact that Greeks were settled in the diocese of Toul at this time, this Greek vestment is probably of no particular significance, for the *sticharion* was often found depicted in Italian art, whence it spread to Germany. We might hazard the guess that the figure represents Gerard, bishop of Toul from 963 to 994, an art-lover who decorated his cathedral with wall-paintings and who was later canonized by Leo IX, the reputed donor of the manuscript to Poussay.

Whatever the identity of the donor, there is little doubt that Italian art inspired these dedication pictures. The concept of angels presenting the donor to Christ is one found early in Italian mosaics, as for example at Ravenna[104] and Parenzo.[105] The treatment of the head, figure, and draperies reflects the influence of Italian paintings of the pre-Carolingian period like those of Santa Maria Antiqua. Furthermore, Veronese illuminations of the eighth century, though tighter in style and probably later than the paintings which inspired the Poussay pictures, are sufficiently close in detail to confirm their Italian pedigree.[106] The Christ in Majesty is a particularly felicitous essay in the early Italian style.

The remaining illustrations of the manuscript are much less satisfying. They are less controlled, less organized, and less integrated. The same misalliance of styles that we have seen in the Egbert Psalter appears again, though here the two styles concerned are Carolingian and Italian. The interest of these remaining illustrations, in fact, lies less in their style than in their iconography. They include the earliest known Ottonian paintings of such New Testament scenes as the Nativity, the Magi, the Crucifixion, the washing of the disciples' feet, the Marys at the Sepulchre, and Pentecost.

That the identity of the patron of the Poussay Gospel Lectionary should remain obscure is surprising. Often the donor of rich manuscripts was named. So, too, might be the scribe. Only the illuminator was ignored. As a result we know the names of many patrons and scribes but of hardly any artist. We do not even know the identity of one of

the most accomplished of all illuminators of the tenth century, who, simply because his paintings include illustrations to the Letters of St Gregory, is clumsily referred to as 'the Gregory Master'.[107]

The Gregory Master was clearly a Trier artist, for though one of the manuscripts he illuminated had associations with Lorsch,[108] his work was primarily connected with Trier and with Egbert. His speciality was the production of full-page illustrations, painted with such ease and breadth that one wonders whether he was not also a wall-painter. It has been suggested that the Gregory Master was an ivory carver, too,[109] and this would not be at all surprising when we recall the versatility of the greatest artists of the period.

We have already seen that two of the artistic traditions to which Ottonian artists turned were those of Carolingian and early Italian painting. These were also the two sources used by the Gregory Master, but, instead of copying or excerpting them like some of his predecessors, he reinterpreted them in his own idiom. He had a particularly close sympathy with the art of the past, and he even took a special interest in restoring ancient manuscripts.[110] He 'restored' an earlier Gospel Book, which is now at Prague (Strahov Library cod. D.F. III, 3), by adding four evangelist portraits and title-pages, and in a pre-Carolingian manuscript from Echternach he inserted four evangelist portraits, of which one, the Mark portrait, survives.[111] All these additions show a deep understanding of Carolingian art, and the master had a particular affinity with the Tours School which was no doubt due to the existence of a Tours Bible at Trier.[112]

The influence of the School of Tours is evident in his own creative work. This is clear, for example, in the Sainte-Chapelle Gospels at Paris (Bibliothèque Nationale cod. lat. 8851),[113] which is written in letters of gold and dated by emperor medallions on the St Matthew title-page to the years 967–83. Not all these illuminations are by the hand of the Gregory Master, but the Christ in Majesty certainly is. Here, the composition, focused on Christ enthroned in a central mandorla but with the evangelists and their symbols placed in the corners (Plate 61), has been quite obviously inspired by the Majesty of a Tours manuscript, the Vivian Bible (Plate 60).[114] No one, however, could mistake this for Carolingian illumination. In the Carolingian painting the division between the figures and the surrounding atmosphere is indeterminate, but in the Sainte-Chapelle Gospels the figures are so sharply separated from their backgrounds that one feels they could be lifted up like carvings of stone or ivory. There is something here of the crisp definition of stained glass, and this precision of form is characteristic of the Ottonian period.

The crystallization of forms is most clearly seen in two full-page pictures,[115] which are now detached leaves, but which originally illustrated a copy of the Letters of St Gregory. They are preserved at Chantilly and Trier (Chantilly, Musée Condé, and Trier, Stadt-bibliothek). The first shows Otto II enthroned beneath a baldacchino against the faintest of blue atmospheres which gives the impression of limitless space behind (Plate 62). He is approached by the personified provinces of his empire, who bear gifts. The second represents St Gregory being secretly observed by his secretary as he dictates his writings under the inspiration of the holy spirit. The breadth of treatment in both these illustrations

suggests the influence of Early Christian or late classical art, and, indeed, the posture of the emperor in the first picture, with the slight imbalance of the widely placed legs, is paralleled in the Christ-figure carved in an Early Christian pyx found near Trier.[116] A noteworthy aspect of these illuminations is the rigid definition in depth of the figures. They have the limited shallow space of a bas-relief or, to change the analogy, seem as if compressed between two sheets of plate glass.[117] They also show an awareness of the relationship of spatial planes, and it is probable that the artist's interest in defining space was derived from his acquaintance with Early Christian or late classical art.

Verses tell us that the manuscript, from which the Trier and Chantilly leaves were detached, was commissioned by Egbert and was magnificently bound in gold and jewels. We are further told that it was made in honour of St Peter (who was the patron saint of Egbert's own cathedral), and this would clearly suggest that it was intended for Trier. A nostalgic reference to the 'tranquil peace' enjoyed under Otto II suggests that it was produced during the unruly period between 983 and 987, when the succession of the three-year-old infant Otto III led first to the unleashing of Henry of Bavaria's ambitions, and then to the French invasion of Lorraine.

Magnificent as we may imagine this manuscript to have been, it must, even in its original state, have been eclipsed by one of the greatest masterpieces of Ottonian art, the so-called Egbert Codex (Trier, Stadtbibliothek cod. 24; Plates 63–5).[118] Originally also, like the manuscript of St Gregory's Letters, bound in gold and jewels, it contains, besides numerous small initials in gold and colour, a dedication picture, four full-page paintings of the evangelists, and fifty New Testament illustrations coloured in gold, purple, blue, green, and red.

The title-page and decorative initials were probably illuminated by the painter of the Egbert Psalter, who may have also painted the two introductory pages bordered with birds and animals which are in the Psalter style.[119] The left of these two folios contains dedication verses written in gold and artistically arranged against a background of purple. On the facing folio is the dedication picture itself, which is dominated by the seated figure of Egbert towering over the small monks on either side of him, one of whom offers him the manuscript bound in gold. These two monks must have been the scribes, and an inscription identifies them as Kerald and Heribert and further informs us that they came from a place called Augia, which is probably Reichenau. Since Reichenau came within the orbit of the monastic reform initiated at Trier, it is not difficult to account for the presence of Reichenau monks at Trier, though the particular circumstances that led them there are unknown.

The manuscript must be accounted the greatest achievement of the Gregory Master. It is true that he executed only a few of the pictures himself, but, by painting the first five narrative scenes (typified here by his portrayal of Christ and the Centurion, Plate 63), he provided both the stylistic model and the artistic standard for the rest. Few may bear the actual hallmark of his personal genius, but all show the imprint of his tremendous influence. The inspiration in the narrative pictures comes from late classical and Early Christian art of the fourth and fifth centuries. The way they are set in simple frames within the text, their horizontal format, the identification of individuals by

adjacent inscriptions, the aerial perspective, the balanced grouping, the organization of space, all these recall late-fourth-century Italian art, whether in the Christian illustrations of the so-called Itala Manuscript of the Book of Kings (Berlin, formerly Staatsbibliothek, theol. lat. fol. 485) or in the pagan illustrations of the Vatican Virgil (Vat. lat. 3225). There are even particular relationships between the episodes of the Ottonian Christian manuscript and the late classical pagan one. So, in the Egbert Codex, the mother beating her breast at the slaughter of the Innocents is paralleled in the Vatican Virgil by the similar expression of anguish at the death of Dido,[120] and the meeting of Christ with the Centurion (Plate 63) is not unlike the meeting of Aeneas and Dido.[121] In style, it is true, the figures of the Gregory Master, which are lifted sharply from their backgrounds by clarity of outline, differ greatly from the sketchy illusionistic figures of these particular earlier paintings, but they do have some affinities with other works of art of the late classical and Early Christian period. We find, for example, the same rather square proportions of the figures and comparable postures and draperies in artistic productions of the fourth century such as the Brescia Casket or the wooden doors of Sant'Ambrogio, and the wig-like hair style coming down low over the forehead and the piercing glance of the eyes, which are so characteristic of figures in the Egbert Codex, have their origin in fifth-century Italian carvings and paintings.

Here, indeed, we have a Western counterpart to the tenth-century manuscript illumination of Byzantium, which also had recourse to late classical and Early Christian sources. It is even possible that the Gregory Master's interest in early art was stimulated by Byzantium, for there are occasional Byzantine influences in his own work. In the Majesty page of the Sainte-Chapelle Gospels, for example, we find Byzantine influences in the Greek inscription and in the typically Byzantine gold background, and it is also probable that the iconography of the narrative scenes in the Egbert Codex was influenced by contemporary Byzantium.[122] It has, it is true, been argued that these scenes derived from an Early Christian manuscript of the West, but this is given little support by known early Western manuscripts such as the St Augustine Gospels.[123]

Whatever questions there may be about the iconographic sources of the Gregory Master and his assistants, there can be none about the quality of their art. Their paintings express a fine sense of compositional rhythms, a feeling for the relationship of figures in space, and a delicate sensibility to tonal grades and harmonies. The Gregory Master's own work is further characterized by a classical reticence and an aesthetic balance which, in the theological terms of St Augustine, might be described as the just relationship of the parts to the whole. His classical composure and detachment is everywhere apparent and neutralizes the emotion even of scenes of particular passion like the Slaughter of the Innocents – a mother may beat her breast in grief and another turn away her head in horror, but no sympathetic feelings are aroused: one is only conscious of the overall aesthetic balance of the picture.

As far as we can judge from surviving evidence, the Gregory Master was one of the most significant figures of Ottonian painting. Before his time there had certainly been some progress in Ottonian illumination, but artists had tended either to be submissive to the Carolingian tradition or to live on uneasy terms with the Italian one. The Gregory

Master showed his contemporaries how to assimilate earlier styles without simply copying the form. His influence led to a complete integration which gave succeeding artists the freedom to discover their own expression.

Though these later painters profited so much technically from the Gregory Master, their own artistic interests were, in fact, very different. They were less interested than he in the late classical and Early Christian art of the West. They were also quite unsympathetic to the objectivity which he himself had probably derived from this earlier art.[124] They felt that emotions should be liberated, not neutralized.

Deviations from the canons of the Gregory Master had already appeared in the work of his two major assistants in the Egbert Codex, who were otherwise so much influenced by him. Their draperies are less strictly in accordance with classical standards than those of their master and already show some response to the Romanesque idiom of abstract forms. Occasionally, too, they will betray a feeling of emotional involvement. This attitude emerges, for example, in the wild gestures and distracted eyes of Martha in the Lazarus scene (Plate 64),[125] in the anguish of the three crucified figures in the second Crucifixion scene,[126] and in the ecstatic movements of the two angels at the Ascension.[127] The elements of Romanesque abstraction and of emotional intensity appear with particular force in the four evangelist portraits that precede the manuscript text (see St Luke, Plate 65),[128] since the effect is not here 'broken up' by a larger setting, for they are isolated against a backcloth of purple and gold. These figures, like other evangelist pictures by the Gregory Master himself, derive from Carolingian pictures of the Tours School;[129] but they are now monumental, almost sculptural in quality, and are interpreted in terms of elliptical and oval forms. All this is heightened by the burning intensity of their eyes. The result is a feeling of psychological tension, compounded of emotional pressure and abstract balance.

This attitude finds yet more powerful expression in the illumination of the so-called Liuthar group, where the classical canons of the Gregory Master are repudiated in favour of an art which, though controlled, expresses physical vibrancy and passion.

The Liuthar group[130] represents the final stage in the development of Trier painting and the ultimate expression of Ottonian art. Its finest works were produced towards the end of the tenth and at the beginning of the eleventh century, so that it apparently began during the lifetime of Egbert and continued after his death. Under Egbert himself, illumination at Trier had been characterized by considerable diversity: for example, the paintings of the Poussay Gospel Lectionary and of the Egbert Psalter are quite different from the narrative pictures of the Egbert Codex. In the Liuthar group, however, we see the emergence of a new unity. Its manuscripts are illustrated by different artists but show an interrelationship of style, iconography and colour harmony, and draw on a common reservoir of artistic experience. In this sense it can be called a School. Its best-known manuscripts are two Gospel Books of Otto III, one in the treasury of Aachen Cathedral (Plate 66) and the other at Munich (Staatsbibliothek cod. lat. 4453),[131] a Gospel Lectionary made for Henry II to present to Bamberg Cathedral (Munich, Staatsbibliothek cod. lat. 4452),[132] two theological commentaries at Bamberg (Staatliche Bibliothek cod. bibl. 22 and 76),[133] and also the Bamberg Apocalypse there (cod. bibl. 140).[134]

The centre of this group must clearly have been a monastery, since Liuthar, who gave his name to the group and who is represented as the scribe or donor of the Aachen Gospels of Otto III, is shown wearing a monastic habit.[135] Most scholars hold that this centre was Reichenau, as they do for all the manuscripts discussed so far. But where the Liuthar group is concerned, this view is particularly difficult to sustain. I have expressed the view that the Egbert Codex was made at Trier under the supervision of a Trier artist. It is certainly undisputed that, after Egbert's death, it remained at Trier in the abbey of St Paulinus. Now the artists of the Liuthar group of manuscripts, quite independently of each other, show an intimate knowledge of its paintings; this is demonstrated not only by their use of the same colour harmonies but also by their adoption of other elements of style,[136] and this is difficult to account for unless the Liuthar group itself was centred at Trier.

Some supporting evidence for this attribution is given by the liturgical evidence in one of the manuscripts, which points unmistakably to the diocese of Trier.[137] Other confirmation is suggested by the known relationship between Trier and owners of Liuthar manuscripts. Two, for example, were owned by Otto III, who not only gave an important privilege to St Maximin at Trier but is represented with his mother on a Trier book-binding.[138] Two others,[139] and probably a third,[140] were made for Henry II (1002–24) to present to his foundation at Bamberg, and both Henry and Bamberg had connexions with Trier – Henry had associations both with Megingaud (consecrated archbishop of Trier in 1008) and with his successor Poppo (1016–47); moreover Megingaud had also sent important Trier relics to Bamberg in 1012 and Poppo had actually come from Bamberg, where he had been a provost of Bamberg Cathedral before his elevation.

The evidence for placing the Liuthar group at Trier is, then, very powerful, though, since Trier was the centre of monastic reform, we cannot (despite their artistic cohesion) overlook the possibility that some manuscripts may have been made, not at Trier itself, but by Trier monks at one of its dependencies. Trier must certainly, however, be considered the focal point.

Of the influences at work on the Liuthar group one seems reasonably well established – Early Christian art.[141] This does not mean the fifth-century Western branch of it which inspired the Egbert Codex, but the sixth-century Eastern, or Byzantine, branch. Such influences are clearly visible in one of the earliest manuscripts of the group, the Aachen Gospels of Otto III. This is prefaced with a representation of Otto III in the full panoply of power and includes among its illuminations twenty-one full-page scenes of the New Testament (Plate 66). Floating colours, tremulous brush-strokes, the technique of working direct with the brush, Late Antique views of cities, the handling of trees and clouds, and certain features of the decoration all point to the influence of sixth-century illumination of the Eastern Church.

But if some influences came from early Eastern art, others may have come from contemporary Byzantium. These would explain the frequent use of gold-leaf backgrounds, the heavy modelling of the faces, and the obvious Eastern elements in the iconography. All this, however, does not imply slavish copying. Within the Liuthar

group, indeed, there are striking examples of free adaptation and even of spectacular originality, especially in two Commentaries at Bamberg (Staatliche Bibliothek cod. bibl. 22 and 76; Plates 67 and 71).

When all has been said, however, we come back to the fact that a major influence on the Liuthar illumination was from the Egbert Codex itself. Similarities in the drawing of heads and faces, in styles of drapery, in the range and harmony of colours make this evident. Yet, if the Liuthar artists were somewhat dependent on the Gregory Master, their relationship with him was equivocal. Closeness of letter is accompanied by alienation of spirit; similarity of detail by a contrast of mood. If the style of the Liuthar artists evolves from that of the Gregory Master, it repudiates most of the premises on which his art was built. Reticence is exchanged for dramatic vehemence, poise and balance for colour and movement, calm for turbulence, and aesthetic objectivity for emotional ardour. It is this passionate feeling that separates the Liuthar group from the Gregory Master. Indeed, whatever their relationship, they ultimately belong to two very different traditions: the Gregory Master to the tradition of aesthetic containment and the Liuthar illumination to the tradition of psychological involvement – a tradition now more and more favoured during this Ottonian period of fervent religious reform.

The contrast with the style of the Gregory Master is particularly clear in manuscripts of the Liuthar group which actually take over complete scenes from the Egbert Codex – manuscripts like the Gospel Book of Otto III and the Gospel Lectionary of Henry II (Munich, Staatsbibliothek cod. lat. 4453 and 4452; Plates 68–70). These dispense with the delicately graduated backgrounds of the Egbert Codex which softened the immediacy of human feelings. They replace them with 'backcloths', often of gold, which thrust the figures forward and throw into relief every impetuous action and gesture. To increase the forceful effect, the arms and fingers are lengthened, and the body attenuated. The dramatic effect is yet further enhanced by the strength of highlights and vibrancy of texture. The eyes glow, as if to express the intensity of the emotional forces within and the whole human figure has become a tongue to speak with apocalyptic vehemence. A figure like that of St Luke on folio 139 verso (Plate 69), encompassed by Old Testament symbolism and aflame with celestial fire, becomes the very embodiment of divine inspiration.

It would be a mistake to think that such expressions of emotional energy are uncontrolled. These paintings – like fugues – have their own strict, formal structure, regulated by geometric balance. As an example we may take the work of one of the greatest of these Ottonian illuminators. His portrayal of Isaiah's vision in a Bamberg manuscript (Bamberg, Staatliche Bibliothek cod. bibl. 76 folio 10) is incandescent with spirit and energy (Plate 71). Enthroned in a gold mandorla, God is surrounded with protective flames of blues and purples glowing white at the edges. Outside, the seraphim are caught up in an exhilarating harmony – a harmony created by the swaying lines of their bodies and the complex rhythm of their wings. Agitated glances and dramatic gestures add to the intensity of this scene, as if the prophet's vision has been galvanized by some unearthly power. Despite all this, the basic composition is simple and geometric. God is the centre of three ovals – the oval of His mandorla, the oval circuit traced by the

seraphim, and the oval field of the background. This geometric simplicity lies at the base of almost all the illuminations of this group. Yet, far from reducing the emotional impact of the figures, it enhances it.

The illumination of the Liuthar group varies considerably in quality, and it would be idle to pretend that all, or even many, of its pictures are entirely successful. But the best are pre-eminently creative. They portray spiritual and emotional passions with a new power and purity and express the Ottonian idiom in a manner that is unique and triumphant. The finest work was produced between about 990 and 1025. After that the tradition of Trier painting passed to a daughter house still within the Trier diocese – the monastery of Echternach.

The School of Echternach

Originally founded as a Benedictine abbey by St Willibrord in the eighth century, Echternach for more than a century after the disintegration of the Carolingian empire was a community of canons. When it reverted to the Benedictine rule in 973, it drew its abbot and forty monks from St Maximin at Trier. Later, in the eleventh century, after a disastrous fire in 1016 and the exile of its abbot in 1028, it looked to Trier again and brought Humbert, a monk of St Maximin, to restore its discipline and prestige. He remained in office from 1028 to 1051 and, true to the St Maximin tradition, combined zeal for reform with an interest in art. He made gifts of metalwork, decorated the church 'most beautifully with images and pictures'[142] (fragments of these paintings still survive in the crypt), and encouraged illumination. As a result, Echternach now took over from Trier the task of providing emperors with manuscripts. One such manuscript – the Bremen Gospel Lectionary written between 1039 and 1040 for Henry III (Bremen, Stadtbibliothek cod. b. 21) – actually contains a picture of the scriptorium of Echternach.[143] It shows a monk and a layman together preparing a manuscript, which is then ceremoniously handed to the emperor himself.

Three particularly splendid Gospel Books survive from Echternach, two of which were commissioned by emperors.

The earliest is the Nuremberg Golden Gospels,[144] formerly in the Ducal Museum of Gotha, but now in the Germanisches National-Museum (Plates 72 and 73). It is written in gold, sumptuously illuminated, and bound in gold covers studded with precious stones. The covers originally belonged to an earlier Trier manuscript,[145] and if, as it has been argued,[146] they originally bound the Sainte-Chapelle Gospels of the Gregory Master, then this latter Trier manuscript may have been specially made for donation to Echternach. Certainly, the presence in the Echternach manuscript of a Christ in Majesty, evangelist portraits, canon tables, and initials, all derived from the Sainte-Chapelle Gospels, shows that the latter manuscript was available in the Echternach scriptorium at the time that the Nuremberg Gospel Book was produced.

Though a number of artists worked on the Nuremberg Gospels, and its illumination varies in quality, there is throughout a general taste for the decorative. So, in taking over the representation of Pentecost from the Egbert Codex, the Echternach version

transforms its delicate background into decorative bands of colour and makes the whole composition heavy and ornamental. Often this taste leads to fussiness of detail, though sometimes, as in the portrayal of St Luke, it can produce a composition of vigorous and cheerful patterns.

The paintings of Christ in Majesty (Plate 72) and the evangelists were derived (as we have seen) from the Sainte-Chapelle Gospels. The Majesty has the same 'stained-glass' composition of roundels and medallions; its distribution of colours is also the same; so also is the Greek inscription round Christ in His mandorla. The Christ itself is quite massive, but the potential strength of the compositions is frittered away by the ornamental vagaries of the artist which lead him to dwell on external decoration rather than on the intrinsic conformations of the figure. This unfortunate weakness is even more flagrant in the evangelist portraits, where the small decorative band across the upper of two of the Trier evangelists is now extended into garrulous proliferations over arms, legs, and bodies.

The Echternach manuscript contains numerous scenes from the Gospels, including some comparatively rare illustrations of the parables. Some of these pictures show iconographic influences from Byzantium,[147] but others are closely dependent on the iconography of the Egbert Codex.[148] (This latter manuscript, incidentally, also inspired another Echternach production, for the Bremen Gospel Lectionary, referred to above, has a number of illustrations derived from the Trier masterpiece.) However, unlike the arrangement of the Egbert Codex, where the pictures are on the same pages as the text, the Echternach narrative scenes are painted on full-pages independent of it and are now divided into three vertical panels or compartments with the particular action described on a narrow gold strip.

The figure-style derives from the Egbert Codex but devalues what it borrows, for it lacks both conviction and impact; there is no feeling of weight or structure under the draperies, which might equally well have clothed inanimate objects such as furniture or cushions. In some pictures (as in the one of two angels holding up an inscription opposite the Christ in Majesty) there is a strong decorative effect in which the heraldic regularity of design, the stylization of line, and the overall harmony of colour seem more proper to silks and textiles than to pictures. This decorative interest may well, in fact, have been inspired by Eastern silks, for such silks are carefully reproduced in three double folios of the manuscript (Plate 73). These paintings, unlike the less accomplished narrative scenes, are entirely successful and combine sumptuousness with tastefulness, delicacy with vigour, and a heraldic symmetry with a real animation.

A very different aesthetic is represented by the next Golden Gospel Book,[149] the most important manuscript produced by the Echternach School. Now preserved in the Escorial library, it was prepared between 1045 and 1046 for Henry III to present to the cathedral of Speier.

The illumination of the Speier manuscript by five different artists is even more lavish than that of the Nuremberg one. Its decoration recalls that of the Carolingian School of Tours[150] and its iconography that of Byzantium.[151] But it also has a relationship with the earlier Nuremberg Gospel Book itself, from which it derives some of its narrative scenes,

its evangelist portraits, and its imitation of Eastern silks on decorative purple pages.

The tendency to reduce the human figure to decoration is, however, completely rejected. The figures are no longer ornamental mannikins but have an individual strength and composure which enable each one to make its full impact. Sharply outlined against plain coloured backgrounds, they possess a hard, statuesque quality, and, as they move slowly across the picture in carefully balanced groups, they give a feeling of liturgical solemnity. The firmness of the figures, the economy of composition, and the unobtrusive nature of the decoration reverse the trend of the earlier Golden Gospels.

All this is clearly seen in the two dedication pictures, in which the painting of Christ in Majesty, though derived from the Christ of the Nuremberg Gospels, has now become particularly impressive. The first portrays Henry's father, Conrad II, the founder of Speier, with his empress, Gisela, at the feet of the enthroned Christ (Plate 74). The second shows Henry, before a representation of Speier Cathedral, offering the manuscript to its patron saint, the Virgin Mary, who is approached by his consort, Agnes, on the other side. The fact that a Byzantine artist helped in these paintings[152] means that to the Romanesque strength and power of these pictures are added the smoothness and finesse of Byzantine art.

Though their work shows some associations with the Nuremberg Gospel Book, from the point of view of figure style the present artists have simply by-passed it and returned to the fountain-head of the Echternach tradition – to the Gregory Master and the Liuthar School. They have assimilated something from both Trier Schools, but they also have something personal to offer. This is a feeling for bodily structure. This quality adds massiveness to figures already statuesque in conception and gives them a monumentality which is quite Romanesque. When this is combined with boldness of composition and vigour of outline, the result can be a figure of considerable power. This we find in the portrait of St Mark (Plate 75), for example, where the hard contours shaping the figure seem hardly able to contain the thrusting diagonals within. In its monumentality and impact, in its clarity and strength, in its interpretation of figure and drapery in terms of vigorous abstract forms, this figure is truly Romanesque. Here lies the real significance of the Speier Gospels.

Echternach produced other important manuscripts which reflect the polarities of artistic taste already expressed in the Nuremberg and Speier Gospel Books. For example, the evangelists of the Luxeuil Gospels (Bibliothèque Nationale, nouv. acq. 2196)[153] are highly decorative, and the stark Christ of the Uppsala Gospels (Uppsala University Library)[154] produced for Henry III to present to Goslar Cathedral at its dedication in 1050 is powerfully Romanesque (Plate 76 illustrates Henry and his queen being crowned by Christ). Nothing, however, surpassed the Speier Gospels, which was its greatest achievement.

The School of Cologne

The effect of Trier styles on the painting of Echternach is very clear, but the influence of Trier extended well beyond its own diocese and is seen, for example, in the art of Cologne in Lower Lotharingia.

Cologne, like Echternach, was a centre reformed from Trier. It was to Trier that Otto I's brother, Archbishop Bruno (953–65), turned for an abbot to rule his new foundation of St Pantaleon, and it was also Trier that later provided Archbishop Gero with a pastor for his new foundation of Gladbach. At Cologne, there was a time-lag between the initial reform and the emergence of painting which first appeared at the turn of the century and found its complete expression during the first half of the eleventh.

As far as we know, the Cologne School of illumination[155] did not have the benefit of imperial or princely patronage and it produced no costly *manuscrits de luxe*. But, if the size and outward appearance of the manuscripts were modest, their number was large and their illumination distinguished. During the first half of the eleventh century, in particular, it was a vital centre of manuscript-painting. There were (as we shall see) variations of style, but its best work had a distinct individuality. The influences bearing on it came from Trier and Carolingian and Byzantine art.

It seems that a Trier Gospel Book, illuminated by the Gregory Master at the very end of the tenth century and now in a sadly mutilated condition (Manchester, John Rylands Library MS. lat. 98), was actually at Cologne during the eleventh century and influenced the decoration of the manuscripts there.[156] Possession of such a manuscript would indicate that relationships between Trier and Cologne remained close long after the initial monastic reform had taken place. It may even be that a Trier manuscript like this represented Trier's own sense of indebtedness to Cologne for, under pressure from Egbert, Cologne had sent to Trier part at least of a very precious relic which Trier claimed as its own – the staff of St Peter (the patron saint of both cathedrals), now in Limburg.

But, if there were influences at Cologne from the style of the Gregory Master, there were others of even more importance from the Liuthar style, for one of the Liuthar manuscripts was specifically made for the cathedral there. This was a Gospel Book (Cologne, Domschatz cod. 12)[157] which, despite the loss of three of its evangelist portraits, still contains rich canon tables, a picture of St Jerome and of St Matthew, and a dedication picture. A long preface[158] informs us that the book was written by twin brothers named Purchard and Conrad for Cologne Cathedral at the request of one of its canons named Hillinus. It seems probable that the illuminator of the pictures (as opposed to the initials) was a Trier monk then probably residing at Cologne, which means that this manuscript cannot itself be claimed for the Cologne School of illumination. However, it certainly influenced Cologne manuscripts. This is clearly seen in a Gospel Book of the second quarter of the eleventh century now at Bamberg (Staatliche Bibliothek cod. bibl. 94),[159] which is closely related to Liuthar manuscripts like the commentaries on Isaiah and Daniel also at Bamberg. Here, as for example in the Majesty picture (Plate 77), we meet the same intense, heightened atmosphere, the dramatic gestures and passionate expression of the eyes. We do not find here, however, the same delicate colour harmonies and purity of figure style as in the Liuthar manuscripts themselves.

Most of the manuscripts produced at Cologne were Gospel Books. The evangelist portraits contained in these often show influences from the Carolingian period and indicate that a Carolingian manuscript derived from the Vienna Gospels of Charlemagne must have been at Cologne.

We can see this in the evangelist portraits of manuscripts such as the Gundold Gospels (Stuttgart, Landesbibliothek bibl. 4°2)[160] and the St Andreas Gospels (Darmstadt, Landesmuseum A.E. 679).[161] In two related manuscripts from St Gereon we can trace the gradual transformation of the Carolingian into an Ottonian style. In the first (Cologne, Stadtarchiv MS. W312),[162] produced during the early part of the eleventh century, the atmospheric quality of the Carolingian style is much in evidence. In the second (Stuttgart, Landesbibliothek cod. bibl. fol. 21),[163] made during the second quarter of the century, the whole style has been tightened up by an Ottonian incisiveness and crispness as we see in the picture of John (Plate 78). The backgrounds are 'banded' in simple colours without attempt to convey a sense of reality: figures are interpreted in terms of semicircular and oval forms. A comparable development at Trier (in the evangelists of the Egbert Codex, for example) and also at Echternach has been noted already. But at Cologne this style was not sustained, and in the Abdinghof Gospels of about 1061 (Berlin, Kupferstichkabinett MS. 78 A 3)[164] the evangelists are almost decorative parodies of what has gone before. This particular Carolingian style influenced a number of Cologne manuscripts, but another Carolingian style, that of Reims, was also of importance. That this style was known at Cologne seems evident from a very late Carolingian manuscript there (Cologne, Dombibliothek MS. 56)[165] which has the sketchy, impressionistic backgrounds and the agitated linear figures associated with the Reims School. We shall see later how strongly this influenced Cologne masterpieces such as the St Gereon Sacramentary and the Hitda Codex.

There were also Byzantine influences at Cologne,[166] which are not difficult to account for. When Otto II married Theophano, his Byzantine bride, Gero, archbishop of Cologne, was sent to escort her from the East to the West. It is understandable then that, when empress, she should favour Cologne, especially since it had been the bishopric of her husband's uncle, Bruno. She often visited Bruno's foundation of St Pantaleon and was buried there after her death, and she presented an important hanging to the Cologne monastery of St Mary. These Byzantine influences find their fullest expression in manuscripts such as the Sacramentary from St Gereon (Bibliothèque Nationale lat. 817)[167] and the Hitda Codex (Darmstadt, Landesbibliothek cod. 1640).[168]

The first was probably produced early in the eleventh century and was made at the house of St Gereon. (Its picture of the Nativity is shown on Plate 79.) The second, though a little later, also belongs to the early decades of the eleventh century and was made for Hitda, abbess of the Westphalian nunnery of Meschede. Both manuscripts represent Cologne illumination at its most individualistic. If one of these manuscripts is to be singled out to typify the whole Cologne school of illumination, it must be the Hitda Codex. This has fifteen scenes from the Gospels – two of which are here illustrated: the storm at sea (Plate 80) and the miracle at Cana (Plate 81) – a dedication picture, evangelist portraits, and pictures of St Jerome and Christ in Majesty. The illuminations in the manuscript vary somewhat in quality but show how the various influences from the Liuthar School of Trier, from the Carolingian School of Reims, and from Byzantium have been completely absorbed.

Byzantine influences[169] are expressed in the figure-style, the backgrounds, and even

the colour harmonies, but the whole spirit of the original Byzantine style has been transformed by the influences from Trier and Carolingian art: in particular, the Byzantine composure has been psychologically disturbed by the Trier intensity of eye and gesture, and physically disturbed by the Carolingian tremulousness of the brush-strokes. This tremulousness derives from the Reims School, but, whereas the Reims painters extended the perturbation to the whole scene, the Ottonian artist restricts this feeling to the figure.

What chiefly differentiates Cologne work from other German art is its painterliness. The Cologne illuminators often worked direct with a brush, without making a preliminary sketch. What is more, they often worked with an overloaded brush, so that the colours sometimes run slightly. This feeling for the fluid qualities of paint, combined with a dramatic use of colour, gives Cologne illumination much of its individuality. Both these characteristics may have been inspired by Byzantine painting, though we should note that whereas the painterly qualities of Byzantine painting led to an interest in the subtle gradation of tones to indicate the modulation of planes, here the brushstrokes, though rich, are essentially linear in expression and in some ways are an extension into more painterly terms of the Reims tradition of dramatic line.

Apart from this, Cologne illumination is often characterized by emotionalism and agitation. These are found in narrative scenes, but even inanimate objects are imbued with this perturbation so that, in a picture, for example, of the storm at sea (Plate 80), the boat itself lunges forward like some fearful animal of the depths with ominous and threatening head. This highly charged atmosphere of Cologne illumination produces in the hands of an accomplished artist an expression of genuine emotional feeling, but in less skilful hands the results are simply theatrical and melodramatic.

Not surprisingly, the Cologne painters chose to focus their attention at times on the emotional aspects of the Crucifixion, which becomes an occasion for compassion. The picture is one of anguished pain and sorrow – the body limp and poignant, the face tortured, if resigned. This is the interpretation given in the Hitda Codex and Gundold Gospels (Plate 82) and, with greater intensity, in the Giessen Gospels (Giessen, Universitätsbibliothek cod. 660; Plate 83). However, this new conception of the Cross did not actually originate at Cologne: it had been adumbrated at Trier in the Egbert Codex and given passionate expression there in the Aachen Gospels.

The School of Regensburg

The reforming vitality of Trier was such that its influence spread far and wide. And where its religious influence went, its artistic influence went also. The chief effect of this was to stimulate the local production of manuscripts, though the development of these local schools might well be moulded by styles other than those of Trier itself. Something of this has been seen at Cologne. But it is also evident well beyond the boundaries of Upper Lotharingia, at Regensburg in the distant duchy of Bavaria. Though both Cologne and Regensburg owed their original impetus to Trier, they offered a sharp contrast to each other in their full maturity. Painting at Cologne, as I have indicated,

had a tremulous, painterly quality and strong emotional content: painting at Regensburg favoured an incisive linear style and a content of abstract theological thought.

When St Wolfkang, bishop of Regensburg, wished to reform the house of St Emmeram in his diocese, he had turned not to Einsiedeln, where he himself had been prior, but to St Maximin at Trier. From it he brought Ramwold, who ruled over St Emmeram as abbot from 974 to 1001; his interest in books is reflected in the remarkable catalogue of manuscripts drawn up during his term of office.[170] Ramwold returned to Trier during a period of civil insecurity and carried back with him to St Emmeram relics[171] and possibly also manuscripts. Certainly, the Regensburg School of illumination which he initiated shows, side by side with influences from Carolingian sources, influences from Trier.

The Carolingian influences derive from the Gospel Book of Charles the Bald (Munich, Staatsbibliothek cod. lat. 14000),[172] which was brought from France by the emperor Arnulf and given to St Emmeram in the ninth century.[173] Often known as the Codex Aureus of St Emmeram, it was one of the monastery's most precious heirlooms. The binding was adorned with scenes from the New Testament embossed in gold and with precious stones: the text was written in gold and illuminated with paintings, one of which depicted Charles the Bald enthroned. Following the example of the Gregory Master, Ramwold decided that this splendid manuscript should be renovated, and an inscription states that the two persons who restored it on the abbot's orders were Aripo and Adalpertus.[174] Ramwold appears by himself on the added prefatory picture simply described as 'the unworthy abbot'.[175]

The style of this figure has been influenced by Trier illumination, notably the Egbert Psalter, but the rest of the illumination is inspired by the Carolingian paintings already in the manuscript: these comprised evangelist portraits and illustrative scenes as well as pages almost completely filled with decoration. The ornamental quality of the Golden Codex influenced the whole Regensburg School, which also seized on the same features in Trier illumination. It is no accident that the figures of Henry the Quarrelsome and St Benedict[176] in the manuscript of St Benedict's Rule made under Ramwold's direction for the nunnery of Niedermünster (Bamberg, Staatliche Bibliothek Lit. 142) have ornamental backgrounds similar to some in the Egbert Codex and the Egbert Psalter.

The full impact of the Golden Codex Gospel Book can be seen in the illumination of a Sacramentary made for Henry II between 1002 and 1014 (Munich, Staatsbibliothek cod. lat. 4456).[177] Six of the illuminated pages derive from the Golden Codex. Five of these are highly ornamental and the sixth, which is a portrait of Henry II, is an Ottonian paraphrase of the picture of Charles the Bald. The Sacramentary also contains pictures which are not derived from the Golden Codex. These, representing St Gregory, the Crucifixion, and the spiritual coronation of Henry II, reflect the art of Byzantium – in fact, the Crucifixion is accompanied by a Greek inscription. This Byzantine influence gives a new sense of modelling to the faces and a new spaciousness to the figures, though its full effect can sometimes (as in the St Gregory picture) be impaired by the florid decorative background. The ornamental background of the coronation scene is more

discreet, so that the Ottonian sharpness of outline, combined with the Byzantine smoothness, makes the picture hieratic and impressive.

The Regensburg School of illumination, then, received some influences from Trier and Byzantium. But its tastes were primarily moulded by the Carolingian Codex Aureus, which gave it a feeling for the linear and the ornamental, and also for geometric design, the latter interest being strengthened by influences from other arts, such as textiles and metalwork.

The fullest effects of all this are found in two manuscripts of the first quarter of the eleventh century, the Gospel Book of Abbess Uta of Niedermünster (Munich, Staats-bibliothek cod. lat. 13601; Plate 84)[178] and the Gospel Book of Henry II (Vatican Library Ottob. lat. 74; Plate 85).[179] In these the figures, which are remote from life and personifications rather than persons, stand out against a background of geometrical patternwork with the metallic precision of enamelwork. The composition is held together by bold designs made up of double gold bands bent into simple or complex forms. These frame and isolate the personages, give clarity and coherence to the decoration, contribute harmony to the background, and contain inscriptions which elucidate the symbolism. The inscriptions, let us add, are an integral part of the pictorial design, and contribute to the aesthetic harmony of the illumination at the same time as they offer, as it were, an intellectual extension of it.

An excellent example of this is the Crucifixion in the Uta Gospel Book (Plate 84). Christ is here seen on the Cross as the victor, wearing the stole of eternal life.[180] Incidents depicted on the right typify His victory over death, others on the left represent the new resurrection of life. Inscriptions clarify all this symbolism and extend its significance, indicating, for example, the necessity of the Cross to Salvation and the relation of God's rule both to the human knowledge of proportions and to the harmony of the spheres, and comparing the length and breadth of the Cross to charity and perseverance. All this reflects the development of scholarship which accompanied reform at Regensburg and which now gives a new intellectual depth to painting.[181] Pictorial symbolism had, of course, been known to Christian art ever since the days of the catacombs. But it had always been based on familiar associations and could only repeat known relationships. At Regensburg, where the commentary becomes an integral part of the picture, symbolism is given a new intellectual content, and the distinction made by St Augustine between the profundity of text and immediacy of painting is no longer quite valid. 'When we see a beautiful script,' he had claimed, 'it is not enough to praise the skill of the scribe for making the letters even and alike and beautiful. We must also read what he has signified to us through those letters. With pictures it is different. For when you have looked at a picture, you have seen it all and have praised it.'[182]

The feeling for geometric design remained an element of Regensburg illumination until the end of the century and is still evident in the Gospel Book made for Henry IV between 1084 and 1093 (Cracow Cathedral cod. 208).[183]

One of the great masterpieces of the school is the Gospel Lectionary made probably about 1040 and now at Munich (Clm. 15713).[184] This has more than twenty narrative scenes, painted by three artists. The pictures exhibit the three influences that conditioned

the Regensburg style: from Trier, from Byzantium, and from the Golden Codex. In over half of them, the influence of the Liuthar style is strongly marked. There are some decorative tendencies, but on the whole the treatment is vigorous and energetic, particularly in scenes such as that of the doubting Thomas. Other illustrations reflect Byzantine influence similar to that in the Sacramentary of Henry II. This Byzantinism expresses itself in the modelling of the head, in the colour harmonies, and, most of all, in the figure and drapery style. But if the figures retain a Byzantine breadth of treatment, their hardness of outline is essentially Ottonian, and the geometrical folds of the drapery are almost Romanesque. Combined with this is a linear quality of draughtsmanship that gives texture to the surface.

The School of Salzburg

This 'linearization' of a Byzantine style is carried a stage further in the related illumination of Salzburg,[185] and is particularly found in three Salzburg manuscripts of the third quarter of the century. The first is a Gospel Lectionary made by or for (the Latin is ambiguous) a certain Berthold to present to his house of St Peter at Salzburg, where he was sacristan (Pierpont Morgan Library MS. 781).[186] This contains seventeen illustrations, related to, and perhaps partly copied from, the Regensburg Gospel Lectionary. The second is a Gospel Book at Admont (Stiftsbibliothek Admont) which was presumably taken there when the abbey was founded in 1074 with monks from St Peter at Salzburg.[187] The third is a Gospel Book now at Graz (Universitätsbibliothek cod. 805).[188]

Salzburg had been reformed from Regensburg, just as Regensburg had been reformed from Trier, and here, after a century of foreign invasions and civil wars during which one archbishop of Salzburg had been killed in battle against the Hungarians and another blinded and burned by his own Bavarian ruler, artistic activity was slowly renewed. In abeyance since the ninth century, illumination was recommenced about the turn of the tenth. During the first half of the eleventh it passed from a close dependence on Carolingian prototypes (whether at first or second hand remains uncertain) to a more independent expression of the Ottonian idiom in terms of a harder and more incisive figure-style. This finds a very crisp and lively expression in the evangelist portraits of the St Peter's Gospels (formerly Salzburg, St Peter's Library MS. a X 6 and now New York, Pierpont Morgan Library MS. 780).[189] During this development, strong influences came to Salzburg from the Trier/Echternach School, no doubt by way of Regensburg: they are evident, for example, in the presentation of the evangelists within an architectural framework. The style of the nineteen narrative scenes of the St Peter's Gospels is, in fact, the same Liuthar style that we know was received in Regensburg. The effect here, however, is altogether less happy and more provincial. As if wearied by too many transpositions, the style has become something quite deflated. It is now completely devoid of its original inspiration and simply dressed up in an empty decoration.

After the middle of the eleventh century, the artistic relationship of the two houses was so intimate that we have now to think in terms of a Regensburg/Salzburg school, just as in Lotharingia we have had to bracket together Trier and Echternach. It is this period

that produced the masterly 'linear Byzantine' style common to both houses. The school was not without its influence on wall-paintings. This, at least, is suggested by the related style of the very impressive frescoes at Lambach,[190] which were probably made at the end of the eleventh century and which represent incidents from, or relating to, the life of Christ. Here the way in which Italo-Byzantine influences invigorate the figure style (particularly evident in the scene of Joseph's dream illustrated on Plate 86) already points towards the twelfth century. It was in this century that Salzburg blossomed into a great and independent centre of Bavarian painting, as we shall see in another chapter.

Other Schools

Of other centres of German illumination during the Ottonian period, the most interesting is Fulda, the most eclectic Hildesheim, the most impressive Weser-Corvey, the most uncertain Mainz, the most intelligible Prüm, the most controversial Reichenau, and the most pedestrian the Bavarian monastery school.

At Fulda[191] – as at Lorsch and Regensburg – early Ottonian illumination was directly inspired by Carolingian sources. This is clear from the calendar picture of the months and seasons found in a Sacramentary fragment of about 975 (Berlin, Staatsbibliothek theol. lat. fol. 192). This picture, which has been directly copied from a Carolingian model, retains some of the flavour of a Late Antique archetype. The Widukind Gospels (Berlin, Staatsbibliothek cod. theol. fol. 1),[192] the masterpiece of the Fulda School, also shows Carolingian influence. Bound originally in precious metal studded with gems and decorated with ivories, it is a manuscript of particular splendour. Its illumination includes four masterly evangelist portraits with sumptuous decorative pages *en face* and sixteen pages of canon tables illuminated with great taste.

The Widukind Gospel Book is so called because of a seventeenth-century tradition that it was given by Charlemagne to Widukind after his defeat and subsequent conversion. Since the manuscript belongs to the last quarter of the tenth century the tradition is clearly erroneous. But it is at least understandable in art-historical terms, for its illumination was derived from a Carolingian manuscript of the Court School of Charlemagne.[193] This is clearly evident from the picture of St Matthew reproduced on Plate 87. The particular manuscript which inspired it no longer survives, but of other manuscripts relating to the Court School, the Erlangen Gospels (Erlangen, Universitäts-bibliothek cod. 141) provides parallels to the pictures of Matthew and Mark, and the Soissons and Harley Gospels (Bibliothèque Nationale lat. 8850 and British Museum MS. 2788) of the Court School itself offer parallels for the canon tables.[194] We saw earlier that, at Lorsch, the influence of this particular Court School led to a crisp and incisive style more in accordance with Ottonian tastes. At Fulda the exact reverse happened for the fluttering, restless quality of the Carolingian draperies was enhanced, as in contemporary Anglo-Saxon manuscripts, and this, indeed, may be due to English influences. That the one masterpiece of illumination produced at Fulda in the Ottonian period should be so little Ottonian in feeling is paradoxical, but there is something appropriate about the marriage in it of English and Carolingian influences, for Fulda had been founded by the

English missionary St Boniface and it was during the Carolingian period that it had reached the apogee of its fame.

Despite the importance of the Widukind Gospels, Fulda was normally more interested in the production of Sacramentaries and Lectionaries than in that of Gospel Books. In these manuscripts – in the Göttingen Sacramentary for example (Göttingen, Universitätsbibliothek cod. theol. fol. 231) – we find Carolingian influences[195] simply accepted and even debased, with no admixture of English style. The freshness and refinement of the earlier illumination has gone, the style has coarsened, and we are presented with little more than a provincialized Carolingian style.

In the first half of the eleventh century Fulda's illumination becomes more and more eclectic. The Sacramentary at Bamberg (Staatliche Bibliothek cod. lit. 1)[196] shows strong influences from Cologne, and the Sacramentary at Rome (Vatican, cod. vat. lat. 3548)[197] strong influences from Salzburg. These latter influences are not difficult to understand if we recall that Fulda and Salzburg came within the reform orbit of Regensburg. Some of the illumination of the first half of the eleventh century is interesting and some – like that of the last two Sacramentaries quoted – is highly successful. But, essentially, this is an art that is borrowed and rearranged rather than developed or created.

At Hildesheim,[198] we find illumination of even greater eclecticism. When this centre was indirectly reformed from Trier through Cologne in 1013, the bishop was the famous St Bernward (983–1022). His biographer speaks highly of his artistic interests and his artistic skill, remarking that he would copy from various works of art anything that attracted him.[199]

The illumination in the few manuscripts of St Bernward that survive confirms this eclectic taste. The Crucifixion scene, the only illustration in his Sacramentary (Hildesheim, Domschatz Nr 19),[200] reflects Carolingian influences from the Court School of Charles the Bald. The Christ in Majesty and the evangelist portraits in the first of his two Gospel Books (Hildesheim, Domschatz Nr 33)[201] derive ultimately from the Court School of Charlemagne. The figure-style, symbolism, inscriptions, and general ornamental effect of the second show the influence of Regensburg (Hildesheim, Domschatz Nr 18).[202] This latter manuscript is more lavishly illustrated than the others: its symbolism is intriguing, and the pen-sketch of St Matthew quite individual. In this, however, it is exceptional, for the rest of the illumination shows the enthusiasm of the amateur rather than the competence of the professional, a statement generally true of Hildesheim manuscript-painting.

More homogeneous and far more impressive than Hildesheim is the so-called Weser-Corvey School.[203] Its decoration, often consisting of large ornamental initials, was influenced by Franco-Saxon styles but expressed them with such sumptuous, interwoven colours that the vellum page begins to vie with rich tapestries. Its illustrations, usually pen-and-ink drawings with a colour wash, are among the most impressive of Ottonian art and represent Carolingian styles being brought to terms with an aesthetic that can only be described as Romanesque. Manuscripts of particular importance are to be found in New York (Pierpont Morgan Library MS. 755 and a Gospel Book in the New York

Public Library), Kassel (Landesbibliothek cod. theol. fol. 60), and Wolfenbüttel (Landesbibliothek Heinemann 2187).

Of other centres, Mainz, though characterized by competence rather than by creative ability, was probably important, but more research is needed before the exact significance of this school can be ascertained. A small prayer book made there for Otto III (Gräflich Schönbornsche Bibliothek, Pommersfelden) [204] bears no comparison in splendour with the normal imperial manuscripts.

Prüm in Upper Lotharingia was, essentially, a tributary of the Trier/Echternach School, but with an individuality of its own expressed in the rarefied, wraith-like quality seen in the illumination of the Rylands Gospel Lectionary (Manchester, John Rylands Library MS. 7). [205]

Reichenau remains a controversial centre but, in my view, it was like Einsiedeln [206] a Swabian atelier of only local importance, showing in its initials influences from St Gallen and from Trier.

The so-called Bavarian monastery school [207] (which, in fact, spread over the three centres of Tegernsee, Niederaltaich, and Freising) was long-lived rather than inspired. Its work had a modest competence, but was never creative and ultimately became quite reactionary. It flourished chiefly in the eleventh century, but survived into the twelfth.

All these centres have something of interest, but none has the significance of the three major schools of Ottonian art – the Trier/Echternach School in Upper Lotharingia, the Regensburg/Salzburg School in Bavaria, and the Cologne School in Lower Lotharingia. Of these the most important was the first. It is no accident that most of the imperial manuscripts were made either at Trier itself or at one of its reform dependencies – Echternach or Regensburg or Tegernsee. The Trier diocese was, indeed, the main workshop in which Ottonian art was created and developed. Here there emerged the 'classical' work of the Gregory Master; here were developed the qualities that gave Ottonian painting its individuality and significance; here were evolved those styles that bridge the ninth and twelfth centuries in the world of art and take us from Carolingian to full Romanesque.

FRENCH PAINTING AND THE TRADITIONS
OF THE WEST

Historical Background

WE have seen that the general Carolingian Renaissance of the ninth century was followed in the tenth and eleventh centuries by an artistic renaissance in Germany. France, however, did not enjoy a comparable efflorescence until the Ottonian renaissance was well on the wane.

The reasons for this are not difficult to suggest. Whereas the German part of the old Carolingian empire had developed into a wealthy kingdom consisting of a few strong duchies, recognizing a central imperial authority, the French part had disintegrated into a patchwork of small and hostile provinces giving grudging recognition to a series of unfortunate kings. The resultant bloody feuds in France are referred to in the chronicles, and memory of them sank deep into the national consciousness to emerge in the later epic poems. 'Evil and plundering men of blood have burnt the churches,' says a bishop in one of them.[1] 'Monks and priors have been put to flight . . . the flower of Christianity has perished. Rich towns have been laid low, the common people are in tears.' France, then, did not have settled and wealthy ecclesiastical and secular princes to offer the patronage to art that we find in Germany. At a time, for example, when the powerful archbishop of Trier, Egbert, was raising the art of his diocese to the zenith of its fame, the archbishop of Reims (his opposite number in France) was having to cope with attacks by brigands not only on Reims but also on the archiepiscopal palace itself.[2]

A period which saw the emergence of the Cluniac order was not one of unmitigated disorder, but circumstances in France during the tenth and eleventh centuries were such that art was more sporadic, more evanescent, and more particularist than in Germany. It depended overmuch on an occasional local patron instead of catering for the more cosmopolitan and less transient needs of imperial and episcopal courts. It was also more often content than German art to perpetuate or borrow rather than to innovate and there was considerable dependence either on the traditions of the Carolingian past or on styles then current in Germany and England.

CAROLINGIAN INFLUENCES

During the early phases of the Ottonian Renaissance, German painters, as we have seen, made use of Carolingian art. But, after gaining self-confidence, they had been ready to leave its broad waters and to seek other rivers of their own. In France, on the other hand, painters showed less initiative before the twelfth century. For them, the Carolingian tradition was not an anchorage to sail from but a reservoir to return to. In French art of

the tenth and eleventh centuries, there is a frequent recourse to the Carolingian past.

At some of the former great centres of Carolingian art this recourse is understandable. At Saint-Denis, for example, there was in the mid eleventh century a reversion to the style current there two centuries before. This is evident in the illustrations of a Missal now in the Bibliothèque Nationale (lat. 9436).[3] There is, it is true, a slight elongation of figure, as we see in the picture of Christ in Majesty on folio 15 verso (Plate 88), and this is possibly due to a little Ottonian infiltration, but otherwise the elements of these handsome pictures, whether of format or frame, decoration or figure-style, are largely Carolingian in inspiration. At about the same time, we find in the Paris house of Saint-Germain-des-Prés[4] Carolingian influences almost as strong. These, however, came from the school of Reims[5] not that of Saint-Denis, and they were somewhat modified by Romanesque attitudes, derived no doubt from Germany, which give more tautness to the original evanescent style. An excellent example is the Crucifixion[6] drawn in bistre against a purple ground in a Psalter of the second half of the eleventh century (Bibliothèque Nationale lat. 11550 folio 6). As at Saint-Denis, the quality is high but the modes are those of a vanished epoch.

To the north of Paris we find the Carolingian School of Reims influencing manuscript-painting at Saint-André in the eleventh century.[7] Earlier, in the tenth century, monasteries like Saint-Omer had been producing rustic drawings adhering to Carolingian formulae.[8] At the end of the tenth century and the beginning of the eleventh, the near-by house of Saint-Bertin evoked the Carolingian past in some fine but entirely derivative paintings, and, a little later, Saint-Vaast at Arras revived the old Carolingian decorative styles. In both these centres the Carolingian influences were confronted by Anglo-Saxon ones which we shall examine in more detail when we come to analyse the Anglo-Saxon influences on France. We might remark *en passant* that Carolingian and Anglo-Saxon influences also met in central France and are evident in the vigorous illustrations of the *Life of St Radegund* (Poitiers, Bibliothèque Municipale MS. 250; Plate 89).[9] This came from her monastery at Poitiers, which had connexions with England.

Just as Carolingian influences encountered influences from England in the north, so, in the south, they met influences from Italy and Spain. The very fine Bible of Saint-Martial of Limoges of the second half of the eleventh century (Bibliothèque Nationale lat. 8)[10] evinces both Carolingian and Italianate inspiration. From the coalition of Carolingian and Spanish influences a particularly magnificent masterpiece resulted: it is the famous Beatus Apocalypse of Saint-Sever in Gascony, which was made under Abbot Gregory Muntaner (1028–72) and is now in Paris (Bibliothèque Nationale lat. 8878; Plate 90).[11] This takes over from the Visigothic Apocalypses their wild and grandiose inspiration and their bright barbaric colours, but controls them with a clarity of line and orderliness of composition derived from Carolingian sources, so that the tempestuous outpourings of Spanish art are given a new dignity and coherence of expression. Here, the Carolingian tradition had a positive part to play in the creative process whereas too often in France it simply provided the excuse for negative repetitiveness. Some Spanish exoticism continued occasionally to touch French painting in the twelfth century and is evident, for example, in the Burgundian illumination of the Saint-Bénigne Bible (Dijon,

Bibliothèque Municipale MS. 2), but nowhere was its influence as fruitful as here. Despite the masterly quality of the Saint-Sever paintings, there seems to have been no development from them, though a tamer and domesticated version of the style is found in the dancing woman and jugglers of a mid-eleventh-century Troper from the region of Auch (Bibliothèque Nationale lat. 1118).[12] The vigorous drawings on two folios of a Toulouse *Josephus* (Bibliothèque Nationale lat. 5058),[13] however, show a renewal of Carolingian influence, and here, in the fluted folds, there is a hardening of forms which does show a positive progression towards the Romanesque styles of the twelfth century.

It is worth remarking, in this context, that not only did Spanish and Carolingian influences meet in the south but also Spanish and Ottonian ones. The result, in a Sacramentary of Saint-Étienne of Limoges made about 1100 (Bibliothèque Nationale lat. 9438; Plate 91),[14] is a remarkable and impassioned style in which figures, painted in hot, torrid colours, seem to perform some frenzied, but ritualistic dance. This ritualistic element is enhanced by the gold sheen and decorative lustre which have been derived from metalwork (possibly the celebrated enamels of Limoges).

We would expect to find Ottonian influences more readily in the east of France than in the south, and here we do find them. At places like Saint-Pierre at Senones in the early eleventh century they combined with, or rather were juxtaposed to, Carolingian influences, for if the initials there were Ottonian, the canon tables were Franco-Saxon.[15] Farther north, on the other hand, they tended to be confronted by influences from England, and this we shall deal with in detail later.

It is sometimes true that the children of a particularly great man find it difficult to grow up in his shadow. To some extent this was true of manuscript-painting in France in the tenth and eleventh centuries, which seemed to find the shadow of the Carolingian past too dark for its own health and vitality. The shadow extended even further into the twelfth century, when it fell on the field of monumental painting. Carolingian influences here are possibly explained by the fact that the wall-painter himself returned to Carolingian illuminated manuscripts. It is more probable, however, that the original Carolingian traditions had been sustained in lost frescoes of the intervening period and that these provided the immediate source of inspiration.

All the elements of the Carolingian decorative grammar continued into the wall-paintings of Romanesque France – the stepped pattern, the interlace of ribbon-ornament, the medallion and lozenge, and the division of the background into horizontal bands.[16] (The latter had originated in late classical art as a naturalistic attempt to distinguish between the earth and the atmosphere, but was now used for exactly the opposite purpose as decorative grounds to isolate the figures from reality.)

The Carolingian figure-style also continued. At Méobecq (Indre),[17] for example, the flying angels in the choir holding a medallion (Plate 92) not only repeat a familiar Carolingian motif (itself derived from Antiquity) but also continue a Carolingian style, for their fluid impressionism relates them to Carolingian manuscript-paintings like those of the Lothar Psalter. These Carolingian styles were, of course, assimilated to the Romanesque tastes for clarity and stringency. This is well demonstrated by two Christs in Majesty – the one at Saint-Jacques-des-Guérets (Loir-et-Cher) (Plate 93),[18] and the

other in the priory chapel of Saint-Gilles at Montoire-sur-le-Loir (Plate 94).[19] In the first (which is given a mauve tonality by its red and yellow ochres and touches of blue), despite some continued freedom in the draperies, there is a clear tightening up of a Carolingian style to conform to Romanesque tastes. In the second (which is, in fact, the earlier) this development has gone much further. The Christ of the Montoire apse derives from the Carolingian tradition, but it has now been completely assimilated to the Romanesque idiom and provides us with a delightful abstract composition of swaying linear rhythms and geometric forms.

Besides being adapted to Romanesque tastes, these Carolingian styles were, of course, themselves subjected to other influences. The relaxed but purposeful figures of Christ and four angels on horseback in the crypt-chapel of Auxerre Cathedral (Plate 95)[20] show a blend of Carolingian and Italian influences. These two influences are juxtaposed rather than fused in the church of Saint-Léger at Ébreuil[21] in the Bourbonnais. There, the paintings on the west wall of St Martial and the martyrdom of St Valerius are still basically Carolingian in style, whereas the paintings on the south wall of local saints and the martyrdom of St Pancras reflect influences from Rome and central Italy. At Saint-Aignan-sur-Cher (Loir-et-Cher),[22] the angels holding the Lamb in the apse of the crypt are ultimately of Carolingian lineage, though here tempered by influences from the north-east, and for parallels to the slender high-waisted figures below with their delicately pleated draperies, we should have to look to manuscript-paintings of the Channel areas, or under Channel influences, such as those of Valenciennes, St Albans, and Cîteaux, which will be discussed in the next section.

CHANNEL INFLUENCES

Flanders

It has earlier been remarked that, during the tenth and eleventh centuries, art in France was more particularist than that of Germany. This is given special point when we learn that, at the turn of the tenth century, when Ottonian art in Germany was being encouraged by powerful princes of the Church and patronized by emperors, the most important centre of painting in France was under the patronage of an abbot of a small Flemish community who was himself one of the chief artists of his own scriptorium. This was the house of Saint-Bertin, a Benedictine house on the Flemish north-east coast of France, and the abbot's name was Odbert.[23]

The exact dates of Odbert's abbacy of Saint-Bertin are unknown, though he was certainly in office by 990[24] and he survived into the eleventh century. The year of his death is variously given by later sources as 1007 or 1012. The fact that a number of manuscripts was made during his abbacy and at his behest we know, both from inscriptions[25] and from palaeographical evidence.[26] The further fact that Odbert was an artist as well as patron we derive from an inscription in one of the most important of the manuscripts of his abbacy – the Saint-Bertin Psalter (Boulogne MS. 20).[27] The stylistic evidence of his work here enables us to attribute to him illustrations in other manuscripts.

Odbert's own style owed something to the Carolingian past, but these influences only became significant when they were cross-fertilized by more powerful influences from England. Left to themselves, they became – like fossils – indications of earlier developments rather than precursors of later ones. Examples of this are Odbert's illustrations of two copies of an *Aratus*, which show Carolingian influences at their clearest and most undiluted. The finer of the two, from which the figure of Andromeda is reproduced (Plate 14), is at Boulogne (MS. 188),[28] the other, which is drabber in colour and harsher in line, is at Bern (Stadtbibliothek MS. 88).[29] The Carolingian model actually used by Odbert still fortunately survives: it is now in the University Library at Leiden (Voss. lat. Q. 79; Plate 13).[30]

By a curious chance, the Carolingian illustrations which Odbert so faithfully copied were themselves faithful copies of Late Antique illustrations and retain the flavour and soft modelling of the original late classical style. What this means is that Odbert's paintings are reflections of reflections. It is, indeed, a little ironic to think of the Benedictine abbot, at some time near the apocalyptic year 1000, painting the virile classical gods and voluptuous classical goddesses which were included among the illustrations. Technically, these pictures provide adequate testimony to Odbert's abilities as a painter, but they do not present him in a particularly favourable light as a creative or progressive artist. There is nothing in them of originality, and there is no development from them.

A much healthier and far more powerful influence on Odbert's painting came from England, which was then reaching the full flood of its own artistic efflorescence. Indeed, it would be no exaggeration to say that, despite some modifications, the forward-looking painting of Saint-Bertin represents an extension of Anglo-Saxon art to the Continent.

That there should be a close artistic relationship between Flanders and England at this time is not surprising in view of the links forged between the two countries by the movement of monastic reform.[31] But a special relationship with Saint-Bertin was induced by more particular factors. To begin with, Saint-Bertin monks had earlier settled in England both to promote reform and to escape its worst excesses.[32] Then, Saint-Bertin was near the English gateway to the Continent and close to the point of disembarkation[33] of Englishmen travelling abroad. It was, therefore, a convenient reception point for English ecclesiastical dignitaries travelling to and from Italy. We know from a letter written by Odbert himself[34] of two visits paid to Saint-Bertin by Ethelgar, archbishop of Canterbury (988–90), when travelling to Rome and back, and the same letter presses his successor, Sigericus, to visit the house also.

Apart from visits by Anglo-Saxon bishops, there is clear evidence of Anglo-Saxon artists actually working at Saint-Bertin. We have seen that the one manuscript with which Odbert is firmly linked as an artist is the Saint-Bertin Psalter,[35] which 'Odbertus decoravit'. As we shall see later Odbert was responsible for the historiated initials and three prefatory full-page paintings, but a second artist added fine tinted drawings in the margins to illustrate seven of the psalms. These marginal illustrations express the tremulous sensitiveness of contemporary English drawings to perfection, and they were clearly made by an Anglo-Saxon. Iconographically, they are associated with a later Anglo-

Saxon manuscript that belonged to Bury [36] but which probably followed a Canterbury prototype,[37] and one is led to believe that this English artist at Saint-Bertin was from Canterbury.[38]

There was a second Anglo-Saxon artist working at Saint-Bertin whose stylistic affinities were with Ramsey[39] rather than with Canterbury. Apart from two small decorative initials executed by Odbert, he was responsible for all the decoration and illustrations of a lavishly painted Gospel Book from Saint-Bertin which is now at Boulogne (MS.11).[40] This contains several pages of canon tables, enlivened at times with vivacious drawings, a full-page Christ in Majesty of superb quality (Plate 96), and pictures of the evangelists with sumptuous 'title-pages' to the Gospels *en face*. Executed in full colour, with purple, gold, blue, and green predominating, the paintings are conceived in linear terms and have the swirling vitality of the finest contemporary English work. Though essentially English in execution, they nevertheless reflect in their composition and format influences from Germany:[41] the architectural settings in which the evangelists are placed are derived, for example, from Ottonian paintings, and the insertion of narrative scenes on the 'title-pages' to the Gospels comes from Fulda.[42]

Anglo-Saxon artists were clearly working at Saint-Bertin under Odbert, and they strongly influenced his own painting. This is evident in the illustrations he made for a Gospel Book which is now at Saint-Omer (MS.56).[43] His Christ in Majesty (Plate 97) has been largely copied from the Majesty of the Anglo-Saxon artist in the Boulogne Gospel Book (Plate 96) and, despite some modifications, such as the insertion of symbols of the four evangelists and the interpretation of the original painting as a coloured line-drawing, the dependence is clear. All the stylistic features – the fluttering drapery-end above the knee, the particular fall of the garment over the body and legs, and the billowing folds around the ankles – are derived from the English illustration in the Saint-Bertin Gospels. Odbert's own Christ is an impressive and pleasing composition, but the fluid spontaneity of the original has been replaced by something drier and firmer. This is typical of the changes wrought in most Anglo-Saxon art when it was adopted on the Continent.

Odbert must also have had access to Anglo-Saxon models which are now lost to us. An Anglo-Saxon manuscript clearly lies behind the most splendid of his own manuscripts, which is another Gospel Book now in New York (Pierpont Morgan MS. 333).[44] This has three full-page evangelist portraits with sumptuous 'title-pages' to the relevant Gospels *en face* (Plate 98), as in the Saint-Bertin Gospel Book already discussed. It also contains fine decorative initials and a dedication picture showing two figures – presumably Odbert himself and the scribe – presenting the book to St Bertin, and is further enriched by narrative scenes and symbolic figures, set within the large initials of the 'title-pages' and the frames of two of the evangelist portraits.

Odbert is here responsible for both the decoration and illustration, and he captures the English idiom with great conviction. The evangelists, for example, against their purple backgrounds are painted in the exuberantly linear style which is found in contemporary England: the draperies cascade in linear profusion over their legs and even the curtains hanging above have an animation of their own. The fact that Odbert was not himself an

Anglo-Saxon is, however, betrayed first by the stolidness of the heads and the wooden-ness of the hands, which conflict with the spontaneity of the draperies, and secondly by the way in which he tempers Anglo-Saxon styles of the present with a completely different style of the past. In this manuscript the decorative initials of the text have the animal- and bird-head style of contemporary Canterbury manuscripts, and the figure-style is also completely in accordance with contemporary English taste. Yet, instead of the lushly exuberant borders which were popular in the English manuscripts of his day and which restricted the picture in only a very nominal way, Odbert prefers a firmly disciplined framework. This, on folio 51 (Plate 98), is filled with carefully controlled and fastidious decoration which derives from English styles current some sixty or seventy years earlier and which finds a close parallel in the Anglo-Saxon Life of St Cuthbert[45] given by King Aethelstan to the shrine of St Cuthbert in 934. There can be no doubt that the revival of this earlier stylistic feature changes the whole atmosphere of the painting. The borders no longer partake of the emotional vibrancy of the picture but act as a frame to contain it and tone it down. There is, in fact, a positive dissonance between the floating exuberance of the draperies and the flat, meticulously careful decoration of the frame which an Anglo-Saxon artist would never have countenanced. However, this slight mixing of styles frees Odbert from the sterility of his Carolingian phase, when he was simply producing copies of copies, and gives his 'English' work a flavour of its own.

In a different way we find a mixing of influences in the critical Odbert Psalter (Boulogne MS. 20) from which we drew our initial information about Odbert's rôle as an artist. As we have already seen, the marginal drawings of this manuscript were made by an English artist probably from Canterbury. The main illustrations, however, which include three prefatory full-page paintings in colour and gold and drawings of biblical scenes, which occupy thirty-two of the small initials in the text, were made by Odbert himself. The first of the prefatory paintings (folio 2) shows David and other musicians with an interesting display of musical instruments,[46] the second depicts David playing his harp, and the third has a large historiated initial to the psalms which contains a representation of Pentecost and illustrations from the life of David set into the arcade around. The figure-style here has affinities with Canterbury work.[47] The figure-style of the smaller historiated initials, with its slender, high-waisted proportions and fluttering draperies, is also unmistakably English in inspiration, but, as so often happened when English art emigrated to the Continent, the line is drier and less vibrant than in Anglo-Saxon work and the atmosphere more tranquil. Furthermore, although the figure-style is Anglo-Saxon in origin, the interlaced decoration of these initials belongs to the Carolingian Franco-Saxon style, which had been particularly popular in the north of France. There are other influences from Carolingian art, too.

Odbert's particular use of the historiated initial seems itself to come from Carolingian sources. In English manuscripts, we find the occasional use of a historiated initial on a sumptuous title-page,[48] and this was taken over by Odbert both in the Morgan Gospels (Plate 98) and in this very Psalter. But the historiated initial as an intrinsic part of the text page is extremely rare in Anglo-Saxon manuscripts and probably here derives from a Carolingian tradition. We find it, for example, already well developed in the Drogo

Sacramentary of the Metz School (Paris, Bibliothèque Nationale lat. 9428)[49] and in a heavier form in the Corbie Psalter (Amiens MS. 18).[50] Odbert's method of interpreting the Psalter is Carolingian also. Artists in contemporary England tended to illustrate the Psalter in literal terms, but here we find it illustrated in allegorical terms instead. The artist is not, in fact, depicting the Psalter text but the commentaries on that text, as in the Carolingian Stuttgart Psalter.[51]

There is, however, more to this Odbert Psalter than a mingling of influences. To begin with, though it has not the lavishness or visual richness of the Morgan Gospels, it is much more unmistakably Odbert's own. Then, Odbert's ready acceptance of the historiated initial is quite unique for the period, and if, in their smallness of size, they look back to the Carolingian past, in their richness of content they foreshadow the Romanesque future. Again, twenty-four of the historiated scenes are concerned with the life of Christ and, though influences from lost Anglo-Saxon sources cannot be discounted, we at least see here an early and tentative statement of that association between the text of the Psalter and the pictorial cycle of the life of Christ which was later to become part of the tradition of Psalter illustration in the West.

The efflorescence of art at Saint-Bertin owed its origin and being to Odbert and it did not survive his death. Odbert, however, had set an example for others to follow. It was one which stimulated the important Flemish house of Saint-Vaast at Arras.

That there was an artistic relationship between the two houses is shown by the extremely close similarity between decorative details like the inhabited scroll-work of two Odbert manuscripts (the Morgan Gospels and Saint-Omer MS. 56) and that of a Saint-Vaast manuscript (Boulogne MS. 12 folio 15). It is, however, impossible to assess the full extent of this association in view of the destruction or mutilation of so many of the Saint-Vaast manuscripts during the nineteenth century.[52] What concerns us more is that there were strong influences on Saint-Vaast from England (with which this house had its own relationship)[53] and further influences from the Carolingian past, when Saint-Vaast had been an important centre of the Franco-Saxon style.[54]

A curious example of the mixture of Carolingian and English styles in the early eleventh century is found in a Gospel Book known as the Anhalt-Morgan Gospels (Pierpont Morgan Library MS. 827).[55] Though a Saint-Bertin provenance cannot be entirely excluded, this probably came from Saint-Vaast. Originally decorated with large borders and initials in the Franco-Saxon style (a Carolingian style which continued long after the Carolingian period), it was left unfinished and was completed by an English artist who, on pages which had been left empty by the earlier painter, inserted portraits of the four evangelists from which the picture of St Luke is illustrated (Plate 99).[56] In style and composition these added Anglo-Saxon figures are closely related to the evangelists painted in the Saint-Bertin Gospel Book and some scholars have even claimed an identity of hand.[57] What is important, however, is that though this juxtaposition of Carolingian decoration with English figure style was entirely fortuitous, it was to play an important part in the manuscript-painting of Saint-Vaast.

This is best seen in the Saint-Vaast Bible (Arras MS. 559),[58] which is a giant Bible in three volumes, produced in the first half of the eleventh century but with some twelfth-

century additions. Even after ruthless mutilation in the nineteenth century, it still retains twelve half-page or whole-page illustrations and no less than eighteen decorative borders and initials. Stylistically, this important manuscript represents a deliberate blend of just those two styles which were accidentally juxtaposed in the Anhalt-Morgan Gospels – the Franco-Saxon and the Anglo-Saxon. The large initials and the borders of the manuscript are in the Franco-Saxon style of geometric interlace, which gives a delicately ornamental effect. Occasionally, however, these have been 'modernized' by the addition of Anglo-Saxon elements such as the combination of bird-heads, interlace, and acanthus leaves on folio 158 of volume I. The style of the figures, which are often set within Franco-Saxon borders, is often Anglo-Saxon, too, though it is difficult to know whether these influences came through Saint-Bertin or direct from England. What really matters is that here we find a deliberate marriage of those two traditions that had quite accidentally met together in the pages of the Anhalt-Morgan Gospels.

More than one artist worked on the Saint-Vaast Bible, and the detailed origins of their figure styles still await a definitive analysis. The predominant influences, however, clearly came from across the Channel, even though the way these English influences were absorbed depended on the particular artist. The figure on folio 29 of volume III (Plate 100) might almost have been drawn by an Anglo-Saxon. It has the sensitive line, the long figure proportions, and the fluttering draperies of that Anglo-Saxon figure style which was first crystallized out in the drawings of the Sherborne Psalter of the late tenth century. On the other hand, the scenes of Elisha and Elijah, on folio 144 verso of volume I[59] (which should be stylistically compared to the Bury Prudentius)[60] retain the Anglo-Saxon lightness but sacrifice its spontaneity. Again, the illustrations on folio 128 verso[61] preserve the floating quality of the figures but schematize the drapery folds into decorative patterns. The artists make little use of body colour, and their pictures are basically drawings either in colour outline or with a colour wash. In general, they tend to simplify and schematize the English styles. Their backgrounds have not the atmospheric quality of some Anglo-Saxon paintings, and their figure styles are less volatile and impressionistic. This follows a tendency we have already observed, for whenever Anglo-Saxon art reached the Continent, it was transposed to a quieter and more restrained key. None the less, some measure of the lightness, movement, and proportions of Anglo-Saxon art is preserved in what we may call the Channel styles of northern France in the eleventh century and (as we shall see in a later chapter) went on to influence some of the great wall-paintings of France in the twelfth century.

When Anglo-Saxon art crossed the Channel it naturally encountered influences other than Carolingian ones from the past, and there was a natural tendency for new styles to be formed from the mingling of influences. This is evident in the second half of the eleventh century in Flanders, or rather in the area centred on present-day Flanders, which was then divided between France and Germany. Here the Anglo-Saxon and Ottonian Renaissances met, and a fusion took place between two very different aesthetics.

Ottonian and Anglo-Saxon art each had its own vitality, but whereas the one was concerned with the human, the other was concerned with the abstract. Despite the fact that Ottonian figure styles were not naturalistic, the Ottonian artist was still bent on

impressing us with the psychological vitality of his figures, and even when their bodies are reduced to mere symbols he persuades us by the fervent glance and the excited gesture of the reality of emotional and spiritual passions within. For the Anglo-Saxon, on the other hand, the human figure was simply an excuse for an aesthetic experience – a departing point for an exhilarating exercise in the shimmering mobility of line and colour. For him, the humanness of the human figure was an irrelevance: he would give to his leaf-work, his decoration, his hanging draperies every bit as much life and vivacity as to the human figure itself. When Ottonian art met Anglo-Saxon art on the Continent, a fusion took place producing new forms which were Ottonian in externals, but Anglo-Saxon in spirit. Stylistic details, types of figure and drapery, can often be traced back to Ottonian sources, but the Anglo-Saxon dynamism of the abstract prevails, the human passions and emotions of the figures are denied, and everything is interpreted in terms of surface movement.

This is seen, for example, in the illustrated life of St Quentin (Saint-Quentin Chapter Library)[62] which was produced at Saint-Quentin (to the south-east of Flanders) in the second half of the eleventh century. A good deal of the decorative features are German in origin, and the figure style itself, with its loose-limbed proportions and rather boyish faces, goes back ultimately to the Trier style of the Gregory Master. But, however close may be the external relationship to Ottonian work, the Saint-Quentin figures are imbued with an Anglo-Saxon spirit which gives them a spirit and zestfulness far removed from the rather self-conscious gravity of the Trier master. There is not here the gold or richly coloured backgrounds of Ottonian art, but simply the empty vellum, across which the figures lightly run. The figures themselves have not the weight or depth, the psychological intensity or the seriousness of German art. Even the tortures of the saint (on folio 43: Plate 101) are pictures of almost gay abandon, with the pagans flitting over the surface of the page and flagellating and tormenting the saint with good-humoured zest. When (on folio 17) the torturers themselves are hurled down by an angel, they respond to no gravitational forces, but, in ways not difficult to parallel in Anglo-Saxon illumination, are simply galvanized into a more abandoned animation. If the figures are Ottonian in dress and appearance they are animated by a spirit that is entirely Anglo-Saxon.

In another Flemish manuscript of the second half of the eleventh century – the life of St Omer from Saint-Omer (Saint-Omer MS. 698)[63] – the figures are given a clarity of outline that is Ottonian but represented in the nimble dancing postures of Anglo-Saxon paintings. The draperies may have some of the substance of some Ottonian art, but they also are informed with an Anglo-Saxon exuberance which sends them fluttering in steep folds behind the figure or (more rarely) swirling dramatically over the head in a way which irresistibly recalls drawings in Anglo-Saxon *Psychomachias*. This is very clearly evident in the scene from St Omer's Life on folio 34 (Plate 102).

At Saint-Amand, English and Ottonian influences are sometimes juxtaposed and sometimes combine. The dedication picture of a *Cassian* showing the monks offering their own copy of his *Collationes* to the author (Valenciennes, Bibliothèque Municipale MS. 169 folio 2) is imbued with Anglo-Saxon influences: the long, loose-limbed propor-

tions of the figure of Cassian (Plate 103), the zigzag fall of his draperies, and (despite the heavier line) the floating quality of the drawing find ready parallels in English manuscripts. On the other hand, a finely illustrated manuscript of the life of the patron saint of the abbey (Valenciennes MS. 502)[64] looks towards Ottonian art. Ultimately its figure style has been influenced by the Liuthar group of Trier, though possibly derived from later recensions of this style at Prüm, and illustrations such as the descent of the angel on folio 117 verso recapture some of the transcendentalism of the originals. English influence, however, adds its own vitality and also means that what was originally expressed in terms of paint is now expressed in more vigorously linear terms. From this house also comes an illustrated copy of St Augustine's Commentary on the Psalms in two volumes (Valenciennes MS. 39 and Paris, Bibliothèque Nationale lat. 1991)[65] which gives witness to the fact that north Carolingian influences could still be felt, and which is given added interest by the use of historiated initials.

At Cambrai, Ottonian influences, refracted through Liège, combined with Anglo-Saxon ones to produce a figure style that was highly extravagant and idiosyncratic and which emphasizes almost to the point of caricature the stylistic influences on the area. This is particularly evident in the evangelists of a Gospel Book (Amiens MS. 24; Plate 104). The figures with their long gawky arms and misshapen hands are not the work of a great painter, though somehow by dramatic distortion he gives his pictures a good deal of vigour. The bold, heavy outline is Ottonian, and the types of head and the figure style betray influences from Liège, but in the contortions of the limbs and the restless turbulence of the draperies there is an English sense of dramatic movement. The figure of St Matthew, for example, is reduced to a vortex of swirling stripes, which, though ultimately derived from Carolingian sources, can be closely paralleled in Anglo-Saxon art and therefore probably represent a simplification of the impressionistic brush-strokes and floating colours of English painting. This particular 'striped' style became characteristic of painting in an area of the north which will be conveniently, if inaccurately, referred to as 'Flanders'. Later it will also be found in Normandy, whither 'Flemish' influences spread towards the end of the eleventh century to meet another powerful wave of English influence on northern France.

Normandy

The great monastic reform movement, which had influenced France, Germany, and England in the tenth century, had made its impact on Normandy at the beginning of the eleventh century, and there it had been encouraged and directed by the dukes themselves. In Normandy, however, reform did not stimulate art, and there was very little manuscript-painting in the duchy before the mid eleventh century. Even this little was parochial in quality – a few tentative initials of Merovingian or Franco-Saxon pedigree, a few illustrations debasing their Carolingian models.[66] In Normandy, it was conquest that stimulated illumination. The conquest of England brought the duchy into intimate association with a highly artistic race, whose embroidery and metalwork wrung admiration even from French chroniclers as hostile as William of Poitiers.

After the Battle of Hastings in 1066, the duchy of Normandy and the kingdom of England were united in a way that was more than political. The Norman clergy took control of the English Church and they did not hesitate to reinforce, and even recolonize, whole monastic communities with Norman monks. This intermeshing of the ecclesiastical organizations of the two countries and this mingling of Norman and English monks led to a thorough interfusion of the art of the two areas. Indeed, when English works of art were sent to Normandy,[67] when Norman illuminated manuscripts (themselves under English influence) were transferred to England,[68] when Normans in English houses decorated manuscripts for use in Normandy,[69] when we find English manuscripts being copied in Normandy[70] and Norman scribes and artists working on both sides of the Channel, then it would be more realistic to speak of an Anglo-Norman art of the period from 1070 to 1100 than to try to separate the paintings of England and Normandy as the exigencies of this volume require.

An example of this criss-crossing of influences is the Bayeux Tapestry.[71] It has been described by some scholars as being English and by others as being Norman, but it is properly seen as an Anglo-Norman production. If the cartoonist was English, the patron was Norman: if the embroidresses were Anglo-Saxon, they were – whether they knew it or not – depicting an account of a turning-point in the history of their own country which was seen entirely from the point of view of the Norman invader.[72]

The effects of the Norman Conquest on English art were various, and limits of space prevent a full discussion of its influence here. In a few areas, Anglo-Saxon styles did survive – though intermittently.[73] Generally, however, a rustic and provincial element was introduced which had never been seen in pre-Conquest painting and, for a generation, there was a considerable coarsening of quality. Against this, there were one or two gains. In particular, the introduction of flat body colours and the strengthening of outlines pointed the way towards Romanesque. But the most important single result of the Conquest on English art was that, by ruthlessly battering down the door and letting in cool air from the Continent, it saved England from the danger of becoming an artistic hothouse in which artists would continue to cultivate traditions already over-sophisticated by too intense an inbreeding. During the two hundred years in which Anglo-Saxon art had flourished, it had maintained a level of painting and drawing which, for sheer consistency of taste and refinement, was unparalleled in the West. But coupled with this Chinese refinement of style was a Chinese preoccupation with tradition. This was broken by the Norman Conquest.

From the point of view of Normandy, the Norman Conquest had a quick and obvious effect.

It is true that links between Normandy and England had been established well before the Conquest. Edward the Confessor had then shown a marked favour for Norman monks and clergy, and Robert, abbot of the Norman house of Jumièges, had in turn been bishop of London and archbishop of Canterbury (1051–2). English art was already passing into Normandy: the sumptuously illustrated Anglo-Saxon Sacramentary that Robert presented to Jumièges and an illustrated Pontifical, perhaps also given by him, still survive in Normandy:[74] there was a third Anglo-Saxon manuscript of his – a psalter

'decorated with various pictures' – which no longer remains, but we know that before the Conquest it had by dubious means found its way to the Norman house of Saint-Évroult, and that it was there described by the twelfth-century chronicler of the house who had himself been born in England.[75] It was after the Conquest, however, when Normans poured into England and sent back the much admired English works of art across the Channel that the full impact of Anglo-Saxon art was felt in the duchy of Normandy. In the last decades of the eleventh century and the early twelfth century, the influence was powerful and unmistakable. We find English paintings and drawings being faithfully copied. At Jumièges, a drawing of a Crucifixion (Rouen MS. 26 folio 48)[76] catches a good deal of the spirit of its Anglo-Saxon original. At Fécamp, a copy of a full-page English drawing has a typical Anglo-Saxon surround (Bibliothèque Nationale lat. 2079)[77] and a lightly drawn angel catches the Anglo-Saxon manner (Rouen MS. 1404 folio 81 verso).[78] At Mont-Saint-Michel, a beautifully illustrated Sacramentary (Pierpont Morgan Library MS. 641),[79] from which the Ascension of the Virgin is here reproduced (Plate 105), is so sensitively rendered in the Anglo-Saxon idiom that one might suspect the participation of an Anglo-Saxon artist. We find various initial styles – the dragon style, the biting-head style, the clambering style – all derived from England, and figure styles which, though simplified and schematized,[80] are obviously inspired by Anglo-Saxon exemplars.

Artistically, however, Normandy was no mere colony for Anglo-Saxon influences. For one thing, other influences crept in to temper them: some from Italy, whence Lanfranc and Anselm had come, others from Flanders, which was dynastically allied to William the Conqueror by marriage and which not only made its own impact but which probably transmitted Ottonian iconographic influences.[81] For another, the Norman attitude to books was very different from the English. It reflected the difference between the scholar and the artist. The Normans were primarily interested in the text, and they subordinated the artistic embellishment to it, so that illustration and decoration were more and more confined to the initial. Except when Anglo-Saxon models had themselves been too closely followed we rarely find what was so frequent among the Anglo-Saxons – a manuscript lavishly interspersed with full-page pictures and decorative pages which, in an Anglo-Saxon translation of the first Books of the Old Testament (British Museum Cotton MS. Claud. B. IV), will become virtually a book of pictures with the text subjoined.

The Norman use of the historiated initial was probably derived from Flanders. Though known to the Anglo-Saxons, it was (as we have seen) normally used by them as a colourful centre for a sumptuously decorated title-page. In 'Flemish' art, on the other hand (at Saint-Bertin, for example, and Saint-Amand), it had been used as an integral part of the text. The Norman artists focused their attention on the historiated initial, which, under their influence, became a dominant element of the page. If their use had been suggested by 'Flemish' art and if their style often showed an intimate relationship with England, their development and full exploitation was something particularly Norman.

This use of the historiated initial is well illustrated in a Saint-Ouen Bible (Rouen MS.

467) where the text is illustrated by figures inside the initials[82] (those on Plate 106 represent Christ healing the Blind). The ebullient acanthus-leaf decoration of the initials reflects Anglo-Saxon influences, which are also seen in the buoyancy of the figure style and the steep zigzag fall of the lower drapery. We find also the 'striped' style that we earlier saw in Flanders and which has now been freed from the Ottonian associations of the 'Flemish' area and re-exposed to Anglo-Saxon influences, so that the body outline is less severe and more vibrant. This is a style that was to play an important part in Normandy in the last thirty years of the eleventh century before being re-adopted in England, the land of its origin. It occurs at Bayeux.[83] It is found in a spirited and refined form in a Bible made for Bishop Carilef when he was exiled in Normandy.[84] It is seen again in a splendid Gospel Book now in the British Museum (MS. Add. 11850) which has fine pictures of the evangelists (see St John on Plate 108) and which on stylistic grounds must be assigned to Saint-Ouen.[85]

The canon tables and full-page pictures of evangelists of this latter manuscript are among the finest examples of the Norman art of the period and show a felicitous blend of the English and 'Flemish'. However, not all Norman art was of this refinement. There was a surprising variation of quality within the duchy. A Gospel Book of about 1100 from Jumièges, for example (British Museum MS. Add. 17739),[86] makes an embarrassing contrast. Here, though canon tables and two evangelist portraits have been drawn in bistre, a particularly jarring combination of sulphur-yellows, muddy greens and blues, and brighter tones disfigures the other pictures. (The colours suggest Spanish influence but not the way they are combined.) The figure style manages to be both effete and over-fussy. It owes a good deal to England but much also to the Mosan area. From here it derives this proliferation of tetchy pen-strokes for decorative effect, though, in Mosan art, there is a less obvious gulf between effort and achievement. The real interest of the manuscript is iconographic rather than stylistic, and its emphasis on the Virgin is of special importance.

In many Jumièges manuscripts there is a Romanesque hardening of form. The flat body colours and decided outlines of the Christ in Majesty of Rouen MS. 1408,[87] for example, give it a weight and Romanesque severity which is the very antithesis of the Anglo-Saxon impressionism palely reflected in the saints on either side. A style which is a half-way house between this and the Jumièges Gospel Book in the British Museum found its way to Exeter, where it is associated with the name of one of the very few painters of this period whose identity is known – Hugh the painter or, as he signs himself, Hugo Pictor.[88]

The development towards a more Romanesque severity of form which was cultivated at Jumièges is expressed with particular felicity in some of its outline drawings and initials. One of the manuscripts concerned has the added interest not only of being dated but of having an inscription indicating that it was made for their native house[89] by Jumièges monks working in England. These monks were then at Abingdon. The Abingdon chronicle of the period lamented the way in which the Norman monks there would steal Abingdon treasures for their own mother house in Normandy,[90] and it is at least refreshing to have in this manuscript evidence that their largesse was not entirely

confined to the property of others! The most admirable example of the Jumièges out-line style, however, comes from Jumièges itself. This is an early-twelfth-century Bible (Rouen MS. A 6) whose decorative and historiated initials (see Plate 107) have a vigour, incisiveness, and clarity which are impressive by any standards. The Normans were the first to exploit the full potential of the historiated initial, and in this, their own field, their best work could rival anything in Europe.

The great achievement of the Normans was, in fact, this development of the historiated initial, which made possible the complete synthesis of decoration, illustration, and text in the manuscripts of the twelfth century. And, even apart from this, though they owed so much to Anglo-Saxon art, they ultimately transformed what they borrowed. They tempered English influences with others from Flanders, Germany, and Italy, they intro-duced their own bracing colours, chose their own points of emphasis, and produced an art which was peculiarly Norman or Anglo-Norman. The Normans also have to their credit the widening of the scope of manuscript illumination. Before then, the decoration and illustration of Continental manuscripts had normally been confined to a very limited range of religious texts – to Bibles and parts of Bibles, to lives of saints and liturgical texts. There had certainly been some exceptions – particularly where it had seemed desirable to preserve traditional knowledge in pictorial form (as in the illustra-tions to astronomical manuscripts) – but these had been few. The idea which the Normans developed was that any and every manuscript might be illustrated or decorated – not only religious works but mathematical works, for example, or works of poetry. This, in its turn, led to such a spreading out of manuscript-painting that scribes, unskilled in drawing, had now to try out their hands at work hitherto confined to the trained artist. It is this that accounts for the variation in quality of Norman work, which at its lowest can only embarrass, but which at its highest can only impress.

To limit these remarks to Normandy because of the restrictions of this book is – as we have already remarked – entirely academic. The art produced on either side of the Channel in the last decades of the eleventh century was Anglo-Norman rather than English and Norman. There are, it is true, some distinctions and differences of emphasis – the Anglo-Saxon figure style, for example, survived in a purer form in England – but, generally speaking, what is true of Norman manuscript-painting is also true of English. This generalization, however, does not long survive the turn of the century. In the twelfth century, English art, adjusted to its new relationship with the Continent and invigorated with a new dynamism, went forward to produce some of the greatest manuscript-painting in Europe. Norman art, on the other hand, petered out into a trickle which was itself tributary to England.

Cîteaux

English influences pervaded northern France in the eleventh century. Shafts of influence also penetrated deeper and reached down to Fleury,[91] Angers,[92] and Poitiers.[93] In the first half of the twelfth century these spear-thrusts of influence broadened out and concen-trated in strength on a vital area of central France – Burgundy.

We have seen that in an age when most art was religious there was often an association between an efflorescence of art and a religious movement of reform. This is nowhere more clearly typified than at Cîteaux in Burgundy, where the wind of reform fanned artistic life into a blaze of activity unparalleled in contemporary France.

The Cistercian reform movement, which originated in Burgundy, was different from the movements that had gone before. It was not simply concerned to restore the decencies of monastic life but also to give monasticism itself a new interpretation. This was achieved by placing the emphasis not, as hitherto, on divine service but on personal toil and labour. However, the early Cistercians, whom St Robert led from Molesmes in 1098 to clear the Forest of Cîteaux and build their 'New Monastery' (as it was originally called), were far from being simply muscular Christians. We know from their scholarly attempts to set up critical texts of the Bible and of the Ambrosian hymns that they were a highly literate community. An essential part of their work was the production of manuscripts containing the basic texts for their monastic life, and the decoration and illustration of these show an artistic creativity and fertility, a sheer *joie de vivre*, that have few parallels. Indeed, as far as manuscript-painting is concerned, this new community, which was devoted to the sanctity of toil and labour, became the most important artistic centre of France in the first half of the twelfth century.

Unhappily, this artistic activity was ultimately smothered by an excess of those reform energies that originally brought it to life. A decision to ban artistic representations from manuscripts and wall-paintings was forced on the Order by the overbearing zeal of St Bernard, who had joined Cîteaux with thirty followers in 1112, who three years later became abbot of the daughter house of Clairvaux, and who, until his death in 1153, was to be one of the most formidable personalities of Europe. Reacting violently against the lavishness of the Cluniacs, he saw art as a superfluous luxury which distracted the mind from religious meditation, and his authority was such that he was able to persuade one of the most artistically endowed of Orders to forsake its inheritance.

St Bernard's thundered imprecation against Cluniac art[94] is well known and what, ironically enough, emerges from it is how much he himself was moved by the art he was attacking. As St Augustine's particular virulence towards heresy is partly explained by the fact that he himself had once been a heretic, so we may ask ourselves whether the forcefulness of St Bernard's attacks on art was not due to his own susceptibility to its more sensual aspects. Another point that emerges from the denunciations both of St Bernard and of later Cistercians is the importance that the twelfth century attached to monumental art. It was because of its powerful impact on the lay spectator that it was thought essential to control it and to define, for example, the subject-matter of church wall-paintings.[95] St Bernard and his followers would have banned from such church paintings the decorative, the whimsical, and the irrelevant – 'the vain and profane pleasures that catch the eyes of our contemporaries' – but from their own Order they would, and did try to, ban everything, not only monumental art but manuscript decoration and illustration, too.

The precise date of the ban is uncertain. It is incorporated in a statute said to have been issued in 1134, but this may well have been pre-dated by zealots for purely polemical

reasons within the Order. Its effective date was more probably 1152, when the constitutions and statutes were redrawn and submitted for papal approval. It should be noted that it was not absolutely observed, and, in the second half of the twelfth century, we occasionally find manuscripts of high artistic quality at Cistercian monasteries such as Pontigny, Jervaulx, Morimondo, Rievaulx, and even Clairvaux and Cîteaux itself.[96] But all this was exceptional, and what the ban did mean is that the splendours of art at Cîteaux were confined to the first half of the twelfth century.[97]

During this period there was a variety of styles and a mixture of influences in a centre which gathered manuscripts for copying from many areas[98] and whose members were themselves of more than one nationality.

The first two volumes of a famous Bible of Cîteaux written before 1110 (Dijon MSS. 12 and 13) contain scratchy red penwork initials against blue backgrounds[99] which are clearly influenced by Normandy, and this Norman influence emerges elsewhere both in initial and figure styles. There seems a particular connexion with the Norman scriptorium of Jumièges, with which Cîteaux shared a common dedication. Flemish influences are also present: they are found in initial and figure styles, in some types of foliage, and in the layout of title-pages, which can be particularly delicate and elegant. We know, in fact, that there were associations between the founder of Cîteaux, St Robert, and Flanders[100] and that these led to the possession by Cîteaux of illustrated Flemish manuscripts (which still survive).[101] During the greater part of the artistic activity of Cîteaux, however, its ruler was an Englishman, Stephen Harding. He was abbot from 1109 to 1133, and there can be little doubt that England provided both the primary impetus to manuscript-painting and the dominating influence on it.

The English art that influenced Cîteaux was different in style, if not in spirit, from the Anglo-Saxon art which had pervaded northern France in the eleventh century. Recovered from the shock of invasion, English painting was going forward with renewed vigour. Norman influences meant that simpler and more pungent colour harmonies were accepted and that decorative and historiated initials now absorbed much of the creative activity of manuscript-painters. Influences from other areas, particularly north-east France, Germany, and Italy, affected the figure styles of various centres. But what was important was the way in which the various styles from abroad tended to be assimilated to the very essence of the Anglo-Saxon tradition and interpreted in terms of dynamic line and zestful movement. Human figures sprint in and out of the initials, animals and dragons snarl and pounce, the tendrils of the foliage coil savagely like agitated serpents, and everything is caught up in a general frenzy of movement.

The zestful feeling of English art certainly transmitted itself to the early Cistercians. Their initials, like those of England, are invigorated by a turmoil of twisting figures and animals (see, for example, the one on folio 156 of Dijon, Bibliothèque Municipale MS. 173; Plate 109). They even use the same decorative repertory and, though the human figure is given more independence inside the initial, we find the same savage dragons and irrepressible birds and beasts that agitate the initials of English manuscripts. Probably there were examples of Canterbury illumination at Cîteaux, since in Dijon MS. 135,[102] for example, the decorative motifs, the choice of colours, the forms of foliage, and the

vigorously patterned treatment of birds and animals can all be paralleled in Canterbury manuscripts.[103] If the figure styles also owe something to Canterbury, they owe more to other English centres, and points of comparison can be made with styles at Shaftesbury, St Albans, and, particularly, Bury St Edmunds.

One obvious example of this general English influence is the appearance of the 'striped' style, the style which was originally developed in 'Flanders' from Anglo-Saxon art (see Plates 101 and 104) but then returned, via Normandy (see Plate 106), to England, where it became an important ingredient of figure styles of the first half of the twelfth century. In the English treatment of this style, the colour is applied with a lively brush and follows lines which are often curved and supple, so that the results can be both rhythmic and spirited. A good example at Cîteaux is found in the initial Q to a text of St Gregory (Dijon MS. 169 folio 5),[104] which is painted in red, green, pale blue, and ochre, and where the tumbling folds reflect the flamboyant sense of decoration found in English manuscripts. A more severe and more disciplined example, which might be compared to a figure from the St Albans Psalter,[105] is represented in a fine portrayal of David (Plate 110) in the third volume of Stephen Harding's Bible (Dijon MS. 14 folio 13 verso).[106]

If the earliest figure styles at Cîteaux were influenced from England, they also shared the same general development as English art. The pungency of the earlier styles is toned down. The figures become more drawn out and elegant in proportions, more grave and dignified in feeling. There are accomplished examples of this later phase in the third volume of the St Stephen Bible (Dijon MS. 14)[107] and in the Cîteaux Lectionary (Dijon MS. 641; Plate 111).[108] One or two of them might be compared to the figure style of the Gospels of Bury St Edmunds (Cambridge, Pembroke College MS. 120),[109] where we find a similar linear elongation and a similar, rather delicate, mood of contemplation.

Many of the Cîteaux initials are purely decorative and as meaningless as the Cluniac sculpture against which St Bernard inveighed so bitterly. But others – particularly in the early years – reveal a feeling for the contemporary scene that is quite remarkable. In an abbey recently built within a wild forest, the artist set down his pictorial observations. In one initial a monk begins to fell a tree while a lay brother trims the upper branches (Plate 112),[110] and in another two monks split a recently felled trunk.[111] In other initials, monks are shown cutting the corn (Plate 113),[112] threshing the harvest,[113] gathering grapes from the vineyard,[114] and measuring out cloth.[115] All these little scenes are found in volumes of a manuscript which was completed in 1111.[116] A fine sense of line and movement transforms them into rhythmic compositions – almost rhythmic patterns – to conform to the geometric demands of the initials. But, despite all this, they were clearly taken from observed life, and the harsh realities of life for the early Cistercians are, for example, reflected in the torn hems of their habits. These small pictures of the pursuits of the primitive Cistercian community are quite extraordinary for their period and, within their stringent limits, represent the first freshly observed scenes of nature since the days of classical art.

From the same manuscript, but in a different context, comes another example of this keen graphic sense. It is a small vignette, which illustrates the secular pride to which

St Gregory refers in the text. We are given a delicate and spirited painting of a finely clad woman, out falconing on a richly caparisoned horse (Plate 114).[117] Everything is carefully observed, from the woman's luxurious clothes, including her foppish long-toed shoes and rich red cloak with its blue and white diapered lining, to the birds she passes in a river, which are so well caught that they are readily recognizable as cranes and shovellers. All this is far different from the highly symbolic representations of pride so usual in Romanesque art. This graphic sense owes much to England, where the Bayeux Tapestry, for example, portrays the realities of contemporary warfare in a quite unromantic way and where an artist might caustically illustrate a boy's schoolbook with a nicely observed drawing of a pupil being soundly thrashed.[118]

The freshness of approach of the Cistercian artists extended to more strictly theological paintings, and Cîteaux may have claims to be the creator of the pictorial Tree of Jesse which was to become an important theme in Late Romanesque and Gothic art.[119] On the face of it, this was simply a portrayal of the lineal descent of Christ from Jesse, but its purpose, in fact, was to focus attention on the Virgin as the essential link in this line of descent. Dedicated as it was to the Virgin, the Cistercian Order would naturally take an interest in the development of this theme, and we find two fine pictorial statements of it in the manuscripts of Cîteaux. One is in a Lectionary (Dijon MS. 641 folio 40 verso), where the Virgin and Child are encircled in symbolic branchwork above Jesse (Plate 204). Here the Virgin is understandably given rather more emphasis than Jesse, but she is not obtrusive in the general context. In the second painting, however (Dijon MS. 129 folio 4 verso; Plate 205), she appears as an imposing and intimidating figure which dominates the whole picture space. The two portrayals are more or less contemporary but they are utterly different. In fact, they represent the impact of two very different aesthetics on Cîteaux – the one from the north and the other from the south. The vibrant sense of movement in the first reflects influences from England, the formal and hieratic feeling of the second the impact of Byzantine art.

We have so far been considering English influences at Cîteaux. At a time when England, Normandy, and Flanders had each in varying degrees influenced each other, there are bound to be some areas in which particular influences are mixed or obscure, and there are also some aspects of the manuscript-painting of Cîteaux which still need clarification. Despite all this, it is clear that England had the dominant impact on the art of Cîteaux in its early stages. Later this 'English' tradition was joined by another important trend, in some ways opposed to it. This insists on the independence of the figure and refuses to treat it simply as an aspect of vigorous decoration. Rather than subordinate the figure to the initial, it will simply place the figure in front of the initial or by its side. The figure itself is given a new spaciousness and breadth of treatment. All this is the result of Byzantine influences which (as we shall see later) had a tremendous impact all over the West.

Wall-Paintings

It has been suggested that Anglo-Saxon styles, domiciled in northern France in the tenth and eleventh centuries, there combined with other styles to form what we might call

a 'Channel' art. This had a dynamism of its own which influenced not only manuscript-painting but monumental painting as well. These influences were not related to obvious historical patterns and may simply be explained by the existence of a few travelling artists. Such Channel influences are often variable and sometimes considerably diluted, but they are found in a particularly pure form at Tavant (Indre-et-Loire).

Smaller in scale and more intimate in feeling than most wall-paintings, those of Tavant[120] are among the most sensitive and lyrical of Romanesque France. The most important are in the small crypt, where they decorate the low vaults. They are painted (one is tempted to say delineated, since they are so deftly linear in style) in earth colours in which russet browns and greens predominate, and they tend to represent not elaborate scenes but single or double figures. Some of these come from the Old Testament – Adam digging, David harping (Plate 115), and Saul enthroned (Plate 116), and some from the New Testament – the Virgin, Christ deposed from the Cross, the Harrowing of Hell, Christ in Majesty, and two angels with candlesticks; a few are contemporary or allegorical – a pilgrim with palm and staff, two men with branches, a knight or a virtue fighting a devil, a man slaying a lion, and a personification of lust or lasciviousness thrusting a spear into her own bosom.

All these paintings have a close stylistic relationship with the northern idiom. The dancing buoyancy of the figures relates them in general terms to the figure style of English and north French manuscripts of both the eleventh and twelfth centuries; indeed, associations with manuscript-painting come particularly easily with wall-paintings as small in scale and intimate in feeling as these. The figure of David, bending with fastidious attentiveness over his harp (Plate 115), can be paralleled in both posture,[121] head, and tremulous quality of line with English drawings after the Conquest: the arrangement of drapery folds and disposition of highlights in the dancing male figure find close associations with earlier English manuscripts such as the *Caedmon* at Oxford[122] or the Tiberius Psalter:[123] and the swirling impressionistic backgrounds of the Deposition scene relate it to the fluid illusionism of English eleventh-century art, which was certainly known in France. There are also stylistic affinities with the area now known as north-east France. Some of the draperies remind us of illustrations of manuscripts from Saint-Quentin and Valenciennes, and the closest parallel to the reduction of Saul's garment to a voluptuous threaded patternwork of curves (Plate 116) is in the less accomplished but stylistically related St Matthew of an Amiens manuscript (Amiens MS. 24 folio 15).

The paintings themselves have been given dates which vary from the eleventh to the early thirteenth centuries (I would personally attribute them to the early twelfth). But they belong in context to the sensitive, tremulous Channel art of the eleventh century, which we know survived well into the twelfth. For lightness of touch and sheer wind-swept delicacy of feeling they have no equals in the Romanesque wall-paintings of Europe.

One of the characteristics of the Channel styles was an interest in linear vitality which, in the eleventh century, found one form of expression in the exuberance and luxuriance of drapery folds. This was expressed in Flemish manuscripts like those of Saint-Bertin

and Saint-Vaast[124] (Plates 97–9) and, farther west, in manuscripts from Normandy like the Pierpont Morgan Sacramentary[125] (Plate 105). It was not lost in the twelfth century, though the Romanesque development gave the style a new hardness and discipline.

This twelfth-century interpretation of an eleventh-century Channel style is well exemplified at Saint-Martin-de-Vic (Indre),[126] where there are scenes from the Old Testament, the life of Christ, and the lives of saints. It cannot be claimed that these pictures are masterpieces: the proportions tend to be chunky, the faces vacant, and the figure style repetitive. There is, none the less, a good deal of vigour and vitality in the radial interplay of the fluted and patterned folds of the draperies. A strong Carolingian element in the style is very clear, and the figure to the right of Christ in Majesty might almost have been taken from a Carolingian painting. Other influences, however, are from the Channel areas. Parallels to the Christ in Majesty with His firmly set feet and widely splayed knees are provided by the manuscript-paintings of Normandy and the Liège area, and it is also particularly to the north that we shall look for similarities to the pleated folds which fall in tight geometric patterns over legs and feet. The kneeling Christ at the washing of Peter's feet typifies a basic feature of this style which is repeated elsewhere: the upper draperies are pulled tightly over the knees to release, as it were, the lower hem in a cascade of folds fluttering behind. The ultimate source is the Carolingian School of Tours but, for the more immediate influences, we must look to the Life of St Omer from Saint-Omer (MS. 698), where the heavily pleated draperies and swinging folds on folio 34 (Plate 102) obviously anticipate those of the Christ here, and where we also find a similar violence of gesture and action. It is an interesting reflection on the wide dissemination of Romanesque styles that the closest contemporary parallel is found in an English manuscript from Winchcombe (Dublin, Trinity College MS. 53), and that the style of the Spanish wall-paintings of San Juan de Bohí is closely related.

The most striking example of Channel influences on French wall-paintings of the second half of the twelfth century is found at Petit Quevilly in Normandy.[127] The small chapel of Saint-Julien at Petit Quevilly was founded by the English king Henry II as a lepers' chapel towards the end of the twelfth century, and there survive in the vault of the choir medallion scenes of the birth and childhood of Christ which take us from the Annunciation to the Baptism (Plate 117). It is probable that the artist here was an Englishman. But, whether English or north French, the linear purity of his paintings and their fluent sense of movement convey all that is best in the Channel tradition. These paintings have a new lyrical charm which shows that we are already in the second half of the twelfth century witnessing the transition from Romanesque to Gothic that we shall discuss more fully in a later chapter. We shall also leave to another chapter an examination of the Channel influences on the most impressive frescoes of Romanesque France – those of Saint-Savin.

These latter frescoes, like those of Vic, had, as we shall see, their own influences on Spanish wall-paintings, for monumental painting in twelfth-century Spain participated in the international Romanesque movement of the West. We cannot, however, make the same statement about the manuscript-painting of Spain, which always tended to be insular and idiosyncratic.

SPAIN: MANUSCRIPT-PAINTING

The Tradition of the Apocalypse in Spain

THOUGH the manuscript-paintings of Germany, England, and France showed many differences, they all had one thing in common: they all drew their initial sustenance from the Carolingian tradition. Spanish vellum-painting, on the other hand, lay outside this tradition. As a result, her art – as strange and exotic as the colourful birds discovered by explorers in countries cut off from the mainland – seems equally remote from normality. The explanation for this is not that Spain remained outside the Carolingian empire, for England did also. Nor was it because she was cut off from the rest of Europe, for she remained in touch with Italy and France. It was because the historic experience of Spain was different from that of the rest of Europe and, in particular, because her energies were absorbed by the Moslem invasion and occupation.

The breakdown of the Roman empire and the barbarian invasions throughout Europe had left the barbarian Visigoths in possession of the Spanish peninsula in the fifth century just as it had left the barbarian Franks and Burgundians in occupation of what is now France. However, unlike the Franks, the Visigoths were themselves displaced in the early eighth century by an Arab invasion of Spain from North Africa which was more successful than the Arabs had dreamed possible. Not only were the Moslems able to occupy virtually the whole of Spain but they were also able to cross the Pyrenees and might well have taken possession of 'France' had it not been for their defeat by Charlemagne's grandfather, Charles Martel, at the Battle of Poitiers in 732. Even so, future Carolingian policy had to take cognizance of this threat, which it did by forming the Spanish March, from which later developed the county of Barcelona and the kingdom of Catalonia. The Arabs themselves meanwhile retained effective control of the Spanish peninsula. A Christian resistance group, however, had survived in the Asturian mountains in the north, and smaller bodies maintained themselves in Navarre, Aragon, and Catalonia. The history of medieval Spain is the story of how – despite variations of fortune – these small groups gained control of areas which were welded into kingdoms and then gradually expanded farther and farther south to reconquer more and more of the peninsula. By the end of our period, fortunes had been reversed: in the early eighth century, the Christians were confined to a small area in the north of the peninsula, but at the beginning of the thirteenth it was the Mohammedans who were confined to a small area of the south.

The Arabs themselves were a more cultivated and more tolerant race than the Visigoths they displaced and, generally speaking, there was no religious persecution under their occupation. Even in the regrettable lapse when Christians died for their faith in Cordova in the decade following the mid ninth century[1] it was quite clear that the Christians were determined on martyrdom, and some certainly needed persistence to

secure their aim. The Arabs made no attempts to proselytize – indeed, since the Christian paid a special tax, it was not in their financial interest to do so – and Christian worship was permitted. In one sense, the very slowness of the Christian reoccupation was an indication of the tolerance of the Arabs, for they themselves were divided, and, if the Christians under their domination had been more restless or the Christians in the north had themselves been more united, their final expulsion would hardly have taken more than seven hundred years.

In speaking of Mohammedans and Christians, there are inevitably religious overtones. There certainly was some religious feeling on each side, but this was retrospectively exaggerated after the Crusading concept emerged in the eleventh century by chroniclers who were anxious to re-edit the past in order to invest the whole of the Reconquest with the spirit of Crusade. In the earliest conflicts between the two races the differences had been as much political as religious. The motive force of each could be self-interest as much as religious principle and plunder as much as piety. Christian rulers would not scruple to ally themselves with Moslems against other rulers of their own faith, and the Moslems were equally prepared to seek Christian support if it suited their own interest. This could apply even to the future Holy Roman Emperor himself. The later *chanson de geste*, *The Song of Roland*, might represent Charlemagne's crossing of the Pyrenees in 778 as a crusade against the infidel, and the death of his nephew, Roland, at Roncesvalles in terms of an epic stand of the Cross against the Crescent, but in fact Charlemagne's campaign was to help one Moslem faction against another, and Roland's death was due not to the Moslems but to the Basques. We know that Charlemagne received gifts from the caliph of Baghdad, Haroun-al-Raschid, and these included an elephant.[2] Later we find Charles the Bald sending rich gifts to a Mohammedan ruler in Spain[3] and Otto the Great receiving an embassy from another led by a Christian bishop – Recemendus, bishop of Elvira.[4] In the eleventh century, the most famous of Spanish Christian leaders, Ruy Díaz de Bivar, better known as El Cid, was prepared to ally himself with Moslems, and the poetic accounts of his exploits place their emphasis less on religious faith than on feudal equity. As the Franks later discovered in the Crusading kingdoms of North Africa, where the rôles of Christian and Moslem were reversed and Christian kingdoms were set up in Moslem territory, the physical proximity of the two opposing faiths did much to dilute religious intolerance. A really overwhelming Crusading zeal was only instilled into the conflict in Spain in the eleventh century, when it was influenced by forces far from its centre such as Cluny and Rome. It was Pope Alexander II (1061–73) in particular who associated the conflict in Spain with the idea of Crusade, and by encouraging contingents from Italy and southern and northern France to support the Spanish Christians prepared the way for the more general Crusading movement.

Despite all this, to the monasteries sheltered in the Christian areas of the north in the seventh and eighth centuries, who had no contact with the Moslem either as ruler or political ally or enemy and whose natural associations lay with Rome, the knowledge of the Mohammedan heresy that had taken possession of most of the land must have been as horrifying as it was inexplicable. Moreover, local schismatics were making their influence felt in the Christian communities.

Spain was a country which had always seemed susceptible to heresies. Though all attempts had been made to suppress it, a particular Spanish heresy known as Priscillianism had spread in the peninsula during the fourth and fifth centuries and was still prevalent in the sixth. The Visigoths themselves had been heretics until the conversion of their king in 587 and the third Council of Toledo in 589, for they believed in Arianism, which postulated that Christ had a different nature from God. The bitterness between the two faiths is reflected in the seventh-century work of Paul of Mérida. In a passage[5] whose significance will be seen later, he describes the Arian heresy in terms of the Apocalypse as 'the false priest who is the servant of the devil, the angel of Satan and the precursor of Antichrist'. Even when the Moslem occupation should have fused together the forces of Spanish orthodoxy, the Spanish interest in metaphysics reasserted itself in the form of new heresies. In the eighth century there sprang up the heresy of Migetianism, which was followed by the larger heresy of Adoptionism. The latter heresy was promoted by two distinguished Spanish churchmen, Elipandus, bishop of Toledo, and Felix, bishop of Urgel, and, according to their adversaries (who were no doubt inclined to exaggerate), divided the whole Church in Spain.[6] Though this particular heresy was first minted in the days of the early Church, it gained new currency in eighth-century Spain because it offered an answer to the Mohammedan criticisms of the divinity of Christ. It preached that Christ was not both God and Man at birth but simply human, and that it was only later that He had been adopted by God and promoted to divinity because of the perfection of His holiness.

The capacity of heresy not only to dominate the land but also to break out within the very citadel of the faith must have seemed as intolerable as it was incomprehensible to the monasteries of the north. And it is this which may explain the incredible popularity of the Apocalypse in Spain – or rather of Beatus's edition and commentary on it.

Beatus of Liébana was a monk of northern Spain who lived in the eighth century. He was teacher and adviser to Queen Adosinda, wife of King Silo, at León (774–83) and died about 798, just two years before Charlemagne became Holy Roman Emperor. He is known to us for two reasons. First, for his assaults on heresy in Spain. This, in particular, led him to attack the Adoptionists and, as a result of the joint treatise of himself and his pupil Etherius, bishop of Osma,[7] three synods convened outside Spain condemned the heresy which, by now, had given concern both to Charlemagne and Pope Hadrian I. Secondly, Beatus is known for his edition and commentary on the Apocalypse or Book of Revelation. Like so much medieval exegesis, this was a patchwork of the early Fathers in which the allegorical and deeper meanings of the sacred word were expounded at length. Yet, despite influences from St Augustine with all his poetic imagination and despite the intoxicating prose of the Apocalypse itself, this remains a dry and academic work.

Nevertheless, it enjoyed an extraordinary popularity. Well over twenty illustrated copies of it have come down to us, and these must represent only a proportion of those originally produced. There is no parallel for this and no evidence that any other illustrated Book of the Bible was copied and recopied with such remarkable enthusiasm and assiduity. One small but significant indication of the importance of the Apocalypse in

Spain is the fact that, whereas in England, say, the most precious charters of a monastery or church would be copied into a Gospel Book for safe conservation, in Spain they were copied into a Book of the Apocalypse.[8] It has been suggested that the popularity of this Book was due to the fact that the Spanish Church required the Apocalypse to be read and explained during the Paschal season.[9] However, this Visigothic rite ceased at the end of the eleventh century, yet the Apocalypse tradition continued – in fact, more illustrated copies survive from the twelfth century than from the eleventh. Moreover, almost all the surviving Beatus manuscripts were made for monastic use and not for lay churches. Some further explanation is needed to account for the power which the Apocalypse exercised over the Spanish imagination and why this should need a visual expression which liturgical considerations themselves did not warrant.

The answer, perhaps, is to be found in the consonance between its message and the religious situation in Spain. As we have seen, not only was domestic heresy ulcerating the body of the orthodox Church but the tremendous and apparently triumphant cancer of Mohammedanism was in possession of most of the land. For the true believer all this must have seemed difficult to understand. Yet – as Paul of Mérida had already indicated in the seventh century – there was one source which offered explanation, solace, and hope. It was the Book of the Apocalypse, which, said Beatus, is the key to all Books.[10] According to medieval interpretation, this declared that, before the Day of Judgement and the ultimate triumph of the Church, the world would be ruled by Antichrist and there would then be turmoil and tribulation both in the world and the Church – 'Woe to you earth and sea for the devil is come down unto you having great wrath because he knoweth that he hath but a short time' (Apoc. XII, 12).

The relationship between the Apocalypse and internal heresy in the Church of Spain was very clear to Beatus himself. It was given considerable emphasis in the treatise against Adoptionism, where the writers state that there are many of Antichrist in their own Church,[11] and time and again revert to the symbolism of the Apocalypse.[12] Apart from all these references and the explanation of different verses from the Apocalypse in terms of the new heresy, the writers devote a complete Book of no less than 104 chapters entirely to the theme of heresy as the expression of Antichrist. This is contrasted with the spirit of the Church as the expression of the body of Christ.[13] The theme of Antichrist is further stressed in the Beatus editions of the Apocalypse not only in the text of his own commentary but in the illustrations, which include complex tabulations[14] relating to Antichrist's name and number.

It is more than probable that the first illustrated copies of his edition of the Apocalypse were associated in Beatus's own mind with his broadside against the particular heresy of Adoptionism, which he so strenuously attacked because it rejected the dogma that Christ was divine at birth. This would explain the prefatory illustrations of some manuscripts.

One is a genealogy of Christ[15] extending over three or four folios, in which His Old Testament antecedents are depicted or named in numerous medallions. This relates to an account of the Old Testament patriarchs[16] in a chapter[17] of the commentary which defines the true Church and which emphasizes the fact that this is the Church of

a Christ who was both God and Man.[18] But it also has associations with the treatise of Beatus and Etherius against the Adoptionists. One chapter of this[19] gives a good deal of emphasis to the Old Testament genealogy of Christ which, through figures like Abraham and Noah, ultimately takes His descent back to Adam. This enables the authors to make two points. The first is that, since God gave His word to Old Testament patriarchs like Abraham that redemption would come through their seed, then, though Christ was born of the seed of these Old Testament figures, He was also at His birth the divine Redeemer promised through them: 'And the word was made flesh and dwelt among us' (John I, 14). The second is that, since Adam was made from dust and represented the physical, carnal side of Man which Christ Himself inherited, He could only have transcended and conquered this carnal inheritance if He had also been informed with the divinity of the Spirit 'in one person, God and Man: Jesus Christ'. Beatus quotes in this context the angelic message to the shepherds which begins by proclaiming Christ's divinity and concludes with a message of hope: 'Peace on earth' (Luke II, 11 and 14). Since Adam was made from earth, Beatus can interpret the latter phrase again in terms of the line of Adam, and sees in the proclamation from heaven the message that because Christ is both divine and of the line of Adam He can bring redemption to the world.

In some manuscripts a few New Testament scenes have been added to the genealogical tables[20] and – in view of the concern of Beatus to stress the fact that Christ was both divine and human at birth in opposition to the Adoptionist view that He was simply human – it is, perhaps, not surprising to see that they give emphasis to the divine nature of Christ. They include the Annunciation to the Shepherds[21] on which Beatus and his co-author have discoursed, the Annunciation to Mary[22] with its message that the Virgin shall give birth to the Son of God, the arrival of the Magi[23] to worship the newly born Redeemer, and also an apocryphal account of Herod's pursuit of the Child[24] when the Holy Family fled to Egypt which was thwarted by the intervention of an angel. Five manuscripts also contain a pictorial allegory which exactly conveys the point at issue in the mind of Beatus.[25] It is of a bird killing a serpent. As the bird slays the serpent with its beak, says the text,[26] so does Christ slay evil by the word of His mouth. And, as the bird is surrounded with plumage, so did Christ conceal His divinity with the plumage of human weakness, for, in order to deceive and extinguish the Evil One, He Himself took on human flesh. This, in brief, is a pictorial allegory of the Incarnation.

Though the genealogical tables themselves must have been in the original manuscript of Beatus, it is difficult to ascertain which of these other pictures were also. The fact that the illustrations of the Annunciation to the Shepherds, the Magi, and the bird killing the snake appear in two separate families of the manuscript would, however, suggest that these at any rate were found in Beatus's own copy. And, even supposing that the others already cited were added later, they do at least indicate that consonance of mind between Beatus himself and later generations without which his work would never have become so popular.

The emphasis on the divinity of Christ was, of course, as much a refutation of Mohammedanism as of the Adoptionist heresy, which was itself an attempt to compro-

mise with Mohammedan thought. And, though in the mind of Beatus his edition of the Apocalypse may have been closely associated with his own attacks on Adoptionism, it had no less relevance to the broader issue between Christianity and Islam.

The Apocalypse had clearly been a source of strength to the Christians of the Arab-occupied south in their own resistance to Islam. If not persecuted, they were in an inferior position to the Moslems, whose faith and social position they could themselves have easily embraced by the simple pronouncement of the formula: 'There is but one God and Mohammed is His prophet.' This prophet readily lent himself to identification with the false prophet of the Apocalypse – the servant of Antichrist and of Satan. The Cordovan martyrs,[27] who were largely inspired by the Christian monks in Cordova, did not hesitate to proclaim this to the Moslems themselves. It is recorded that six, who were to meet death together, cried out with one voice that Mohammed was the false prophet, the precursor of Antichrist.[28] This was also the message of Eulogius, the last and most venerable of these martyrs.[29] And others of their number did not hesitate to proclaim that Mohammed was the minister of Antichrist and follower of Satan.[30]

Passages of Beatus's own commentary added point to the association.[31] We know, says Beatus, that the true Church in this world is at war.[32] Indeed, the hot furnace of chapter 7 (v. 15) represents those wars and trials and tribulations which the true Christian has to endure in order to be proved.[33] The Apocalypse contains many symbols of our enemies and their fate. The Mother of Harlots of chapter 17, for example, represents those infidels who attack the Church from without and those schismatics who attack it from within,[34] and a twofold vengeance will fall on them as on her.[35] The fall of Babylon in chapter 18 symbolizes the final damnation of all heretics and schismatics.[36] The false prophet of chapters 16, 19, and 20 represents those who do not preach the true faith of the apostles,[37] but he, together with the Beast his master, will finally be 'cast into the lake of fire burning with brimstone ... and shall be tormented day and night for ever and ever' (Apoc. XIX, 20, and XX, 10). The four horsemen of the Apocalypse (chapter 6) are themselves symbolic.[38] The first horseman on the white horse (which represents the true Church) is Christ Himself. But the rider of the red horse is the Devil, the rider on the black horse is his priest the false Prophet, and, finally, the rider of the pale horse is Death, who shall give all heretics over to sword and famine. If one dredged the academic commentary of Beatus, one could find allegories and explanations for the agonized position of the Church and the encouragement also to endure it. As the Apocalypse itself said: 'He that overcometh shall inherit all things. ... But the fearful and unbelieving ... shall have their part in the lake which burneth with fire and brimstone' (Apoc. XXI, 7–8).

All this carried an obvious message to a body of Christians who felt more and more combative towards the powerful forces of the infidel without, as the strength diminished of the Christian schismatics within. Indeed, if positive pictorial evidence is needed for the association between the Apocalypse and the threat of Islam, it is found in the Apocalypse at Urgel Cathedral where the Antichrist is actually represented as an Arab.[39] The Apocalypse, indeed, symbolized and explained the position of the Christians in Spain at the same time as it offered assurance of inevitable victory and deliverance. This is well

I

allegorized by the picture of Noah's Ark which appears in the earliest surviving manu-script[40] as well as later ones[41] and which, in the well-known medieval interpretation[42] to which Beatus alludes,[43] was a figure of the true Church: those who entered and remained in her would assuredly be saved while those outside would as certainly be lost.

It is not surprising in this context to find that the Beatus manuscripts contain illustra-tions of the Book of Daniel, for this carried a message similar to that of the Apocalypse itself. It also, according to medieval exegesis, was concerned with the rule of Antichrist before the final salvation and victory of the true Christian. This is remarked on by the Spanish theologian St Isidore of Seville,[44] whose works were particularly well known. He specifically interpreted the Book of Daniel in terms of the relationship between the true Church and the kingdom of heretics and thought that Jerusalem represented the first and Babylon the second.[45] The illustrations[46] include representations of Babylon, of Nebuchadnezzar's visions (see Plate 118), and of two incidents which always typified the victory of the true Christian from the days of the early Church – the three children in the fiery furnace and Daniel in the lions' den.

That the Spanish Christian felt some consonance between the Beatus illustrations and his own position in confrontation with the heretic is demonstrated by a prefatory picture which was inserted in manuscripts. This was a picture of the so-called Cross of Oviedo,[47] traditionally known as the Victory Cross. The latter (a relic in Oviedo Cathedral) had been carried before Alfonso the Great (866–910), who was the most famous leader of the early Christian Reconquest, on one of his most celebrated victories against the Mohammedan. It became a symbol of Christian resistance and Christian conquest. The militancy of its Christian associations is underlined in some manuscripts by an accom-panying inscription telling the pious to uphold this sign since it conquers the enemy.[48]

Other pictures emphasize by implication the view that the one pure religion is the Christian one. This is conveyed by evangelist pictures which were most probably in the original prototype, for they are found not only in the earliest surviving manuscript but also in seven others.[49] They either show the Gospel being handed to the relevant evangelist by Christ or they depict that Gospel being held by two angels below the evangelist's symbol. Clearly their message is that the Gospels contain the true word of God handed down either through the medium of Christ Himself or by other divine inspiration. A pictorial reference to the preaching of the apostles in the world may carry with it associations of the same kind, for it presumes a knowledge of Pentecost and of the divine inspiration of the apostles. This takes the form of a map of the known world, indicating the places in which they preached.[50] It relates to a part of Beatus's own com-mentary in which he discusses the missions of the apostles[51] and, naturally, follows the celebrated Spanish tradition that St James preached the Gospel in Spain. The map would, no doubt, take on a new significance in the first half of the ninth century, when the actual tomb of St James was said to have been discovered at Compostela in Galicia. As everyone knows, this was to become at once a shrine attracting pilgrims from all over Europe and also a symbol of national unity and Christian militancy in Spain. Indeed, as the Christian Reconquest of the peninsula was more and more invested with a real religious zeal and

dynamism, the message of the Apocalypse would gain a wider and newer impact. It is recorded that, when a Spanish ruler was asked to join the Crusades, he retorted that Spain was always on a Crusade,[52] and the Crusading movement itself was informed with ideas and concepts of the Apocalypse.

Painters and Scribes of the Spanish Apocalypses

It has been remarked that the art of Spanish manuscripts seemed cut off from the main stream of Western art. In another sense also these manuscripts were unrelated to the rest of Europe, for they give us a fullness of information about their production and date which is of the greatest rarity elsewhere. In 213 manuscripts of the tenth and eleventh centuries there are no less than fifty-nine identifications of scribe or painter.[53]

In other countries during our period, we occasionally find inscriptions and even dedication pictures in manuscripts. But, as we have already seen, these were primarily – almost exclusively – concerned with patron and scribe. The patron was normally given pride of place, and in the dedicatory inscriptions and pictures of Carolingian and Ottonian manuscripts it is the patron – whether emperor, ecclesiastical prince, or abbot – who is emphasized. (This extended to other arts, and in the twelfth century this concern with the patron reached almost the point of caricature at Saint-Denis, where the patron, Abbot Suger, was identified in no less than thirteen inscriptions of the church as well as being represented in stained glass, stone, and gold.)[54] The scribe also might find himself named. Under the Ottonians a picture of the scribe occasionally appears in dedication pictures showing him presenting the book to the patron, and his name – though subordinated to that of the patron – is sometimes perpetuated in dedicatory verses.[55] In the twelfth century the importance given to the scribe reaches its climax when an enormous picture of the scribe, Eadwine, with a very flattering inscription, is inserted at the end of a giant English Psalter.[56] But, though the names of patrons and scribes might be given, those of the painters were extraordinarily rare outside those areas (like the Crusading kingdoms) which were subject to direct and intimate Byzantine influences.

In Spain, however, the situation was quite different. Here the name of the painter was quite normally recorded. Further to this, the Spanish scribe often gave the date of the manuscript, and this also was extremely rare in other countries. As if to emphasize her independence from the rest of Europe, we find yet further that Spain adhered to her own methods of dating and used a chronology which was thirty-eight years ahead of the rest of Christendom. So there is always a disparity of thirty-eight years between the dates given in Spain and those of other countries, though here we shall adapt them to the normal conventions of the West.

To all this, we may add that the Spanish scribe was far more expansive than scribes elsewhere: 'The labour of the writer,' writes one in a *Beatus* manuscript, 'is the refreshment of the reader. The one depletes the body, the other advances the mind. Whoever you are, therefore, do not scorn but rather be mindful of the work of the one labouring to bring you profit. . . . If you do not know how to write you will consider it no hardship, but if you want a detailed account of it let me tell you that the work is heavy: it

makes the eyes misty, bows the back, crushes the ribs and belly, brings pain to the kidneys, and makes the body ache all over. Therefore, O reader, turn the leaves gently and keep your fingers away from the letters, for as the hailstorm ruins the harvest of the land so does the unserviceable reader destroy the book and the writing. As the sailor finds welcome the final harbour, so does the scribe the final line. Deo gratias semper.'[57]

To such scribal loquacity, we owe a good deal of information. We learn, for example, from the earliest of all the surviving manuscripts (Pierpont Morgan Library MS. 644) that it was made in the monastery of St Michael at the behest of Abbot Victor.[58] The painter and scribe were the same person – Magius (or Majus) by name. The date is given but, owing to an erasure, there have been disputed interpretations. The most acceptable is 922. The date of the second earliest surviving *Beatus* manuscript which was made at Valcavado is quite clear: it is 970. Its painter was Obeco and the name of the abbot who commissioned it was Sempronius.[59] A lengthy colophon of another *Beatus*[60] produced in the same year at San Salvador de Tábara tells us that it was begun by 'the chief painter, the good priest Magius', who, however, died after an illness of three days on 29 October 968. Emeterius was called in by his own master (who had himself been a pupil of Magius) to complete the work in the tower of the monastery of Tábara. This he did between 1 May and 26 July 970. The illustrations include a picture of Emeterius at work in the tower (folio 139; Plate 119), and his inscription concludes with a sigh of relief: 'Thou lofty tower of Tábara made of stone ! There, over thy first roof Emeterius sat for three months bowed down and racked in every limb by the copying. He finished the book on July 26th in the year 1008 (i.e. A.D. 970) at the ninth hour.' The particular interest of another tenth-century *Beatus*, produced in 975, is that the inscription informs us that both a male and a female artist cooperated in its painting – the first named Emeterius and the second Erde. This must indicate that the scriptorium was in a 'double house' for both monks and nuns. And, though there is ample evidence of the nun as embroidress and author during our period, references to the nun as painter are of the utmost rarity. Some colophons are diffident, such as those of the *Beatus* written in 1047 where the scribe simply writes: 'Remember me, Peter the priest,' and the painter adds on another page: 'Remember Martin, the sinner.'[61] Others are more fulsome, such as that of a *Beatus* from Santo Domingo de Silos which tells us that it was actually begun by order of Abbot Fortunius in 1073, the scribes being Nunnius and Dominicus and the painter the prior Peter, that the death of Fortunius intervened, that it was continued under his successor Abbot Nunius and only finally completed under Abbot John in 1109.[62] But, in various ways, means are often found for recording the names of those responsible for the manuscript.

There can be little doubt that the identifications of those responsible for a manuscript in the West originated in a real feeling of piety. Inscriptions will often carry with them a plea to the reader to remember the scribe or to pray for his soul. 'Pray for the scribe, the priest Vincent', says one manuscript[63] (if we confine ourselves to Spain alone); 'O pious reader pray for Alburanus the scribe', says another,[64] and others explain that they have been written for the redemption of the soul of patron or of scribe.[65] We find the same in the colophons of these *Beatus* manuscripts. 'Whoever you are', reads one,[66]

'who approaches anxious to read this, do not disdain to pray for the priest Obecus and perhaps you may procure indulgence for my unworthy self and I may come to the Lord our Redeemer without confusion.' In another *Beatus*,[67] Emeterius asks that the master who trained him may merit the crown of eternal life. An inscription like the latter goes further than a direct request for prayer and conveys the hope that those responsible for Christian good works in this life will be remembered by Christ in the life to come. This idea is conveyed with pictorial succinctness in a manuscript-painting which is completely outside our present context. In it, the representation of the Last Judgement includes a small figure who holds a label saying that he, William de Brailes, has made this, and an angel descends to take him to the body of the elect.[68] Now, of all books, the Apocalypse was the one most preoccupied with future life and the Last Judgement. This, in fact, is emphasized in the verses of the earliest surviving *Beatus*, which, on the one hand gives us the names of those responsible for ordering, writing, and illustrating the manuscript and, on the other, tells us that these paintings were made to remind the prudent of the coming Day of Judgement and all its terrors.[69] It may then be precisely because of the relationship between the Apocalypse and the Last Judgement that more identifications are found in the *Beatus* colophons than in other manuscripts, and particularly that the names of painters are often given, which is so exceptional elsewhere. And, since the dating of manuscripts is so very rare during our period in other parts of Christendom that it calls for some explanation here, one might argue that this practice was somehow related to the considerable interest which the Apocalypse and its commentaries showed in the date and number of Antichrist. More probably, however, this represents an influence from Arabic sources, where it was normal for manuscripts to be dated.

Mozarabic Art

There is nothing in the long commentary of Beatus to match the glowing prose of the Apocalypse text, but in some ways there is an affinity between the vivid poetic splendours of the Apocalypse and the pictures which illustrate it. Not that we can claim for these paintings anything of the majestic sweep and rich oratory of the Apocalypse, for they represent a simple, even naïve, folk art, but they still convey something of the visionary power of St John's prophecy.

There are, of course, various styles in so many manuscripts and the later ones reflect European trends. The earlier ones, however, are in a Spanish style of great individuality, which is known as Mozarabic. In fact, the word Mozarabic itself means no more than the Christian art of Spain when it was dominated by the Mohammedans, for the Christians who remained in the Arab-occupied part of Spain, faithful to their own religion, were known as *mozárabes* – the unconverted.

To pass from the Western art of Italy or Germany or England to this Mozarabic art is like stepping from a European garden into a tropical greenhouse full of garish and exotic flowers, flowers which are bizarre, strident, and colourful, flowers whose sheer torrent of colour is a little suffocating in its insistence and which leave an indelible impression of colour and unreality on the mind.

There is a number of ingredients in this Mozarabic art, but fundamentally it represents a continuation of the barbarian tradition in Spain.

We have seen that, when the barbarian tribes flooded into Europe in the fifth and sixth centuries, they brought their own arts with them – arts which at their finest could present an extremely high technical achievement combined with a strong feeling for colour and design, arts whose primary purpose was to ornament and which therefore might almost be called an art of display. The Visigoths in Spain had their own crafts, and there even survive from their period representational carvings in stone of Christian subjects such as Daniel in the lion's den and the Ascension. The fact that the craftsmen here conceived their subjects in decorative 'coloristic' terms of light and shadow and lacked the technical ability to express their own aims gives these carvings a certain gaucheness. But in metalwork the Visigoths were much more at home. A fine example of this craft is the pair of large eagle-shaped fibulae now in the Walters Art Gallery at Baltimore. These are of gilt bronze overlaid with gold and are set with garnets and blue and green stones; they also have a cabuchon crystal as a central boss on the breast and a large amethyst to represent the eye.[70] In some ways, Mozarabic art might be said to continue this tradition of the setting of glowing colours, though in paint rather than in precious stones.

There are (as we shall see later) important general points of similarity between Mozarabic painting and the barbarian arts of the Anglo-Saxons which found such superb expression during the seventh and eighth centuries in Northumbria. Yet, despite these, Anglo-Saxon art and Mozarabic art represent two opposite poles of the barbarian aesthetic: the first is linear and the second coloristic.

Manuscript-painting in England before the ninth century does, indeed, show a feeling for colour which should not be underestimated and which – in the Lindisfarne Gospels, for example – gently suffuses the page with great subtlety and skill. But in these paintings the colour is always controlled by the line, and it is the superb quality and rhythm of line – its sheer refinement and dexterity – that makes it such a joy to look at. In Mozarabic painting, on the other hand, it is the colour that is supreme. The line itself can be harsh or gauche or inconclusive. What matters is the colour.

The backgrounds are normally zoned in wide bands of solid, intense colours such as orange and green and yellow. The figures themselves are painted in warm, even garish colours such as crimsons, greens, and red-ochres set off by deep purples and grey-blues, but often with bright yellows predominating. Everywhere the primary impression is of colour and of patterning which is expressed in terms of a gusty primitiveness that one might find today in a fairground or circus. Where form is concerned, there is not the slightest regard for reality. The figures are simply areas of colour segmented by line. In the many crowd scenes which the illustration of the Apocalypse demands, the figures often dissolve into one interrelated multicoloured pattern, as, for example, in the twenty-four elders adoring Christ in the earliest dated *Beatus* (folio 207) or in the British Museum *Beatus* (Plate 121). Only the punctuation of these extended patterns by pairs of intense eyes indicates that they are meant to represent a mass of humanity and not simply a brightly patterned length of unsmoothed material. The patterning by heavy line is itself

simple and elementary, with none of the suavity of Anglo-Irish work. Compared to the latter, Mozarabic art is rude and primitive, though not without its own robustness and uninhibited vigour.

The strong, almost primitive, feeling for colour is reminiscent of the jewel-setting in which the Visigoths were so proficient. Often in their metalwork we find large stones set with only the slightest regard for the formal outline of the figure represented – they are simply chunks of glowing colour. The Mozarabic painter had much the same interest. This can be seen in its simplest form in the initials of manuscripts like those of Santo Domingo de Silos [71] where figures are seen entirely in terms of adjacent colour areas, but it is no less evident in the narrative illustrations of the *Beatus* manuscripts. Indeed, there the colours have a wax-like surface which even gives them something of the sheen of precious stones. And, though most of his colours are 'solid', the Mozarabic painter can in his finest work occasionally capture something of their flame-like quality, as we see in the León Bible (Plate 128), which will be discussed later, and the San Millán *Beatus*, where the greens, blues, purples, and yellows of the picture of the Lamb and the evangelists (Plate 120) have a vibrancy that can be compared to the play of light on gems. The parallel must not, however, be taken too far, for there is not in Mozarabic painting the disciplined control of form which is given to the jewels by their metal settings.

In yet another way Anglo-Saxon and Mozarabic art contrasted with each other; for, whereas the Anglo-Saxon accepted the limitations of his own artistic tradition, the Spaniard refused to do so. Fundamentally, as we have seen, [72] barbarian art was an art of adornment. This the Anglo-Saxon recognized, and the exquisitely subtle interwoven patterns of his manuscript-painting could have been transmitted by a fastidious crafts-man either into the filigree of metalwork or into the open designs of textiles. The human figure he rarely essayed. When he did, however, it was made to conform to the barbarian aesthetic: it became a decorative abstraction – a brooch. So the figure of St Matthew in the Lindisfarne Gospels suspended against its neutral background is quite magnificent but, basically, it is a cloisonné enamel. Indeed, the few figures that we find in Northumbrian art would be equally at home in the craft of metalwork.

The Spaniard, on the other hand, refused to accept such limitations and, grouping together his abstract figures in scenes, tried to make this art of adornment meet the needs of narrative art. The result is difficult for the Western eye at first to comprehend. It is like someone taking a number of differently coloured precious stones and organizing them on a richly coloured surface with a view to conveying a pictorial message. Inevit-ably, the result is a picture in which the figures have no physical or psychological relationship. It fails completely to convey a narrative message, but what it does convey is a feeling of colour and other-worldliness. Perhaps, in some ways, there is a consonance between just this latter feeling and the mood of the Apocalypse itself, which also imposes by the rich colour of its oratory and the visionary power of its message rather than by any interest in mere reality. And however strange these pictures may appear to us today and however unsophisticated, they do have in them something of the visionary world of the Middle Ages whose imagination (as evinced, for example, in the visions of

Paradise of Hildegard of Bingen) dreamt in terms of colour and luminosity rather than of form.

Though there are areas of uncertainty, the general influences on this Mozarabic art seem fairly clear.

First and foremost was the Visigothic tradition itself. This emerges not only in the preoccupation with colour but in other directions as well. So the narrow silhouettes of figures in one or two manuscripts[73] and the face, normal in most, with its large, almond-shaped, bulging eyes and nose reduced to two parallel lines, are clearly related to Visigothic sculpture.[74] Then there is a more general connexion with the styles of Visigothic sculpture. The latter was very linear in the sense that the draperies were heavily and profusely incised with narrowly spaced lines.[75] But these incised lines are dead: there is no life or energy in them. Looked at not in terms of light and shade but in terms of form the figures are weighty and enervated. There is some of this in Mozarabic painting too. If we look at the figures there, not in terms of coloristic pattern but in terms of form, we are conscious of the real weakness of this style – the heavy, lack-lustre line which easily gives a feeling of gaucheness and ineptitude. This, unfortunately, is evident in a number of *Beatuses* such as those of Urgel (Archivo de la Catedral)[76] and of Valladolid (Biblioteca Santa Cruz).

Another influence was from Anglo-Saxon or Anglo-Irish art, an art, as we have seen, that was not only to be found in northern England and Ireland but also on the Continent, whither it had been brought by Irish monks and by the Anglo-Saxon missionaries of the seventh and eighth centuries.

Many of the figures of Mozarabic art have draperies reduced to a 'swathed', almost cross-banded pattern-work. This is found in the early Morgan *Beatus* (folios 26, 117 verso, 118, etc.) and in the Valladolid[77] and Escorial *Beatuses*,[78] all of which are of the tenth century (Plate 118). It can be closely paralleled in Anglo-Irish manuscripts both in the British Isles and on the Continent – for example, in the Book of Kells,[79] in the Macdurnan Gospels,[80] and in the Gospels from St Gallen.[81] It could be argued that this style represents the parallel reduction of a classical style to decoration in two separate areas. And, in support of this, one might, indeed, point to a late classical sepulchral mosaic actually in Spain which represents this style in its more naturalistic form[82] and to a seventh-century capital of St Matthew from Cordova[83] in which it is already being converted to decoration. But, despite this, the relationship between Mozarabic and Anglo-Irish art is so clear that the style is more simply explained by their association than by two separate developments. (Even the stone-carving itself may represent not an indigenous development but influences from the north, and another in the series, a carving of St John,[84] is close to Anglo-Saxon figure painting such as that of the Durham *Cassiodorus*[85] or the Lindisfarne Gospels.) In the earliest dated *Beatus* of the Morgan Library (MS. 644), we find that the Christ on folio 83 has similarities to the Christ in a Northumbrian manuscript now at Durham,[86] the evangelist symbols on folios 2 and 3 verso have been clearly influenced by the patterned, almost heraldic, manner of Anglo-Irish symbols, and the background or background material on folios 2 verso and 3 have the mosaic-like patterning that we also find in Anglo-Irish art. Again (although the

motif ultimately derives, of course, from Late Antiquity), the two angels holding a casket containing the Gospel beneath the symbol of St Mark on folio 2 remind one of a similar device in an Anglo-Saxon manuscript from Trier, where a placard takes the place of the casket.[87] Elsewhere, we find in the Escorial *Beatus*[88] details like the figure of Christ reduced to a lobed pattern-work which can be paralleled in an Anglo-Saxon manuscript at Echternach[89] and the Dimma Gospels from Dublin,[90] and in the Burgo de Osma *Beatus*[91] we see a general figure style which has affinities with Anglo-Saxon styles. In these manuscripts we furthermore find Anglo-Saxon or Franco-Saxon interlace,[92] all of which would suggest that some influences from the British Isles were percolating into Spain.

Despite such influences from other 'barbaric' arts of Europe, Mozarabic painting can best be understood within its own barbaric tradition of Visigothic art, and it has even been suggested[93] that Visigothic illustrations of the Apocalypse existed which were seen by Beatus himself. All this does not mean, however, that Mozarabic painting was simply a continuation of Visigothic art. It needed a catalyst to precipitate Spanish painting into its Mozarabic form. At once a major influence and probably the catalyst itself was Islam.

The fact that the *Beatus* paintings reflected physical influences from an Arab civilization against which, on a spiritual level, they were a form of protest need not surprise us. Culture is not indivisible. In the eighth century the mosaics of the great mosque of the Omayyads at Damascus were made by Christians, and even later – during the religious heat of the great century of the Christian Crusades – we find Arabs who had fought fiercely for Islam in North Africa commissioning Christian artists to provide monumental (but decorative) mosaics in their mosques. Indeed, the fact that Moslem art, being opposed to figural representation, was primarily decorative meant at least that there was no theological problem of artistic exchange between the Moslem and Christian. In southern Spain, where the intermingling of East and West was so pervasive, influences from Arab culture were readily accepted, which were also received in the north.

The Arabs were too few to colonize the peninsula they had conquered and, as we have seen, the Mozarabic Christians settled down with them in the areas under Moslem rule. Intermarriages took place and the two cultures influenced each other at almost every point. This was freely recognized by the leaders themselves. So, in 961, we find the bishop of Elvira dedicating a calendar to Hakim II, caliph of Cordova,[94] and in the eleventh century the Mohammedan ruler Motomid-ibn Abbad, whose wife was a Christian, restored and renovated the many Christian churches in Seville.[95]

It is one of the truisms of the later-twelfth-century Renaissance in Europe that it owed much of its incentive to the intellectual ferment of the Arab culture in Spain whence (in their Arabic form) the West certainly recovered lost classical works such as those of Aristotle. But the Western appreciation of Arabic culture goes back to a much earlier time, and some of its superior aspects were already recognized by the true Mozarabs. As early as the mid ninth century Alvar was declaring in eloquent terms that his fellow-Christians in the south were 'taking delight in Arab poetry and their thousand stories' and examining the religion and philosophy of the Mohammedan 'not in order to refute their errors but on account of their elegance of diction and clarity of expression'. 'Are

not all our young Christians Chaldeans,' he cried, 'skilled in heathen learning, lifted into the fields of Arabian eloquence, eagerly turning over the pages of the Chaldeans? . . . Oh, grief! Christians do not know their own tongue, Latins cannot understand their own language . . . while innumerable crowds are found who can most learnedly explain the beautiful order of Chaldean words, and can add the final flourish which their language requires with greater skill and beauty than the heathen themselves.'[96]

Later, we find Arab fashions spreading to the Christian kingdoms of the north. For example, in the eleventh century Alfonso VI, king of Castile, who before his accession had spent several years at Toledo and Seville, dressed himself in Moorish costume and surrounded himself with Arabic musicians, poets, and sages,[97] and his contemporary, Sancho I of Aragon, habitually signed his name in Arabic script.[98]

That there was some intercommunication even between Christian and Arabic scriptoria is indicated by the number of Christian manuscripts with Arabic comments or additions. Examples include an eighth-century Bible,[99] a ninth-century *St Augustine*,[100] and at least three texts of Isidore from the eighth, ninth, and tenth centuries,[101] all with comments in Arabic, and a complete text of the Spanish Councils in Arabic survives from the eleventh.[102] Arabic influences in the Christian scriptoria themselves could further be promoted by the fact that members of the Christian communities might occasionally be of mixed marriage and have Arab or Berber blood in them. One of the scribes of the famous Latin text of the Spanish Councils of 976, the *Codex Vigilianus*, which is one of the earliest Latin manuscripts to contain Arabic numerals, was a priest named Sarracinus.[103] And in one monastery of Sahagún there are records during the tenth century of six monks apparently of mixed blood, for they have names like Sarracinus or Zarrazenz.[104] The awareness of the two civilizations within the Christian scriptorium itself is well conveyed by the colophon to a text of the Dialogues of St Gregory, written in 938, which reads: 'I Isidore, a humble priest, have written this book at the request of the Abbess Gundissa in the year 976 on the fourth of the Kalends of November under the rule of Habdirrahmen, son of Muhammed, nephew of Habdalla, in the twenty-seventh year of his reign, in the month which in Arabic is called Almuharram.'[105]

As far as the visual arts are concerned, Moslem crafts could find their way to the Christian kingdoms in a number of direct ways. One was for Moslem craftsmen themselves to travel north. This was probably most exceptional, but there is record of the fact that, in the eleventh century, Moslem craftsmen found employment as ivory-carvers or metal-workers with Christian rulers and even Christian abbots.[106] Primarily, however, Islamic crafts would come into Christian hands either in the form of gift or in the form of booty. We have seen that Christian leaders might ally themselves on occasions with the Moslems, and they might be well rewarded by gifts. After a victory in 997, the Mohammedan leader Almanzor conferred on his Christian allies no less than 2,285 pieces of silken stuff of various colours and patterns.[107] A more spontaneous gesture is recorded in 1063. When the bishop of Astorga was leaving Seville with the relics of St Isidore, his procession was approached by the Moslem ruler, Mutadid, who threw over the sarcophagus an exquisite brocade adorned with arabesques.[108] Then, again, Christians travel-

ling from the south on pilgrimages might bring gifts to donate to churches. It was because of these that a Catalan church like Estany possessed such a rich collection of Hispano-Moresque textiles.[109] Christian churches might also find themselves in possession of Mohammedan crafts acquired as plunder rather than as gifts. Even in France, we learn that in 1002 the abbey of Sainte-Foy at Conques was given the booty won in Spain by Raymond III, count of Rouergue. It consisted primarily of twenty-one engraved and gilded silver vases from which the monks made 'a great cross retaining the richly engraved Saracenic ornament'.[110] Whether the monasteries of northern Spain accepted Arabic styles quite so deliberately is difficult to say. But, conscious or unconscious, the reception of these influences was no less real.

There were, in fact, certain affinities between Mozarabic and Moslem art. Each represented a decorative aesthetic. This remains true despite the fact that the first involved itself in a narrative art and the second only occasionally admitted figural styles. The Moslem theologians, we know, wished to ban figural arts from Islam since they thought that to create figures in this way was to blaspheme the Supreme Creator, and could further quote in their own support an alleged saying of Mohammed that figural artists would suffer most at the Day of Judgement. But in certain areas and in certain periods of the Moslem world this stricture was relaxed and we may presume that occasional examples of Moslem figural art did find their way into Arab-occupied Spain.

We know, of course, that there were Moslem painters in Spain and also craftsmen in ivory and metal. Indeed, in the twelfth century, Theophilus singles out metalwork as the craft in which the Arabs excelled.[111] But, of all Moslem crafts, the most widely deployed and most widely known was that of decorative textiles. Cordova was an important centre for their export, and there were centres for their manufacture at Cádiz and Seville. We have already seen how they could be dispersed as gifts and with what ease they could find their way into the Christian kingdoms of the north.

One of our *Beatus* manuscripts has illustrations which must have been very strongly influenced by such textiles. It is a comparatively late manuscript originally from Santo Domingo de Silos and now in the British Museum (Add. MS. 11695).[112] If we look at the different scenes in terms of narrative art (see, for example, Plate 121) then the squat, heavily swathed figures in their closely serried ranks gazing fixedly outwards from gimlet eyes are, frankly, ridiculous. But if we see them as decorative surfaces, then they emerge for what they are – colourful patterns and designs. There can be little doubt that textiles exerted a powerful influence on these particular paintings and they have given a feeling of threaded texture to the figures themselves.

In numerous other ways Arabic influences made themselves felt. Saracen decorative patterns are found in the canon tables of Mozarabic manuscripts. Persons, who include even Christ Himself, adopt the cross-legged seated posture known throughout the East, which is almost inevitably taken up by someone sitting on a cushion on the floor.[113] Figures wear turbans which, when a sense of movement is needed, have a flying 'band' behind.[114] We find dragons with pear-shaped and highly decorative tails whose ancestry can be traced back to Sassanian prototypes now preserved to us in stone.[115] Trees and fauna appear which, however schematized, belong clearly to the East and not the

West.[116] The representation of two lovers in bed in one *Beatus* manuscript has been iconographically related to a similar theme from a later traditional Persian painting[117] and, though this comparison is not wholly convincing, the idea of representing sexual love in this anecdotal form belongs to an Eastern rather than a Western tradition: in the West it would normally be represented by a simple female personification, as in the wall-paintings of Tavant[118] or in the illustrations of the numerous Prudentius manuscripts. Figural styles from the Moslem world have almost certainly influenced one of the very latest *Beatus* manuscripts (Plate 122),[119] where, though sent as a plague (IX, 17), the horse-men of the Apocalypse ride in buoyant leisure over the surface of the page in a way which inevitably reminds one of the later and much more accomplished horsemen of Persian manuscripts.[120] The earlier riders of the Madrid *Beatus* (Biblioteca Nacional B. 31)[121] and the Burgo de Osma *Beatus*[122] may well reflect a similar influence.

The Mozarabic style itself remained at such an unsophisticated level and contains so many stylistic and qualitative variations within itself that it is difficult to generalize about the results of these Moslem influences. One result, however, was certainly to give an oriental and exotic flavour to what was always basically a folk art. Another was to give it an overwhelming interest in surface decoration.

The primary concern of Arabic art was decorative texture. Whether it was a delicately carved ivory or a finely woven fabric, the aim was to provide a close overall pattern, so delicately wrought that it gives the impression of a decorative surface. In essence this is exactly what the calligraphy of the Arabs itself achieved and why we can find this script used ornamentally (as on the curtain of the door of the Kabah at Mecca)[123] with such superb decorative effect. This, too, explains why this script could make its way as a purely decorative form into Christian works of art – into reliquaries like the silver *Arca Santa* in Oviedo Cathedral,[124] into carvings like those at San Juan de las Abadesas,[125] and even into our own *Beatus* manuscripts, for the Saint-Sever *Beatus* in the Bibliothèque Nationale (MS. lat. 8878) has a Cufic inscription interwoven into its frontispiece. Though Mozarabic art did not approach the sophistication of Arabic work, we can see in its interest in surface pattern and texture an influence from it. For example, in the figures and animals of manuscripts like the Morgan manuscript of 922 (MS. 644 folio 157 verso) and the Madrid *Beatus* of 1047 (Madrid, Biblioteca Nacional) we find a similar threaded texture to that of contemporary Moorish ivory-carvings in Spain. In Mozarabic as in Mohammedan art there seems, in fact, an assimilation to the decorative quality of textiles. This reaches a point from which no further development is possible in the Santo Domingo de Silos Apocalypse in the British Museum (MS. Add. 11695; Plate 121) which we have already discussed. But the same interest in close surface decoration is found in most of these manuscripts. It characterizes the very fine Apocalypse of Gerona Cathedral made in 975, as we can see in the reproduction on Plate 123. It is evident in the earliest dated *Beatus* (Pierpont Morgan Library MS. 644) and the dragon, for example, which squirms over two large folios (152 verso and 153) is decorated throughout its entire length with closely packed pearl and crescent patterning in red and yellow against a blue background. Unfortunately its reproduction in black and white on Plates 124 and 125 gives but a feeble impression of the sharply coloured original, where the effect of

ornamental scaling has close parallels to the representation of the dragon as a constellation in a Persian manuscript on astronomy.[126] The latter manuscript, it is true, is much later than the *Beatus*, but Arabic works on astronomy, which may have contained illustrations, were already being translated into Latin in the tenth century.[127] In other manuscripts of Beatus the interest in decoration extends not only to dragons and animals but also to backgrounds and human figures and architectural representation. The reduction of architecture to terms of geometric texture has an oriental flavour which again finds parallels in later Persian work, and we can compare a picture from the Madrid *Beatus*[128] with a later Persian illustration from the History of the Mongols.[129] The feeling for decorative texture reaches into *Beatus* manuscripts even of the late twelfth or thirteenth century such as those of the Bibliothèque Nationale (nouv. acq. lat. 2290; Plate 126) and the Pierpont Morgan Library (MS. 429), where the pictures are given a colourful spangled effect. Indeed, over most of Mozarabic painting there is a patina of exotic decoration which derives from Moslem art. This is not like the idiom of the Anglo-Saxons, which assimilated everything to a sinuous patterning intrinsic to the whole: it is the extrinsic patterning of the East. The pattern is sown or scattered over the surface, and the feeling of exoticism derives from the contradiction between its own artificial fastidiousness and the forms of animal and human life beneath.

In the later manuscripts other traditions assert themselves. We have already seen that the Saint-Sever Apocalypse (Bibliothèque Nationale lat. 8878) draws as much on the Carolingian tradition as on the Mozarabic, and the Turin Apocalypse (Biblioteca Nazionale lat. 93) pays homage to the same non-Spanish source. The very late *Beatuses* such as the Madrid and later Pierpont Morgan ones are in the international style of Late Romanesque with all its Byzantine ingredients. Yet though the real life of Mozarabic art lay between the eighth and eleventh centuries, its influence never really died in medieval Spain. In fact, Spanish manuscript-painting during our period could never entirely emancipate itself from this tradition. The result, in the twelfth century, was that it found difficulty in adapting itself to the Romanesque idiom then current in the West, and its efforts to do so could lead to styles that were simply bizarre. Such a style was that of the Book of the Testaments made between 1126 and 1129 and now in the archives of Oviedo Cathedral. Here, pictures of the kings and queens offering charters as on folio 49 verso (Plate 127) are rich in colour, surface texture, and the articulation of detail but show in their general deflated formlessness an incomprehension of the real meaning of Romanesque. The path of wall-paintings, on the other hand, was different, and, as we shall see later, though some were touched in the twelfth century by the Mozarabic tradition, most were able to emancipate themselves completely from it and to follow vigorously a course that was Romanesque.

Bibles in Spain

The *Beatus* manuscripts are the most important examples of the Mozarabic style, and without them our knowledge of it would be only fragmentary. However, this style is also found in tenth-century Bibles of no little interest.[130]

A particularly important one of the first half of the tenth century at León Cathedral (cod. 6) was commissioned by Abbot Maurus and produced in 920 by the monks Vimara and John at San Martín de Albeares. Of its illumination, the pictures before each Gospel of single angels with symbols of the relevant evangelist are particularly fine; their flame-like vibrancy and quality of colour can only be hinted at in the black and white reproduction of the picture before St Luke's Gospel (Plate 128).

Another Bible, of significance because of its narrative content, was produced by a certain Sanctius and by a Florentius (whose name as scribe appears in another dated manuscript).[131] At the end they give thanks to the King of Heaven for enabling them to complete His work and are portrayed congratulating each other on having completed their task (Plate 129).[132] The manuscript is dated 960 and is now at León (San Isidro).

The Old Testament part of the Bible is well illustrated – some Books, such as that of Daniel, Exodus, and Kings, more than others. The style is comparable to that of *Beatus* manuscripts like the one from Urgel, and there are, furthermore, iconographic relationships between the illustrations of this Bible and the Old Testament representations interpolated into the *Beatus* manuscripts. The Daniel cycles in the latter, for example, are similar to that of the León Bible,[133] and both the genealogical tables of the *Beatus* and the pictures of the Bible commence with a similar Adam and Eve. These are here presented frontally in a naïve but eloquent form, for the very clumsiness with which they hold their fig-leaves in front of them emphasizes their nudity and somehow makes them appear as naked as plucked chickens.

It seems probable that there was a tradition of Bible illustration in Spain before the advent of the Moslems – a tradition no doubt nourished by Early Christian, particularly Coptic,[134] art in North Africa on the one hand and by Byzantine art[135] on the other, for, after being called into the peninsula to give military help to the Visigoths in the fifth century, the Byzantines remained in occupation of part of the south of Spain until the sixth. Some evidence for the existence of such a tradition is provided by the celebrated Ashburnham Pentateuch, now in the Bibliothèque Nationale (nouv. acq. lat. 2334)[136] but still known after the name of its former private owner. This is a seventh-century manuscript, normally attributed to Spain,[137] with many illustrations in what has been called the sub-Antique style. It is possible that the Spaniards who withdrew before the Moslem flood to the north of Spain took with them illustrated biblical manuscripts comparable to, but earlier than, this Pentateuch, and these may have nourished the later tradition in the peninsula. This later tradition is seen in its Mozarabic form in the Bible from León, but it is much more lavishly represented in two Bibles from Catalonia of the early eleventh century.

Catalonia could boast splendid Mozarabic illustration, as, for example, in the *Beatus* manuscripts from Gerona and Urgel. But this particular style was developed in León and Castile rather than here, and it was more rapidly superseded in Catalonia than elsewhere because of her closer ties with the rest of Europe.

In this context it should be remembered that Charlemagne himself, conscious of the threat to his own kingdoms from the Arabs in Spain, had formed a Spanish March under Frankish authority as a buffer zone; this, on his death, included the southern slopes of the

Pyrenees and extended as far as Tortosa on the coastline and as far as Huesca on the plain. In this area Spanish rulers of Visigothic descent were able to establish themselves, under Frankish protection, free of Islam. The Spanish March remained under Carolingian suzerainty until about 877, when the county of Barcelona became independent under Count Wilfred the Hairy, who united the counties of Urgel and Cerdaña to Barcelona, extended his power to Montserrat, and is said to have founded the monastery of Ripoll of which we shall hear more later. In the eleventh century, Count Ramón Berenguer extended his frontiers southwards by conquest and northwards by marriage, and when he died in 1076 he held almost as much territory north of the Pyrenees as in the peninsula itself. In other words, at first Catalan Spain was attached to the Frankish kingdoms, and, later, part of the Frankish kingdoms was attached to it.

Under these circumstances, it is understandable that this part of Spain had closer ties with other parts of Europe than the rest of the peninsula. It was when on a visit to France that a count of Barcelona, Borrell II, in 967 came upon Gerbert in the monastery of Aurillac. He took the young monk back with him to Spain to complete his education, and Gerbert was later to become not only abbot, archbishop, and finally pope but also the greatest scholar of his age. The grandson of Wilfred, original founder of the house of Barcelona, was Count Oliba of Besalú,[138] nicknamed the goat because of his habit of scratching the earth with his foot and also, no doubt, because of his thick red hair and long beard. He often travelled in Italy, where he visited Rome, stayed for a year at Montecassino, and even persuaded the doge of Venice and builder of St Mark, Peter Urseolus, to return with him to the Spanish March and live in retirement there. One of his sons, another Oliba, became abbot of Ripoll in 1008 and bishop of Vich in 1018. He too visited Italy and was furthermore in close touch with France. In particular, a friendship developed between him and Gauzlin, abbot of Fleury, a friendship perhaps initiated by the fact that in the French monastery were two monks, born at Barcelona and educated at Ripoll. One of them, John, was destined to become abbot after Gauzlin's own death.

Abbot Oliba devoted his considerable energies to building up the power and reputation and scholarly facilities of Ripoll. Some think that it was at Ripoll that Gerbert completed his education, and certainly it was an outstanding academic centre. The care for scholarship shown there is indicated by the fact that two monks were sent on a special mission to Naples to collate a single manuscript – a concern for textual accuracy that anticipates the scrupulous care of the early Cistercians. Oliba himself doubled the number of manuscripts in the library, and in the inventory of books left at his death in 1046 there is a record of four Bibles. One of these is thought to be one of the most lavishly illustrated surviving Bibles of our period, which is now in the Vatican Library (cod. vat. lat. 5729). A Ripoll provenance was suggested by the correlation between its illustrations and the later sculptures of Ripoll, which led to the conclusion that both derived from a similar prototype.[139]

The Ripoll Bible[140] is the most profusely illustrated Bible of our period. Among biblical books only the Carolingian Utrecht Psalter and its derivatives and the Anglo-Saxon version of part of the Old Testament (British Museum Cotton MS. Claudius B.

iv) contain illustrations on a scale as extensive as this. And these are only parts of Bibles. There is only one other Bible to compare in lavishness of illustration – a sister Catalan Bible from San Pedro de Roda (Bibliothèque Nationale MS. lat. 6). Even this, however, is less profuse in pictures, since it does not contain the remarkably extensive cycle of New Testament scenes that we find here.

Stylistically, there are many hands at work. Some betray Mozarabic influence, which can – as in the battle scene of the Maccabees on folio 342 – lead to an appropriately colourful mêlée. It can also, however, produce a garishly decorative effect, as in the scenes of the blinding of Tobit (folios 323 and 323 verso), or Nebuchadnezzar's appointment of Holofernes (folio 327 verso), where the bitty patterning of both figures and architectural details produces a jarring effect. These Mozarabic influences are residual compared to influences from elsewhere. They include influences from Byzantium, apparent, for example, in the style and iconography of the opening sequence of pictures representing episodes from the life of Moses on folio 1. They may well have come through Italy, for the general influences on these illustrations are from Italy in general and, perhaps, Montecassino in particular.

Though this Bible is so profusely illustrated, it cannot be pretended that the pictures themselves are very accomplished. There is a general lack of linear discipline which gives an unpleasing feeling of imprecision and even smudginess. On one folio, however (209; Plate 130), there is a particularly fine illustration which represents the valley of dry bones described in Ezechiel. The artist of this picture was responsible for a number of illustrations in the other Catalan Bible which comes (as we have seen) from San Pedro de Roda – a house which in 1008 appears in the confraternity list of Santa María de Ripoll. This Bible is much more accomplished artistically and probably rather later.

It is recorded that Abbot Oliba of Ripoll brought relics from Italy and from France. And if influences from the first country appear in the one Catalan Bible, influences from the second emerge in the other.

The Roda Bible is in four volumes, and volume 1 opens with a large initial decorated with Franco-Saxon interlace which betrays the French influence. Pictures in volumes 2 and 3 have something of the small-proportioned sketchiness of the Drogo Sacramentary, though here the harder line and the use of flat body-colours gives a less impressionistic effect. The finest illustrations of the Bible, chiefly in volume 3, are drawn with clarity and confidence and are of fine quality. Good examples are Hosea communicating with God (vol. 3, folio 74 verso; Plate 131) and the dream of Mordecai (vol. 3, folio 122 verso). In these illustrations the elongation of the figure, the heart-shaped disposition of the hair, the particular fall of the drapery, sometimes fluttering over the knee and sometimes billowing out behind, all point to northern France. It is to north France also that we can trace the affection for the 'umbrella' folding of draperies (as in Isaiah's vision, vol. 3, folio 2 verso, or Zechariah calling, vol. 3, folio 91) which also emerges in the representation of the sails in the Jonah scene on folio 83 verso of volume 3. We have seen a similar characteristic in the manuscript-painting of scriptoria like Saint-Omer and Saint-Quentin. Then, again, some of the illustrations, such as that of Joel receiving the Word (vol. 3, folio 77 verso) and Malachi preaching (vol. 3, folio 96), have a tenuousness

of line pointing to the north of France and the Channel styles. This quality of line continues in some drawings of volume 4 which were probably added in the twelfth century and which, for linear texture, find their closest associations with Anglo-Norman art in England such as that at Durham and Canterbury.[141] Initials in volume 3, composed of human and animal figures, confirm the impression of strong French influences, for comparable initials appear in north France from the time of the Corbie Psalter onwards.

These are but general remarks on the Bibles, for we have still much to learn about them in detail. But their historical message is clear: Catalonia was much less insulated from Europe than other parts of Spain. This emerges with even stronger force in her wall-paintings, which partook of the Byzantine influences which surged through Europe in the twelfth century. We shall examine these more closely in a later chapter, but first we must consider developments in Italy, for it was from here that many of these influences were transmitted.

CHAPTER 7
PAINTING IN ITALY

Traditional Elements

WE earlier saw that the revival of the Western empire with the coronation of Charlemagne was followed by one 'renaissance' of mosaic art in Rome in the ninth century. The defeat of that empire by the power of the papacy in the twelfth century was followed by another such efflorescence. Mosaic art was clearly associated in the West with ideas of power and splendour. It was also associated with the traditional, for the finest mosaics belonged to the Early Christian period.

These associations can be seen in a mosaic which survives from the tenth century. It is a representation of Christ between St Peter and St Paul (now in the Vatican crypt).[1] This, significantly, was made to adorn the tomb of Otto II, who like the other Ottos had great imperial ambitions and was himself buried at Rome. It can, therefore, be dated 963. Despite the woodenness of figure and embarrassing sense of contrivance, there is here an obvious reliance on earlier traditions and an attempt to copy the style of drapery and capture some of the spaciousness of Early Christian mosaics like those of Sant'Apollinare Nuovo at Ravenna. The mawkishness of this work reminds one of the decline in culture at Rome after the ninth century, when secular power passed to local adventurers and the chair of St Peter to their nominees. After this period, wall-paintings somehow limped on,[2] though the life of mosaic-work was only spasmodically and artificially extended. When, however, the art of mosaic took on a new life in the twelfth century we find that, as in the ninth, it was imbued with traditionalism. Even if the theme was new, it was incorporated into a decorative and symbolic context that was highly traditional.

The representation of the Crucifixion in the early-twelfth-century apse of San Clemente,[3] which we can be fairly sure was made before 1128, has Early Christian associations (frontispiece and Plate 132). Twelve symbolic doves, representing the apostles, perch on the arms of the Cross itself, and this connexion between doves and the Crucifixion is found in Early Christian mosaics[4] and sarcophagi. Though the dry treatment of the exhausted Christ and the tight representation of the Virgin and John are hardly Early Christian in style, they are nevertheless engulfed by traditional elements. The great, bold acanthus scrolls which surround and overshadow the Cross derive from those of the fourth-century Lateran Baptistery: the interspersing of these acanthus scrolls with figures (of Church Fathers), with group scenes (of the legend of Sisinius), and with delightful birds and animals also finds its parallel in fourth-century mosaics such as those of Santa Costanza. Furthermore, the symbolism – whether of the stags drinking at the rivers of paradise under the Cross, or of the sheep approaching the Paschal Lamb – belongs again to the Early Christian period. Few works of art of the twelfth century are so Early Christian in spirit.

Though very different, the mosaic of the Coronation of the Virgin in the apse of Santa Maria in Trastevere (Plate 133)[5] is not less impressive. Among the flanking figures of saints is that of the donor, Innocent II, holding the model of the church. This conveniently dates it between about 1130 and 1143. Its breadth of treatment, jewelled quality of texture, and sombre richness of colour place it high in the ranks of Roman mosaics. There is here something of the magnificence and spaciousness of Early Christian mosaics, and, though the theme of the Coronation of the Virgin is a highly original one at this period, the general composition of the mosaic is none the less compiled from traditional elements. In Early Christian art, Christ was often shown enthroned with standing figures of saints and the donor. The simple iconographical change made here is that He is joined on His throne by His Mother. Below Him, the symbolic sheep of Early Christian iconography approach the Paschal Lamb. The use of a border consisting of foliage growing out of urns belongs to an old Roman tradition. Even the composition of the triumphal arch, where the prophets Isaiah and Jeremiah are represented with evangelist symbols above, also probably owes something to Early Christian art, for we find some similarities in the sixth-century mosaics of San Vitale at Ravenna. We may add that the half-figure of Christ in mosaic which once decorated the church of San Bartolomeo all'Isola[6] is in a similar style and that (if the description of Ciampini is correct) the same style may have influenced the lost mosaics of Santa Maria Nuova consecrated in 1161.[7]

The apsidal mosaic of Santa Francesca Romana of about 1161[8] is more Byzantine in technique and less successful in treatment, but the composition in which the Virgin is approached by saints within arcades may also reflect influences from Early Christian art, for we find similarities in Early Christian sarcophagi.

There are certainly non-traditional elements in these Roman mosaics of the twelfth century, as in those of the ninth, but they exhibit to a remarkable degree the tenacity of the Early Christian tradition. And what to a large extent is true of the mosaics of Rome is to a very small degree true of the wall-paintings of Rome and central Italy. There is in them a perceptible undercurrent of traditionalism.

This, indeed, is partly due to the influence of the mosaics themselves.

It is well known that the tastes of the Middle Ages favoured the translucent and the coloristic, and no art form expressed these with such majesty and such lavish splendour as the mosaic. Within the dark churches and basilicas, the sumptuously coloured mosaics, throbbing with vibrancy and glowing in their own radiance, might well, as twelfth-century writers were to suggest of other arts, overwhelm the spectator and lift his soul to a new perception of the life to come. The makers of the mosaics were not themselves unconscious of the impact of their art in terms of light and colour and even faith. So, an inscription in gold on a blue ground in the sixth-century Roman mosaics of SS. Cosma e Damiano reads:

The house of God shines with the brilliancy of the purest metals and the light of the faith glows there the more preciously.[9]

And inscribed in the seventh-century Roman mosaics of Sant'Agnese are the words:

The shaped metals produce a painting of gold and the light of day seems to be compressed and enclosed in it. One could think that the dawn, assembling the clouds from liquid sources, burns and spreads life to the fields. Such a light, the rainbow produces among the stars; such a purple brilliance are the colours of the peacock.[10]

The sumptuous, semi-precious art of mosaics always carried with it more prestige and éclat than the art of wall-painting, and it is clear that the painters were conscious of this[11] and tried hard to emulate its rich jewelled quality.

The results of attempting to capture in one medium the qualities peculiar to another were not always felicitous. Indeed, a weakness of some Italian painting is that it saw itself as a cheap substitute for the more sumptuous art of mosaic. Lesser artists might be completely intimidated, and the attempt to capture the gorgeousness of mosaics might lead to tastelessness. In these inferior works, the figures with cheeks crudely daubed red and draperies vulgarly overburdened with jewellery suggest that, by the side of mosaics, painting saw itself as a fallen profession. Even in better quality paintings, imitation could lead to parody. For example, the procession of virgins in the twelfth-century painting of Castel Sant'Elia near Nepi (Plate 134),[12] north of Rome, is clearly based on the sumptuous processions in Early Christian mosaics like those of Sant'Apollinare Nuovo, and though something of the hypnotically decorative quality of the mosaics has indeed been captured in the delicate patterning of the draperies, the heads themselves are so wooden and out of phase with this treatment that the general effect is one of slight caricature.

Since mosaics tended to adhere to earlier traditions in their iconography, it is no coincidence that wall-paintings which emulated mosaics in their techniques also reflect Early Christian traditions in their compositions. This is best seen in the apse painting of San Sebastianello al Palatino at Rome (Plate 135),[13] which probably belongs to the end of the tenth century. A representation of Christ between saints is separated from the lower picture of the Virgin with saints and archangels by a 'frieze' of the twelve lambs issuing from Bethlehem and Jerusalem. The brilliant and contrasting colours are apparently an attempt to create in paint the impression of mosaics. Some of the draperies do, in their highly ornamental effect, capture some of the jewelled quality of the mosaic art, though the coarse texture of the central figure of Christ, which may represent an attempt to create in paint the uneven surface of mosaic, is less felicitous. Unfortunately, whereas the very unevenness of the mosaic adds life and lustre by reflecting light from a myriad delicate shifts of angle, the effect here is one of weight and heaviness. But what is significant is that the apse follows the mosaic in composition as in technique, and this leads to the adoption of an Early Christian iconography. As in the sixth-century mosaics of SS. Cosma e Damiano, which were themselves repeated in the ninth-century ones of Pascal I, Christ is the dominant central figure, with one hand holding a scroll and the other held aloft. On either side of Him are two saints. The mystic symbolism of the Early Christian period appears here as in the mosaics: the palm trees to represent

Paradise or the Victory of Martyrdom, the phoenix to symbolize everlasting life; and, below, the lambs which approach the Paschal Lamb from the symbolic cities of Jerusalem and Bethlehem.

A lost fresco in the apse of San Lorenzo in Lucina, believed to be of the twelfth century but now only known to us by a copy,[14] follows the same basic composition, though without the ancillary symbolism. It is impossible, of course, to say from a copy such as this whether mosaics influenced the original. However, in other wall-paintings whose bright colours or jewelled decoration clearly indicate stylistic influences from mosaic work we often do find traditional elements of composition. To take but two examples, the apses of Sant'Elia near Nepi (Plate 156)[15] and of San Silvestro at Tivoli (Plate 136)[16] contain the so-called *Traditio legis* that is familiar in Early Christian mosaics like those of Santa Costanza[17] in which the towering figure of Christ is centrally placed between St Peter and St Paul. The paintings of San Silvestro are so poor in condition that they are hardly discernible, but those of Sant'Elia clearly include the mystic symbolism of Early Christianity – the twelve lambs leaving the cities of Bethlehem and Jerusalem below and the twenty-four elders of the Apocalypse above.

There is, then, in the themes of Roman mosaics and wall-paintings an undercurrent of Early Christian traditionalism. This was partly due to the wealth of early mosaics in Rome that encouraged imitation or emulation: but it was due also to the presence in Rome of the papacy, whose strength lay in tradition.

In view of the weight given to Byzantine influences in the next section, it should be stressed that this was a tradition often interpreted in specifically Western terms. This is evident, for example, in the unceasing interest in the symbolism of the Apocalypse, which the East did not accept as a canonical Book until the twelfth century. It is seen in the repeated representations of the Roman disciples, St Peter and St Paul. It is apparent in the continuing appearance of contemporary popes not simply as donors but as heirs of St Peter; for it is this which enables them to take their place with Christ and His saints. Apart from sporadic influences from Early Christian art, there are even very occasional influences from more remote classical times.

The most curious are, perhaps, the paintings of the lower church of San Clemente in Rome, made between 1085 and 1115; for though the style is by no means classical, the techniques do suggest an acquaintance with classical ceramics and murals.[18] The deep decorative patterns of ochre, shining against a black background, which frame some of the pictures, suggest the rich impression of classical ceramics. Furthermore, the placing of narrative scenes, lightly and softly coloured, within these rich dark surfaces can itself be paralleled in Hellenistic painting in Italy.

There is even evidence – though extremely rare – of influences on figure style from the classical past. We occasionally find in a consciousness of the solidness and fleshy quality of the human figure a feeling which in an elemental way may be referred to as 'classical'. We sometimes find it in the Exultet Rolls of southern Italy, where, for example, the nude figures of Adam and Eve in the eleventh-century Montecassino roll (British Museum Add. 30337; Plate 137)[19] have a positive feeling of softness and amplitude. We find it, too, in the giant Bibles of the first half of the twelfth century of central

Italy, where, despite a clumsiness of execution, figures like the Adam and Eve of the Pantheon Bible (Plate 165)[20] can occasionally register a feeling for the structure of the human figure. We even find it in wall-paintings of the second half of the century – most particularly in the Creation scenes of San Giovanni a Porta Latina[21] and of San Pietro near Ferentillo.[22] In the picture of Adam naming the animals from the latter (Plate 138), direct influences from classical sources are suggested by the subtle disposition of flesh tones to indicate the roundness and weight of the figure, and by the poise and self-assurance of Adam and the unabashed way in which he flaunts his nudity.

It would be absurd to read too much into these 'classical' ingredients, for they are both rare and erratic and certainly have none of the continuity or self-consciousness of a tradition. Yet, though they add up to nothing positive in direction or development, they may have combined with the far more potent Early Christian influence (which itself conserved elements of the classical tradition) to condition Italian art in some directions. Perhaps it was this combination which inhibited Italy from a complete acceptance of the Romanesque aesthetic which dominated other Western countries, for such an aesthetic, with its readiness to sacrifice the human figure to formal abstractions, was alien to all that classical and Early Christian art stood for. Perhaps this combination also made Italy so sympathetic to the art of the Eastern empire, which itself was ultimately based on traditions that were 'classical' and Early Christian.

Whatever the reason, Italy during our period was never free of Byzantine influence.

Byzantine Influences

Reference has been made to Early Christian influences in Italy and, though they are not synonymous, Early Christian and Eastern Christian art are not themselves easily disso-ciated. In terms of composition, as we have seen, Rome had a certain traditional and genuine independence. But in terms of style many of her own early mosaics and paintings were suffused with influences from the East.

Early Christian art in Byzantine-occupied areas of Italy such as Ravenna were, of course, actually made by Eastern Christian hands and formed part of the patrimony of Early Christian art in the West. There is also ample evidence to show that after the Early Christian period Greek artists worked elsewhere in Italy including Rome.[23] Here, in the seventh and eighth centuries, many popes were themselves from Byzantium or its empire, and even the architect and chamberlain of the pope who crowned Charlemagne was a Greek.[24]

When, after the fallow period of religious art during the iconoclastic period, Byzantine art burgeoned forth into one of the richest harvests of its history in the tenth and eleventh centuries, its mosaics, metalwork, and paintings became the focus of an admira-tion which captivated both Moslem East and Latin West. To some extent, all Western Europe was hypnotized by the art of Constantinople. It had magnificence, it had splendour. It also had a fastidious craftsmanship whose traditions even survived the iconoclastic periods when secular art probably continued after religious art had been condemned. But no area of Europe was closer than Italy to the art of the East. Some

part or other of the peninsula had, in fact, been occupied by the Byzantines until almost the end of the eleventh century and, after their departure, strongholds of their influence still remained in certain areas, particularly of the south, whither large numbers of Greeks had emigrated during the Byzantine occupation.

Even when Italy had freed herself completely of Byzantine religious and political tutelage, she could never entirely detach herself from artistic dependence, for she could never forget the splendours of art in the East. The schism between the Eastern and Western Churches which was to last for more than nine hundred years was announced in 1059. Yet, within two years, Desiderius, who was head of Montecassino, the most venerable monastery of Italy, was sending to Byzantium for craftsmen and works of art,[25] and in the early twelfth century many Greek artists were actually working at Rome.[26] South Italy and Sicily were wrested from the Byzantines by the Normans in the latter part of the eleventh century, and the relationship between the two races was particularly bitter. Yet, already in the first half of the twelfth, the Normans were beginning to send for Byzantine craftsmen to decorate cathedrals and palaces in the areas they had taken.[27] Innocent III must accept some responsibility for the military expression of animosity towards Byzantium which diverted the fourth Crusade to the capture of Constantinople in 1204, yet his successor, Honorius III, did not hesitate to send to the Doge of Venice for mosaic artists to help with his own work in Rome,[28] and these were either Byzantine or trained by the Byzantine school.

All this must be put in its proper perspective and seen in the general context of the movement of art and artists in Christendom. We should not forget that Italian wall-painters themselves were invited to France and Germany,[29] that a French archbishop might have his gold-work made for him in another Western country, that a German wall-painter might work in England[30] and English wall-painters in Spain.[31] Within Christendom as a whole, there was a certain give and take in the monumental arts. But, when all has been said, in the relationship between East and West Byzantium did most of the giving and little of the taking, and Italy was the immediate beneficiary of her largesse.

It is no accident that Byzantine artists in the eleventh and twelfth centuries were summoned to places such as Venice, Torcello, Montecassino, and Sicily, for they were in areas originally occupied by the Byzantines which for various commercial or traditional reasons remained in close touch with the empire of the East. From the point of view of Western art, the most important of these areas was certainly southern Italy, where Byzantine power had survived longest. Even when squeezed out of northern Italy by Lombard expansionism and Carolingian intervention in the eighth century, the Byzantines still remained in possession of parts of the south. Here, though eroded by the Arab invasions of the ninth century and challenged by the Ottonian intervention of the tenth, their authority remained until the second half of the eleventh century, when the conquest of Bari by the Normans in 1071 marked the final eclipse of their Italian power.

SOUTHERN ITALY

Basilian Art

During the Byzantine occupation there had been immigrations from the Eastern empire which had been accelerated during the iconoclastic troubles.[32] Byzantine monks of the Order of St Basil had crossed the Mediterranean in large numbers. Already by the end of the tenth century there were three Basilian monasteries in Campania, and the 'heel' and 'instep' of Italy are still dotted with grottoes and subterranean chapels of Basilian monks.[33] These contain paintings which are usually simple and unpretentious but in a pure Byzantine style, and this Byzantine painting continued to be practised in modest oratories on Italian soil throughout the Middle Ages. So the chapel of San Lorenzo near Fasano has a Byzantine picture of the two great founders of monasticism in the East and West – St Basil and St Benedict – together with other saints, and a representation of Christ between the Virgin and St John the Baptist.[34] The inscriptions are, of course, in Greek. An earlier painting of Christ in a grotto near Carpignano includes inscriptions showing that it was made in 959 for the Greek priest Leo by the Greek artist Theophylactos,[35] and a later picture there was made in 1020 for Hadrianos by the Greek painter Eustathios.[36] These 'signatures' of wall-paintings are of interest. They are of great rarity in the West, where their appearance itself probably represents Eastern influence, and it is significant that they are found in those areas such as Italy and the Crusading kingdoms which came within the orbit of Byzantine culture.

Byzantine painting, then, survived on Italian soil as a modest and underground vein of East Christian monastic art. But it also had a powerful overt influence on the monastic art of the West.

Byzantine Influences at San Vincenzo and Rome before 1000

This effect can be seen in southern Italy as early as the ninth century in a monastery not far from Montecassino – San Vincenzo al Volturno,[37] which had been founded in 703. In view of the fact that (like Montecassino) San Vincenzo and its churches around were ruthlessly devastated by the Saracens in the second half of the ninth century, it is surprising that anything at all survives. However, one small chapel escaped the frenzy of the Saracens, and this contains wall-paintings in the crypt. Happily these can be dated by the appearance of the donor, Abbot Epiphanius, at the foot of the Crucifixion scene,[38] for we know that he ruled from 826 to 843. A representation of the donor is often found in Roman mosaics and paintings and is by no means unusual. But, if the monk who kisses the foot of the Virgin in the scene of the Virgin and Child[39] represents the painter, as is usually thought, then this is something exceptional in monumental art. The pictures include the Annunciation and Nativity, the Crucifixion, the Holy Women at the Sepulchre, Christ between St Laurence and St Stephen, the martyrdom of these two

saints, figures of other saints, and the Virgin and Child. They are not masterpieces, and there is a certain gaucheness in the more ambitious attempts to capture Byzantine jewelled richness. However, the simpler narrative scenes like those of the martyrdoms have a gusty linear quality and an effective dramatic sense and, in the Annunciation picture, the angel floating forward with his brown wings curving backwards and white garments fluttering in a balanced rhythm behind is rather fine (Plate 139).

In discussing these wall-paintings, scholars have seen connexions with Carolingian art and have suggested that influences travelled either from here to the north or in the reverse direction.[40] It is known that the Carolingians did have associations with this area.[41] The builder of the church of San Vincenzo was Abbot Joshua (793–818), who was a relative of the Carolingian emperor Louis the Pious, and Charlemagne himself had visited Montecassino in 787 and asked for monks and books to be sent from there to the north. Despite all this, the relationship between these paintings and Carolingian manuscript illustrations is too general to be of real significance, and it is to Byzantium that we must turn for their real source of inspiration.

The standing female saints holding their jewelled crowns in a hieratically frontal composition are clearly Byzantine in influence and, like the archangels and the Virgin Herself, they wear Byzantine regalia. The Christ at the summit of the vault dominates the chapel like the Pantocrator of a Greek cupola.[42] The iconography of the Nativity scenes is East Christian. The personification of Jerusalem which witnesses the Crucifixion fits easily into the Byzantine tradition that was to produce the Joshua Roll with all its personifications of cities. Even the martyrdom scenes have their real association with the illustrations of Byzantine monastic manuscripts, where we find similar figural representations and the same simple and effective vigour.[43]

The artist himself was obviously Western, and there are non-Byzantine elements present. However, the evidence suggests that the monastic art of the East was here being adapted by monastic artists of the West, and there is fragmentary evidence of a similar process in other Campanian churches.[44]

A particularly good example of a Byzantine style being naturalized on Italian soil is found in another important Benedictine centre of the Duchy of Lombardy – Santa Sofia at Benevento.[45] Here, wall-paintings of the finest quality, representing scenes from the life of St Zacharias, have some of the stylistic qualities of the San Vincenzo murals, though they are more tranquil in mood and spacious in treatment (see Plate 140 for the Annunciation to Zacharias). The date of these paintings is uncertain. Some attribute them to the period when the church was built – that is about 762 – and others to the period of about 847 when the church was repaired after an earthquake. Yet a third possibility is about the year 906, when the church suffered a third earthquake. On present evidence, the earliest date is to be preferred.

Byzantine influences on contemporary wall-paintings at Rome were leading to styles that were not unlike those of San Vincenzo.

The most striking example of these is in the lower church of San Clemente,[46] where the donor portrait of Leo IV dates the paintings to between 847 and 855. They include representations of the Crucifixion, the Marys at the Tomb, and a vigorous portrayal of

the Descent into Hell. But most powerful by far is the picture of the Ascension (Plate 141) where, above the standing Virgin, Christ is being raised into heaven in a mandorla borne by angels. The apostles who witness it are represented in a rapid sketchy style with considerable dramatic power: one covers his face in a sudden impulsive gesture, another recoils with his body but cannot avert his eyes, and others signify their amazement by emphatic gesticulation. Flanking this dramatic composition are the unperturbed standing figures of Leo IV with the rectangular nimbus of the living and of St Vitus (?) with the circular nimbus of the dead. The composition itself perhaps derives from a mosaic in the Church of the Ascension at Jerusalem placed there by Constantine and thought to be reflected in ampullae of the seventh century. The illustrations of a Syriac Gospel Book of the sixth century (Florence, Laurentian Library MS. Plut. I, 56)[47] suggest that the ultimate origin of the style is Syrian. Of some significance for the Eastern origins of this style is a contemporary Roman manuscript of *Job* (Vat. gr. 749),[48] written in Greek but with illustrations made by Romans, which share some of the stylistic traits of the wall-paintings.

This San Clemente style is seen in the earlier ninth-century paintings of the subterranean church of Santa Maria in Via Lata.[49] Here the only well-preserved pictures are two scenes of the martyrdom of St Erasmus, where the action of the executioner compares in posture and vigour with a similar action in the Carolingian wall-paintings of Auxerre.[50] It is also found in the added wall-paintings of the aisles of Santa Maria Antiqua[51] which are attributed to the pontificate of Nicholas I (858–87). The fragmentary scenes from the Old and New Testaments are executed with a naïve vigour which contrasts favourably with the more jadedly archaic picture of Christ with a long row of saints. Its influence also extends to the wall-paintings of Müstair.[52] Let us return, however, to southern Italy and San Vincenzo.

The continuing influence of Byzantium there can be traced in the next century in three illustrated rolls which, in view of their size and the spacious treatment of figure, may be not unreasonably associated with monumental paintings. Here we see – as in the San Vincenzo wall-paintings – a linearization of a Byzantine style. The first is an illustrated ordination ritual for Bishop Landolfus I of Benevento, which can be dated 957–84 and is now separated into five sections.[53] The second is a roll (now dismembered) containing the ritual of the benediction of the font and illustrated by an actual benediction scene together with appropriate illustrations of biblical scenes relating to baptism.[54] (Both have the same press-mark – Rome, Biblioteca Casanatense MS. 724 B 1 13.) Though much formalized and deliberative in style and though drawings rather than paintings, their illustrations may be compared with those of the famous Byzantine Menologion of Basil II (cod. vat. gr. 1613). The third roll is an Exultet Roll (Vatican cod. vat. lat. 9820)[55] which can be dated 981–7 and which includes among its illustrations a particularly impressive picture of the donor, the priest John, before St Peter (Plate 142). Its combination of spaciousness and linear vivacity reminds one of the earlier wall-paintings of the archangel Gabriel. There is here also strong evidence of Early Christian influences, but it was Byzantine art that played the dominant rôle in the illustrated rolls of southern Italy.

Liturgical Rolls of South Italy

The liturgical roll[56] was a form peculiar to the south, and all but two come from Apulia or Campania. They were large in size (often more than five metres in length and generally between twenty-three and thirty-two cm. wide) and were mostly made during the eleventh and twelfth centuries. Though three other forms of liturgical roll are known (one Pontifical and two Benedictionals), the vast majority were Exultet Rolls, twenty-eight of which have survived. These contain the text for the blessing of the Paschal candle and take their names from the first words of the commencing hymn of praise: 'Exultet iam angelica turba caelorum' (let the angelic host of heaven exult).

In the ceremony of Holy Saturday the blessing of the font was preceded by the blessing of the Paschal candle. The deacon mounted the pulpit and read the appropriate liturgy (ascribed to St Augustine). This celebrated the victory of Christ over Death and Night, called upon heaven, the earth, and the Church to exult and associated with the general jubilation one or two of the more impressive episodes of the Old and New Testaments. This blessing of the Paschal candle was of considerable importance in southern Italy. It was isolated from the prayers of the Sacramentary and written on a large roll with illustrations which were often deliberately placed upside down in relation to the text so that they might appear the right way up before the congregation as the unrolled part of the roll was displayed before them. Like wall-paintings, the illustrations were intended for public exhibition, and they have some of the largeness of treatment of this art. The representations of liturgical services in these rolls give them significance for the historian of liturgical vestments; the portrayal of contemporary secular rulers[57] from the Eastern emperor Basil II to German emperors as late, perhaps, as Frederick II gives them some interest for the social historian; their use of musical notation makes them valuable for the musicologist, and for the palaeographer they provide important evidence for the development of the south Italian or Beneventan script. Yet, above all else, they are of value to the art-historian. Their illustrations provide a variety of theme and a continuity of production that make them a particularly rich source for our knowledge of art in southern Italy. They are, indeed, among the most important cycles of graphic art left to us by the Middle Ages.

These Exultet Rolls vary, of course, in quality and some suffer from unfortunate repainting during the Middle Ages. They were made in different centres – Gaeta, Mirabella-Eclano, Sorrento, Fondi, Benevento, and Troia. The finest, however, come from three major centres – Volturno, Bari, and Montecassino – and are noble works of art. In general, they represent an adaptation to the more linear tastes of the West of a Byzantine tradition. But this is also tempered by Early Christian art in Italy, and it has, indeed, been claimed that the Western tradition of illustrated Exultet Rolls itself goes back to Early Christianity.[58]

Byzantine influences are particularly apparent at Bari, which was occupied by the Byzantines until 1071. In an Exultet Roll of about 1000,[59] now in the cathedral archives, the saints commemorated in the medallions of the highly decorative vertical borders are primarily of the Eastern Church and are even identified in Greek. The fact that the

prayer for the rulers is illustrated by a picture of the two Byzantine emperors Basil II and Constantine X, and that this is a little later followed by the depiction of the pope between two deacons gives some idea of how East and West confront each other. A Byzantine Pantocrator sits inside a large initial which is south Italian in style. The biblical quotations are, of course, in Latin, but one illustration is to the Greek, not the Vulgate text. The liturgy itself is Western, but the illustrations are overwhelmingly Byzantine in influence. This is everywhere clear. The iconography of traditional scenes such as the Descent into Hell (Plate 143) is Byzantine. The ceremonial draperies of the personification of Tellus and the ornate dalmatic and lora worn by the Basileis are typically Byzantine. The figures have a dignity and poise that are Byzantine and the compositions a Byzantine balance and deliberativeness. Though the low-toned colours, which include deep blues, maroons, and wine-reds, are less plangent than in most Byzantine paintings, we find comparable tones in the Byzantine wall-paintings of the Basilian grottoes on Italian soil. The affinities with Byzantine art are close and unmistakable. Despite this, they have their own individuality. The interest in achieving the desired effect by sureness of line rather than subtle modelling of colour is Western rather than Eastern and is already evident in Early Christian work in Italy such as the catacomb paintings. Reminiscences of such Early Christian work may also be responsible for the feeling of spaciousness in the figure.

Another liturgical roll from Bari Cathedral (this one a Benedictional of the font of the early eleventh century)[60] is equally fine in quality and represents exactly the same stylistic features. An interesting element of this is the picture (Plate 144) of the scribe, or donor, Silvester, prostrating himself before a composition which is particularly Byzantine in composition and treatment – the Deesis, or representation of Christ between the Virgin and St John the Baptist. As in the Exultet Roll, we find the colours laid on rather flatly; the modulations are attained by line and the illustrations are essentially spacious drawings rather than paintings. In this they differ from Byzantine pictures, where the modelling is more intricate and the colours more lustrous, but what they lose in subtlety and brightness they gain in simplicity of statement and serenity of mood. Indeed, despite the very considerable strength of Byzantine influences on the painting of southern Italy, it is in no way a provincial art but an art with its own dignity and nobility.

This is nowhere more apparent than at Montecassino, which has left us at least three and possibly four Exultet Rolls[61] of the eleventh century. One, in particular, surpasses all others in its fastidiousness of taste, delicacy of line, and purity of colour. This is now British Museum Add. MS. 30337 (Plates 137 and 145)[62] and was produced about 1060. Despite some later retouching, these elegant illustrations were originally intended as outline drawings and, in this, reflect the tastes of the West. There are even some Carolingian influences apparent: for example, the earth, which in some Exultet Rolls is represented as an Eastern princess crowned with flowers and leaves, is here given its warmer Carolingian personification as a woman half rising from the ground and suckling at her breasts the animals of the earth. None the less, the Byzantine influences clearly predominate and the delicate and supremely successful drawing of Christ between angels (Plate 145) is quite clearly a Western recension of a Byzantine style. The remark-

able feature of these illustrations is that, though bearing the unmistakable imprint of Byzantine art, they both rival it in quality and have an unmistakable individuality of their own.

This achievement was primarily due to the Abbot Desiderius, under whom this particular Exultet Roll was made. He was personally responsible for a renaissance of art at Montecassino that was to carry its influence to the wall-paintings of Rome. Other south Italian centres, of course, assimilated Byzantine influences, even if none quite achieved the refinement of Montecassino. But what gives Montecassino its primary distinction is that it not only assimilated these influences but also transmitted them.

Montecassino

Founded in the sixth century as the centre of Benedictine humility, Montecassino[63] had by the eleventh century become a focus of monastic power. It was the controlling force of a large monastic state, more integrated than the papal state and more able to withstand military pressure. Its power was due to a number of factors, but foremost among them was the early benevolence of the Byzantine empire, which had given support to the monks when the protection of the Carolingians had failed. This assistance was even extended to the monks when they were at Teano in the Campagna, whither they had fled after the sack of their own abbey by the Saracens in 883. When the monks returned to Montecassino in the mid tenth century, it was the Byzantine governor in south Italy who helped them to regain their possessions. The area which had been the prey of the infidel was now to become a battlefield between the Christian empires of the East and of the West, and in this conflict Montecassino tended to give its support to the East. This was only checked by Henry II's personal intervention. His approaching army led to the flight of the Abbot Atenulf (1011–22) to Byzantium and to his death in a storm. The capture of his brother and ally, the prince of Capua, is commemorated in an Ottonian manuscript which (as we shall see later) is of unique historical interest in indicating the part played by Montecassino in the conflict between East and West.

It should not be supposed, however, that Montecassino was the creature of Byzantium. On the contrary, it was a powerful political force in its own right, ready to make those alliances that suited its own principles and interests. Yet, even when these arrangements were inimical to Byzantine policy, it remained on good terms with the Byzantine empire. Frederick of Lorraine, who in 1055 became abbot of Montecassino, had been one of the papal legates who had excommunicated the Eastern patriarch in Constantinople in 1054. His successor, Desiderius, arranged for the alliance between the Normans and the papacy which was contrary to all Byzantine diplomacy. Yet there was no rift in the relationship between the Benedictine abbey and the Byzantine court. The Eastern emperor, indeed, continued his benevolence and gave to Montecassino an annual pension of two pounds of gold in 1055 and another of twenty-three pounds of gold and four pallia in 1076. Such grants were no doubt motivated as much by diplomatic assessments of the importance of Montecassino as by emotional regard for its venerable traditions, but Montecassino was always seen as a link between the West and the East.

So, just as an abbot of this monastery was chosen to negotiate between the Lombard princes of Capua and the Byzantine empire at the beginning of the tenth century, another abbot of Montecassino was selected to mediate between the Crusaders and the Byzantine empire at the end of the eleventh. In art, as in politics, Montecassino was a mediator between East and West, and this is nowhere more apparent than under Desiderius.

Like his predecessor, Desiderius (1058–86) was a member of the lay aristocracy before entering monasticism and only left the cloister to become the ruler of the Church in the West. In the picture of him at Sant'Angelo in Formis (Plate 146), one can still sense in his proud bearing and sombre, aquiline features an aristocratic power and presence that the cowl of St Benedict had done little to subdue. The head of an ecclesiastical state in the heart of Italy, he was, says the chronicler of Montecassino, 'held in such great honour by all the inhabitants around that not only the lesser people but even their princes and leaders obeyed him like their father and seigneur'.[64] But Desiderius combined cultural tastes with his political power and patronized culture in much the same way that Frederick II was to do later in Sicily. He drew to himself writers like Albericus, whose poetical themes in some ways anticipate those of Dante, and Alphanus, who translated Nemesius of Euresa from the Greek, and scientists like Constantine of Africa, whose translations from the Arabic influenced the whole course of medical science in the Middle Ages.[65] Most important of all, he patronized art and the artist. He threw all his considerable energies into the renovation, rebuilding, and embellishment of the churches of Montecassino, and not least into the particularly ambitious transformation of the monastic basilica itself. To some extent, no doubt, this new sense of grandeur and prestige both derived from the new feeling of authority in Montecassino and reflected the quickening power of the papacy with which the Benedictine abbey was so closely allied. But most of all it derives from Desiderius himself, who is described in adulatory inscriptions as being second only to St Benedict. 'He excels all his predecessors,' says one such inscription, 'in the monuments of his greatness.'[66] As the lay rulers of Sicily and the Crusading kingdoms were to do later, so this Benedictine ruler of an ecclesiastical state turned to Byzantium for his artistic terms of reference and made every attempt to draw on their traditions and skills.

It has been said that Desiderius was not exceptional at this period in turning to Constantinople. We know, indeed, that bronze doors with figurative or decorative work were commissioned in Constantinople for Italian churches during the eleventh century, particularly by the noble family of the Amalfi in the south.[67] One pair of doors was ordered by Pantaleon I of this family for the cathedral of Amalfi and his son, Mauro, paid for those of the abbey church of Montecassino itself.[68] Another was given by Pantaleon II in 1076 to the church of St Michael at Monte Gargano[69] and yet another by Pantaleon III to the cathedral of Atrani in 1087.[70] In 1070 the famous Hildebrand ordered lavishly illustrated doors for the portal of San Paolo fuori le Mura at Rome,[71] and about this time Salerno Cathedral also received bronze doors from the East.[72] There is, however, a difference between shipping artistic goods from Constantinople and shipping artistic talent. Greek artists had, of course, long been at home on Italian soil, but there is something particularly impressive in Desiderius's determined attempt to draw

on Byzantine experience in order to develop a school of his own. He not only commissioned bronze doors in Constantinople but also asked for Greek artists who were not simply to provide mosaics at Montecassino but to train Italian pupils there. Leo of Ostia's account of his action is well enough known but will bear requotation, for rarely is an event of such importance so well chronicled in the history of medieval art.

He [Desiderius] sent envoys to Constantinople to hire craftsmen skilled in mosaic and stone work, some of whom were to decorate with mosaics the apse, the arch, and the vestibule of the main basilica and others to lay the pavement of the whole church with a variety of different stones. The degree of perfection attained by the masters of these arts that he appointed can be gauged by their works. In the mosaic work, one would almost suppose that the figures were alive and that one could distinguish vegetation, and in the marble of the pavement one might think that flowers of every colour bloomed in lovely variety. And, though, for five hundred years and more, the Latins had lost their aptitude for these arts, by the zealous application of this man and the help of God, they recovered it in our own time. Such was the foresight of Desiderius that, in order to prevent it perishing from Italy, he took care that several of the boys of the monastery should be well grounded in these arts. And he arranged that the most zealous craftsmen among them should be immediately instructed not only in these but in all the arts that can be executed in gold, silver, bronze, iron, glass, ivory, wood, gypsum, and stone.[73]

Desiderius was a great rebuilder, and one picture shows him offering a number of churches to St Benedict.[74] His greatest achievement must certainly have been the basilica of Montecassino itself, which was described even by the Byzantine emperor as 'the most celebrated and famous church . . . praised, propagated, and cultivated in the West as well as the East'.[75] This, unfortunately, does not survive. We know from the accounts both of Leo of Ostia and of Alphanus[76] that the narthex contained pictures of Old and New Testament scenes which, despite their Byzantine workmanship, may have followed arrangements traditional in the West. But all that exists of the Byzantine work itself is a decorative mosaic pavement in the sacristy, two slabs from the pavement before the altar, and an engraving of the decorative pavement in the nave.[77] However, the technique initiated at Montecassino of installing geometrically and figured patterned pavements remained in vogue in neighbouring churches until the thirteenth century.[78]

Fortunately, another church rebuilt by Desiderius does remain to give some idea – if not of the actual workmanship of the Byzantine artists summoned by him – at least of the monumental art which flowed from the Byzantine training. This is Sant'Angelo in Formis near Capua.[79] Built originally in the sixth or seventh century on the foundation of a temple of Diana, the church of Sant'Angelo was given to Montecassino in 1072. With his usual energy, Desiderius began to enlarge and embellish it. Though many of the wall-paintings have perished, those that remain still represent one of the most extensive and interesting cycles in Italy of this period.

The paintings of the half-figures of St Michael and the Virgin over the doorway[80] rival fastidious jewellery in their exquisite delicacy, and one of the two original angels supporting the Virgin's mandorla (the other is repainted) has a nobility and equilibrium which represent the very finest work of Byzantium.[81] These paintings are clearly the

work of Greek artists and they contain Greek inscriptions. It has generally been thought that they were made by the Byzantine artists summoned by Desiderius, but more recent research indicates that they were made in the twelfth century, when the porch of the church was rebuilt.[82] They remain, then, outside the context of art under Desiderius. So, too, do the paintings in the porch of episodes from the lives of the anchorites St Anthony and St Paul, which, though less well preserved and less refined, use the same palette of blues, ochres, reds, and greens and are more obviously the twelfth-century work of Byzantines.

Where the paintings within the church are concerned, the Latin workmanship is undisputed but the dates are not. The impressive donor picture in the apse of Desiderius proffering the church and wearing the rectangular nimbus of the living shows conclusively that they were begun before he left Montecassino in 1086. But a number of artists worked on the complete paintings, and this has led to suggestions of various dates. Despite this, there is sufficient stylistic coherence and a close enough relationship with eleventh-century manuscript-painting of the Campagna to suggest that all the paintings inside the church were made before 1100.[83]

The whole ensemble is dominated by the brilliantly coloured painting in the main apse with its almost violent contrasts of light and shade. Here Christ appears on a jewelled throne with the symbol of the Holy Spirit above and the symbols of the evangelists around. In the zone below are three frontally placed archangels with the noble donor picture of Desiderius on the left and a much restored picture of St Benedict on the right. The rest of the church was originally a profusely pictured Bible. Numerous New Testament scenes unrolled in three zones on the left wall of the nave and continued on the right wall, where only the lowest zone survives. The spandrels of the arches contain Old Testament figures, and there is an impressive Last Judgement on the entrance wall of the nave. At least five artists worked on these paintings,[84] and there is a surprising range of interpretation, from the hard frontality of the angels in the right apse to the loose texture of the expulsion from Paradise, from the linear excitement of the arrest of Christ to the heavy, almost ponderous evangelist symbols.

There are variations of quality as well as of mood. In some areas, the attempt to emulate mosaics leads to brashness – an over-emphasis on bright colours and excessively jewelled costumes and accessories. In the apse, particularly, there are contrasts of colours obviously intended to rival the effect of mosaics, and the strong reds, orange, greens, and whites stand out harshly against the intense blue of the background. The figures here catch the eye by vividness of colour rather than detain it by refinement of taste. When, however, the artists could resist the glittering allurement of mosaics and concentrate on qualities that were linear or painterly they could produce pictures that were competent and even, on occasions, masterly. The portrayal of the Entombment (Plate 147), for example, has a certain tenderness, the scene of the adulteress a vivid dramatic tension, the Desiderius portrait an aloof nobility (Plate 146), and the pictures of prophets like Malachia (Plate 148) a poise and graveness that make them particularly impressive.

Byzantine influences are everywhere apparent.[85] The iconography is largely from the

East. So, too, is the figure style which, though eclectic in origin, is much influenced by the 'classicism' of the Macedonian Renaissance. As in Byzantine paintings and mosaics, the ample draperies are 'gathered' at the shoulders and, more particularly, at the thighs, whence they fall away in rippling folds. The figures themselves are often quite spacious, and one might compare the Christ in Majesty of the apse to the Christ of Hagia Sophia at Istanbul[86] and find parallels to the figures of the Entombment scenes with those of a similar scene in Hosios Lukas.[87] Some of the Old Testament figures are almost purely Byzantine in the suave rhythms of their draperies, their statuesque poise, and their grave nobility. The apprenticeship to Byzantium is unreserved and enthusiastic. Yet, even so, the Latin temperament breaks through and gives even this Byzantine art its own Western interpretation.

To begin with, this very use of the walls of a church as a picture-book of the Bible belongs to the Western rather than the Eastern tradition[88] and may go back ultimately to the fifth-century paintings of the Lateran in Rome, which also, it is thought, had a series of Old and New Testament episodes in the nave.[89] Eastern churches, of course, contained illustrations from the Bible, too, but these were selected for their symbolic function and were not, in the Western sense, a narrative sequence of events. Then, though the styles are certainly Eastern, they are given a new organization and accentuation which makes them quite Western in their orchestration.

When, after the period of the iconoclastic controversies, Byzantine art renewed itself, it drew on the heritage of Latin and Greek Antiquity. A degree of non-classical transcendentalism was present, but the essential classical quality of balance remained. The Byzantine art of this golden age is an art of self-contained equilibrium. There is everywhere a perfect adjustment of weighted rhythms. Every action is controlled by a balancing action: each point has its counterpoint: all elements contribute to the poise of the whole. This is essentially an orthodox art in the sense of St Augustine's definition of orthodoxy – something in which no part is out of relationship to the whole. One result of this is that the spectator must always be insulated from narrative excitement or emotional feelings, for this would distract from the equipoise of the whole. There is no Byzantine action that will quicken the pulse and no Byzantine Crucifixion that will raise a pang.

In the West, on the other hand, attitudes were different, and to some extent these differences reflect historical divergences between the West and the East. The heartland of the West – unlike that of the East – had been settled by pagan barbarians who first needed conversion and then instruction. The 'public' wall-paintings of churches had long been associated with this process of instruction, and even as late as the twelfth century Honorius of Autun described such paintings as being primarily 'the literature of the layman'.[90] There was, to be sure, considerable symbolism in the Western paintings, but more important was the powerful tradition of narrative art – of preaching in paint – which did much to condition aesthetic tastes.

This emerges in Sant'Angelo, where the aim of the artist was less to integrate his pictures into a melodic balance than to underline a particular dramatic or narrative message. Even when the underlying composition is quite clearly based on the Byzantine

aesthetic of equipoise, the artist does not hesitate to distort or even shatter the balance if, by so doing, he can underline a particular point or detail or even simply draw the eye to a vigorous passage of colour or line. The anguished gaze of Pilate,[91] the distraught expression of the adulteress,[92] the dramatic gesture of the Virgin[93] – all these rivet the attention on a dynamic point or a particular message at the expense of the aesthetic integration of the whole. The result is that, though so closely based on Byzantine art, the paintings follow it primarily in externals. Indeed, despite some masterly areas, there is an unresolved clash between two different art-forms – the one symbolic with an aesthetic of internal equilibrium and the other narrative with an aesthetic of external tension.

Amatus of Montecassino speaks of the influence which the buildings and decoration of Desiderius had elsewhere,[94] and we can still trace the effect of the Sant'Angelo paintings in other churches,[95] such as those of Ausonia. The pictures in the ancient basilica of Foro Claudio are in a comparable style, though these already mark a decline rather than a progression. For a full understanding of future developments in monumental painting not only in southern Italy but also in Rome itself, we must turn for a while from the wall-paintings commissioned by Desiderius to his manuscript-paintings. They also are Byzantine in inspiration.

That Desiderius was interested in manuscripts as well as buildings is very clear. One manuscript illustration shows him offering manuscripts as well as churches to St Benedict with the inscription: 'Together with these buildings, O father, receive these many wonderful books.'[96] Another has the inscription: 'Among the monuments of his greatness, wherein he excels all his predecessors, Desiderius ordered this most beautiful book to be written.'[97] The suggestion here that Desiderius surpassed his predecessors in the field of manuscripts as in other arts is supported by the historical evidence.

Of manuscript-painting at Montecassino before the tenth century we know nothing, for most of the manuscripts perished when the abbey was devastated by the Saracens in 883, and those that survived and were taken by the monks to Teano were destroyed by fire there. The first abbot to take an interest in artistic manuscripts after the destruction was apparently John (914–34), who moved the monks from Teano to Capua and began the rebuilding of Montecassino itself. A noteworthy survival of his activity is a commentary of Paul the Deacon on the Rule of St Benedict which was written in Capua and is now Montecassino MS. 175.[98] Apart from small coloured initials and an historiated one, it contains a dedication picture of John before St Benedict. After the abbacy of John, there was an almost unbroken tradition of manuscript-painting at Montecassino in which we find the development of a particular style of decorative initial which suggests influences from Franco-Saxon or English sources. This is composed of interlace and often contains small bounding animals harmoniously balanced in relationship to each other. Examples of this Cassinese initial are found in a Book of Homilies (Montecassino MS. 269) written by the monk Jaquintus,[99] who was working under Aligernus (949–86). Aligernus was the abbot who finally ended the exile of the monks and who returned them to Montecassino, whereupon something of an artistic revival began in the scriptorium of the house.

Evidence of this revival is already seen in the exceptionally fine initials of a manuscript made by the scribe Martin in 1010 (Montecassino MS. 148),[100] when John III was abbot. But it was the Abbot Theobald (1022–36) who did most to promote the artistic development of the scriptorium. Although imposed on the abbey by the emperor Henry II against the will of the community and detained during his last years as a virtual prisoner by the brother of his predecessor, he none the less took a particular interest in the manuscript production of the house. 'He had several manuscripts made,' says the chronicler, 'of which there was a great lack until his time.'[101] They are artistically somewhat eclectic and include the celebrated illustrated copy of the encyclopedia of Hrabanus Maurus,[102] which was probably derived from a Carolingian model, a copy of St Gregory's *Liber Moralium* (Montecassino MS. 73)[103] containing a dedication picture of Theobald with St Gregory[104] which suggests influences from early Ottonian sources, and other manuscripts which show an increasing sophistication of the characteristic Cassinese decorative initial.

It was during Theobald's rule that Montecassino was given by Henry II a particularly lavish Gospel Book which was bound in gold, inlaid with gems, and 'wonderfully decorated with figures in gold'.[105] The chronicler supplements his description of the manuscript with the information that it was given by the emperor as a token of thanks to St Benedict for his miraculous cure of 1022.[106] But the illustrations show that gratitude to the saint could be combined with a minatory warning to his monks. The manuscript has been identified with a Regensburg one (cod. vat. Ottob. lat. 74) and has already been mentioned on page 70 in the context of Regensburg illumination. The pictures on one page (Plate 85) clearly represent a threatening denunciation of the monks of Montecassino for having supported the Byzantine cause against the Ottonian.[107] Together with his brother, Pandulf of Capua, Atenulf, abbot of Montecassino, had allied himself to Constantinople. As we have seen, he had escaped the wrath of the emperor, though not the inexorableness of the elements, for he had been drowned on his flight to Constantinople. However, his brother Pandulf had been apprehended, and he is here shown humbly pleading for his life before Henry, who is represented as the apotheosis of Law and Justice.[108] Given as an acknowledgement of a religious debt and a reminder of a political offence, the manuscript remained as an artistic influence. Some fifty years later we find its typically Ottonian initials influencing the manuscripts of Montecassino[109] and giving them something of the openwork precision of metalwork. This sudden fertilizing effect of a manuscript that had been lying in a monastic library for some decades is a phenomenon already seen in the West, particularly in Germany, for example in the Ada Gospels and in the Golden Gospels of Charles the Bald. In Germany it may not be an entire coincidence that manuscripts with imperial associations made their impact at a new period of imperial or dynastic ambition. Possibly also it was not entirely accidental that the influence of this imperial manuscript emerged at Montecassino under Desiderius, who consciously associated his own creations with those of Rome and Constantine the Great.[110] None the less, in manuscript-painting as in wall-painting, it was to the imperial art of the East rather than that of the West that he primarily turned for inspiration. The result was the production of an art that not only

eclipsed the Montecassino manuscript-painting of the past but also was to be of critical significance for the monumental painting of Rome for the future.

Three major artistic manuscripts have survived from the time of Desiderius.[111] All of them are of the very highest quality. One, which is referred to in the chronicle of Montecassino and which may well have been made for the dedication of the basilica in 1071, contains the lives of St Benedict, St Maurus, and St Scholastica (Vat. cod. lat. 1202).[112] Another, which is palaeographically a companion volume closely related in date, is a Book of Homilies (Montecassino MS. 99).[113] From the dedication picture and verses (Plate 150) we know that it was paid for by a newly enrolled monk, John, and written by a monk, Leo, whom some would identify with the chronicler of Desiderius's own activities. The third also is a Book of Homilies (Montecassino MS. 98).[114] The initials of the first two (as well as those of an artistically less interesting manuscript – Vat. lat. 1203) show influences from the Ottonian manuscript given by Henry. However, their primary interest lies in their illustrations.

By far the most lavishly illustrated is the Lives of the Saints, which contains almost one hundred pictures by two different hands depicting the lives of St Benedict and St Maurus. It is prefaced (Plate 149) by a dedication picture of Desiderius offering books and buildings to St Benedict which – though iconographically related to earlier dedication pictures of the abbey – makes the former ones look wooden and clumsy in comparison. The natural contours of chest, thighs, and legs are emphasized by the use of highlights to suggest convexity and of darker tones to indicate recession. In particular, the figure of St Benedict in his blue cowl is painted with consummate ease and fluency and with a fine sweep of contour. The influences are obviously and overwhelmingly Byzantine.

These same influences are remarkably strong in the illustrations to the life of St Benedict, where, despite a slightly drier treatment of the heads and a more linear treatment of the draperies, many figures could almost pass as Byzantine work. The style is closely related to that of contemporary monastic Byzantine manuscripts like the British Museum Psalter (Add. MS. 40731), where there is the same svelteness of figure and vivacity of action. Despite the contrast which scholars draw between imperial and monastic art in Byzantium, the action in the monastic illustrations, as in the imperial mosaics, is controlled by the Byzantine sense of rhythm and poise. And this transmits itself to the Montecassino paintings. There is always a certain restraint, which continues even into those scenes whose subject-matter might suggest strong dramatic action and human commitment – scenes, for example, in which a monk flees from a dragon or in which the saint strikes an offending brother or frees another from the devil. Though there is an expressiveness and eloquence of gesture, one is conscious throughout of the Byzantine reticence of human action and human involvement. The movement is a suspended movement. There is little psychological communication, for the figures are still largely seen in Byzantine terms, as elements of a composition whose balance must not be hazarded by emotional involvement either between the actors themselves or between them and the spectators. Few works of art in the West capture so convincingly the Byzantine style and the Byzantine idiom. We know that Desiderius had an altar

frontal depicting scenes from the life of St Benedict made in Constantinople,[115] and it is not impossible that this earliest full-length cycle of illustrations of the life of the founder of the greatest monastic Order in the West was based on models or drawings made in the East.[116]

The illustrations of the two Books of Homilies are no less Byzantine in feeling. They are primarily of New Testament scenes, which are mostly full-page and follow an East Christian iconography. They show occasional influences from Byzantine metalwork – particularly (in MS. 98) from the bronze doors of San Paolo fuori le Mura made in Constantinople or something comparable – but, in general, they reflect the spacious and deliberative style of Byzantine imperial painting. Some of the pictures (for example, the Annunciation and Ascension of MS. 99) have a suaveness that might even suggest the participation of Byzantine artists, but various factors preclude this and lead to the remark-able conclusion that, within only a few years, the artists of Montecassino could rival their own Byzantine tutors in the ease and finesse of their craft. One clear indication of Cassinese authorship is the intrusion of the traditional decorative motif of Montecassino initials within the actual architectural framework of the Annunciation scene (Plate 151).[117] Another is the fact that – unlike the painted illustrations of the life of St Benedict – these pictures are drawings, for, though not entirely without precedent in the East, the outline drawing technique found little favour in Byzantine manuscripts, whereas (as we have already seen) it was traditionally used in southern Italy. Finally, the dedication picture of MS. 99 (Plate 150)[118] is a clear Western mutation of a Byzantine style. Here, the newly made monk John who had paid for the expenses of the manuscript is being presented by Desiderius to St Benedict, at whose feet kneels the scribe Leo. The indivi-dual figures, outlined in pen and heightened in colour, are firmly but delicately drawn and have spaciousness and weight. The lines are used organically, as in Byzantine art, to suggest the contours of the body and limbs below the draperies, but they are also – parti-cularly in the drawing of St Benedict – given a new precision which marks a shift of emphasis towards the definition of forms and registering of patterns. There has been no loss of quality, but, in a sense, the Byzantine style is being externalized.

In this combination of a spacious dignity of style with a delicate linear fragmentation of texture there may possibly be an influence from Byzantine ivories, where we find a comparable association, but here the interest in the exploration of surface texture is selective and is at the expense of the Byzantine aesthetic of compositional balance. This Byzantine equipoise is further disturbed by an emotional involvement between the figures that Byzantine art would normally eschew. The scene may be a purely formal one, but the arm which Desiderius places around the monk John and the glance which St Benedict directs towards his newest disciple bring the trio into a psychological involvement with each other which makes it difficult to see them impersonally as balancing elements of a composition. The Byzantine art of compositional equilibrium with a symbolic content is being given a Western accent by Latin artists whose own tastes favour an art of surface texture with a narrative content.

This process – particularly of exploring surface texture – continues in the drawing of St Benedict in another Montecassino manuscript (Naples, National Library MS. VIII

c 4). But it finds its further expression not in the manuscripts of Montecassino but in the wall-paintings of Rome,[119] whither Desiderius had been translated as Pope Victor III in 1086. Here, in Rome, we find Byzantine influences being transmitted both from Montecassino and from Byzantium itself.

ROME AND CENTRAL ITALY

During the eleventh century, when Montecassino was the bright focus of art in Italy, Rome itself was suffering an eclipse. In the first half of the century the papacy was often the pawn of local intrigues or the subject of notorious scandal. In the second half it was absorbed in a struggle for power with the empire which had, ironically, been made possible by the very anxiety of the emperor to reform it and raise its prestige. This conflict eventually brought warfare and destruction into the actual heart of the city. Rome was besieged by Henry IV between 1081 and 1084 but suffered even more severely from the pope's own ally, Robert Guiscard, who took a savage revenge on it for capitulating to the emperor. There followed a decade of violence and disorder in which popes competed with anti-popes. From this turbulence, soon after his elevation to the papal throne as Pope Victor III in 1086, Desiderius himself had to flee. He took refuge in Montecassino, where he died the year after his election. It was not until the very end of the eleventh century and the early twelfth that normality was re-established in Rome and a real resumption could be made of the arts of peace. In view of all this it is not surprising that there was little monumental painting in Rome during the eleventh century.

Although we do not know how many wall-paintings have disappeared from Rome, and those that remain are variously dated by different scholars, there is no evidence of a slow and tedious recovery in pictorial art after the unsettled interregnum. Surprisingly, one of the earliest of monumental works after the long period of unrest and dissension was immediately one of the most accomplished. It is the cycle of frescoes in the lower church of San Clemente.[120] From these it is clear why Rome did not have to struggle laboriously through an artistic recuperation and convalescence – she simply turned to Montecassino for a transfusion of that centre's artistic energies and traditions.

That these paintings represented an adoption of Cassinese traditions is more or less agreed.[121] There is less agreement, however, about their actual date. It is tempting, of course, to see Desiderius himself as the link between Montecassino and Rome, but, in view of the turbulence of the Roman scene during his short period as Supreme Pontiff, this seems improbable. Nor is it necessary to assume such a personal link. Montecassino, after all, continued to cultivate the arts after his death.[122] At the critical time when Rome, restored to peace, wished to renew its own art, it was one of the most eminent artistic centres of Italy and would understandably attract the attention of the City. There is some evidence to suggest that the San Clemente frescoes were made before 1115. To begin with, the painters make no use of a basic source for the life of St Clement which was written before that date by a former Cassinese monk at the request of a Roman cardinal;[123] furthermore, a manuscript illustration actually dated 1104[124] is stylistically

related. The frescoes may, therefore, have been painted during the early part of the twelfth century. A safer attribution of these critically important paintings, however, is to the period between 1085 and 1115.

It is of interest to see that two frescoes were paid for by a secular patron, for inscriptions twice mention Beno de Rapiza as the donor. Beno was, in fact, the patron of other paintings of a different style elsewhere in Rome, now almost completely faded away – frescoes on the end wall of a chapel dedicated to St Gabriel off the Appian Way – San Gabriele sull'Appia.[125]

The San Clemente cycles portray the lives and miracles of St Clement and St Alexis. In the narthex are three scenes. The topmost one (Plate 152) depicts a miracle wrought at the tomb of St Clement, which was said to be on an island in the Black Sea from which the sea ebbed once a year to allow a passage to pilgrims. On one of the annual pilgrimages, a child, accompanying its mother, was forgotten and left behind, but when the following year the mother returned and prayed to the saint, her child was restored to her. In the lowest scene (Plate 153) is represented the translation of St Clement's body to Rome. The middle picture shows Beno de Rapiza with his wife Mary and children Clement and Altilia before a medallion bust of St Clement. There are three other pictures – also one above each other – on a pillar near the end of the left wall of the nave. They show first, St Clement accompanied by other saints being enthroned by St Peter: secondly, St Clement saying Mass with his convert, Theodora, and her husband on the right (Plate 154), and votive pictures of Beno and his wife on the left: and thirdly, the story of the conversion of Theodora by St Clement. The top half of the first scene was cut off by the building of the upper chapel. On another pillar, three further pictures represent the life and death of St Alexis.

Though made, perhaps, by two or possibly three hands, all these paintings are in the same style – one which combines a liturgical richness with a particular delicacy and finesse. In terms of sheer quality, they remain unsurpassed in Rome in the twelfth century. In the low-pitched colours of warm ochres, grey-blues, and soft yellows, there is no histrionic attempt here to emulate the bright splendour of Byzantine mosaics by methods which reduce brightness to brashness, yet these pictures can vie with Byzantine art on its own terms of taste and fastidiousness. There is a noble elegance about the figure-drawing, a firm delicacy about the craftsmanship, and a general overall refinement. There is also here something of the exquisiteness, colour, and overall sense of design of fine embroideries.

The pictures were possibly taken from illustrated manuscript-lives of the relevant saints, for they have all the delicacy of fine miniatures. Moreover, their immediate pedigree leads straight back to the manuscript illustrations of Montecassino. From the stylistic point of view, they are developments from the linearized Byzantine style of illustrations made under Desiderius and his successor, Oderisius, with all that style's quality.

The actual Byzantine elements in the style are very clear – the ease and elegant proportions of the slender swaying figures, the derivation of the patterning of the draperies from motifs used in Byzantine art, the building up of flesh tones by modelling in green

and red, the jewelling of thrones and vestments, and so on. But no one could confuse this with Byzantine art. To begin with, the delicate fragmentation of the figure which we have already seen in Cassinese manuscripts here goes considerably further, and the reduplication of line and iteration of pattern shows how a style, originally Byzantine, is being subordinated to an aesthetic that is more Western. For, whatever element of patterning there may be in Byzantine painting, it is there no more than a suggestion – a response to the structure and organism of the figure itself. Here, on the other hand, the patterning of the figure is being intensified and is already beginning to express a more purely abstract interest in linear rhythm and design. Then, in Byzantine art one is conscious of the autonomy of the figure – its independence of the accidents of nature. Here, the figures – though still preserving a certain poise and dignity – are also elements in a tapestried interweave of design and colour. Again, though in the representation of these figures something of the sonorous nobility of Byzantine figure painting comes through, there is not that perfect insulation of the spectator from emotions that we suggested was an essential element of art in the Eastern empire. In the painting of the miracle of St Clement's tomb, for example (Plate 152), there is a real poignancy in the way in which the mother takes up her long-lost child. The painting of the saint saying Mass (Plate 154) is, further, accompanied by a marginal picture which injects a touch of homely, even crude, humour into the solemn scene. This represents the conversion by St Clement of Theodora, whose husband and servants were blinded for opposing her Christian worship. When ordered to seize St Clement and his followers the blind servants mistakenly carry off pillars instead, and this genre scene is included, together with inscriptions of the coarse oaths used to urge them on.

It has been suggested that the pictures in the lower chapel of San Clemente represent the transfer of the miniature styles of Montecassino to the monumental paintings of Rome, and during the first half of the twelfth century this style, or comparable ones, dominated the wall-paintings of Rome and the surrounding areas. At one time it reached out to a strength that approached Romanesque, and at another it was almost overwhelmed by new Byzantine elements. But the basic style remained recognizable throughout.

A comparable but more robust example of the Byzantinizing style is the frescoes in the Chapel of St Sebastian in the Old Lateran Palace,[126] some of which were only uncovered after the Second World War. They depict figures of saints and martyrs, a partial representation of the Creation, the entombment of St John the Evangelist, the martyrdom of St Sebastian, and the Crucifixion. Some of these scenes are fragmentary and others in poor condition. Surviving drawings of the cycle made in the seventeenth century[127] do, however, help in the iconographical reconstruction and show, for example, that the Creation scenes reflect the compositions of manuscript illustrations in the Roman area which themselves may follow a much earlier tradition of monumental paintings at Rome. Some details – particularly in the representation of the entombment of St John and the martyrdom of St Sebastian (Plate 155) – are sufficiently unrubbed to allow stylistic assessments, and here we see all the essentials of the San Clemente style.

These paintings have not the delicacy of the latter style, on which they impose more

strength and robustness, but they are obviously of the same school, though a little later. The dating of these, as of most Roman frescoes, remains controversial, but it would seem reasonable to place them between 1100 and 1130. The drapery themes – as at San Clemente – are still recognizably Byzantine and include a pattern, shaped like a teardrop, over the shoulder and nested V-folds over the knees. But the visual orchestration is un-Byzantine, for there is little interest here in using these patterns to respond to the organism of the human body. The interest, instead, is in exploring their possibilities for abstract rhythms. The delicately sharpened pattern-works of line of San Clemente are simplified into bolder geometric patterns and forms which have not the precision and commitment of Romanesque but which do suggest a reaching out in that direction.

Clear evidence for the spread of the San Clemente style from Rome is found in a further development of it in the basilica of Castel Sant'Elia[128] near Nepi, where, as we have earlier seen, the composition in the apse is a traditional one which goes back to Early Christian art. A monumental figure of Christ (Plate 156) stands between St Peter and St Paul, and behind them are two saints, one St Elias, the other, though unidentified, probably St Anastasius since episodes from his life are painted to the right of the apse. Below Christ is the divine lamb in a medallion. Twelve other lambs, representing the apostles, issue in four groups of three from Jerusalem and (in its original state) from Bethlehem. In the zone below a procession of female martyrs approach the (now almost obliterated) figure of Mary or Christ to offer their crowns. Above the apse are the elders of the Apocalypse carrying chalices instead of crowns. On the lateral walls are figures of saints and prophets with a number of scenes from the Apocalypse in varied condition.

There is variation of quality as well as of preservation, for we shall see that three artists were at work. There were also differing influences. Some, as we have already suggested, came from mosaics,[129] but influences from San Clemente are also quite unmistakable. Not that these rather laboured paintings have the delicacy or quality of the earlier paintings, for they give that style a stiffness and hardness which some would argue represents a Romanesque progression from it. On occasions like this it is always difficult to know how far the hardening of treatment is due to deliberate intention and how far to coarser talent, but the figures of the apse scene attain a certain monumentality and the patterns are more heavily chiselled into forms that are increasingly sculptural in weight.

The fact that an abbot is represented with one of the archangels in the apse indicates that the paintings were made under monastic patronage. And an inscription on the architrave of the door leading to the crypt mentions a Bovo who may perhaps be the same abbot Bovo who renovated the altar of the small near-by church of San Michele in 1126.[130] But though made under Benedictine patronage, the paintings were probably executed by secular artists. Such, at least, is suggested by the inscription below the figure of Christ in the apse (though others have interpreted it differently). The names of the painters are here given as the brothers John and Stephen working with John's nephew Nicholas.[131] It is stated that they are Roman painters, so that we have here firm evidence of the painters of Rome travelling outside the city. On the strength of their

affinities with the illustrations of the St Cecilia Bible of 1100–25, these frescoes may, perhaps, be dated c. 1100–30.

Related to the Sant'Elia frescoes are paintings in the large altar niche of the crypt of San Pietro in Tuscania[132] to the north-east of Tarquinia. In the niche itself is a damaged painting of the Madonna and Child, flanked by two saints with two half-length angels behind. Medallions on the archivolt (reminiscent of similar ninth-century ones from Santa Prassede) contain busts of eight apostles which lead downwards from a central lamb at the top to a full-length saint on each side. Here – as at Sant'Elia – the San Clemente interest in texture by line is giving way to the articulation of decorative motifs in bolder terms.

Evidence of exposure of the San Clemente style to a new wave of Byzantine influences is found in fragments of frescoes originally in the vault of the crypt of San Niccolo in Carcere[133] but which were transferred to canvas in the nineteenth century and are now in the storerooms of the Pinacoteca Vaticana. They may have been painted shortly before the re-dedication of the church in 1128 and can be safely attributed to the period 1115–45. Most of the twenty-four fragments are decorative, but five contain figures inside medallions – four of them half-length figures of Old Testament prophets with scrolls and the fifth a representation of the Baptism. The Byzantine influences on the drapery styles and heads and the modelling of the flesh are quite evident.

The same is true of the Apostles of the Ascension in the apse of the upper church of San Pietro at Toscanella (Plate 157) which, in their self-confident handling of tones, their spirited vigour and more decisive articulation of the Byzantine motifs, represent particularly fine examples of this phase of Italo-Byzantine art.

This new exposure or reversion to Byzantine influences is also clearly seen in remains of paintings in the Roman church of Santa Pudenziana.[134] The original cycle contained scenes from the life of the saint and the two most impressive survivals are, first, a picture of the children of St Pudenziana being baptized by St Paul and, secondly, a painting of St Pudenziana and St Prassede on either side of the Madonna (Plate 158). The dignity and *gravitas* of these figures, the elegance of their proportions and the hieratic solemnity of the composition are thoroughly Byzantine, though the brushwork has its own breadth and freedom which gives an un-Byzantine sense of buoyancy and fluency to the swirling folds.

As we might expect, panel-paintings reflect the current idioms of frescoes, and a more linear version of the Santa Pudenziana style is found in one of the finest panel-paintings of Romanesque Italy. It is the great Redeemer painting in the cathedral of Tivoli,[135] long venerated there and thought for centuries to have been painted by St Luke himself. In fact, it belongs to the period 1110–40. Technically, it is a tabernacle, that is a cult-image (here a panel-painting) so venerated that it is normally concealed by doors and only exhibited on special religious occasions. Eight such cult-images of the Redeemer as panel-paintings survive from the twelfth and thirteenth centuries.[136] They all derive from the cult of the renowned Redeemer enthroned in the Sancta Sanctorum in Rome, which gave rise to local Redeemer cults throughout Lazio and to the painting of local icons.[137] This one, though at Tivoli, is generally thought to have been painted in Rome.

When the two shutters which protect the image of the Redeemer are opened, they depict the full-length pictures of the Virgin and St John the Evangelist. Fully revealed, the complete composition, therefore, presents a Deesis – an intercession with Christ. Below the Virgin are represented her Dormition and Assumption, and the picture below St John depicts either his last prayer or his own Assumption. The predominant colours are warm, with reds and blues mingling into purples at times and strengthened by yellows glowing against the background of gold.

Both full-length figures inside the shutters are obviously Byzantine in inspiration and that of John is particularly fine, for it has a delicate clarity of definition.

Where the primary image of Christ the Redeemer (Plate 159) is concerned, the head has a Byzantine nobility, and the large, all-seeing Byzantine eyes shine through the patina of age. The body, on the other hand, is rather a linear version of the Santa Pudenziana style: in fact, it is as though the broad brush-strokes of these paintings have been translated into threads of red and gold. One is conscious of some contradiction between the weight and authority of the face and the insubstantial evanescence of the figure, which now seems to dissolve away behind the patterned web of line.

Here, in fact – despite its obvious qualities – is epitomized one of the weaknesses of so much Italian painting of the first half of the twelfth century. It is an art of compromise. It can never release itself sufficiently from the aesthetic of Byzantium to embrace wholeheartedly the quite different aesthetic of Romanesque Europe. The painting of central Italy could never detach itself from the powerful magnetic field of Byzantium. Whatever urges its artists may have had towards the Romanesque were always inhibited in the last resort by the pull of the Eastern empire. The result is a state of suspension. There is no real progress. Despite a neo-classical interlude in the second half of the twelfth century which is represented by the frescoes of San Giovanni a Porta Latina and of San Pietro near Ferentillo (which have been touched on earlier), the wall-paintings even of the first half of the thirteenth century continue to reiterate the Italo-Byzantine formulae of the first half of the twelfth.

What is true of central Italian wall-paintings in the twelfth century is, to a large degree, true of its manuscript-paintings. But, before surveying the manuscript-painting of the twelfth century, we must briefly describe its earlier development. This will take little space, for there is little of it.

We have earlier seen the quality of mosaics and frescoes in Rome in the ninth century. Where manuscript-painting is concerned, however, it is true to say that, during the period from the early ninth to the mid eleventh centuries when (apart from the efflorescence in England) transalpine Europe was experiencing two renaissances, central Italy had remained a provincial backwater. Ironically enough, it was only after the first half of the eleventh century, when both these renaissances were spent forces in their own homelands, that Italian manuscript-painting made some response to their influences. This was particularly apparent in the field of decorative initials, where Carolingian influences became an appreciable factor and Ottonian influences (especially in the last quarter of the eleventh century) a dominant one.[138] At this time, Ottonian-type initials with the tight, stiff leaf-work of Ottonian decoration become everywhere apparent.

Two of the innumerable examples are found in dated manuscripts – the one a Gradual from Santa Cecilia dated 1071 and the other a *Remigius* also from Santa Cecilia dated 1067 and now at Oxford (Bodleian, Add. D. 104).[139] This actual duplication of Ottonian initials continued well into the twelfth century in the more conservative scriptoria of Rome or of the papal territories such as those of Farfa and Subiaco.

But Ottonian influences were not entirely confined to initials. They also appeared in the figure style, particularly in the last quarter of the eleventh century. Examples of this are found in the great Palatine Bible in three volumes (Vatican, Pal. lat. 3, 4, 5)[140] which was made before 1095 and can probably be dated between 1080 and 1090. This has a number of illustrations, most of them of the Old Testament. They generally consist of single figures or of pastiches of single figures. Even when actual scenes are represented, such as the Creation (before the Book of Genesis) or God speaking to Moses (before the Book of Leviticus), we find a simple juxtaposition of figures without any communication between them.

The figures themselves show influences from Ottonian as well as Byzantine and Carolingian sources. It cannot be pretended that they have the quality of the originals, and their clumsiness sometimes gives a measure of parody to the Ottonian style. However, some figures, such as those of Solomon and Tobias, are acceptable and indicate at least how this art was moving to full-colour works which have massiveness and monumentality. This is an advance on the crude outline styles of earlier eleventh-century manuscripts like the Santa Cecilia *Remigius* (Bodleian MS. Add. D. 104). This development is further evident in two contemporary manuscripts of this region which were illustrated in a similar style to that of the Palatine Bible. The one is a *Moralia in Job* (Bamberg, Staatsbibliothek bibl. 41)[141] and the other a *Liber Decretorum* of Burchard (Florence, Laurenziana Plut. 16. 21).[142] The figures of the first, which also show an admixture of Carolingian and Anglo-Saxon (or Channel) influences, evince a particular feeling for weight and monumentality. Both manuscripts are of further interest in the stress given by their illustrations to the importance of the relationship of the Old Testament and the New. In the *Moralia in Job* this is not difficult to understand, for St Gregory's commentary does, in fact, represent this Old Testament Book as an allegory of Christ and the Church faced by their enemies, the heretics. But, in a text as apparently unrelated as the *Liber Decretorum*, the artist has been able to intrude a tabloid message on the necessary relationship between the two Testaments, for he represents the Trinity by the three Old Testament patriarchs – Abraham, Isaac, and Jacob.[143] The reasons for this will emerge in the discussion of giant Bibles.

The influence of this style spread northwards, and a particularly good example of it is a giant Passional of the eleventh century which was made in the neighbouring area of Tuscany in the diocese of Chiusi (Florence, Biblioteca Nazionale F.N. II. I. 412).[144] This is lavishly illustrated with some sixty-nine illustrations. One of these is of interest in demonstrating the sheer casualness of some influences, for the picture of S. Saturnino[145] is clearly based on pre-Carolingian styles from England or Ireland and, indeed, conserves an iconography which may have inspired the Alfred jewel.[146] But this influence was as short-lived as it was wayward. Most of the illustrations are, in fact, in the Palatine style,

to which they impart a new crispness and a new impact. Figures like those of St Leucio, St Tirso, and St Galenico on folio 33 verso (Plate 160) and St Faustino and St Giovita on folio 39[147] have the monumentality of the figures of the Palatine Bible but are more clean-cut and are quite impressive.

German influences are also evident in the Munich Bible (Munich, Staatsbibliothek cod. lat. 13001),[148] which is of a slightly later date, though still quite probably of the very end of the eleventh century. It was certainly made before 1106, for inscriptions tell us that it was given to the monastery of Hirsau by Henry IV, who died in that year. Iconographically, its illustrations are related to those of the Palatine Bible and, though the stylistic relationship is less marked, the style is still orientated towards Germany. Of the illustrations, the picture of the four evangelists preceding the Gospels is the most successful. The other illustrations are single figures which are mostly laboured and un-gainly. Of these, the happiest is the depiction of Solomon (Plate 161) before the Book of Proverbs which indicates clear Ottonian influences. The style of the other figures points to Germany and, particularly, to the north-west area (which today includes Belgium and north-east France). It was, indeed, just this area and the bordering Flemish regions that were already producing their own giant Bibles in the eleventh century. These Bibles, such as those of Saint-Vaast[149] and Stavelot,[150] had masterly illustrations which serve as a foil to the less skilful Italian ones.

During the tenth and the first half of the eleventh century there had been little interest in such illustrated Bibles in Europe. Both the Ottonians and the Anglo-Saxons had been much more concerned with lavishly illustrated Gospel Books and Service Books, mostly intended for the personal use of the patron, who was often a bishop. Indeed, many of the great masterpieces of Anglo-Saxon and Ottonian manuscript illustration are still known by the names of these original private owners – the Benedictional of St Aethelwold, the Gospels of Grimbald, the Pontifical of Robert of Jumièges, the Gero Codex, the Egbert Psalter, the Bernward Sacramentary, and so on. In contrast to this, the huge Bibles in two or three volumes of the late eleventh and twelfth centuries were clearly intended for institutional not private use and were specifically made to be read in monasteries or churches. As we shall see, this symbolized a deliberate attempt by the Church to assert its claims to be the sole interpreter of the Bible after a period when some had argued otherwise.

Large Bibles with decoration and illumination had indeed been produced under the Carolingians and, if the local tradition is true that the Carolingian Bible of Charles the Bald was given to the house of San Paolo fuori le mura by Gregory VII, then it is possible that this gift sparked off the new interest in great Bibles in Italy and that there is a real link between the giant Carolingian and the giant Italian Bibles. There is certainly a relationship between Carolingian and Italian Bibles in size and shape and arrangement of text. The chief impetus, however, more probably came from the Flemish region of France, where already in the first half of the eleventh century one giant Bible in three volumes had been produced which mirrors these Carolingian characteristics. This is the Saint-Vaast Bible, which has been discussed in another chapter.

There is no indication that the Saint-Vaast pictures themselves were taken from actual

Carolingian Bibles. Yet they do offer an interesting parallel to those of one group of Carolingian Bibles, for, like them, they represent a deliberate attack on heresy.[151] It has been shown in an earlier chapter that the illustrations of the Moutiers-Grandval and related Carolingian Bibles derived from pictures of a lost Bible of Pope Leo (440–61) which were specifically intended to combat contemporary heresy,[152] and there is some indication that the illustrations of the Saint-Vaast Bible had exactly the same object.

Certainly, heresies were particularly vigorous in the eleventh century and also in the twelfth. They had begun (like the orthodox reform movements) with attacks on the unchastity or other lack of virtue of the priests, but had gone on from there to repudiate the sacraments, to disclaim the rôle of the Church as an essential intermediary between the Christian believer and the Gospel message, and (as in the time of Leo I) to reject the Old Testament or part of it as a necessary part of the divine message.

Though, as a result of mutilation in the nineteenth century, the Saint-Vaast Bible is now incomplete, it is significant that two of its surviving full-page illustrations represent pointed attacks on current heresies. The first is in very general terms. It is the picture prefacing the Song of Songs, which suggests in allegorical form that only those faithful to the visible Church will achieve salvation.[153] The second, which is in more particular terms, precedes the Book of Ecclesiasticus and shows how Christ will crush the enemies of the Church and how salvation will be exclusively reserved for the members of the true Church.[154] This salvation, however, is represented in the picture as being achieved not simply by the exercise of virtue but by the necessary comprehension of the divine wisdom of *both* Testaments through the traditional interpretation of the Church (here represented by a knowledge of the liberal arts). So the mediation of the Church and the acceptance of the Old Testament are both emphasized as essential for salvation. This is a particular example of a general tendency in the West, for the attacks on the Old Testament led gradually, during the late eleventh and the twelfth centuries, to an emphasis on the Old Testament in illustrations of the Bible and, furthermore, to a stress on just those Old Testament incidents which are referred to in the New Testament, so that the New Testament was made to validate the Old. This exactly parallels theological developments as seen, for example, in Peter the Venerable's tract against the heretic Peter of Bruys, which significantly begins with a *Probatio totius Veteris Testamenti ex Evangelio*.[155]

The giant Bibles did not originate in Italy but it was there – particularly in the papal territories[156] – that they were most intensively produced. It cannot be pretended that the Italian Bibles compare in terms of quality with the finest of the transalpine North, but it should be recognized that it was Rome and the papal states that set the fashion which led to the production of these huge ceremonial Bibles throughout the West in the twelfth century. It was Rome which approved, if it did not actually initiate, the programme of illustration which, with variations, was to become general in the Roman Catholic world. It was also Rome that both determined and popularized the form of layout which was to become the protocol[157] for the whole of Latin Christendom. This begins with a magnificent title-page, gives a grand and elaborate initial to St Jerome's Prologue and usually to the Book of Genesis itself, and then marks the important

divisions of the Bible with decorated or historiated initials which tended to increase in number as the twelfth century advanced. Rome and the papal states, then, did have a part to play in the programming of manuscript-painting of twelfth-century Europe.

In terms of style, after a German-dominated interlude in the latter part of the eleventh century, central Italian manuscript-painting passed at the beginning of the twelfth century into a protracted Byzantine phase that was to continue to the end of the century and well beyond.

It has been said that after about 1100 there was a revival of manuscript-painting in Rome and the papal states. Certainly, art before this time had been anaemic, but we should not too readily assume from this phrase that it was suddenly and miraculously restored to new life and vigour. In fact, despite an apparent glow of health, Italian manuscript-painting never gained a completely independent life of its own in the twelfth century, but always relied to some extent on crutches borrowed from southern Italy and Byzantium.

Where decorative initials are concerned, there was, indeed, a positive development towards a life of independence, even though these were based on styles that were already themselves archaic. The most important initials were considerably influenced by the Franco-Saxon style of the Carolingian period.[158] They probably originated in Rome, whence they spread through central Italy and Tuscany (which was to replace Rome as the leader in their development after the mid twelfth century). Though clearly limited as an aesthetic means of expression, these geometric styles have their own clarity and elegance. But they are of more than artistic significance. By plotting their gradual development and refinement (which includes a lightening of texture and freshening of colour) it has been possible to use them as pointers towards the chronology of Italian manuscripts of this region, and they have been very successfully used as a form of stylistic palaeography to date the relevant manuscripts.[159]

Figure styles in the twelfth century followed much the same trends as wall-paintings. We find here also influences both from Montecassino and more particularly from Byzantium uneasily trying to adjust themselves to the Romanesque modes of the north.

This is evident in the Roman scriptorium of Santa Cecilia.[160] Its work in the second half of the eleventh century had been jejune and fumbling (as we can see from a *Remigius* at Oxford dated 1067 – Bodleian MS. Add. D. 104), but now, with the turn of the twelfth century, there was a change. This is clear from the illustrations of a Gospel Lectionary (Laurenziana Plut. 17. 27)[161] and a giant Bible (Vat. Barb. lat. 587).[162]

The Gospel Lectionary has three evangelist portraits (the fourth is replaced by an initial), and they are of quite outstanding quality for this area. The style of St Mark has something in common with that of the frescoes of Castel Sant'Elia, and the figure of St Matthew (Plate 162) shows some Romanesque hardening of this Italo-Byzantine style when exposed to Western influence. But, despite all this, the figures are still obviously within the Byzantine orbit, and in one sense the very fineness of their quality is due to this servility, for they have adhered in the closest way to Byzantine evangelist models.

In the Bible, Byzantine influences are also dominant, though the general quality is less

consistent. A number of artists worked on the twenty-six illustrations. The draperies even of the less skilled are very Byzantine in style, though the heavy stiffness of the eleventh century asserts itself in the figure painting and leaves us with the impression of clumsy and stolid Western peasants gauchely parading in the mantles of Eastern emperors. The finer illustrations, however, like the St Peter prefacing his Epistles on folio 358 verso (Plate 163), have their own finesse. And despite a lushly linear quality, they represent a Romanesque tightening of a Byzantine style such as we saw earlier in Roman wall-paintings like those of Castel Sant'Elia, Magliano Romano, and San Pietro in Tuscania. As in these, the linearization of a Byzantine style suggests transmission from Montecassino. The almost calligraphic representation of the folds of draperies looped over the legs of prophets like Daniel and Amos, further, anticipates the style of the Tivoli Tabernacle. This Santa Cecilia style – which is ultimately no more than a recension of a general style current in Rome at this period – had an influence outside its own scriptorium. It influenced, for example, the stilted but copious illustrations of a Lombard Psalter now at Mantua (Biblioteca Comunale C. III. 20)[163] which came from the Cluniac house of Polirone near Mantua and whose numerous marginal illustrations suggest a knowledge of Byzantine 'monastic' psalters. It also influenced an Umbro-Roman *St Augustine* in Madrid (Biblioteca Nacional cod. 193)[164] which has a capable full-page picture of St John writing and St Augustine preaching (Plate 164).

The same unevenness of quality combined with the same exposure of a Byzantine style to a Romanesque idiom is found in the most lavishly illustrated of all the giant Bibles of the Umbro-Roman area. This is the Pantheon Bible (Vat. lat. 12958),[165] which had a widespread influence.[166] Its Creation scenes, for example (Plate 165), had an iconographic and stylistic influence on the Todi Bible originally in the cathedral of Todi (Vat. lat. 10405),[167] on the Angelica Bible of about 1125 made for an Umbrian area outside Rome (Rome, Biblioteca Angelica cod. 1273),[168] and on the Perugia Bible (Biblioteca Comunale L. 59).[169] The Pantheon Bible was made in the second quarter of the twelfth century and in the fifteenth belonged to Santa Maria ad Martyres. This does not, of course, necessarily mean that it was actually made there, though it probably was produced in a Roman scriptorium. It has no less than forty-eight illustrations which include seventeen scenes, all of the Old Testament. Four artists were responsible for these illustrations. The most important, if not the most prolific, was responsible for five scenes of the Old Testament and two evangelist portraits of the New. His work has competence, but its chief interest is to see its relationship to Cassinese painting as expressed, for example, in the Cassinese Exultet Roll in London. We find here much the same linearization of a Byzantine style that we earlier saw at Montecassino. Though they do not attain the fluent grace of the wall-paintings of the lower church of San Clemente, the illustrations also invite comparisons with them. This style is slightly caricatured by a second artist, who is less able than the first but never sinks to the bathos of the third. The four illustrations which this second artist made for a contemporary Homiliary-Passional (Vat. lat. 6074)[170] are, however, rather more mature and more successful. His style influenced the illustrations of a giant Umbro-Roman Bible originally in the cathedral of Todi (now Vat. lat. 10405)[171] which has a particularly interesting illustration to the

Acts of the Apostles fusing the picture of the Ascension with that of the Mission of the Apostles.[172]

What then emerges from an examination of the vellum-paintings of the Umbro-Roman area is that, despite a much greater unevenness of quality, they follow developments similar to those of the monumental paintings. In both, a basically Byzantine style is given a more linear, more schematic, and even at times a more Romanesque expression.

And, as in the wall-paintings of the second half of the twelfth century, so in the vellum-paintings of the first half, we are conscious of a slight undercurrent of traditionalism. This appears to a limited extent in the iconography; the most popular scenes in the giant Bibles – the scenes of Creation – are based on an iconography which comes neither from the South nor from the East but which is traditional to Rome.[173] It appears also occasionally in the style. In the scenes of the Expulsion of Adam and Eve in the Pantheon Bible (Plate 165),[174] for example, we are conscious of some response to the substance and structure of the human figure. Whatever the technical shortcomings of the artist, he is making a real attempt to indicate the substance of the flesh and the conformation of the muscle. This feeling for the human shape and figure thrusts itself through the Ottonian fashions of the end of the eleventh century and the Byzantine mantles and draperies of the first half of the twelfth. The lack of skills of some artists means that this is often clumsily expressed, but the feeling itself is never entirely lost. And it is this, as I have earlier suggested, which may explain why Byzantine influences in Italy were never happily assimilated to Romanesque. Romanesque demands the complete sacrifice of the human figure to an aesthetic of forms and abstractions, and this sacrifice the Italian artist would never make. His sympathies lay rather with the art of Byzantium, which, like his own traditions, was ultimately rooted in the art of Antiquity. When, in fact, art-historians refer to Italian art of the period as being Italo-Byzantine, they are summing up the real affinities of the artist. If, in the first half of the twelfth century, he was influenced by Romanesque, this was an act of dalliance rather than real attachment, and one which was to lead nowhere. Italian art could never make a complete break with the East.

The Byzantine dominance that we see in southern and central Italy is also apparent in the north – both in Tuscany and in Lombardy – though, as we might expect, the farther north we go, the larger is the admixture of transalpine influences.

TUSCANY

In Tuscany, as in central Italy, we find giant Bibles and other giant manuscripts. They were not produced here in the same numbers, but there can be a prodigality of illustration within the individual manuscript. It is indeed in the important Tuscan centre of Florence that we find the most lavishly illustrated of all giant Bibles. This is in two volumes, was probably made in the second quarter of the twelfth century, belonged originally to the cathedral of Florence, and is now in the Laurenziana (Edili 125/6).[175]

Apart from the purely decorative figures inside the numerous initials, it contains more than forty-three illustrative figures and over thirty-five scenes. It is more extensively illustrated than the Roman Pantheon Bible, though associated with it in style; for it represents a similar phase of the Italo-Byzantine style. Most of the illustrations are in the familar Italo-Byzantine style of contemporary Rome, though we also find evidence of the impact of Burgundian art. In particular, we can perhaps see influences from Cîteaux, where the assimilation of Byzantine influences had led to styles so consummate that they make the illustrations of this Bible seem rustic in comparison. There is a considerable variation of quality in the Florentine illustrations, and even the best of them are afflicted with a certain woodenness, but, despite this, they have a particular interest, for they represent the closest approach which the Italo-Byzantine style made to Romanesque.

It is difficult to say whether the close association between this style and contemporary styles of Rome was the result of direct influences or simply of parallel developments. In favour of the former hypothesis is the fact that we know of one Roman artist (known as the Ávila Master) [176] who did travel to Florence about the middle of the twelfth century and who set up a fashion there for styles evolved in Rome and central Italy. [177] His artistic career in Rome in the second quarter of the century included an ancillary rôle in the illustration of a Psalter Commentary (Bibliothèque Nationale lat. 2508). [178] He was responsible for adding to it a frontispiece portraying Christ and David which follows the traditional Italo-Byzantine style of Rome in a rather pedestrian way. In the third quarter of the century we find him removed to Florence, where he activated a whole school of manuscript-painting based on Roman styles. [179] He is, indeed, the centre of the largest group of pictorially associated manuscripts known to us from twelfth-century Italy. The key work is a profusely illustrated giant Bible, formerly in the cathedral of Ávila and now in the Biblioteca Nacional of Madrid (Vitr. 15). [180] Of a number of stylistically associated manuscripts, the most important are a giant Bible at Trent (Museo Diocesano cod. 2546), from which the frontispiece picture on folio 13 is illustrated (Plate 166), a giant Old Testament at Turin (in the Archivio Capitolare), and a giant Bible at Florence (Laurenziana Conv. Soppr. 630). [181] In this group there are (as always) variations of quality which become particularly erratic when assistants take over. But the work of the Ávila Master himself shows clearly that he matured after his Roman days into an artist of some competence, and his best figures have an assurance and nobility which make them very attractive.

Another important artistic centre of Tuscany was Lucca. Here we find, as in Florence, the impact of some transalpine influences. [182] These are particularly apparent in the grace-ful and elegant initials which reflect Channel styles in a most felicitous way. [183] But the general basic trends are parallel to those of Rome and the figure styles are comparable to those of central Italy.

As one example of this, we may take a giant Passional of about 1125 (Lucca, Biblio-teca Capitolare cod. C). [184] In some ways comparable to Cistercian illumination, its pellucid colours and lively drawing, as evidenced in the picture of St Barnabas on folio 185 (Plate 167), make this one of the masterpieces of Italian manuscript-painting. There seems every evidence of direct Byzantine influence particularly in the drapery styles,

facial types, and use of green and red tones in the flesh areas, but the original Byzantine style has been linearized in much the same way as at Rome and, indeed, particular comparisons have been made with the frescoes of San Pietro at Toscanella.[185]

The panel-paintings of Lucca[186] also give evidence of the taste and finesse of Lucchese painting. This is clear in its large and splendid panel Crucifixions. These are painted on wood, often against backgrounds of panelled scenes from the life of Christ which, in their format, are reminiscent of Early Christian art in Italy as represented in the St Augustine Gospels.[187] One of the most splendid of these is the great Crucifix of Sarzana (Plate 168),[188] which has an inscription telling us that it was painted by a certain Gulielmus in 1138. Despite some repainting of the head and body in the thirteenth century, the draperies remain in their pristine condition and show the quality and linear delicacy of Lucchese art of the period. Though more sensitive than much Roman art of the time, it reflects a similar stylistic development. It can be compared to Roman wall-paintings like those of the Old Lateran Palace Chapel and shows a similar linearization of Byzantine styles.

The Sarzana Crucifix is only one particularly fine example of Italian Crucifixes which survive in considerable numbers. These reflected the current styles of wall- and vellum-painting. They also embalmed them, for they continued to iterate twelfth-century styles well after the age of Cimabue.

LOMBARDY

In Lombardy,[189] as in Tuscany and other parts of Italy, there were strong Byzantine influences. This is apparent in the fragmentary wall-paintings which survive and which can only hint at the wealth of frescoes originally in Lombardy. Even the little that remains, however, makes it clear that north Italy, like south Italy, could produce very fine paintings in the eleventh century.

Just sufficient of the frescoes of Sant'Orso at Aosta[190] survives to indicate the quality of this eleventh-century work. The colours here are strong and used not simply to adumbrate the tones of the figure but also to induce a feeling of drama and movement by colour contrast alone. There is a strong suggestion here of Ottonian influence, though elsewhere the influences are overwhelmingly Byzantine.

Byzantine elements are so strong in the frescoes of San Vincenzo at Galliano[191] that they argue the domestication of a Byzantine style in northern Italy. This is not of itself significant in a country where Byzantine art found so ready a foster-home, but they have an interest in representing one channel for the transmission of Byzantine influences to transalpine Europe; the style represented here, in fact, influenced a group of Spanish frescoes including those of Esterri de Cardós,[192] and it may not be a complete coincidence that the pose of Jeremiah (Plate 169) is duplicated in wall-paintings of Canterbury Cathedral. The Galliano frescoes are no longer complete, but a part of the apse painting survives which shows Christ in Glory flanked by the archangels Michael and Gabriel and the prophets Jeremiah and Ezechiel. Some details also remain from the scenes below

of the life of St Vincent. The style has a spaciousness and ampleness clearly derived from one of the more 'classicizing' styles of Byzantium, though the stilted use of bold highlights makes it more ponderous than it would be in Byzantine hands. The paintings can be dated quite narrowly. They belong to the period of the consecration of the church by Ariberto, later bishop of Milan. This was in 1007, and Ariberto proffering a model of the church to Christ appears in the frescoes (or, rather, appeared, for this particular painting is now preserved in the Ambrosiana Library at Milan). Vestiges of paintings in the chapel of San Fedelino at Novate[193] are in a similar style.

A more vigorous assimilation of Byzantine influences is evident in the finest of all surviving Lombard wall-paintings – those of San Pietro di Civate.[194] Though given a wide range of different datings by differing scholars, they probably belong to the very end of the eleventh century or the beginning of the twelfth. The original cycle is not complete, but the few surviving paintings, which are primarily concerned with the Book of the Apocalypse, are of the finest quality. From the point of view of style, the angels who slay the dragon around Christ in one of the lunettes (Plate 170) have simply migrated from Byzantium, but they have lost nothing on the journey. Iridescent with colour and invigorated by northern influences, they make a superbly throbbing composition as they thrust out at the magnificent multicoloured dragon. In contrast to this, the picture of the Heavenly Jerusalem in the vault has a tranquillity and freshness which does not register well in the black-and-white reproduction (Plate 171). All the symbolism of the Apocalypse is here – Christ as the lamb of God, the gates to the north, to the south, to the east, and to the west, the twelve precious stones representing the apostles, and so on. And it is presented with great delicacy. There is a gentle, pastoral quality about the picture of Christ in the celestial garden, where the apple-greens and blues are soft and cool, where a stream gushes forth below the lamb, and where the foliage of the trees can only be described as naturalistic in its sensitive delineation. It is difficult to account for the influences here, unless they derive from the aspect of classical naturalism that was revived in a minor form in illustrated texts of natural history during the tenth-century Byzantine Renaissance. But, after the arid repetition of the more usual Byzantine formulae in so much Italian painting, this draught is as refreshing as it is unexpected.

When surviving Lombard frescoes exhibit this freshness and accomplishment, the losses of so many other wall-paintings from Lombardy seem a particular misfortune. And, apart from questions of artistic excellence, the vanished paintings must have offered important pointers to the transmission of influences over the Alps. This is of particular significance in the context of Western art as a whole, for Italy had a special importance as a line of communication between the art of the East and the art of the West. Of the Byzantine influences that surged over Northern Europe in the twelfth century, many had first been channelled through Italy.

CHAPTER 8

BYZANTINE INFLUENCES ON THE CRUSADING
KINGDOMS AND SICILY

Byzantium and the West in the Twelfth Century

IN the twelfth century, even outside Italy, tides of influence on Western painting set un-
mistakably from the East. In this century, wave after wave of Byzantine influence broke
over 'Europe'. The artists of Latin Christendom themselves seem to have been aware of
what was happening, for, in discussing painting in his exhaustive treatise on the arts,
Theophilus singled out Byzantium for special attention and, in particular, emphasized
the Byzantine skill in blending colours and tonal shades.[1]

This Western interest in Byzantine art was not, of course, new. To Byzantine inspira-
tion Carolingian manuscript-painting owed some of its finest work and Ottonian art
elements of its iconography as well as pictorial concepts by which to express imperial
power.[2] What was new was the extent of its diffusion and infiltration. Although Byzan-
tine ivories had had easy access before the twelfth century, the entry of Byzantine
paintings had tended to be erratic and haphazard – the result of occasional embassies and
personal relationships – and their influence had been local and sporadic. Now Byzantine
paintings had a readier entrance to the West and their influence became international
and all-pervasive. In this they reflected the closer and more general associations of the
West with the East which was a direct result of the Crusading movement. The fact that,
in the political field, the closeness of this association brought envy, equivocation, and
animosity in its train so that the Christian West, which had been called upon to save
Byzantium from the Turks in the first Crusade, turned the energies of the fourth
Crusade to the capture and plunder of the Byzantine capital need not detain us here.
What matters more to our purpose is that between the time of the first Crusade and the
fourth – between the end of the eleventh and the beginning of the thirteenth century
– Western civilization was at all levels in close touch with Byzantine culture.

Byzantium had, of course, always been a byword for splendour in the West. The
highest praise that William of Poitiers could find to bestow on Anglo-Saxon metalwork
was that even Byzantium would have considered it precious.[3] In the preaching of the
first Crusade, Urban II had himself emphasized the terrestrial glories of Constantinople
as well as the spiritual glories of Jerusalem. Now all this magnificence was seen at first
hand by thousands of Crusaders of all classes, who poured into the Holy Land over
routes taking large numbers through the Byzantine empire and who, according to
the Byzantine chronicler, Anna Comnena, gazed open-mouthed at its splendours. 'How
many monasteries, how many palaces are there, and how wonderfully constructed,'
wrote one of the Crusaders, 'and what marvellous sights. . . . It would be tedious to
recite how many good things there are, of gold and silver, and cloths and relics.'[4] Apart

from Crusaders, there were those who travelled to the Holy Land between Crusades. Some, like Wibald, abbot of Stavelot and Corvei,[5] might bring back *objets d'art* from Constantinople, and others might return with detailed descriptions of her treasures. All this stimulated the artistic ambitions of Western prelates. Whether Suger placed in the tympanum of Saint-Denis the carving of himself as donor in imitation of a similar donor picture in mosaic at Hagia Sophia is a matter of conjecture; but his anxious efforts to make the contents of his own treasury rival and outshine those of Hagia Sophia are well documented. The way in which he would seize on people returning from Constantinople and press them to make comparisons in favour of the art of Saint-Denis[6] exemplifies, in a human way, the stimulus given to Western art by a first-hand knowledge of the art of the East. This stimulus may have been largely provided by the Crusades themselves, but it was sustained by the success of the first Crusade in setting up French colonies in the Holy Land. By surviving, if only precariously, for almost two hundred years, they gave continuity and some measure of permanence to the interchange with the East.

The actual means by which Byzantine styles reached the transalpine West are difficult to determine. Illustrated Byzantine manuscripts brought into 'Europe' from Byzantium itself and, even more significant, from areas within its artistic orbit like the Crusading Kingdoms may have been important sources of inspiration. Painters travelling from Sicily, Italy, and even the Holy Land may have had their own rôle, though this is impossible to assess with the loss of so many panel-paintings and frescoes. Artists' notebooks may have played a small part. These by their nature have almost all disappeared, but a famous example survives from the thirteenth century. It is the notebook of the architect, Villard de Honnecourt,[7] and consists of a number of unrelated sketches of objects and motifs which aroused Villard's interest and which he jotted down for future reference. There is a single leaf from an artist's notebook of the late twelfth century at Freiburg, and this is of particular interest in our present context, since it contains a drawing of a Byzantine figure, possibly made in Sicily. A twelfth-century manuscript at Einsiedeln, which is thought to be an artist's pattern-book, evinces the same trend, for the drawings clearly transmit an Italo-Byzantine style.[8] Still, the influence of such notebooks must have been very circumscribed, since the jottings in them would be desultory. Probably, they would not compare in importance with the more highly organized drawings of cycles of pictures which were intended to provide the artist with guides to iconographic cycles.[9] Unfortunately, the cloud of anonymity which obscures the identity, let alone the activities, of artists of the twelfth century makes speculation about the actual methods by which Byzantine influences were transmitted particularly difficult. But certainly these influences reached almost every region of the West.

Their particular effect varied according to time and place. It depended on the other influences and other traditions that they accosted in different parts of the West and the ease or difficulty with which these various ingredients could be combined. Then the particular form of the influences was itself controlled by developments within the Byzantine empire. So, the linear emphasis seen in Byzantine-influenced art of the earlier decades, the more painterly and more dynamic qualities of the later decades, and the

tranquil, almost classical, phase of the turn of the century all reflect developments in Byzantine art itself.[10]

Despite occasional exceptions, we should never assume that Eastern influences overwhelmed the art of the West. It certainly brought to Latin art a new appreciation of the dignity and majesty of the human figure which, in painting as in sculpture, had been in danger of becoming absorbed into pure decoration. It also gave artists a better understanding of the articulation of the human figure and of the modelling of flesh, and perhaps also a finer appreciation of balanced weights and rhythms in compositions. But there was no question of Western artists being simply subservient to the art of Byzantium. Indeed, they were primarily interested in making use of it for their own purposes. They were usually uninterested in that inner glow, the feeling of warmth that irradiates the Byzantine figure from within: they were more often concerned with the externals of the figure and drapery which, as they readily saw, offered them an extensive repertory of shapes and forms to adapt to their own Romanesque tastes. The sensitive brushstrokes which, in the finest Byzantine originals, had simply been used to suggest the organic parts of the body were, therefore, hardened and tautened into abstract rhythms and forms and assimilated to the Romanesque aesthetic. One result was the so-called 'damp-fold' style of the West. The phrase, originally used[11] to suggest the manner in which the folds of damp draperies would outline the contours of body and limbs, graphically conveys the way in which the Byzantine style was externalized by artists whose primary interest was the ebullient interplay of abstract forms and rhythms.

The Crusading Kingdoms

Byzantine influences on the West were nowhere more obvious than in the Frankish kingdoms of the Holy Land themselves. Though these had been wrested from the Moslems by the Crusaders, they had (as the Franks were reminded in Constantinople) formerly been part of the Byzantine empire and were still to some extent imbued with Byzantine influences.

When, for example, the Franks entered Jerusalem and took possession of the Church of the Holy Sepulchre – the most venerated church of Christendom, raised in the very place of Christ's resurrection – they found there a church built by Byzantine architects only half a century before and decorated by Byzantine artists; for after the Arabs had destroyed this citadel of the Christian faith in 1009, it had been rebuilt in 1048 (with Arab consent) by a Byzantine emperor. A contemporary description of these Byzantine mosaics survives from just before the middle of the eleventh century, though, since the observer was a Persian to whom the craft of mosaics was unknown, he described them as paintings covered with a fine layer of glass.[12] They included representations of the prophets, a depiction of the Christ Child and renderings of the Annunciation, the Entry into Jerusalem, the Harrowing of Hell, and the Ascension.[13] Repairs and extensions to this church were made by the Crusaders in the first half of the twelfth century and, in renewing and considerably extending the cycle of mosaics,[14] it is quite probable that they made use of Byzantine artists.

Second only to the Church of the Holy Sepulchre in the veneration of Christendom was the Church of the Nativity at Bethlehem. Originally built by Constantine, it had been embellished with mosaics from the century of its foundation, but these had been despoiled during the Arab occupation.[15] Under Frankish rule the church was now so magnificently decorated that even in the Arab world itself the mosaics became a byword for quality.[16] In the words of a later-fifteenth-century Italian observer,[17] the walls were 'adorned with mosaic work with wondrous art on either side, like the Church of St Mark at Venice, with figures from the New Testament and corresponding figures from the Old Testament, and the whole church was either cased with white polished marble or adorned with mosaic work'. A surviving inscription in the mosaic-work tells us that it was finished in 1169.[18] Probably artists from Byzantium were responsible for it. The fact that contemporary inscriptions show that they had the names of Ephrem and Basilius,[19] which were popular in the Eastern Church, is not in itself significant, since we know that the use of Greek names became fashionable in the Frankish community. But though – as we shall see – the Franks had their own competent Western painters, it is probable that, like the contemporary rulers of Sicily[20] and like Desiderius of Monte-cassino earlier and their own Arab conquerors[21] later, they turned to Constantinople for artists in mosaic-work. A contemporary Byzantine observer[22] claims, in fact, that it was the Byzantine emperor himself who 'adorned the entire church with golden mosaic work'. This may well be so, for, at this time, the king of Jerusalem, Amaury, was married to the niece of the Byzantine emperor, Manuel, and in general this was a time of *rapprochement* between Constantinople and the Crusading Kingdoms.

Manuel's interest in reviving the idea of union between the Eastern and Western Churches may well be reflected in the portrayal on the south wall of the seven general councils with statements setting forth the chief doctrinal decisions of each.[23] On the opposite wall were represented the councils provincial and, on both walls, appeared the ancestors of Christ labelled alternately in Latin and Greek. Though we may presume the full cooperation of the Latin authorities, the whole scheme is Byzantine in feeling. The large mosaic of a Tree of Jesse, originally on the western wall, supports the view that, in planning the decoration, East and West worked amicably together, for this symbolism was developed in the West rather than in Byzantium. This Tree has now disappeared, though appreciable sections of the councils on both walls survive, as well as some of the ancestors of Christ and three figures of angels. Of the New Testament scenes in the transepts, four survive, two almost complete (the Entry into Jerusalem and the Incredulity of Thomas) and two only fragmentarily (the Ascension and Transfiguration). Apart from the lavish mosaic decoration, the round columns of the church were painted with single figures of saints reflecting both Western and Eastern interests and inscribed in Latin and Greek. These are now considerably faded. The remains of both mosaics and paintings are too indistinct to admit of any accurate assessment, but, in this joint artistic enterprise of East and West, it seems possible that the mosaicists were Byzantine and the painters were Western artists imbued with Byzantine influences.

Where manuscript-painting is concerned, there is adequate evidence to show that Western artists practised this craft in the scriptorium attached to the Church of the Holy

Sepulchre.[24] The production of *manuscrits de luxe* there had probably already begun in the first quarter of the twelfth century, but the earliest examples survive only from the second. They were commissioned by the small court of Jerusalem in an attempt to emulate the splendours of the Byzantine court, and, in their form of patronage, in their sumptuousness, and in their artistic styles, they mirror Byzantine tastes.

The initials, it is true, reflect influences from the West, but this is due to the fact that here Byzantine manuscripts offered few sources of inspiration, since they took little interest in this form of decoration. The painters of Jerusalem had necessarily, therefore, to turn to the West, where the initial formed a major aesthetic element of the manuscripts. Even these Western styles, however, were given a Byzantine lustre. In a kingdom which saw itself simply as an extension of France overseas, where the royal family and nobility were French, and where sculpture reflected French regional styles, it is surprising to find no French influence on these Western initials. The influences came in the first place from England and in the second from southern Italy.[25] The fact that both these regions were ruled by Normans and that the Normans were well known for their predilection for pilgrimages may offer some explanation for this particular combination of influences. However, it should also be noted that the prior of the Holy Sepulchre, before his elevation to the archbishopric of Tyre in 1127, was an Englishman, William, who made at least one journey to southern Italy. Whatever the historical explanation, it should be observed that English influences, which were strong enough in the twelfth century to reach as far south as Burgundy in metropolitan France, could extend even farther and penetrate into the French kingdom of Jerusalem.

At once the most important, the earliest, and the most lavish of these Jerusalem manuscripts is the Psalter of Melisende, Queen of Jerusalem, which was made between 1131 and 1143 (British Museum MS. Egerton 1139).[26] The fact that the Psalter is prefaced with a cycle of illustrations of the life of Christ indicates influences from England, where this practice, apparently begun by the Anglo-Saxons, was particularly cultivated during the twelfth century. The initials also reflect strong English influences, particularly from Canterbury, though the original English buoyancy is now stringently controlled, and the technique (borrowed from Montecassino) of drawing the initials in black on a gold background gives them a new lavishness and exotic splendour.

The illustrations, however, mirror powerful Byzantine influences, both in style and iconography.[27] These come largely from Byzantine art of the previous century, and may either reflect the strong impression made on the artists by the eleventh-century mosaics of the Church of the Holy Sepulchre or be explained by gifts of eleventh-century painted manuscripts made to the court of Jerusalem by Byzantine emperors.

Four artists worked on this manuscript.[28] The most important, although a Western craftsman trained in a Western scriptorium, must also have had experience in a Byzantine atelier. He signs his work with the Greek name Basilius. It can hardly be a coincidence that, like his great contemporary, Gislebertus, sculptor of Autun, he places his name at the feet of Christ the Judge, for, as we have already suggested,[29] signatures were often made in a spirit of piety rather than of ostentation – in the hope that the work of the artist might be considered a religious offering when Christ came to judge on the

Great Day. Basilius was responsible for the christological cycle of twenty-four pictures which begins with the Annunciation and ends with the Deesis (the portrayal of Christ between the Virgin and St John which symbolizes the Last Judgement). These pictures are of excellent quality and have a vigour of line and warmth of colour which gives them their own individuality. All the same, they depend to varying degrees on Byzantine prototypes. The Deesis (Plate 172) is virtually a copy of a Byzantine model from which even the Greek names survive. The Nativity, on the other hand, is more a compendium of Byzantine influences. None the less, they belong to the art of the West. For, despite the Greek name he adopts and despite his Greek training, Basilius remained a Western artist who never quite mastered the Greek idiom. His colours come from a Byzantine palette but are laid on without the Byzantine refinement. His compositions come from Byzantium but lack the Byzantine spaciousness and fluidity. His figures come also from Eastern art but lack the feeling of inner necessity of the Byzantine originals. The artist cannot suppress his interest in externals – in the texture of draperies, the crystallization of shapes and forms. Just as he signs his Greek name in Latin characters, so he is transliterating a Byzantine art into a Romanesque idiom.

This is even more true of the artist responsible for the remaining figural illustration, which consists of pictures of saints, here typified by the painting of St Peter on folio 206 verso (Plate 173). It is not so much that this artist fails to understand the Byzantine idiom as that he is completely indifferent to it. He uses Byzantine models, but the tones and contours originally employed to suggest the rhythms of a living organism now interest him for themselves and are hardened into an abstract pattern-work. The Byzantine idiom is, in fact, externalized. The artist is less interested in the inner life of the figures than in the interplay of the purely abstract shapes and rhythms of which the figures are composed. In this he typifies the attitude of the Western artist of this time, who was less concerned to understand the art of the East than to assimilate it to his own Romanesque taste.

Other sumptuous manuscripts survive from Jerusalem. But, despite further influences from England and Italy in the first half of the century, the paintings show a growing subservience to the Byzantine East in the second. The evangelist portraits of two Gospel Books of the third quarter of the century (Paris, Bibliothèque Nationale lat. 276, and Rome, Biblioteca Apostolica Vaticana Vat. lat. 5974) are, in fact, straightforward copies of Byzantine originals,[30] and pictures like those of the four standing evangelists in the Vatican manuscript (folio 3 verso; Plate 174) probably represent as close an imitation of Byzantine art as was ever achieved by Western painters. As status symbols of a small court, they are colourful and sumptuous. But, in terms of creative art, they are simply splendid reflections. They lack the vigour and interest of the paintings of the first half of the century, which were much more characteristic of the West's attitude to the East.

Byzantine Influences on Sicily

Though Sicily was far more cosmopolitan in its culture than the Crusading Kingdoms, its art also tended to be controlled by royal courts which looked towards the Byzantine

East. The results in the monumental arts were the great and splendid mosaics commissioned by King Roger and his grandson, William II, at Cefalù, the Palatine Chapel at Palermo, and Monreale.[31] These were actually made by Byzantine artists and, though tempered by Latin tastes and of importance in transmitting Eastern influences to Latin Christendom, they fall within the context of Byzantine and not of Western art.

We know little of the general Latin manuscript-painting on the island.[32] What we do know suggests that its ingredients were similar to those of the Crusading Kingdoms, but that its development was in a different direction. Whereas in Jerusalem the vellum-painting fell more and more under the domination of Byzantium, in Sicily there was an increasing assertion of independence. The school, best known from surviving evidence,[33] was developed under the patronage of Richard Palmer, the English archbishop of Messina from 1182 to 1195, who was a scholar and a patron of the arts, responsible for the decoration of the apse of the cathedral of Syracuse and for presenting it with a silver reliquary. During his pontificate a group of illuminated manuscripts of exceptional quality was produced at Messina. Like the early Jerusalem manuscripts, they show a mingling of influences, but display higher standards of craftsmanship. The primary influences came from the painting of Byzantium and of Jerusalem itself (with which Sicily maintained monastic and commercial connexions) and from the mosaics of Monreale. There was also an admixture of transalpine influence which led, for example, to an interest in figured or historiated initials. An impressive surviving production of this school is a Missal, now at Madrid,[34] which is brilliant and exquisite in its ornamentation. Despite their Western dramatic overtones, the splendid full-page illustrations – as, for example, the Virgin and Child on folio 80 (Plate 175) – are Greek in inscription, Byzantine in iconography, and Byzantine in style; a Gospel Book in Florence[35] and another in Malta[36] have initials influenced from the Jerusalem scriptorium. Four volumes now at Madrid[37] contain paintings influenced by Siculo-Byzantine mosaics and central Italian manuscripts (the St John on folio 175 of cod. 6 is reproduced on Plate 176), and a Bible, also now at Madrid, in no less than seventeen volumes[38] has initials showing a growing conflation of the styles of the East and the West. How much further this process would have continued it is impossible to say, for the Messina School was, in both senses of the word, meteoric: if it was brilliant it was also brief, and it did not survive the death of its patron.

BYZANTIUM AND GERMANY IN THE ELEVENTH AND TWELFTH CENTURIES

The Meuse Valley

IT is tempting to associate the appearance of Byzantine influences on the vellum-paintings of the Meuse valley with our knowledge that contingents from this area participated in the first Crusade and, in particular, with the fact that the greatest secular leader of the Crusade, Godfrey of Bouillon, was a local magnate. However, these Byzantine influences antedate the first Crusade. So, we must suppose that it was through Italy that they found their way to the north and the Meuse valley. Certainly, they were early domiciled in this region which was one of the most important of Europe; it was an area which was economically of great wealth, culturally of considerable distinction, and artistically one of the most vital centres of metalwork of the West. Here, the Byzantine influences combined with various other influences – not least with the native Ottonian tradition – to produce a Romanesque art that was as mature as it was precocious.

The three major Mosan manuscripts of the last quarter of the eleventh century were all written by the same scribe. And, thanks to his lengthy colophons, they can all be located and two can be dated. The scribe was a monk named Goderannus, who originated at Lobbes and was perhaps later transferred to Stavelot, for his earliest manuscript was written for the first house and his two later ones for the second. The first manuscript is the Lobbes Bible, now in the Seminary of Tournai. The colophon[1] tells us that it was finished in 1084 and, by its reference to the fact that the Emperor Henry IV was besieging Rome in an attempt to crush the rebellion of 'that Gregory who is also called Hildebrand', reminds us that the bishopric of Liège gave strong support to the emperor in his conflict with the papacy. The second is the Stavelot Bible (British Museum MSS. Add. 28106 and 28107) which, with the help of Brother Ernesto, was completed in 1097 after four years. This was the year of the first Crusade, to which the colophons of both volumes refer.[2] The third manuscript is a *Josephus* (Bibliothèque Royale MS. II 1179). It is of less artistic interest than the others and is undated, but was probably made within a few years of the Stavelot Bible, for it is artistically related to it.[3]

The illustrations of the Lobbes Bible show strong influences from Italy and are highly linear in treatment. One or two (for example, the picture of Jeremiah on folio 196 verso) even suffer from an excessive effusiveness of line which the art of this area occasionally shares with that of Flanders. The artistic interest of the Bible is twofold. First, it shows a full appreciation of the historiated initial. Secondly, its style and iconography reflect influences from Byzantium.

One of the distinguishing features of the great twelfth-century Bibles was the use of the historiated initial, and here we find this practice already highly developed. The illustrations of various Books are succinctly contained inside initials. Despite some Carolin-

gian influences the iconographic sources of these scenes and the stylistic sources of the figures are primarily Italo-Byzantine. The Byzantine 'damp-fold' has occasionally (as on folio 116, for example) been hardened into such metallic segments that at some stage in the transmission of stylistic influences from south to north it seems possible that metalwork acted as an intermediary. This association with metalwork is found in other Mosan manuscript paintings, particularly in the Stavelot Bible, which is a greater and more interesting monument than its Lobbes predecessor, and represents in some ways an anthology of influences.

The Stavelot Bible[4] is divided into two volumes and, with one magnificent exception, is illustrated by historiated initials, executed by a number of hands and betraying various influences. In the decoration there are influences both from the Channel School and from Ottonian art, and in the figure style influences from Carolingian, Byzantine, and Ottonian sources.

The Carolingian influences are ultimately from the Reims School and may possibly represent a delayed testimony to the fact that Ebbo of Reims, with whom the style was particularly associated in its origins, had himself been an abbot of Stavelot.[5] The felicity with which the medieval artist could pick up a style of the distant past and infuse a new animation into it is a continual source of surprise, and these drawings – far from being dead and outmoded – have a delightful ease and freshness. They are among the most vibrant and delicate pictures of the two volumes and have none of that garrulity of line which afflicts some of the illustrations of the Bible. A trained eye might detect in these 'Carolingian' drawings a slight infusion of Byzantine influence. These Byzantine influences emerge much more strongly elsewhere and in their linear emphasis suggest transmission through Italy.

Ottonian influences (particularly from Echternach) are also found. These influences from the German past, cross-fertilized with others from the Byzantine present, inspire the most majestic and impressive of all the illustrations – the full-page Christ in Majesty (British Museum MS. Add. 28107 folio 136; Plate 177). Byzantine influences appear here in the 'damp-folds' of the lower drapery, but the real line of descent is from Ottonian representations of the Majesty, particularly those of Echternach, with which Stavelot had been closely associated. The Christ should in particular be compared with the Majesty of the Uppsala and Madrid Gospels (the last of which we saw earlier was overpainted by a Byzantine artist). In view of the developments towards massiveness and weight in Ottonian art which contributed so much to the Romanesque styles of Europe, it is fitting that this early example of the monumental in Romanesque painting should be found on German soil. The Stavelot Christ has indeed even more impact than its Ottonian predecessors, and its feeling of power is enhanced by the fact that the figure is squeezed into the frame and can barely be contained by it. The resultant impression is of a figure of such size and power that one feels nothing can hold it, and the picture becomes endowed with a feeling of monumentality on the one hand and claustrophobic tension on the other. This is a device which became popular in the twelfth century in France (see Plates 207 and 208)[6] and England,[7] though it was never more successfully used than here. The Romanesque maturity of this figure is such that some have argued

that it is a later addition of the original manuscript. In fact, however, contemporary German metalwork shows a similar maturity, and there is no obvious reason to doubt the date of this painting.

It has been said that the great metalworkers of the twelfth century might have found in the Stavelot Bible sources of inspiration particularly for obtaining movement in space by the use of back views, foreshortening, and moving contrappostos.[8] This may well be so, but there can be no doubt of the converse, namely that the Stavelot Bible itself was influenced by contemporary metalwork, which was astonishingly precocious in this area. It was especially developed in its sense of modelling, as the remarkable figures of the bronze font of Reiner of Huy,[9] made at Liège or Huy between 1107 and 1118, so clearly demonstrate. One of the most magnificent of the Stavelot historiated figures (folio 161 verso vol. 2) has a boldness and sense of modelling in the face and a feeling of taut weight in the draperies that suggests the influence of repoussé work. Other figures, such as the prophet on folio 197 verso of volume 2, show a disposition of highlights on the draperies which strongly suggests the influence of champlevé enamels. This early wave of influence from metalwork set into a strong tide during the course of the twelfth century and joined with a fresh current of Byzantine influence to produce an art with a distinctive Mosan personality.

A small group of manuscripts probably made near Liège in the third quarter of the twelfth century is of special importance.[10] It includes a splendid but now fragmented Psalter[11] with full-page illustrations to the Old and New Testaments which are iconographically derived from the Byzantine mosaics of Sicily. There is also the Averboden Bible (Liège, Bibliothèque de l'Université MS. 363 C).[12] To its figures Byzantine influences have given not only new weight and spaciousness but also a brooding sense of melancholy, matched by the sombre colours in greenish-blues and golds lightened by orange and highlighted blues. The draperies here have a lushly linear quality which reminds one of a comparable taste in eleventh-century Mosan painting and also of a similar taste in twelfth-century metalwork, where it was used to add richness of texture to the draperies. The influence of metalwork asserts itself unmistakably in the picture of a lioness on folio 57 (Plate 178), which has the weight and strength and robustness of a bronze statue.[13] We find its influence again in the picture of a physician in a manuscript probably from the Mosan area and now in the British Museum (Harley 1585 folio 13; Plate 179).[14]

Artistically derived in part from the Averboden Bible,[15] the two-volume Floreffe Bible in the British Museum (MS. Add. 17738) exceeds it in importance. It dates from about 1160 and, though it may have been made in a Liège scriptorium, it was in the possession of Floreffe during the Middle Ages. Here, Byzantine influences are strong and influences from metalwork reach a new peak.[16] In the illustrations (see Plate 180) the draperies are divided into segments reminiscent of geometric champlevé work: the backgrounds have the crisp colours of enamels and, like enamels, are divided into sharply separated zones: the compositions have the geometric disposition – that is, the architectural ground-plan – of metalwork, and into them are incorporated those explanatory inscriptions on scrolls which are particularly appropriate to metalwork, where any text

must necessarily be incorporated in the picture. The illustrations to the Floreffe Bible are extremely close in spirit to figured enamels, and for their real terms of reference we must turn to contemporary enamel-work. The portable altar of Stavelot,[17] for example, shows similarities of composition, and the Saint-Bertin cross has stylistic affinities.

The allegorical and symbolic nature of the illustrations also reflects the same influences, for, apart from stained-glass windows (which in the crisp and fine style of the Mosan area[18] itself exhibit influences from metalwork), it is in metalwork that we find the earliest and most developed use of these types and antitypes. Both the Stavelot altar and the Saint-Bertin cross, therefore, have scenes which prefigure the events of the New Testament with incidents from the Old. In the Floreffe Bible there is a comparable juxtaposition of the type and antitype, the literal and the allegorical. So, below the Crucifixion scene in front of St Luke's Gospel (folio 187; Plate 180) is a representation of the Old Testament sin-offering of the calf which prefigures it – a relationship emphasized by quotations from the Old Testament and the New. Associated, too, with the scene of the Ascension before the text of St John (folio 199) are symbolic figures which refer to the Books of Ezechiel and Deuteronomy. Conversely, the Book of Job is illustrated by New Testament scenes including the Transfiguration and the Last Supper.

The formative influence of metalwork on painting was by no means confined to the Meuse valley. Farther west, on the border of Flanders and the Empire, we find it emerging with particular force in masterpieces from Saint-Amand like the magnificent Life of St Amand (Valenciennes, Bibliothèque Municipale MS. 501; see Plate 209), some of whose figures are obviously influenced by champlevé enamels, and the distinguished Sacramentary of Saint-Amand (Valenciennes, Bibliothèque Municipale MS. 108; see Plate 210), which has an accomplished Crucifixion scene in which the figures are given a fine incisiveness of line. And if we travel deeper into Flanders and France, we shall find it at Saint-Bertin (Saint-Omer, Bibliothèque Municipale MS. 12, and Boulogne, Bibliothèque Municipale MS. 14), at Marchiennes (Douai, Bibliothèque Municipale MS. 250), Liessies (Avesnes, Société Archéologique detached leaf; see Plate 211), and so on.

Returning, however, to Mosan art, we may draw attention to its influence on illumination of the Lower and Middle Rhineland. At Cologne, for example, manuscripts like the St Pantaleon Gospels (Cologne, Stadtarchiv MS. 312a)[19] of the mid twelfth century have illumination which (like that of the Floreffe Bible) shows mixed influences from metalwork and Byzantium, and a related style appears in the Siegburg Lectionary from Cologne or Siegburg (British Museum Harley MS. 2889). Other Mosan influences are found at Arnstein, near Coblenz: for example, in the Harley Bible (British Museum Harley MSS. 2798 and 2799) of about 1175, where the colours are stronger than in Mosan work but where both figure and initial styles relate to the Floreffe Bible. These Mosan influences combined with a new surge of influence from Byzantium to produce a more individual style at Worms, where, in another Bible in the British Museum (Harley MSS. 2803 and 2804),[20] we find an initial style that is Mosan but a figure style that has some of the strong Byzantine emphasis of the Swabian School that we shall come to later.

North-West Germany

A close reading of medieval sources suggests that metalwork appealed to the medieval taste with particular strength. This emerges in the chronicles and is quite clear in the two major treatises on art of the Romanesque period. So Suger, who has not a word to say about the sculpture of Saint-Denis, which was then revolutionizing the styles of Europe, gives considerable attention to the golden altar frontals, gilded doors, golden chalices, crucifixes, and reliquaries of the monastery. Theophilus, though interested in all the arts of the Romanesque period, devotes four times as much space to metalwork as to any other craft. It is not surprising, therefore, to find metalwork affecting the styles of painting, though both crafts were now so thoroughly imbued with Byzantine influences that, in the broader context, their own interplay is only a minor variation on the major theme of the relationship between the arts of Western and Eastern Christendom.

Theophilus himself, though skilled in many crafts, was primarily a metalworker. He is, in fact, to be identified with Roger of Helmarshausen, one of the greatest German metalworkers of the early twelfth century, who significantly influenced the development of this craft in Germany and whose surviving work at Paderborn[21] indicates the impact of Byzantine styles on metalwork there. Helmarshausen was the most important centre of illumination in Saxony and Westphalia,[22] but it was an even more important centre of metalwork, and it is not surprising, therefore, to learn that paintings here were influenced by metalwork.[23]

A group of Helmarshausen manuscripts of the mid twelfth century has illumination stylistically connected in some ways with Mosan art but also influenced by the style of the earlier altars of Roger of Helmarshausen at Paderborn.[24] This is evident in the treatment of draperies, heads, and hair, in the decoration of the arcades, and in the use of medallion figures. Its pictures are richly coloured in gold, purple, and other warm colours and it includes a Gospel Book (formerly MS. 120 of the Dyson Perrins collection) and three manuscripts made for two houses with which Helmarshausen had ties of confraternity – Lund in southern Sweden, and Corvey, which was itself an important artistic centre. The Lund manuscripts are Gospel Books (Uppsala, University Library MS. C.83 and Copenhagen, Kongelige Bibliotek MS. Thott. quart 21) and the Corvey one is a Confraternity Book (Münster, Staatsarchiv MS. 1, 133).

The development of illumination at Helmarshausen owed much to the patronage of Henry the Lion (1129–95),[25] who was virtually sovereign in the north of Germany until his downfall in 1180 and who devoted his final years to cultural pursuits. He commissioned two particularly splendid manuscripts there. A third, more modest but pleasing, manuscript (Baltimore, Walters Art Gallery MS. 73) was probably made at his instruction for his daughter Gertrud,[26] who in 1177 married at Lund in southern Sweden the Crown Prince of Denmark. The first, and most costly, manuscript was a Gospel Book made about 1175 for presentation to Brunswick Cathedral (formerly Collection of the Duke of Brunswick). Apart from dedication verses in gold on purple, it contains a sumptuous dedication picture featuring Henry and his wife Mathilda with two saints.

Above them is a Virgin and Child of undoubted Byzantine inspiration. Later in the manuscript there is another representation of them both, here being crowned in the presence of their relatives with a portrayal of Christ and His saints below. The manuscript has a large number of initials (the colours of which reflect the influence of enamels); it also has canon tables with a sequence of personified virtues and vices, a Majesty and some Creation scenes, a formalized representation of the genealogy of Christ, and a selection of New Testament scenes, two to a page. The second manuscript, probably by the same artist, is a Psalter (British Museum MS. Lansd. 381) which is no longer complete but which has pictures of Henry and his wife in the Crucifixion scene. In such details as the fluttering folds, but, most of all, in the long slender proportions of the figures, there are influences here from England,[27] where Henry had been exiled, and with which he had a permanent association, for he was married to the daughter of the English king Henry II. These English influences, however, were swamped by other influences from metalwork, and it is these which give pictures like that of the Purification and the two Old Testament prophets with their testimony (folio 8; Plate 181) their highly ornate and somewhat 'frozen' look. Such influences account not only for the delicate 'filigree' scrollwork in the backgrounds, but for the general sheen and colour and the fastidious sumptuousness of the whole. There can be little doubt that the colourful and contrived splendour, which, in effect, registers in paint the values of goldsmithery and enamels, is one which would have made a particular appeal to the tastes of the contemporary.

Some English influence continued at Helmarshausen to the very end of the twelfth century and even into the thirteenth,[28] and one manuscript which is firmly dated 1194 (Wolfenbüttel, Herzog-August Bibliothek MS. Helmst 65) even betrays influences from Anglo-Saxon art produced before the Norman Conquest. However, the influences from metalwork remained predominant and gave to the paintings of Helmarshausen their characteristic qualities of formal structure and ornamental detail. Still (as I have already remarked), we should never forget that the metalwork itself in this period was imbued with Byzantine influences and that the painter who was consciously influenced by the one was very often unconsciously influenced by the other.

Originally there was a considerable number of Romanesque wall-paintings in North Germany, particularly along the Rhine. Changes of taste in the fourteenth and fifteenth centuries led to the loss of several, for at this time some Romanesque paintings, like those in the side-chapels of St Maria im Kapitol at Cologne, were covered with Gothic pictures. Their return to favour in the nineteenth subjected them to even more devastating hazards, for many were then hopelessly mutilated by the various attempts at restoration. The Majesties of the abbey church of Knechtsteden on the Lower Rhine and in the apse of St Gereon at Cologne: the elaborate scheme of decoration in the church of Schwarzrheindorf near Bonn: the frescoes representing the victory of the faith in the chapter house of the abbey church of Brauweiler: these are but a few of the victims of this academic goodwill. Very few frescoes survived unscathed, but these few all agree in their testimony to the Byzantine influences that were sweeping over Germany.

Among these are the late-twelfth-century frescoes in the crypt of St Maria im Kapitol

at Cologne,[29] which represent scenes from the life of John the Baptist (the vault is illustrated on Plate 182). Those on the walls are in poor condition, but the scenes in the vault are well preserved. The elegant proportions of the figures, which are tastefully portrayed in a linear style, are clearly derived from Byzantine, or more probably Italo-Byzantine, sources. The surviving fragments of a cycle of the life of Christ in the crypt of St Martin at Emmerich on the Lower Rhine[30] are in a less taut and less linear style. But, as we see from the portrayal of Christ before Caiaphas (Plate 183), they also reflect obvious Byzantine influences in their use of dramatic highlights and the fall of the draperies, as well as influences from northern France. They probably belong to the latter part of the twelfth century.

If not of the finest quality, the frescoes of the church at Idensen[31] have the distinction of being among the best preserved of northern Germany. They include a Majesty and biblical scenes which tend to give some emphasis to Peter as the prince of the apostles. The influences again are Byzantine, though the style is somewhat mannered. A more suave example of the assimilation of Byzantine influences is the style of the famous painted ceiling of St Michael of Hildesheim,[32] which is dominated by an elaborate Tree of Jesse. Made after the fire of 1186, one is already conscious in it of a relaxing of the Romanesque intensity and a stirring of Gothic.

Denmark and Sweden

Though outside the borders of Germany, the kingdoms of Denmark and Sweden fall within the context of its art. Here Byzantine influences were being transmitted both from Germany itself and from Italy. Unhappily, here again nineteenth-century restorations have drastically reduced the number of actual original works of twelfth-century art. In what survives there is an occasional decorative feature, which seems particularly characteristic of these Scandinavian areas, such as the frieze with medallions containing busts or birds or floral motifs, which ultimately derives from Italo-Byzantine art and which is found in such Danish churches as Hjørlunde and Alsted.[33] In figural painting, however, the trends were the same as those of Germany and at times directly influenced from it. The fragmentary Last Judgement in the church of St Ibbs at Roskilde,[34] for example, suggests influences from Saxony. It is still Romanesque, though painted in the early thirteenth century. Danish apse paintings can show family resemblances. So, the pictures in the Danish churches of Alsted, Slaglille, Hagestad,[35] and Saeby, the latter (Plate 184) much restored, are all similar in composition: a Majesty surrounded by symbols of the evangelists with the Virgin and St John accompanied by two other figures or archangels below. The compositions are elegant but the styles highly dubious, since they are all so much restored. However, the more authentic painting on the triumphal arch at Slaglille of a donor presenting a model of the church would suggest influences from Italy.

Italo-Byzantine influences are very clear in Swedish painting. In the parish church of Garde[36] on the island of Gotland, for example, the two figures of saints on the intrados of the tower arch, happily unrestored, carry reminiscences of Italo-Byzantine painting

at Rome of a much earlier date. Fragments of paintings at the church of Källunge,[37] also on Gotland, are again very Italo-Byzantine in inspiration. At Övraby[38] there is on the triumphal arch a fragment of a donor with a model of the church which, as at Slaglille, indicates Italian influence. The apse contains the traditional Majesty (though here with saints, instead of apostles, below) and the border around the apse, punctuated with heads in medallions, again suggests influences from early Italo-Byzantine art, possibly trans-mitted by manuscripts. We find busts in medallions also in the church of Finja,[39] where there is a dignified portrayal of the Last Judgement from the end of the twelfth century. Unexpected influences from Spain emerge in the composition of a late-twelfth- or early-thirteenth-century apse painting in the church of Lackalänga.[40] The elaborate Tree of Jesse (Plate 185) which decorates the vault of the choir of the church of Bjäresjö[41] has its parallels both in French manuscript-painting of the turn of the century and in the painted ceiling of St Michael at Hildesheim. It is flanked by scenes from the Old and New Testaments to the south and north. The apse contains a Trinity with the apostles and the Virgin and St John, the triumphal arch has a half-figure of Christ and other figures, and there is a Majesty above the arch leading to the choir. These paintings are comparatively extensive but they are also considerably restored. It is therefore hazardous to try to assess them. As far, however, as one can read their style through the work of the restorers, they suggest a hint of the spirit of Gothic which, in this region, may mean that they belong to the thirteenth century and not to the twelfth.

As far as Norway is concerned, it would be pleasant to take the Romanesque ingre-dients which persist into the thirteenth century as an excuse for dwelling on the paintings of the stave churches, for their fresh colours and clean line make them particularly appealing. However, chronologically they come after our period and stylistically (what-ever Romanesque elements remain) they belong to the Gothic aesthetic.

South Germany

We might expect that one important area for the reception of Italo-Byzantine styles in the West would be southern Germany, which is so close to Italy. And this is what we do find. Here the most significant centre was Salzburg, which was a great ecclesiastical power in the twelfth century. It was also an artistic centre of the first importance, as the literary sources alone make clear, for they record the existence there in the twelfth century of architects, goldsmiths, carvers, and painters.[42] The waves of Byzantine in-fluence which surged over Western art in the twelfth century are nowhere better observed than in the manuscript-painting here. There was, in fact, a direct relationship between Salzburg and Byzantium in the second half of the eleventh century when Archbishop Gebhard (1060–88) received a costly present from the Greek emperor,[43] but, historically, it seems probable that many of the twelfth-century Byzantine influences came through Italy.

This would derive some support from the early-twelfth-century Florian Bible (St Florian, Stiftsbibliothek cod. XI. 1),[44] whose initials and figures are of Italian inspiration. In the second quarter of the century Italo-Byzantine influences are evident in another

giant Bible (Michelbeuern, Stiftsbibliothek cod. perg. 1)[45] which is known as the Walter Bible, since it was purchased by Abbot Walter (1161–90) for his monastery of Michelbeuern. The second volume is missing, but the first has a number of illustrations in warm colours some of which show a combination of Italo-Byzantine and Ottonian styles. The Byzantine influences are particularly apparent in the scene of Daniel in the lions' den on folio 191 (Plate 186).

The middle decades of the twelfth century saw a remarkable blossoming of manu-script-painting.[46] To this period belongs the Admont Bible (formerly Admont, Stifts-bibliothek cod. I, 1 and 2, now Vienna, National Library of Austria ser. nov. 2701–2),[47] which was, perhaps, made in the 1150s and is lavishly illustrated with twenty-eight pictures, with another picture on two detached leaves in Paris.[48] These show Byzantine influences[49] not only in style, iconography, and in the use of antique personifications but also in actual techniques such as the modelling of the flesh tones. There is, however, at times a sharp linearization which betrays the fact that Italy or Sicily was the intermediary. Confirmation of this is given by the remarkable kinship between the figure of Joseph in one scene (folio 27 verso) and the figure of Jacob in the Palermo mosaics.[50] Some of the figures, like that of the prophet Haggeus on folio 246 (Plate 187), which also has points of comparison with Cistercian paintings, are highly accomplished and even sophisticated with their suavity and poise and elegantly drawn-out proportions. Others, like those in the scene of Daniel in the lions' den on folio 227 (Plate 188), have a feeling of strength and power. Related to the styles of this Bible are the statuesque and Byzantine-influenced half-figures of saints at Kloster Nonnberg[51] of the mid twelfth century which are all that remains at Salzburg of monumental paintings of the period, for, though we know that Salzburg Cathedral itself was decorated with frescoes[52] between 1106 and 1146, this cycle does not survive.

The fifty-six miniatures of the Gospel Lectionary of St Erentrud (Munich, State Library Clm. 15903)[53] are also strongly Byzantine. Here, however, as we see in the picture of the Magi on folio 17 (Plate 189), the artist has imbued the formal Byzantine elements with a psychological intensity which may owe something itself to Byzantium, but which has been reinforced by influences from Ottonian sources, and it is not alto-gether surprising to learn that some of the christological scenes derive their iconography from Ottonian paintings. Though the colours are brighter, there is the same emotional feeling in the illustrations of a Gospel Book made at Salzburg for Passau (Munich, State Library Clm. 16003).[54]

The same is true of one of the most sumptuous of all the manuscripts of this great school (formerly Stiftsbibliothek St Peter cod. a. XII, 7, and now Vienna, National-bibliothek cod. S.N. 2700).[55] It is an Antiphonary which, besides the dedication pictures, has no less than fifty biblical scenes, disposed two to the page. Some of these are icono-graphically related to the Gospel Lectionary, but others, for example the Nativity and the Harrowing of Hell, show a particularly close association with Byzantine sources. These sources must account for the drapery styles and the heavy modelling and also for the dramatic highlights, which are here exaggerated and combine with the feverish glances of the figures to give a histrionic effect. In those pictures of the cycle where the

bright body-colours are eschewed (typified here by Christ's double appearance to the disciples after His Crucifixion; Plate 190) the effect is quite different. In these tinted drawings, set against backgrounds of blue and green which owe something to metal-work, we come face to face with Salzburg art at its finest – the line has quality, the composition clarity, and the atmosphere a general assurance. These tinted drawings, in fact, point the way to the most consummate art of the Salzburg School: the drawings of a number of manuscripts of the mid twelfth century, known, from the name of a scribe of a related group, as the Liutold School.[56] Here Byzantine influences are as strong as ever, but they are now completely absorbed into the canon of Romanesque. At times, it is true, there can be an over-effusiveness of line, but in general we find a vivacity of rhythm, a dignity of poise, and a majesty of conception which place them among the masterpieces of the West.

They include, in an *Augustinus* at Munich (State Library Clm. 15812 folio 1 verso),[57] a dedication picture of Archbishop Eberhard giving a manuscript to St Rupert, in which the saint is represented with particular felicity (Plate 191). The figure itself is given a sculptural quality of weight and the draperies are endowed by linear rhythms with an ornamental texture. In the portrayal of the miracle of Lazarus (Plate 192) in a Book of Necrologies (Stiftsbibliothek St Peter cod. a IX 7, pag. 128)[58] the figures in red and brown combine a suavity of line, a nobility of proportions, and a nice balance of composition. The drawings of episodes from Genesis around a first initial of a Salzburg Bible (formerly Stiftsbibliothek St Peter cod. A. XII. 18–20, vol. 1 folio 8; Plate 193)[59] are particularly sensitive examples of this style, and a drawing of Christ in Majesty in Vienna (Hofbibliothek cod. 953; Plate 194) is a particularly powerful one. This splendid and monumental figure, which might almost have served as a sketch for a wall-painting, shows the immense impact of Byzantine art. All the elements – the posture, the drapery folds, and even the weighted rhythms – are thoroughly Byzantine, but the artist has, in fact, taken over the externals of Byzantine art to express a very different aesthetic. He replaces the fluidity of the Byzantine prototype by a sharpened astringency. He ignores the inner radiance of the figure which, in Byzantine hands, would have been its essential quality and instead gives us a strong and incisive statement of grandeur, aloofness, and closely knit power.

Salzburg continued until the end of the century to produce important illuminated manuscripts:[60] manuscripts like the Erlangen Bible (Erlangen, Universitätsbibliothek cod. 121)[61] and its related codices, which combine sumptuousness with quality: manu-scripts like the St Erentrud Orational of about 1200 (Munich, State Library Clm. 15902),[62] where a new wave of Byzantine influences is very clear in the accomplished figural style of pictures like that of Christ between St Peter and St Paul (folio 113 verso; Plate 195). In fact, in the twelfth century Salzburg was one of the very greatest centres of manuscript-painting in Europe.

Situated as it was on a major route between Italy and the north, it is probable that Salzburg played a major rôle in the transmission of Italo-Byzantine or Siculo-Byzantine styles through transalpine Europe, although, with the surge of Byzantine influences through the West, it is always difficult to establish whether any given development is

a related or simply a parallel one. We can, however, trace the effect of its styles on the manuscript-painting of Seitenstetten, Lambach, Göttweig, Passau, and Seckau.[63] It also had an impact on wall-paintings. For example, the mid-twelfth-century remains of a Majesty and of apostles under arches in the choir of the Rosenkranzkapelle at Maria Wörth,[64] near Friesach in Carinthia, show a relationship with the Salzburg Antiphonary and Gospel Lectionary. There is also some evidence of its influence on other wall-paintings of south Germany and also the Tirol.

Particular mention should be made here of the related or parallel style of the paintings at Perschen not far from Regensburg,[65] where, in the central Christ in Majesty, Byzantine influences have been impressively converted into terms that are crisp and Romanesque. Associated with these are also the twelfth-century Reichenau wall-paintings in the apse of Niederzell,[66] dominated by the Christ of the Apocalypse between St Peter and St Paul, though the style here is already softer and less categorically Romanesque. In the church of Prüfening at Regensburg[67] there are cycles of frescoes in a comparable linear idiom, though these are so restored that assessments are difficult; however, we know that in the manuscript-painting of Prüfening, Salzburg influences were very strong.

At the centre of Regensburg, which encompasses Prüfening,[68] there was produced in the second half of the twelfth century a series of manuscripts illustrated by Byzantine-inspired drawings, outstanding in style, and showing the closest kinship with the art of Salzburg. Almost all are now in the State Library of Munich. An early example is an *Isidorus* (Clm. 13031)[69] of about 1150, containing a portrayal of Adam holding a tabulated representation of the degrees of consanguinity, which was to be widely familiarized in Romanesque art by its use in copies of Gratian's *Decretals*. A manuscript of medical tracts and biblical glosses (Clm. 13002)[70] is a little later, for it was written between 1158 and 1165. Its illustrations are of particular interest. One shows man as the microcosm of the universe – the hair related to the grass of the fields, the chest to the air, and the head, with its seven openings, corresponding to the seven planets of the celestial heavens; others illustrate different forms of medical treatment, and yet others interpret biblical scenes in a highly mystical way. An *Hexaëmeron* of St Ambrose (Clm. 14399) contains an impressive cycle of scenes of the Creation from which the creation of the stars on folio 52 is illustrated (Plate 196). All the pictures are obviously under strong Byzantine influence and closely linked to Salzburg work. The same is true of a *Lives of the Apostles* (Clm. 13074), the quality of which is represented by the scenes of St Peter and St Paul on folio 15 verso (Plate 197). A *Laudes Sanctae Crucis* (Clm. 14159)[71] has some typological scenes of particular interest and other illustrations which evince that particularly German genius in the Romanesque period for expressing profoundly mystical and allegorical thought in terms of artistic clarity. This genius emerges at its most remarkable in one of the greatest of all twelfth-century manuscripts, which, though produced in an area of Germany far removed from Salzburg and Regensburg-Prüfening, seems to be related to art there not only by general terms of style and particular points of iconography but also by the immense breadth of its interpretative vision. The manuscript is the *Hortus Deliciarum*.

The Hortus Deliciarum

The *Hortus Deliciarum* was produced in Alsace at the nunnery of Sainte-Odile, a house which recruited its nuns from the noble families of Swabia and Alsace. Its abbess in 1167-95 was Herrad, who composed this literary and pictorial 'Garden of Pleasures' for the edification of her nuns. 'For the love of you, my sisters in Jesus, and for the honour of Christ and of the Church and with the inspiration of God, I have composed this book. Like a small, active bee, I have extracted the sugar of the flowers of divine and philosophical literature and from it formed a honeycomb running with honey to divert your soul . . . and preserve you from the vanities of this world and urge you to eternal beatitude.' The manuscript itself was destroyed in the Franco-Prussian war at the siege of Strasbourg in 1870. However, copies had already been taken of several of the remarkable number of pictures,[72] and, furthermore, drawings from the same workshop survive on a long strip of parchment in the British Museum (Add. MS. 42497)[73] which probably originally decorated a flabellum (an ornate fly-whisk used during divine service).[74] From all this evidence, it is clear that most of the original tinted drawings were in a highly linear Byzantinizing style, comparable to that of Salzburg and its related schools and, in quality, every bit as fine. There is further evidence of Byzantine influence on the iconography, which, as far as the Adam and Eve cycle is concerned, has been worked out in detail.[75]

In effect, the *Hortus Deliciarum* was an encyclopedia. But there is a whole world of difference between this encyclopedia of the Romanesque period and earlier compilations, like that of the Carolingian *Hrabanus Maurus* which we have earlier mentioned. The latter, despite some allegorical extensions, was largely based on the more famous encyclopedia of Isidore of Seville[76] and was, like that, an attempt to salvage the learning of the ancient world in dryly etymological terms. By the time of the twelfth century, however, the encyclopedist's interest was far more universal and was in a knowledge that was Christian and cosmological.[77]

An earlier Romanesque encyclopedia exists at Ghent (University Library MS. 16).[78] It is the original illustrated text of Lambert of Saint-Omer, which was made about 1120. Like the work of Herrad, it is frankly compilatory and begins with much the same approach (which both may have derived from a popular monastic treatise, the *Diadema Monachorum* of Smaragdus).[79] Lambert's compilation is offered as a *Liber Floridus*, a bouquet of flowers plucked from the heavenly meadow 'that the faithful bees may fly together to them and drink from them the sweetness of the heavenly potion'. It shows some interest in local history, but everything possible is related to Church teaching and dogma. So, man is pictorially conceived in relationship to the six ages of the world propounded by St Augustine; the trees represented are eight in number, to designate the eight beatitudes, and the work concludes with pictures of the apocalyptic age and the Final Judgement.[80]

Compared to the *Hortus Deliciarum* the *Liber Floridus*, however, is rudimentary. In Herrad there is a vast cathedral of knowledge, extensive and integrated, mystic and

visionary, human and divine. This is typified in one of its numerous illustrations by the portrayal of philosophy and the liberal arts – a picture which bridges all knowledge and yet which is represented with clarity and economy (Plate 198). The *Hortus* deals with all history from the Creation onwards, spanning the Old and New Testaments and the history of the Church until the final Last Judgement. Dovetailed into these main themes are ancillary ones. So, the Babylonian confusion of tongues offers an opportunity for a discourse on pagan theology and philosophy, the exodus from Egypt leads on to a discussion of geography, the birth of Christ to a consideration of ancient history up to the time of His death, and the star of the Magi to the subjects of astronomy and medical astrology.[81] Here is a whole Bible of medieval learning, envisaged on the grandest, most universal, scale and always ennobled by its basic underlying interest in man and his salvation. Not the least remarkable part of this immense undertaking was the degree to which it relied on pictures to convey its information. The (reconstructed) text seems to have been used to explain particular points and to underline the mystical or allegorical sense of the pictures, but it was on the pictures themselves that Herrad chiefly relied. Originally, there were no less than 636 of these containing something like 9,000 figures. Even through the copies of the nineteenth century we can see that these must have radiated a feeling of fastidious elegance and mystical exaltation which did full justice to the grandeur of conception of the whole. This manuscript, before its loss, was certainly one of the great monuments of art of the twelfth century.

Though it is much less encyclopedic in range than the *Hortus Deliciarum*, we do possess illustrated manuscripts of another important text, which was likewise inspired by a German abbess and likewise evinces the German genius for representing the abstract and mystical in terms of pictorial clarity. This is the *Speculum Virginum*, which was written at the request of an abbess, Theodora, by Conrad of Hirsau and which offers the nuns a 'mirror' in which to see their path to Christ. The manuscript contains a number of pictures which, though theological and even mystical in content, are surprisingly lucid in meaning. Among them, for example, is the picture (Plate 199) of the nuns struggling up the ladder of virtue and thrusting aside the evils of this world in the form of a dragon and demon to reach their Heavenly Bridegroom (a concept itself Byzantine in origin). The earliest surviving manuscript (British Museum MS. Arundel 44) probably derives from Swabia and may have been made during the author's lifetime, but other twelfth-century copies exist of which the finest (which is contemporary with the *Hortus Deliciarum*) is from Clairvaux in Burgundy (Troyes, Bibliothèque Municipale MS. 252). Its illustrations make it clear that some Cistercian art continued in the second half of the twelfth century even in St Bernard's own monastery. They also show the strong penetration of German influence into Burgundy.

BYZANTIUM AND FRANCE IN THE TWELFTH CENTURY

Burgundy

SOME, at least, of the Byzantine influences which swept through Burgundy in the first half of the twelfth century probably came via Germany. The two major artistic centres of Burgundy, Cluny and Cîteaux, were in fact both near the German border. Where Cluny is concerned, we know that its twelfth-century initials showed strong Ottonian influences[1] and that one of the most highly regarded members of the scriptorium in the first half of the twelfth century was a German from Trier.[2] We know, too, that if during the conflict between emperor and papacy the abbots supported the popes, they also maintained a very close connexion with the German emperors. In a spiritual sense St Hugh (1049–1109) may have been the special son of the pope, but he was also in a very literal sense the godfather of the emperor. The fact, however, that some Byzantine influences (particularly on manuscript-painting) reached Cluny after traversing Germany does not mean that other influences (particularly on wall-painting) might not here come direct from Italy and Rome.

Founded in 910, the house of Cluny in Burgundy had by the twelfth century become the head of the greatest monastic Order in Christendom. It was an Order linked together in an international organization under the firm control of the mother house, which was subject only to the papacy. This direct and close connexion between Cluny and Rome was always cultivated and emphasized. On the one hand it kept Cluny free of diocesan control. On the other it offered Rome a means of maintaining papal authority over the bishops. If Cluny turned frequently to the papacy, the papacy itself was the first to recognize the reputation which a succession of great and saintly abbots had brought to Cluny. The autocratic Gregory VII did not disdain to solicit her prayers, and it was said that one of his predecessors, Stephen IX, was only saved from the torments of the devil on his death-bed by the presence of the great abbot of Cluny, St Hugh. To this Cluniac abbot another pope, Urban II, turned for guidance, imploring him on the day of his consecration to come to Rome or at least send some brothers of Cluny. There are, perhaps, undertones of this special relationship between Rome and Cluny in the emphasis on the power of St Peter and the saints of Cluny in the masterly Cluniac wall-paintings at Berzé-la-Ville.[3] These are the most famous surviving monuments of Cluniac pictorial art and show what spaciousness and dignity Italo-Byzantine influences could give to Romanesque frescoes.

The priory of Berzé-la-Ville is still locally known as the 'Château des moines', for it originally belonged to the house of Cluny, which lay only a few miles to the north. The lower chapel has traces of decorative painting, and in the nave of the upper chapel are

figures of saints and what remains of scenes from the Gospels of which only the Entry into Jerusalem can now be discerned. Neither of the nimbed abbots painted on either side of the arch leading into the apse is identified, but they almost certainly represented two of Cluny's former saintly pastors. It is in the apse itself, however, that we find the really significant work of art, which is one of the finest of all French Romanesque wall-paintings.

A magnificent Christ in Majesty is seated within a mandorla, with the hand of God the Father holding a crown above (Plate 200). On either side are the twelve apostles. Most prominent among them are St Peter and St Paul (the two saints to whom Cluny was dedicated), but special emphasis is given to St Peter, who not only holds the key but also receives from Christ a scroll. Below the apostles are two saints on the left, identified as the deacons St Vincent and St Laurence, and two unidentified saints on the right. In blind arcades to the right and left of the semi-dome are paintings of the martyrdom of St Laurence (a prominently Roman saint; Plate 201) and of scenes from the life of St Blaise (the patron saint of the priory). At floor level, underneath the windows below the apse, are half-figures of a number of saints who were particularly venerated at Cluny (including some of the Eastern Church). Though some identifications are uncertain, the whole ensemble is clearly a pious memorial to the traditions, associations, and aspirations of Cluny.

As a work of art, the Berzé painting is a masterpiece. The vibrant warm colours – the dark and russet browns and olive greens – are richly orchestrated against backgrounds of deeper tones such as the heavy bluish-greens, and the overall feeling is one of brooding meditation and liturgical mystery. The composition is so magisterially organized on the curving wall of the semi-dome that, from the right viewing point, the whole complex scene falls into a complete and rhythmically interrelated whole. The influences are unmistakably from Italy and explain the rich linear texture. For detailed points of comparison we can look particularly to the frescoes of the chapel of St Sebastian in the Old Lateran Palace at Rome (Plate 155), which offer some clue to the date of the Berzé paintings, which is still a subject of controversy. It is known that St Hugh favoured the Berzé priory as a place of retreat from the burdens of office, particularly during the last years before his death in 1109, and for this reason these paintings have often been ascribed to the period just before 1109. Such evidence is, however, highly circumstantial and of little real historical validity. On the other hand, the paintings of the Old Lateran Palace have been attributed to the first thirty years of the twelfth century on stylistic grounds. In view of this, we might, perhaps, cautiously attribute these Cluniac paintings to the period 1100–40.

The Italo-Byzantine influences that we find in the Berzé wall-paintings emerge almost as strongly in Cluny's manuscript-painting, where, however, they are tempered by German influences.

The manuscript on which we must base our chief knowledge of Cluny's manuscript-painting is the well-known Cluny Lectionary in Paris (Bibliothèque Nationale nouv. acq. lat. 2246),[4] which belongs, perhaps, to the early twelfth century. Though some of the paintings have been removed, it still retains illustrations of the Annunciation, the

Crucifixion, Pentecost (Plate 202), the Dormition and Assumption of the Virgin, and the liberation of St Peter from prison. The portrayal of the Crucifixion is given an added interest by the substitution of Isaiah the prophet for John the evangelist. There are both Byzantine and Ottonian influences on the iconography[5] and the style. Stylistically, the Ottonian influence expresses itself in the purple backgrounds, but the linear figure style with its long, loose proportions is unmistakably Italo-Byzantine in inspiration. Here we find the so-called 'damp-fold', which is a sure sign of ultimate Byzantine influence.

The illustrations vary in quality, but the finest are quite masterly and show the typical Romanesque hardening of the Byzantine style that we shall find as we follow its passage through the West. The easy amplitude and rich linear texture of the Cluniac wall-painting are here given a firmer organization of composition, a stricter clarity of figural outline, and a more rigid definition of the constituent parts. Romanesque taste always tended in this direction – to discipline and organize the styles that came to it.

This manuscript certainly comes from Cluny, and another has been attributed to it. This is a manuscript now at Parma (Palatine Library MS. 1650) of St Ildefonsus's *De Virginitate*[6] – an impassioned treatise against those who disbelieved in the virginity of Mary. Though small in size, it is illustrated with no less than thirty-five pictures, some of them full-page. The initials, with their metallic elegance, are Ottonian-inspired,[7] and so, too, is the figure style of the pictures which illustrate the text. Indeed, though much smaller in format, there is here a clear attempt to emulate the 'display' manuscripts of the Carolingian and Ottonian emperors.[8] The sheen of gold and richness of purples and blues – not only in the pictures but also in the pages of text, for these are set in ornate borders – give an air of opulence to the manuscript, an air not, however, matched by the actual quality of the figure style, for this is stilted and uninspired. This is a style that has lost the passion of Ottonian art without achieving the power of Romanesque. The final two pictures[9] are an exception to this. These do not relate to the actual text but to an old colophon, which recorded that a copy of the work was made by a monk Gómez for Gotiscalc, bishop of Le Puy, during the latter's visit to Spain in 951. They show Gómez writing the work and then presenting it (Plate 203). Here, we have an excellent version of the Byzantine style in the north, which is fused with Ottonian accessories and given a colourfully ornate quality, reminiscent of mosaics. The manuscript may be ascribed to the first quarter of the twelfth century.

Cluny was clearly an artistic centre of importance. But its importance in the context of Romanesque painting as a whole is difficult to assess in the absence of most of the evidence. The Order that in the twelfth century had wielded a power second only to that of the papacy had, by the eighteenth, become such a focus of hostility that during the French Revolution her manuscripts were deliberately burnt. As a result there is insufficient evidence for a balanced assessment of her artistic significance and influence.

One school of thought holds that Cluny was a focal centre of art in transalpine Europe and that it was from Cluny that styles were disseminated all over the West. This, in view of the international power and authority of Cluny, is an attractive theory, but it is based on no actual evidence. The fact that Cluny has come down to us today as almost a

synonym for artistic pomp and ostentation is largely due to the passionate oratory of St Bernard. His castigation of the luxury of Cluny forms part of one of the most famous diatribes of the twelfth century.[10] In this celebrated passage St Bernard, however, seems more occupied with the splendour and richness of the metalwork and the unedifying curiosities of the sculpture than with paintings. But he does refer to them, and we have knowledge of them from other sources.

The abbey church of Cluny itself was destroyed soon after the French Revolution, but we know of a fine Majesty in the apse there which survived into the nineteenth century.[11] We also know from literary sources that an Anglo-Norman, William of Warenne, paid for panel-paintings to be installed at the end of the eleventh century,[12] and that during the first half of the twelfth century there existed frescoes of the miracles of Christ[13] and also pavements inlaid with effigies of saints.[14] We may allow ourselves to assume that all these were of very fine quality, but this means no more than that Cluny could afford to pay for the best artists. We have already seen that the greatest wall-painters might travel long distances, and these might well have come from a quite different region, as did the painters of Saint-Denis whom we shall refer to later. In the field of manuscript-painting, which would be locally developed within the scriptorium of Cluny itself, we would certainly look in vain for evidence that she was a great and influential centre. The few Cluniac illuminated manuscripts that survive from the tenth and eleventh centuries[15] show none of that interest in the development of narrative painting that we find in Germany and Italy: they are content with decorative initials which are not distinguished by any particular felicity. The Cluny chronicle itself shows little concern for painting. When it describes a Bible made between 1109 and 1122 which was considered one of the glories of the library, it refers to the splendours of the binding and the accuracy of the text, but it draws no attention to any manuscript-paintings in it – whether illustrative or decorative.[16] Again, in the later dialogue between the Cluniac and Cistercian which continued St Bernard's attacks on the luxuriousness of Cluny, the most damning indictment against her manuscript-painting was that Cluny allowed the use of gold in her initial letters,[17] a practice (needless to say) which was common even in minor monasteries. We can assume that Cluny had its reasonable share of decorated and illustrated manuscripts, and we must allow that the state of the evidence makes any firm conclusions impossible, but we should not too readily suppose that the little Cluniac manuscript-painting that survives is the tip of a huge lost Atlantis of Cluniac art.

The near-by house of Cîteaux was almost certainly a more vital centre of manuscript-painting than Cluny. In an earlier chapter[18] we have already discussed the influences from the Channel regions on its art, but these (as we then indicated) were joined in the second quarter of the twelfth century by other influences from Byzantium.

The delightful Tree of Jesse in the Cîteaux Lectionary (Dijon, Bibliothèque Municipale MS. 641 folio 40 verso; Plate 204) has been earlier mentioned.[19] This represents a linear interpretation of the Byzantine style which is comparable to that of the Cluny Lectionary, though the vibrancy of line shows that Channel influences were not to be easily displaced from Cîteaux. Jesse stands upright holding the branches that encompass him in a graceful ellipse. Framed in a circle of foliage above is the Virgin, designated

with a Greek title, *Theotokos* (as in a Salzburg manuscript),[20] and offering her breast to the Christ Child. Surmounting the whole is the dove of the Holy Spirit, and on either side are Old Testament allegories of Mary's virginity. A very different representation of the Virgin is found in the Tree of Jesse of another Cistercian manuscript (Dijon, Bibliothèque Municipale MS. 129 folio 4 verso; Plate 205), which has also been mentioned earlier.[21] Here she is no longer the gentle and tender mother suckling her babe, but rather the powerful and intimidating matriarch guarding the divine offspring who will redeem the world. Closest in spirit to this hieratic figure are the ivory-carvings of Byzantium, where the Virgin is given a similar gravity and aloofness. The style of the Cîteaux Virgin is not actually derived from these ivories, and it shows the Flemish feeling for heavily pleated draperies that we have seen at Saint-Omer, but none the less some Byzantine stylistic influence is evident in the 'damp-folds'. A similar style is seen in other paintings of the manuscript and in the paintings of another Cistercian manuscript (Dijon, Bibliothèque Municipale MS. 132).[22]

Some of the saints illustrated in the Cîteaux Lectionary[23] are yet more Byzantine in character. These follow the recognized Byzantine convention for the representation of patriarchs – one hand held in blessing, the other holding a jewelled Bible, which is reverently protected by drapery from contact with the bare arm. Though it has a fine quality and linear assurance of its own, the figure of St Agipitus on folio 21 verso[24] is particularly close to Byzantine sources. In other figures of the same manuscript, however, we see Byzantine styles more and more absorbed to Western Romanesque tastes, and here we find parallels, if not an actual relationship, with the illumination of Salzburg, particularly that of the Admont Bible. The figures are lengthened and drawn into swaying, flowing lines of great elegance and power. The draperies retain their weight and texture, but they are now manipulated to provide a masterly interplay of linear rhythms which is almost three-dimensional. Excellent examples of this are the saints on folios 24 verso, 57, 64, and 113 (Plate 206). These figures are some of the most accomplished examples of the assimilation of Byzantine influences in the west at this period and, in view of the extent to which Byzantine influences pervaded western art, this says much for the quality of Cistercian manuscript-painting before it was almost stifled by the extremist views of St Bernard.

At Cîteaux, then, we find a distillation of the two major influences on French Romanesque manuscript-painting – those from the Channel areas and those from Byzantium. And, just as the Channel influences gave to Cistercian manuscript-painting the vigour, vitality, and élan which characterized their finest work, so Byzantine influences had something positive to offer. To them may be ascribed the new autonomy given to the human figure. Romanesque tastes may fragment the Byzantine draperies into écheloned designs and forms, but, despite this, the figure as a whole retains a certain independence and majesty. If it has to be included with the initial, it now stands at the side or in front of it, refusing to be absorbed like the foliage and animal-life into its decoration and used simply as something to invigorate its life.

This feeling for the dignity of the human figure was a Byzantine contribution to the whole West, and where Byzantine influences asserted themselves strongly the human

figure achieved a new tranquillity and spaciousness. We see this in the illustrations of Flanders and north-east France, and at Saint-Amand, for example, styles appear similar to that of the Cîteaux Lectionary (see Valenciennes, Bibliothèque Municipale MS. 84 folio 8 verso). This may not be a coincidence, for (as we have already seen) Cîteaux had close relations with Flanders and north-east France.

Northern France

The Byzantine influences which pervaded manuscript-painting had naturally to come to terms with other influences. One such influence was from the Carolingian tradition. At Saint-Amand (Valenciennes, Bibliothèque Municipale MS. 5 folio 51)[25] we find figure styles that are still recognizably Carolingian, despite the Byzantine form of drapery and the tautening of forms to conform with Romanesque tastes.

A more important influence was the Ottonian tradition. In the magnificent Christ of the Stavelot Bible we have already seen the latent power of the Ottonian tradition in the Mosan area at the end of the eleventh century. To some extent this was reanimated by contact with Byzantine art in the twelfth, and this accounts for the size and massiveness of some of the twelfth-century figures of north-east France. Examples of this are author portraits of St Augustine and St Gregory in manuscripts from Marchiennes (Douai, Bibliothèque Municipale MS. 250 folio 2; Plate 207) and Saint-Amand (Bibliothèque Nationale MS. lat. 2287 folio 1 verso; Plate 208), both of which derive ultimately from the Ottonian tradition. Despite the weakness in representing the hands, the St Gregory from Saint-Amand, whose monumentality seems too much for the frame to hold and whose wine-coloured chasuble falls in deep, heavily weighted folds, is particularly impressive. When Ottonian and Byzantine influences on France were completely fused to express the Romanesque idiom, the result could be a splendid work of art with some impact. This is evident in the mid-twelfth-century *Life of St Amand* from Saint-Amand (Valenciennes, Bibliothèque Municipale MS. 501). Here the illustrations, as, for example, the picture of the two saints on folio 60 (Plate 209), reflect Ottonian and Byzantine influences and also influences from metalwork, but all these are completely assimilated to the Romanesque taste for the abstract. The result is highly successful, and the incisiveness of pictorial statement is pleasingly matched by the striking clarity of colour.

Of all influences with which the Byzantine styles had to contend, however, the strongest was that of the Channel tradition. This could be sufficiently powerful at times even to absorb the Byzantine styles into its own tradition, and at a centre as far from the coast as Fleury (Orléans, Bibliothèque Municipale MS. 13) we find the Byzantine 'damp-fold' style simply absorbed into a flux of line so that – whatever the Byzantine particularities of detail – the general effect is exactly that of the ebullient Channel art of the eleventh century. In general, however, under the firm discipline of the Romanesque aesthetic there was a more balanced synthesis of the Channel and Byzantine traditions, and this provided some of the masterpieces of French art of the mid twelfth century. These French paintings, we should add, had close associations with the art of England, as we shall soon see. There Byzantine influences had also been assimilated to the Channel

tradition of linear animation and expressed in controlled terms of Romanesque idiom.

In northern France we find this new synthesis in the highly linear but tautly controlled Christ of an historiated initial of the Marchiennes manuscript already referred to. It is present in the fine Bible from Sainte Marie de Parc near Louvain (British Museum Add. MSS. 14788, 89, 90), which was written in 1148 and whose vigorous decoration is closely related to the Bury St Edmunds School in England. We encounter it in the superb Crucifixion from Saint-Amand (Valenciennes, Bibliothèque Municipale MS. 108 folio 58 verso; Plate 210). We see it in the pictures of Christ's life which preface a Psalter from Angers (Amiens, Bibliothèque Municipale MS. 19), where the drapery styles of Byzantium are interpreted with the assured linear emphasis of Northern Europe. We discover it also at Liessies in Hainault in a particularly fine Gospel Book, made in 1146 for its abbot, Wedric. The actual manuscript (formerly Metz, Bibliothèque Municipale MS. 1151)[26] was unfortunately destroyed during the Second World War, but two detached leaves survive in the possession of the Société Archéologique of Avesnes. The first depicts St Mark and the second (Plate 211) St John, whose ink-horn is being held by Abbot Wedric, who appears in a side roundel. These pictures are consummate examples of the assimilation of Byzantine influences to the Channel tradition. They have the closest possible associations with the art of southern England (particularly with the Lambeth Bible)[27] and intimate relations, too, with the manuscript-paintings of northern France. Though now crisply segmented in Romanesque abstract terms, the draperies are clearly Byzantine in origin, but the delicious freshness of the picture is due to the linear fluency and calligraphic rhythms which are unmistakably derived from the Channel tradition.

Some of the finest manuscript-painting of mid-twelfth-century Europe is represented by a synthesis of these influences, and, perhaps, it is the very tension between the two idioms that gives force to the paintings. Despite the incisive Romanesque control of the whole, one is sometimes aware of conflict. Occasionally the faces, gazing out with their meditative awareness, seem anxious to assert the human autonomy of the Byzantine tradition, whilst the bodies – despite the Byzantine particularities of the draperies – seem only too anxious to melt away into an exuberant flux of line in response to the Channel tradition. But all this, of course, is usually held firmly together by the power of the Romanesque idiom, which was the more easily able to reconcile differing styles by its own capacity for assimilating everything to its own taste for abstract forms and designs.

Wall-Paintings

As in French vellum-painting, so in French wall-painting, the surge of Byzantine influences was very evident in the twelfth century. We have already seen some evidence of this at Berzé-la-Ville,[28] though elsewhere this tide from the East might have to accommodate itself to other currents and traditions. Much of the Byzantine influence on frescoes was clearly brought from Italy, probably by travelling wall-painters, and might therefore more accurately be described as Italo-Byzantine.

Some evidence for the movement of wall-painters has already been adduced, but in

the twelfth century there is excellent confirmation of it in Suger's famous account of his rebuilding of Saint-Denis, which was finally consecrated in 1144. He actually begins with a reference to the paintings:

The first work on this church which we began under the inspiration of God was this: because of the age of the old walls and their impending ruin in some places, we summoned the best painters I could find *from different regions* and reverently caused these walls to be repaired and becomingly painted with gold and precious colours.[29]

When he comes to a description of the stained-glass windows, we find a similar procedure, namely that the artists were brought in from other areas:

Moreover, we caused a splendid variety of new windows to be painted by the exquisite hands of many masters *from various regions*.[30]

Now, we may presume that a large number of wall-paintings in France in the twelfth century was the work of local or regional painters, but it is probable that the great masters who set the trends were accustomed to travel. The few real masterpieces that survive do, in fact, show influences from afar, as we have already seen at Berzé-la-Ville. Such masterpieces are rare. This, ironically, is because wall-paintings had the least chance of survival in areas that were artistically dynamic, for there they were most quickly replaced by changes of architectural or artistic taste. Indeed, although (if we include fragments) the wall-paintings which remain in France in various stages of completeness number over one hundred and thirty,[31] they are not often found in the obvious centres of ecclesiastical power.

The disappearance of the great masterpieces has deprived us of the significant pointers to the influences on wall-painting, and it has also deprived us of important guides to their chronology, for literary sources will sometimes inform us of the date of paintings made at the more celebrated centres, but we shall look in vain for such information about minor ones. One result of this is that the dating of Romanesque wall-paintings has always been a problem. In establishing the date of manuscript-paintings there are controlling factors such as the palaeography of the script and the internal evidence of the text. But with wall-paintings there is none of this. Stylized inscriptions, made by wall-painters indifferent to scribal fashions, and sometimes even copied from earlier material, make hazardous evidence. Attempts to align dates to drapery styles can also itself become circular, for our knowledge of these styles is mainly derived from other paintings. Even the use of stylistic criteria in the paintings themselves has its dangers when applied to isolated ensembles in particular churches, especially when the paintings are not of the first quality; for there is no means of testing how up to date or how conservative a particular artist may have been; we can find wall-paintings in both France and Italy where a mid-twelfth-century style is still used as a thirteenth-century cliché. When the date of the dedication of a church can be established (which is rarely) there is a natural disposition to associate with it the date of its paintings, but even this is not infallible. We know that Desiderius refused to dedicate the church of Saint-Martin before the paintings were made, which meant, in fact, that it was not dedicated until four years after his death. This has been used to argue that the date of dedication and the date of wall-

paintings must be the same; but it can be used to argue the reverse. It shows how even a medieval Diaghilev like Desiderius could have difficulty in getting appropriate artists in sufficient time, and we can hardly suppose that all the provincial bishops and abbots of France would share his artistic scruples and postpone their own dedications. All these factors do not excuse the writer from giving an opinion, but they should caution the reader against the dangers of over-precision.

The wall-paintings that survive in France are mostly concentrated in two areas. The more important follows the course of the Loire and is particularly rich in Maine, Anjou, and Touraine. The other, less populous one, is along the Rhône and its tributary, the Saône. There are, in addition, some paintings on the French side of the Pyrenees and a few in other areas.

It is clear from literary sources that the present clusterings of wall-paintings have no particular relevance to their original distribution, which must have been widespread throughout the country. The reasons for their survival in one area rather than another are a matter of speculation. There is some relationship between the areas of survival and the areas of low rainfall in France, and, since it is known that medieval paintings will not survive on damp walls, this may be of some significance.[32] There are, however, other factors. One is certainly the relative intensity with which Gothic architecture replaced Romanesque in some regions compared to others. This would be of particular relevance in the Île de France and other areas of the north and east, where Gothic was particularly developed. Gothic architecture was, of course, more interested in replacing walls by windows, and one compensation for the resulting loss of paintings was the development of stained glass.

There is ample evidence of the existence of figural stained glass in Europe before the Romanesque period not only in the form of literary descriptions but also in actual survivals such as the reconstructed ninth-century fragment from Lorsch[33] and the eleventh-century fragment from Magdeburg.[34] Despite this, our knowledge of stained glass which is not reconstructed or fragmentary only effectively begins in the twelfth century. In Germany there remain from the early twelfth century figures of Old Testament prophets from Augsburg Cathedral,[35] and from the second half of the twelfth, stained glass from Weitensfeld,[36] Oberndorf,[37] Arnstein (?),[38] and (until the Second World War) from Ingelheim.[39] The Arnstein glass, attributed to the decade 1170–80, is of excellent quality and has the added interest of containing a representation of the artist, Gerlachus, actually at work.[40] His surviving scenes are of Old Testament episodes, though we do know of an impressive Crucifixion scene by him which, unhappily, was another victim of the Second World War.[41] Important stained glass at Strasbourg,[42] then in Germany, is usually dated about 1200 but is still very Romanesque in spirit.

Though German Romanesque stained glass is significant, France was the country most eminent in this art in the twelfth century, and we have the authority of a German writer, Theophilus,[43] for saying so. The earliest important French glass belongs to the second quarter of the twelfth century and is found in the windows of Saint-Denis, which were commissioned and described by Suger himself.[44] His windows of the Life of Moses and of the Old Testament prefigurations of the New are still in a reasonably original condition,

but his Tree of Jesse window is much restored and the Life of the Virgin window is only fragmentarily original. We know that his glass-painters came from other regions, and their style indicates that some came from the area now known as north-east France and Belgium. Stained glass survives from Chartres Cathedral[45] made only a few years later, between 1150 and 1155. A famous window in the south of the choir represents the Virgin in magnificent reds and blues, and three windows of the west façade depict the Tree of Jesse, the Life of Christ up to His Entry into Jerusalem, and scenes from His Passion and Resurrection.

The importance of Saint-Denis and Chartres does not need stressing, but there is stained glass of the very highest quality in other cathedrals and churches of the north and east. At Le Mans, though the windows with saints' lives are a little later, the striking window of the Ascension (Plate 212) was made about 1158. It is found repeated in a large window of Poitiers Cathedral.[46] The cathedral of Angers has excellent windows made between 1161 and 1177[47] which represent the Passions of two saints and the death and obsequies of the Virgin. Among other stained glass of the Romanesque period, windows in the cathedral of Metz[48] depict the legendary life of St Paul. Roundels from Châlons-sur-Marne[49] (now in the museum there) are perhaps not French in its strictest modern sense (for the artist probably came from the area now known as Belgium), but they have a clarity of composition, a deliciousness of colour, and a delicacy of detail which make them particularly telling examples of Romanesque stained glass at its best. They represent the Vision of Gamaliel and the Crucifixion together with Old Testament prefigurations and personifications of the Church and Synagogue (Plate 213).

Despite the fine examples of French Romanesque wall-painting that survive, it cannot be said that they have the consistent high quality of French Romanesque stained glass. A large number further suffer from the fact that they are in a fragmentary or over-restored condition.

Normally they have been classified by a method that is technical rather than stylistic and which, despite later elaborations, divides them into two basic groups.[50] The first, which is sometimes called the Greek method and is described by Theophilus, is typified by the paintings of Berzé-la-Ville. This makes use of successive coats of pigments, together with glazes, and uses a base of glue. The second, sometimes referred to as the French method and found in the vast majority of wall-paintings, uses simple earth colours which are mixed with lime and water and applied to a dampened wall without glazes. The two techniques produce different effects and different colour relationships and are often distinguished by these – the first being referred to as brilliant paintings on dark blue grounds and the second as matt paintings on light grounds. Generally speaking, the first technique is found in the east of France – in Burgundy and to some extent Auvergne – and the second in the west along the River Loire. Despite its traditional acceptance, this division by method rather than style has many disadvantages. To begin with, there are extremely few paintings in the first category and a preponderant number in the second. Then, we find – for example, in the Auvergne – an intermingling of the two methods. Finally, though technique may influence style, it should not be confused with it; the same artist might quite conceivably work in both techniques, in very much

the same way as artists of a later period might work in both watercolours and oils.

Our own interest will be to analyse in terms of style rather than technique, and here we shall find that Byzantine, or Italo-Byzantine, influences coming from Italy were of overwhelming importance.

At Le Puy Cathedral, there is a remarkable painting of St Michael of the second half of the eleventh century.[51] A long, loose figure of enormous size (some eighteen feet high), he stands on the dragon and looks out with large fixed eyes. The painting is in sombre colours such as dark blues and muddy reds, set off with yellows, and the vestments are adorned with large red and blue precious stones. The model for this painting was unmistakably Italian and may even have been a picture of St Michael from Monte Gargano[52] on the Adriatic coast, which had become a famous centre of pilgrimage after the saint's appearance there in 492. Other portrait figures of saints in the transept show equally unmistakable evidence of Italian influence.

Though very much later, the figures, painted in quiet harmonious earth-colours, of the small chapel of Le Liget at Chemillé-sur-Indrois (Indre-et-Loire)[53] are also related to Italian paintings – particularly those of Rome and central Italy. Their dry-textured, linear sweep provides an excellent example of this particular style of French painting, which here gives considerable emphasis to the Virgin, for (among other biblical scenes) it includes the Annunciation, the Nativity, the Presentation, the Descent from the Cross, and the Death and Assumption of the Virgin herself. Elsewhere – for example, in the pictures of saints in the nave of Saint-Hilaire-le-Grand at Poitiers[54] and in Saint-Martin at Tours[55] – we find comparable Italian influences. We also find them in the softly coloured paintings of Brinay (in Berry), which represent scenes from the childhood and early public life of Christ. Despite attempts to animate the draperies with a patterned crinkling of folds that can be paralleled in Anglo-French manuscript-paintings, the Italian influences predominate and explain the general feeling of suavity and ease.

Influences, still Italian, but of a different kind emerge in the paintings of the abbatial church of Saint-Chef in the Dauphiné,[56] which probably belong to the late eleventh or early twelfth century. In the chapel of St George is a representation of the heavenly Jerusalem which has been most felicitously composed (Plate 214). Christ in Majesty is painted on the inner apex of the vault so that one must look upwards – as if to heaven – to see Him, and the figures of the heavenly city are painted on the surfaces which curve downwards from the vault in such a way that they seem both to flow from His power and be irradiated by His presence. But, however harmonious may be the composition, there is a perceptible 'bittiness' of texture about the figure style which admits of only one explanation: it has been influenced by Italo-Byzantine mosaics. The style of the mosaics of Santa Prassede at Rome is, in fact, quite similar.

Yet another form of Italian influence emerges at Saint-Émilion (Gironde),[57] where a painting of the Virgin of the second half of the twelfth century with its strongly modelled features and hieratic pose is clearly a French interpretation of an Italo-Byzantine model whose ancestry can be ultimately traced back to the mosaics of Hagia Sophia. Comparable Italo-Byzantine influences are found at Saint-Jacques-des-Guérets (Loir-et-Cher),[58] where the personifications of the sun and moon which appear above the Crucifixion

and the painting of the raising of Lazarus are rendered with particular dramatic power.

Such Italian influences need not, of course, have been direct. In Italian paintings like those of Sant'Angelo in Formis, the cheeks are heightened with a patch of red, and this (rather unfortunately) became one of the clichés of French painting, spreading to areas with no direct knowledge of Italian art. The so-called 'damp-fold' used in the representation of drapery was originally an unmistakable sign of Byzantine or Italo-Byzantine influence. In the paintings of Berzé-la-Ville (Plates 200 and 201) it appears in almost a classical form. But it soon became part of the stock-in-trade of Western painting and no longer indicates direct influences from the south. It is seen in the earliest surviving French stained glass from Saint-Denis, where the representation of the martyrdom of St Vincent exhibits this stylistic feature well. Even as late as the thirteenth century, it is found in the painting of the mystic marriage of St Catherine in the church of Notre Dame at Montmorillon (Vienne).[59]

Apart from these powerful Italian influences from the south, the major influences on French wall-paintings (as we have seen in an earlier chapter) were Carolingian influences from the past and Channel influences from the north. It seems appropriate, therefore, that the greatest of all masterpieces of French Romanesque wall-painting should show a blend of all three. These are the paintings of Saint-Savin-sur-Gartempe[60] near Poitiers.

In range, scale, and quality the Saint-Savin paintings represent the finest ensemble left to us by Romanesque France. There are, in fact, four cycles in all. The crypt under the choir has paintings of the martyrdom of St Savin and St Cyprian (Plate 215); the porch at the west entrance to the church is decorated with scenes from the Apocalypse, from which we illustrate St Michael's attack on the rebel angels (Plate 216); the tribune over the porch contains paintings of Christ's Passion; and the vault of the long nave is covered with a pictured Pentateuch – scenes which take us from the Creation of the world to the reception of the Covenant and continue with the epic story of Moses and his successful leadership of the Israelites to the promised land (the scene of God commanding Noah to build the Ark and the picture of the Tower of Babel are illustrated on Plates 217 and 218). Since in patristic commentaries the epic of Moses symbolized the epic of Christ, this, in the theological sense, is the comprehensive story of man's sin and man's redemption. It is not surprising, therefore, to learn that a cycle such as this had been known to an earlier period, though it also had a particular relevance to the contemporary historical situation.

For over a century, there have been discussions about the date of these paintings – some scholars have even seen them as the work of different ateliers at different periods. Though the majority favours the twelfth century, opinions have ranged from the middle of the eleventh century to the beginning of the thirteenth. For myself, I believe that, although different influences emerge in the different schemes, they are all the work of the same atelier and the same period, which is probably the early part of the twelfth century.

The paintings in the crypt are ultimately Carolingian in origin and the noble figure of Ladicius in the martyrdom scene, for example, has a stylistic pedigree which would take us back to the Tours School of the ninth century. This Tours style continued, as we have

seen, in France after the Carolingian period and emerged in the paintings of Tours manuscripts like the Life of St Martin (Tours, Bibliothèque Municipale MS. 1018) and the Poitiers Life of St Radegund (Poitiers, Bibliothèque Municipale MS. 250; Plate 89). Though the wall-paintings are more mature, more painterly, and more severely highlighted, it is to the pictures of the Poitiers manuscript that they particularly relate. There are few stylistic features that the wall-paintings do not share with the illuminations, from general traits like the bold outlining of the figures and their somewhat stocky proportions to details like the sharply upturned eyes, the wig-like rendering of the hair, the occasional forward thrust of head and neck, and the schematized curves of the chest (compare Plate 89). The closeness of the two styles suggests that the painters may have been working from a manuscript *Life of St Savin* with illustrations in this genre. If this were so, the transference was highly successful, for the wall-paintings combine powerful vigour with mature accomplishment.

The Christ in Majesty of the crypt, in dark brown and ochres, follows the Majesties of the Carolingian Tours tradition, but the Romanesque predilection for abstract rhythms leads to an interpretation of the lower draperies in terms of close-threaded pear-shaped designs.

A different Romanesque interpretation of a Carolingian style is found in the porch, where the warm-coloured, dramatically highlighted scenes of the Apocalypse (Plate 216) are magnificent examples of twelfth-century wall-painting. There is nothing here of the horror or apprehension of the apocalyptic vision, for, despite an element still of Carolingian impressionism, the angels, dragons, and men are all interpreted in terms of sweeping contours and buoyant rhythms, and the curving highlights themselves are used to add variety and vivacity to the general rhythm. There is quite a remarkable feeling here for balance and composition.

However, despite this, it is for the Old Testament paintings extending in four rows along the length of its nave vault that Saint-Savin is probably best known. Here, the rather sober colours – the flesh tints, the russet browns, the dark greens – act as a foil to the sometimes overladen highlights, yet, despite the heaviness of the latter and the weight of the draperies, one feels oneself in the presence of large coloured drawings rather than of painterly paintings. The influences are not the same as on the porch paintings. Though Italian associations give the figures spaciousness, their real associations are with Channel styles. Indeed, the only general terms of comparison for the sense of inevitable movement in these scenes unrolling across the vault is with the Bayeux Tapestry, which, though less sophisticated in detail and more pungent in action, carries the same feeling of irrepressible forward movement in length. The long, loose-limbed figures belong to a tradition clearly evident in the eleventh century in north France and the adjacent areas and finely expressed in the drawings of Saint-Bertin, Saint-Vaast, and Saint-Amand (Plates 96–100 and 103). It is also to this area that one can look for comparisons of detail, such as the hatched highlights on the figure of God in the scene of the blessing of Abel, which can be paralleled in manuscript-painting from Saint-Amand. There are many associations with English painting – the eloquent language of the hands and their delicate fastidiousness of gesture, the nervous energy causing the figures to lift

their arms and to cross their legs on pirouetting feet as though caught up in some compulsive celestial dance, the hems of draperies swirling around ankles, and the buoyancy which enables figures to swim effortlessly across their frames. (See the detail of God before the Tower of Babel reproduced on Plate 218 for some of these characteristics.) Even structural details like those of Noah's Ark can be closely paralleled in English manuscripts such as the Oxford *Caedmon*.[61] The treatment of the hair and occasional folds of the lower draperies indicate that the artists had already worked in the Poitiers style, but it seems clear that the main source of influence was from the Channel area.

The influence of Saint-Savin is found in other churches. It is, to some extent, evident in the paintings of the Moses story (now considerably deteriorated) in the abbey church of Saint-Julien at Tours[62] and also appears in the Genesis paintings of the church of Saint-Jean-Baptiste at Château-Gontier (Mayenne).[63] But it is seen at its strongest in near-by Poitiers, not only in the rather unsophisticated crypt paintings of Notre-Dame-la-Grande but also in the extremely fine paintings of the baptistery of Saint-Jean.[64] Here there is a representation of the Ascension of Christ between two angels and two groups of apostles, and particularly attractive paintings of Constantine and three other Early Christian emperors on horseback. One of the horsemen is reproduced on Plate 219, and they combine a splendid feeling of movement with spaciousness. Yet, although these are superb paintings, there is nothing in France to rival those of Saint-Savin itself in scope and quality. Such was the stylistic impact of these Saint-Savin paintings even in their own day that they influenced not only the frescoes of France but (as we shall see in the next chapter) those of Spain also.

SPANISH WALL-PAINTINGS AND PANEL-PAINTINGS

THE monumental Romanesque paintings of Spain are naturally to be found in those areas that were in Christian occupation during the Romanesque period. Of these the most important by far is Catalonia. Indeed she is richer in panel- and wall-paintings than any other area of the West, north of the Alps.

In a sense, Catalonia's present artistic wealth is due to her former economic poverty. Most of the Romanesque painted panels from this area were formerly parts of altar-frontals or *antependia*. In wealthier countries, such altar-frontals were often made of precious metals, finely wrought and inset with gems. Most have long since disappeared into the melting-pot because of economic appetites which might (as in England) conveniently partner religious reform. Even within the period of the Middle Ages we learn how insecure was this form of art. Abbeys which fell on hard times might have to melt down the gold and silver objects of their church, and abbots faced with famine in adjacent areas might possibly follow the same path in the exercise of a very real form of charity. At the house of St Albans in England the shrine of the patron saint was twice deprived of its precious metal because of various financial pressures.[1] In Spain, where the majority of churches could not afford such luxury, paintings on wood had to suffice. And the reason that brought them into being was the reason that they survived – they were not costly to make and, in terms of raw material, worth no one's while to retrieve.

Again, there is a greater wealth of Romanesque wall-paintings in Catalonian Spain than in almost any other comparable area. In part, at least, this originated in the fact that buildings were made of cheap rubble masonry, the rough surface of which was most easily masked by paintings. It is significant that in those parts of Spain where the masonry was more finished and more expensive, there were fewer paintings.[2] Though many of these paintings have now been transferred to museums, they were originally largely found in small rustic churches, and their survival again is partly due to lack of wealth. Economic conditions did not allow the churches themselves to be enlarged, extended, or completely rebuilt in order to keep up with changing tastes or new artistic traditions.

Yet, whatever lack of material resources there may have been in Spain, there was certainly none of artistic talent, and some of the finest Romanesque paintings in Europe are to be found here. For sheer power and magnificence, the paintings of Spain are unsurpassed elsewhere.

There is, in fact, an obvious affinity between the tastes of the Spanish artists and the Romanesque aesthetic, which nowhere else is expressed with such single-minded integrity. It is true that – as in all Romanesque art – strong influences appear from outside sources, but these are completely assimilated, and the most characteristic Romanesque painting always emerges with a very distinctive Spanish personality of its own.

But the purity of the Romanesque idiom in Spain is also partly due to the fact that

it was unencumbered and unadulterated by earlier traditions. We know that a few wall-paintings existed before the mid eleventh century, but there is no evidence that Spain had as many pre-Romanesque wall-paintings as France. This may be attributed to various reasons. One is Spain's perpetual embroilment in warfare, which France itself was spared – at least in such continuing terms. Another was the undercurrent of iconoclasm in the country. It is well known that the Synod of Elvira of 305 forbade monumental figural painting in churches, and, though this certainly did not prevent representational art (which found some expression even in Visigothic sculpture), there probably remained an underlying tradition of opposition to it in the country. We have already seen, for example, that, at Charlemagne's court, it was a theologian from Spain, Theodulf, who objected to figural representation during the Carolingian Renaissance.[3]

PRE-ROMANESQUE PAINTING

Such an underlying tradition might explain why, in Oviedo (which claimed to be the capital of Christian Spain), as far as we know, the only pre-Romanesque paintings were purely decorative. They could have ornamented a Moslem mosque as fittingly as they did a Christian church.[4]

The most important which survive are found in the church of San Julián de los Prados, popularly known as Santullano.[5] This, the finest pre-Romanesque church of Spain, was built by Alfonso II, and the paintings were probably made between 812 and 842. They have suffered a good deal, but enough remains to make it clear that the whole scheme was entirely decorative. The painting consists partly of abstract and floral motifs. Panels in the nave and transept also contain representations of decorative 'stage' architecture which is certainly classical in origin and reminiscent of Pompeian paintings like those of the Villa dei Misteri.[6] There are also panels representing doll's house architecture with ancillary furniture which have their parallels in Early Christian art such as that of Ravenna and Salonica. Indeed, there is a late classical and Early Christian feeling about the organization as well as the detail of the decoration. We have seen that Charlemagne, who founded the Holy Roman Empire, turned back to the Early Christian era for some sources of artistic inspiration. It seems that, in a kind of Spanish footnote, the kings of Asturias, who founded the Christian capital of Spain, followed the same course in their own tiny way.

Other Asturian churches retain fragmentary evidence of similarly inspired decoration which later also absorbs Moslem ornamental motifs. Only in one (San Miguel de Lillo) is there any evidence of human representation, and this is a crude drawing of a seated and a standing figure.[7]

In Catalonia, with its stronger links with the rest of Europe, there are some examples of pre-Romanesque figural art, but these are very few and mostly confined to the group of three churches at Tarrasa (formerly Egara), which is near Barcelona. The churches are San Pedro, Santa María, and San Miguel.

The frescoes are closely akin to manuscript-painting, or, more strictly, manuscript-

drawing, for basically they are drawings made in a reddish-brown. They are much ruder than the decorative work of Oviedo, and this has led to disputes about their date, for, on the whole, the more rustic the art the more difficult it is to date. But, since the Santa María figures have something of the quality of line of Spanish manuscript-drawings of the tenth century,[8] we may reasonably ascribe them to that period.

The paintings in the church of San Pedro[9] take the form of a mural retable. Four niches, containing symbols of the evangelists, are set below two, occupied by Christ bearing the Cross and an apostle. The upper two niches are flanked by seraphim, and angels are depicted on the spandrels of the lower ones.

The pictures of Santa María[10] are much more fragmentary but also much more important. They are in the 'cupola' of the vault. The central figure (now lost) was the focus of two surrounding circles of figures. These are so fragmentary that precise identification is impossible, but there are certainly pictorial references in the surrounding groups to the Passion of Christ. Possibly the whole painting was a representation of Jerusalem at its two levels of meaning: on the one hand the earthly Jerusalem of the Gospels, and on the other the heavenly Jerusalem of the Apocalypse made possible by Christ's death. The general organization of the painting is reminiscent of the rendering of the Ancient of Days in the *Beatus* manuscripts (Daniel VII), where God Himself appears as the focus of two encircling bands of angels.[11] But the manuscript-painter was himself here possibly influenced by monumental paintings and mosaics, and this arrangement is found in Early Christian mosaics including one in Spain itself not far from Tarrasa.[12]

In the third church, that of San Miguel, the painting in the apse[13] is again fragmentary. But it clearly represents the Ascension, and some of the apostles – half sitting and half kneeling in a garden conventionalized to ornament – are still in good condition. The position of the hand at the cheek is reminiscent of a similar gesture in Anglo-Irish manuscript-painting on the Continent,[14] and, though this may be quite coincidental, we have already observed the influence of such art on manuscript-painting in Spain.

Reference in our present context should also be made to two paintings in the greater apse of San Quirce de Pedret (Barcelona).[15] They are, in fact, little more than crude coloured drawings, difficult to date but probably as late as the second half of the eleventh century. It is their subject-matter that is of interest, for they indicate the crusading associations of the wars in Spain and remind us of the fact that in 1061 Alexander II specifically declared this conflict with Islam to be a crusade. The first represents a mounted knight with a peacock, symbolizing immortality, above him. The group is inside a medallion set within a cross which is reminiscent in design of the illustrations of the Oviedo Cross (with its own militant associations) in the *Beatus* manuscripts. The other 'painting' shows a figure with arms outstretched in the form of a cross within a circular border, above which is a bird possibly symbolizing the Holy Spirit. Late as these simple pictures are, they still belong to the pre-Romanesque tradition.

ROMANESQUE PAINTING

In the Romanesque period most of the monumental paintings are concentrated in Catalonia, and the reason for this within the Spanish context is not difficult to see. Though she was, in fact, invaded as late as 1114 by the Arabs who ravaged the country as far as Barcelona, her energies were less sapped than those of other areas by continual warfare with the Moslem, and opportunities were more favourable for artistic development. Many of the Romanesque wall- and panel-paintings of Catalonia have now been removed from their original churches to museums, particularly to the Museum of Catalonian Art in Barcelona.

Influences on Spanish Romanesque painting come largely from outside the peninsula, but, in the finest work, they are completely assimilated. Spanish painting shares in the internationalism of Romanesque Europe, but it has an unmistakable and impressive personality of its own. In the wall-paintings of Spain the Romanesque style is, in fact, more uncompromising than elsewhere in the West. There is a stronger and more rigorous formulation of the figure, which is given emphasis by the intimidating expression of the large devouring eyes. This combination of an inner intensity with an outer inflexibility produces a tension which we have already seen in Ottonian art, though, in the more monumental and inexorable style of Romanesque wall-paintings, a new effect is achieved of forceful power and thrustful impact.

Mozarabic Influences

Unlike the manuscript-painting of the peninsula, Spanish wall-painting was little influenced by Mozarabic art. Even when these influences do appear, they probably represent a response to the manuscript-painting which adhered so tenaciously to Mozarabic traditions rather than to any original Mozarabic source. So the narrow, almost chinless, pear-shaped heads with low foreheads and large eyes in the apse-picture of the Catalan church of Esterri de Cardós (Lérida),[16] now in the Barcelona Museum, seem to derive their Mozarabic characteristics from Spanish illuminations.[17] The same seems true of Mozarabic influences, which can be traced in other frescoes, such as those of the nave of Santa María de Tahull (Lérida)[18] also now in the Barcelona Museum, of the Creation scenes of the Ermita de la Vera Cruz of Maduerelo (Segovia)[19] now in the Prado, and of the Christ of the Apocalypse from the apse of Santa Coloma (Andorra)[20] now in the collection of Barón de Cassel at Cannes. All these paintings are different in style but have in common something of that combination of decorative texture and deflated formlessness which characterized Mozarabic art. Mozarabic art did have a general and diffused influence in the sense that its affection for close surface decoration emerges as a sprinkling of pattern in many of the great Romanesque wall-paintings, but close and specific relationships with Mozarabic styles are very few. On the whole, frescoes took a different course from illumination with its strong Mozarabic orientations.

Where panel-painting is concerned,[21] the position was different. Like the child of divorcees, it vacillated between two separate parent-traditions – at one time associating with wall-painting and at another with manuscript-painting. When it was closest to the latter, it was most exposed to Mozarabic traditions. This is apparent, for example, in the ateliers of Vich. The figures from altar panels of the church of San Juan de Mataplana near Montgrony (now Vich and Barcelona)[22] have been almost completely assimilated to manuscript-paintings, and so, too, have the figures from the altar-frontal with scenes of the life of Santa Margarita (now in the Museum of Vich) from which the centre panel of the Virgin and Child is reproduced (Plate 220). It is further seen in the painted altar-panels from Sagars (now in the Diocesan Museum of Solsona),[23] where, as in Mozarabic art, a 'textilization' of surface combines with an indifference to structure. To a greater or lesser degree, we find it also in the representation of the Ascension from an altar from Martinet (Lérida),[24] today in the Worcester Art Museum, the scenes of the life of St Julita from an altar at Durro (Lérida)[25] now in the Barcelona Museum, and the scenes from the life of St Martin originally decorating an altar at Montgrony (Gerona)[26] and now in the museum of Vich. A late example of this indirect influence – from Mozarabic art through manuscript-painting – is found in an altar-frontal from Vich (Barcelona) with scenes from the Life of the Virgin.[27] The tormented and dis-integrating line decoration is related to Late Romanesque manuscript-paintings like those of the Paris Apocalypse (Bibliothèque Nationale nouv. acq. lat. 2290) which themselves, in a new form and despite other (Byzantine) influences, continue to express sensibilities which are ultimately Mozarabic.

Mozarabic stylistic influences like these were variable in panel-paintings. But in one sense they exerted an overall effect. The intense glowing colours of these panels represent an inheritance from the Mozarabic coloristic sense of the past, and the particular tones, like the luminous yellows of the altar-frontal from the Seo at Urgel (Lérida)[28] in the Barcelona Museum (Plate 221), find their parallels in earlier *Beatus* manuscripts. This feeling for lustrous colour gives to these paintings on wood something of the vibrancy and richness of stained-glass windows.

This was not generally true of wall-paintings, with their more subdued range of earth colours. Here, there was less influence from traditional styles. On the other hand, there were influences from traditional themes. In the field of subject-matter if not of style, wall-painting claimed its inheritance.

It has been suggested in an earlier chapter that both the popularity of the illustrated Apocalypse in Spain and the reason for the pictures interpolated in it were due to the particular consciousness of the Christians there of the threats to their faith from the Christian heretic and Moslem infidel. This led on the one hand to an emphasis on the eschatological future, when the Christian would reap his reward and the heretic his punishment, visually expressed by the pictures of the Apocalypse itself and the added illustrations from the Book of Daniel; on the other it led to an accentuation of those aspects of the Christian faith that were particularly questioned by heretic or Moslem. This meant, in general, affirming the necessity and self-sufficiency of the New Testament message, and, in particular, stressing the inborn divinity of Christ, which had been

attacked by Adoptionist and Moslem alike. The first, we shall recall, was depicted in manuscripts in pictorially simple terms – by associating the evangelists and their Gospels with evidence of divine inspiration and power, and by maps of the evangelizing missions of the apostles. The second was represented by those New Testament scenes which subsumed the innate divinity of Christ – in particular, the worship of the Magi in the scene of the Epiphany, and God's own message to Mary and to the Shepherds in the form of the Annunciations.

The subject-matter of Spanish Romanesque wall-paintings continues these older traditions in a new form. It rarely presents episodes from the lives of saints, which were so popular in France. In Spain, these were normally confined to panel-paintings. The frescoes concentrate on those themes of the Bible that (like the main *Beatus* illustrations) are apocalyptic in inspiration or on those that (like the interpolated scenes in the *Beatus* manuscripts) emphasize the divinity of the Saviour.

The most frequent of all pictures in Spanish wall-painting is the apse painting of Christ in a mandorla with the Virgin and the Apostles below (see Plate 222). The fact that this derives from earlier dramatic representations of the Ascension[29] where Christ disappears into Heaven in a mandorla and is watched by the astounded apostles and Virgin below, is of historic and iconographic interest. But in these hieratic and timeless pictures of Spain the mood, the significance, and the associations are quite different. Here, Christ is essentially the God of the Apocalypse – the great Judge, normally surrounded by the apocalyptic symbols of the evangelists and often connected with other apocalyptic symbols. And, just as in the *Beatus* manuscripts the evangelists were closely related to the idea of celestial inspiration and power,[30] so here in wall-paintings (and in panel-paintings also) both they and the apostles are intimately associated with the ultimate divine sanction of the final Judgement. And, as in the vellum-paintings emphasis is given to the spiritual authenticity and necessity of their writings,[31] so here they are normally seen clasping the divine Gospel or Testament and from time to time drawing particular attention to it either by holding it dramatically aloft or,[32] as at Santa María at Tahull (Plate 223), by pointing conspicuously to it.[33] The Christ of the Apocalypse appears, of course, in the paintings of other countries, but nowhere is it given such remarkable emphasis as in Spain, and nowhere is there this close connexion with the apostles and Virgin which is here so unremitting as to become a Spanish formula.

Within the scope of the biblical narrative scenes, emphasis is given to those episodes which affirm the inborn divinity of Christ. Most popular by far is the Epiphany – the acknowledgement of the Magi by their gifts of the birth of a Saviour.[34] In churches like Santa María at Tahull, it will become the dominant theme of an apse. This, of all narrative illustrations, is the most favoured in Spain, whether expressed by the hands of a master as at Santa María de Barbará (Plate 225) and Santa María at Esterri de Aneu (Lérida) or given less impressive interpretations by less talented artists. The Annunciation to the Virgin is also a quite popular subject.[35] So, too, is the Annunciation to the Shepherds,[36] which becomes a particular centre of focus at the Panteón de los Reyes in San Isidro at León (Plate 229), where it emerges as a Romanesque masterpiece. All these three themes (which also appear in panel-paintings) symbolized the immanent divinity

of Christ, and all three, too, had been interpolated into the *Beatus* manuscripts. This is by no means to infer that Spanish monumental painting was confined to the pictorial themes of earlier manuscripts but simply to suggest that, in their own way, they continued to express the same Spanish consciousness.

Italo-Byzantine Influences

Though, in terms of style, some Mozarabic influences did percolate through to Spanish wall-painting, at its best Spanish painting has a hard discipline of form, a vitality of line, and a sheer monumentality which is the reverse of the exotically decorative and coloristic art of Mozarabic work.

The primary influence is from Byzantium. Indeed, in the Iberian peninsula we can almost watch Byzantine art being uncompromisingly and inexorably transformed into the new idiom of Romanesque. The inner radiance of the physical figure which Byzantine art achieved was of no relevance to the Spanish painter's needs. Like the rest of Romanesque Europe, Spain was unconcerned with the glow which animates the figure as a whole: its interest was the analysis and articulation of the figure into abstract forms so that it is at once dehumanized and raised above the accidents of nature into a world of the eternal. What attracted the Spanish painter in Byzantine art was a figure style which, by suitable accentuations and abridgements, lent itself to just such a treatment. This is true of Romanesque art as a whole, but, to a greater degree than other countries, Spain learned from Byzantium the means of representing the figure as an architectural structure. As a result, her painting achieves a power and a monumentality rarely attained elsewhere.

The intimate stylistic associations between Spain and Byzantium cannot be explained by a residual tradition of Byzantine art in the peninsula, for both historical and stylistic factors are opposed to such an idea. They are best accounted for by seeing Italy and Sicily as the intermediaries.

Indeed, epigraphic, stylistic, and iconographic elements in the wall-paintings all suggest this rôle of Italy as mediator. So, inscriptions on a scroll held by Gabriel in paintings of Esterri de Cardós (Lérida), Santa Eulalia at Estahón, and Santa María at Esterri de Aneu (now in the Barcelona Museum) all contain an incorrect reading in which POSTULATIUS is rendered as POSTLACIUS. This, it has been claimed, derives from a similar misreading in a scroll held by Gabriel in the apse painting of the Lombard church of San Vincenzo at Galliano[37] (though it should be added that the strength of this particular argument is much diluted when we realize that this change of spelling is not untypical of the general transition from Latin to the Romance languages). However, from the stylistic point of view, the powerful hypnotic heads of Spanish frescoes like the Christ in Majesty from San Clemente at Tahull (Plate 222) are demonstrably derived from Italian panel-paintings like the Redeemer panels from Casape and Tivoli, and the costumes worn by angels and others also show general Italo-Byzantine influence. Finally, there is an iconographic relationship[38] which is typified by the representation of Ecclesia: in Spain (for example, at San Quirce de Pedret) she is represented as a woman

seated on a church, and this exceptional form of personification is quite certainly derived from Italian paintings.[39]

There were many connexions between Spain and Italy. In an earlier chapter,[40] we have seen how a secular potentate like Count Oliba of Besalú could travel to Rome and Italy in the eleventh century, stay for a whole year at Montecassino, and return with the doge of Venice himself, who spent the last nineteen years of his life in Spain. We have also seen that monks from Ripoll were sent to Naples to correct a single manuscript. There were monastic affiliations between Spanish houses and Montecassino, the great source of the Benedictine tradition in the West. Some Catalan monasteries were also subject to the rule of the Italian priory of San Michele at Chiusi, which lay on the ancient road from Piedmont to France. On a wider level, the growing popularity of pilgrimages to Rome, or through Rome to the Holy Land, drew increasing numbers of the Spanish to Italy. And links forged in the heat of piety were confirmed in the cold interests of materialism, for Catalonia had commercial relations with both Pisa and Genoa, joining both in 1114 in an expedition against the Balearic Islands and uniting with the second in 1147 in the conquest of Almería.[41]

Among the masterpieces of Western Romanesque art must certainly be counted the Catalan paintings of San Clemente at Tahull, now in the Barcelona Museum.[42] The church itself was dedicated in 1123 and the paintings, though advanced for the date, may belong to the period of dedication. It would, at any rate, be safe to place them between 1123 and 1150. The most important of them represent the typical apse composition of Catalonia: Christ in Majesty (Plate 222) flanked by seraphim and surrounded by the symbols of the evangelists with apostles and the Virgin in arcades below. In the power, the vigour, and the monumentality of these paintings is concentrated all that is best in Spanish Romanesque. This is true not only of the dominating figure of Christ but also of the other figures around – of the angel holding the eagle of St John, which combines a feeling of forcefulness with a feeling of animation: of the lion, symbolizing St Mark, whose body, here covered with glaring eyes, is imbued with a savage dynamism and is yet presented with such disciplined precision of outline that it becomes itself an eternal embodiment of evangelical zeal and fervour.

The Spanish personality of these paintings is unmistakable. But so, too, are the Italo-Byzantine influences on them. Strengthened now to a new power and given an almost architectural feeling of weight and mass, the head of Christ has been derived from Italo-Byzantine art of northern Italy and can be compared with the heads of Christ from the Piedmont monastery of Sant'Ilario[43] or from the Redeemer panels of Casape and Tivoli. Italo-Byzantine influences are no less evident in other details of the painting, such as the angel carrying St John's symbol that we have already discussed, where the proportions of the figure and the feeling of inevitable forward movement can be matched in the later mosaics of Palermo.

The hand of God within a medallion, painted in the triumphal arch,[44] has a remarkable vitality of its own. There were also less accomplished paintings there of biblical episodes, from which that of the parable of Lazarus survives where the sores of the despondent Lazarus are being licked by a dog.

Italo-Byzantine influences on the Catalan apse paintings of Santa María de Tahull[45] are just as transparent. These, now in the Barcelona Museum, may belong to the mid twelfth century. In the bottom range of the paintings are animals, real and mythical, set heraldically within medallions. Above them the evangelists, within niches, who point to their Gospels (Plate 223), are represented with a forceful vigour. Then, in the semi-dome is the massively set Virgin in Majesty, holding the Christ Child squarely in front of her (Plate 224) and approached on either side by the Magi. The composition is completed above by the Lamb of the Apocalypse over the arch and, on the right, by the offering of Abel, which originally may have been balanced on the left by the offering of Cain, or even Melchisedech (as in the mosaics of San Vitale at Ravenna).

The imposing and hieratic frontal disposition of the Virgin, the form of her head-dress, and even the dramatic highlighting of the face all belong to a Byzantine tradition expressed in the mosaics of Hosios Lukas and Monreale. The splendidly impressive figures of the Magi and the evangelists, with their dramatic highlights and rather squat, powerful, block-like proportions, also derive from traditions of the Byzantine mosaic, which can be traced from those of the Baptistery of the Arians in Ravenna to Hosios Lukas and Palermo. In all these paintings, however, we see how the line, originally used in Byzantine art to indicate the lineaments of the figure, has been strengthened into something altogether more bold and forceful. We see, too, how, despite the almost hypnotic gaze of the eye, the life of the figure is not derived from a gentle suffusion within but from the external strength of line and vigour of modelling. These vehement and forceful paintings have something sculptural in their quality.

Other paintings from the triumphal arch and nave, now incompletely preserved in the Barcelona Museum, were made by an inferior apprentice artist. His rustic hand was responsible for a Last Judgement (which was associated with a battle of angels perhaps from the Apocalypse), Old Testament incidents from the story of David and Goliath, and also New Testament episodes such as the Magi and the appearance of the angel to Zacharias. These are represented in heavy, unexciting terms. The style of these pictures has affinities with that of the paintings of the lateral apses of San Clemente.[46] Here, however, it is so ponderous that the living David is as inanimate as the dead Goliath.

Italian mediation in the transmission of these Byzantine influences is confirmed by the linear quality with which they are expressed. This is particularly evident in the pictures of three apses of Santa María de Barbará.[47] Though these were damaged by fire during the Civil War in 1936 and are now much restored, one can still glean something of the fine quality of the original pictures. They have a lushly linear quality. Their themes, ranging over the Old and New Testaments, are fairly extensive, and reference has already been made to that of the three Magi (Plate 225). In the vault of the nave there is a picture of Christ with the elders of the Apocalypse, and in the minor apses representations of the martyrdoms of St Peter and St Paul and the discovery and exaltation of the True Cross by Constantine and Helena.

The Romanesque paintings of San Quirce de Pedret[48] probably belong to the first half of the twelfth century. The long, lissom figures with draperies tightly drawn in outline, but replete with folds within, owe much to Byzantium but are now invigorated

with a new linear suavity. They are here exemplified by the foolish virgins reproduced on Plate 226, and clearly derive from Italy. To some extent they can be compared to the frescoes of Santa Pudenziana in Rome, and the face of one angel from a scene of the Apocalypse is particularly close to the paintings of Santa Maria del Piano. The paintings from this church, which are now divided between the Barcelona Museum and the Diocesan Museum of Solsona, are characterized by a felicity of line and an intensity of colour. Together with biblical episodes, they include symbolic or allegorical scenes such as a group of angels at Mass and Christ with the wise virgins at a celestial banquet.

The artist of these paintings, who was active about the middle of the twelfth century, influenced the paintings of Santa María at Esterri de Aneu[49] and of San Pedro del Burgal (Lérida),[50] though the later figures are more powerfully and monumentally conceived.

A large part of the main scene of the apse painting of Santa María is unfortunately lost, though enough still survives in the Barcelona Museum to give some idea of its former magnificence. It was dominated by a Virgin and Child, approached by the three Magi and flanked by St Michael and, probably, St Gabriel. Of this imposing scene only the splendid figure of one of the Magi is now complete. This clearly indicates Byzantine influences assimilated to a Romanesque style and a Spanish individuality. The painting below of two seraphim with Isaiah and Elias is still in good condition, and the picture of a deacon on the left, who was, perhaps, the patron, is particularly vigorous and powerful.

A comparable figure – here it is a countess – in the apse of San Pedro del Burgal (Lérida)[51] is certainly that of the patron, though her identity is uncertain. Despite the considerable restoration that the paintings underwent after their removal to Barcelona, there can be less controversy over the fact that the artist was the same as that of Santa María, for even the decorative themes are the same. The paintings of the Virgin and various apostles are massively conceived and uncompromisingly Romanesque in their rigidly abstract forms, as we see from the illustration of St John the Baptist and St Paul (Plate 227). In some ways, indeed, like the earlier ones of Santa María at Tahull, these adamant figures with their assured heads, strong features, and intimidating looks, whose bodies are clearly outlined and whose very draperies are moulded into categorical and inflexible forms, represent the apotheosis of the power of Romanesque.

This particular artist must have been especially vigorous, for his influence extended over a wide geographical area and is found in such places as the church of San Pedro at Sorpe (Lérida)[52] and the chapel of the castle of Orcau.[53] The paintings of the grave and dignified apostles from the latter (now in the Barcelona Museum and here represented by St John and St Paul, Plate 228) probably belong to the second half of the twelfth century. They clearly represent a Byzantine style translated into a Western idiom. Indeed, the graceful elongation of the figures, their balanced poise, the draperies which combine weight with life and which fall cascading over the knees, can be paralleled in the Byzantine mosaics of Palermo. There is, however, here a precision of formulation which is unmistakably Romanesque.

Influences from Italo-Byzantine art reached other areas of Spain outside Catalonia and emerge in some of the finest of all Romanesque wall-paintings – those of the Panteón

de los Reyes of San Isidro at León.[54] They can be dated between 1157 and 1188 and include a particularly memorable Annunciation to the Shepherds (Plates 229 and 230).

Here we find the Spanish strengthening of the figure into a bright hardness which gives it a sculptural quality, and this is so pronounced in depth that one feels almost able to walk right round it. Highlighting, too, gives a robust convexity to the figures and an 'undercut' quality of recession within the drapery folds. Added to all this is a slightly florid decorative detail (inherited from the Mozarabic past) which gives a lively relish of surface to the bold clarity of form. This is very clear in the painting of the angel (Plate 230). The pictures are unmistakably Romanesque and categorically Spanish, but this mastery of highlighting to give depth and weight clearly comes from Byzantine experience. There is also, perhaps, some influence from Late Antiquity, for the scene of the Annunciation to the Shepherds has a certain pastoral quality which suggests reminiscences of a much earlier period. One shepherd is feeding a sheep and two are playing pipes as the angel appears to indicate, by an expansive gesture of his hands, the news that suffuses the messenger's own face with tranquil expectancy.

In other paintings by the same master there is occasional evidence of added French influence, though the powerful Spanish personality assimilates everything to itself.

An impressive painting of Christ in Majesty in the east vault of the nave is given individuality by the representation of the evangelists as angels with the heads of the evangelist symbols – an interpretation first seen in eighth-century manuscript drawings of England and France and familiar in the Spanish manuscript-painting tradition.

In another vault there is a portrayal of Christ as the great figure of the Apocalypse, together with other elements of the Book of the Apocalypse – the kneeling St John, the angel, the candlesticks, the book of seven seals, and the seven Asian churches. In yet others, there are paintings of the chief events of the New Testament, together with portrayals of prophets and archangels. This is the most extensive ensemble of Romanesque painting in Spain and, in quality, ranks among the finest of Europe. The scene of the Crucifixion is given added interest by the representation of Fernando II (1157–88) and Doña Sancha. It is an indication of the changing sensibilities of the period that, whereas in the eleventh century the German emperor and empress appeared in prayer before the Christ of Power and Glory, in the twelfth century a king and queen now appear as suppliants before the foot of the Cross.

The paintings of two churches in different parts of Castile show Italo-Byzantine influences comparable to those at Tahull. They probably belong to the second half of the twelfth century.

The first is in the hermitage of the Vera Cruz near Maderuelo,[55] and the second is in the hermitage of San Baudel de Berlanga in the province of Soria.[56] Both chapels are almost identical in shape and size and the stylistic affiliations of their paintings, which include the treatment of heads and hair, some details of drapery, and a similar colour scheme with an emphasis on reds, oranges, and yellows, can hardly be accidental. The entire surface of the barrel-vault of the Maderuelo chapel is filled with a Christ in Majesty in a mandorla supported by angels. The other pictures are now incomplete but include an Agnus Dei set in a cross supported by angels and scenes from the Old and

New Testaments, together with representations of the Virgin, the apostles, and some Church Fathers. Most of the paintings of San Baudel de Berlanga have been removed to museums, but originally they represented a remarkably extensive cycle of Romanesque Spain. Little remains of the upper zone, which originally contained New Testament scenes, but the nearly life-size paintings from the life of Christ which formed a continuous frieze below survive in good condition and, from it, the picture of the Three Marys at the Tomb, now in the Museum of Fine Arts, Boston, is reproduced (Plate 231). These Berlanga pictures included scenes, rare in Spain, of Christ's miracles and Passion. However, in the painting in the diminutive oratory, the more conventional tradition asserts itself, and we are given the Adoration of the Magi. Below the main christological scenes, on a background painted to simulate textiles, were representations of sporting activities such as stag-hunting and falconing and portrayals of real and mythical animals. These themes probably indicate Byzantine or Italo-Byzantine influence, for they are found in the paintings of Kiev[57] and Palermo.[58]

Though occasional Mozarabic influences do emerge in these two churches – as in the Creation scene of Maderuelo[59] – the basic formative influences are from Italo-Byzantine art. These are quite transparent in figures such as the warrior of Berlanga[60] and the Church Father on the south wall of Maderuelo,[61] which latter might be compared with the painting of St Gregory at San Pietro at Civate.[62] Byzantine influences are clear in the scenes from Christ's life from Berlanga (Plate 231), where the heads and stocky figure proportions have something in common with the Byzantine mosaics of Hosios Lukas, though the draperies themselves are made Romanesque, and are more formalized and stringent than anything in the art of the Eastern Church. Mosaics themselves may have played a part in the transmission of Byzantine influences, for these same paintings have a broken texture reminiscent of mosaic-work. In the paintings of these Castilian churches there are variations of quality, but the finest of them, such as the seated apostles of Maderuelo, show a complete assimilation of Byzantine influences and their re-expression in Spanish and Romanesque terms of clarity and strength.

It is clear from all that has been said that the most formative influence on Spanish Romanesque painting was that of Byzantine art refracted through Italy. But important influences also entered Spain from France.

This, in the historic context, is not unexpected, for France had long been interested in the Iberian peninsula. Cluny, for example, had already extended her monastic authority into Spain in the tenth century, just as Cîteaux was to do later in the twelfth. When Alexander II declared the war in Spain against the Moslems to be a crusade, large forces from France crossed the Pyrenees as Christian crusaders. Apart even from this, Santiago by the twelfth century had become the shrine of northern Europe and was drawing the French in vast numbers. It is not without significance that the one twelfth-century guide-book we have to this centre of pilgrimage was written for Frenchmen to indicate the various routes through France[63] and that the name of the major route in Spain itself was *camino francés*.

Let us only add in parentheses that influences between France and Spain did not simply flow in one direction, and that there are twelfth-century frescoes on French soil,

in Roussillon, which, despite an admixture of French influence, are basically Spanish. The most important of these are at San Martín de Fonollar (or Saint-Martin-de-Fenouillar) in the Pyrénées Orientales.[64] The Spanish feeling for structure is evident in the style and Spanish interpretation clear in the subject-matter. Not the least interest of these pictures is to show how closely packed with frescoes even small and poor churches could be, for the barrel-vault and the walls are covered with paintings. These comprise the half-figure of the Virgin flanked with angels, Christ surrounded by angels holding (as at Tahull) evangelist symbols in their arms, and other scenes familiar in Spanish churches – the Annunciation, Nativity, Annunciation to the Shepherds, and Adoration of the Magi.

Where French influences in Spain are strong, there is a linear emphasis which gives a certain fluency but which also dilutes the powerful quality of monumentality which characterizes Spanish painting at its best. This linear 'flattening' is evident, for example, in the Catalan wall-paintings of San Pedro at Sorpe (Lérida),[65] which is now in the Barcelona Museum. The Virgin and Child here (Plate 232) may be contrasted with the more massive and impressive representation of the same subject from Santa María at Tahull (Plate 224).[66] There is certainly some Byzantine influence in the Sorpe painting, for the iconography of the hieratic Virgin and Child follows a Byzantine formula and the particular highlighting of the face a Byzantine tradition. But there are influences from France too, and these lead to the reduction of the whole figure of the Virgin to terms of linear geometry in which the upper draperies are interpreted as a diamond shape superimposed on the richly patterned rectangle of the lower draperies beneath. A comparable schematization is found in later painted stucco altar-frontals such as those of Bohí (Lérida) and Chía (both now in the Barcelona Museum), where the two focal figures of St Peter and St Martin respectively[67] are fundamentally treated in the same terms of linear geometry. This formulation did not originate in Spain but on the northern border of France and Germany, where (as we have seen)[68] its genesis and development can be traced in the manuscript-paintings of Saint-Omer and Saint-Quentin. There is a comparable schematization of a standing figure in the painting of a bishop in the apse of the hermitage of San Pelayo de Perazancas (Palencia).[69]

Nowhere are French influences more obvious than in the Catalan apse paintings of San Saturnino at Osormort (Barcelona),[70] now in the museum of Vich. Despite the fact that these paintings probably belong to the last thirty years of the twelfth century and are, therefore, appreciably later than those of Saint-Savin-sur-Gartempe, they have obviously been derived from these earlier French frescoes. The figures have the same long proportions, the draperies are similar, and the heads with their lantern jaws and threaded hair are particularly close. As far as they go, even the scenes themselves follow the Saint-Savin examples, for they also portray the Creation and the Fall and, what is more, follow the Saint-Savin iconography. These paintings could, in fact, well be mistaken for French ones, even though the standing apostles in the zone above belong to the tradition of Spanish rather than French painting. It is just possible that the important house of Ripoll near by,[71] whose own wall-paintings have disappeared but whose manuscript illustrations in the eleventh century were influenced from France and which

was certainly French-orientated in the twelfth century under a line of Provençal abbots, was the active centre of French influence in this area.

The same artist, expressing the same influences from Saint-Savin, also worked at San Martín at El Brull (Barcelona)[72] and San Juan de Bellcaire (Gerona).[73] The paintings of the former (now in the museum of Vich) include, or included, Genesis scenes similar to those of Osormort, a Christ in Majesty, a Nativity, an Annunciation to the Shepherds, a scene of the Magi, and a Presentation in the Temple. The paintings here are not in good condition, but earlier copies of them exist which show a particularly close relationship to the illustrations of the Life of St Radegund from Poitiers which inspired some of the Saint-Savin paintings.[74] The paintings of San Juan de Bellcaire (now in the museum of Gerona) represent Pentecost. Paintings of the Crucifixion and martyrdom of St Stephen in the apse of the church of Marenyá in the province of Gerona[75] are, alas, poorly conserved, but they indicate stylistic affiliations with the same artist.

Though less pronounced, there are also some influences from Saint-Savin on the now damaged paintings of San Juan at Bohí (Lérida)[76] in the Barcelona Museum. This is particularly evident in the head of St Stephen and in the treatment of the drapery of his assailants. The latter also repeats some of the mannerisms of the paintings of Vic – particularly in the stylization of the draperies over the abdomen into a pear-like outline with a proliferation of small lines issuing from its apex. The figure proportions, though not those of Vic, are also clearly of French inspiration. French influences indeed are quite appreciable and remain comparatively unassimilated. The subject-matter of the paintings is not without interest. It includes one of the prophecies of Daniel in which the jugglers and musicians present at the adoration of the statue of Nebuchadnezzar are represented. The paintings originally on the south and the north walls are by two separate artists, and a third is responsible for the frescoes of the portal.

Other influences from France (and, again, specifically from Vic) take a different form in the Catalan paintings of Santa María at Mur (Lérida).[77] The church itself was originally part of an Augustinian monastery endowed by Raymond, count of Pallars, and consecrated in 1069 by the bishop of Urgel. The paintings must have been a good hundred years later. Only those of the central and southern apse survive, the first (and most important) being now in the Museum of Fine Arts at Boston (Plate 233). Here the conventional Spanish tradition is followed of representing Christ in Majesty surrounded by symbols of the evangelists with the apostles standing in the zone below, though only here and at Sescorts is the number of these apostles actually complete. Further below, in the lowest zone of all, are representations of the Nativity, the Annunciation to the Shepherds, and the Epiphany. The stylistic relations between the painting of Christ here and that of Vic are of the clearest. But, despite this, the Santa María painting has now assumed its own Spanish personality – the fluted folds are categorically interpreted in terms of rigorously decisive forms, and the figure itself has a monumentality and an architectural feeling of weight and mass which are unmistakably Spanish.

We may add that the splays of the windows between the apostles have paintings of Cain and Abel and of two or three figures with upstretched hands. The interest of the latter is that they show yet other French influences, for they are reminiscent of the

paintings of Tavant. To this may be added in parentheses the fact that the much later paintings in the cathedral of Roda de Isábena (Huesca) also suggest influences from Tavant. These influences are distilled by the hand of a master into a new purity and precision, so that the grouped heads in the scene of the Descent from the Cross[78] become a masterpiece of clarity, economically stated. Despite their thirteenth-century date, they are still in the Romanesque idiom.

Further French influences are strong in paintings from three Catalonian churches which form one stylistic group – San Martín Sescorts (Barcelona),[79] San Esteban at Poliñá,[80] and Santa María de Barbará (Barcelona).[81] The first church had fragmentary scenes from the Book of Genesis which are now in the museum of Vich; the second pictures of Christ in Majesty, the Annunciation, and Christ before Pilate, which are now divided between the Barcelona Museum and the Prats Collection in the same city; and the third (in fragmentary form) the martyrdoms of St Peter and St Paul, the Agnus Dei and elders of the Apocalypse, and the exaltation of the True Cross before Constantine and Helena. These pictures are flatly linear in a long, loose-limbed figure style that can be paralleled in French wall- and manuscript-paintings and show a modest competence rather than an outstanding talent.

In figures like the Sescorts angel in the Expulsion from Paradise, the highlights originally used to indicate the convexity of the chest are reduced to patterned and semi-circular bands. Though already apparent in the Byzantine-inspired Christ of Tahull, this is a familiar aspect of French twelfth-century wall-painting that was already well known in French eleventh-century manuscript-painting. We see it again in the more powerful figure of St Augustine in the apse of the cathedral of Roda de Isábena,[82] which might be stylistically compared to the figure being healed by St Gilles in the French paintings of Saint-Aignan-sur-Cher.[83]

When we pass from frescoes to Catalan panel-paintings[84] we find that the finest represent a synthesis of all the influences on Catalan art and yet remain unmistakably Spanish. In this group the figures and draperies of the central Christ have some of the stylistic qualities of French paintings, though strengthened to a new severity, and the heads have the power of the Byzantine Pantocrator, though given a new intimidation. Mozarabic influences emerge discreetly in the controlled decorative detail and more richly in the luminous colours of the backgrounds – particularly the intense yellows and reds. The frequent restriction of the palette to blacks, greens, yellows, and reds produces an arpeggio of colour that is uniquely Spanish.

The two finest examples of this stylistic group of altar-frontals are both now in the Barcelona Museum and were probably produced by the same atelier in the second half of the twelfth century. The first (Plate 221) comes from the Seo at Urgel (Lérida)[85] and represents Christ as the central focal figure with the apostles facing towards him from two lateral compartments. Their heads are lifted above each other in a pyramidal composition – an inverted perspective originating in Late Antiquity and retained as a convenient formula in an age more interested in the perspective of values than the perspective of space. The second is from Hix (Roussillon)[86] (Plate 234), and here Christ remains in the same central position within a double mandorla. The sides are now divided into four

frames containing sixteen figures which include the twelve apostles. In both these altar panels the central figure of Christ has some of the power of the best wall-paintings, and the singing colours give these paintings on wood something of the rich vibrancy of stained-glass windows.

A slightly earlier example – perhaps of the mid twelfth century – is a fragment from an altar canopy in the museum of Vich which originally portrayed a Christ in Majesty, flanked by angels.[87] The two angels on the right are still complete and the one nearest the border is particularly fine.[88] Influences here from France are strong and, though now frozen into a Romanesque timelessness, the fluttering drapery folds, the fluent firmness of line, and the long, easy proportions ultimately derive from the Channel School of manuscript-painting. The latter, as we have seen, had earlier influenced the illustrations of the Ripoll Bible. The manuscript-painting of Limoges also offers parallels to these panel pictures.

The central figure of Christ in an altar-frontal from the church of San Lorenzo dels Munts (south of Vich)[89] has something of the long, loose proportions of the last-named Christ. The figures, particularly of the lateral panels, however, are much inferior and represent an unhappy combination of a strong archaizing tendency with Italian and French influences. The altar-frontal belongs to the second half of the century and is now in the museum of Vich. The panel scenes are of the life of the early Spanish martyr St Lawrence, who was particularly venerated in Spain.

The earliest example of this stylistic group, and one closer than the last two to the Hix and Seo de Urgel frontals, is an altar-frontal from Montgrony[90] in Bergadà in the western Pyrenees. It is now in the Vich Museum and has claims to be among the earliest panel-paintings of Spain, for it can be attributed to the early twelfth century. In the centre is Christ, and there are scenes from the life of St Martin in rectangular frames to His right and left. Though it cannot be said to have their force and power, it shares (or anticipates) some of the stylistic traits of the Barcelona panels, including the convex banding of the chest. In the lateral scenes, there is evidence of a deliberate archaizing so that the figures are brought into an artificial relationship with such figures of the past as those of the tenth-century Codex Vigilianus.[91]

Finally, as an indication of the continuity of this style throughout the twelfth century, we can point to an antependium from Vich (Plate 235), now in the Espoña Collection of Barcelona,[92] which is exceptional in its uncompromising use of the coloured, broad-stripe backgrounds of Mozarabic manuscript-painting. Christ here is portrayed with the symbols of the evangelists around and with the apostles in the lateral wings. The fact that the elliptical frame within which He sits is inscribed in hexameters and that the rectangular frames at the sides are 'inset' with simulated precious stones suggests the influence of metalwork. Basically, however, the figure style is in the tradition of earlier panels – not only in the representation of the figures but also in details of drapery. A breath of Gothic gives the central figure a more relaxed, human quality. This panel must indeed belong to the very end of the twelfth century, if not to the beginning of the thirteenth.

It may not be a complete coincidence that a wall-painting of the martyrdom of

St Thomas of Canterbury in the lateral apse of Santa María at Tarrasa[93] has something in common with these panel-paintings. We have already seen that episodes from the lives of saints were normally in Spain confined to panel-paintings. Perhaps this one itself was copied from a panel-painting or made by a panel-painter.[94] It represents the martyrdom of St Thomas and the ascent of his soul to Christ, who is represented in a mandorla in the semi-dome of the apse. St Thomas was martyred in 1170 and canonized in 1173, and this apse painting, which may have been made before the end of the century, is only one testimony to the rapid and extraordinary popularity of St Thomas in art.[95] One factor in this, no doubt, was the anxiety of Henry II's own family to atone for the deed precipitated by the king's angry words. It is no accident that the mosaic of St Thomas at Monreale was made at a time when one of Henry's daughters was queen of Sicily, and the fresco at Tarrasa at the time when another daughter of the English king was married to Alfonso III of Castile. However, this in itself by no means explains the remarkable fact, testified to in literature as well as art, that an English bishop should be so readily accorded after his death a universal regard which his inflexible personality had prevented during his own life.

There is a number of representations of St Thomas in art, but the significance of the one at Tarrasa is that it also reveals how even contemporary events evoked apocalyptic associations in Spain. Christ receiving Becket into heaven is flanked by the candlesticks of the Apocalypse, and the open books which He holds over Becket's head have equally clear reference to the words of the Apocalypse: 'And they sung a new song, saying, Thou art worthy to take the book, and to open the seals thereof: for thou wast slain and hast redeemed us to God by thy blood' (v, 9).

The convex 'banding' of the chest that characterized a whole group of panel- and wall-paintings also appears in the frescoes of San Pedro at Urgel,[96] where there is a mingling of French and Byzantine influences. The painting, now in the Barcelona Museum and probably of the end of the twelfth century, is the familiar apse picture of Christ in Majesty above the Virgin and apostles. It is particularly colourful and viva-cious, but cannot be said to have the full Romanesque integrity. That powerful simpli-fication of figures to monumental and eternal symbols which is evident in the greatest Catalan paintings is not here apparent. In fact, the Romanesque probity of the whole has been weakened both by older traditions and by a newer ethos. On the one hand, the fluttering and cascading draperies of Christ, which become of interest in themselves to the detraction of an overall Romanesque synthesis, indicate influences from the wall-paintings of the Loire, which themselves reflect Carolingian and early Channel School traditions. On the other, the attempt to infuse the Virgin and apostles (Plate 236) with a new humanity already represents a weakening of the very spirit of Romanesque before the incoming forces of Gothic. Instead of standing frontally before us as fixed and eternal symbols, they now turn towards each other as human beings in animated conver-sation. One may argue that this reflects a very early Palestinian iconography, but more important than the tradition of iconography is the way the figures are handled. If they are presented in Romanesque form, they have already rejected its spirit. This mingling of influences undoubtedly gives the pictures a certain piquancy and vivacity. But these

are at the expense of its force and power. The Romanesque idiom here is being weakened by the old and superseded by the new.

The further weakening of the power of Romanesque is seen in paintings influenced by those of Urgel but now in the hands of less skilled artists. These are from the Andorra churches of San Miguel d'Engolasters,[97] Anyós,[98] and San Román de las Bons at Encamp.[99] Apart from the Anyós paintings, now in a private American collection, they are all in the Barcelona Museum. In the San Román paintings, particularly, one is conscious of the thawing out of the Romanesque immobility and the emerging spirit of a new humanity in the portrayals of St Peter and the Virgin. All this mirrors a transition from Romanesque which we have already seen in Germany and which is particularly evident in France in the final decades of the twelfth century.

TRANSITIONAL

ROMANESQUE, we have often stressed, is an art of the abstract. It regards the naturalism of everyday life as something but transient and inconsequential, compared to the enduring reality of the spirit. Indeed, in the fervent rejection of this world in favour of something more abstract and abiding, it represents an aesthetic that is fundamentally religious, even monastic, in outlook. It is no accident, then, that the art traced in this volume, which culminates in Romanesque, is the art of the great monastic era of the Western Church. It was an era when many artists were themselves monks, when many abbots (or bishops with monastic sympathies) were patrons of art, but when, above all, the monasteries, as the cultural strongholds of the West, could impose their own tastes on Europe.

After the mid twelfth century, this long period began to draw to an end. The years of the decade after 1150 already begin to announce its parting. In 1151 died Suger, who was not only abbot of Saint-Denis but whose political influence was such that he has been called the father of the French monarchy. In 1153 died St Bernard, abbot of Clairvaux, whose ecclesiastical authority enabled him to launch the second Crusade and whose spiritual authority caused him to be named the last of the Fathers. In 1156 died Peter the Venerable, the last outstanding abbot of the powerful house of Cluny. The bell was knelling the parting not simply of great monks but also of a great era. The Benedictine centuries were drawing to a close; the future lay with the schools, the universities, and the friars. Monasteries would, of course, continue to patronize art, but the domination of the taste of the West was moving slowly but irrevocably away from the cloisters.

As if uneasily conscious of this momentous change, the art of Europe is occasionally touched in the later twelfth century by a sudden, if ephemeral, flamboyance. In northern France, the illustrations of the Bible of Saint-André-au-Bois, near Saint-Omer (Boulogne, Bibliothèque Municipale MS. 2; Plate 237),[1] have a wild eccentricity of line which gives to the figures an impression of wilful irresponsibility. In Germany – especially in Swabia – there enters into the paintings a dramatic, even histrionic element which may derive from Ottonian or Byzantine sources but which chooses this moment to emerge. It is evident (as we have seen) in the manuscript-painting of Salzburg and emerges, after the turn of the century, at Weingarten, in the passionately turbulent paintings of its magnificent Missal (New York, Pierpont Morgan Library MS. 710),[2] whose figures combine with their sculptural feeling an electrifying sense of dynamism.

But although the Romanesque outlook itself was by no means dead and indeed continued to pervade styles even in the thirteenth century, by the last decades of the twelfth century it had already passed its zenith as a new and creative force. In the more progressive areas – particularly in France – the general trend is already clear. There is a gradual relaxing of Romanesque intensity and power as the West begins to feel the

ground-swell of Gothic. Indeed, one of the excitements of art at the end of our period is to watch the confrontation of the two aesthetics which can at some times lead to confusion but at others to great exhilaration.

In central France, we see this confrontation in the Souvigny Bible (Moulins, Bibliothèque Municipale MS. 1),[3] which is one of the most important of twelfth-century Bibles from France. It is illustrated both by historiated initials and by pictures (here represented by scenes from the life of David; Plate 238) separate from the text. The figure style is still Romanesque and has Byzantine ingredients, but its tension is being released. Conscious now of the spirit of Gothic, the artists have a dawning interest in the human figure as such, instead of seeing it simply as a departure point for abstractions.

We experience something comparable in north France in illumination as well as in the wall-paintings of Petit Quevilly that we earlier examined. The splendid illustrations of the third *Life of St Amand*, made at Saint-Amand between 1170 and 1200 (Valenciennes, Bibliothèque Municipale MS. 500), are particularly instructive since they are based on pictures of a mid-twelfth-century cycle (Valenciennes, Bibliothèque Municipale MS. 501; Plate 209) which represented the Romanesque development at its peak. Now, however – as we see from the reproduction of folio 51 (Plate 239) – the Romanesque decisiveness is beginning to melt. The draperies are no longer resolved into quite such abstract shapes and rhythms but fall more loosely; the figure is already more suave and less inflexible, and one is conscious of flesh and warmth; the faces lack the spiritual intensity of expression of earlier ones and have the more human expressions of puzzlement or surprise. In points of detail, Romanesque antecedents are clear, and there are certainly still Romanesque ingredients present, but the whole approach is more human and less rigid than in the second *Life of St Amand*. At Anchin the illumination of a *Hrabanus Maurus*, belonging perhaps to the 1160s or 1170s (Douai, Bibliothèque Municipale MS. 399),[4] shows a similar slackening of the Romanesque tenseness. In the Tree of Jesse of another manuscript there (Douai, Bibliothèque Municipale MS. 340 folio 11; Plate 240) we are conscious, too, of an increasing interest in ornate detail for its own sake. The historiated initials are pleasingly colourful, but the figures are becoming both decorous and decorative in treatment, and there is already an introduction of the inconsequential for purely decorative effect, such as the curved, formalized, foliated scroll held unnecessarily over the heads of figures. This almost deliberate breaking up of Romanesque intensity by the insertion in narrative scenes of a contrived decoration appears again in a Bible from Saint-Bertin (Bibliothèque Nationale MS. lat. 16746),[5] where the scrolls held by the figures curve across the initials like streamers.

The actual quality of the illumination continues to be as high as ever in this latter part of the twelfth century. The initials, bright with warm colours and occasionally shimmering with gold, have an increasingly ornamental glamour. This is already evident in a group of manuscripts made between 1165 and 1185 and associated with Thomas Becket and his secretary, Herbert Bosham,[6] which may have been produced in the Cistercian abbey of Pontigny in Burgundy. These have a number of colourful initials which are enlivened at times with little white lions and strange tadpole-like creatures, but on the whole they rely for effect on their rich colours and bright, decorative foliage.

Comparable decoration can be found in both England and France, which continued, as in the earliest Carolingian and all later periods, to exchange influences.

This interrelationship is well demonstrated by the Manerius Bible (Paris, Bibliothèque Sainte-Geneviève MSS. 8–10),[7] which was made between 1170 and 1200 and which conveniently sums up some of the most progressive tendencies of the end of the twelfth century. Its scribe was an Englishman named Manerius, who was a native of Canterbury. This we know from a lengthy colophon which exhibits a lack of diffidence already witnessed in the scriptorium of Canterbury itself.[8] He not only gives his name with full details of his family but also appends a gratuitous and highly flattering interpretation of it to show that he was a particularly skilled and expert calligrapher. The scene of his writing, however, was not England but France. It might possibly have been Pontigny, for the illumination has stylistic links with a fragment of a Bible from Pontigny and with another Bible from Sens in the neighbourhood.[9] If made in this Cistercian house, it would not be without irony, for it contains just those irrelevant curiosities which St Bernard had so vehemently attacked in Cluniac sculpture and which contemporary Cistercians were attacking in wall-paintings. It is also possible, however, that the scriptorium in which Manerius was working was Saint-Bertin[10] in north-eastern France, which had its own intimate ties with Canterbury and which also produced related vellum-painting.

The illumination, at any rate, is French and combines excellence of quality with a sumptuousness of gold and colour. But the forcefulness and impact of Romanesque is being succeeded by something more human and more forbearing. The passionate intensity of the figure style is being toned down to something softer and gentler, and the extravaganza of the irrelevant and the episodic in the borders anticipates Gothic manuscripts of the future. Painting is losing its spiritual mission and becoming more of a human indulgence, an arbour of pleasures for the eye to rove in. It is, in fact, already beginning to point in the direction of the Gothic future.

In the final decades of transition of the twelfth century, the traditional aesthetic of Romanesque and the incoming aesthetic of Gothic meet. There is a confrontation but not yet a resolution, and it is this that gives a sense of turmoil and complexity to these closing years. We are in a period of conflicting tidal flows when, like anchored vessels at this state of the tide, artists take differing directions. Some still resolutely face the Romanesque tide, though it is almost spent: others veer away from it to anticipate the incoming tide of Gothic. Not until the thirteenth century, however, will they really feel the smooth flow of its suave elegance.

NOTES

CHAPTER I

p. 2 1. For which, see E. Heinrich Zimmermann, *Vorkarolingische Miniaturen* (Berlin, 1916).

2. Jean Porcher, 'La Peinture provinciale', 56, figures 2 and 3, in *Karl der Grosse: Lebenswerk und Nachleben*, III (entitled *Karolingische Kunst* and edited by Wolfgang Braunfels and Hermann Schnitzler, Düsseldorf, 1966).

3. See Margaret Rickert, *Painting in Britain: The Middle Ages* (Pelican History of Art) (London, 1954), chapter 1 and bibliography.

p. 3 4. See British Museum, *The Sutton Hoo Ship Burial*, 5th impression (London, 1956); R. L. S. Bruce-Mitford, 'The Sutton Hoo Ship Burial, recent theories and some comments on general interpretations', *Proc. Suffolk Institute of Archaeology and Natural History*, XXV (1949).

5. See Sir T. D. Kendrick and others, *Evangeliorum Quattuor Codex Lindisfarnensis* (Olten, 1956).

6. For which, see O. M. Dalton, *Byzantine Art and Archaeology* (Oxford, 1911); Otto Demus, *Byzantine Mosaic Decoration* (London, 1947); André Grabar, *Byzantine Painting* (New York, 1953); Philipp Schweinfurth, *Die Byzantinische Form* (Worms, 1954); John Beckwith, *The Art of Constantinople* (London, 1961); David Talbot Rice, *Art of the Byzantine Era* (London, 1967), etc.

7. See below, Chapters 2 and 7.

p. 4 8. See below, pp. 22–3, 26, 29, 31, 36.

9. See William of Malmesbury, *Gesta Pontificum* (Rolls Series), 103 and 96.

10. See, for example, P. E. Schramm and F. Mütherich, *Denkmale der deutschen Könige und Kaiser* (Munich, 1962).

p. 5 11. See below, pp. 22–3.

12. See below, pp. 25 ff.

13. *Ibid.*

14. See Adolph Goldschmidt, *Die deutsche Buchmalerei* (Florence and Munich, 1912), plate 52.

15. See C. R. Dodwell, *The Great Lambeth Bible* (London, 1959), 19.

p. 6 16. See below, pp. 103 ff.

17. See below, p. 78.

18. *Gesta Abbatum Fontanellensium* (*Monumenta Germaniae Historica Scriptores* [hereafter quoted as *Mon. Germ. Hist. SS.*], II), 296.

19. André Wilmart, 'La Légende de Ste Édith en prose et vers par le moine Goscelin', *Analecta Bollandiana*, LVI (1938), 50 and 87.

20. *Ekkehardi IV Casus S. Galli*, cap. III, 97 (*Mon. Germ. Hist. SS.*, II).

21. *Vita Balderici ep. Leodiensis*, 730 (*Mon. Germ. Hist. SS.*, IV).

22. *Ibid.*, 729.

23. Quoted by Paul Deschamps and Marc Thibout, *La Peinture murale en France* (Paris, 1951), 21.

24. See Otto Pächt, 'A Cycle of English Frescoes in Spain', *Burlington Magazine*, CVI (1961), 166–75.

25. Hugh of St Victor, *De Bestiis et aliis rebus* (Migne, *Patrologia Latina*, CLXXVII, col. 46).

26. See C. R. Dodwell (ed.), *Theophilus De Diversis Artibus* (London, 1961).

27. The fact that the painters were paid suggests that they were not monks, for they, of course, had taken a personal vow of poverty, and any payment would be made to their house. The further fact that they are described as thieves would certainly, in the religious context of the account, go some way to suggesting that they were seculars. See *Casus Monasterii Petrishusensis*, 633 (*Mon. Germ. Hist. SS.*, XX).

28. G. G. Coulton, *Art and the Reformation* (Oxford, 1928), 75.

29. Cambridge, Corpus Christi College MS. 4 *p. 7* folio 241 verso. See Virginia Wylie Egbert, *The Medieval Artist at Work* (Princeton, 1967), plate VII (where they are, however, described as illuminators).

30. See below, p. 141.

31. See *Les Trésors des églises de France* (exhibition catalogue of the Musée des Arts Décoratifs, Paris, 1965), no. 336 and plate 100, with bibliography.

32. Paul Meyer (ed.), *Girart de Roussillon* (Paris, 1894), lxxviii–lxxx.

33. Otto Demus, *The Mosaics of Norman Sicily* (London, 1950), plates 112–19.

p. 7 34. Meyer (ed.), *op. cit.*, lxxx, sections 2, 113, 116.

35. Lines 994–6.

p. 8 36. C. R. Dodwell, 'The Bayeux Tapestry and the French Secular Epic', *Burlington Magazine*, CVIII (1966), 549 ff.

37. P. E. Schramm and F. Mütherich, *op. cit.* (Note 10), 163–4, plates 130–2; M. Schuette and S. Müller-Christensen, *The Art of Embroidery* (London, 1964), xvi ff., 298, and plates 14–22.

38. Schuette and Müller-Christensen, *op. cit.*, xiii, 330, and plates 57–9.

39. É. Bertaux, *L'Art dans l'Italie méridionale* (Paris, 1904), 70.

40. Otto Lehmann-Brockhaus, *Schriftquellen zur Kunstgeschichte des 11. und 12. Jahrhunderts für Deutschland, Lothringen und Italien*, II (Berlin, 1938), no. 2606.

41. *Ibid.*, no. 2627.

42. *Ibid.*, no. 2643.

43. *Ibid.*, nos. 2575–2602.

44. *Ibid.*, no. 3058.

45. Schuette and Müller-Christensen, *op. cit.*, 299 (with bibliography), plates 40–5.

p. 9 46. Lehmann-Brockhaus, *op. cit.*, no. 2611.

47. *Ibid.*, no. 2710.

48. *Ibid.*, no. 2605.

49. Hermann Schnitzler, *Rheinische Schatzkammer, die Romanik* (Düsseldorf, 1959), 42–3, with bibliography.

50. Schuette and Müller-Christensen, *op. cit.*, xvii, 302, plates 81–4.

51. *Ibid.*, xvii, 302, plates 78–80.

52. Schramm and Mütherich, *op. cit.*, 163, plate 131.

53. Schuette and Müller-Christensen, *op. cit.*, xvi–xvii, 298, and plates 23–6.

CHAPTER 2

p. 10 1. J. de Wit, *Die Miniaturen des Vergilius Vaticanus* (Amsterdam, 1959).

2. Francis Wormald, *The Miniatures in the Gospels of St Augustine* (Cambridge, 1954).

3. Dodwell (ed.), *Theophilus* (*op. cit.*, Chapter 1, Note 26), 1 and 2.

4. *Eraclius De Coloribus et Artibus Romanorum,*

183, in Mrs Merrifield, *Original Treatises . . . on the Arts of Painting*, 1 (London, 1849).

5. Jaffé, *Regesta*, 2182. p.

6. Migne, *Patrologia Latina*, XCVIII, cols. 1284–8.

7. E. W. Anthony, *A History of Mosaics* (Boston, p.
1935), 149.

8. Raimond van Marle, *La Peinture romaine au moyen âge* (Strasbourg, 1921), 71 and 72; *idem, The Development of the Italian Schools of Painting*, I (The Hague, 1923), 113, 114, 115, and figure 55; *Karl der Grosse* (catalogue of Aachen exhibition of 1965), figure 8.

9. Van Marle, *Italian Schools*, 114.

10. Van Marle, *Peinture romaine*, 73; Guglielmo Matthiae, *Mosaici medioevali delle chiese di Roma* (Rome, 1967), 229 and 269.

11. Anthony, *op. cit.*, 79 ff.; Matthiae, *op. cit.*, p.
135.

12. Anthony, *op. cit.*, 146 ff.; Matthiae, *op. cit.*,
233.

13. See Ciampini, *Vetera Monumenta*, II, plates 51 and 52.

14. Anthony, *op. cit.*, plate XIX.

15. Anthony, *op. cit.*, plate XXVI; Matthiae, *op. cit.*, plate 196.

16. Anthony, *op. cit.*, plate VIII.

17. Anthony, *op. cit.*, plate XXXVII; Matthiae, *op. cit.*, plate 145 and p. 236; Van Marle, *Peinture romaine*, 75.

18. Anthony, *op. cit.*, plate XXV.

19. Van Marle, *Peinture romaine*, 83 ff.; P. Toesca, p.
La Pittura e la miniatura nella Lombardia (Milan, 1912).

20. Matthiae, *op. cit.*, plates 176 ff.; Van Marle, *Peinture romaine*, 76.

CHAPTER 3

1. *B. Caroli Magni Imperatoris Vita, auctore Ein-* p.
hardo, Migne, *Patrologia Latina*, XCVII, col. 310.

2. For Merovingian illumination, see E. Heinrich Zimmermann, *Vorkarolingische Miniaturen* (Berlin, 1916).

3. For which see, for example, G. L. Micheli, *L'Enluminure du haut moyen âge et les influences irlandaises* (Brussels, 1939).

4. See Julius von Schlosser, *Schriftquellen zur Geschichte der karolingischen Kunst* (Vienna, 1892),

and Friedrich Leitschuh, *Geschichte der karolingischen Malerei* (Berlin, 1894).

5. Hubertus Bastgen (ed.), *Mon. Germ. Hist. Legum Sectio III Concilia Tomi II Supplementum*.

6. Edgar de Bruyne, *Études d'esthétique médiévale* (Bruges, 1946), 264.

7. See, for example, *Capitulare Aquense* of about 807 in Migne, *Patrologia Latina*, XCVII, col. 310.

8. *Op. cit.*, 204, 213.

9. Schlosser, *op. cit.*, no. 924.

10. *Ibid.*, no. 925.

11. *Ibid.*, no. 926.

12. *Ibid.*, no. 931.

13. *Ibid.*, no. 974.

14. *Ibid.*, no. 1023.

15. *Ibid.*, no. 1007.

16. See Roger Hinks, *Carolingian Art* (London, 1935), 101-2.

17. See H. Schnitzler, 'Das Kuppelmosaik der Aachener Pfalzkapelle', *Aachener Kunstblätter*, XXIX (1964), 17-44.

18. See Peter Bloch, 'Das Apsismosaik von Germigny-des-Prés – Karl und der alte Bund', in Wolfgang Braunfels and Hermann Schnitzler (eds), *Karolingische Kunst* (Düsseldorf, 1966), 234-61. See also A. Grabar, 'Les Mosaïques de Germigny-des-Prés', *Cahiers Archéologiques*, VII (1954), 171 ff.

19. Schnitzler, *op. cit.*

20. Grabar, *op. cit.*; Bloch, *op. cit.*

21. Three Bibles of Theodulf are known, two in the Bibliothèque Nationale (MSS. lat. 9380 and 11937) and one in the treasury of Le Puy Cathedral. They can be sumptuous with gold letters and fine canon tables, but none has illustrations. See L. Delisle, 'Les Bibles de Théodulphe', *Bibliothèque de l'École des Chartes*, XL (1879), 1 ff.

22. Schlosser, *op. cit.*, nos. 1026, 1031, etc.

23. Bloch, *op. cit.*, 256, 261.

24. Edward S. King, 'The Carolingian Frescoes of the Abbey of Saint Germain d'Auxerre', *Art Bulletin*, XI (1929), 359-75.

25. *Ibid.*, 375 ff.

26. J. Zemp and R. Durrer, 'Das Kloster St Johann zu Münster in Graubünden', *Mitt. der Schweiz. Ges. zur Erhaltung hist. Kunstdenkmäler* (Geneva, 1906-10); L. Birchler, 'Zur karolingischen Architektur und Malerei in Münster-

Müstair', *Akten zum III Internationalen Kongress für Frühmittelalterforschung* (Lausanne, 1954), 167 ff.; G. de Francovich, 'Il Ciclo pittorico della chiesa di S. Giovanni a Münster (Müstair) nei Grigioni', *Arte Lombarda*, II (1956), 28 ff.; G. de Francovich, 'I Problemi della pittura e della scultura pre-romanica', *Centro italiano di Studi sull' Alto Medioevo*, Spoleto, II (1955), 435 ff.

27. De Francovich, 'I problemi...', 452 ff.; J. Garber, 'Die karolingische St-Benedikt-Kirche in Mals', *Zeitschrift des Ferdinandeums*, LIX (1915); E. W. Anthony, *Romanesque Frescoes* (Princeton, 1951), 121.

28. Anthony, *op. cit.*, 117 ff.

29. Friedrich Behn, *Die karolingische Klosterkirche von Lorsch an der Bergstrasse* (Berlin and Leipzig, 1934); Anthony, *op. cit.*, 119 ff.; P. Toesca, *La Pittura e la miniatura nella Lombardia* (Milan, 1912), 34 ff.

30. H. Eichler, 'Peintures murales carolingiennes à Saint-Maximin de Trèves', *Cahiers Archéologiques*, VI (1952), 83 ff.; André Grabar and Carl Nordenfalk, *Early Medieval Painting* (Lausanne, 1957), 73 ff.

31. Heinrich Fichtenau, *The Carolingian Empire* (Oxford, 1957), 46 ff.

32. Ed. K. A. Eckhardt (Weimar, 1953), 82 ff.

33. E. Kantorowicz, *Laudes Regiae* (Berkeley, 1946), 56 ff.

34. *Ibid.*

35. Fichtenau, *op. cit.*, 71; and see H. Lilienfein, 'Die Anschauungen von Staat und Kirche der Karolinger', *Heidelberger Abhandlungen zur mittleren und neueren Geschichte*, I (1902), 28 ff.

36. Quoted by Peter Bloch, *op. cit.*, 259.

37. *Ibid.*

38. *Ibid.*

39. See the dedication verses in the Vivian Bible (*Mon. Germ. Hist.*, PL III, 250, no. x):
 'O decus, o veneranda salus, o splendide David,
 Rex Carole....'

40. D. H. Green, *The Millstätter Exodus* (Cambridge, 1966), 204. And see, more generally, F. J. E. Raby, *A History of Christian-Latin Poetry from the Beginnings to the Close of the Middle Ages* (Oxford, 1953), for example, p. 155.

41. Bloch, *op. cit.*, 260, with bibliography.

42. *Ibid.*, 259.

43. See below, p. 41.

44. *Op. cit.*, 151 ff.

p. 22 45. Utrecht University Library Script. eccl. 484. See below, pp. 30 ff.

46. P. A. Amelli, *Miniature sacre e profane dell'anno 1023* (Montecassino, 1896); F. Saxl, 'Illustrated Encyclopaedias', in *Lectures* (London, 1957), I, 234 ff., and II, plates 155–65; Erwin Panofsky, 'Hercules Agricola: A further Complication in the Problem of the Illustrated Hrabanus Manuscripts', in Douglas Fraser and others (eds), *Essays in the History of Art presented to Rudolf Wittkower* (London, 1967), 20 ff.

47. Rome, MS. Vat. lat. 3868. See Leslie Webber Jones and C. R. Morey, *The Miniatures of the Manuscripts of Terence* (Princeton, 1931), 27 ff. and relevant plates.

48. H. Stern, 'Le Calendrier de 354', *Institut français d'archéologie de Beyrouth, Bibliothèque archéologique et historique*, xv (Paris, 1953).

49. British Museum MS. Harley 647. See Saxl, *Lectures*, 101 ff. and plate 54.

p. 23 50. Leiden, Univ. Library Cod. Voss. lat. Q. 79. See G. Thiele, *Antike Himmelsbilder* (Berlin, 1898), 76 ff.

51. E. M. Thompson, *An Introduction to Greek and Latin Palaeography* (Oxford, 1912), 122, 145.

p. 24 52. See Charles Niver, *A Study of Certain of the More Important Manuscripts of the Franco-Saxon School* (Harvard University Thesis, 1941); A. Boutemy, 'Le Style franco-saxon, style de Saint-Amand', *Scriptorium*, III (1949), 260 ff.

p. 25 53. See Wilhelm Koehler, *Die karolingischen Miniaturen*, II, *Die Hofschule Karls des Grossen*, 2 vols. (Berlin, 1958); Florentine Mütherich, 'Die Buchmalerei am Hofe Karls des Grossen' (pp. 9–54 of *Karolingische Kunst*, ed. Wolfgang Braunfels and Hermann Schnitzler, being vol. III of *Karl der Grosse*, ed. Braunfels).

54. Koehler, *Hofschule*, 34.

55. See K. Menzel, P. Corssen, H. Janitschek, A. Schnütgen, F. Hettner, and K. Lamprecht, *Die Trierer Ada-Handschrift* (Leipzig, 1889); Albert Boeckler, 'Die Evangelistenbilder der Adagruppe', *Münchner Jahrbuch der bildenden Kunst*, 3. Folge, III/IV (1952–3), 121–4; *idem*, 'Formgeschichtliche Studien zur Adagruppe', *Bayerische Akademie der Wissenschaften Phil.-Hist. Klasse, Abhandlungen*, Neue Folge, Heft XLII (Munich, 1956).

56. Apart from those listed in the text, there is the Dagulf Psalter made between 784 and 795 for presentation to Pope Hadrian I and now Vienna, Nationalbibliothek cod. 1861 (see *Karl der Grosse*, the catalogue of the 1965 Aachen exhibition, Aachen, 1965, no. 413, with bibliography); the Abbeville Gospels, now Abbeville, Bib. Mun. MS. 4 (I) (see *ibid.*, no. 414, with bibliography). For the Gospel Book from Saint-Martin-des-Champs, see *ibid.*, no. 412, with bibliography. It has recently been suggested that an incomplete Gospel Book at Munich (Universitätsbibliothek cod. 29) may be from this school – see Mütherich, *op. cit.*, 25 ff. For the fragment of a Gospel Lectionary which is stuck on folio 132 verso of British Museum MS. Cotton Claudius B v, see Wilhelm Koehler, 'An Illustrated Evangelistary of the Ada School and its Model', *Journal of the Warburg and Courtauld Institutes*, xv (1952), 48–66.

57. *Karl der Grosse*, no. 416, with bibliography.

58. *Ibid.*, no. 417, with bibliography.

59. *Ibid.*, no. 418, with bibliography. See also the facsimile *Lorsch Gospels* with introduction by Wolfgang Braunfels (New York, 1967).

60. Mütherich, *op. cit.* (Note 53 above), 15 ff. p. 2

61. *Ibid.*, and Zimmermann, *op. cit.*, Taf. 288.

62. Mütherich, *op. cit.*, 25; Boeckler, *op. cit.*, 26.

63. See Elizabeth Rosenbaum, 'The Evangelist Portraits of the Ada School and their Models', *Art Bulletin*, XXXVIII (1956), 81–90, and Boeckler, *op. cit.*

64. Robert M. Walker, 'Illustrations to the Priscillian Prologues in the Gospel Manuscripts of the Carolingian Ada School', *Art Bulletin*, xxx (1948), 1–10. p. 2

65. See Paul A. Underwood, 'The Fountain of Life in Manuscripts of the Gospels', *Dumbarton Oaks Papers*, no. 5 (Harvard, 1950), 44–138.

66. *Ibid.*, 46. It appears once in the Godescalc Gospel Lectionary (Paris, Bib. Nat. nouv. acq. lat. 1203) and twice in the Gospels of Saint-Medard de Soissons (Paris, Bib. Nat. cod. lat. 8850). It is also found in the Gospels of St Emmeram (Munich, Staatsbibl. Clm. 14000 cim. 55), which belongs to the court school of Charles the Bald and copies from the last-named manuscript.

67. Koehler, *Hofschule*, 9–10, 22–8, and plates 1–12; Mütherich, *op. cit.*, 32 ff.

68. Rosenbaum, *op. cit.*, 82 ff.

69. Koehler, *op. cit.*, 49–55, plates 33–41; Mütherich, *op. cit.*, 39 ff.

70. Rosenbaum, *op. cit.*, 85–6.

71. *Ibid.* p. 28

72. Koehler, *op. cit.*, 88–100, plates 99–107; Mütherich, *op. cit.*, 36 ff.

73. See Boeckler, 'Evangelistenbilder' (Note 55).

74. Koehler, *op. cit.*, 56–69, plates 42–66; Mütherich, *op. cit.*, 35 ff.

75. Koehler, *op. cit.*, 70–82, and plates 67–93; Mütherich, *ibid.*

76. *Ibid.*, 88–100, plates 99–107; *ibid.*, 36 ff.

77. Mütherich, *op. cit.*, 39 ff. See also *Karl der Grosse*, nos. 466–77.

78. Mütherich, *op. cit.*, 44 ff., and see below, p. 52.

79. See Wilhelm Koehler, *Die karolingischen Miniaturen*, III, *Die Gruppe des Wiener Krönungs-Evangeliars*, 2 vols (Berlin, 1960); Mütherich, *op. cit.*, 45 ff.

80. *Ibid.*, 25 ff.; *ibid.*, 47.

81. Koehler, *op. cit.*, 49 ff.

82. G. P. Bognetti, G. Chierici, A. de Capitani d'Arzago, *S. Maria di Castelseprio* (Milan, 1948); K. Weitzmann, *The Fresco Cycle of S. Maria di Castelseprio* (Princeton, 1951); E. Kitzinger, 'Hellenistic Heritage in Byzantine Art', *Dumbarton Oaks Papers*, no. 17 (1963), 108.

83. See below, p. 32.

84. See the facsimile of the Utrecht Psalter issued by the Palaeographical Society (London, 1874); G. Swarzenski, 'Die karolingische Malerei und Plastik in Reims', *Jahrbuch der Preussischen Kunstsammlung*, XXIII (1902), 91 ff.; E. T. DeWald, *The Utrecht Psalter* (Princeton, 1933); Gertrude T. Benson and Dimitri T. Tselos, 'New Light on the Origin of the Utrecht Psalter', *Art Bulletin*, XIII (1931), which gives a complete bibliography; to which add Dora Panofsky, 'The Textual Basis of the Utrecht Psalter Illustrations', *Art Bulletin*, XXV (1943), 50–9, Francis Wormald, *The Utrecht Psalter* (Utrecht, 1953), and Dimitri Tselos, *The Sources of the Utrecht Psalter Miniatures* (privately printed, Minneapolis, 1955).

85. Folio 17, Psalm XXX (31).

86. Folio 64, Psalm CVIII (109).

87. See Panofsky, *op. cit.*, and Wormald, *op. cit.*

88. Benson and Tselos, *op. cit.*, 53–79.

89. Dimitri Tselos, 'A Greco-Italian School of Illumination and Fresco Painters', *Art Bulletin*, XXXVIII (1956), 3; Koehler, *Die Schule von Tours* (see Note 105 below), I (2), 259 ff.

90. Amédée Boinet, *La Miniature carolingienne* (Paris, 1913), plates LXVI–LXIX.

91. Benson and Tselos, *op. cit.*, figures 4–11; Wormald, *op. cit.*, plates 10 and 11; A. Goldschmidt, 'Der Utrechtpsalter', *Repertorium für Kunstwissenschaft*, XV (1892), 158.

92. Benson and Tselos, *op. cit.*, figures 16 and 17.

93. Boinet, *op. cit.*, plate LXXVIII.

94. *Ibid.*, plate LXXVII.

95. See Jones and Morey, *op. cit.*, I, 53–67.

96. Facsimile ed. Chr. von Steiger and O. Homburger (Basel, 1964); O. Homburger, *Die illustrierten Handschriften der Bürgerbibliothek Bern* (Bern, 1962), 101 ff.

97. Reims, Bib. Mun. MS. 7. See Boinet, *op. cit.*, plate LXXVII; *Les Manuscrits à peintures en France du VIIe au XIIe siècle* (Exhibition catalogue of Bibliothèque Nationale, Paris, 1954), no. 43, with bibliography.

98. Paris, Bib. Nat. lat. 17968. See Boinet, *op. cit.*, plates LXXIII–LXXIV; *Manuscrits à peintures*, no. 44, with bibliography.

99. Paris, Bib. Nat. lat. 265. See Boinet, *op. cit.*, plates LXXI–LXXII; *Manuscrits à peintures*, no. 45, with bibliography.

100. The Framegaud Gospels, called after the name of its scribe, Paris, Bib. Nat. lat. 17969 (see Boutemy in *Scriptorium* (1948), 289, and *Manuscrits à peintures*, no. 50, with bibliography); the Pierpont Morgan Gospels, New York, Pierpont Morgan Library MS. 640 (*Manuscrits à peintures*, no. 47, with bibliography); the Saint-Frambourg de Senlis Gospels, Paris, Bib. Sainte-Geneviève MS. 1190 (*ibid.*, no. 48); and the Morienval Gospels, Noyon Cathedral Treasury (*ibid.*, no. 49).

101. See the second part of Wilhelm Koehler, *Die karolingischen Miniaturen*, III, *Die Gruppe des Wiener Krönungs-Evangeliars*, and *Metzer Handschriften* (Berlin, 1960).

102. *Ibid.*, 102 ff., 128 ff.

103. *Ibid.*, 103 ff., 128 ff.

104. *Ibid.*, 147 ff. and *passim*.

105. The definitive work on Tours is Wilhelm Koehler, *Die karolingischen Miniaturen*, I, *Die Schule von Tours*, 3 vols (Berlin, 1930–3).

106. Quoted by Heinrich Fichtenau, *The Carolingian Empire* (Oxford, 1957), 94.

107. Koehler, *op. cit.*, I (I), 14–28.

108. *Ibid.*, chapter I and p. 434.

p. 34 109. *Ibid.*, 81–2.

110. *Ibid.*, 76 ff.

111. *Ibid.*, 146–54.

112. *Ibid.*, 381–92.

113. *Ibid.*, 194–209.

114. *Ibid.*, 235–89.

115. *Ibid.*, I (2), 212.

116. *Ibid.*, 237 ff.

117. *Ibid.*, 106–7.

p. 35 118. *Ibid.*, 237 ff.

119. *Ibid.*, 164 ff.

120. *Ibid.*, I (1), 194 ff., I (2), chapter 2.

121. *Ibid.*, I (2), 193–212.

p. 36 122. *Ibid.*, 213 ff.

123. *Ibid.*, 244 and 262.

p. 37 124. *Ibid.*, I (1), 250 ff., I (2), chapter 2.

125. *Ibid.*, I (2), 29–65, for an analysis of their work.

126. See below, pp. 57 and 64.

p. 38 127. Koehler, *op. cit.*, I (2), 237 ff.

128. *Ibid.*, 279 ff.

129. *Ibid.*, I (1), 256–60, 348–61.

130. *Ibid.*, I (2), 263–4, 270–1.

131. *Ibid.*, I (1), 279–88, 298–303, 307–9, 406–8.

132. *Ibid.*, 241–3, 260–9, 269–77.

133. *Ibid.*, I (2), 71.

p. 39 134. *Ibid.*, plate 15b.

135. *Ibid.*, 94–109.

136. *Ibid.*, 106–7.

p. 40 137. *Ibid.*, 94 ff.

138. *Ibid.*, 102 ff. and plates 55–8.

139. *Ibid.*, 96 ff.

140. See A. M. Friend, 'Carolingian Art in the Abbey of St Denis', *Art Studies*, I (1923), 67–75, and 'Two Manuscripts of the School of St Denis', *Speculum*, I (1926), 59–70.

141. In the exhibition of 1954 at the Bibliothèque Nationale, it was ascribed to a Corbie School. See *Manuscrits à peintures*, no. 52.

142. H. Schnitzler, *Die Sammlungen Baron von Hüpsch* (Cologne, 1964), no. 54, plates 67–70.

p. 41 143. Though it is ascribed to Reims in H. Schade, 'Studien zu der karolingischen Bilderbibel aus St Paul von den Mauern in Rom', *Wallraf-Richartz-Jahrbuch*, XXI (1959), 99 ff., and XXII (1960), 13 ff.

144. See Ernst H. Kantorowicz, 'The Carolin-gian King in the Bible of San Paolo fuori le Mura' (pp. 82–94 of *Selected Studies by Ernst H. Kantoro-wicz*, where it is reprinted from Kurt Weitzmann and others (eds), *Late Classical and Mediaeval Studies in Honor of Albert Matthias Friend Jr* (Princeton, 1955), 287–300), 92 ff. and plates 21–3.

145. See Schramm and Mütherich, *op. cit.* (Chapter 1, Note 10), 134.

146. See Note 52 above.

147. Boinet, *op. cit.*, plates 100–2; *Manuscrits à peintures*, no. 58, with bibliography.

148. Boinet, *op. cit.*, plates 97–9; *Manuscrits à* p. 42 *peintures*, no. 59, with bibliography.

149. *Manuscrits à peintures*, no. 61, with bibliography.

150. Boinet, *op. cit.*, plate 109; *Manuscrits à peintures*, no. 70.

151. *Manuscrits à peintures*, no. 71.

152. Boinet, *op. cit.*, plates 113–14; *Manuscrits à peintures*, no. 74.

153. Jean Porcher, *La Peinture provinciale* (pp. 54–73 of *Karolingische Kunst*, ed. W. Braunfels and H. Schnitzler), 59 ff.

154. *Ibid.*, 61. (See on this manuscript also A. M. Friend Jr, 'The Canon Tables of the Book of Kells', in vol. 2 of *Medieval Studies in Memory of A. Kingsley Porter*, ed. W. Koehler, Cambridge, Mass., 1939, 632–3.)

155. *Ibid.*, 60, and J. Porcher, 'L'Évangélaire de Charlemagne et le Psautier d'Amiens', *La Revue des Arts*, VII (1957), 51–8.

156. See the facsimile, Ernest DeWald, *The Stuttgart Psalter* (Princeton, 1930). Porcher (as Note 155, p. 61) attributes it to the Amiens area and Professors Bischoff and Nordenfalk (see *Karl der Grosse* catalogue no. 490) to Saint-Germain-des-Prés.

157. Boinet, *op. cit.*, plates 153–9; *Manuscrits à peintures*, nos. 96–8, with bibliography; *Karl der Grosse*, no. 444, with bibliography.

158. Porcher, *op. cit.*, 62 ff.; Boutemy, in É. de Moreau, *Histoire de l'Église de Belgique*, II (Brussels, 1954), 320.

159. Willibrord Neumüller and Kurt Holter, *Der* p. 43 *Codex Millenarius* (Linz, 1959), *passim*; D. Wright, 'The Codex Millenarius and its Model', *Münchener Jahrbuch der bildende Kunst*, 3. Folge, XV (1964).

160. *Ibid.*

161. *Ibid.*

162. G. Swarzenski, *Die Salzburger Malerei von den ersten Anfängen bis zur Blütezeit des romanischen Stils*, 2 vols (Leipzig, 1908–13), I, 13 ff.

163. See Adolf Merton, *Die Buchmalerei in St Gallen*, 2nd ed. (Leipzig, 1923).

164. *Ibid.*, chapter I.

165. *Ibid.*, chapter II.

166. Franz Landsberger, *Der St Galler Folchart-Psalter* (St Gallen, 1912).

p. 44 167. Merton, *op. cit.*, chapter III.

168. St Gallen MS. 53. See Landsberger, *op. cit.*, 32 ff.

169. Merton, *op. cit.*, chapters IV and V.

CHAPTER 4

p. 45 1. See Margaret Rickert, *Painting in Britain: the Middle Ages* (Pelican History of Art) (London, 1954), chapter 2; Francis Wormald, *English Drawings in the Tenth and Eleventh Centuries* (London, 1952); T. D. Kendrick, *Late Saxon and Viking Art* (London, 1949).

2. See, for example, *Vita Gebehardi*, 36 (*Mon. Germ. Hist. SS.*, XI).

3. To take but one example, see the verses of the Gero Codex; Dodwell and Turner, *Reichenau Reconsidered* (see Note 43 below), 35.

4. See, for example, the references to Adalbert of Hornbach in *Miracula Sancti Pirminii Hornbacensia*, 32 (*Mon. Germ. Hist. SS.*, XV).

p. 46 5. See below, pp. 53, 54, and 56.

6. See below, p. 135.

7. Kurt Weitzmann, 'Various Aspects of Byzantine Influence on the Latin Countries from the Sixth to the Twelfth Centuries', *Dumbarton Oaks Papers*, no. 20 (1966), 14–15.

8. Also Percy Ernst Schramm and Florentine Mütherich, *Denkmale der deutschen Könige und Kaiser* (Munich, 1962), plate 82.

9. *Ibid.*, plate III.

10. *Ibid.*, plate 52.

11. *Ibid.*, plate 141.

12. *Ibid.*, plate 103.

p. 47 13. For Ottonian views of empire, see the relevant sections of P. E. Schramm, *Kaiser, Rom und Renovatio* (Leipzig and Berlin, 1929), Robert Folz, *L'Idée d'Empire en Occident du Vᵉ au XIVᵉ siècle* (Paris, 1953), and Walter Ullmann, *The Growth of Papal Government in the Middle Ages* (London, 1955).

14. With typical generosity, Dr Hanns Swarzenski has made available to me his own views on the importance of the *Notitia Dignitatum*, on which he hopes to publish a paper. The observations on the subject which follow are entirely his.

Compare *Notitia Dignitatum*, ed. Otto Seeck (Berlin, 1876), illustrations of provinces with tributes on p. 9.

15. Schramm and Mütherich, *op. cit.*, 163, plate 132.

16. Quoted by Ullmann, *op. cit.*, 250.

17. See *Chronicon abbatum monast. Tegernsensis* c. 6 (*Mon. Germ. Hist. SS.*, IX), 818, and Migne, *Patrologia Latina*, CXLII, col. 721.

18. *Ekkehardi IV Casus S. Galli*, 136, 138, 150, p. 48 151 (*Mon. Germ. Hist. SS.*, II), and *Casus Mon. Petrishusensis*, 632 and 638 (*Mon. Germ. Hist. SS.*, XX).

19. *Purchardi Carmen De Gestis Witigowonis Abbatis*, 629 (*Mon. Germ. Hist. SS.*, IV).

20. Otto Lehmann-Brockhaus, *Schriftquellen zur Kunstgeschichte des 11- und 12-Jahrhunderts für Deutschland, Lothringen und Italien* (Berlin, 1938), 563, 565, 3000.

21. *Vita S. Gerardi Ep. Tullensis* (*Acta Sanctorum Aprilis Tomus III*), 210.

22. Lehmann-Brockhaus, *op. cit.*, 222.

23. *Ibid.*, 273.

24. *Ibid.*, 201.

25. *Ibid.*, 654.

26. *Ibid.*, 717.

27. *Ibid.*, 852 and 2573.

28. *Ibid.*, 1600.

29. *Mon. Germ. Hist. SS.*, IV, 729.

30. Lehmann-Brockhaus, *op. cit.*, 3014 and 1420.

31. *Ibid.*, 5053.

32. *Ibid.*, 338.

33. *Ibid.*, 1712.

34. *Ibid.*, 273.

35. *Thangmari Vita Bernwardi ep.*, 761 (*Mon. Germ. Hist. SS.*, IV).

36. Lehmann-Brockhaus, *op. cit.*, 338.

37. *Ibid.*, 2573.

38. *Vita B. Gebehardi*, 586 (*Mon. Germ. Hist. SS.*, X).

p. 48 39. *Ekkehardi IV Casus S. Galli*, 138, 122, 136, and 150, note 16 (*Mon. Germ. Hist. SS.*, II).

40. *Ibid.*, 150.

41. *Ibid.*, 151.

42. *Purchardi Carmen*, 629 (*Mon. Germ. Hist. SS.*, IV).

43. See C. R. Dodwell and D. H. Turner, *Reichenau Reconsidered, A Re-assessment of the Place of Reichenau in Ottonian Art* (Warburg Institute Surveys, II) (London, 1965), 20 ff.

p. 49 44. Otto Lehmann-Brockhaus, *Die Kunst des X. Jahrhunderts im Lichte der Schriftquellen (Sammlung Heitz Akademische Abhandlungen zur Kulturgeschichte III. Reihe Band 6)* (Strassburg, 1935), 45–51.

45. See Anton Schmitt, *Die Fuldaer Wandmalerei des frühen Mittelalters* (Fulda, 1949).

46. For a general survey, see J. Sauer, 'Die Monumentalmalerei der Reichenau', in K. Beyerle (ed.), *Die Kultur der Abtei Reichenau*, II (Munich, 1925), 902–55.

47. See Sauer, *op. cit.*, figure 9.

48. *Ibid.*, figures 10 and 11.

49. See Sauer, *op. cit.*, and F. X. Kraus, *Die Wandgemälde in der S. Georgskirche zu Oberzell auf der Reichenau* (Freiburg im Breisgau, 1884).

50. Kraus, *op. cit.*, plates I, III, XI, and XII.

51. Sauer, *op. cit.*, figure 13.

p. 50 52. Sauer, *op. cit.*, figures 1–8; Kraus, *op. cit.*, plates II and IV–X.

53. See Albert Boeckler, 'Ikonographische Studien zu den Wunderszenen in der ottonischen Malerei der Reichenau', *Bayerische Akademie der Wissenschaften Phil.-Hist. Klasse, Abhandlungen*, Neue Folge, Heft LII (Munich, 1961), Abb. 38 and 40–5, Abb. 52 and 56–8, Abb. 66–9.

54. Cod. Vat. grec. 1613. See *Il Menologio di Basilio II*, II (*Codices e Vaticanis selecti*, XII) (Turin, 1907), plates 59, 78, 97, 308, etc.

55. Hugo Buchthal, *The Miniatures of the Paris Psalter* (London, 1938), plates 27, 42, 43, and 65.

56. Sauer, *op. cit.*, 914.

57. *Ekkehardi IV Casus S. Galli*, 136 and 138 (*Mon. Germ. Hist. SS.*, II).

58. *Ratperti Casus S. Galli*, 68 (*Mon. Germ. Hist. SS.*, II).

59. See above, p. 6.

60. *Ibid.*

61. *Ibid.*

62. *Ibid.*

63. See Wilhelm Vöge, 'Eine deutsche Malerschule um die Wende des ersten Jahrtausends', *Westdeutsche Zeitschrift für Geschichte und Kunst*, VII (Trier, 1891), and Boeckler, 'Ikonographische Studien', as quoted in Note 53.

64. This generally accepted viewpoint was first p. 51 stated in its completeness by A. Haseloff in his contribution to *Der Psalter Erzbischof Egberts von Trier* by H. V. Sauerland and A. Haseloff (Trier, 1901) and is most clearly and cogently expressed by Albert Boeckler in 'Die Reichenauer Buchmalerei', in K. Beyerle (ed.), *Die Kultur der Abtei Reichenau*, II (Munich, 1925), 956–98. More comprehensive claims for Reichenau are made in a Munich dissertation by Walter Gernsheim, *Die Buchmalerei der Reichenau* (1934).

65. Dodwell and Turner, *op. cit.* (see Note 43).

66. *Ibid.*, plate 1.

67. Boeckler, 'Reichenauer Buchmalerei', 958– p. 52 70.

68. See Adolf Schmidt, *Die Miniaturen des Gerokodex* (Leipzig, 1924).

69. Dodwell and Turner, *op. cit.*, 10 and 36.

70. Schmidt, *op. cit.*, plate XII.

71. Part in the Vatican Library (cod. Pal. lat. 50) and part in the Biblioteca Documentara Batthayneum, Alba Julia, Romania.

72. *Chronicon Laureshamense*, 394 (*Mon. Germ. Hist. SS.*, XXI).

73. For the full comparisons, see Schmidt, *op. cit.*, plates I, III, V, VII, IX, and Köhler, *Hofschule*, plates 104–6, 108, 110.

74. Schmidt, *op. cit.*, plates XIII and XI.

75. Sauerland and Haseloff, *op. cit.*, 128 ff., and plate 62, 1–4.

76. See below, p. 58.

77. Described with illustrations by A. von Oechelhaeuser in *Die Miniaturen der Universitäts-Bibliothek zu Heidelberg*, I (Heidelberg, 1887), 4–55, and plates 1–9.

78. Folio 41 recto.

79. Oechelhaeuser, *op. cit.*, plate 2. p. 53

80. Dodwell and Turner, *op. cit.*, 12.

81. See Peter Bloch, *Das Hornbacher Sakramentar und seine Stellung innerhalb der frühen Reichenauer Buchmalerei (Basler Studien zur Kunstgeschichte*, XV, 1956).

82. *Ibid.*, Tafeln 1–4.

54 83. Kassius-Hallinger, *Gorze-Kluny: Studien zu den monastischen Lebensformen und Gegensätzen im Hochmittelalter*, I (Rome, 1950), 95–128.

84. Dodwell and Turner, *op. cit.*, 17 ff.

85. *Ibid.*, 18 and 94.

86. *Ibid.*, 30.

87. *Ibid.*

88. Letters 104, 106, and 126 (ed. J. Havet, Paris, 1889).

89. R. C. Brower, *Antiquitates et Annales Trevirenses* (Leodii, 1670), I, 481.

90. *Ibid.*, 492–3.

91. See H. V. Sauerland and A. Haseloff, *Der Psalter Erzbischof Egberts von Trier, Codex Gertrudianus in Cividale* (Trier, 1901).

55 92. As Dr Swarzenski kindly points out to me. See Hermann Schnitzler, *Rheinische Schatzkammer*, I (Düsseldorf, 1957), 24–5, with bibliography.

93. *Gesta Treverorum*, 170 (in *Mon. Germ. Hist. SS.*, VIII).

94. Letter 13 (ed. Havet).

95. Sauerland and Haseloff, *op. cit.*, 15 ff.

96. Dodwell and Turner, *op. cit.*, 16 and 70 ff.

97. *Ekkehardi* (*op. cit.*), 126 (*Mon. Germ. Hist. SS.*, II).

98. Kassius-Hallinger, *op. cit.*, 187–99.

99. *Ekkehardi* (*op. cit.*), 132.

56 100. *Ibid.*, 147.

101. See Sauerland and Haseloff, *op. cit.*, 81 ff., and plates 53–6.

102. E. Gaspard, 'L'Abbaye de Chapitre de Poussay', *Mémoires de la Société d'archéologie Lorraine*, 2e série, XIII (Nancy, 1871), 122.

103. See Adolph Goldschmidt, *Die deutsche Buchmalerei*, II (Florence and Munich, 1928), Tafel 22, and Ph. Lauer, *Les Enluminures romanes des manuscrits de la Bibliothèque Nationale* (Paris, 1927), planche LXVI.

104. C. R. Morey, *Early Christian Art* (Princeton, 1953), plate 177.

105. *Ibid.*, plate 186.

106. Albert Boeckler, 'Bildvorlagen der Reichenau', *Zeitschrift für Kunstgeschichte*, XII (1949), 13 ff., figures 1–6.

57 107. We are chiefly indebted to Professor Haseloff and Professor Nordenfalk for identifications of the Gregory Master's work. See Sauerland and Haseloff, *op. cit.*, 77 ff., and Carl Nordenfalk, 'Der Meister des Registrum Gregorii', *Münchner Jahrbuch der bildenden Kunst*, 3. Folge, I (1960), 61–77. A convenient list of manuscripts attributed wholly or partly to the Gregory Master is given in Hubert Schiel, *Codex Egberti der Stadtbibliothek Trier* (Basel, 1960), 81 ff.

108. Sauerland and Haseloff, *op. cit.*, 78.

109. Nordenfalk, *op. cit.* (see Note 107), 73 ff.

110. *Ibid.*, 62.

111. *Ibid.*, figures 3 and 4. Compare the Carolingian Cleves Gospels: A. Boinet, *La Miniature carolingienne* (Paris, 1913), plate LXXA.

112. Nordenfalk, *op. cit.*, 66.

113. Lauer, *op. cit.* (see Note 103), planches LXXI–LXXIII; Sauerland and Haseloff, *op. cit.*, 75; Nordenfalk, *op. cit.*, figure 9.

114. Nordenfalk, *op. cit.*, 66.

115. Goldschmidt, *Buchmalerei*, II, plates 7 and 8.

116. W. F. Volbach, *Early Christian Art* (London, p. 58 1961), plate 95.

117. Nordenfalk, *op. cit.*, 69.

118. See the facsimile edition with introduction by Hubert Schiel already quoted in Note 107.

119. Walter Gernsheim, *op. cit.* (see Note 64), 33. For a cogent summary of various views of the artists, see Schiel, *op. cit.*, 71 ff.

120. Compare Egbert Codex folio 15 verso and p. 59 J. de Wit, *Die Miniaturen des Vergilius Vaticanus* (Amsterdam, 1959), plate 16 (1).

121. *Ibid.*, plate 14 (1).

122. Boeckler, 'Ikonographische Studien', plates 4–7, 13–16, 36–7, 39–45, 78–82; Hugo Buchthal, 'Byzantium and Reichenau', in *Byzantine Art and European Art Lectures* (Athens, 1966), 47 ff.

123. See Wormald as quoted in Chapter 2, Note 2.

124. Folio 15 verso. p. 60

125. Folio 52 verso.

126. Folio 84 verso.

127. Folio 101.

128. Folios 3 verso–6.

129. Boeckler, 'Bildvorlagen der Reichenau' (see above, Note 106), 22, figures 18 and 19.

130. See Boeckler, 'Die Reichenauer Buchmalerei', 982–98.

131. For the first, see Stephan Beissel, *Die Bilder der Handschrift des Kaisers Otto im Münster zu Aachen* (Aachen, 1886). For the second, see G. Leidinger,

Miniaturen aus Handschriften der Kgl. Hof- und Staats-bibliothek in München, Heft I, Das sogenannte Evangeliarium Ottos III (Munich, 1912).

p. 60 132. Adolph Goldschmidt, *op. cit.* (Note 103), plates 35-8.

133. See Hans Fischer, *Mittelalterliche Miniaturen aus der Staatlichen Bibliothek Bamberg* (Bamberg, 1926).

134. Heinrich Wölfflin, *Die Bamberger Apokalypse* (Munich, 1918).

p. 61 135. Beissel, *op. cit.*, plate II.

136. Dodwell and Turner, *op. cit.*, 28.

137. *Ibid.*, 29.

138. Peter Metz, *The Golden Gospels of Echternach* (London, 1957), 41 and 59.

139. Munich, Staatsbib., Clm. 4452, and Bamberg, Staatliche Bib., cod. bibl. 140.

140. Munich, Staatsbib., Clm. 4453. See Vöge, 'Malerschule' (Note 63), 8.

141. Boeckler, 'Reichenauer Buchmalerei', 982 ff.

p. 63 142. Lehmann-Brockhaus, *Schriftquellen*, no. 1712.

143. Goldschmidt, *Deutsche Buchmalerei*, II, plate 52.

144. See Metz (quoted in Note 138).

145. Albert Boeckler, *Das Goldene Evangelienbuch Heinrichs III* (Berlin, 1933), 72, and Carl Nordenfalk, 'Neue Dokumente zur Datierung des Echternacher Evangeliars in Gotha', *Zeitschrift für Kunstgeschichte*, I (1932), 153.

146. See Note 145.

p. 64 147. Boeckler, *Das Goldene Evangelienbuch*, 59 and 60.

148. *Ibid.*, 55, 63, and 69.

149. See Boeckler's facsimile as quoted in Note 145.

150. See Philipp Schweinfurth, 'Das Goldene Evangelienbuch Heinrichs III und Byzanz', *Zeitschrift für Kunstgeschichte*, X (1942), 45, and, for a recent view that the Byzantine painting was contemporary and not of a later period, see Kurt Weitzmann, 'Various Aspects of Byzantine Influence on the Latin Countries from the Sixth to the Twelfth Century', *Dumbarton Oaks Papers*, no. 20 (1966), 4.

151. Schweinfurth, *op. cit.*, 65-6.

p. 65 152. *Ibid.*, 59-61.

153. Boeckler, *Das Goldene Evangelienbuch*, plates 192-7.

154. *Ibid.*, plates 200-5.

155. See Heinrich Ehl, *Die Ottonische Kölner* p.
Buchmalerei (Bonn and Leipzig, 1922), and, more recently, Peter Bloch and Hermann Schnitzler, *Die Ottonische Kölner Malerschule* (Düsseldorf, 1967).

156. Nordenfalk, *op. cit.*, 64-6; also André Grabar and Carl Nordenfalk, *Early Medieval Painting* (Lausanne, 1957), 210.

157. Vöge, *op. cit.*, 134-6; Ehl, *op. cit.*, plate 16.

158. Vöge, *op. cit.*, 135.

159. Ehl, *op. cit.*, plates 73 and 74; Bloch and Schnitzler, *op. cit.*, plates 307-36, XIX and XX.

160. Ehl, *op. cit.*, plates 58-9; Bloch and p.
Schnitzler, *op. cit.*, plates 214-34.

161. Ehl, *op. cit.*, plate 35.

162. Bloch and Schnitzler, *op. cit.*, plates 9-41, III and IV; Ehl, *op. cit.*, plate 26.

163. Bloch and Schnitzler, *op. cit.*, plates 342-65, XXI and XXII; Ehl, *op. cit.*, plates 80-1.

164. Bloch and Schnitzler, *op. cit.*, plates 436-61 and 503; Ehl, *op. cit.*, plates 85-7.

165. Ehl, *op. cit.*, plates 4 and 5; Boinet, *op. cit.*, plate LXXXIV.

166. For which see Albert Boeckler, 'Kölner ottonische Buchmalerei', in Herberg v. Einem (ed.), *Beiträge zur Kunst des Mittelalters* (Berlin, 1950), 144-9.

167. Bloch and Schnitzler, *op. cit.*, plates 81-111, 500, VII and VIII; Ehl, *op. cit.*, plates 15-26.

168. See Elisabeth Schipperges, *Der Hitda Codex* (Bonn, 1938), and Bloch and Schnitzler, *op. cit.*, plates 113-70, IX and X.

169. Boeckler, 'Kölner ottonische Buchmalerei', 144 ff. But there are Trier/Echternach influences as well. Compare, for example, the Ascension in the Gereon Sacramentary with that of the Egbert Codex and, in the Hitda Codex, such scenes as the healing of the youth at Nain, the healing of the blind man, and the storm at sea with comparable incidents portrayed in the Liuthar school.

170. *Annales et Notae S. Emmerammi Ratisbonenses*, p.
567, note I (*Mon. Germ. Hist. SS.*, XVII).

171. *Arnoldus de S. Emmerammo Lib. II*, 568 (*Mon. Germ. Hist. SS.*, IV).

172. A. Boinet, *La Miniature carolingienne* (Paris, 1913), plates CXV-CXX.

173. *Epitaphia Arnulfi Imperatoris*, in *Recueil des*

historiens des Gaules et de la France, IX (Paris, 1757), 102.

174. Georg Swarzenski, *Die Regensburger Buchmalerei des X. und XI. Jahrhunderts* (Leipzig, 1901), 30.

175. *Ibid.*, plate I (1).

176. *Ibid.*, plate II (4 and 5).

177. *Ibid.*, plates IV–XI.

p. 70 178. Swarzenski, *op. cit.*, plates XII–XVIII, and part IV, chapter II.

179. *Ibid.*, plates XIX–XXI, and part IV, chapter III.

180. The stole is a familiar symbol in literary sources for everlasting life (cf. *Mon. Germ. Hist. SS.*, XV, 33, and *Analecta Bollandiana*, LVI, 45), though it may also simply represent Christ's rôle as High Priest.

181. For the development of scholarship at Regensburg and its relationship to art, see Bernhard Bischoff, 'Literarisches und künstlerisches Leben in St Emmeram während des frühen und hohen Mittelalters', *Studien und Mitteilungen zur Geschichte des Benediktiner-Ordens*, LI (1933), 102–42. Professor Bischoff identifies the mind behind the theological thought of the Uta Codex as that of the scholar Hartwic.

182. *In Joannis evang. tractatus*, XXIV, 2, Migne, *Patrologia Latina*, XXXV, col. 1593. Quoted by Meyer Schapiro, p. 150 of 'On the Aesthetic Attitude in Romanesque Art', being pp. 130–50 of K. Bharatha Iyer (ed.), *Art and Thought* (London, 1947).

183. Swarzenski, *op. cit.*, plates XXXIII–XXXV, and part VI, chapter II.

184. *Ibid.*, plates XXII–XXVII.

p. 71 185. See Paul Buberl, 'Über einige Werke der Salzburger Buchmalerei des XI. Jahrhunderts', *Kunstgeschichtliches Jahrbuch der K.K. Zentralkommission für Erforschung und Erhaltung der Kunst und Historischen Denkmale*, I (1907), 28–60, and Georg Swarzenski, *Die Salzburger Malerei*, 2 vols (Leipzig, 1913).

186. Swarzenski, *Regensburger Buchmalerei*, plates XXVIII–XXXII; Buberl, *op. cit.*, figures 19–27.

187. Buberl, plate VI (1–4).

188. *Ibid.*, plate VII (1–4).

189. *Ibid.*, plates XI–XIII.

p. 72 190. Norbert Wibiral, 'Die Wandmalereien des 11. Jahrhunderts im ehemaligen Westchor der Stiftskirche von Lambach', *Alte und Moderne Kunst*, XCIX, 1–13.

191. See E. Heinrich Zimmermann, 'Die Fuldaer Buchmalerei in karolingischer und ottonischer Zeit', *Kunstgeschichtliches Jahrbuch der K.K. Zentral-Kommission für Erforschung und Erhaltung der Kunst- und Historischen Denkmale*, IV (1910), 1–105.

192. Albert Boeckler, *Der Codex Wittekindeus* (Leipzig, 1938).

193. *Ibid.*, 13 ff.

194. *Ibid.*, and see plates XVIII, XX, and XXVIIIa and b.

195. *Ibid.*, 19. p. 73

196. Zimmermann, *op. cit.*, 21 ff. and figures 14–16.

197. *Ibid.*, plate IV.

198. See Stephan Beissel, *Des hl. Bernward Evangelienbuch im Dome zu Hildesheim* (Hildesheim, 1891), and Francis J. Tschan, *Saint Bernward of Hildesheim* (Indiana, 1951–2).

199. *Thangmari Vita S. Bernwardi*, 758 (*Mon. Germ. Hist. SS.*, IV).

200. Tschan, *op. cit.*, III, plate 45.

201. *Ibid.*, plates 18, 21, 25, 29, 33.

202. *Ibid.*, plates 54–78.

203. See Paul Lehmann, 'Corveyer Studien', in *Abhandlungen d. Bayer. Akadem. d. W. Phil.-Hist. Kl.*, XXX, 5; A. Boeckler, *Abendländische Miniaturen* (Berlin and Leipzig, 1930), 51–2.

204. Grabar and Nordenfalk, *op. cit.*, 209. p. 74

205. Goldschmidt, *Buchmalerei* (see Note 103), II, plates 69–71.

206. Ernest T. DeWald, 'The Art of the Scriptorium of Einsiedeln', *Art Bulletin*, VII, no. 8 (1925), 79–90.

207. See E. F. Bange, *Eine bayerische Malerschule des XI und XII Jahrhunderts* (Munich, 1923).

CHAPTER 5

1. Paul Meyer (ed.), *Girart de Roussillon* (Paris, 1884), 298. p. 75

2. Gerbert's letters nos. 169, 173, 175.

3. Jean Porcher, *French Miniatures from Illuminated Manuscripts* (London, 1960), 10, figure 10, and plate II; Ph. Lauer, *Les Enluminures romanes des manuscrits de la Bibliothèque Nationale* (Paris, 1927), 109, plates A and XI; S. Schülten, 'Die Buchmalerei p. 76

im Kloster Saint-Vaast d'Arras im XI. Jahrhundert', *Münchner Jahrbuch der bildende Kunst*, VII (1956), 49.

p. 76 4. Porcher, *op. cit.*, 15 ff., plate III; Y. Deslandres, 'Les Manuscrits décorés au XIᵉ siècle à Saint-Germain-des-Prés par Ingelard', *Scriptorium*, IX (1955), 3–16.

5. Porcher, *ibid.*

6. Porcher, *op. cit.*, plate III; Lauer, *op. cit.*, 124, and plates XXXII, LI, and LII.

7. Porcher, *op. cit.*, 17, and plate IV.

8. Porcher, *op. cit.*, 12–13.

9. The figural style is Carolingian and the decoration Anglo-Saxon. See Porcher, *op. cit.*, 30, and Walter W. S. Cook, in *Art Bulletin*, V (4) (1923), 99.

10. See *Manuscrits à peintures du VIIᵉ au XIIᵉ siècle* (Bib. Nat. 1954), no. 325, with bibliography.

11. Porcher, *op. cit.*, 27; Lauer, *op. cit.*, 94 f., and plates XIV–XXVII.

p. 77 12. Porcher, *op. cit.*, 28, plate XVI; Lauer, *op. cit.*, 75 f., and plate XII.

13. Porcher, *op. cit.*, 28, and plate XIX.

14. *Ibid.*, 24; Lauer, *op. cit.*, 110 f.

15. Porcher, *op. cit.*, 22.

16. Paul Deschamps and Marc Thibout, *La Peinture murale en France* (Paris, 1951), chapter V.

17. *Ibid.*, 105 f., with bibliography.

18. *Ibid.*, 126 f., with bibliography.

p. 78 19. *Ibid.*, 118 f., with bibliography.

20. *Ibid.*, 88 f., with bibliography.

21. *Ibid.*, plate XLIX and p. 113 f.

22. *Ibid.*, plate LII and p. 117 f.

23. For a brief survey of his work, see A. Boutemy, 'Un Grand Enlumineur du Xᵉ siècle, l'abbé Odbert de Saint-Bertin', *Annales de la Fédération Archéologique et Historique de Belgique* (Antwerp, 1950), 247–54, and also, now, *Illumination at Saint-Bertin at Saint-Omer under the abbacy of Odbert*, a thesis submitted to the University of London for the Ph.D. degree in 1968 by Claire Kelleher.

24. Philip Grierson, 'The Relations between England and Flanders before the Norman Conquest', *Transactions of the Royal Historical Society*, 4th series, XXIII (1941), 94, note 1.

25. Apart from Boulogne-sur-Mer, Bib. Mun. MS. 20, the following MSS. contain inscriptions recording that the manuscript was made at Odbert's

request: Boulogne, MS. 102, Saint-Omer, Bib. Mun. MSS. 161, 342 bis, and 765.

26. André Wilmart recognizes twenty MSS. of the Odbert atelier in his 'Les Livres de l'abbé Odbert', *Bulletin de la Société des Antiquaires de la Morinie*, IX (1924), 169–88.

27. Folio I verso – ME COMPSIT HERIVEUS ET ODBERTUS [in gold] DECORAVIT EXCERPSIT DODOLINUS. There are two other references in this long poem to 'pater Odbertus', whose name is honoured by gold letters.

28. Hanns Swarzenski, *Monuments of Romanesque* p. 79 *Art* (London, 1954), 50, with bibliography.

29. G. Thiele, *Antike Himmelsbilder* (Berlin, 1898), 83.

30. *Op. cit.*, 77 ff.; A. A. Byvanck, *Les Principaux Manuscrits à peintures conservés dans les collections publiques du royaume des Pays Bas* (Paris, 1931), 65 f.

31. Philip Grierson, *op. cit.* (see Note 24), 71–112.

32. *Ibid.*, 84 f. and 89 f.

33. i.e. Wissant; *ibid.*, 80.

34. *Ibid.*, 94.

35. Chanoine V. Leroquais, *Les Psautiers manuscrits latins des bibliothèques publiques de France*, 3 vols (Mâcon, 1840–1), I, 94–101; III, plates XV–XXI.

36. Rome, Vat. reg. lat. 12. See Francis Wor- p. 80 mald, *English Drawings of the Tenth and Eleventh Centuries* (London, 1952), plates 26–8.

37. There are stylistic and iconographic links with Canterbury.

38. Compare the praying monk on folio 36 with St Pachomius in British Museum MS. Arundel 155 (Wormald, plate 24a) and the figure of Victory on folio 29 verso with the Canterbury drawing of Christ (Wormald, *op. cit.*, plate 17a).

39. See Charles Niver, 'The Psalter in the British Museum Harley 2904', in Wilhelm R. W. Koehler (ed.), *Medieval Studies in Memory of A. Kingsley Porter* (Harvard, 1939), 667–87.

40. Porcher, *op. cit.*, plate V.

41. André Boutemy, 'Un Monument capital de l'enluminure anglo-saxonne: le manuscrit 11 de Boulogne-sur-Mer', *Cahiers de Civilisation Médiévale*, I (Poitiers, 1958), 181.

42. There is a number of examples in the Fulda Sacramentary (Göttingen, Universitätsbibliothek MS. 231).

43. A. Boutemy in *Scriptorium*, IV (1950), 101 f. and 245 f.

44. Hanns Swarzenski, *op. cit.*, 50.

p. 81 45. Cambridge, Corpus Christi College MS. 183. See Rickert, *op. cit.*, plate 20A. True, it is also revived in England in Lambeth MS. 200 (see T. D. Kendrick, *Late Saxon and Viking Art*, London, 1949, 39), but only in relationship with an initial.

46. Leroquais, *op. cit.* (see Note 35), plate XX.

47. Particularly with the Aelfric Heptateuch, thought to come from Canterbury (British Museum MS. Claudius B iv), though this is later.

48. As, for example, in the Trinity Gospels – Cambridge, Trinity College MS. B. 10. 44.

p. 82 49. See Koehler, *Die karolingischen Miniaturen*, III, plates 79, 81–5, 89.

50. A. Boinet, *La Miniature carolingienne* (Paris, 1913), plate CXLIX.

51. See Ernest T. DeWald, *The Stuttgart Psalter* (Princeton, 1930).

52. Philip Grierson, 'La Bibliothèque de Saint-Vaast d'Arras', *Revue Bénédictine*, LII (1940), 120 ff.

53. Grierson, 'England and Flanders' (see Note 24), 93.

54. Arras, Bib. Mun. MS. 1054. See Boinet, *op. cit.*, plates XCIII–XCVI.

55. Hanns Swarzenski, 'The Anhalt Morgan Gospels', *Art Bulletin*, XXXI (2) (June 1949), 77–83.

56. *Ibid.*, 79.

57. Boutemy, 'Un Monument capital' (see Note 41).

58. Described with illustrations by André Boutemy in 'Une Bible enluminée de Saint-Vaast à Arras', *Scriptorium*, IV (1950), 67–81.

p. 83 59. Boutemy, *op. cit.*, plate 2.

60. British Museum Add. MS. 24199. See Wormald, *op. cit.* (Note 36), plate 6a.

61. Boutemy, *op. cit.*, plate 1.

p. 84 62. Hanns Swarzenski, *Monuments of Romanesque Art*, figure 191.

63. *Ibid.*, 53, with bibliography; Porcher, *op. cit.*, plate XXI.

p. 85 64. Swarzenski, *op. cit.*, figure 178; Porcher, *op. cit.*, figure 35. Also Francis Wormald, 'Some Illustrated Manuscripts of the Lives of Saints', *Bulletin of the John Rylands Library*, XXXV (1952), 256 ff.

65. *Manuscrits à peintures*, no. 160, with bibliography.

66. François Avril, *La Décoration des manuscrits dans les abbayes Bénédictines de Normandie aux XI^e et XII^e siècles* (thesis), chapters I and II.

67. See C. R. Dodwell, *The Canterbury School of* p. 86 *Illumination* (Cambridge, 1954), 14–15.

68. *Ibid.*, 115–18.

69. *Ibid.*, 10, note 2.

70. See below, p. 87.

71. Sir Frank Stenton and others, *The Bayeux Tapestry* (London, 1957).

72. C. R. Dodwell, 'The Bayeux Tapestry and the French Secular Epic', *Burlington Magazine*, CVIII (1966), 549–60.

73. Dodwell, *Canterbury School*, chapter II.

74. Rouen, Bib. Mun. MSS. Y 6 and Y 7. See Rickert, *op. cit.* (Chapter 4, Note 1), 44 and 45.

75. Dodwell, *op. cit.*, 14. p. 87

76. *Ibid.*, plate 5b.

77. Avril, *op. cit.*, part II, chapter I.

78. Dodwell, *op. cit.*, plate 5c.

79. Swarzenski, *op. cit.*, figure 174. See also J. J. G. Alexander, *Norman Illumination at Mont St Michel in the 10th and 11th Centuries* (Oxford thesis, 1964), 199 ff.

80. Dodwell, *op. cit.*, chapter I.

81. Alexander, *op. cit.*, 205 and *passim*.

82. Dodwell, *op. cit.*, plates 71f and 72d. p. 88

83. *Ibid.*, plate 72b; Hanns Swarzenski, 'Der Stil der Bibel Carilefs von Durham', in *Form und Inhalt – Festschrift für Otto Schmitt* (Stuttgart, 1951), 89–97.

84. Dodwell, *op. cit.*, 115–17.

85. D. Talbot Rice, *English Art 871–1100* (Oxford, 1952), plate 77b.

86. C. R. Dodwell, 'Un Manuscrit enluminé de Jumièges au British Museum', *Jumièges, Congrès Scientifique du XIII^e Centenaire*, 737–41.

87. Dodwell, *Canterbury School*, plate 70 f.

88. O. Pächt, 'Hugo Pictor', *Bodleian Library Record*, III, no. 30 (October 1950).

89. Rouen, Bib. Mun. MS. 32. See Dodwell, *op. cit.*, 10, note 4, and plate 8b.

90. J. Stevenson (ed.), *Chronicon Monasterii de Abingdon*, I (Rolls Series), 345.

91. See Niver (as quoted in Note 39), Wormald p. 89 (as quoted in Note 36), frontispiece, and Porcher, *op. cit.*, 17, figure 12, for participation of an Anglo-Saxon artist at Fleury.

92. See Amiens, Bib. Mun. MS. Lescal. 2, where the draperies show Anglo-Saxon influences.

p. 89 93. See Note 10 above. (For English influences at Vendôme in the twelfth century, see also Porcher, *op. cit.*, 22.)

p. 90 94. See below, p. 176.

95. See M. R. James (ed.), 'Pictor in Carmine', *Archaeologia*, XCIV (1951).

p. 91 96. See Dodwell, *Canterbury School*, 109, and, for Morimondo, J. Leclercq, 'Les Peintures de la Bible de Morimondo', *Scriptorium*, X (1956), 22–6.

97. A number have been published in C. Oursel, *La Miniature du XIIe siècle à l'abbaye de Cîteaux* (Dijon, 1926), which will be quoted as Oursel. Some are reproduced in colour in Charles Oursel, *Miniatures cisterciennes* (Dijon, 1960).

98. This is stated in a famous colophon to vol. II of the St Stephen Bible (Dijon, Bib. Mun. MS. 13) printed in Migne, *Patrologia Latina*, CLXVI, cols. 1373–6.

99. Oursel, *op. cit.*, plate III.

100. *Ibid.*, 23.

101. Dijon, Bib. Mun. MSS. 30 and 130. See Oursel, *op. cit.*, plates I and LI, and descriptions.

102. *Ibid.*, plates XXXVIII–XLIV.

p. 92 103. Especially British Museum MS. Cotton Claud. E v and Cambridge, St John's MS. 8.

104. Oursel, *op. cit.*, plate XXVI.

105. Otto Pächt, C. R. Dodwell, and Francis Wormald, *The St Albans Psalter* (London, 1960), plate 166c.

106. Oursel, *op. cit.*, plate VI.

107. *Ibid.*, plate XI.

108. See also *ibid.*, plate XXXVIE.

109. Rickert, *op. cit.*, plate 64.

110. Dijon, Bib. Mun. MS. 170 folio 59.

111. Dijon, Bib. Mun. MS. 173 folio 41. See *ibid.*, plate XXV.

112. Dijon, Bib. Mun. MS. 170 folio 6 verso. See *ibid.*, plate XXVI.

113. Dijon, Bib. Mun. MS. 173 folio 148. See *ibid.*, plate XXVI.

114. Dijon, Bib. Mun. MS. 170 folio 75 verso.

115. Dijon, Bib. Mun. MS. 173 folio 92 verso. See *ibid.*, plate XXV.

116. *Ibid.*, 29.

p. 93 117. Folio 174.

118. Durham Cathedral MS. Hunter 100 folio 44. See R. A. B. Mynors, *Durham Cathedral Manuscripts* (Oxford, 1939), plate 37.

119. See A. Watson, *The Early Iconography of the Tree of Jesse* (Oxford, 1934).

120. Deschamps and Thibout (as quoted in Note p. 94 16), 115–17; Paul-Henri Michel, *Romanesque Wall Paintings in France* (London, 1950), plates 1–10; Henri Focillon, *Peintures romanes des églises de France* (Paris, 1938), plates 65–76; P. H. Michel, *Les Fresques de Tavant* (Paris, 1944); M. Webber, 'The Frescoes of Tavant', *Art Studies*, III (1925), 83–92.

121. As in Cambridge, Corpus Christi College MS. 391. See Wormald, *op. cit.*, plate 39.

122. Oxford, Bodleian MS. Junius II. See Sir Israel Gollancz, *The Caedmon Manuscript of Anglo-Saxon Biblical Poetry* (Oxford, 1927).

123. British Museum MS. Tib. C vi. See Francis Wormald, 'An English Eleventh Century Psalter with Pictures, British Museum Cotton MS. Tiberius C.VI', *Walpole Society*, XXXVIII (1960–2).

124. See above, pp. 78–83. p. 95

125. See above, p. 87.

126. Deschamps and Thibout *op. cit.*, 99–102; Focillon, *op. cit.*, plates 80–8; Anthony, *op. cit.* (next Note), 151 ff.; J. Hubert, 'Les Peintures romanes de Vicq et la tradition géométrique', *Cahiers archéologiques*, I (1945), 77–88, and 'Vic', *Congrès Archéologique* (Paris, 1932), 556–76.

127. Edgar Waterman Anthony, *Romanesque Frescoes* (Princeton, 1951), 157.

CHAPTER 6

1. See P. B. Gams, *Die Kirchengeschichte von* p. 96 *Spanien* (Regensburg, 1874), II (2), chapter IV, and F. Meyrick, *The Church in Spain* (New York, 1892), chapter XXI.

2. Paul Clemen, *Die romanische Monumentalmalerei* p. 97 *in den Rheinlanden* (Düsseldorf, 1916), 710 ff.

3. R. P. A. Dozy, *Histoire des Musulmans d'Espagne*, II (Leyde, 1861), 182.

4. *Ibid.*, 47.

5. Migne, *Patrologia Latina*, LXXX, col. 147. p. 98

6. *Heterii et Sancti Beati ad Elipandum Epistola* (*Patrologia Latina*, XCVI, col. 901).

7. *Ibid.*, cols. 893–1030.

8. G. C. King, 'Divagations on the Beatus', *Art* p. 99 *Studies*, VIII (1) (1930), 25, note 3, for documents in the Beatus at Burgo de Osma; for those in the Beatus of Urgel, see P. Pujol i Tubau, 'De paleografia

visigòtica a Catalunya: El Còdex l'Apocalipsi del Beatus, de la catedral d'Urgell', *Butlleti de la Biblioteca de Catalunya*, IV (Barcelona, 1917), 8–9, 16–17.

9. King, *op. cit.*, 9–10, 52–3.

10. Henry A. Sanders, 'Beatus in Apocalipsin Libri Duodecim', *Papers and Monographs of the American Academy in Rome*, VII (Rome, 1930), 2.

11. Migne, *Patrologia Latina*, XCVI, col. 907.

12. *Ibid.*, cols. 910, 913, 918, 919, 922, 924, 931, 933, 963.

13. *Ibid.*, cols. 977 ff. 'De Christo et eius Corpore quod est ecclesia et de diabolo et eius corpore quod est Antichristus.'

14. Wilhelm Neuss, *Die Apokalypse des Hl. Johannes in der altspanischen und altchristlichen Bibel-Illustration*, 2 vols (Münster, 1931), I, 73–80, II, figures 209–18.

15. *Ibid.*, I, 119–25, II, figures, 14–29.

16. Sanders, *op. cit.*, 109 ff.

17. *Ibid.*, 102–58, *De ecclesia et sinagoga*.

p. 100 18. *Ibid.*, 104.

19. Migne, *Patrologia Latina*, XCVI, col. 911.

20. Neuss, *op. cit.*, I, 125 ff.

21. In the Gerona MS. of 975 (Archivo de la Catedral) and in the eleventh-century Saint-Sever MS. (Paris, Bib. Nat. lat. 8878). See Neuss, *op. cit.*, I, 126, and II, figure 30.

22. In the Gerona MS. and in the Turin MS. of the eleventh and twelfth centuries (Turin, Bib. Naz. lat. 93). See Neuss, *op. cit.*, I, 126, and II, figure 28.

23. As, among others, in the Gerona MS., the Saint-Sever MS., and the twelfth-century Rylands MS. (Manchester, John Rylands Library MS. 8). See Neuss, *op. cit.*, I, 126, and II, figure 29.

24. In the Gerona and Turin MSS. See Neuss, *op. cit.*, I, 127.

25. In the two tenth-century MSS. – the Gerona Beatus and the Urgel Beatus (Archivo de la Catedral) – in the Saint-Sever MS., and in the Turin and Rylands MSS. See Neuss, *op. cit.*, I, 133–4, II, figure 221.

26. Neuss, *op. cit.*, I, 133.

p. 101 27. For whom, see P. B. Gams, *op. cit.* (Note 1), II (2), chapter IV, and F. Meyrick, *op. cit.* (Note 1), chapter XXI.

28. *S. Eulogii Memorialis Sanctorum* (Migne, *Patrologia Latina*, CXV, col. 772).

29. *Sancti Eulogii Vita vel Passio* (*ibid.*, col. 717).

30. *S. Eulogii Memorialis Sanctorum* (*ibid.*, col. 791).

31. See Sanders, 'Beatus' (as quoted in Note 10).

32. *Ibid.*, 26–7.

33. *Ibid.*, 74–5.

34. *Ibid.*, 559.

35. *Ibid.*, 27.

36. *Ibid.*, 581.

37. *Ibid.*, 546.

38. *Ibid.*, 7.

39. King, *op. cit* (Note 8), 35.

40. New York, Pierpont Morgan Library MS. p. 102 644 folio 79.

41. In nine MSS. altogether – see Neuss, *op. cit.*, I, 71–3, II, figures 90–5.

42. See St Augustine, Migne, *Patrologia Latina*, XLI, cols. 472–7, and St Hilary, *ibid.*, LX, col. 874.

43. Sanders (ed.), *op. cit.*, 255–63.

44. *In Libros Veteris ac Novi Testamenti Prooemia.*

45. *Allegoriae quaedam Scripturae Sanctae*, Migne, *Patrologia Latina*, LXXXIII, col. 116.

46. See Neuss, *op. cit.*, I, 222–36, II, figures 196–208.

47. *Ibid.*, I, 113–14, II, figure 1; Pedro de Palol and Max Hirmer, *Early Medieval Art in Spain* (London, 1967), plates VII and VIII.

48. Neuss, *op. cit.*, I, 113.

49. *Ibid.*, I, 116–19, II, figures 6–13.

50. *Ibid.*, I, 62–5, II, figures 70–3.

51. Sanders (ed.), *op. cit.*, 116–17.

52. Rafael Altamira, 'Spain 1031–1248', *Cam-* p. 103 *bridge Medieval History*, VI, chapter XII, 421.

53. C. U. Clark, 'Collectanea Hispanica', *Transactions of the Connecticut Academy of Arts and Sciences*, XXIV (1920), 66 ff.

54. Erwin Panofsky, *Abbot Suger on the Abbey Church of St-Denis* (Princeton, 1946), 29.

55. See, for example, above, pp. 52–3.

56. Cambridge, Trinity College MS. R. 17. 1. See C. R. Dodwell, *The Canterbury School of Illumination* (Cambridge, 1954), 36 ff., plate 23.

57. Neuss, *op. cit.*, I, 40. p. 104

58. Neuss, *op. cit.*, I, 12.

59. In the Biblioteca Santa Cruz of Valladolid; see Neuss, *op. cit.*, 16–17.

60. Cod. 1240 of the Archivo Histórico Nacional of Madrid; see Neuss, *op. cit.*, 19.

p. 104 61. In the cathedral library of Burgo de Osma, MS. 1; see Neuss, *op. cit.*, 37.

62. British Museum Add. MS. 11695; see Neuss, *op. cit.*, 39–40.

63. C. U. Clark, 'Collectanea Hispanica' (see Note 53), 60, no. 696; Toledo, Bibl. Capit. MS. 1423.

64. *Ibid.*, 54, no. 669; Bib. Nat. nouv. acq. lat. 2170.

65. *Ibid.*, 58, nos. 686 and 688; Silos, Arch. 3 and 5.

66. In the Biblioteca Santa Cruz of Valladolid; Neuss, *op. cit.*, 17.

p. 105 67. Cod. 1240 of the Archivo Histórico Nacional of Madrid; Neuss, *op. cit.*, 19.

68. Margaret Rickert, *Painting in Britain: The Middle Ages* (Pelican History of Art) (London 1953), plate 99A.

69. New York, Pierpont Morgan Library MS. 644; see Neuss, *op. cit.*, 12.

p. 106 70. M. C. Ross, *Arts of the Migration Period in the Walters Art Gallery* (Baltimore, 1961), 100–1.

p. 107 71. Cf. British Museum Add. MS. 30845 folio 15; Archer M. Huntington, *Initials of Miniatures ... from the Mozarabic Manuscripts of Santo Domingo de Silos in the British Museum* (New York, 1904).

72. See above, pp. 2–3.

p. 108 73. e.g. the Gerona *Beatus* (Archivo de la Catedral) and the Valladolid one (Biblioteca Santa Cruz). A facsimile of the Gerona *Beatus* has been published under the editorship of T. Burckhardt, *Sancti Beati a Liebana in Apocalypsin Codex Gerundensis* (Olten and Lausanne, 1962).

74. Helmut Schlunk, 'Observaciones en torno al problema de la miniatura visigoda', *Archivo Español de Arte*, no. 71 (1954), 241–65, figures 13–15, 25.

75. *Ibid.*, figures 11–19.

76. Neuss, *op. cit.*, II, 54, 65, 113, 181.

77. Schlunk, *op. cit.*, figures 19 and 21.

78. *Ibid.*, figures 47, 78.

79. E. H. Zimmermann, *Vorkarolingische Miniaturen* (Berlin, 1916), III, 170.

80. *Ibid.*, III, 205.

81. *Ibid.*, III, 188.

82. Blas Taracene, 'Arte Romano', in *Ars Hispaniae*, II (Madrid, 1957), plate II opposite p. 220.

83. Schlunk, *op. cit.*, figure 9.

84. *Ibid.*, figure 12.

85. Zimmermann, *op. cit.*, III, 248.

86. *Ibid.*, III, 226.

87. *Ibid.*, III, 248. p. 109

88. *Ibid.*, IV, 269.

89. Neuss, *op. cit.*, II, 47.

90. Zimmermann, *op. cit.*, IV, 225.

91. *Ibid.*, III, 195.

92. Neuss, *op. cit.*, II, figures 48, 66, 71, 86, 110, 127, 143, 170, 188. For the interlace initials, see Jacques Guilmain, 'Observations on some Early Interlace Initials ... in Mozarabic Manuscripts', *Scriptorium*, XV (1961), 23–35; 'Zoomorphic Decoration ...', *Speculum*, XXXV (1960); 'Interlace Decoration and the Influence of the North ...', *Art Bulletin*, XLII (1960), 211–18.

93. Neuss, *op. cit.*, I, 244, and see Schlunk, *op. cit.*, 242.

94. Walter W. S. Cook, 'The Stucco Altar-Frontals of Catalonia', *Art Studies*, II (1924), 74–5.

95. *Ibid.*

96. Quoted by F. Meyrick, *op. cit.* (Note 1), 263. p. 110

97. Cook, *op. cit.*, 75.

98. *Ibid.*

99. C. U. Clark, *op. cit.*, 45, no. 614 (Madrid, Bibl. Nac. Tolet 2, 1 (Vitr. 4)).

100. *Ibid.*, 49, no. 641 (Montecassino, MS. 19).

101. *Ibid.*, 33 and 34, nos. 452, 531, 536 (Escorial, MSS. & 1 14, R II 18, T II 24).

102. *Ibid.*, 44, no. 610 (Madrid, Biblioteca Nacional MS. Gg 132).

103. *Ibid.*, 32, no. 520 (Escorial, MS. d I 2).

104. Cook, *op. cit.*, 75, note 5.

105. *Ibid.*, 63, no. 709 (in Urgel, Chapter Library).

106. *Ibid.*, 76.

107. *Ibid.*, 71, note 5.

108. *Ibid.*, 71.

109. *Ibid.*, 71. p. 111

110. *Ibid.*, 76.

111. Theophilus, *De Diversis Artibus*, ed. C. R. Dodwell (London, 1961), 4.

112. Neuss, *op. cit.*, II, figure 56.

113. King, *op. cit.* (Note 8), 35 and plate I.

114. *Ibid.*, 35 and plate V.

115. *Ibid.*, plate IV.

116. *Ibid.*, plate III. p. 112

117. *Ibid.*, plate VI.

118. See above, p. 94.

119. New York, Pierpont Morgan Library MS. 429 folio 94.

120. Cf. E. Blochet, *Les Enluminures des manuscrits orientaux de la Bibliothèque Nationale* (Paris, 1926), plates XXV, XXXII, XXXIII.

121. Neuss, *op. cit.*, II, figure 182.

122. J. Domínguez Bordona, *Exposición de códices miniados españoles, Catálogo* (Madrid, 1929), plate 22.

123. P. K. Hitti, *History of the Arabs* (London, 1940), frontispiece.

124. Cook, *op. cit.*, 42 and 176.

125. *Ibid.*, 71.

126. Blochet, *op. cit.*, plate 38 (Bib. Nat. MS. arabe 5036).

127. H. P. Lattin, *The Letters of Gerbert* (Columbia, 1961), 69, note 2.

128. Madrid, Archivo Histórico Nacional cod. 1240 folio 139 (see Neuss, *op. cit.*, II, figure 220).

129. Blochet, *op. cit.*, plate 38 (Bib. Nat. MS. supplément persan 1113).

130. Clark, 'Collectanea Hispanica', 192 ff., plates 43–6; Wilhelm Neuss, *Die Katalanische Bibelillustration um die Wende des ersten Jahrtausends und die altspanische Buchmalerei* (Bonn and Leipzig, 1922), 72 ff.

131. A Cassiodorus on the Psalms completed in 953 in the same library; *ibid.*, 36 and 192.

132. Folio 514.

133. Neuss, *Apokalypse*, I, 244.

134. Neuss, *Bibelillustration*, 55, 61, 74.

135. *Ibid.*, 54 and 74.

136. O. V. Gebhardt, *The Miniatures of the Ashburnham Pentateuch* (London, 1883).

137. Though attributed to Tours by Professor Rand.

138. The information which follows on Count Oliba and Abbot Oliba is derived from Joseph Pijoan's article, 'Oliba de Ripoll (971–1046)', in *Art Studies*, VI (1928), 81–101.

139. Neuss, *Bibelillustration*, 22.

140. *Ibid.*, 16 ff.

141. For which, see Dodwell, *op. cit.* (Note 56), chapter 1 and appendix 1.

CHAPTER 7

1. Guglielmo Matthiae, *Mosaici medioevali delle* p. 118 *chiese di Roma*, 2 vols (Rome, 1967), I, 277–8, with bibliography; Raimond van Marle, *La Peinture romaine au moyen âge* (Strasbourg, 1921), 120: *idem*, *The Development of the Italian Schools of Painting* (The Hague, 1923), 152, figure 167.

2. Van Marle, *Peinture romaine*, 113 ff.

3. Matthiae, *op. cit.*, 230 ff. and 279 ff.; E. W. Anthony, *A History of Mosaics* (Boston, 1935), 209.

4. Wilpert (J. Wilpert, *Die römischen Mosaiken und Malereien der kirchlichen Bauten vom IV. bis zum XIII. Jahrhundert*, 4 vols, Freiburg i/B., 1916, II, 516 ff.) thinks it was largely copied from an original mosaic of the sixth century.

5. Anthony, *op. cit.*, 212 ff. p. 119

6. Van Marle, *Peinture romaine*, 158; Matthiae, *op. cit.*, I, 323–5.

7. Van Marle, *Peinture romaine*, 159.

8. Anthony, *op. cit.*, plate LXV.

9. *Ibid.*, 81.

10. *Ibid.*, 134. p. 120

11. Van Marle, *Peinture romaine*, 129.

12. Guglielmo Matthiae, *Pittura romana del medioevo*, 2 vols (Rome, 1965), II, 35 ff., plates 16–21; Edgar Waterman Anthony, *Romanesque Frescoes* (Princeton, 1951), 69 ff., with bibliography, and figures 63–6; P. Toesca, *Storia dell'arte italiana* (Turin, 1927), 925; É. Bertaux, *L'Art dans l'Italie méridionale* (Paris, 1904), 301; G. J. Hoogewerff, 'Gli Affreschi nella chiesa di Sant'Elia', *Dedalo*, VIII (1927–8), 331–43.

13. Van Marle, *Peinture romaine*, 127 ff., *Schools*, 152; Anthony, *Frescoes*, 69; Matthiae, *Pittura*, 242 ff., figures 168, 170, and 171.

14. C. R. Morey, *Lost Mosaics and Frescoes of* p. 121 *Rome of the Mediaeval Period* (Princeton, 1915), plate 1, chapter 1.

15. Anthony, *Frescoes*, 69 ff.

16. *Ibid.*, 71.

17. Anthony, *Mosaics*, plate IV.

18. Toesca, *Storia* (see Note 12), I, 921.

19. J. P. Gilson, *An Exultet Roll illuminated in the XI Century at the Abbey of Monte Cassino reproduced from Add. MS. 30337* (London, 1929).

20. Rome, Vatican, Vat. lat. 12958 folio 4 verso. p. 122

21. Anthony, *Frescoes*, figure 82.

p. 122 22. See also *ibid.*, figure 84, for the creation of Eve.

23. See A. L. Frothingham Jr, 'Byzantine Artists in Italy from the Sixth to the Fifteenth Century', *American Journal of Archaeology*, IX (1894), 32–52.

24. Van Marle, *Schools*, 81.

p. 123 25. See below, p. 131.

26. Van Marle, *Schools*, 176.

27. See Otto Demus, *The Mosaics of Norman Sicily* (London, 1950).

28. Van Marle, *Peinture romaine*, 174 and 179; Bertaux, *op. cit.* (see Note 12), 307.

29. See above, p. 6.

30. See above, p. 48.

31. See above, p. 6.

p. 124 32. See J. Gay, *L'Italie méridionale et l'empire byzantin* (Paris, 1904), 378–85.

33. Bertaux, *op. cit.*, 115 ff.; Ch. Diehl, *L'Art byzantin dans l'Italie méridionale* (Paris, 1894); G. Gabrielli, *Inventario topografico e bibliografico delle cripte eremitiche basiliane della Puglia* (Rome, 1936); A. Medea, *Gli Affreschi delle cripte eremitiche pugliesi*, 2 vols (Rome, 1939).

34. Bertaux, *op. cit.*, 143, figure 56.

35. *Ibid.*, 138.

36. *Ibid.*

37. *Ibid.*, 90 ff.; Toesca, *Storia*, 408 ff.; Toesca, 'Reliquie d'arte della Badia di S. Vincenzo al Volturno', *Bull. dell'Instituto storico italiano*, XXV (1904); C. Brandi, 'Gli Affreschi della cripta di S. Lorenzo a S. Vincenzo al Volturno', *Boll. dell'Instituto centrale del Restauro*, XXXI–XXXII (1957); Anthony, *Romanesque Frescoes*, 86 ff., figures 113–22; G. de Francovich, 'Problemi della pittura e della scultura preromanica', *Settimane di studio del Centro italiano di Studi sull'Alto Medioevo* (Spoleto, 1955).

38. Anthony, *Romanesque Frescoes*, figure 117.

39. *Ibid.*, figure 120.

p. 125 40. Van Marle, *Schools*, 98.

41. Bertaux, *op. cit.*, 107 ff.

42. *Ibid.*, 99.

43. Compare, for example, J. Ebersolt, *La Miniature byzantine* (Paris, 1926), plates XIII and XV.

44. Bertaux, *op. cit.*, 244 ff.

45. See M. Ferrante, 'Chiesa e chiostro di S. Sofia in Benevento', *Samnium*, XXV (1952), 73–9; Janine Wettstein, *Sant'Angelo in Formis et la peinture médiévale en Campanie* (Geneva, 1960), 82.

46. Van Marle, *Peinture romaine*, 79 ff. and 90; Anthony, *Romanesque Frescoes*, I, 221 ff., figures 145–7.

47. See André Grabar, *Byzantine Painting* (Lausanne, 1953), plate on p. 164. p

48. E. B. Garrison, *Studies in the History of Medieval Italian Painting*, 4 vols (Florence, 1953–62), IV, 192.

49. Van Marle, *op. cit.*, 81; Anthony, *Romanesque Frescoes*, 67, figure 54; Matthiae, *op. cit.*, I, 191 ff. and figures 125–8.

50. See Anthony, *Romanesque Frescoes*, figure 270.

51. Van Marle, *op. cit.*, 82 ff.; Matthiae, *op. cit.*, 231 ff., who seems to accept this dating.

52. See above, pp. 19–20.

53. See Myrtilla Avery, *The Exultet Rolls of South Italy* (Princeton, 1936), plates CIV–CIX.

54. *Ibid.*, plates CX–CXVII.

55. Avery, *op. cit.*, plates CXXXV–CXLVI.

56. Avery, *op. cit.*, and Bertaux, *op. cit.*, chapter V. p

57. e.g. Avery, *op. cit.*, plates X, CXLV, CLII; see also Bertaux, *op. cit.*, 232.

58. Peter Baldass, 'Die Miniaturen Zweier Exultet-Rollen', *Scriptorium*, VIII (1954), 217.

59. Bari Cathedral Archives I (Avery, *op. cit.*, plates IV–XI).

60. Avery, *op. cit.*, plates XII–XVI. p

61. London, British Museum Add. MS. 30337 (Avery, *op. cit.*, plates XLIII–LI), Rome, Bib. Vat. lat. 3784 (*ibid.*, plates CXXX–CXXXIV), Rome, Bib. Vat. Barb. lat. 592 (*ibid.*, plates CXLVII–CLIII). For a possible fourth, see Janine Wettstein, 'Un Rouleau campanien du XI^e siècle conservé au Musée San Matteo à Pise', *Scriptorium*, XV (1961), 234–9.

62. Avery, *op. cit.*, plates XLIII–LI; also J. P. Gilson, *op. cit.* (Note 19).

63. See Herbert Bloch, 'Monte Cassino, Byzantium, and the West in the Earlier Middle Ages', *Dumbarton Oaks Papers*, no. 3 (Cambridge, Mass., 1946), 165–224. p

64. Quoted Bertaux, *op. cit.*, 159–60. p

65. *Ibid.*, 158.

66. Quoted Bloch, *op. cit.*, 209, note 151.

67. Bertaux, *op. cit.*, 403 ff.

68. *Ibid.*, 405.

69. *Ibid.*, 606.

NOTES

70. *Ibid.*, 407.

71. *Ibid.*, 406.

72. *Ibid.*, 407.

131 73. *Chronica monast. Casinensis*, lib. II, c. 32 – no. 2274 of Otto Lehmann-Brockhaus, *Schriftquellen zur Kunstgeschichte des 11. and 12. Jahrhunderts für Deutschland, Lothringen und Italien* (Berlin, 1938).

74. Gherardo B. Ladner, *I Ritratti dei Papi nell'antichità e nel medioevo*, I (Rome, 1941), plate XXI.

75. Bloch, *op. cit.*, 195.

76. Wettstein, *op. cit.* (see Note 45), 51.

77. Bloch, *op. cit.*, 196; Bertaux, *op. cit.*, 174.

78. *Ibid.*, 197; *ibid.*, 177.

79. See Wettstein, *op. cit.*; Ottavio Morisani, *Gli Affreschi di S. Angelo in Formis* (Naples, 1962).

80. Morisani, *op. cit.*, plate 5.

81. Appropriately compared by Morisani with Byzantine illumination – see Ottavio Morisani, *Bisanzio e la pittura cassinese* (Palermo, 1955), 23 ff.

132 82. Peter Anker and Knut Berg, 'The Narthex of Sant'Angelo in Formis', *Acta Archaeologica*, XXIX (1958), 95–109.

83. Wettstein, *op. cit.*, 19.

84. *Ibid.*, 55.

85. See Morisani as quoted in Note 81.

133 86. *Ibid.*, plates 1 and 2.

87. *Ibid.*, plates 17 and 35.

88. Bertaux, *op. cit.*, 256.

89. C. R. Morey, *Mediaeval Art* (New York, 1942), 133.

90. Migne, *Patrologia Latina*, CLXXII, col. 586.

134 91. Morisani, *S. Angelo*, plate 43.

92. *Ibid.*, plate 21.

93. *Ibid.*, plate 49.

94. Bloch, *op. cit.*, 196.

95. Bertaux, *op. cit.*, 267 ff. and chapter VII; Wettstein, *op. cit.*, 93 ff.

96. Quoted Bloch, *op. cit.*, 206.

97. Cod. cas. 99 H. See G. Ladner, 'Die italienische Malerei im 11. Jahrhundert', *Jahrbuch der kunsthistorischen Sammlungen in Wien* (Vienna, 1931), 33–160.

98. Bloch, *op. cit.*, 170; Bertaux, *op. cit.*, 194; Wettstein, *op. cit.*, 104 ff.

99. Bertaux, *op. cit.*, 194; Wettstein, *op. cit.*, 104 ff.

135 100. Bertaux, *op. cit.*, 195.

101. *Ibid.*, 196.

102. See Chapter 3, Note 46.

103. Bertaux, *op. cit.*, 197.

104. Avery, *op. cit.*, plate CXCVII.

105. Quoted Bloch, *op. cit.*, 178.

106. *Ibid.*

107. Bloch, *op. cit.*, 183 ff.

108. *Ibid.*

109. Bloch, *op. cit.*, 207.

110. *Ibid.*, 199.

111. See Peter Baldass, 'Disegni della scuola cassinese del tempo di Desiderio', *Bollettino d'Arte* (1952), 102 ff. p. 136

112. D. M. Inguanez and M. Avery, *Miniature cassinesi del secolo XI illustranti la vita di S. Benedetto* (Montecassino, 1934); Bertaux, *op. cit.*, 206 ff.; Baldass, *op. cit.*, 111 ff.; Ladner, *op. cit.*, 47 ff.; Bloch, *op. cit.*, 201 ff.; Wettstein, *op. cit.*, 65 ff., 116, and 123.

113. Bertaux, *op. cit.*, 201 and 204 ff.; Ladner, *op. cit.*, 38 ff.; Baldass, *op. cit.*, 103 ff.; Bloch, *op. cit.*, 201 ff.; Wettstein, *op. cit.*, 116 and 120.

114. *Ibid.*

115. Thomas J. Preston, *The Bronze Doors of the Abbey of Monte Cassino and of St Paul's Rome* (Princeton, 1915). p. 137

116. Baldass, *op. cit.*, 112.

117. Folio 5 recto.

118. Folio 3 recto.

119. Ladner, *op. cit.*, 50 ff. p. 138

120. Wilpert, *op. cit.*, II, 546–7; Garrison, *op. cit.*, I, 1 ff., II, 173 ff., III, 113 ff. (with comprehensive bibliography); Matthiae, *Pittura*, II, 24 ff., and figures 11–15.

121. See, for example, Ladner, *op. cit.*, 64 ff., and Bloch, *op. cit.*, 218. The view is opposed by Ferdinando Bologna, *Early Italian Painting* (London, 1963), 31, who argues that Roman and Cassinese painting followed courses that were parallel rather than related.

122. See Bertaux, *op. cit.*, 208 ff.

123. Garrison, *op. cit.*, III, 117–18.

124. Cesena, Bib. Piano MS. 3.210. See Garrison, *op. cit.*, II, 179, and *Mostra storica nazionale della miniatura, Catalogo* (1954), no. 107.

125. Garrison, *op. cit.*, II, 172; Matthiae, *op. cit.*, II, 30. p. 139

126. Garrison, *op. cit.*, II, 180 ff.; Matthiae, *op. cit.*, p. 140

227

II, 45 ff. and plates 42–6, where an earlier dating is suggested.

p. 140 127. Reproduced Garrison, *ibid.*, figures 197, 199, 201, 203.

p. 141 128. Van Marle, *Peinture romaine*, 129–30, and *Schools*, 154–7; Toesca, *Storia*, 925, 1024; Ladner, *op. cit.*, 85 ff.; Matthiae, *op. cit.*, II, 35 ff., plates 16–25.

129. See above, p. 120.

130. Garrison, *op. cit.*, III, 16 ff.

131. IOH[ANNES ET] STEFANUS FRATRES PICTO[RES] ROMANI ET NICOLAUS NEPUS IOHANNIS. For a claim that they were monks, see G. J. Hoogewerff, 'Gli Affreschi nella chiesa di Sant'Elia presso Nepi', *Dedalo*, VIII (1927), 340.

p. 142 132. Toesca, *Storia*, 924 ff.; Garrison, *op. cit.*, II, figures 23 and 24, III, 195 ff.; Matthiae, *op. cit.*, II, 31 ff., and plates 30–3; C. A. Isermeyer, 'Die mittelalterlichen Malereien der Kirche S. Pietro in Tuscania', *Biblioteca Hertziana Jahrbuch*, II (1938), 289 ff.

133. Van Marle, *Peinture romaine*, 165 ff.; Garrison, *op. cit.*, III, 187 ff.; Matthiae, *op. cit.*, 120, plate 103; L. Magnani, 'Frammenti di affreschi medioevali di S. Nicola in Carcere nella Pinacoteca Vaticana', *Atti della Pontificia Accademia Romana di Archeologia, Rendiconti*, VIII (1931–2), 233 ff.

134. Toesca, *op. cit.*, 924 ff.; Anthony, *op. cit.*, 75 ff.; Garrison, *op. cit.*, III, 12 ff.; Matthiae, *op. cit.*, II, 21 ff., where it is dated to the end of the eleventh century.

135. Garrison, *op. cit.*, II, 5 ff., III, 189 ff.; also Garrison, *Italian Romanesque Panel Painting* (Florence, 1949), no. 279.

136. Garrison, *Studies (ibid.)*; W. F. Volbach, 'Il Cristo di Sutri e la venerazione del S. Salvatore nel Lazio', *Atti della Pontificia Accademia Romana di Archeologia, Rendiconti*, XVII (1942), 97 ff.

137. *Ibid.*

p. 143 138. Garrison, *op. cit.*, I, 23 ff.

p. 144 139. *Ibid.*, II, 81 ff., III, 17 ff.

140. Garrison, *op. cit.*, I, 10 ff., II, 131 ff.

141. *Ibid.*, III, 286 (with bibliography), IV, 179.

142. *Ibid.*, IV, 185 ff.

143. *Ibid.*, 189.

144. *Ibid.*, 194 ff.

145. *Ibid.*, figure 150.

146. See T. D. Kendrick, *Anglo-Saxon Art to A.D. 900* (London, 1938), figure CI (8).

p. 145 147. Garrison, *op. cit.*, IV, figures 145 and 146.

148. P. Toesca, *La Pittura e la miniatura nella Lombardia* (Milan, 1912), 78; Swarzenski, *Regensburger Buchmalerei*, 175–6; Garrison, *op. cit.*, II, 139 ff.

149. See above, pp. 82–3.

150. See below, pp. 161–2.

151. For the working out of this viewpoint, see p. 1 P. H. Brieger, 'Bible Illustration and Gregorian Reform', *Studies in Church History*, II (1965), 154–64.

152. See above, pp. 35–6.

153. Brieger, *op. cit.*, 157 ff.

154. *Ibid.*, 158 ff.

155. *Ibid.*, 163.

156. Pietro Toesca, 'Miniature romane dei secoli XI e XII', *Rivista del R. Istituto d'Archeologia e Storia dell'Arte*, I (1929), 74 ff.; Toesca, *Pittura . . . nella Lombardia*, 928–30, 1052–5.

157. Garrison, *op. cit.*, I, 41 ff.

158. *Ibid.*, I, 46. p. 1

159. By Garrison in his *Studies*.

160. *Ibid.*, II, 81 ff., III, 17 ff.

161. *Ibid.*, III, 17 ff.

162. *Ibid.*

163. Toesca, *Pittura . . . nella Lombardia*, 75. p. 1

164. Garrison, *op. cit.*, IV, 152 ff.

165. *Ibid.*, 118 ff.

166. *Ibid.*, 141 ff.

167. *Ibid.*, 140 ff.; Toesca, *op. cit.*, 78–9.

168. Garrison, *op. cit.*, III, 212 ff.

169. Toesca, *op. cit.*, 928, 1055; Garrison, *op. cit.*, IV, 148 ff.

170. Garrison, *op. cit.*, IV, 142 and figure 111.

171. *Ibid.*, 141 ff.; Toesca, *op. cit.*, 1053.

172. Garrison, *op. cit.*, IV, 142 and figure 111. p. 14

173. *Ibid.*, 200 ff.

174. Rome, Vatican, Vat. lat. 12958 folio 4 verso.

175. P. D'Ancona, *La Miniatura fiorentina* (Florence, 1914), 9 ff., plates III–V; Toesca, *Miniature romane*, figures 20–4; Toesca, *Storia*, 1057; Garrison, *op. cit.*, I, 164–6, 228–33.

176. Garrison, *op. cit.*, I, *Pictorial Histories*, I, III, p. 1 *Pictorial Histories*, IX, 59 ff.

177. *Ibid.*, III, 1, 82–3, IV, 60, 71.

178. *Ibid.*, IV, 61 ff.

179. *Ibid.*, III, 4, 82–3, IV, 60, 71.

180. *Ibid.*, I, 110 ff., and *Pictorial Histories*, I, III, *Pictorial Histories*, IX and IV, 59 ff.

181. For which, see *ibid.*, IV, 59 and 60 with footnotes.

182. *Ibid.*, I, 188 and 190.

183. *Ibid.*, III, 230.

184. *Ibid.*, I, 115 ff.

p.151 185. *Ibid.*, 116.

186. Garrison, *Italian Romanesque Panel Painting* (Florence, 1949), section XXIX, with bibliography.

187. See Note 2 to Chapter 2.

188. G. M. Richter, 'The Crucifix of Gulielmus at Sarzana', *Burlington Magazine* (1927); E. Sandberg-Vevalá, 'Quattro croci romaniche a Sarzana e a Lucca', *Dedalo*, VIII (1928); E. B. Garrison, 'A Lucchese Passionary related to the Sarzana Crucifix', *Art Bulletin*, XXXV (1953).

189. See P. Toesca, *La Pittura e la miniatura nella Lombardia* (Milan, 1912); G. A. Dell'Acqua, 'Affreschi inediti del medioevo lombardo', *Bollettino d'arte*, XL (1955); Ferdinando Bologna, *Early Italian Painting* (London, 1963), *passim*.

190. See Anthony, *op. cit.*, 99 ff.; de Francovich, *op. cit.*; P. Toesca, *Aosta* (Rome, 1911); A. Grabar, 'Fresques d'Aoste et l'étude des peintures romanes', *La Critica d'Arte*, VIII (1949).

191. Anthony, *op. cit.*, 98 ff.; Toesca, *Storia*, 947, and *Pittura*, 42 ff.; G. Ansaldi, *Gli Affreschi della basilica di S. Vincenzo a Galliano* (Milan, 1949).

192. See below, p. 193.

p. 152 193. Toesca, *Pittura*, 62 ff., and *Storia*, 948.

194. Toesca, *Pittura*, 100 ff.; Anthony, *op. cit.*, 99.

CHAPTER 8

p. 153 1. Ed. Dodwell, 4.

2. See Kurt Weitzmann, 'Various Aspects of Byzantine Influence on the Latin Countries from the Sixth to the Twelfth Century', *Dumbarton Oaks Papers*, no. 20 (1966), 14.

3. Guillaume de Poitiers, *Histoire de Guillaume le Conquérant*, ed. Raymonde Foreville (Paris, 1952), 224.

4. Stephen of Blois. Quoted by Steven Runciman in 'Byzantine Art and Western Taste', in M. Chatzidakis (ed.), *Byzantine Art in European Art, Lectures* (Athens, 1966), 8.

p. 154 5. Quoted in Suzanne Collon-Gevaert and others, *Art roman dans la vallée de la Meuse aux XIe et XIIe siècles* (Brussels, 1963), 77.

6. *Abbot Suger*, ed. Panofsky (Chapter 6, Note 54), 33.

7. Robert Willis (ed.), *Facsimile of the Sketch-Book of Wilars de Honecort* (London, 1859); H. R. Hahnloser, *Villard de Honnecourt* (Vienna, 1935).

8. Freiburg: Augustinermuseum. See R. W. Scheller, *A Survey of Medieval Model Books* (Haarlem, 1963); Ernst Kitzinger, 'Norman Sicily as a Source of Byzantine Influence on Western Art in the Twelfth Century', *Byzantine Art* (quoted in Note 4), 135; O. Homburger, 'Der Rest eines Musterbuches der Stauferzeit', *Studien zur Kunst des Oberrheins: Festschrift für Werner Noack* (Konstanz and Freiburg, 1958), 16 ff.; Demus, *Mosaics of Norman Sicily* (Chapter 7, Note 27), 445 ff.

9. Kitzinger, *op. cit.*, 146, note 55.

10. *Ibid.*, 125. p. 155

11. By Wilhelm Koehler in 'Byzantine Art in the West', *Dumbarton Oaks Papers*, no. 1 (Cambridge, Mass., 1941), 61–87.

12. Nâsir-i-Khosrau. Quoted in Hughes Vincent and F.-M. Abel, *Jérusalem Nouvelle*, II (Paris, 1914), 252.

13. *Ibid.*, 253.

14. *Ibid.*, 261 ff.

15. W. Harvey and others, *The Church of the* p. 156 *Nativity at Bethlehem* (London, 1910), 26.

16. *Ibid.*

17. Felix Fabri. Quoted *ibid.*, 67–8.

18. Quoted in full *ibid.*, 43.

19. *Ibid.*, 34 and 43.

20. Demus, *op. cit.*

21. Saladin had the Mosque of Al Aqsa at Jerusalem decorated with mosaics by Byzantine artists in 1187. See De Vogüé, *Le Temple de Jérusalem* (Paris, 1894), 99.

22. John Phocas. Quoted in full in Harvey, *op. cit.*, 65–6.

23. T. S. R. Boase, 'The Arts in the Latin Kingdom of Jerusalem', *Journal of the Warburg Institute*, II (1938–9), 12.

24. Hugo Buchthal, *Miniature Painting in the Latin* p. 157 *Kingdom of Jerusalem* (Oxford, 1957).

25. *Ibid.*, 12, 13, 15, 34.

26. For which, see *ibid.*, 1 ff.

27. *Ibid.*, 2 ff.

28. *Ibid.*, 14.

29. See above, pp. 104–5.

p. 158 30. *Ibid.*, 25 ff.

p. 159 31. See Otto Demus, *The Mosaics of Norman Sicily* (London, 1950).

32. See Hugo Buchthal, 'A School of Miniature Painting in Norman Sicily', in Kurt Weitzmann (ed.), *Late Classical and Mediaeval Studies in Honor of Albert Mathias Friend Jr* (Princeton, 1955), 312–39, and 'The Beginnings of Manuscript Illumination in Norman Sicily', *Papers of the British School in Rome*, XXIV (1956), 78–85.

33. Buchthal, 'A School . . .'.

34. Madrid, Biblioteca Nacional MS. 52; see Buchthal, *op. cit.*, 316 ff.

35. Riccardiana Library MS. 227; *ibid.*, 319 ff.

36. Cathedral Treasure of Città Nobile; *ibid.*, 320.

37. Biblioteca Nacional MSS. 6, 9, 10, and 14; *ibid.*, 322 ff.

38. Biblioteca Nacional MSS. 31–47; *ibid.*, 320 ff.

CHAPTER 9

p. 160 1. Folio 275.

2. Folio 228 of the first volume and folio 240 of the second.

3. See Suzanne Collon-Gevaert and others, *Art roman dans la vallée de la Meuse aux XIe et XIIe siècles* (Brussels 1963), 156; C. Caspar and F. Lyna, *Les Principaux Manuscrits à peintures de la Bibliothèque Royale de Belgique* (Paris, 1937), 66–9.

p. 161 4. See F. Masai, *Art mosan et arts anciens du Pays de Liège* (Liège, 1951); *Art roman dans la vallée de la Meuse*; Karl Usener as quoted in Note 10 and Marcel Laurent as quoted in Note 16.

5. E. de Moreau, *Histoire de l'Église en Belgique* (Brussels, 1945), 321.

6. These are pictures of St Augustine and St Gregory in Douai, Bib. Mun. MS. 250 folio 2 and Bib. Nat. MS. lat. 2287 folio 1 verso (Porcher, *French Miniatures* (see Chapter 5, Note 3), frontispiece and plate XXXIII).

7. See, for example, the picture of Eadwine in the Eadwine Psalter, Cambridge, Trinity College MS. R. 17. 1; C. R. Dodwell, *The Canterbury School of Illumination* (Cambridge, 1954), plate 23.

p. 162 8. Hanns Swarzenski, *Monuments of Romanesque Art* (London, 1954), 30.

9. *Ibid.*, plates 110–13 and p. 58, with bibliography.

10. For which, see P. Wescher, 'Eine Miniaturhandschrift des XII. Jahrhunderts aus der Maasgegend', *Beiblatt zum Jahrbuch der preussischen Kunstsammlungen*, XLIX (1928), 90–4; Suzanne Gevaert, 'Quelques miniatures mosanes du XIIe, siècle', *Revue Belge d'Archéologie et d'Histoire de l'Art*, III (1933), 342–5; Karl H. Usener, 'Das Breviar Clm. 23261 der Bayerischen Staatsbibliothek und die Anfänge der romanischen Buchmalerei in Lüttich', *Münchner Jahrbuch der bildenden Kunst*, 3. Folge, I (1950), 78–92; Dom Nicolas Huyghebaert, 'Le Sacramentaire de l'Abbé Mannasès de Bergues-Saint-Winoc', *Annales de la Société d'Émulation de Bruges*, LXXXIII (1947), 41–51.

11. In Berlin, MS. 78 A 8 of the Collection of Prints. See P. Wescher, *op. cit.* (Note 10), 90–4; Suzanne Gevaert, *op. cit.* (Note 10).

12. See Suzanne Gevaert, 'Le Modèle de la Bible de Floreffe', *Revue Belge d'Archéologie et d'Histoire de l'Art*, V (1935), 17–24.

13. Hanns Swarzenski, *op. cit.*, figure 322.

14. See the comparison made with St Sigismund on base of reliquary head – *ibid.*, figures 483 and 484.

15. Suzanne Gevaert, 'Le Modèle', 17–24.

16. Marcel Laurent, 'Art rhénan, art mosan et art byzantin: la Bible de Stavelot', *Byzantion*, VI (1931), 75–98.

p. 163 17. See *Art mosan*, plates 31–3.

18. *Ibid.*, 79, plates 31 and 32.

19. Hermann Schnitzler, *Rheinische Schatzkammer: Die Romanik* (Düsseldorf, 1959), 28–9, plates II, 72–4.

20. D. H. Turner, *Romanesque Illuminated Manuscripts* (British Museum, 1966), 19.

p. 164 21. Hermann Deckert, Robert Freyhan, and Kurt Steinbart, *Religiöse Kunst aus Hessen und Nassau* (Marburg an der Lahn, 1932), II, nos. 156–7; III, plates 245b–250.

22. Franz Jansen, *Die Helmarshausener Buchmalerei zur Zeit Heinrichs des Löwen* (Hildesheim, 1933), 2.

23. *Ibid.*, 10 ff.

24. *Ibid.*, 21 ff. and 37.

25. *Ibid.*, 61 ff.; Georg Swarzenski, 'Aus dem Kunstkreis Heinrichs des Löwen', *Städel Jahrbuch*, VII–VIII (1932), 241–397.

26. Adolph Goldschmidt, 'A German Psalter of the Twelfth Century written in Helmarshausen', *Journal of the Walters Art Gallery*, I (1938), 19–23.

p. 165 27. Jansen, *op. cit.*, 92 ff.

28. *Ibid.*, 118 ff.

p. 166 29. P. Clemen, *Die romanische Monumentalmalerei in den Rheinlanden* (Düsseldorf, 1916), 220 ff.; E. W. Anthony, *Romanesque Frescoes* (Princeton, 1951), 126 ff.

30. Clemen, *op. cit.*, 97 ff.; Anthony, *op. cit.*, 126.

31. Anthony, *op. cit.*, 130; V. C. Habicht, 'Die neuentdeckten Fresken in Idensen', *Belvedere*, x (1941), 149–55.

32. Clemen, *op. cit.*, 331 ff.

33. F. Beckett, *Danmarks Kunst* (Copenhagen, 1924), 272–5; P. Nørlund and E. Lind, *Danmarks romanske Kalkmalerier* (Copenhagen, 1944), 238 ff. and 264 ff.; Anthony, *op. cit.*, 199 ff.

34. Beckett, *op. cit.*, 273 ff.; Nørlund and Lind, *op. cit.*, 244 ff.; Anthony, *op. cit.*, 201.

35. See Beckett, *op. cit.*, figures 358, 359, 361.

36. J. Roosval, *Swedish Art* (Princeton, 1932), 36 ff. and plate 146. It is here argued that the Byzantine influences come from Russia.

p. 167 37. Anthony, *op. cit.*, 201.

38. Roosval, *op. cit.*, 35 ff.; Nørlund and Lind, *op. cit.*, figure 69; Anthony, *op. cit.*, 202.

39. Anthony, *op. cit.*, figure 499.

40. O. Rydbeck, *Medeltids Kalkmålningar i Skånes kyrkor* (Lund, 1904), figures 10 and 36; Anthony, *op. cit.*, figure 493, p. 202.

41. Rydbeck, *op. cit.*, 16 ff., 23 ff., figures 4, 20, 21, 32–4; Anthony, *op. cit.*, 203.

42. Georg Swarzenski, *Die Salzburger Malerei* (Leipzig, 1913), 58–60.

43. *Ibid.*, 58.

44. *Ibid.*, 63.

p. 168 45. *Ibid.*, 67 ff.

46. *Ibid.*, 71 ff.

47. *Ibid.*, 72 ff., and *Katalog der Abendländischen Handschriften der Österreichischen Nationalbibliothek, Series nova*, part 2/1 (Vienna, 1963), 355 ff.

48. See Hanns Swarzenski, 'Two Unnoticed Leaves from the Admont Bible', *Scriptorium*, x (1956), 94–6.

49. G. Swarzenski, *op. cit.*, 78 ff.

50. Kitzinger, *op. cit*, 135.

51. Anthony, *Romanesque Frescoes*, 132. Also Peter von Baldass and others (eds), *Romanische Kunst in Österreich* (Vienna, 1962), 65 ff. and plate 41.

52. Anthony, *ibid.*

53. G. Swarzenski, *op. cit.*, 83 ff.

54. *Ibid.*, 91 ff.

55. *Ibid.*, 108 ff.

56. *Ibid.*, 93 ff. p. 169

57. *Ibid.*

58. See also the second miracle scene on folio 48 verso, *ibid.*, Abb. 398.

59. *Ibid.*, Abb. 393–4.

60. *Ibid.*, chapter iv.

61. *Ibid.*, 129 ff.

62. *Ibid.*, 144 ff.

63. *Ibid.*, 158, Abb. 455–6. p. 170

64. *Ibid.*, 153 ff.

65. Anthony, *op. cit.*, 132, figures 266 and 267.

66. H. Schrade, *Die Romanische Malerei* (Cologne, 1963), plate 125.

67. Anthony, *op. cit.*, 131, figures 262, 263.

68. Albert Boeckler, *Die Regensburg-Prüfeninger Buchmalerei des XII. und XIII. Jahrhunderts* (Munich, 1924).

69. *Ibid.*, 15 ff.

70. *Ibid.*, 20 ff.

71. *Ibid.*, 33 ff.

72. See A. Straub and G. Keller (eds), *Herrade de p. 171 Landsberg Hortus Deliciarum* (Strassburg, 1899).

73. See *The British Museum Quarterly*, vi (1931–2), 1 ff., plates 1–4.

74. R. B. Green, 'The Flabellum of Hohenbourg', *Art Bulletin*, xxxiii (1951).

75. R. B. Green, 'The Adam and Eve Cycle in the Hortus Deliciarum', in Kurt Weitzmann (ed.), *Late Classical and Mediaeval Studies in Honor of Albert Mathias Friend, Jr* (Princeton, 1955), 340–7.

76. See F. Saxl, *Lectures* (London, 1957), i, 234 ff.

77. *Ibid.*, 242 ff.

78. *Ibid.* And see now the facsimile published by the State University of Ghent, ed. A. Derolez, *Liber Floridus* (Ghent, 1967).

79. Migne, *Patrologia Latina*, cii, col. 593.

80. Saxl, *op. cit.*, 243–4.

81. *Ibid.*, 247 ff. p. 172

CHAPTER 10

1. Meyer Schapiro, *The Parma Ildefonsus: a Roman- p. 173 esque Illuminated Manuscript from Cluny and Related Works* (New York, 1964), 22 ff.

p. 173 2. *Biblia Cluniacensis*, col. 1645.

3. See Fernand Mercier, *Les Primitifs français, la peinture clunisienne* (Paris, 1932); Joan Evans, *Cluniac Art of the Romanesque Period* (Cambridge, 1951), 26 ff.; Edgar Waterman Anthony, *Romanesque Frescoes* (Princeton, 1951), 135 ff.

p. 174 4. See Gérard Cames, 'Recherches sur l'enluminure romane de Cluny', *Cahiers de Civilisation Médiévale*, VII (1964), 145–59.

p. 175 5. *Ibid.*, 152 ff.

6. André Grabar and Carl Nordenfalk, *Romanesque Painting* (Lausanne, 1958), 189; Schapiro, *op. cit.*

7. Schapiro, *op. cit.*, 26 ff.

8. *Ibid.*

9. *Ibid.*, plates 11 and 23.

p. 176 10. *Apologia ad Gulielmum*, in Migne, *Patrologia Latina*, CLXXXII, col. 914 ff.

11. Evans, *op. cit.*, 20.

12. *Ibid.*

13. Henri Focillon, *Peintures romanes des églises de France* (Paris, 1938), 52, quotes from the reminiscences of Peter the Venerable.

14. See Note 10.

15. Evans, *op. cit.*, 10 ff.

16. *Biblia Cluniacensis*, col. 1645.

17. Martène, *Thesaurus*, V, col. 1633.

18. See above, pp. 89–93.

19. See above, p. 93.

p. 177 20. In Munich, Clm. 15902; see G. Swarzenski, *Die Salzburger Malerei* (Leipzig, 1913), Abb. 438.

21. See above, p. 93.

22. C. Oursel, *La Miniature du XII^e siècle à l'abbaye de Cîteaux* (Dijon, 1926), plate XLV.

23. *Ibid.*, plates XXXIII, XXXIV, XXXV.

24. *Ibid.*, plate XXXIII.

p. 178 25. Porcher, *French Miniatures* (see Chapter 5, Note 3), figure 36, illustrates a page that is almost entirely decorative.

p. 179 26. See C. R. Dodwell, *The Great Lambeth Bible* (London, 1959), 16 ff.; Dom Leclerq, 'Les Manuscrits de l'abbaye de Liessies', *Scriptorium*, V (1951), 51–62.

27. Dodwell, *ibid.*

28. See above, p. 174.

p. 180 29. Erwin Panofsky (ed.), *Abbot Suger on the Abbey Church of St-Denis* (Princeton, 1946) – Professor Panofsky's translation.

30. *Ibid.*, 73.

31. For which, see primarily Clémence-Paul Duprat, 'Enquête sur la peinture murale en France à l'époque romane', *Bulletin Monumental*, CI (1942), 165–223.

32. A suggestion I owe to Mr H. Maguire. p. 18[?]

33. *Karl der Grosse* (catalogue), no. 641, with full bibliography.

34. Hans Wentzel, *Meisterwerke der Glasmalerei* (Berlin, 1951), 15.

35. *Ibid.*, 15–16.

36. *Ibid.*, 84.

37. *Ibid.*, 17.

38. *Ibid.*, 19 ff.

39. *Ibid.*, 18 ff.

40. *Ibid.*, plate 19.

41. *Ibid.*, plate 21.

42. F. Zschokke, *Die Romanischen Glasgemälde des Strassburger Münsters* (Basel, 1942).

43. *Theophilus*, ed. Dodwell (see Chapter 1, Note 26), 4.

44. *Suger*, ed. Panofsky, 73 ff., plates 12–18; Louis Grodecki, *Vitraux des églises de France* (Paris, 1947), plates 1 and 2.

45. L'Abbé Y. Delaporte and É. Houvet, *Les* p. 182 *Vitraux de la cathédrale de Chartres*, 2 vols (Chartres, 1926).

46. Marcel Aubert, *Le Vitrail en France* (Paris, 1946), 16.

47. *Ibid.*

48. *Ibid.*, 18.

49. *Ibid.*, 17 ff.; Grodecki, *op. cit.*, plates 9 and 10.

50. Originated by Duprat, *op. cit.*, and followed by many scholars.

51. Henri Focillon, *op. cit.* (see Note 13), plates p. 183 98–9; Paul Deschamps and Marc Thibout, *La Peinture murale en France: Le haut moyen âge et l'époque romane* (Paris, 1951), plates XIV and XV; Paul-Henri Michel, *Romanesque Wall Paintings in France* (London, 1950), plate XII.

52. Deschamps and Thibout, *op. cit.*, 59.

53. Michel, *op. cit.*, plates 73–7.

54. Deschamps and Thibout, *op. cit.*, 64–5, 69–71.

55. *Ibid.*, 63–4.

56. *Ibid.*, 49–52; Michel, *op. cit.*, plates 14–16.

57. Deschamps and Thibout, *op. cit.*, 137.

58. Focillon, *op. cit.*, plates 52–8; Deschamps and Thibout, *op. cit.*, 126–30; Michel, *op. cit.*, plates 60–3.

184 59. Marc Thibout, 'Notre Dame de Montmorillon', *Congrès Archéologique à Poitiers en 1951* (Paris, 1952), 207 ff.

60. G. Gaillard, *Les Fresques de Saint-Savin* (Paris, 1944); P. Deschamps, 'Les Peintures de l'église de Saint-Savin', *Congrès Archéologique de Poitiers en 1951*; Marcel Aubert, 'Saint-Savin', *Congrès Archéologique à Poitiers en 1951*; Élisa Maillard, *L'Église de S. Savin sur Gartempe* (Paris, 1926); Focillon, *op. cit.*, plates 1–39.

186 61. See the facsimile edited by Sir Israel Gollancz, *The Caedmon Manuscript of Anglo-Saxon Biblical Poetry* (Oxford, 1927).

62. Deschamps and Thibout, *op. cit.*, 69.

63. Anthony, *op. cit.*, 143 ff.

64. Focillon, *op. cit.*, plates 40–2.

CHAPTER 11

187 1. At St Albans, one abbot, Geoffrey, sold material for the shrine of St Alban to relieve the poor during a famine, and a later abbot, Rudolf, stripped the shrine for less selfless reasons. See H. T. Riley (ed.), *Abbatum Monasterii Sancti Albani* (Rolls Series), 82 and 109.

2. Charles L. Kuhn, *Romanesque Mural Painting of Catalonia* (Cambridge, Mass., 1930), 69.

188 3. See above, p. 18.

4. The decoration of the mosque of the Omayyads at Damascus is, in fact, comparable. See Ch. Diehl, *La Peinture byzantine* (Paris, 1933), plate XVIII.

5. See Helmut Schlunk, 'Las Pinturas de Santullano. Avance al estudio de la pintura mural asturiano de los siglos IX y X', *Archivo Español de Arqueología*, XXV (1952), 15–37; Helmut Schlunk and Magín Berenguer, *La Pintura mural asturiana de los siglos IX y X* (Madrid, 1957).

6. Schlunk, 'Las Pinturas', 18, figure 5.

7. Walter William Spencer Cook and José Gudiol Ricart, 'Pintura e imaginería románicas', *Ars Hispaniae*, VI (Madrid, 1950), 2 ff., figure 2.

189 8. Such as those of the Barcelona *Moralia in Job* – Barcelona Cathedral MS. 102.

9. Cook and Ricart, *op. cit.*, 22 ff., figure 6.

10. *Ibid.*, 22 ff. and figures 3–5.

11. Neuss, *op. cit.* (Chapter 6, Note 14), figure 193.

12. In the Early Christian mausoleum at Centcellas near Tarragona; A. Grabar and C. Nordenfalk, *Early Medieval Painting* (Lausanne, 1957), 62.

13. Cook and Ricart, *op. cit.*, figure 2.

14. Charles L. Kuhn, 'Notes on some Spanish Frescoes', *Art Studies*, I (1923), figures 1 and 2.

15. Cook and Ricart, *op. cit.*, 25 ff., figures 7 and 8.

16. Cook and Ricart, *op. cit.*, 48, figure 25. p. 190

17. André Grabar and Carl Nordenfalk, *Romanesque Painting* (Lausanne, 1958), appendix, figures 3 and 4.

18. Cook and Ricart, *op. cit.*, 32 ff., figures 11–24.

19. *Ibid.*, 150 ff., figures 119–22.

20. *Ibid.*, 70, figures 50 and 51.

21. For which see Walter W. S. Cook, 'The p. 191 Earliest Painted Panels of Catalonia' – a series of articles in *Art Bulletin*, V (1922–3), 85 ff., VI (1923–4), 31 ff., VIII (1925–6), 57 ff., X (1927–8), 153 ff. and 305 ff.

22. Cook and Ricart, *op. cit.*, 204, 209 ff., figures 181 and 182.

23. *Ibid.*, 188, 193, 204, 209 ff., figures 183–6.

24. *Ibid.*, 190, 194, figure 169.

25. *Ibid.*, 194, figure 170.

26. *Ibid.*, 204, figures 174 and 176.

27. *Ibid.*, 201, figures 177 and 179.

28. *Ibid.*, 193.

29. As in San Clemente, Rome. See, on the p. 192 iconography, Kuhn, *op. cit.* (Note 2), 77.

30. See above, p. 102.

31. *Ibid.*

32. As at San Miguel de Engolasters.

33. See also San Pedro del Burgal.

34. Kuhn, *op. cit.*, 81.

35. It appears, for example, at San Quirce de Pedret, Santa Eulalia at Estahón, San Martín de Fonollar, San Salvador de Poliñá, San Julián de Boada.

36. As, for example, in the frescoes of Santa María de Mur, San Martín de Fonollar, San Martín de Brull, San Salvador de Poliñá, Santa María de Barbará, and San Julián de Boada, and in the altar-frontals of Vich, Llusá, Cardet, and Betesa.

p. 193　37. Kuhn, *op. cit.*, 29.

38. *Ibid.*, 85: 'most of them (i.e. motifs of Catalonian iconography) are found in Italy at an early date'.

p. 194　39. *Ibid.*, 17.

40. See above, p. 115.

41. See Kuhn, *op. cit.*, 88 ff.

42. Cook and Ricart, *op. cit.*, 32, figures 11–16.

43. A comparison made by Professor Grabar in Grabar and Nordenfalk, *Romanesque Painting*, appendix, figures 1 and 2.

44. Cook and Ricart, *op. cit.*, figure 17.

p. 195　45. *Ibid.*, 44, figures 18–22.

46. *Ibid.*, 48.

47. *Ibid.*, 92, figures 66–8; Kuhn, *op. cit.*, 49 ff.

48. *Ibid.*, 53 ff., figures 29–34; Kuhn, *op. cit.*, 16 ff.

p. 196　49. *Ibid.*, 57, figures 35–6.

50. *Ibid.*, 58, figures 38–9.

51. *Ibid.*, 58, figures 38–9.

52. *Ibid.*, 66, figure 43.

53. *Ibid.*, 66, figure 44.

p. 197　54. *Ibid.*, 154 ff., figures 124–35.

55. *Ibid.*, 150 ff., figures 119–23; W. W. S. Cook, in *Art Bulletin*, XI (1929), 340 ff.

56. *Ibid.*, 139 ff. and figures 112–18; W. W. S. Cook, in *Art Bulletin*, XI (1929), 352 ff., and XII, 21 ff.

p. 198　57. C. Diehl, *op. cit.* (Note 4), plate XXV.

58. Otto Demus, *The Mosaics of Norman Sicily* (London, 1950), plate 116.

59. Grabar and Nordenfalk, *op. cit.*, II, 76 and 79.

60. *Ibid.*, illustration on p. 77.

61. Cook, *Art Bulletin*, XI (1929), figure 25.

62. P. Toesca, *La Pittura e la miniatura nella Lombardia* (Milan, 1912), figure 71.

63. See Jeanne Vielliard (ed.), *Le Guide du pèlerin de Saint-Jacques de Compostelle* (Macon, 1960).

p. 199　64. Kuhn, *op. cit.*, 36 ff.; Cook and Ricart, *op. cit.*, 79 ff. and figures 53–5.

65. Cook and Ricart, *op. cit.*, 66 and figures 42–3.

66. *Ibid.*, 44, figures 18–22.

67. Walter W. S. Cook, 'Early Spanish Paintings in the Plandiura Collection', *Art Bulletin* XI, 2 (1929), 1–32 figures 20, 12.

68. See above, p. 84.

69. Cook and Ricart, *op. cit.*, 171, figure 136.

70. *Ibid.*, 88 ff., figures 60 and 61.

71. See Kuhn, *op. cit.*, 11 ff.

72. Cook and Ricart, *op. cit.*, 88 ff.　p. 20

73. *Ibid.*, 88, 91, figure 59.

74. See above, p. 185.

75. Cook and Ricart, *op. cit.*, 91.

76. *Ibid.*, 31, figures 9 and 10; Kuhn, *op. cit.*, 25 ff.

77. *Ibid.*, 53, figures 26–8.

78. *Ibid.*, figure 92.　p. 20

79. *Ibid.*, 87, figure 58.

80. *Ibid.*, 87.

81. *Ibid.*, 87 ff.

82. *Ibid.*, figure 82.

83. Paul-Henri Michel, *Romanesque Wall Paintings in France* (London, 1950), plate 78.

84. See Note 21 above.

85. Cook in *Art Bulletin*, VI (2) (1923), 31 ff.

86. *Ibid.*

87. Cook in *Art Bulletin*, V (4) (1923), 96–101 p. 20 and figure 23.

88. Cook in *Art Bulletin*, VIII (1) (1925), 63 ff. and figure 10.

89. *Ibid.*, 72–102, figures 25–9.

90. *Art Bulletin*, V (4) (1923), 86 ff., figure 1; Cook and Ricart, *op. cit.*, figures 174 and 176.

91. Escorial MS. d. 1. 2. See *ibid.*, 89.

92. *Art Bulletin*, VIII (1925), 57–72, figures 1–6.

93. Cook and Ricart, *op. cit.*, figures 64–5.　p. 20

94. Compare, for example, the head of Becket here with the head of Christ in the altar canopy of Vich.

95. See Tancred Borenius, 'The Iconography of St Thomas of Canterbury' and 'Addenda to the Iconography of St Thomas of Canterbury', *Archaeologia*, LXXIX (1929), and LXXXI (1931).

96. Cook and Ricart, *op. cit.*, figure 46.

97. *Ibid.*, 70, figure 48.　p. 20

98. *Ibid.*, 70, figure 49.

99. *Ibid.*, 70, figure 52.

CHAPTER 12

1. A. Boutemy, 'La Bible de Saint-André-au- p. 20 Bois', *Scriptorium*, V (1951), 222–37.

2. H. Swarzenski, *The Berthold Missal* (New York, 1943).

206 3. Jean Porcher, *French Miniatures from Illuminated Manuscripts* (London, 1959), figure 42.

4. *Ibid.*, plate XXVIII.

5. *Ibid.*, plate XXXVIII; Ph. Lauer, *Les Enluminures romanes des manuscrits de la Bibliothèque Nationale* (Paris, 1927), 137–8, plate LXXXV, 2; C. R. Dodwell, *The Canterbury School of Illumination* (Cambridge, 1954), 50 and 110.

6. Dodwell, *op. cit.*, 104 ff.

7. *Ibid.*, 109 ff. p. 207

8. See the encomium on Eadwine in the Canterbury Psalter (Dodwell, *op. cit.*, 36).

9. Porcher, *op. cit.*, 41.

10. Dodwell, *op. cit.*, 110 ff.

SELECT BIBLIOGRAPHY

I. GENERAL

I. GENERAL

BECKWITH, John. *The Art of Constantinople.* London, 1961.

BRUYNE, E. DE. *Études d'esthétique médiévale.* Bruges, 1946.

DALTON, O. M. *Byzantine Art and Archaeology.* Oxford, 1911.

DODWELL, C. R. (ed.). *Theophilus De Diversibus Artibus.* London, 1961.

FICHTENAU, Heinrich. *The Carolingian Empire.* Oxford, 1957.

FOLZ, Robert. *L'Idée d'Empire en Occident du Ve au XIVe siècle.* Paris, 1953.

HINKS, Roger. *Carolingian Art.* London, 1935.

KENDRICK, T. D. *Late Saxon and Viking Art.* London, 1949.

LEHMANN-BROCKHAUS, Otto. *Die Kunst des X. Jahrhunderts im Lichte der Schriftquellen (Sammlung Heitz Akademische Abhandlungen zur Kulturgeschichte, III. Reihe, Band 6).* Strassburg, 1935.

LEHMANN-BROCKHAUS, Otto. *Schriftquellen zur Kunstgeschichte des 11. und 12. Jahrhunderts für Deutschland, Lothringen und Italien.* Berlin, 1938.

MOREY, C. R. *Early Christian Art.* Princeton, 1953.

MOREY, C. R. *Mediaeval Art.* New York, 1942.

ROSS, M. C. *Arts of the Migration Period in the Walters Art Gallery.* Baltimore, 1961.

SCHLOSSER, Julius von. *Sch.iftquellen zur Geschichte der karolingischen Kunst.* Vienna, 1892.

SCHRAMM, P. E. *Kaiser, Rom und Renovatio.* Leipzig and Berlin, 1929.

SCHWEINFURTH, Philip. *Die byzantinische Form.* Worms, 1954.

SWARZENSKI, H. *Monuments of Romanesque Art.* London, 1954.

TALBOT RICE, David. *Art of the Byzantine Era.* London, 1967.

ULLMANN, Walter. *The Growth of Papal Government in the Middle Ages.* London, 1955.

VOLBACH, W. F. *Early Christian Art.* London, 1961.

WATSON, A. *The Early Iconography of the Tree of Jesse.* Oxford, 1934.

2. INDIVIDUAL COUNTRIES

(a) Austria

BALDASS, Peter von, and others (eds.). *Romanische Kunst in Österreich.* Vienna, 1962.

(b) Belgium

COLLON-GEVAERT, Suzanne, and others. *Art roman dans la vallée de la Meuse aux XIe et XIIe siècles.* Brussels, 1963.

MASAI, F. *Art mosan et arts anciens du Pays de Liège.* Liège, 1951.

MOREAU, E. de. *Histoire de l'Église en Belgique.* Brussels, 1945.

(c) England

WORMALD, Francis. *English Drawings in the Tenth and Eleventh Centuries.* London, 1952.

(d) France

EVANS, Joan. *Cluniac Art of the Romanesque Period.* Cambridge, 1951.

HALLINGER, Kassius. *Gorze-Kluny: Studien zu den monastischen Lebensformen und Gegensätzen im Hochmittelalter.* Rome, 1950.

PANOFSKY, Erwin (ed.). *Abbot Suger on the Abbey Church of St-Denis.* Princeton, 1946.

(e) Germany

DECKERT, Hermann, FREYHAN, Robert, and STEINBART, Kurt. *Religiöse Kunst aus Hessen und Nassau.* Marburg an der Lahn, 1932.

SCHNITZLER, Hermann. *Rheinische Schatzkammer, Die Romanik.* Düsseldorf, 1959.

SCHRAMM, P. E., and MÜTHERICH, F. *Denkmale der deutschen Könige und Kaiser.* Munich, 1962.

TSCHAN, Francis J. *Saint Bernward of Hildesheim.* Indiana, 1951–2.

(f) Italy

BERTAUX, É. *L'Art dans l'Italie méridionale.* Paris, 1904.

BLOCH, Herbert. 'Monte Cassino, Byzantium, and the West in the Earlier Middle Ages', *Dum-*

barton Oaks Papers, no. 3 (Cambridge, Mass., 1946), 165–224.

DIEHL, Ch. *L'Art byzantin dans l'Italie méridionale.* Paris, 1894.

GAY, J. *L'Italie méridionale et l'empire byzantin.* Paris, 1904.

TOESCA, P. *Storia dell'arte italiana.* Turin, 1927.

(g) Jerusalem

BOASE, T. S. R. 'The Arts in the Latin Kingdom of Jerusalem', *Journal of the Warburg Institute,* II (1938–9).

(h) Scandinavia

BECKETT, F. *Danmarks Kunst.* Copenhagen, 1924.

ROOSVAL, J. *Swedish Art.* Princeton, 1932.

(i) Spain

CLARK, C. U. 'Collectanea Hispanica', *Transactions of the Connecticut Academy of Arts and Sciences,* XXIV (1920), 66 ff.

COOK, Walter W. S., and GUDIOL RICART, José. 'Pintura e imaginería románicas', *Ars Hispaniae,* VI (Madrid, 1950).

VIELLIARD, Jeanne (ed.). *Le Guide du pélerin à Saint-Jacques de Compostelle.* Mâcon, 1960.

II. EMBROIDERY

DODWELL, C. R. 'The Bayeux Tapestry and the French Secular Epic', *Burlington Magazine,* CVIII (1966), 549 ff.

SCHUETTE, M., and MÜLLER-CHRISTENSEN, S. *The Art of Embroidery.* London, 1964.

III. MOSAICS

ANTHONY, E. W. *A History of Mosaics.* Boston, 1935.

DEMUS, Otto. *Byzantine Mosaic Decoration.* London, 1947.

DEMUS, Otto. *The Mosaics of Norman Sicily.* London, 1950.

MATTHIAE, Guglielmo. *Mosaici medioevali delle chiese di Roma.* Rome, 1967.

MOREY, C. R. *Lost Mosaics and Frescoes of Rome of the Mediaeval Period.* Princeton, 1915.

WILPERT, J. *Die römischen Mosaiken und Malereien der kirchlichen Bauten vom IV. bis zum XIII. Jahrhundert.* 4 vols. Freiburg im Breisgau, 1916.

IV. PAINTING

A. GENERAL

Eraclius De Coloribus et Artibus Romanorum, in Mrs Merrifield, *Original Treatises . . . on the Arts of Painting,* I. London, 1849.

GRABAR, André. *Byzantine Painting.* New York, 1953.

GRABAR, André, and NORDENFALK, Carl. *Early Medieval Painting.* Lausanne, 1957.

GRABAR, André, and NORDENFALK, Carl. *Romanesque Painting.* Lausanne, 1958.

SCHRADE, H. *Die romanische Malerei.* Cologne, 1963.

INDIVIDUAL COUNTRIES

(a) Austria

SWARZENSKI, Georg. *Die Salzburger Malerei.* 2 vols. Leipzig, 1913.

(b) France

MERCIER, Fernand. *Les Primitifs français, La Peinture clunisienne.* Paris, 1932.

(c) Germany

DODWELL, C. R., and TURNER, D. H. *Reichenau Reconsidered, A Re-assessment of the Place of Reichenau in Ottonian Art (Warburg Institute Surveys,* II). London, 1965.

VÖGE, Wilhelm. 'Eine deutsche Malerschule um die Wende des ersten Jahrtausends', *Westdeutsche Zeitschrift für Geschichte und Kunst,* VII. Trier, 1891.

(d) Great Britain

RICKERT, Margaret. *Painting in Britain: The Middle Ages (Pelican History of Art).* 2nd ed. Harmondsworth, 1965.

(e) Italy

BOLOGNA, Ferdinando. *Early Italian Painting.* London, 1963.

GARRISON, E. B. *Studies in the History of Medieval Italian Painting.* 4 vols. Florence, 1953–62.

LADNER, G. 'Die italienische Malerei im 11. Jahrhundert', *Jahrbuch der kunsthistorischen Sammlungen in Wien* (1931), 33–160.

MATTHIAE, Guglielmo. *Pittura romana del medioevo.* 2 vols. Rome, 1965.

TOESCA, P. *La Pittura e la miniatura nella Lombardia.* Milan, 1912.

VAN MARLE, Raimond. *La Peinture romaine au moyen âge*. Strasbourg, 1921.

VAN MARLE, Raimond. *The Development of the Italian Schools of Painting*, I. The Hague, 1923.

WILPERT, J. *Die römischen Mosaiken und Malereien der kirchlichen Bauten vom IV. bis zum VIII. Jahrhundert*. 4 vols. Freiburg im Breisgau, 1916.

B. MANUSCRIPT

I. GENERAL

BOECKLER, Albert. *Abendländische Miniaturen*. Berlin and Leipzig, 1930.

BOINET, Amédée. *La Miniature carolingienne*. Paris, 1913.

BRIEGER, P. H. 'Bible Illustration and Gregorian Reform', *Studies in Church History*, II (1965), 154–64.

BYVANCK, A. A. *Les principaux manuscrits à peintures conservés dans les collections publiques du royaume des Pays Bas*. Paris, 1931.

CASPAR, C., and LYNA, F. *Les principaux manuscrits à peintures de la Bibliothèque Royale de Belgique*. Paris, 1937.

FISCHER, Hans. *Mittelalterliche Miniaturen aus der Staatlichen Bibliothek Bamberg*. Bamberg, 1926.

HOMBURGER, O. *Die illustrierten Handschriften der Bürgerbibliothek Bern*. Bern, 1962.

LAUER, Ph. *Les Enluminures romanes des manuscrits de la Bibliothèque Nationale*. Paris, 1927.

LEROQUAIS, Chanoine V. *Les Psautiers manuscrits latins des bibliothèques publiques de France*. 3 vols. Mâcon, 1840–1.

STERN, H. 'Le Calendrier de 354', *Institut français d'archéologie de Beyrouth, Bibliothèque archéologique et historique*, XV. Paris, 1953.

TURNER, D. H. *Romanesque Illustrated Manuscripts*. London, British Museum, 1966.

WEBBER JONES, Leslie, and MOREY, C. R. *The Miniatures of the Manuscripts of Terence*. Princeton, 1931.

ZIMMERMANN, E. Heinrich. *Vorkarolingische Miniaturen*. Berlin, 1916.

2. INDIVIDUAL COUNTRIES

(a) Austria

SWARZENSKI, Georg. *Die Salzburger Malerei von den ersten Anfängen bis zur Blütezeit des romanischen Stils*. 2 vols. Leipzig, 1908–13.

SWARZENSKI, H. *The Berthold Missal*. New York, 1943.

(b) Belgium

BOUTEMY, A. 'Un grand enlumineur du Xe siècle, l'abbé Odbert de Saint-Bertin', *Annales de la Fédération Archéologique et Historique de Belgique* (Antwerp, 1950), 247–54.

(c) England

DODWELL, C. R. *The Canterbury School of Illumination*. Cambridge, 1954.

DODWELL, C. R. *The Great Lambeth Bible*. London, 1959.

MYNORS, R. A. B. *Durham Cathedral Manuscripts*. Oxford, 1939.

PÄCHT, Otto, DODWELL, C. R., and WORMALD, Francis. *The St Albans Psalter*. London, 1960.

SWARZENSKI, H. 'Der Stil der Bibel Carilefs von Durham', in *Form und Inhalt. Festschrift für Otto Schmitt* (Stuttgart, 1951), 89–97.

(d) France

DE WALD, Ernest. *The Stuttgart Psalter*. Princeton, 1930.

DE WALD, Ernest. *The Utrecht Psalter*. Princeton, 1933.

DODWELL, C. R. 'Un Manuscrit enluminé de Jumièges au British Museum', *Jumièges, Congrès Scientifique du XIIIe Centenaire*, 737–41.

GRIERSON, Philip. 'La Bibliothèque de Saint-Vaast d'Arras', *Revue Bénédictine*, LII (1940), 120 ff.

KOEHLER, Wilhelm. *Die karolingischen Miniaturen*, I, *Die Schule von Tours*. 3 vols. Berlin, 1930–3.

Les Manuscrits à peintures en France du VIIe au XIIIe siècle (Exhibition catalogue of the Bibliothèque Nationale, Paris, 1954).

OURSEL, C. *La Miniature du XIIe siècle à l'abbaye de Cîteaux*. Dijon, 1926.

OURSEL, C. *Miniatures cisterciennes*. Dijon, 1960.

PORCHER, Jean. *French Miniatures from Illuminated Manuscripts*. London, 1959.

PORCHER, Jean. 'La Peinture provinciale', in *Karl der Grosse: Lebenswerk und Nachleben*, III (entitled *Karolingische Kunst* and edited by Wolfgang Braunfels and Hermann Schnitzler). Düsseldorf, 1966.

SCHAPIRO, Meyer. *The Parma Ildefonsus a Romanesque Illuminated Manuscript from Cluny and Related Works*. New York, 1964.

(e) Germany and Switzerland

BANGE, E. F. *Eine bayerische Malerschule des XI. und XII. Jahrhunderts*. Munich, 1923.

BEISSEL, Stephan. *Die Bilder der Handschrift des Kaisers Otto im Münster zu Aachen.* Aachen, 1886.

BEISSEL, Stephan. *Des hl. Bernward Evangelienbuch im Dome zu Hildesheim.* Hildesheim, 1891.

BLOCH, Peter. *Das Hornbacher Sakramentar und seine Stellung innerhalb der frühen Reichenauer Buchmalerei (Basler Studien zur Kunstgeschichte, xv).* 1956.

BLOCH, Peter, and SCHNITZLER, Hermann. *Die ottonische kölner Malerschule.* Düsseldorf, 1967.

BOECKLER, Albert. *Die Regensburg-Prüfeninger Buchmalerei des XII. und XIII. Jahrhunderts.* Munich, 1924.

BOECKLER, Albert. 'Die Reichenauer Buchmalerei', in K. Bayerle (ed.), *Die Kultur der Abtei Reichenau,* II (Munich, 1925), 956–98.

BOECKLER, Albert. *Das Goldene Evangelienbuch Heinrichs III.* Berlin, 1933.

BOECKLER, Albert. *Der Codex Wittekindeus.* Leipzig, 1938.

EHL, Heinrich. *Die ottonische kölner Buchmalerei.* Bonn and Leipzig, 1922.

GOLDSCHMIDT, Adolph. *Die deutsche Buchmalerei.* 2 vols. Florence and Munich, 1912 and 1928.

JANSEN, Franz. *Die Helmarshausener Buchmalerei zur Zeit Heinrichs des Löwen.* Hildesheim, 1933.

KOEHLER, Wilhelm. *Die karolingische Miniaturen,* II, *Die Hofschule Karls des Grossen.* 2 vols. Berlin, 1958.

KOEHLER, Wilhelm. *Die karolingischen Miniaturen,* III, *Die Gruppe des Wiener Krönungs-Evangeliars.* 2 vols. Berlin, 1960.

LANDSBERGER, Franz. *Der St Galler Folchart-Psalter.* St Gallen, 1912.

LEIDINGER, G. *Miniaturen aus Handschriften der Kgl. Hof- und Staatsbibliothek in München,* Heft I, *Das sogennante Evangelarium Ottos III.* Munich, 1912.

MENZEL, K., CORSSEN, P., JANITSCHEK, H., SCHNÜTGEN, A., HETTNER, F., and LAMPRECHT, K. *Die Trierer Ada-Handschrift.* Leipzig, 1889.

MERTON, Adolf. *Die Buchmalerei in St Gallen.* 2nd ed. Leipzig, 1923.

METZ, Peter. *The Golden Gospels of Echternach.* London, 1957.

NORDENFALK, Carl. 'Der Meister des Registrum Gregorii', *Münchner Jahrbuch der bildenden Kunst,* 3. Folge, I (1960), 61–77.

SAUERLAND, H. V., and HASELOFF, A. *Der Psalter Erzbischof Egberts von Trier.* Trier, 1901.

SCHIEL, Hubert. *Codex Egberti der Stadtbibliothek Trier.* Basel, 1960.

SCHIPPERGES, Elizabeth. *Der Hitda Codex.* Bonn, 1938.

SWARZENSKI, Georg. *Die Regensburger Buchmalerei des X. und XI. Jahrhunderts.* Leipzig, 1901.

WÖLFFLIN, Heinrich. *Die Bamberger Apokalypse.* Munich, 1918.

(f) Italy

AMELLI, P. A. *Miniature sacre e profane dell'anno 1023.* Montecassino, 1896.

ANCONA, P. d'. *La Miniatura fiorentina.* Florence, 1914.

AVERY, Myrtilla. *The Exultet Rolls of South Italy.* Princeton, 1936.

BERG, Kurt. *Studies in Tuscan Twelfth Century Illuminations.* Oslo, 1968.

BUCHTHAL, Hugo. 'A School of Miniature Painting in Norman Sicily', in Kurt Weitzmann (ed.), *Late Classical and Mediaeval Studies in Honor of Albert Mathias Friend Jr* (Princeton, 1955), 312–39.

BUCHTHAL, Hugo. 'The Beginnings of Manuscript Illumination in Norman Sicily', *Papers of the British School in Rome,* XXIV (1956), 78–85.

INGUANEZ, D. M., and AVERY, M. *Miniature cassinesi del secolo XI illustranti la vita di S. Benedetto.* Montecassino, 1934.

Mostra storica nazionale della miniatura. Catalogo (1954).

TOESCA, P. 'Miniature romane dei secoli XI e XII', *Rivista del R. Istituto d'Archeologia e Storia dell'Arte,* I (1929), 74 ff.

TOESCA, P. *La Pittura e la miniatura nella Lombardia.* Milan, 1912.

WIT, J. de. *Die Miniaturen des Vergilius Vaticanus.* Amsterdam, 1959.

(g) Jerusalem

BUCHTHAL, Hugo. *Miniature Painting in the Latin Kingdom of Jerusalem.* Oxford, 1957.

(h) Spain

DOMÍNGUEZ BORDONA, J. *Exposición de códices miniados españoles, Catálogo.* Madrid, 1929.

GEBHARDT, O. V. *The Miniatures of the Ashburnham Pentateuch.* London, 1883.

HUNTINGTON, Archer M. *Initials of Miniatures ... from the Mozarabic Manuscripts of Santo Domingo de Silos in the British Museum.* New York, 1904.

NEUSS, Wilhelm. *Die katalanische Bibelillustration um die Wende des ersten Jahrtausends und die altspanische Buchmalerei.* Bonn and Leipzig, 1922.

NEUSS, Wilhelm. *Die Apokalypse des Hl. Johannes in der altspanischen und altchristlichen Bibelillustration.* 2 vols. Münster, 1931.

C. PANEL

COOK, Walter W. S. 'The Earliest Painted Panels of Catalonia' – a series of articles in *Art Bulletin*, V (1922–3), 85 ff., VI (1923–4), 31 ff., VIII (1925–6), 57 ff., X (1927–8), 153 ff. and 305 ff.

COOK, Walter W. S. 'Early Spanish Paintings in the Plandiura Collection', *Art Bulletin*, XI, 2 (1929), 1–32.

GARRISON, E. B. *Italian Romanesque Panel Painting.* Florence, 1949.

D. WALL

I. GENERAL

ANTHONY, E. W. *Romanesque Frescoes.* Princeton, 1951.

2. INDIVIDUAL COUNTRIES

(a) France

DESCHAMPS, Paul. 'Les Peintures de l'église de Saint-Savin', *Congrès Archéologique de Poitiers en 1951.*

DESCHAMPS, Paul, and THIBOUT, Marc. *La Peinture murale en France. Le haut moyen âge et l'époque romane.* Paris, 1951.

DUPRAT, Clémence-Paul. 'Enquête sur la peinture murale en France à l'époque romane', *Bulletin Monumental*, CI (1942), 165–223.

FOCILLON, Henri. *Peintures romanes des églises de France.* Paris, 1938.

GAILLARD, G. *Les Fresques de Saint-Savin.* Paris, 1944.

MAILLARD, Élisa. *L'Église de S. Savin sur Gartempe.* Paris, 1926.

MICHEL, P. H. *Les Fresques de Tavant.* Paris, 1944.

MICHEL, P. H. *Romanesque Wall Paintings in France.* London, 1950.

(b) Germany

CLEMEN, P. *Die romanische Monumentalmalerei in den Rheinlanden.* Düsseldorf, 1916.

SAUER, J. 'Die Monumentalmalerei der Reichenau', in K. Bayerle (ed.), *Die Kultur der Abtei Reichenau*, II. Munich, 1925.

SCHMITT, Anton. *Die Fuldaer Wandmalerei des frühen Mittelalters.* Fulda, 1949.

(c) Italy

BOGNETTI, G. P., CHIERICI, G., CAPITANI D'ARZAGO, A. de. *S. Maria di Castelseprio.* Milan, 1948.

MATTHIAE, Guglielmo. *Pittura romana del medioevo.* 2 vols. Rome, 1965.

MOREY, C. R. *Lost Mosaics and Frescoes of Rome of the Mediaeval Period.* Princeton, 1915.

WEITZMANN, K. *The Fresco Cycle of S. Maria di Castelseprio.* Princeton, 1951.

WETTSTEIN, Janine. *Sant'Angelo in Formis et la peinture médiévale en Campanie.* Geneva, 1960.

WILPERT, J. *Die römischen Mosaiken und Malereien der kirchlichen Bauten vom IV. bis zum XIII. Jahrhundert.* 4 vols. Freiburg im Breisgau, 1916.

(d) Scandinavia

NØRLUND, P., and LIND, E. *Danmarks romanske Kalkmalerier.* Copenhagen, 1944.

(e) Spain

KUHN, Charles L. *Romanesque Mural Painting of Catalonia.* Cambridge, Mass., 1930.

SCHLUNK, Helmut, and BERENGUER, Magín. *La Pintura mural asturiana de los siglos IX y X.* Madrid, 1957.

V. STAINED GLASS

AUBERT, Marcel. *Le Vitrail en France.* Paris, 1946.

DELAPORTE, l'Abbé Y., and HOUVET, É. *Les Vitraux de la cathédrale de Chartres.* 2 vols. Chartres, 1926.

WENTZEL, Hans. *Meisterwerke der Glasmalerei.* Berlin, 1951.

ZSCHOKKE, F. *Die romanischen Glasgemälde des Strassburger Münsters.* Basel, 1942.

THE PLATES

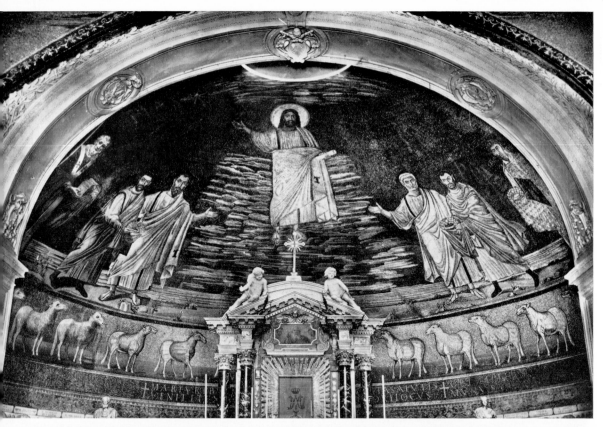

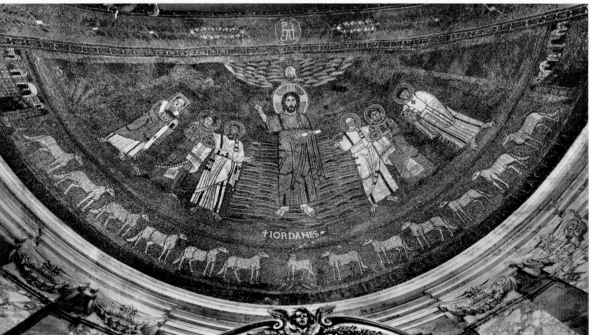

1. Rome, SS. Cosma e Damiano, mosaic of apse. Early sixth century

2. Rome, Santa Prassede, mosaic of apse. 827/44

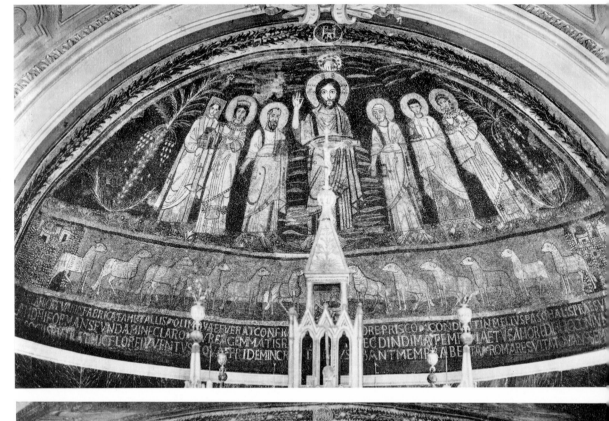

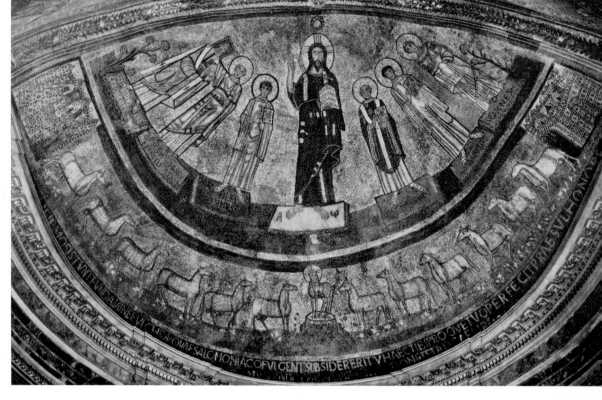

3. Rome, Santa Cecilia in Trastevere, mosaic of apse. 817/24

4. Rome, San Marco, mosaic of apse. 827/44

5. Rome, Santa Prassede, chapel of San Zeno, mosaic of vault. 817/24

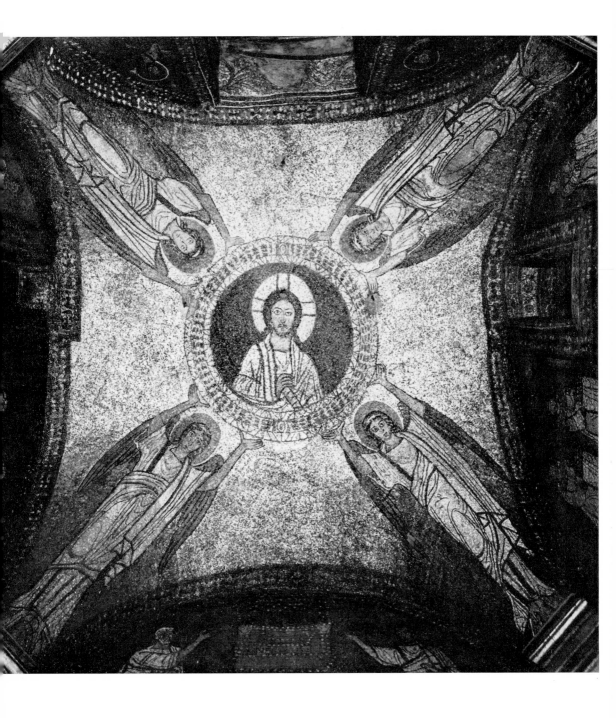

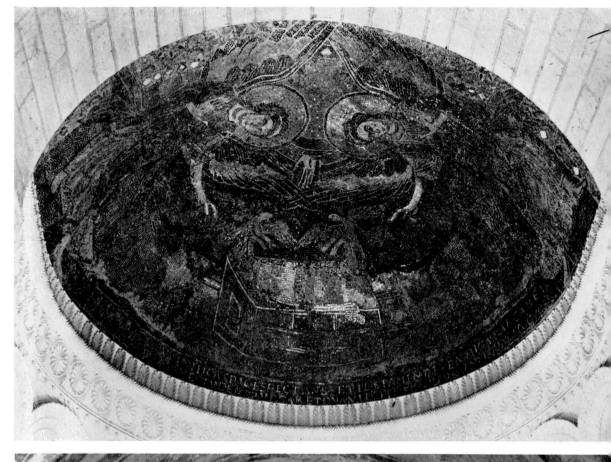

6. Germigny-des-Prés,
Ark and Cherubim.
Mosaic. 799/818

7. Auxerre, Saint-
Germain, west crypt,
St Stephen preaching
to the Jews. Wall-
painting. Ninth
century, second half

8. Mals (Malles), San
Benedetto, secular
portrait. Wall-painting.
Mid ninth century (?)

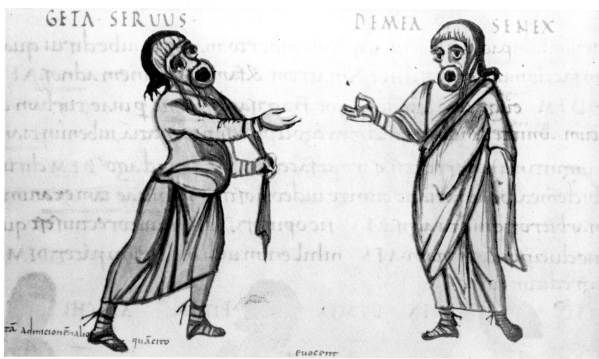

9. Procession of martyrs, from St Maximin. Wall-painting. Ninth century, second half (?). *Trier, Landesmuseum*

10. Actors wearing classical masks, from a copy of a late classical *Terence*. Carolingian. *Rome, Biblioteca Apostolica Vaticana*

11. Illustration from a later copy of a Carolingian illustrated calendar. *Brussels, Bibliothèque Royale*

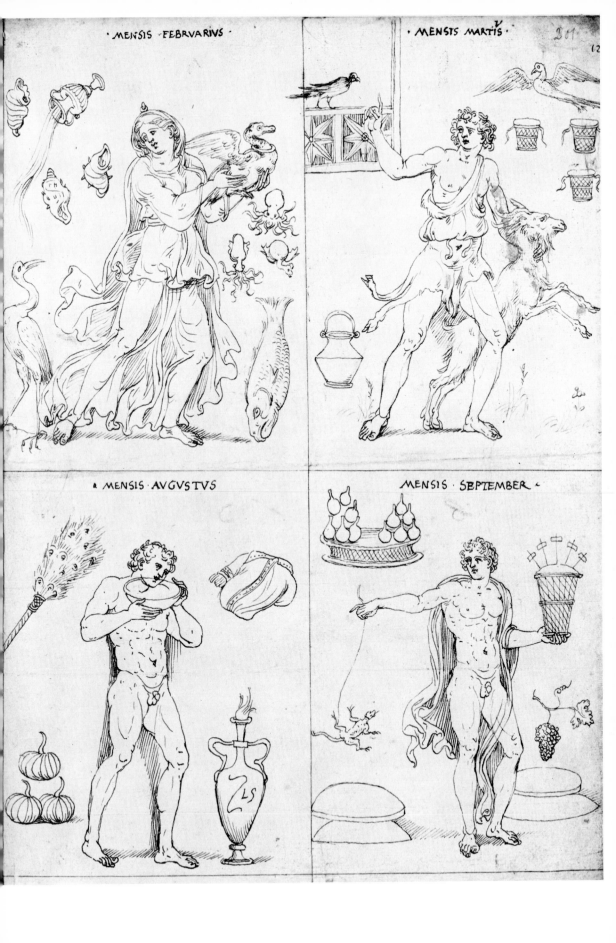

· MENSIS · FEBRVARIVS ·

· MENSIS · MARTIS ·

· MENSIS · AVGVSTVS

MENSIS · SEPTEMBER ·

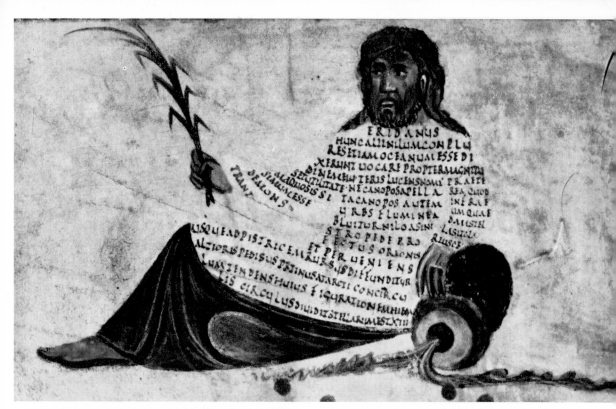

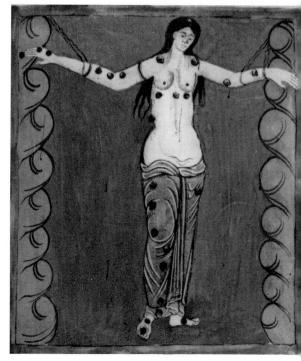

12. Eridanus, from a copy of Cicero's *Aratea*. Carolingian. *London, British Museum*

13. Andromeda, from a copy of Cicero's *Aratea*. Carolingian. *Leiden, University Library*

14. Odbert of Saint-Bertin: Andromeda, from a copy of Cicero's *Aratea*. 990/1012. *Boulogne-sur-Mer, Bibliothèque Municipale*

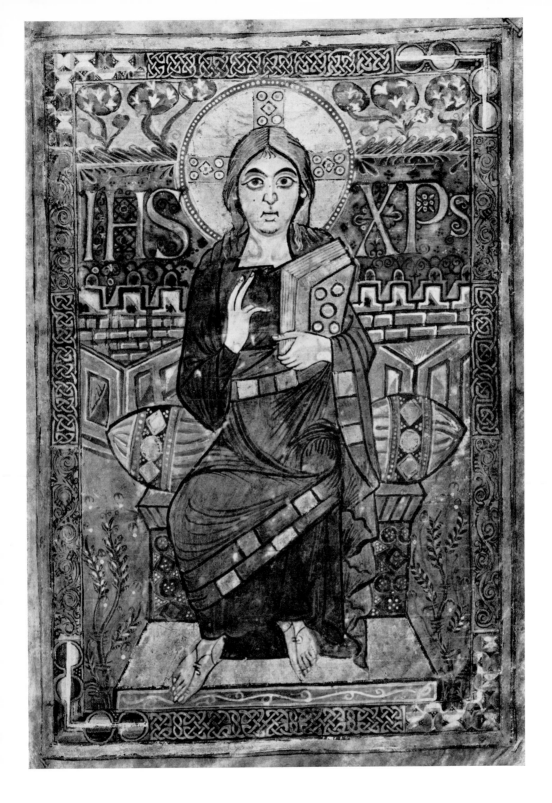

15. Charlemagne's Court 'Ada' School: Christ, from the Godescalc Gospel Lectionary. Completed in 783. *Paris, Bibliothèque Nationale*

INCIPIT
EVANGELIVM
SECVNDVM
MATTHEVM

LIBER

GENERATI

ONIS IHV XPI FILI

dauid filii Abraham
Abraham genuit Isaac

16. Charlemagne's Court 'Ada' School: Frontispiece, from a Gospel Book from Saint-Martin-des-Champs. Late eighth century. *Paris, Bibliothèque de l'Arsenal*

17. Charlemagne's Court 'Ada' School: Evangelist, from the Ada Gospels. Late eighth century. *Trier, Stadtbibliothek*

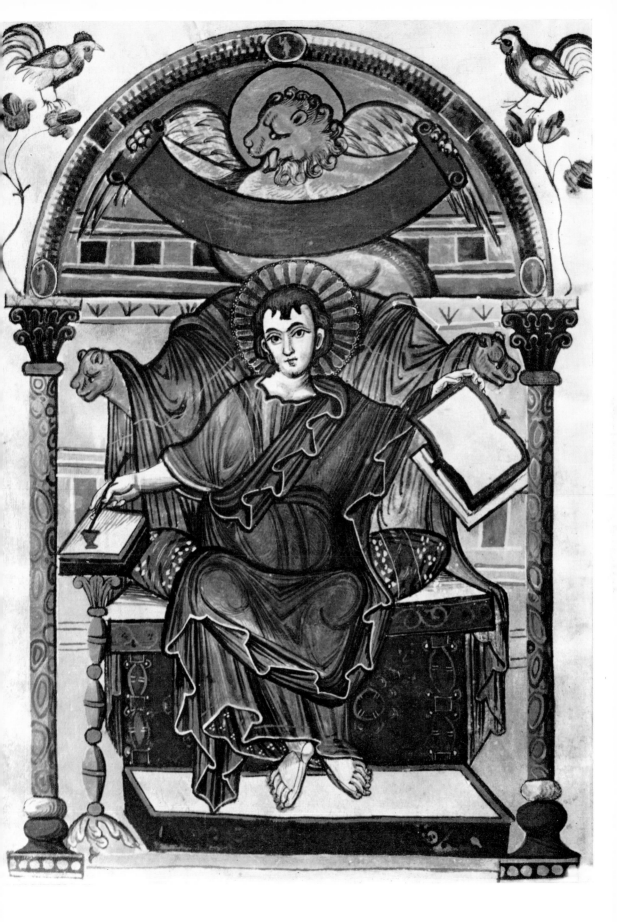

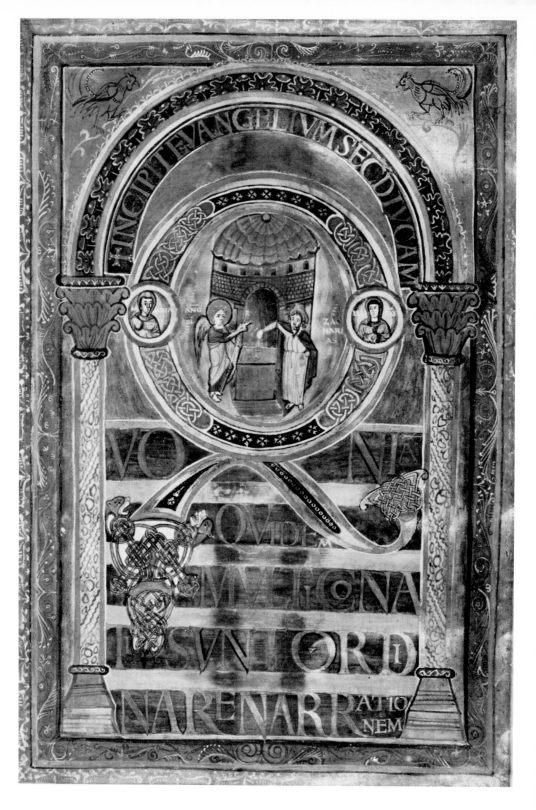

18. Charlemagne's Court 'Ada' School: Initial with the Annunciation to Zacharias, from the Harley Gospels. *c.* 790–800. *London, British Museum*

19. Charlemagne's Court 'Ada' School: Evangelist, from the Harley Gospels. *c.* 790–800. *London, British Museum*

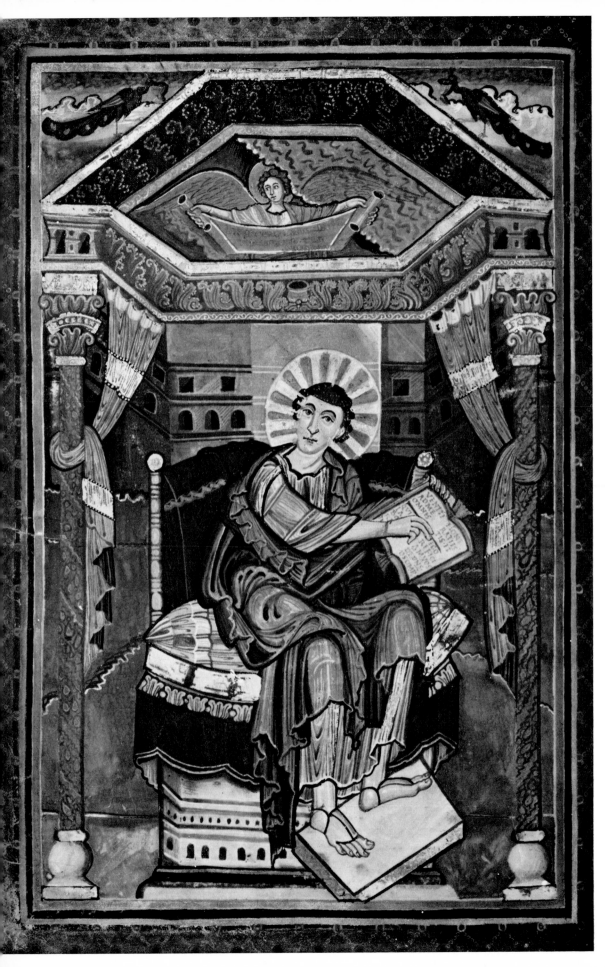

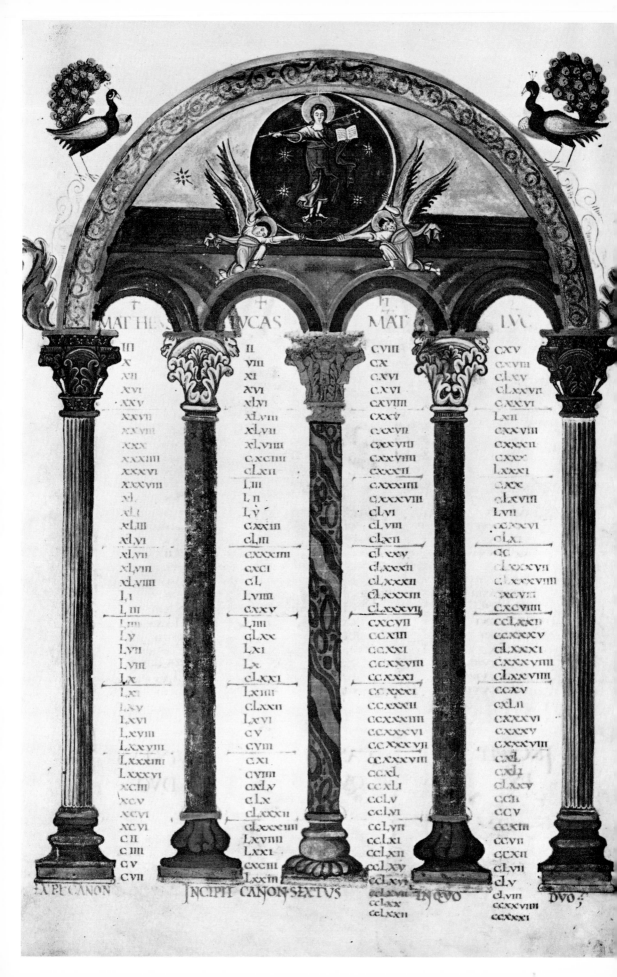

MAT HEVS	LVCAS	MAT	LVC
III	II	C VIII	C XV
X	VIII	C X	C XVIII
XII	XI	C XVI	CL XV
XXV	XVI	C XVI	CL XXVII
XXVII	XLVI	C XVIII	C XXVI
XXVIII	XLVIII	C XXV	L XII
XXX	XLVII	C CXVII	C XXXVIII
XXXIIII	XLVIII	C XXVIII	C XXXII
XXXXVI	C XCIIII	C XXVIIII	C XXX
XXXXVIII	CL XII	C XXXXII	L XXXI
XL	LIII	C XXXIIII	C XX
XLI	L II	C XXXXVIII	CL XVIII
XLIII	L V	CL VI	L VII
XLVI	C XXIII	CL VIII	C CXXXVI
XLVII	CL III	CL XII	CL X
XLVIII	C XXXIIII	CL XXV	CC
XLVIII	C XCI	CL XXXII	CL XXVII
I I	CL	CL XXXII	CL XXXVIII
I III	LVIII	CL XXXII	XXVIII
I III	C XXV	CL XXXVII	C XXVIII
LV	LIIII	C XCVII	CC LXXII
LVII	CL XX	CC XIII	CC XXXXV
LVIII	L XI	CC XXI	CL XXXI
LX	LX	CC XXVIII	C XXXVIII
LXI	CL XXI	CC XXXI	CL XXVIII
LXV	LXIIII	CC XXXXI	CC XV
LXVI	CL XXII	CC XXXII	C XLII
LXVIII	LXVI	CC XXXIIII	C XXXXV
LXXVIII	CV	CC XXV	C XXXVIII
LXXXIIII	CVIII	CC XXXVII	CXL
LXXXVI	C XI	CC XXXVIII	CXLI
XCIII	CVIII	CC XL	CL XXV
XCV	C XLV	CC LV	CCII
XCVI	CL X	CC LVI	CCV
XCVI	CL XXXI	CC LVII	CC XIII
C II	CL XXXXIII	CC LXI	CC VII
C IIII	L XVIIII	CC LXII	CC XII
C V	LXXI	CC LXV	CL VII
CVII	C XCIII	CC LXVI	CL V
	LXXIII	CC LXVII	CL VIII
		CC LXX	CC XXXVIII
		CC LXXII	CC XXXI

20. Charlemagne's Court 'Ada' School: Canon table, from the Soissons Gospels. Late eighth century. *Paris, Bibliothèque Nationale*

21. Charlemagne's Court 'Ada' School: The Twenty-four Elders and the Lamb, from the Soissons Gospels. Late eighth century. *Paris, Bibliothèque Nationale*

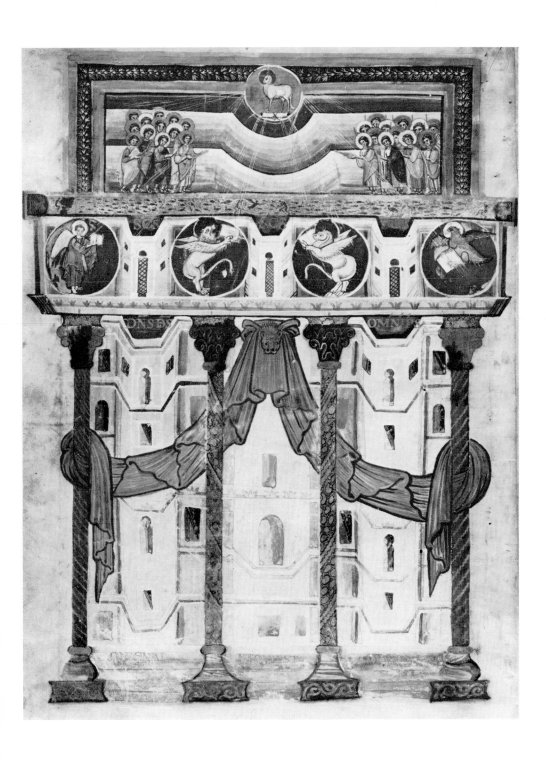

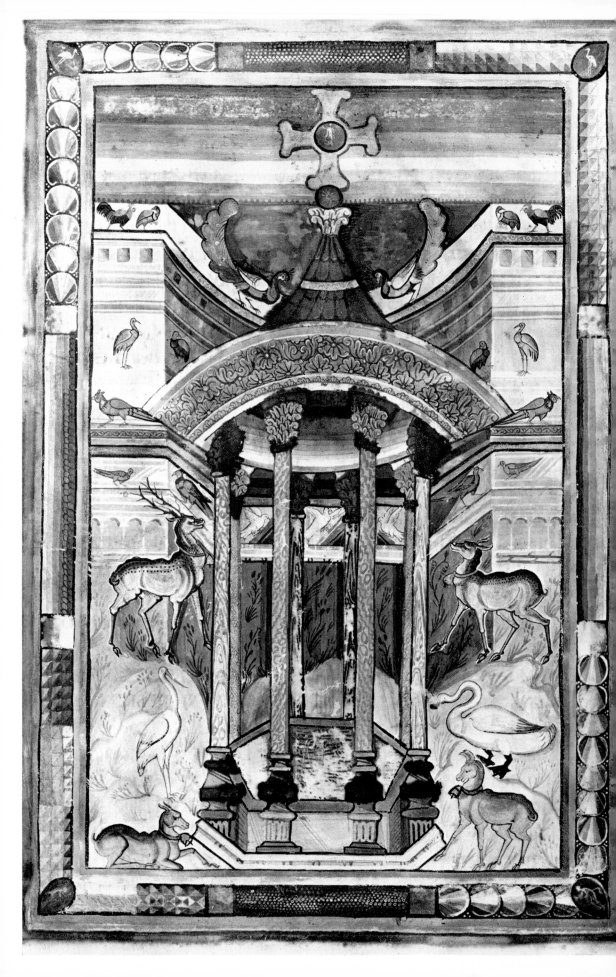

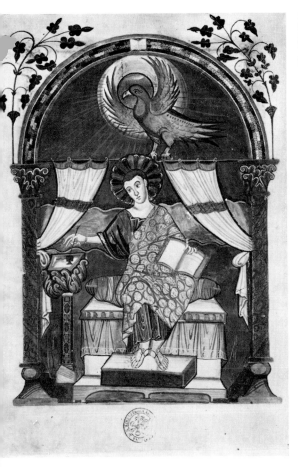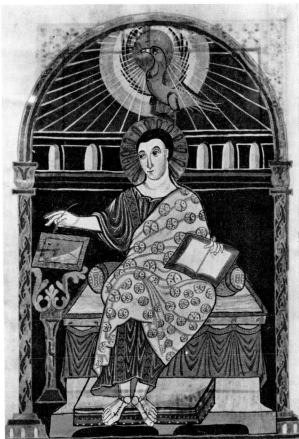

22. Charlemagne's Court 'Ada' School: Fountain of Life, from the Soissons Gospels. Late eighth century. *Paris, Bibliothèque Nationale*

23. Charlemagne's Court 'Ada' School: St John, from the Lorsch Gospels. Late eighth century. *Rome, Biblioteca Apostolica Vaticana*

24. Lorsch School: St John, from the Gero Codex. 950/70. *Darmstadt, Hessische Landesbibliothek*

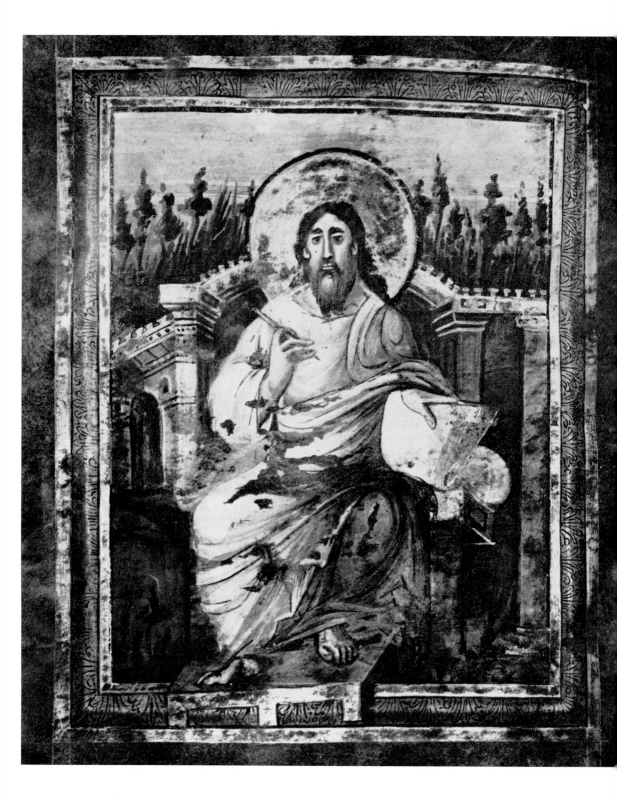

25. Charlemagne's Court 'Palace' School: Evangelist, from the Coronation Gospels. 795/810.
Vienna, Weltliche Schatzkammer der Hofburg

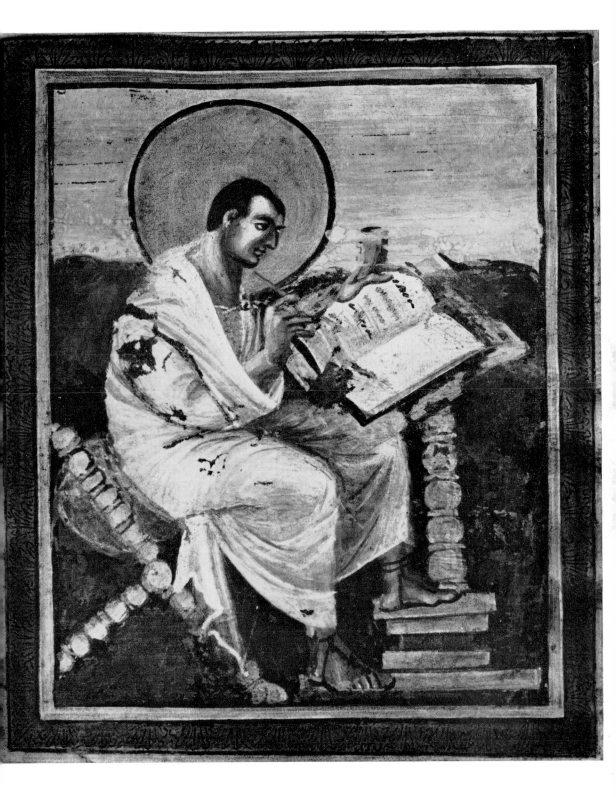

26. Charlemagne's Court 'Palace' School: Evangelist, from the Coronation Gospels. 795/810.
Vienna, Weltliche Schatzkammer der Hofburg

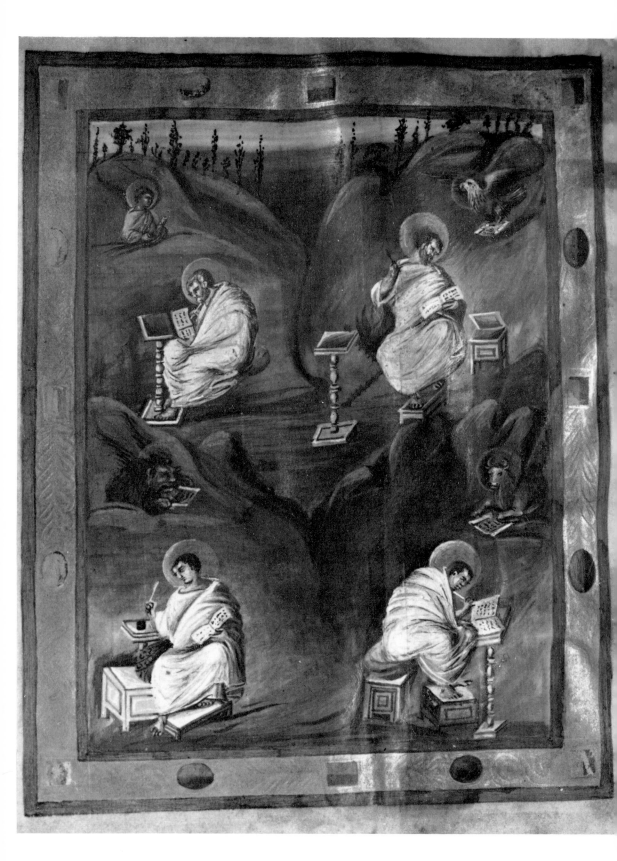

27. Charlemagne's Court 'Palace' School: The Evangelists, from the Aachen Gospels. 795/810. *Aachen Cathedral Treasury*

28. Charlemagne's Court 'Palace' School: Evangelist, bound into a Gospel Book. 795/810. *Brussels, Bibliothèque Royale*

CIABITUERITATEMTUAM
UDIUITDNSETMISERTUS
ESTMEI·DNSFACTUSEST
ADIUTORMEUS;

HI·CONSCIDISTISACCU
MEUMETCIRCUMDEDIS·
TIMELAETITIA·

GAR·DNEDSMEUS
INAETERNUMCONFITEI
BORTIBI·

XXX· INFINEM PSALMUSDAUID·

NTEONESPERAUI ETPROPTERNOMENTUU EGOAUTEMINDNOSPERA
NONCONFUNDARIN DEDUCESMEETENUTRI UI·EXULTABOETLAETABOR

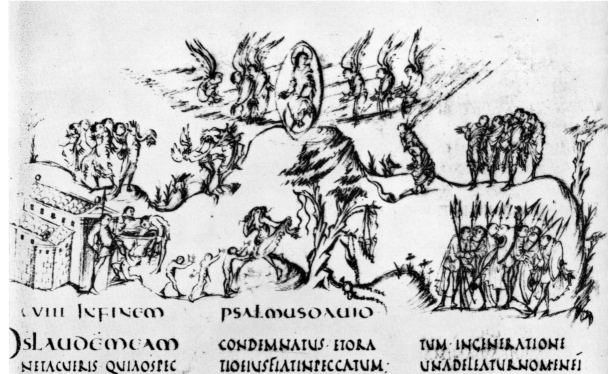

CVIII INFINEM PSALMUSDAUID·

DSLAUDEMEAM CONDEMNATUS ETORA TUM INCINERATIONE
NETACUIRIS QUIAOSPEC TIOEIUSFIATINPECCATUM· UNADELEATURNOMENEI
CATORISETOSDOLOSISU FIANTDIESEIUSPAUCI ETE INMEMORIAMBREDEATINI

29. Reims School: Illustration from the Utrecht Psalter. 816/23. *Utrecht, University Library*

30. Reims School: Illustration from the Utrecht Psalter. 816/23. *Utrecht, University Library*

31. Reims School: Evangelist, from a Gospel Book. 816/23. *Épernay, Bibliothèque Municipale*

32. Reims School: Evangelist, from a Gospel Book. 816/23. *Épernay, Bibliothèque Municipale*

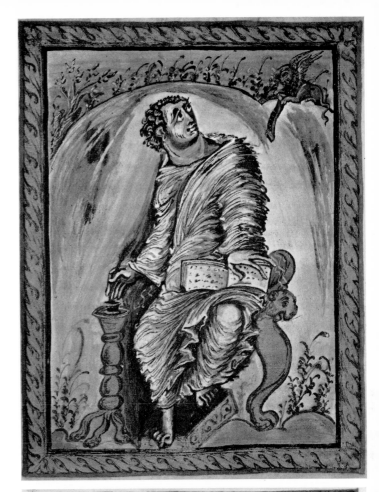

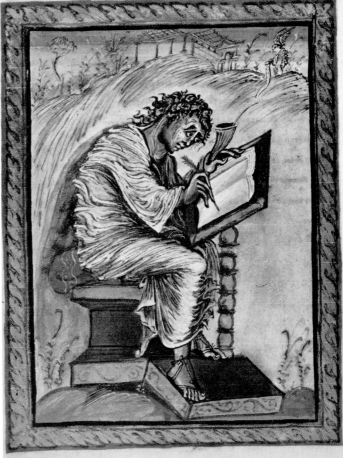

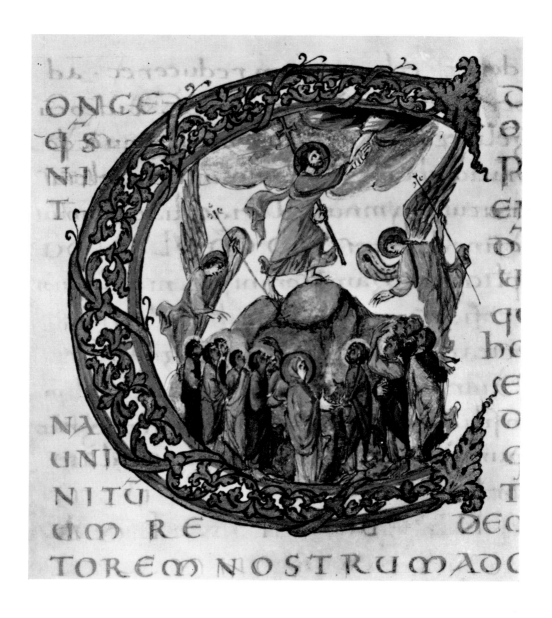

33. Metz School: Historiated initial, from the Drogo Sacramentary. 826/55. *Paris, Bibliothèque Nationale*

34. Tours School: Majesty with the Symbols of the Evangelists, from the Stuttgart Gospels. 804/34. *Stuttgart, Württembergische Landesbibliothek*

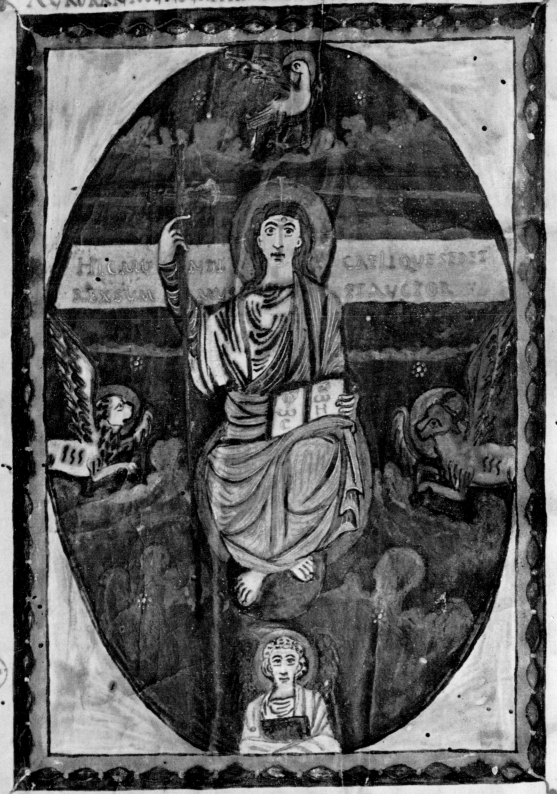

HIC MV | NTI | CAELI QVE SEDET
REXSVM | | ET AVCTOR

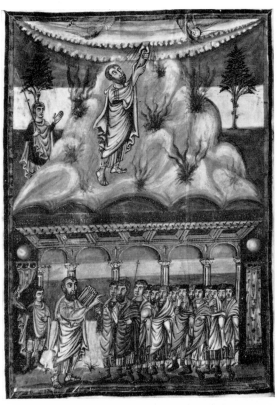

35. Tours School: Moses receiving and dispensing the Law, from the Grandval Bible. Soon after 834(?). *London, British Museum*

36. Tours School: Majesty and Evangelists, from the Grandval Bible. Soon after 834(?). *London, British Museum*

37. Tours School: David, from the Vivian Bible. Completed in 845/6. *Paris, Bibliothèque Nationale*

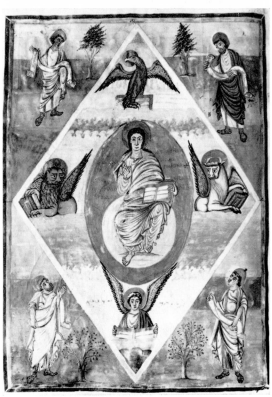

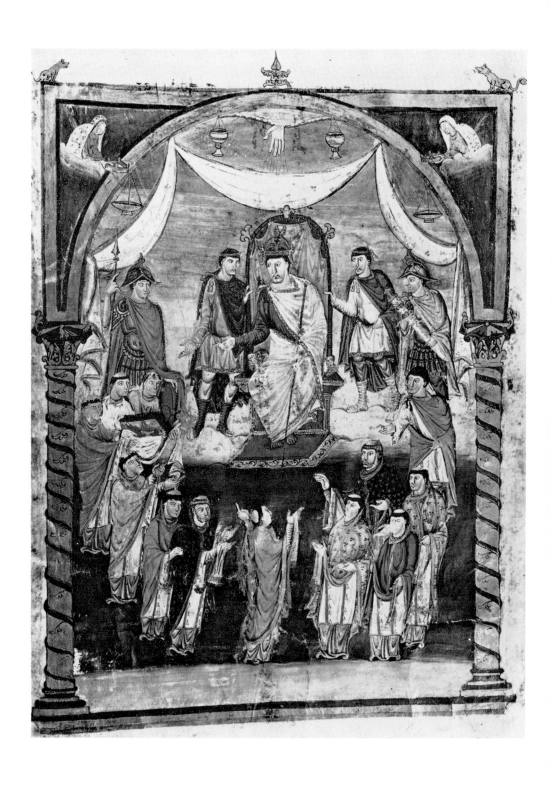

38. Tours School: Presentation of the Bible to Charles the Bald, from the Vivian Bible. Completed in 845/6. *Paris, Bibliothèque Nationale*

39. Tours School: Majesty, from a Gospels. 844/51. *Berlin, Staatsbibliothek*

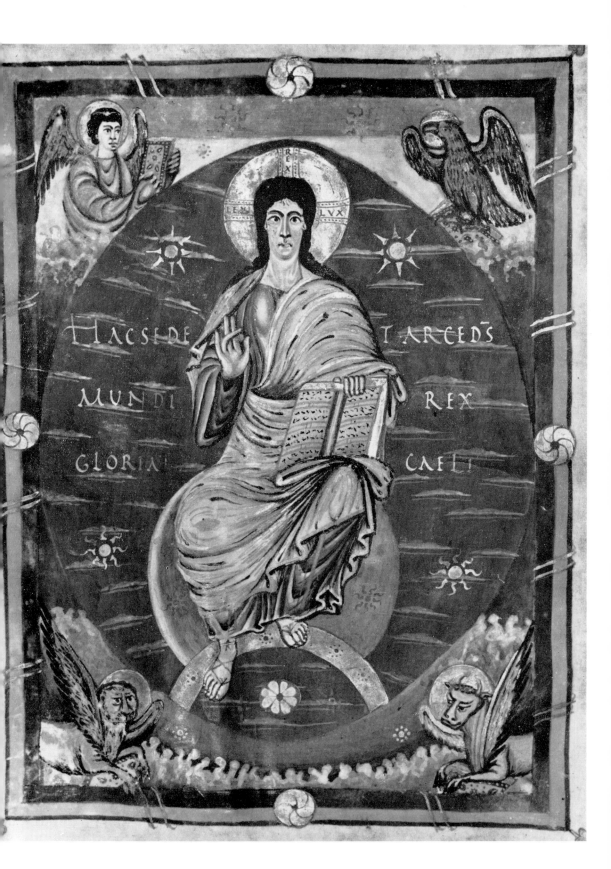

40. Tours School: Majesty, from the Dufay
Gospels. Mid ninth century. *Paris,
Bibliothèque Nationale*

41. Tours School: Emperor Lothar, from
the Lothar Gospels. 849–51. *Paris,
Bibliothèque Nationale*

42. Tours School: Christ, from the Lothar
Gospels. 849–51. *Paris, Bibliothèque
Nationale*

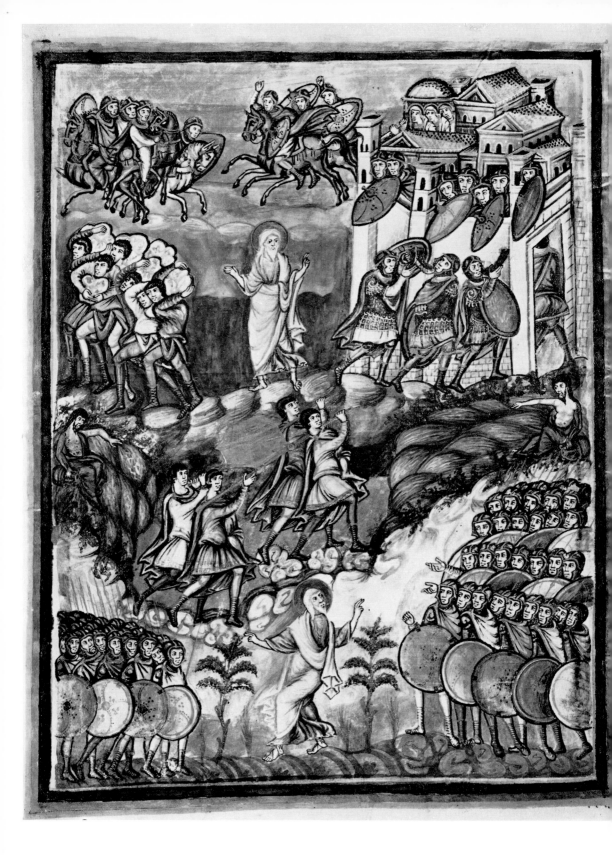

43. Court School of Charles the Bald: The Israelites cross the Jordan and storm Jericho, from the Bible of Charles the Bald. 869/70(?). *Rome, San Paolo fuori le Mura*

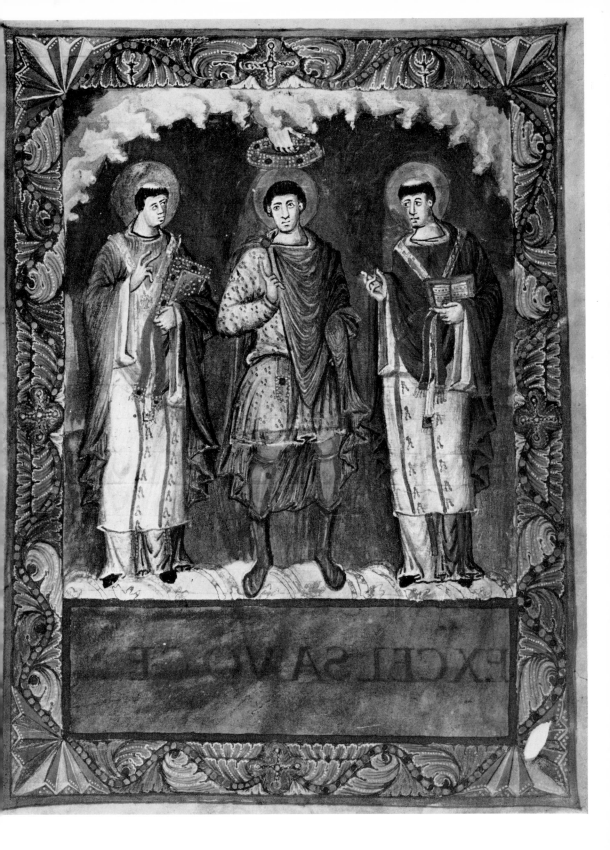

44. Court School of Charles the Bald: Coronation of a Frankish Prince, from the Coronation Sacramentary of Charles the Bald. 869/70(?). *Paris, Bibliothèque Nationale*

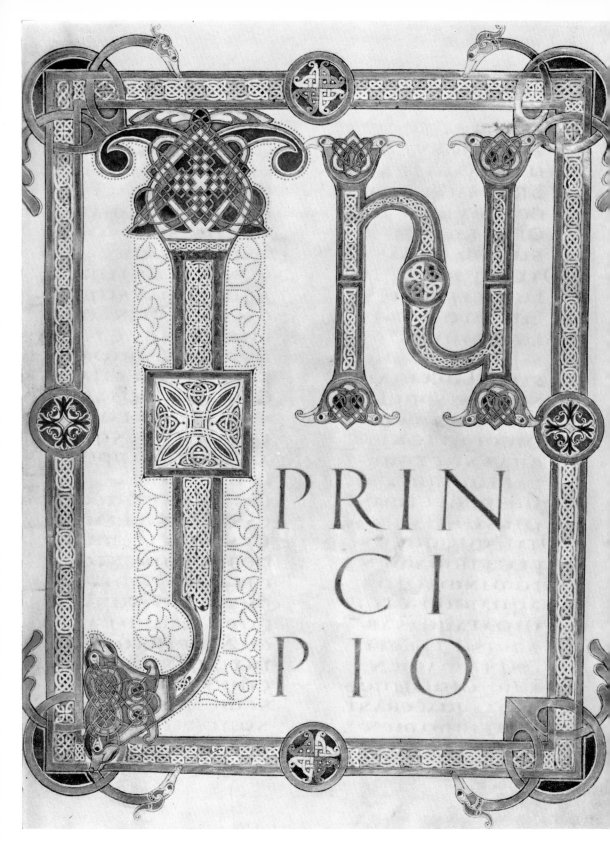

45. Saint-Amand(?): Initial, from the second Bible of Charles the Bald. 871/7. *Paris, Bibliothèque Nationale*

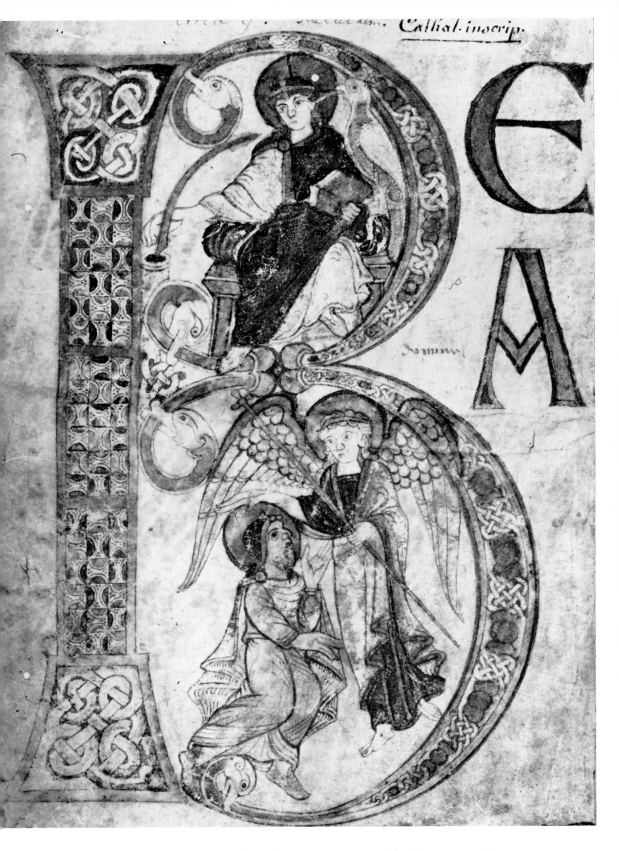

46. North French: Initial, from the Corbie Psalter. *c. 800. Amiens, Bibliothèque Municipale*

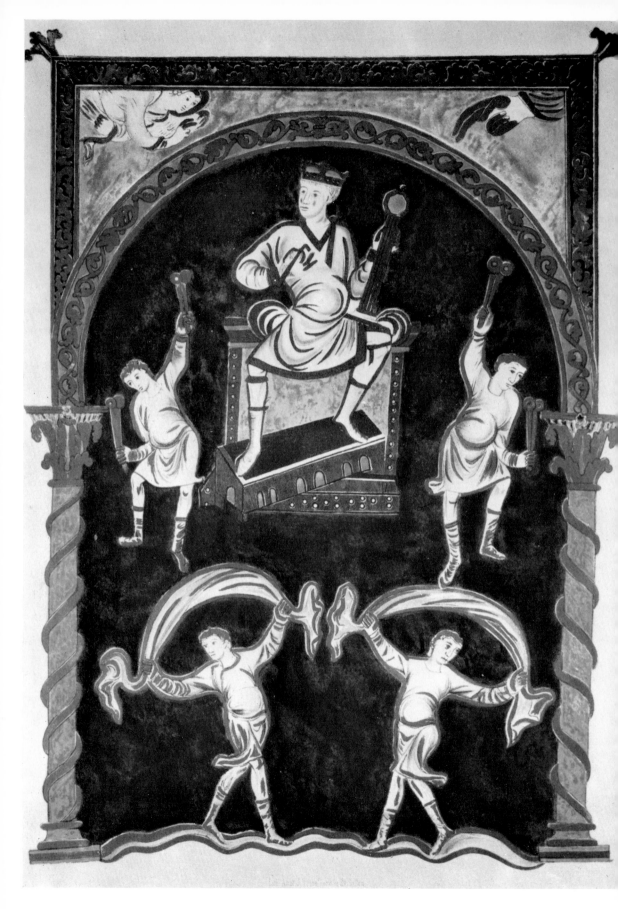

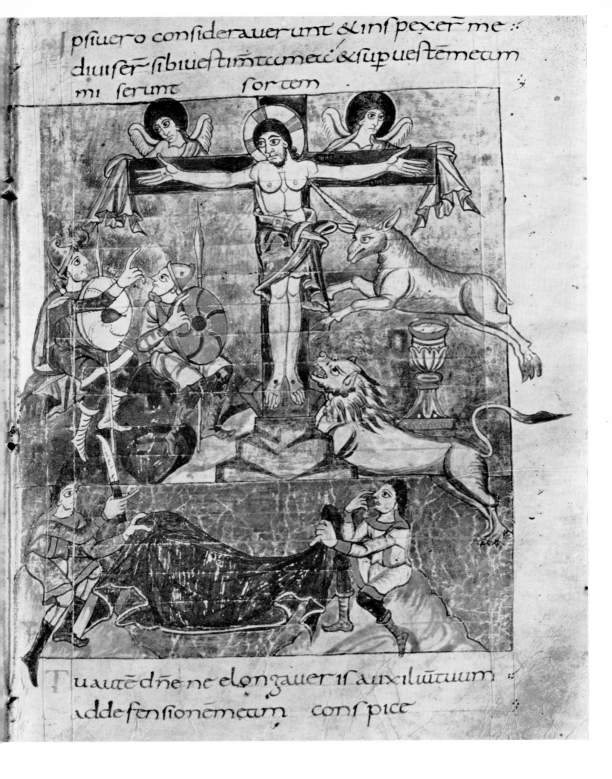

47. St Gallen: Scene from the life of David, from the Golden Psalter. 890/920. *St Gallen*

48. North French: Crucifixion, from the Stuttgart Psalter. *c.* 820–30. *Stuttgart, Württembergische Landesbibliothek*

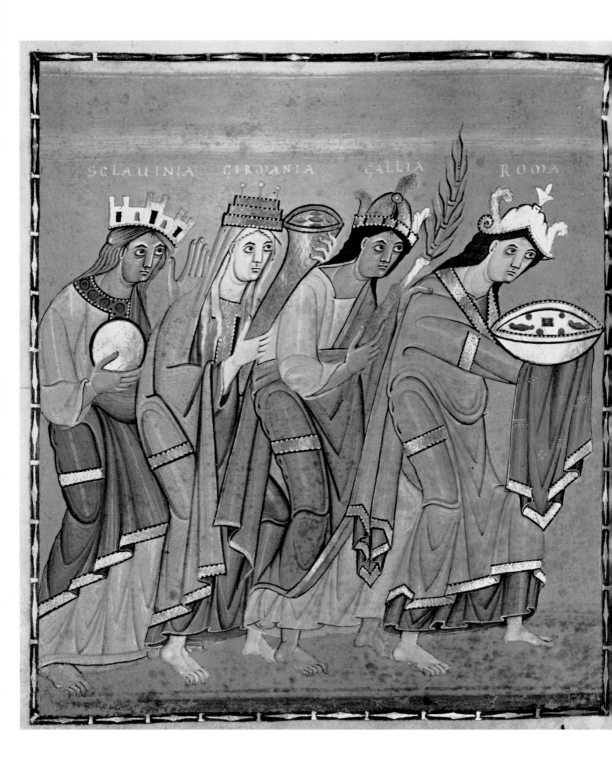

49 and 50. Liuthar School: Otto III receiving the Tributes of the Provinces, from the Gospels of Otto III. 983/1002. *Munich, Bayerische Staatsbibliothek*

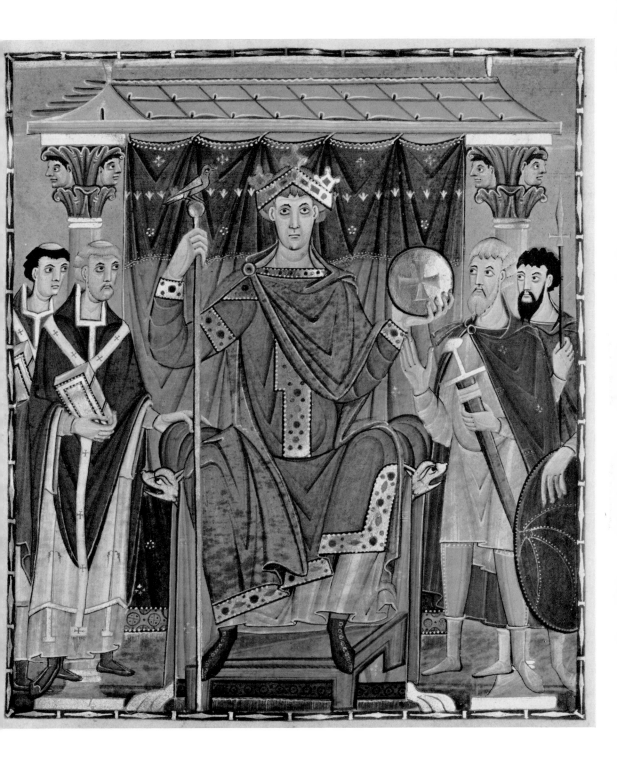

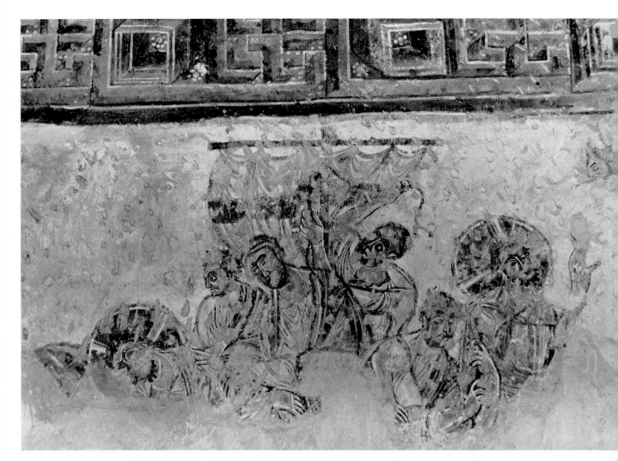

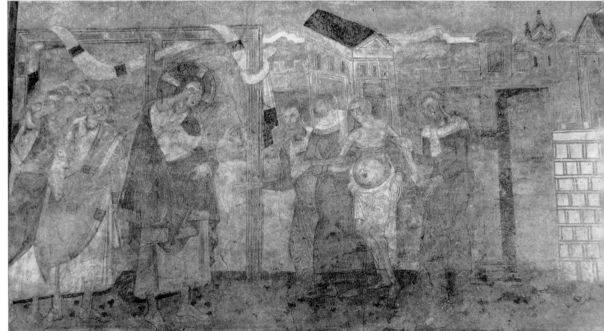

OBVLVS·OCCVRRENS·SANATVR·YDROPICVS·VNVS·HVC·ONERATVS·ADIIT·HINC·SINE

51. Reichenau, Goldbach, Chapel of St Sylvester, Stilling of the Storm. Wall-painting. Late tenth or early eleventh century

52. Reichenau, Oberzell, St Georg, Healing of the Man with Dropsy. Wall-painting. Late tenth or early eleventh century

53. Reichenau, Goldbach, Chapel of St Sylvester, Apostle. Wall-painting. Late tenth or early eleventh century

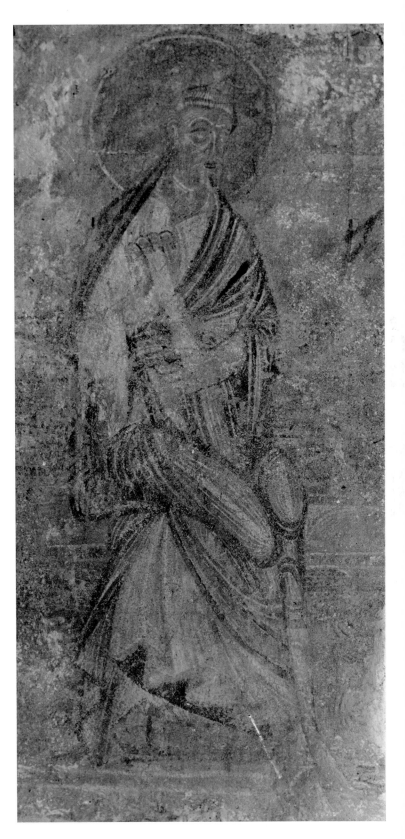

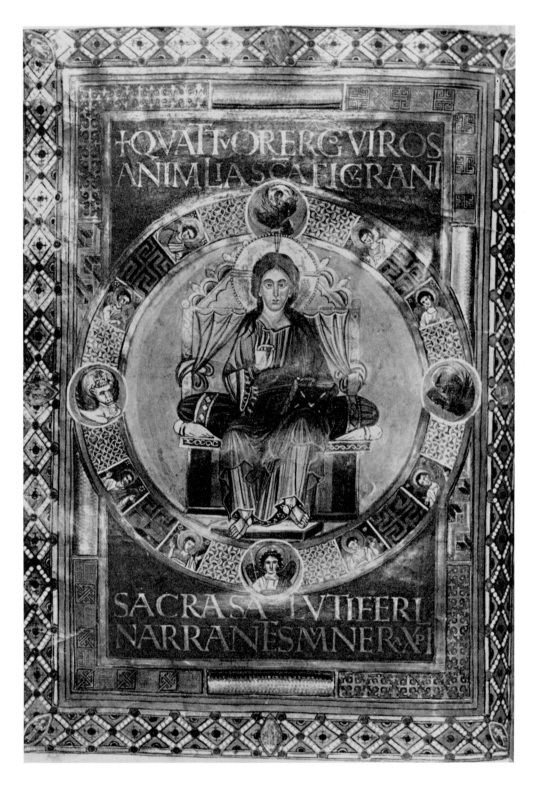

54. Charlemagne's Court 'Ada' School: Majesty, from the Lorsch Gospels. Late eighth century. *Alba Julia, Biblioteca Documentara Batthayneum*

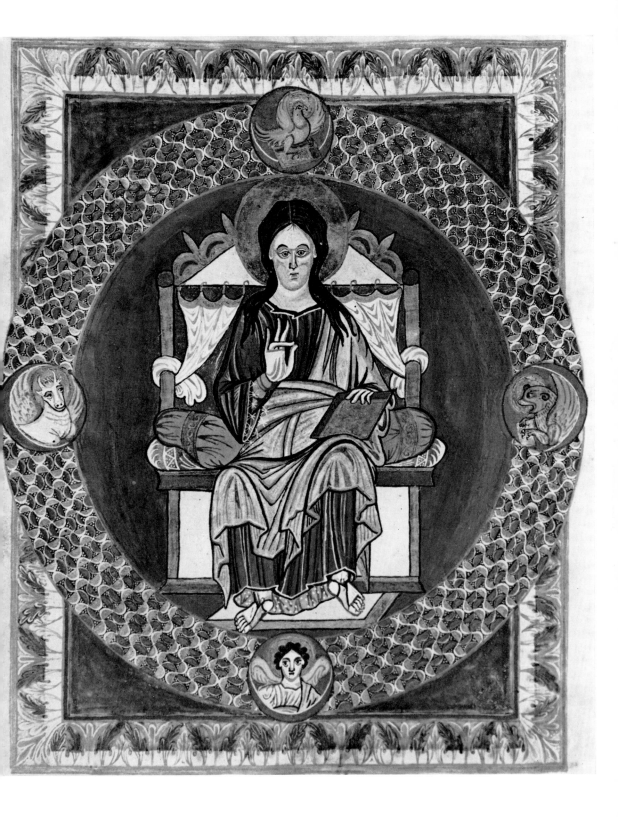

55. Lorsch School(?): Majesty, from the Gero Codex. 950/70. *Darmstadt, Hessische Landesbibliothek*

56. Lorsch School(?): Majesty, from the Petershausen Sacramentary. *c.* 950–70. *Heidelberg, Universitätsbibliothek*

57. Trier School: David, from the Egbert Psalter. 977/93. *Cividale, Museo Archeologico*

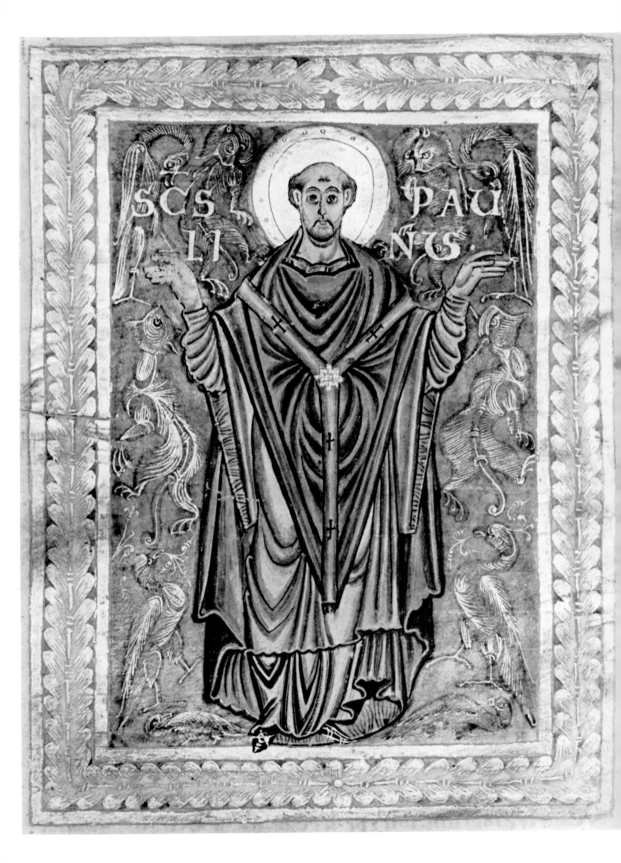

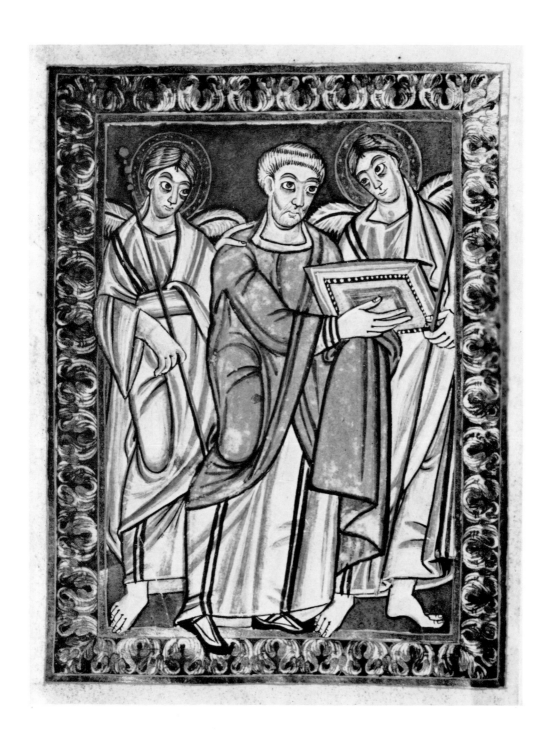

58. Trier School: St Paulinus, from the Egbert Psalter. 977/93. *Cividale, Museo Archeologico*

59. Donor portrait (Gerard, bishop of Toul?), from the Poussay Gospel Lectionary. 963/94(?).
Paris, Bibliothèque Nationale

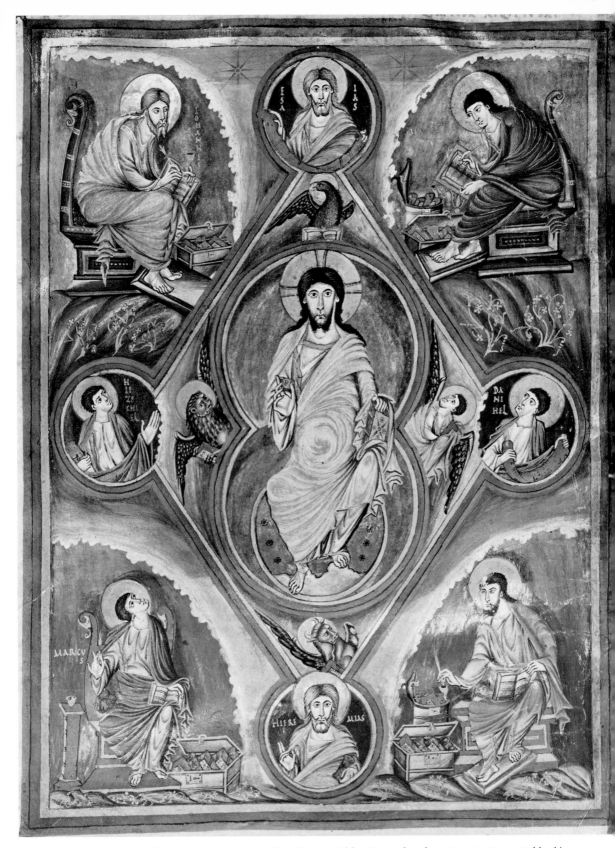

60. Tours School: Majesty, from the Vivian Bible. Completed in 845/6. *Paris, Bibliothèque Nationale*

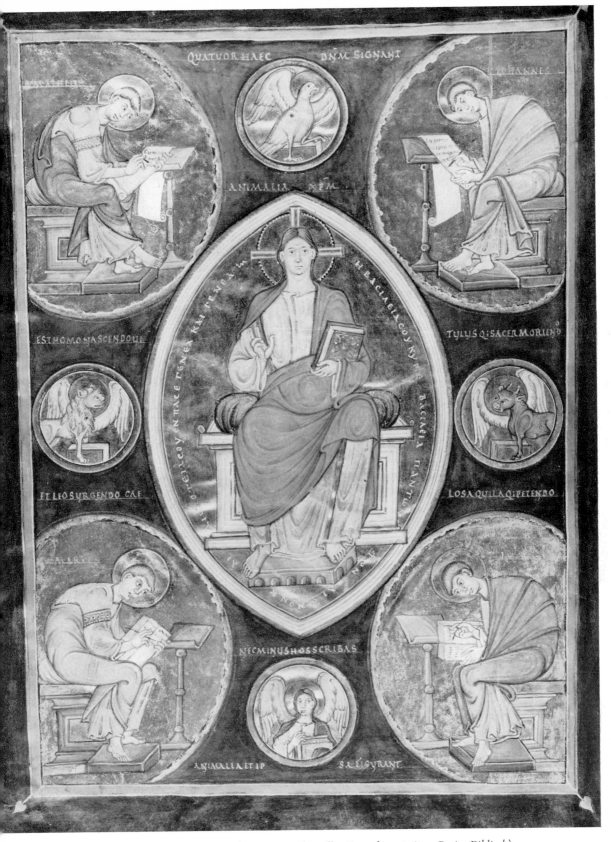

61. Gregory Master: Majesty, from the Sainte-Chapelle Gospels. 967/83. *Paris, Bibliothèque Nationale*

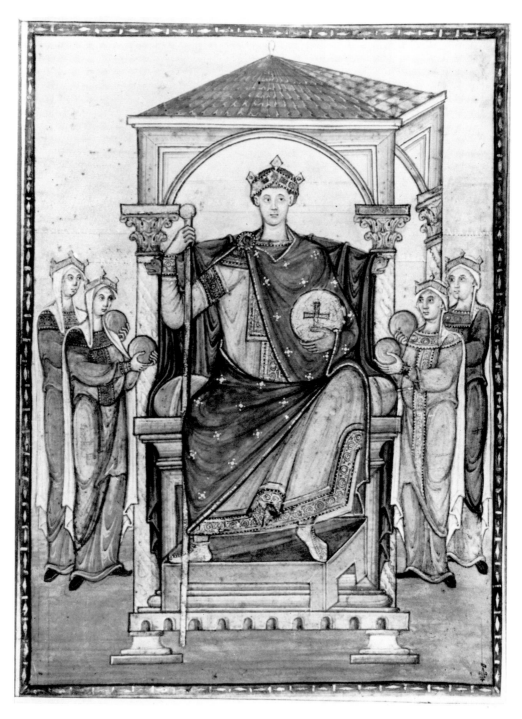

62. Trier School: Otto II enthroned, detached leaf from a copy of the Letters of St Gregory. 983/7(?). *Chantilly, Musée Condé*

63. Gregory Master: Christ and the Centurion, from the Egbert Codex. 977/93. *Trier, Stadtbibliothek*

64. Trier School: Raising of Lazarus, from the Egbert Codex. 977/93. *Trier, Stadtbibliothek*

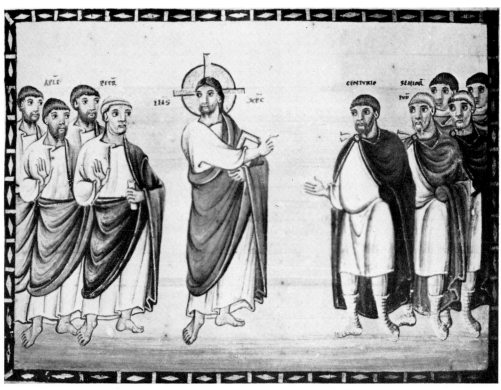

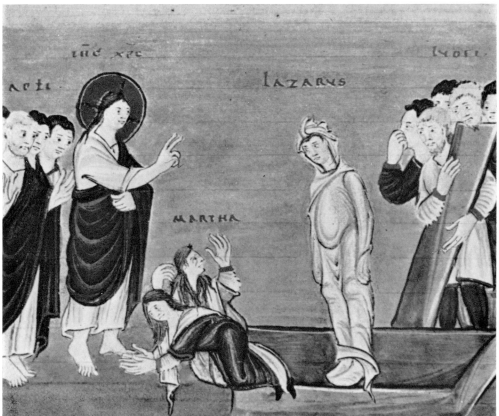

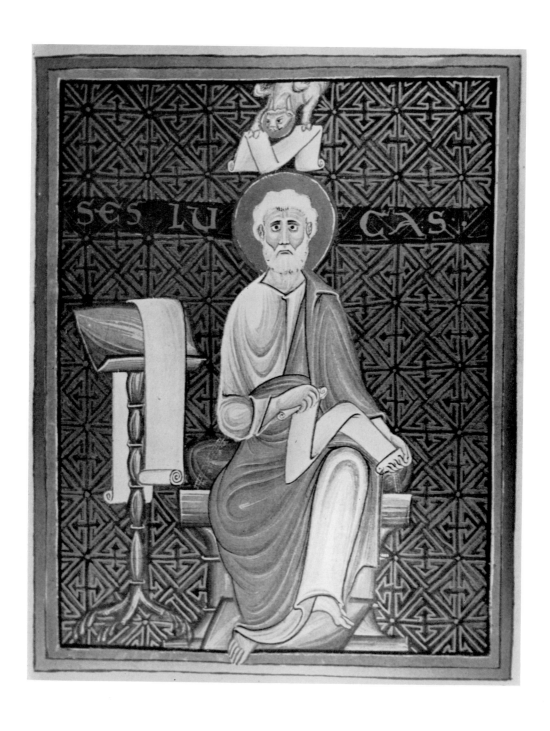

65. Trier School: St Luke, from the Egbert Codex. 977/93. *Trier, Stadtbibliothek*

66. Liuthar group: New Testament scenes, from the Gospels of Otto III. 983/1002. *Aachen Cathedral Treasury*

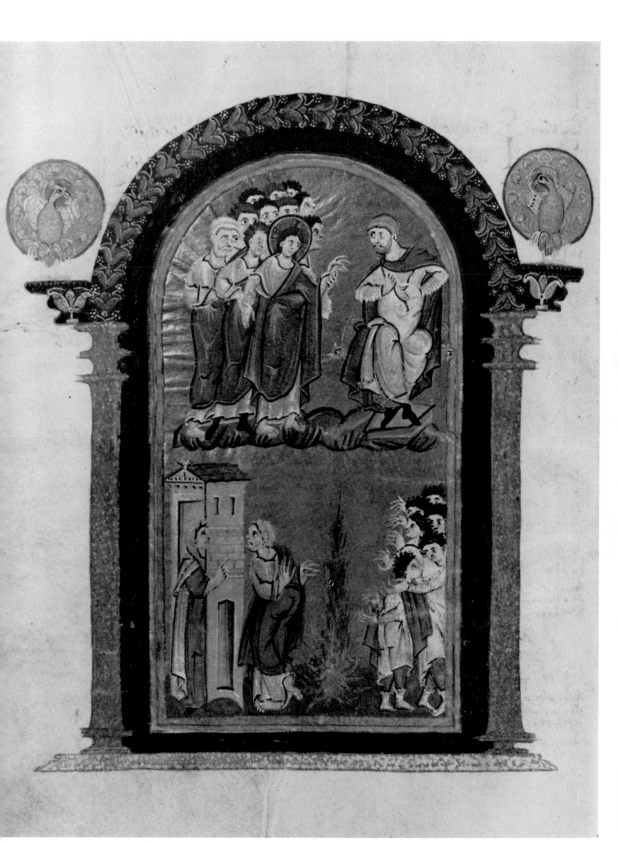

67. Liuthar group: Daniel writing his Prophecy, from a Commentary. Late tenth or early eleventh century. *Bamberg, Staatliche Bibliothek*

68. Liuthar group: Raising of Lazarus, from the Gospels of Otto III. 983/1002. *Munich, Bayerische Staatsbibliothek*

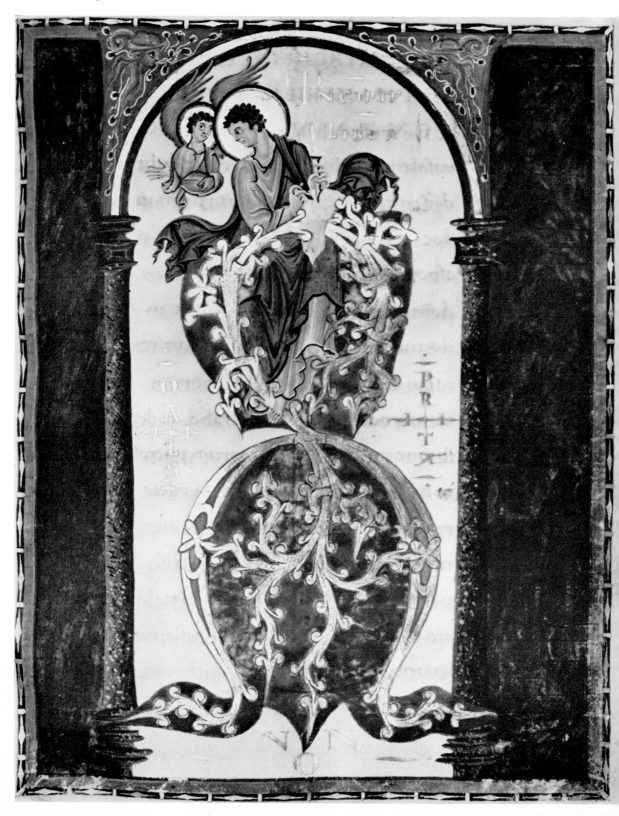

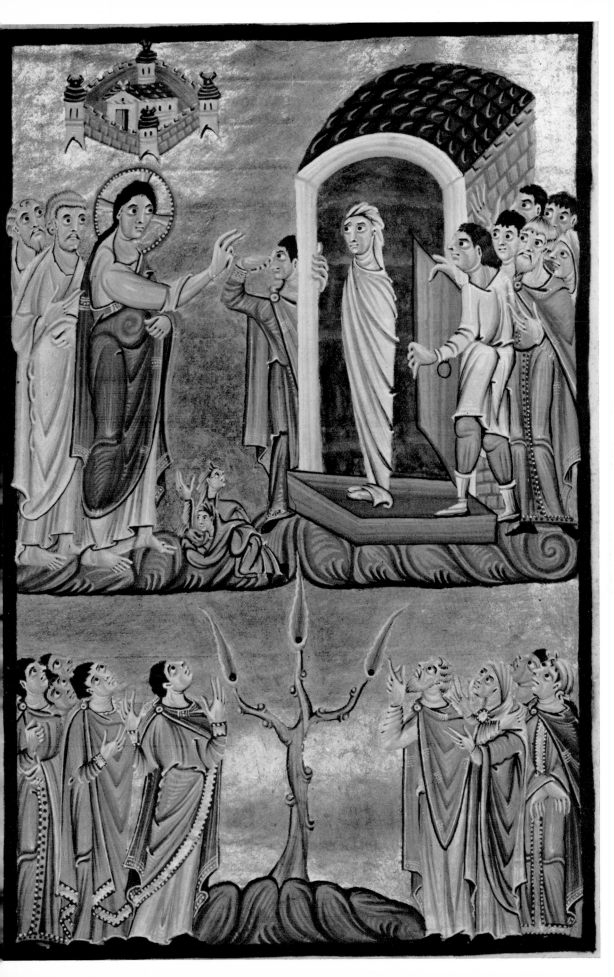

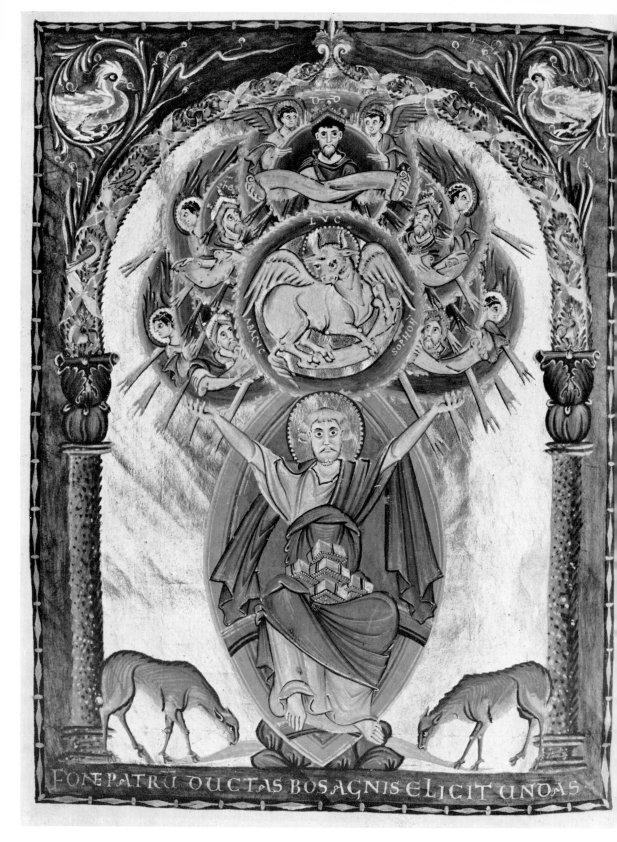

69. Liuthar group: St Luke, from the Gospels of Otto III. 983/1002. *Munich, Bayerische Staatsbibliothek*

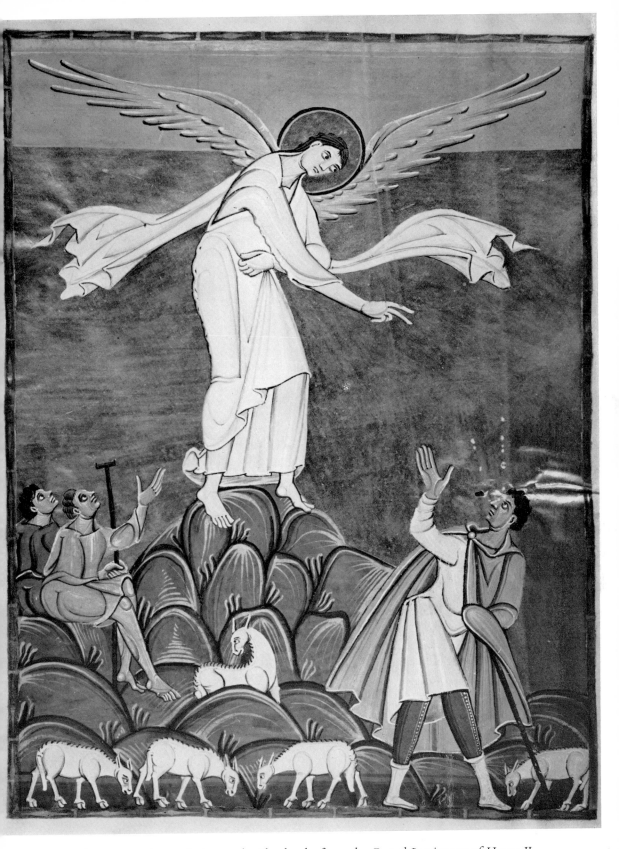

70. Liuthar group: Annunciation to the Shepherds, from the Gospel Lectionary of Henry II.
1002/14. *Munich, Bayerische Staatsbibliothek*

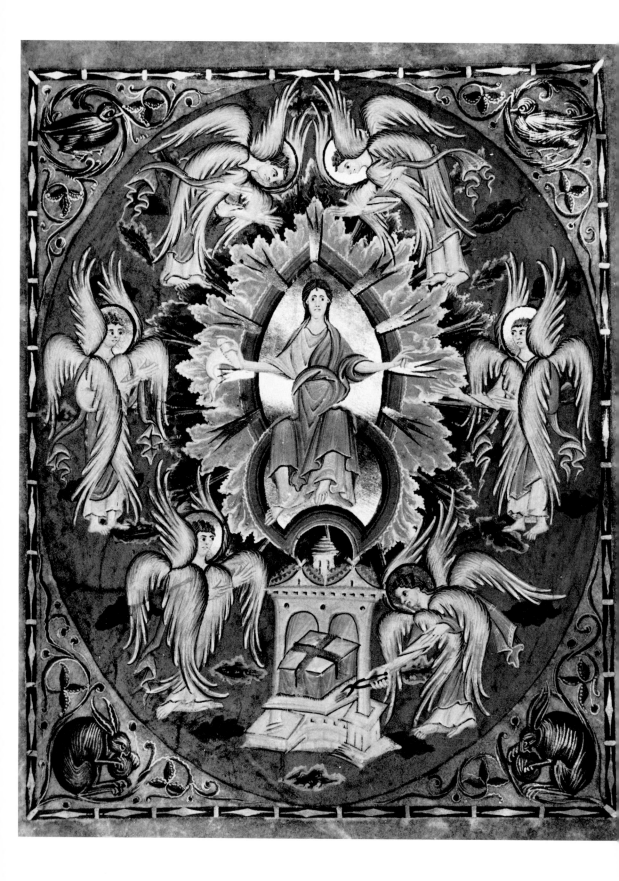

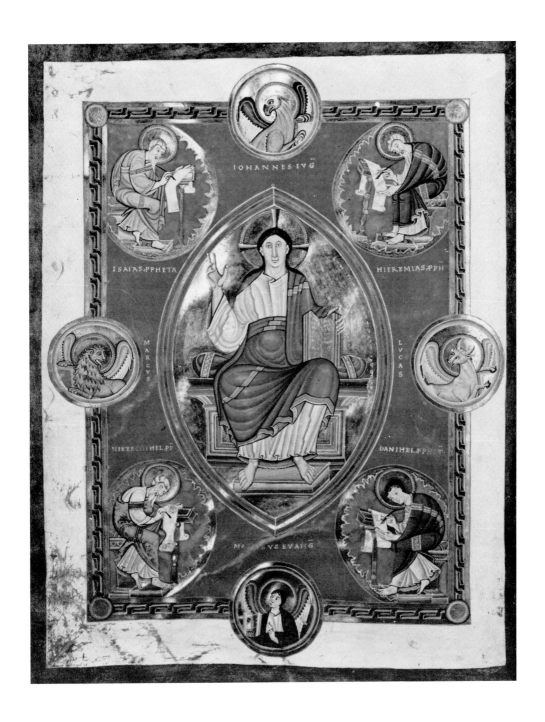

71. Liuthar group: The Vision of Isaiah, from a Commentary. Late tenth or early eleventh century. *Bamberg, Staatliche Bibliothek*

72. Echternach School: Majesty, from the Nuremberg Golden Gospels. Eleventh century, first half. *Nuremberg, Germanisches National-Museum*

73. Echternach School: Decorative page from the Nuremberg Golden Gospels. Eleventh century, first half. *Nuremberg, Germanisches National-Museum*

74. Echternach School: Conrad II and Gisela, from the Speier Golden Gospels. 1045–6. *Escorial*

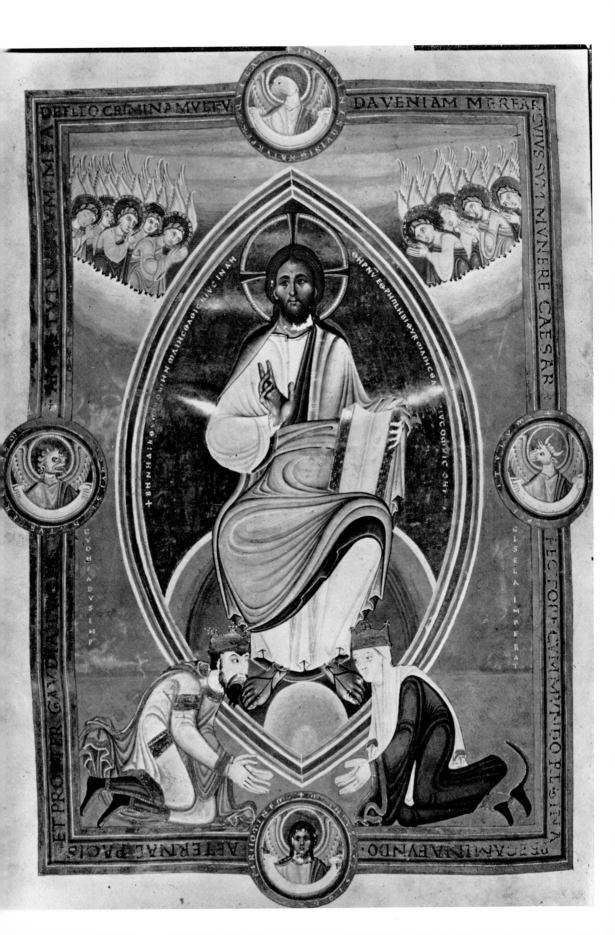

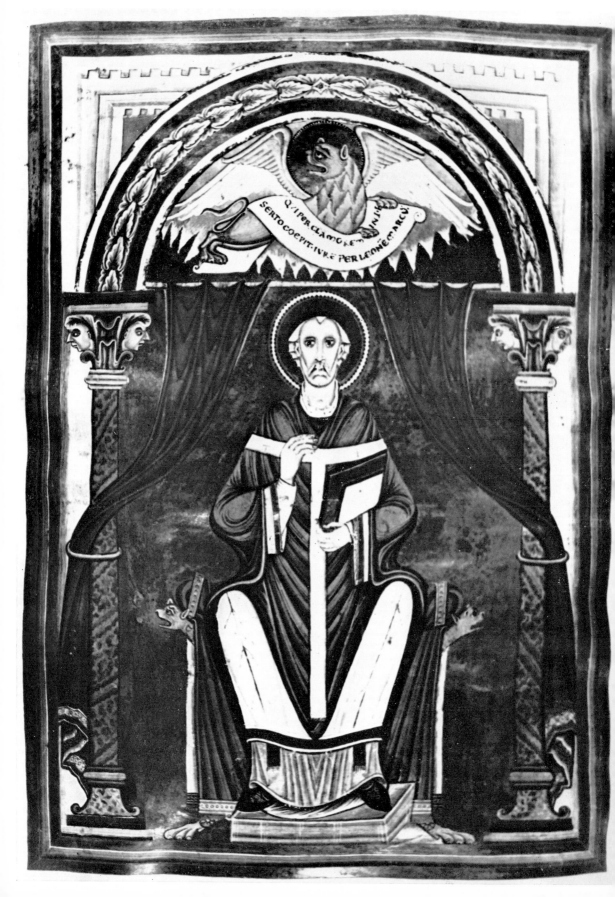

75. Echternach School: St Mark, from the Speier Golden Gospels. 1045–6. *Escorial*

76. Echternach School: Christ crowning Henry III and Agnes, from the Goslar Gospels. Completed in 1050. *Uppsala University Library*

DANIEL· HIEZECHIEL

MATHEVS IOHAÑ

MARCVS LVCAS

ISAIAS· HIEREMIAS

77. Cologne School: Majesty with Evangelist Symbols and Prophets, from a Gospels. Eleventh century, second quarter. *Bamberg, Staatliche Bibliothek*

78. Cologne School: St John. Eleventh century, second quarter. *Stuttgart, Württembergische Landesbibliothek*

79. Cologne School: Nativity, from a St Gereon Sacramentary. Early eleventh century. *Paris, Bibliothèque Nationale*

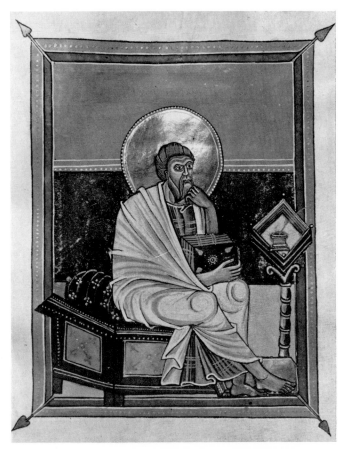

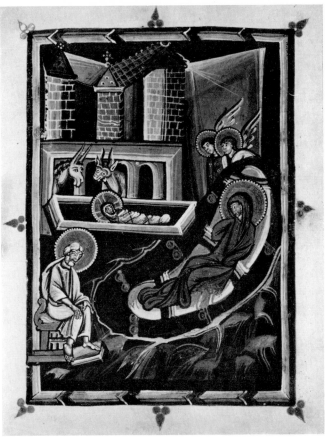

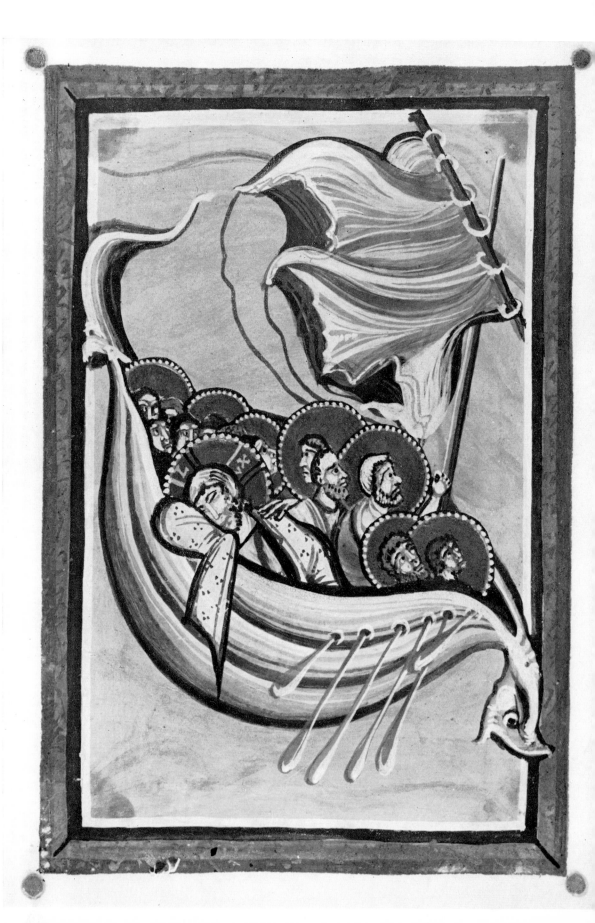

80. Cologne School: Storm at Sea, from the Hitda Codex. Early eleventh century. *Darmstadt, Hessische Landesbibliothek*

81. Cologne School: Miracle at Cana, from the Hitda Codex. Early eleventh century. *Darmstadt, Hessische Landesbibliothek*

82. Cologne School: Crucifixion, from the Gundold Gospels. 1020/40. *Stuttgart, Württembergische Landesbibliothek*

83. Cologne School: Crucifixion, from the Giessen Gospels. *c.* 1020. *Giessen, Universitätsbibliothek*

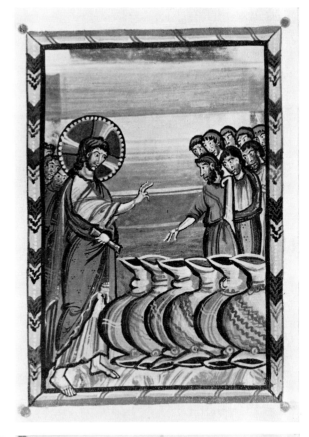

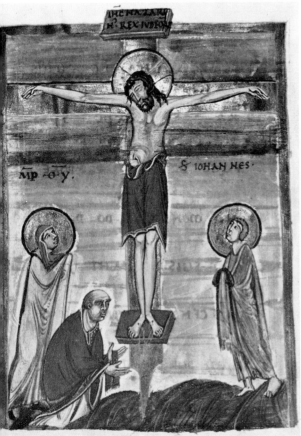

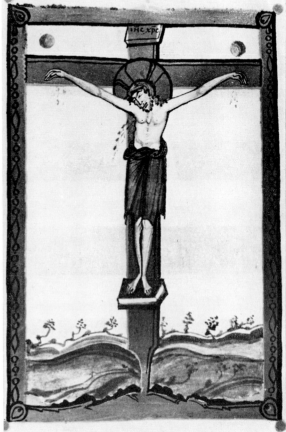

84. Regensburg School: Crucifixion, from the Uta Gospels. Eleventh century, first quarter. *Munich, Bayerische Staatsbibliothek*

85. Regensburg School: Illustration from the Gospels of Henry II. Eleventh century, first quarter. *Rome, Biblioteca Apostolica Vaticana*

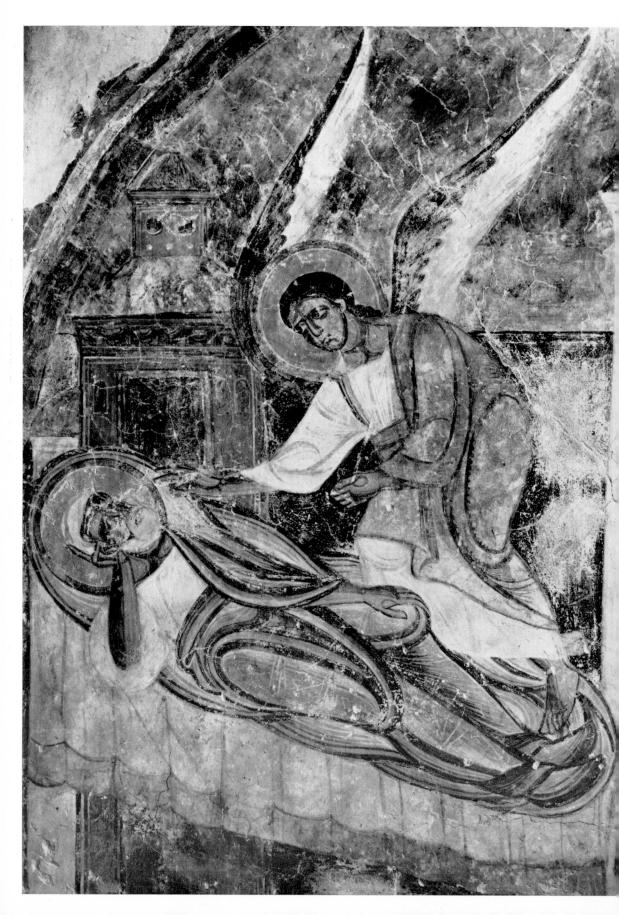

86. Lambach, church, west choir, Joseph's Dream. Wall-painting. Late eleventh century

87. Fulda School: St Matthew, from the Widukind Gospels. Tenth century, last quarter. *Berlin, Staatsbibliothek*

88. Saint-Denis: Majesty, from a Missal. Mid eleventh century. *Paris, Bibliothèque Nationale*

89. Poitiers: Illustration from the *Life of St Radegund*. Late eleventh century. *Poitiers, Bibliothèque Municipale*

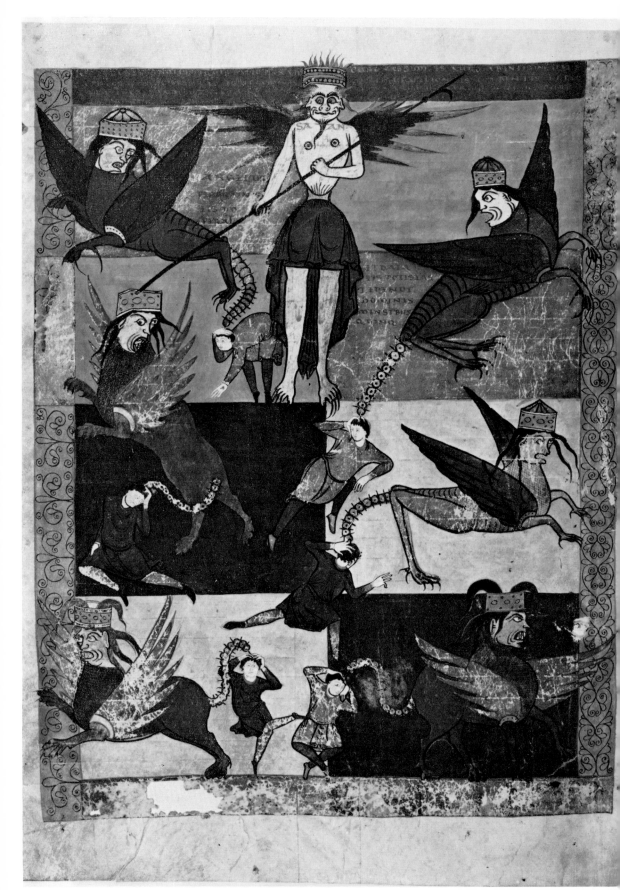

90. Saint-Sever: Illustration from the Beatus Apocalypse of Saint-Sever. 1028/72. *Paris, Bibliothèque Nationale*

91. Limoges: Illustration from Sacramentary of Saint-Étienne of Limoges. *c.* 1100. *Paris, Bibliothèque Nationale*

92. Méobecq Abbey Church, flying angels and medallion. Wall-painting. Twelfth century, second or third quarter

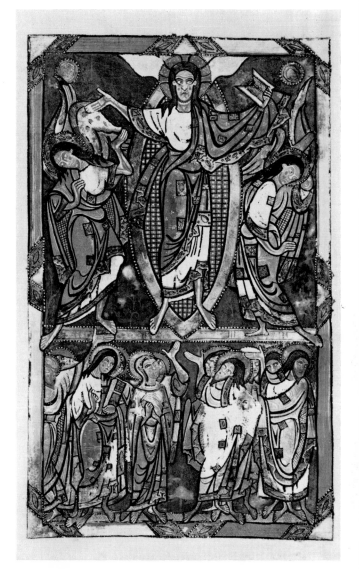

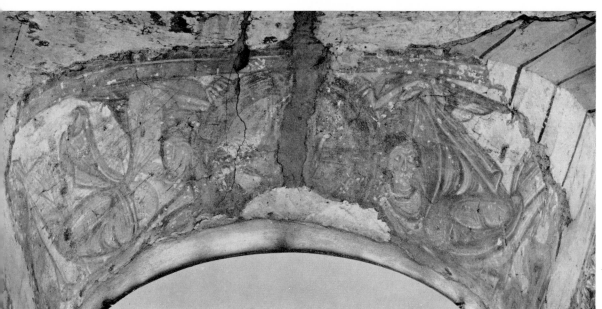

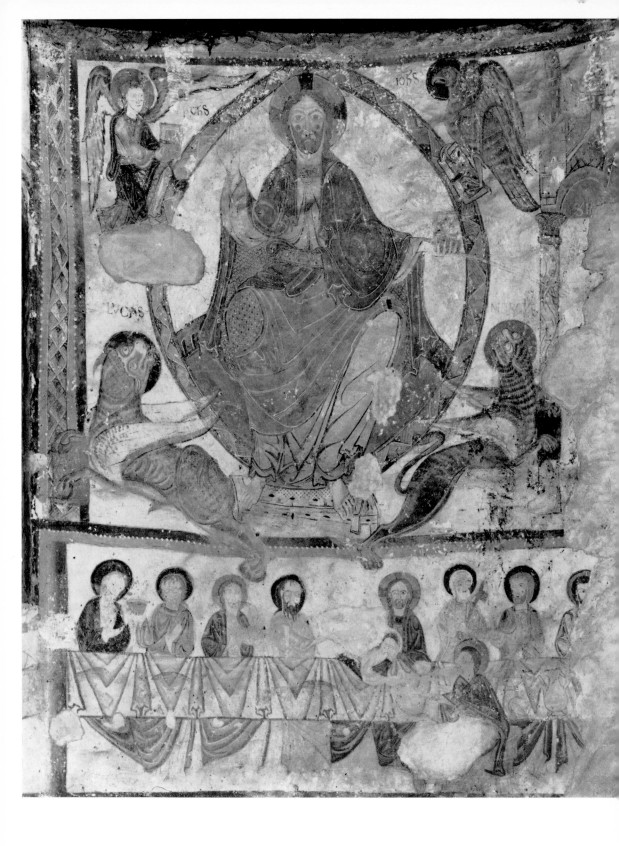

93. Saint-Jacques-des-Guérets, Majesty. Wall-painting. Twelfth century, second half

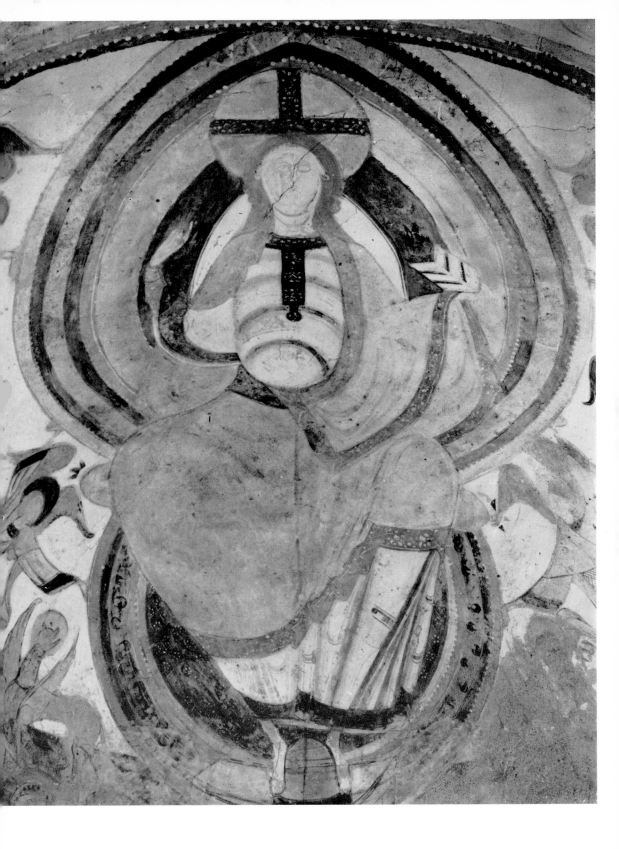

94. Montoire-sur-le-Loir, priory chapel of Saint-Gilles, Majesty. Wall-painting. Twelfth century, first half

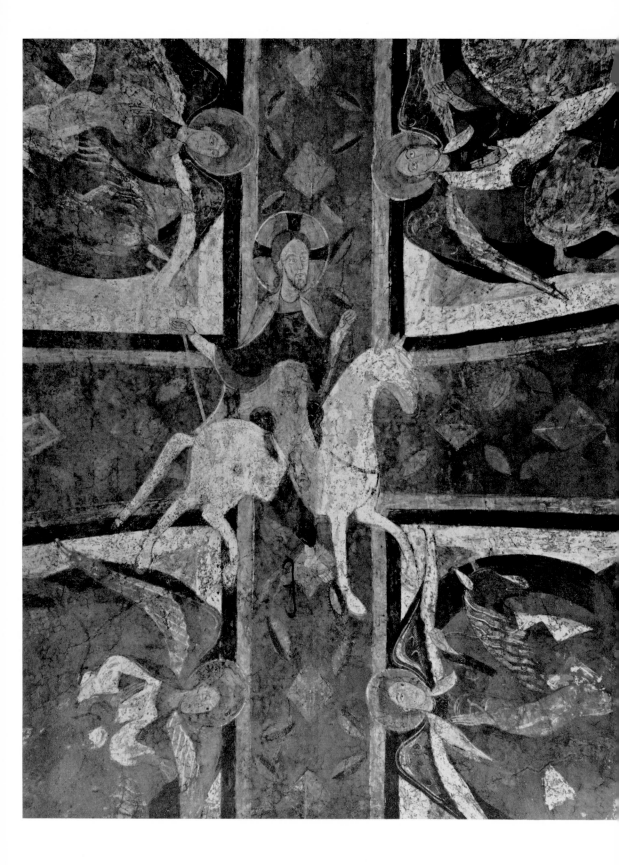

95. Auxerre Cathedral, Christ and four angels on horseback. Wall-painting. Twelfth century, first half

96. Anglo-Saxon: Majesty, from a Gospels. Late tenth century. *Boulogne-sur-Mer, Bibliothèque Municipale*

97. Odbert of Saint-Bertin: Majesty, from a Gospels. 990/1012. *Saint-Omer, Bibliothèque Municipale*

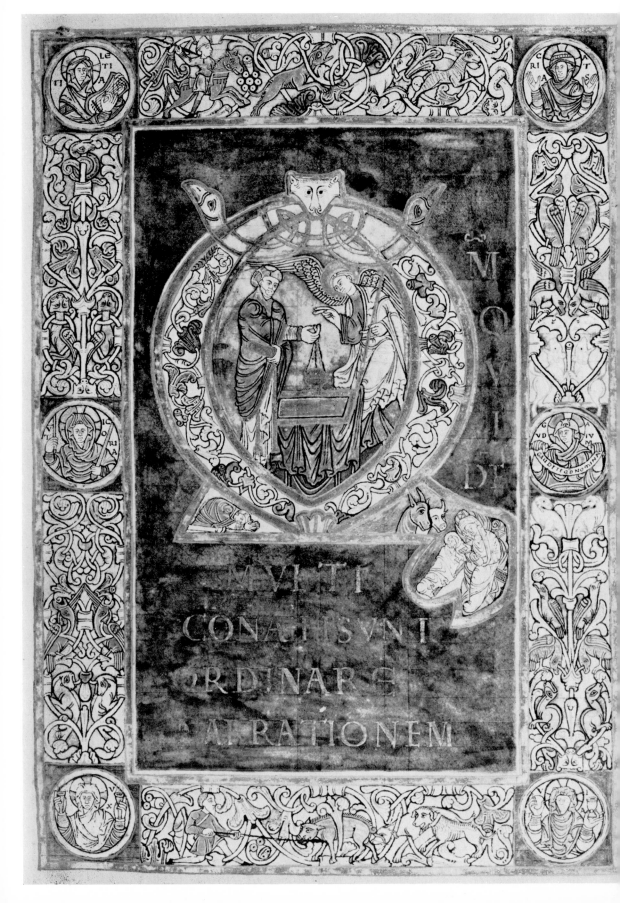

98. Odbert of Saint-Bertin: Title-page to St Matthew's Gospel, from a Gospels. 990/1012.
New York, Pierpont Morgan Library

99. Saint-Vaast, Arras(?): St Luke, from the Anhalt-Morgan Gospels. Early eleventh century.
New York, Pierpont Morgan Library

100. Saint-Vaast, Arras: Illustration from the Saint-Vaast Bible. Eleventh century, first half. *Arras, Bibliothèque Municipale*

101. Saint-Quentin: Tortures of St Quentin, from the *Life of St Quentin*. Eleventh century, second half. *Saint-Quentin Chapter Library*

102. Saint-Omer: Scene from the *Life of St Omer*. Eleventh century, second half. *Saint-Omer, Bibliothèque Municipale*

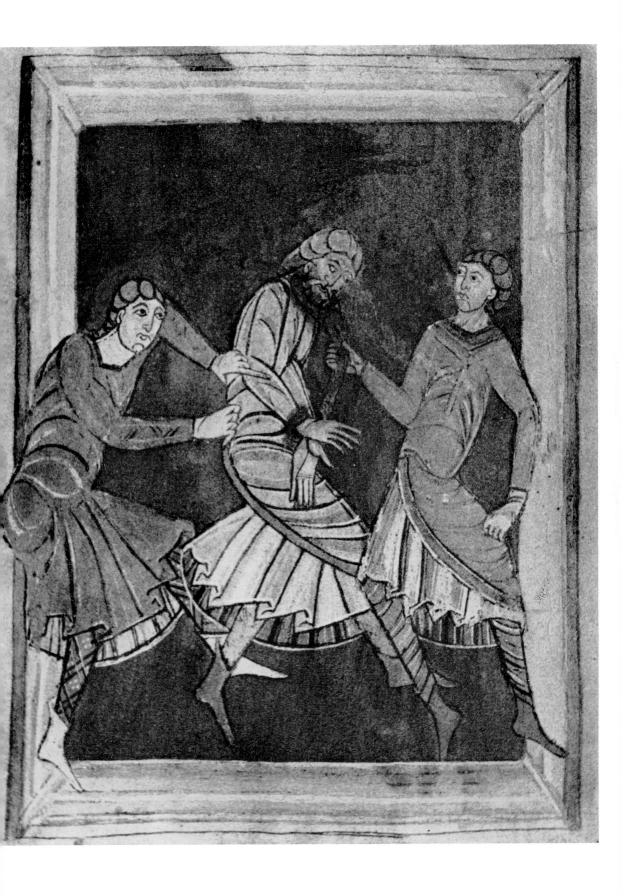

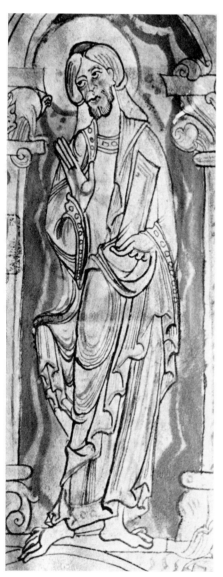

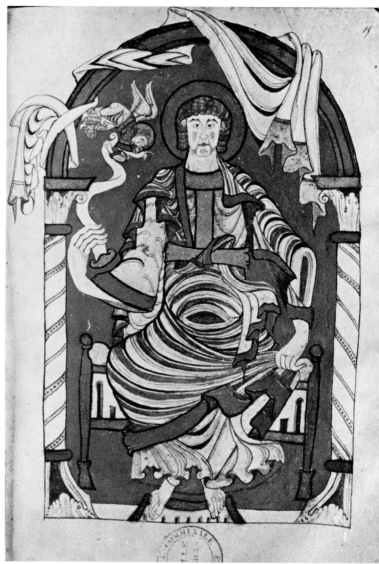

103. Saint-Amand: Cassian, from a *Cassian*. Eleventh century, second half. *Valenciennes, Bibliothèque Municipale*

104. Cambrai: St Matthew, from a Gospels. Eleventh century, second half. *Amiens, Bibliothèque Municipale*

105. Mont-Saint-Michel: Ascension of the Virgin, from a Sacramentary. 1070/1100. *New York, Pierpont Morgan Library*

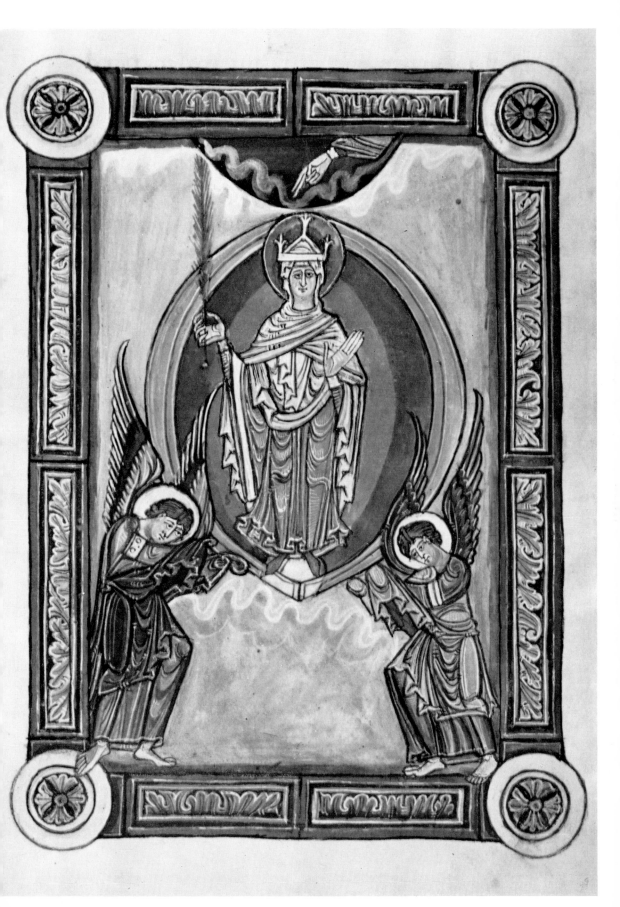

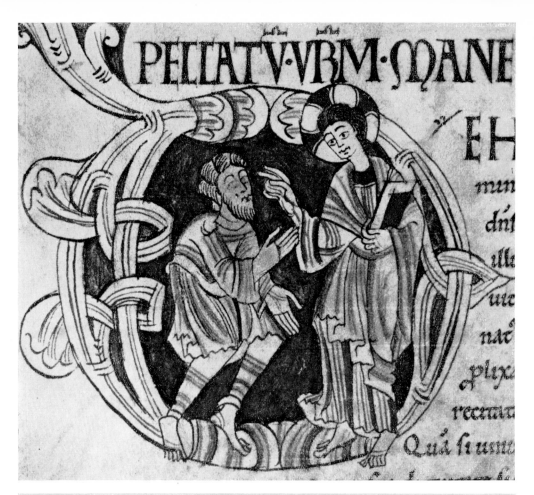

PELLAT·VRM·MANE

EH
mun
dnt
ull
ute
nat
plixa
recul
Qua siume

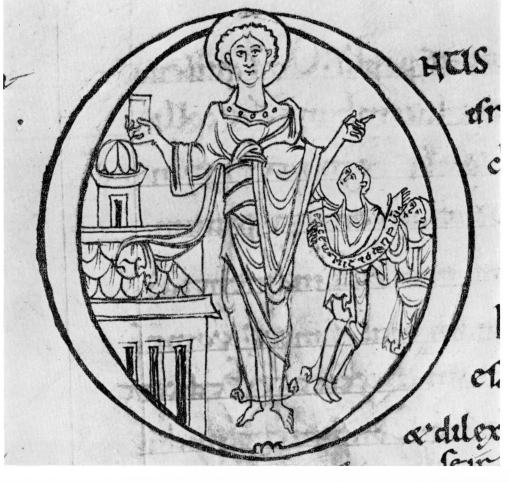

HIS
tr
c

el
&dilex

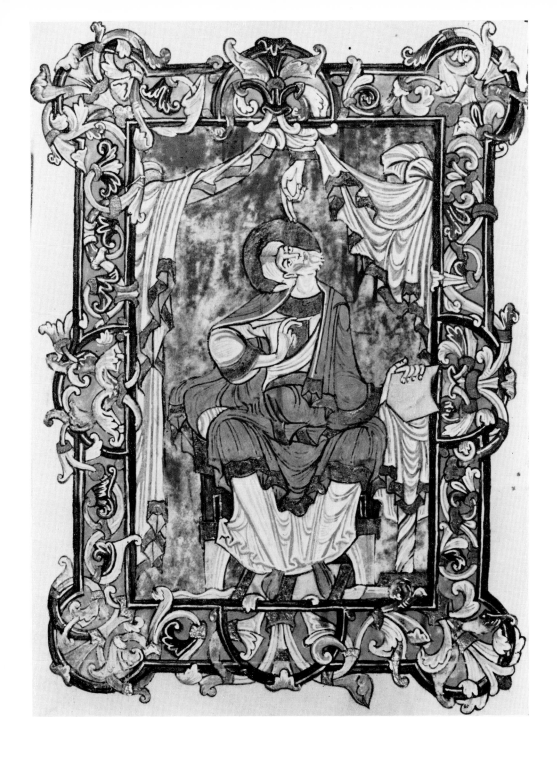

106. Saint-Ouen, Rouen: Christ healing the Blind, from a Bible. 1070/1100. *Rouen, Bibliothèque Municipale*

107. Jumièges: Historiated initial, from a Bible. 1100/30. *Rouen, Bibliothèque Municipale*

108. Saint-Ouen, Rouen: St John, from a Gospels. 1070/1100. *London, British Museum*

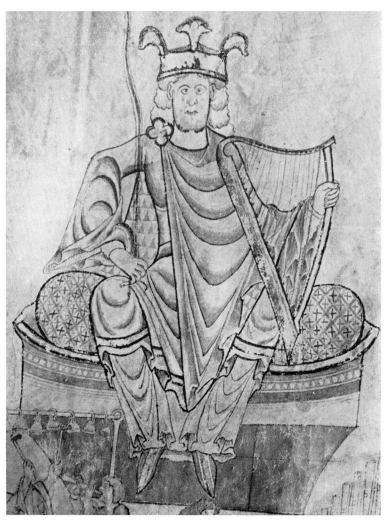

109. Cîteaux: Initial, from St Gregory's *Moralia in Job*. 1110/20(?). *Dijon, Bibliothèque Municipale*

110. Cîteaux: David, from Stephen Harding's Bible. 1109/33. *Dijon, Bibliothèque Municipale*

111. Cîteaux: Initial, from a Lectionary. 1120/50. *Dijon, Bibliothèque Municipale*

112. Cîteaux: Monks felling a tree, from St Gregory's *Moralia in Job*. Completed on 24 December 1111. *Dijon, Bibliothèque Municipale*

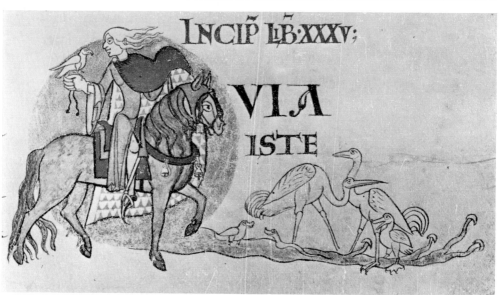

113. Cîteaux: Monk cutting corn, from St Gregory's *Moralia in Job*. Completed on 24 December 1111. *Dijon, Bibliothèque Municipale*

114. Cîteaux: Lady falconing, from St Gregory's *Moralia in Job*. 1110/20(?). *Dijon, Bibliothèque Municipale*

115. Tavant, Saint-Nicolas, crypt, David harping. Wall-painting. Early twelfth century(?)

116. Tavant, Saint-Nicolas, crypt, Saul enthroned. Wall-painting. Early twelfth century(?)

117. Petit Quevilly, Saint-Julien, choir vault, scenes from the Birth and Childhood of Christ. Wall-painting. 1160/90

118. Magius: Vision of
Nebuchadnezzar, from a *Beatus*. 922.
New York, Pierpont Morgan Library

119. Emeterius of Tábara: The
Artist at Work, from a *Beatus*.
Completed in 970. *Madrid, Archivo
Histórico Nacional*

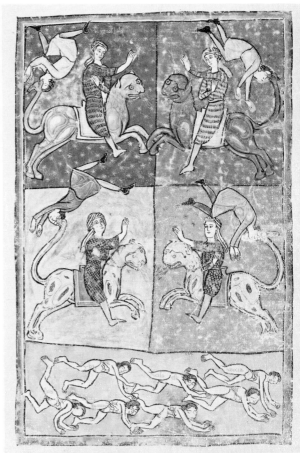

120. San Millán de la Cogolla:
Vision of the Lamb, from a *Beatus*.
Tenth century, second half.
Madrid, Academia de la Historia

121. Santo Domingo de Silos:
Twenty-four Elders adoring Christ,
from a *Beatus*. 1109.
London, British Museum

122. Las Huelgas (Burgos): Plague
of Horsemen of the Apocalypse
(IX, 17), from a *Beatus*. 1220. *New
York, Pierpont Morgan Library*

123. Spanish: Worship of the Beast
and Dragon, from a *Beatus*. 975.
Gerona Cathedral

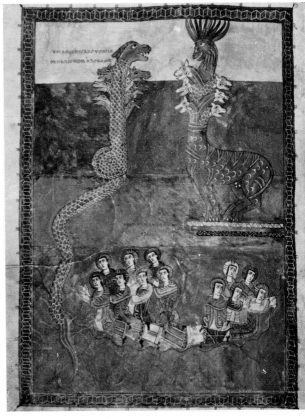

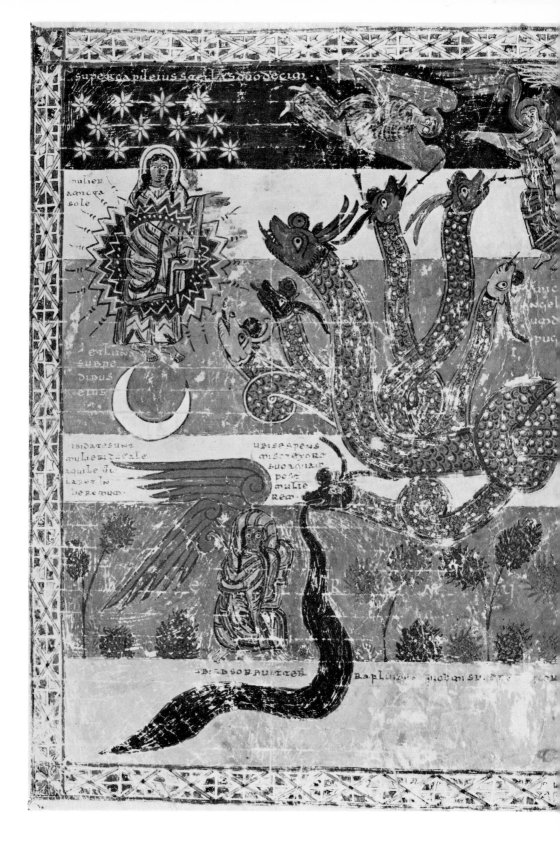

124 and 125. Magius: The Seven-headed Dragon attacks the Woman and the Angels, from a
Beatus. 922. New York, Pierpont Morgan Library

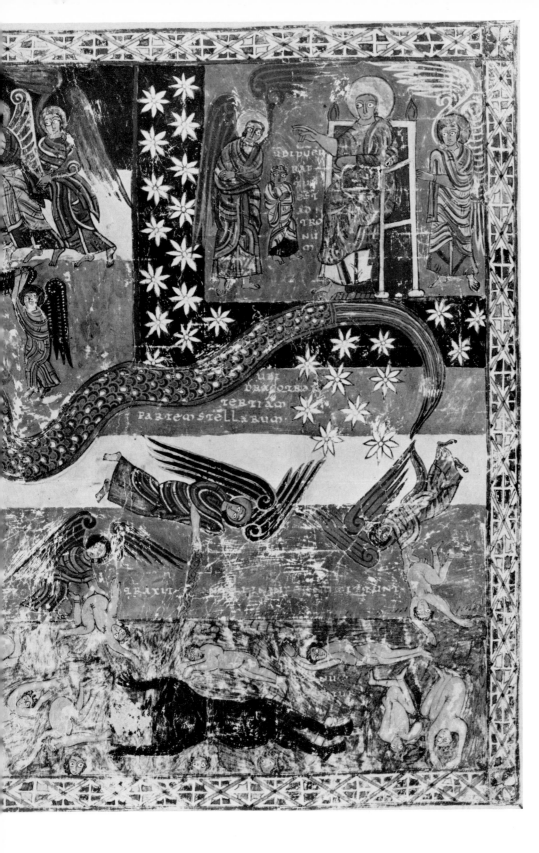

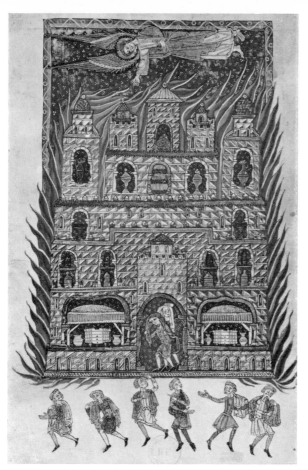

126. Spanish: The Fall of Babylon, from a *Beatus*. Late twelfth or early thirteenth century. *Paris, Bibliothèque Nationale*

127. Spanish: Kings and Queens offering Charters, from the Book of the Testaments. 1126–9. *Oviedo Cathedral*

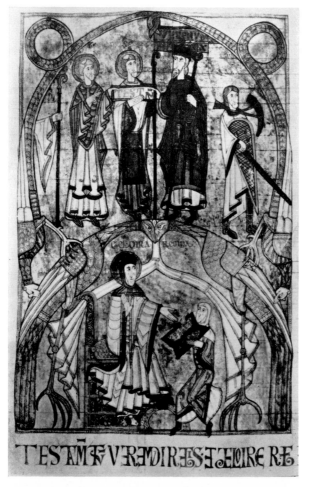

128. Vimara and John of San Martín de Albeares: St Mark, from a Bible. 920. *León Cathedral*

129. Florentius and Sanctius: The Artists, from a Bible. 960. *León, San Isidro*

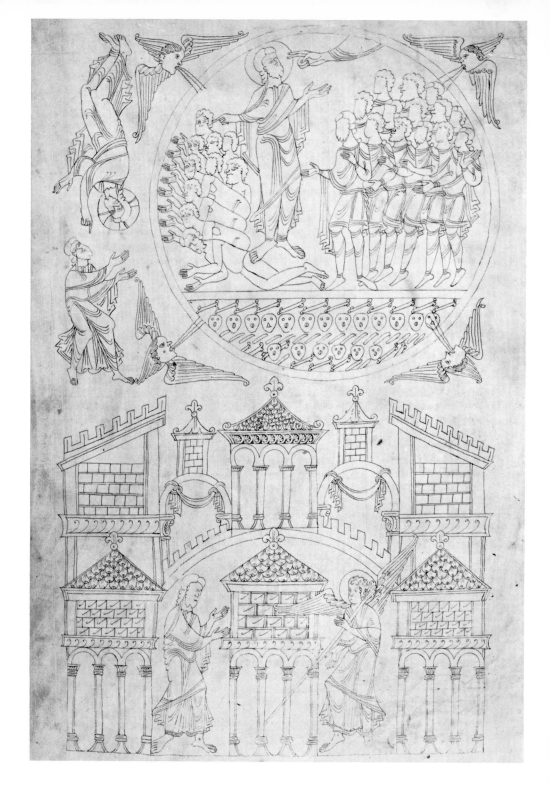

130. Ripoll: The Valley of Dry Bones, from the Farfa Bible. Mid eleventh century. *Rome, Biblioteca Apostolica Vaticana*

131. San Pedro de Roda: Hosea communicating with God, from the Roda Bible. Mid eleventh century. *Paris, Bibliothèque Nationale*

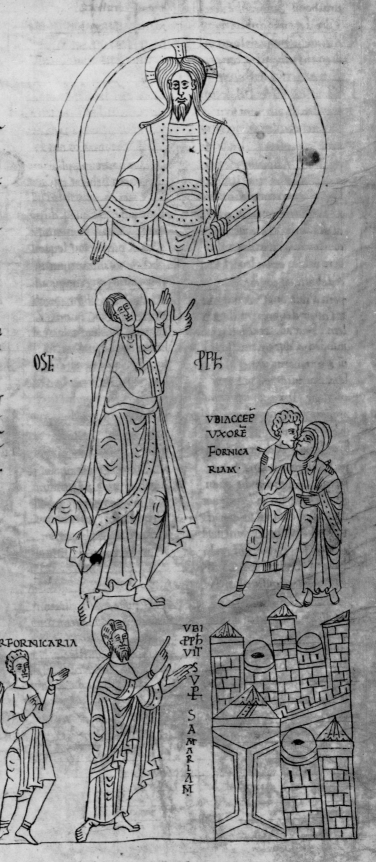

theu p eliseu inregnu sanguinē
Haboth cuiusiezrahel quetūc
tpus metropolis erat· quē ze
zabel hab regisisti filia inte
rimerat· sic ftoria regū expo
nit· Hiscū grauiter uixti diui
nū pceptū uindicandi sangui
nis causa inoīs memoria mar
tarum· cuiꝯ ppote therobo
am quiletione cōphensus ē
origins sui facti immutate·
hanc contra eli pcepta &re
ligione cū ppto isrt agente·
sanguis haboth qui inloco cer
to iezrahel fuerat pfusus· in
domo theu patris memoratu
theroboe ppt peccata redun
daturus significat· Hinc fac
tumē· ut ira di inppto isrt p
denunciatione pphe· pcessura
diceret· Domui aū uida mea
lectione cōphensa adhoc pro
missa ē· quia ezechias rex iu
de fili achath· sublatisidolis
que tam pat eī quā ceteri re
ges consecrut eꝛ· templu di pur
gasse ac purificasse mōstrat
Ꝓ xLicit PROLOG HIERONIMI·

OSE PPħ

VBIACCEP
VXORE
FORNICA
RIAM·

FILII SVIQd PEPERIT EIVXORFORNICARIA

VBI
PPħ
VIT
SVE
SAMARIAM

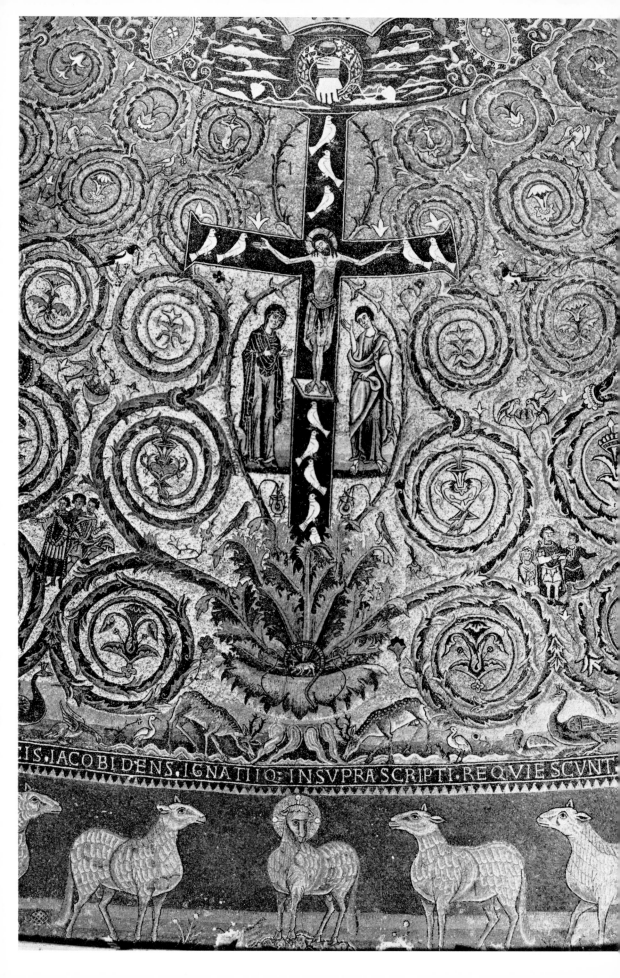

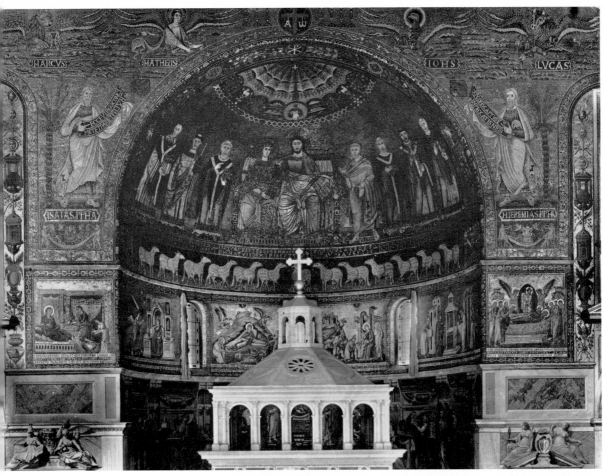

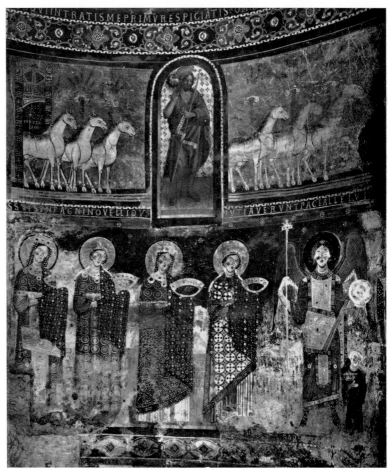

132. Rome, San Clemente, apse, Crucifixion. Mosaic. Before 1128

133. Rome, Santa Maria in Trastevere, apse, Coronation of the Virgin. Mosaic. 1130/43

134. Castel Sant'Elia, apse, procession of virgins. Wall-painting. 1100/30(?)

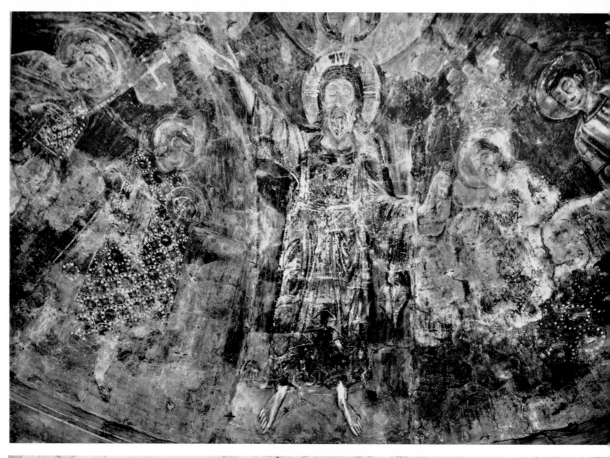

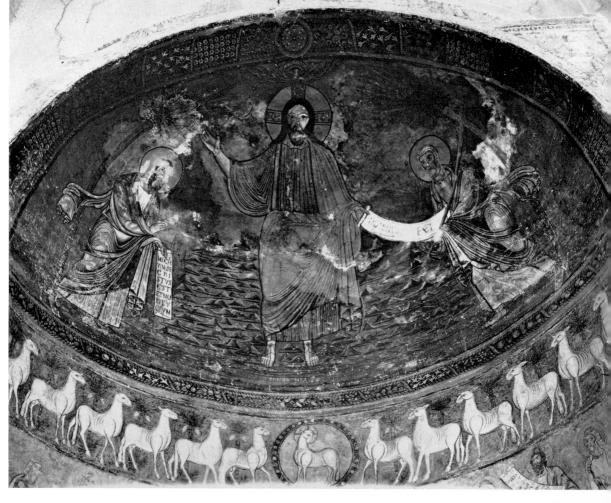

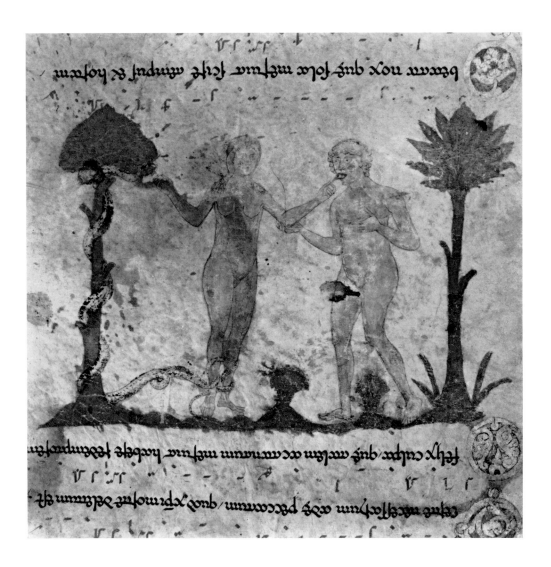

135. Rome, San Sebastianello al Palatino, apse. Wall-painting. Late tenth century

136. Tivoli, San Silvestro, apse, Christ between St Peter and St Paul. Wall-painting. Twelfth century, second half

137. Montecassino: Adam and Eve, from an Exultet Roll. *c.* 1060. *London, British Museum*

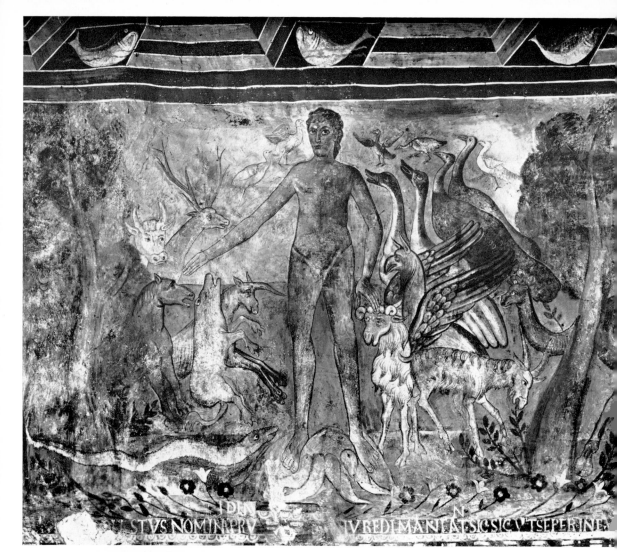

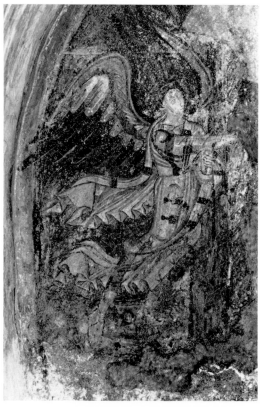

138. San Pietro near Ferentillo, nave,
Adam naming the Animals. Wall-painting.
Late twelfth century

139. San Vincenzo al Volturno, crypt,
Angel of the Annunciation. Wall-painting.
826/43

140. Benevento, Santa Sofia, Annunciation
to Zacharias. Wall-painting. *c.* 762(?)

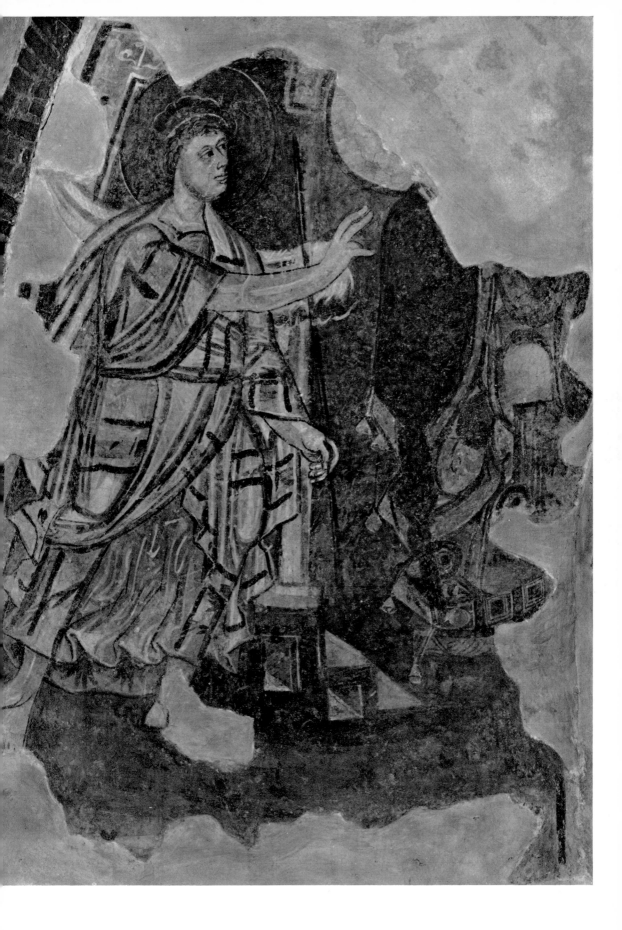

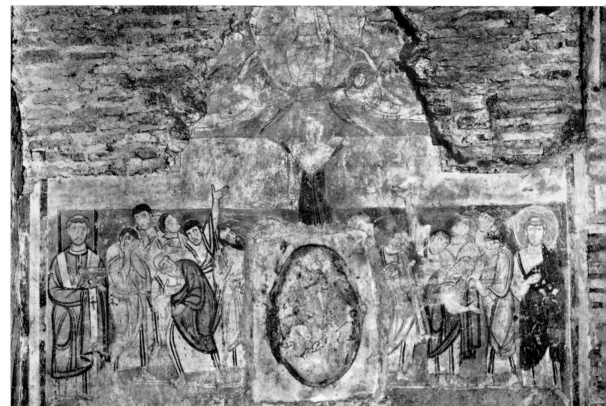

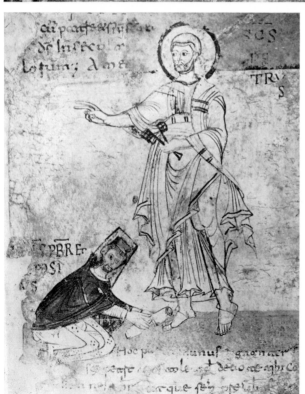

141. Rome, San Clemente, lower church, nave, Ascension. Wall-painting. 847/55

142. Southern Italy: John, presbyter and prepositus, presenting the roll to St Peter, from an Exultet Roll. 981–7. *Rome, Biblioteca Apostolica Vaticana*

143. Bari: Descent into Hell, from an Exultet Roll. *c.* 1000. *Bari Cathedral*

144. Bari: Deesis with donor, from a Benedictional Roll. Early eleventh century. *Bari Cathedral*

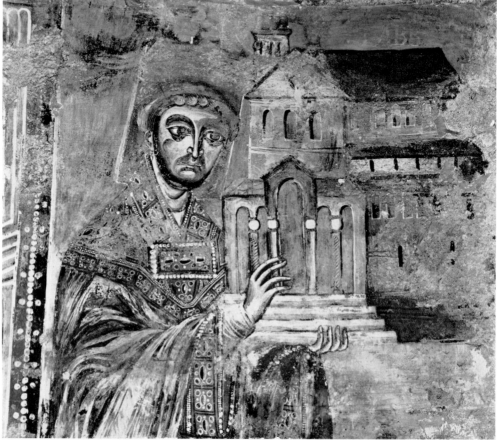

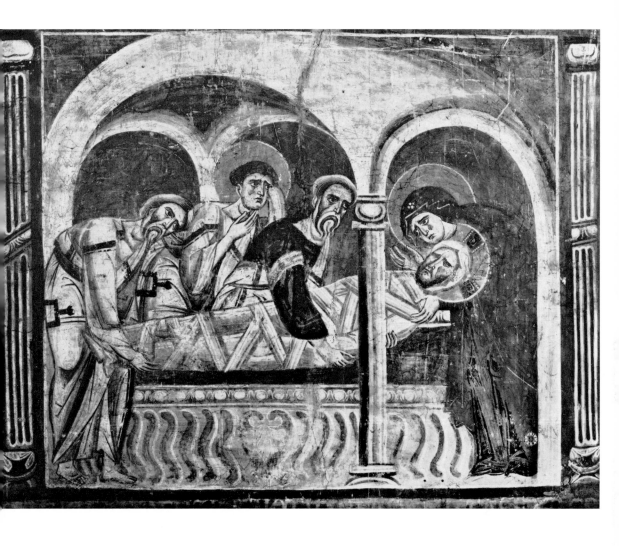

145. Montecassino: Christ enthroned between Angels, from an Exultet Roll. *c.* 1060. *London, British Museum*

146. Sant'Angelo in Formis, Desiderius offering the church. Wall-painting. 1072/1100

147. Sant'Angelo in Formis, Entombment. Wall-painting. 1072/1100

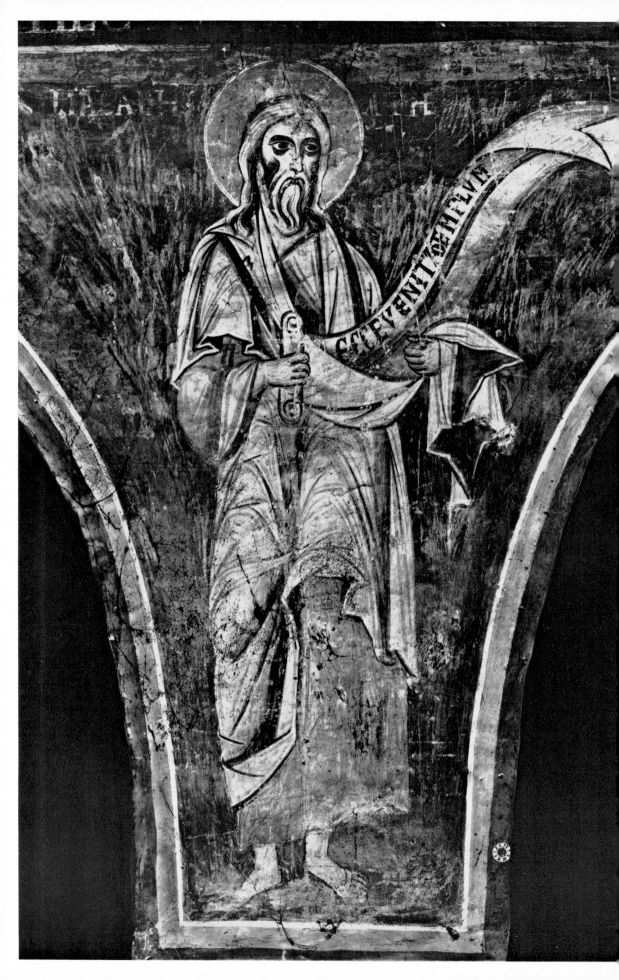

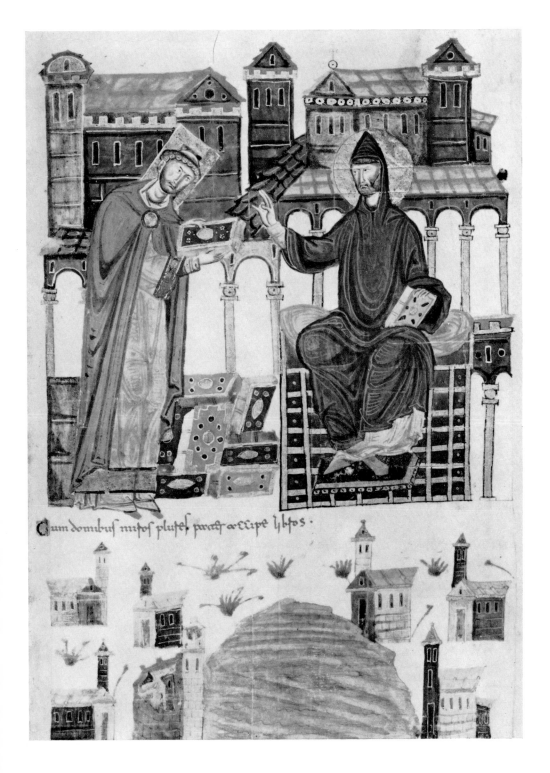

Cum domibus mitos pluies preses accipe libros .

148. Sant'Angelo in Formis, Malachia. Wall-painting. 1072/1100

149. Montecassino: Desiderius offering books and buildings to St Benedict, from a *Lives of SS. Benedict, Maurus, and Scholastica*. 1071(?). *Rome, Biblioteca Apostolica Vaticana*

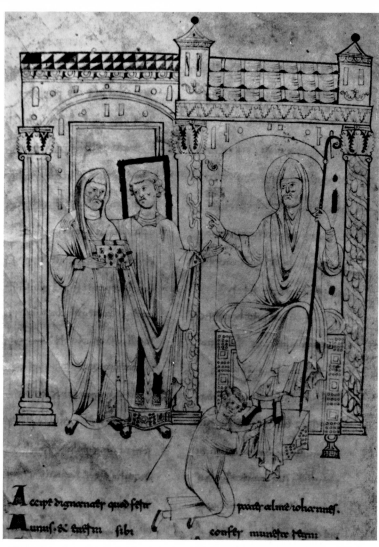

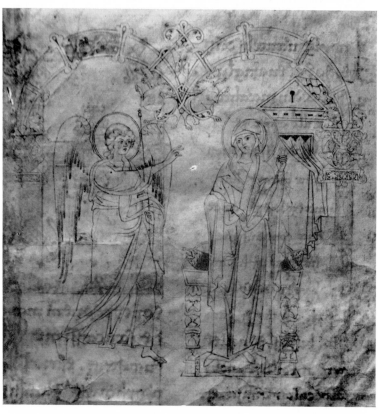

150. Montecassino: Dedication picture, from a Book of Homilies. 1058/86. *Montecassino*

151. Montecassino: Annunciation, from a Book of Homilies. 1058/86. *Montecassino*

152. Rome, San Clemente, lower church, narthex, Miracle at the Tomb of St Clement. Wall-painting. 1085/1115

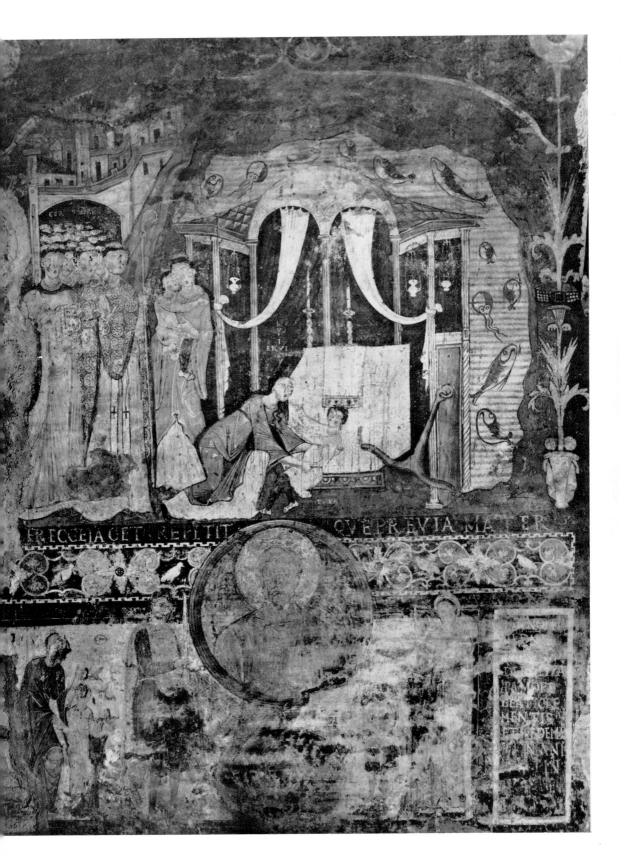

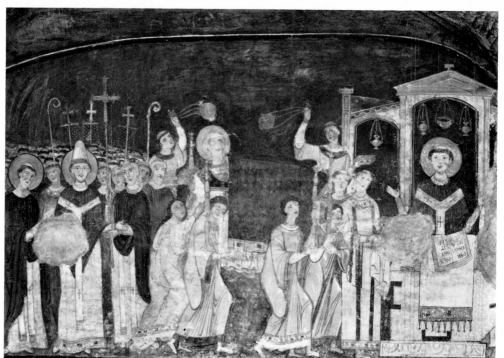

HVC A VATICANO FER TVR PP NICOLAO IMNISDIVINIS QDAROMATIB SEPE

ECO MARIA MACELLARIA P TIMORE DEI ETREMEDIO ANIMEME EEC

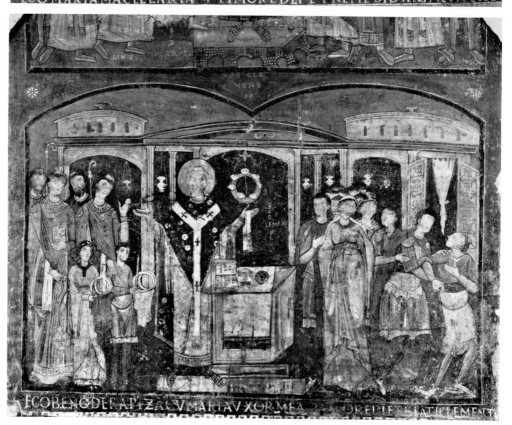

ECOBENODERAPIZACVMMARIAVXORMEA ORDEDIE LATICLEMENTI

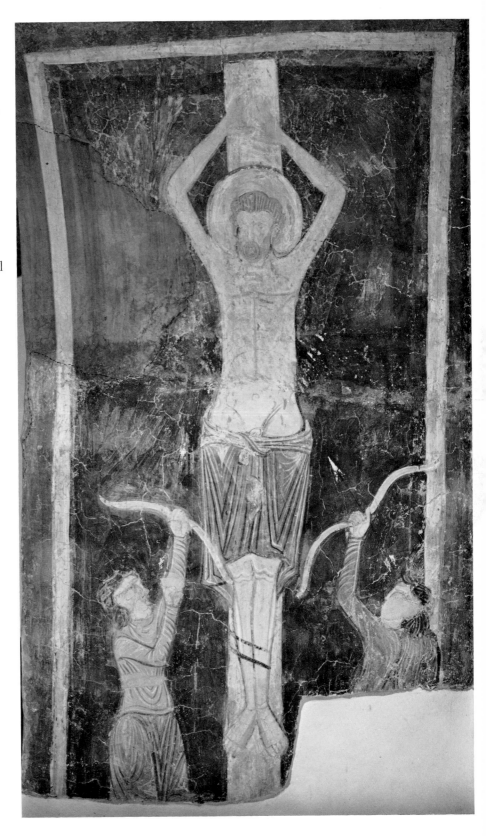

153. Rome, San Clemente, lower church, narthex, Translation of St Clement's Relics to Rome. Wall-painting. 1085/1115

154. Rome, San Clemente, lower church, narthex, St Clement celebrating Mass. Wall-painting. 1085/1115

155. Rome, Old Lateran Palace, Chapel of St Sebastian, Martyrdom of St Sebastian. Wall-painting. 1100/30(?)

156. Castel Sant'Elia, apse, Christ between St Peter and St Paul. Wall-painting. 1100/30(?)

157. Toscanella, San Pietro, upper church, Apostles from the Ascension. Wall-painting. 1100/40(?)

158. Rome, Santa Pudenziana, Virgin and Child with St Pudenziana and St Prassede. Wall-painting. 1100/40(?)

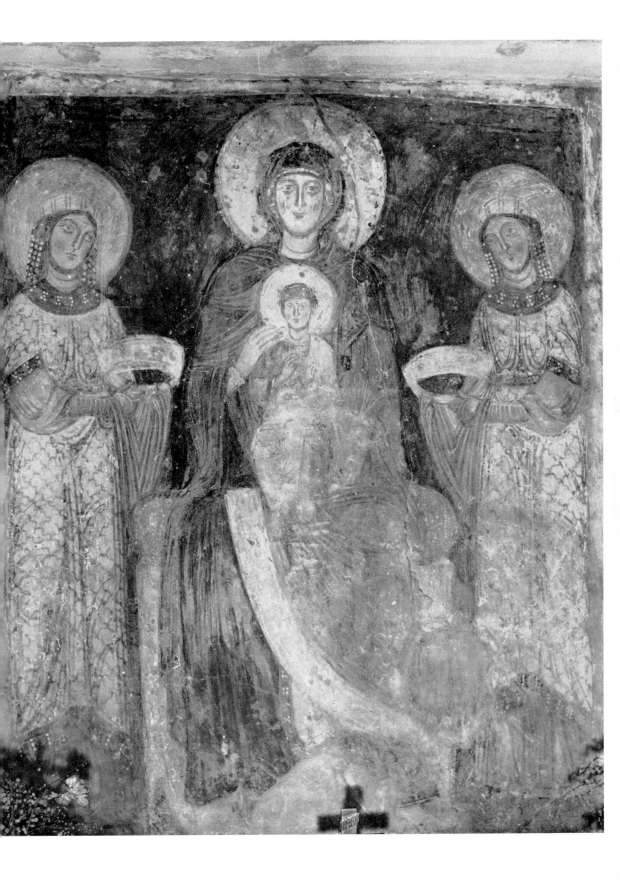

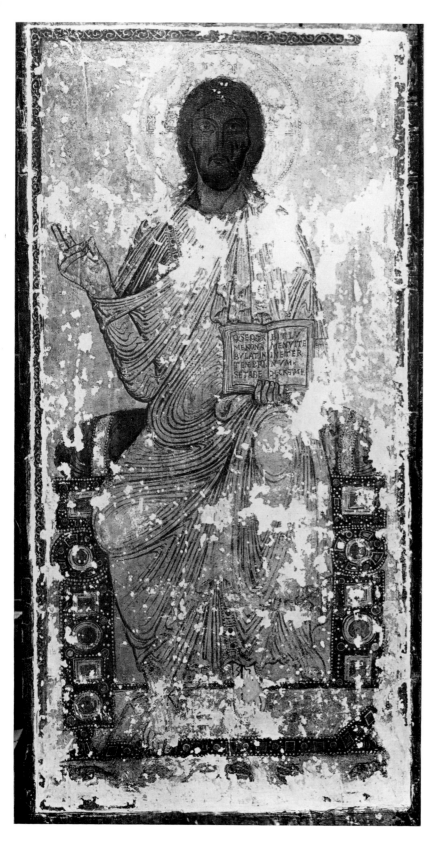

159. Roman: Christ, from the Redeemer panel. Panel-painting. 1110/40. *Tivoli Cathedral*

160. Chiusi: St Leucio, St Tirso, and St Galenico, from a Passional. Late eleventh century. *Florence, Biblioteca Nazionale*

161. Umbro-Roman: Solomon, from the Munich Bible. Before 1106. *Munich, Bayerische Staatsbibliothek*

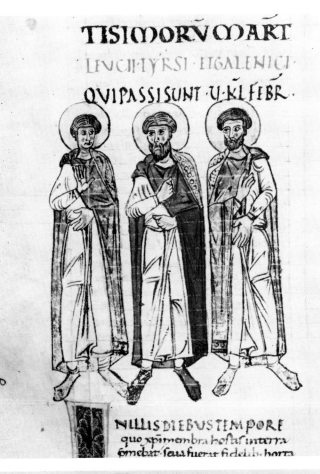

TISIMORVMART
LEVCIHYRSI HGALENICI
QVIPASSISUNT V·KI·FEBR

NILLISDIEBUSTEMPORE
quo xpimembra hostas interra
gmebat seua fuerat fidelib. horra

nete coronas. sps scs spal
pdixit · Etideo quia an
tasunt. restat unumut
transeamus adcaelum. E
N onte talem eximprouiso
Nechocmihi quos hodie
miserant din · Sedintorm
aut po te greca hodie si
Leuaus dixit · Quidcum
iudex etexsuria uerba con
sermonibus non acommu
quit utrabidus inpigeris
bens do auctore · tuauter
exnihilo fecit din · Al den
stantiam tibi pditionis
dixit · Eculeum adplica
poenissubiate · Leucius d
incinum dis ostende huic
cecus ptenebras offendit ·
sunt inrationabilib; sacr
dixit · Fortius eumtorqu
uerborum poena confec
sapore conditum · Leuci
rta sunt saporata · uttui
sulsam · tuauter sicut i
postmodum regno pri
utconculceris abhomin
fesos tum reddidat labe
iudex · Adplica alteros
exdefectu uanas pimen

tobi et machabeoru libros legit quidē eos
eccta. seclimer canonicas scriptras nonreci
pit! Sicetheccduolumina legat ad edifica
tionem plebisnonad auctoritatem ecclesi
asticoru docmatu confirmandam sicut
sane sepurt gusta interpretum magis edno
placet Haber eam anobis oli emendara
nequenimsicnoua eu dimus itutetera des
truimus Ettamen cum diligentissime lege
tit scutmagis nra intellegi que n interuu
uas trans sus coa euen nt seclstatum depre
lopurissime commendata testis suum saporem
seruauerint EXPLICIT PROLOGYS

INCIPIVNT CAP
I Dquab otesalomonis.
II Affecturi paris alloquitur filium. bdictus peccatorum nonadquiescet.
III N oneamb aland sim comonps.
IIII S apientia dest xps loquitur idest inluceparum idest inrebus interna mania.
 Parisulis somer.
V S apientia hortaur coutera adelim reprofert rpm.
VI S apiena comonecur conterupromp sius.
VII S apentia hortatur dnisuscepere sermonesfuos sapientiae reprudena.

In parabolas
INCIPIT PROLOGUS LIBSALOMONIS IDEST VII

ad uenuisal uatoris . dedecetur
ginub7 . dctalentis . deonub7 adex
tris . echaedis asinistris ;

162. Santa Cecilia, Rome: St
Matthew, from a Gospel
Lectionary. 1100/30. *Florence,
Biblioteca Laurenziana*

163. Santa Cecilia, Rome: St
Peter, from a Bible. 1100/30.
*Rome, Biblioteca Apostolica
Vaticana*

164. Umbro-Roman: St John and
St Augustine, from a *St
Augustine.* 1125/50. *Madrid,
Biblioteca Nacional*

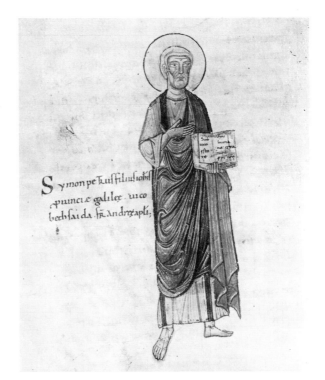

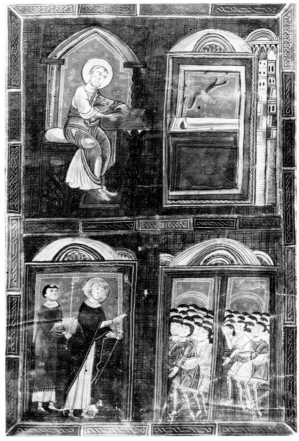

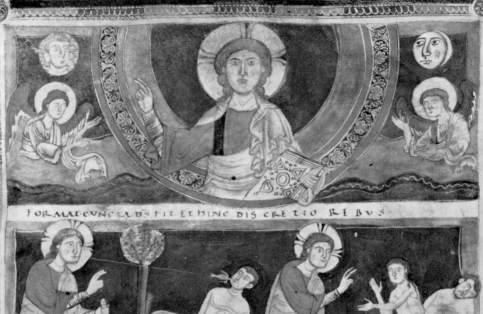

FORMAT CUNCTA DS̄ FIT ET HINC DISCRETIO RERBVS

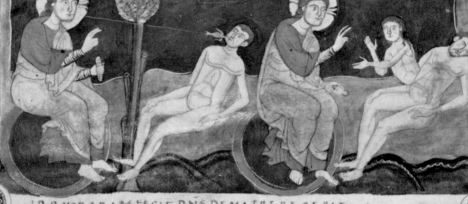

ID QVOD ADAM FECIT DN̄S DE MATRE RECEPIT

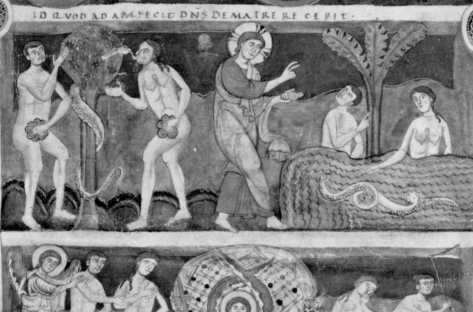

165. Umbro-Roman: Expulsion of Adam and Eve, from the Pantheon Bible. Twelfth century, second quarter. *Rome, Biblioteca Apostolica Vaticana*

166. Florence: Frontispiece, from a Bible. Twelfth century, third quarter. *Trent, Museo Diocesano*

O HA

tur qui e

xp̄i · disc

pauli · et

opera q

diligenti

s̄cilicet

et famul

om̄ib; fi

moranti

patendo

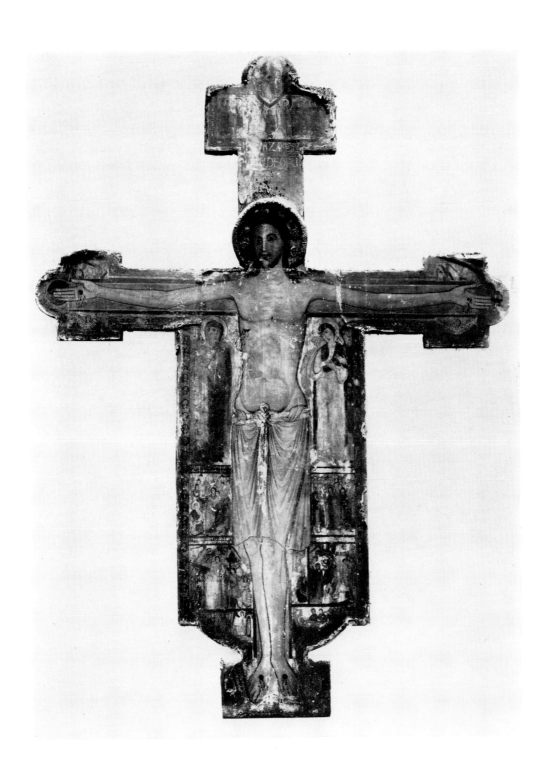

167. Lucca: St Barnabas, from a Passional. *c.* 1125. *Lucca, Biblioteca Capitolare*

168. Guglielmo of Lucca: Crucifix. 1138. *Sarzana Cathedral*

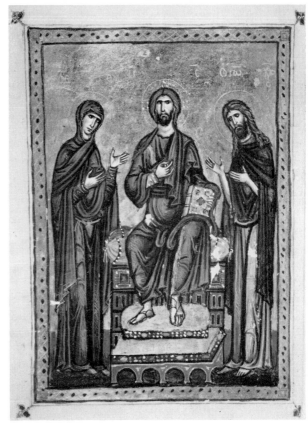

169. Galliano, San Vincenzo,
Jeremiah. Wall-painting. *c.* 1007

170. Civate, San Pietro, Angels.
Wall-painting. Late eleventh or
early twelfth century

171. Civate, San Pietro, Heavenly
Jerusalem. Wall-painting. Late
eleventh or early twelfth century

172. Jerusalem: Deesis, from the
Psalter of Queen Melisende.
1131/43. *London, British Museum*

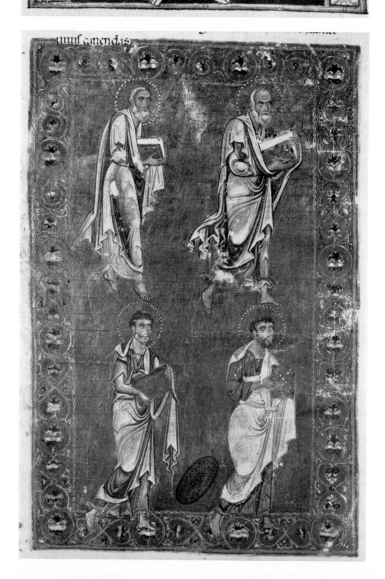

173. Jerusalem: St Peter, from the Psalter of Queen Melisende. 1131/43. *London, British Museum*

174. Jerusalem: The Evangelists, from a Gospels. Twelfth century, third quarter. *Rome, Biblioteca Apostolica Vaticana*

175. Messina: Virgin and Child, from a Missal. 1182/95. *Madrid, Biblioteca Nacional*

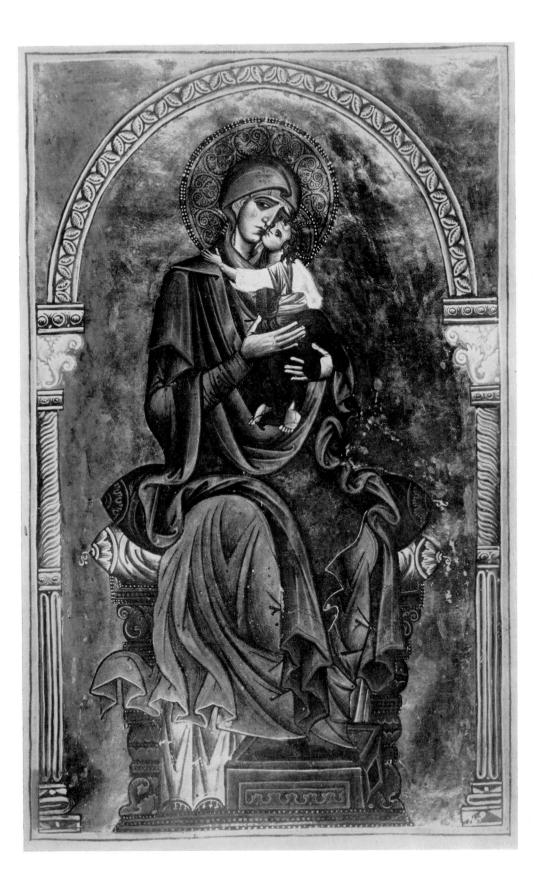

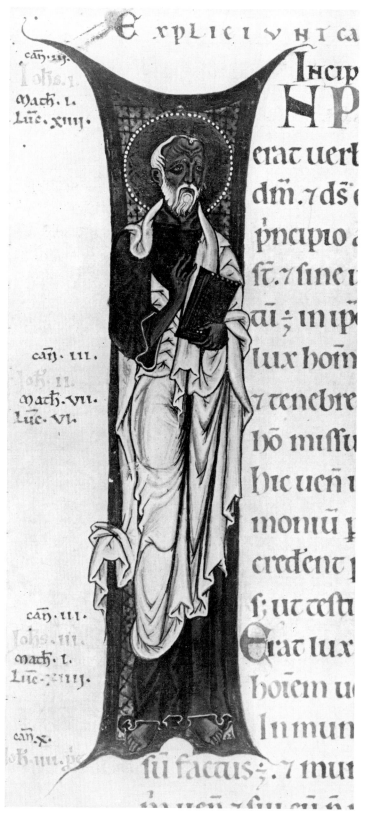

176. Messina: St John, from a Bible. 1182/95. *Madrid, Biblioteca Nacional*

177. Stavelot: Majesty, from the Stavelot Bible. 1093–7. *London, British Museum*

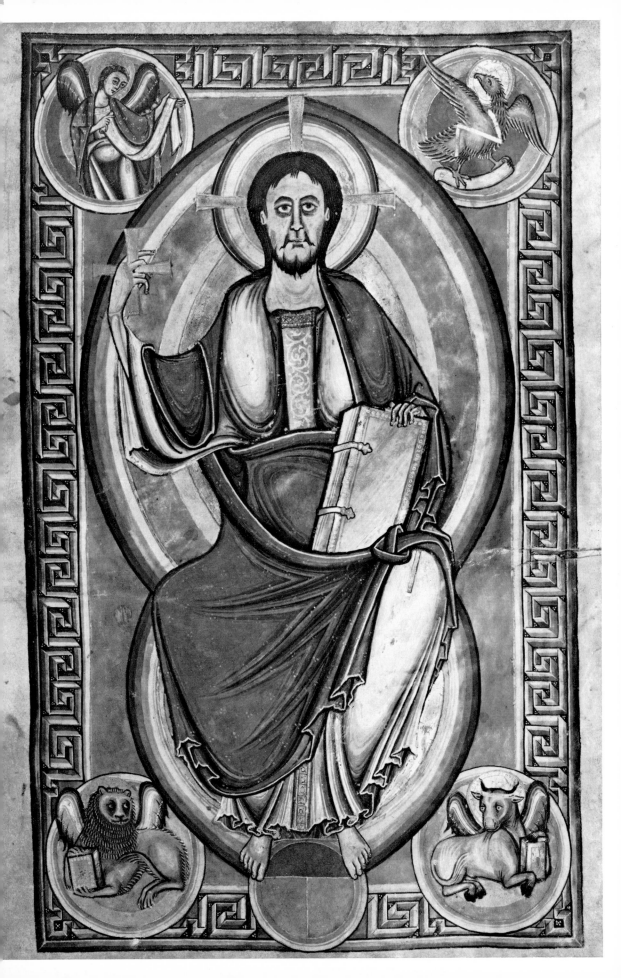

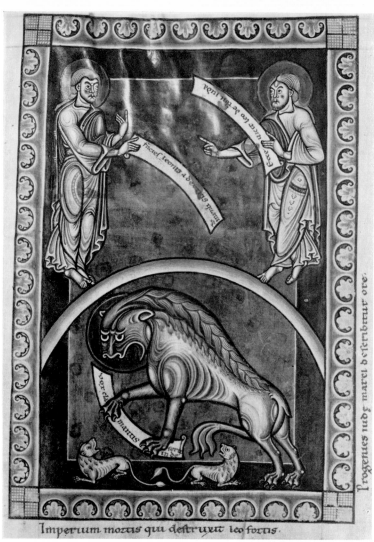

Imperium mortis qui destruxit leo fortis.

178. Liège: Lioness, from the Averboden Bible. Twelfth century, third quarter. *Liège, Bibliothèque de l'Université*

179. Mosan(?): Physician, from a Book of Medical Treatises. 1170/1200. *London, British Museum*

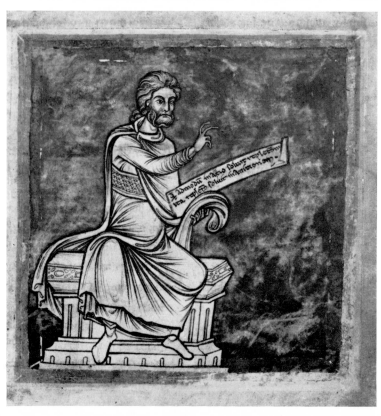

180. Liège(?): Crucifixion and Sin-offering of the Calf, from the Floreffe Bible. *c.* 1160. *London, British Museum*

181. Helmarshausen: The Purification and two Prophets, from a Psalter. 1168/89. *London, British Museum*

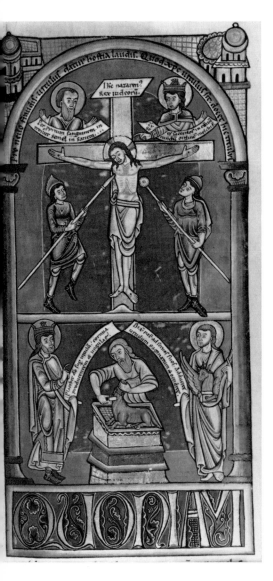

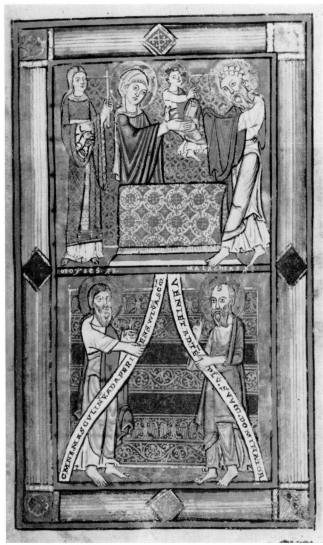

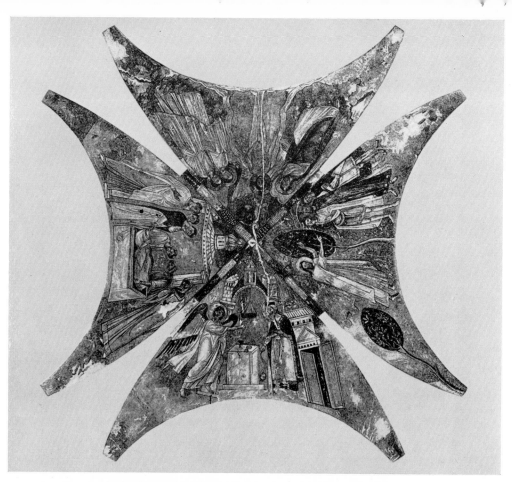

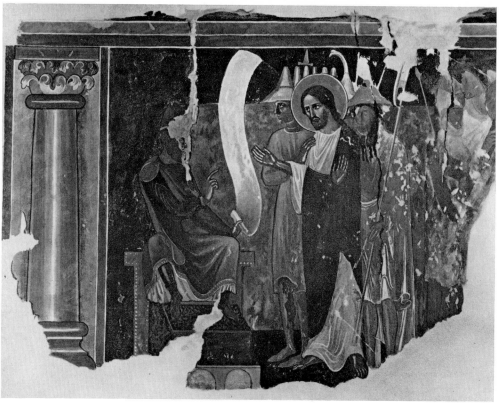

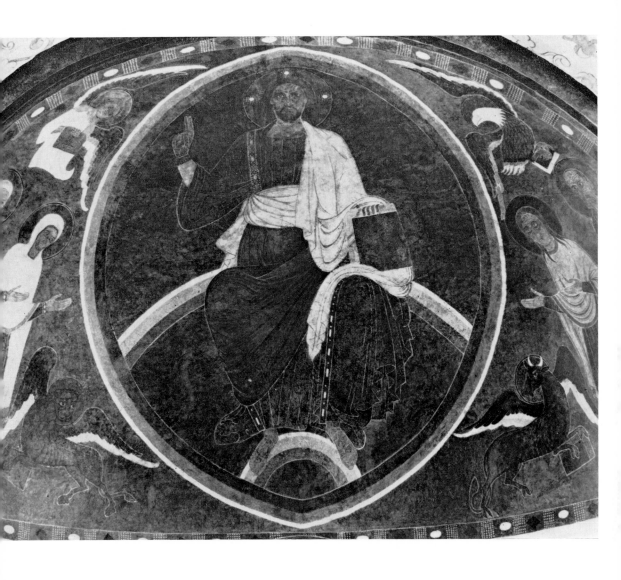

182. Cologne, St Maria im Kapitol, crypt, scenes from the life of St John the Baptist. Wall-painting. Late twelfth century

183. Emmerich, St Martin, crypt, Christ before Caiaphas. Wall-painting. Late twelfth century(?)

184. Saeby church, painting in apse. Thirteenth century, first half

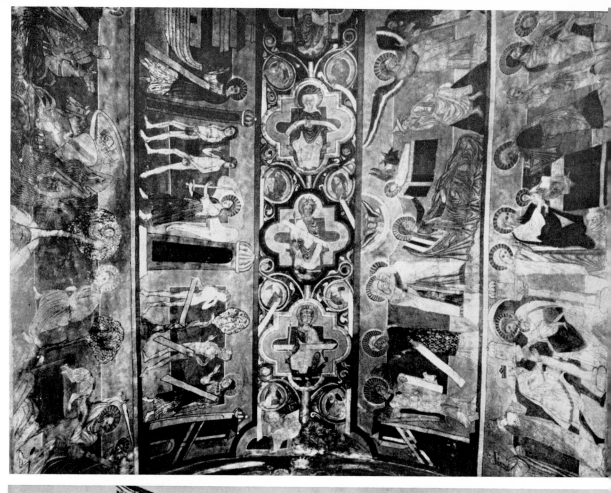

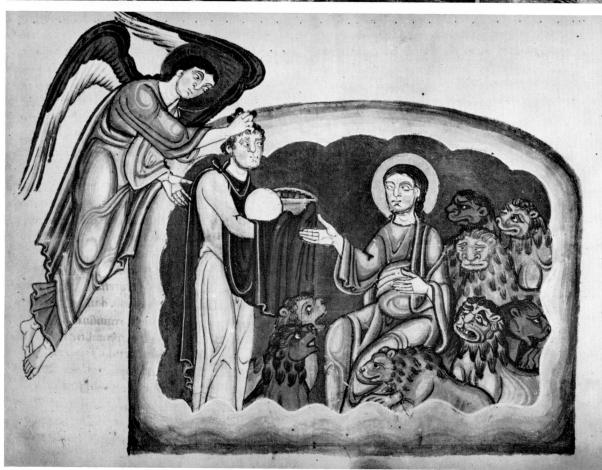

Explicit prologus. Incipit liber aggei pphe.

NANNO
SCDO
DARII
REGIS.
IN MENSE
sexto·indie
una mensis·
factū est uer
bū dñi inma
nu aggei p
phete·ad
zorobabel

185. Bjäresjö church, choir vault, Tree of Jesse and biblical scenes. Wall-painting. Thirteenth century, first half

186. Salzburg: Daniel in the Lions' Den, from the Walter Bible. Twelfth century, second quarter. *Michelbeuern, Stiftsbibliothek*

187. Salzburg: Haggeus, from the Admont Bible. Mid twelfth century. *Vienna, Nationalbibliothek*

incorpore'sciduntsse siue incorpore si
ue extra corpus nescio ds scit hisa ta
libus arguments apocrifas inlibro ec
clesie fabulas arguebat; sup quare lec
toris arbitrio iudiciu relinquens; illud
admoneo n haberi daniele apt hebreos
int ppʰas; s; int eos quia ΙΤ ΡΑΘΑ
conscripsert; Inter es siquide partes om
nis hͤhcͤo scriptura diuiditur; inlegem
inppʰas; INATIΩꞂ ΡΑΘΑ ide uiquinq
ͤuioctͦ ͤimundecim; De quo non est
hui temporis disserere; que aut exhoc
appʰa immo contra hunc librū porphi
rius obiciat; testes s methodius; euse
bius; apollinariis; qui multis uersuu
milib; ei uesanie respondentes nescio
ancurioso lectori satis feceriī;
Unde obsecro o paula ͤcustochiū fun
datis ꝑme addnm preces; ut quādiu
inhoc corpusculo sū scriba aliquid gra
tum uobis; utile ecclͤ; dignū posteris;
ͤsentiū quippe iudiciis non satis mo
ueor; qͤ inutrāꝗ parte aut amore la
buntur; aut odio;

EXPLICIT PROLOGVS DANIE

LIS PROPHETE;

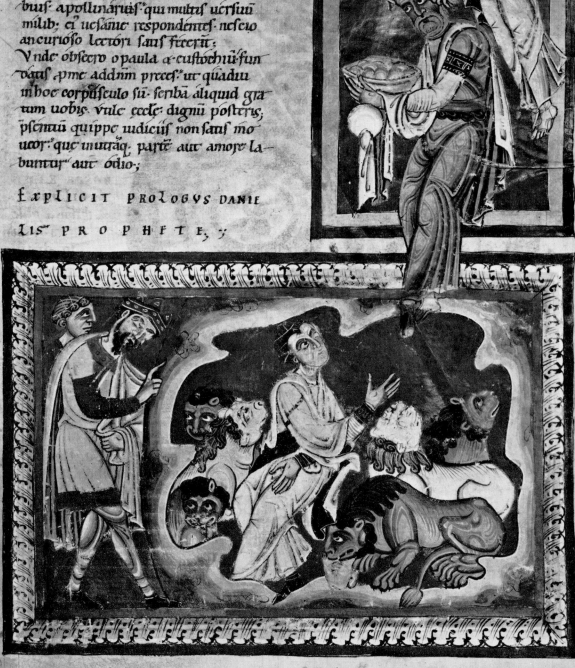

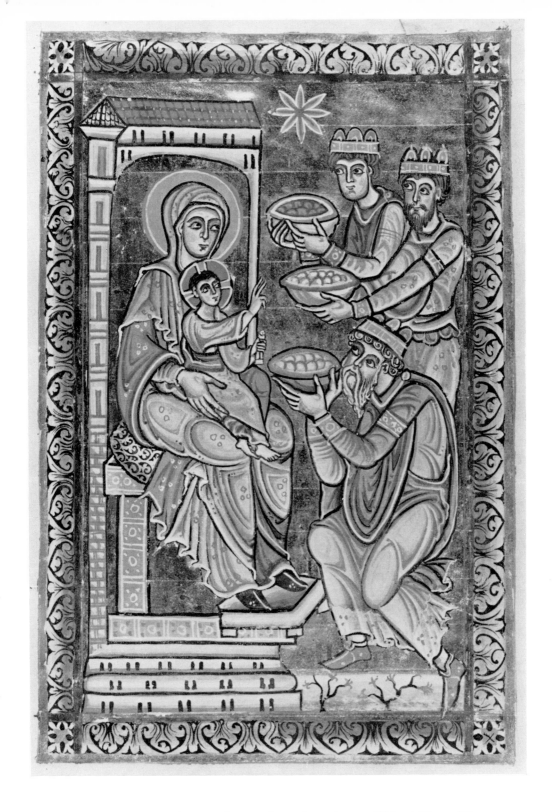

188. Salzburg: Daniel in the Lions' Den, from the Admont Bible. Mid twelfth century. *Vienna, Nationalbibliothek*

189. Salzburg: The Magi, from the Gospel Lectionary of St Erentrud. 1150/75. *Munich, Bayerische Staatsbibliothek*

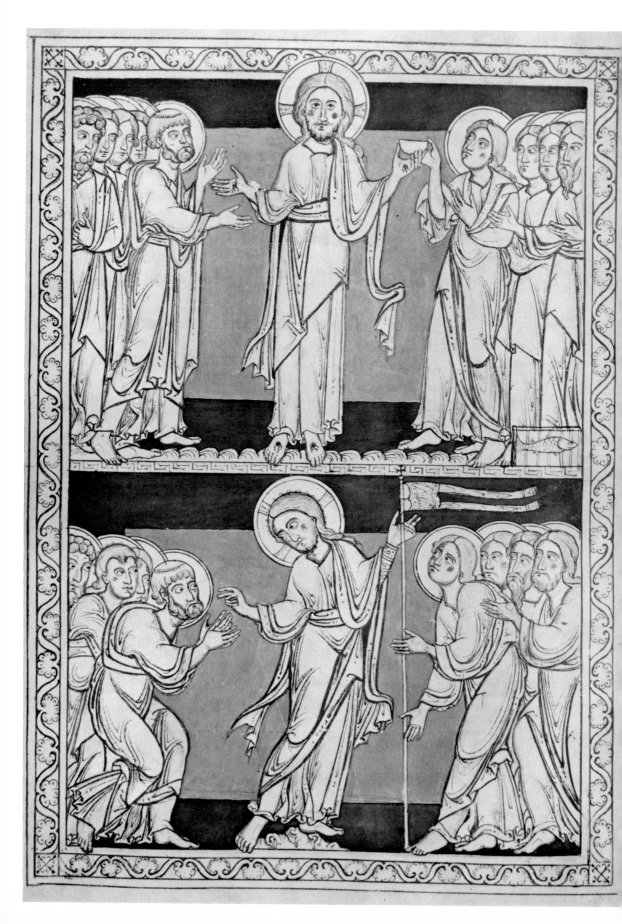

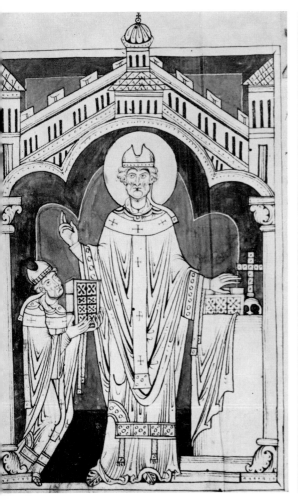

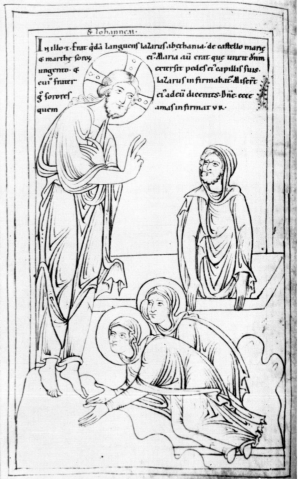

190. Salzburg: Christ appearing to the Disciples, from an Antiphonary. Mid twelfth century. *Vienna, Nationalbibliothek*

191. Liutold School: Archbishop Eberhard giving a manuscript to St Rupert, from an *Augustinus*. Mid twelfth century. *Munich, Bayerische Staatsbibliothek*

192. Liutold School: The Raising of Lazarus, from a Book of Necrologies. Mid twelfth century. *Salzburg, Stiftsbibliothek St Peter*

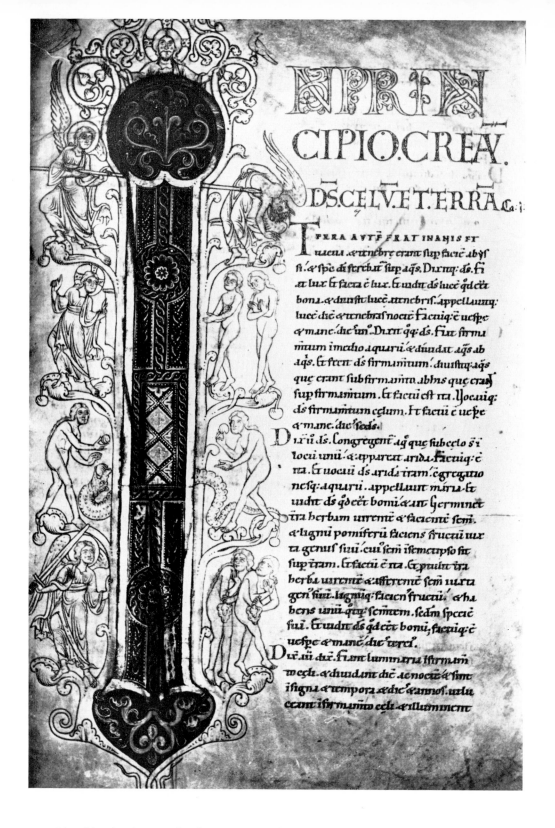

N PRIN
CIPIO.CREA.
DS.CELV.E.TERRA.

193. Liutold School: Episodes from Genesis, from a Bible. Mid twelfth century. *Formerly Salzburg, Stiftsbibliothek St Peter*

194. Liutold School: Majesty, single sheet. Mid twelfth century. *Vienna, Hofbibliothek*

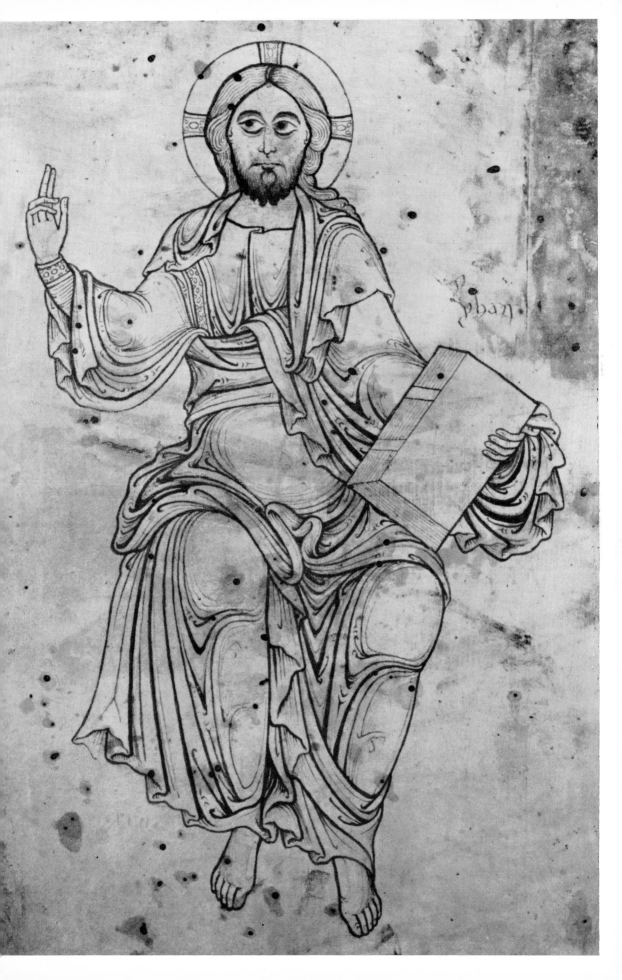

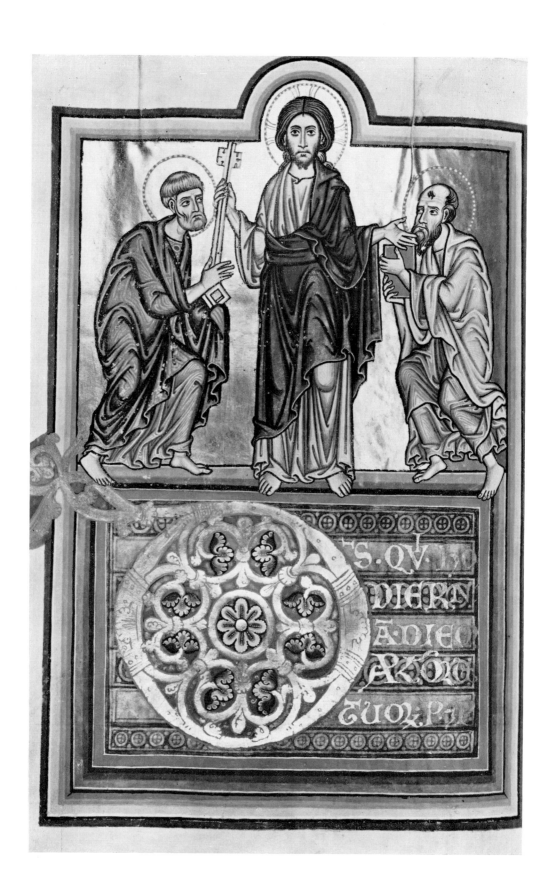

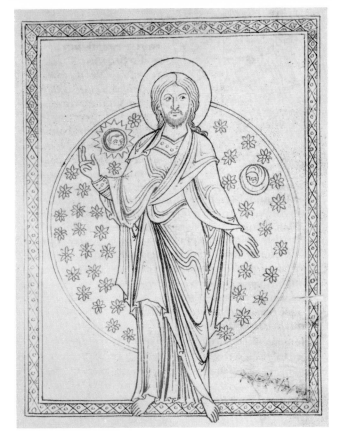

195. Salzburg: Christ between St Peter and St Paul, from the St Erentrud Orational. *c.* 1200. *Munich, Bayerische Staatsbibliothek*

196. Regensburg: Creation of the Stars, from an *Hexaëmeron* of St Ambrose. Mid twelfth century. *Munich, Bayerische Staatsbibliothek*

197. Regensburg: Scenes of St Peter and St Paul, from a *Lives of the Apostles*. Mid twelfth century. *Munich, Bayerische Staatsbibliothek*

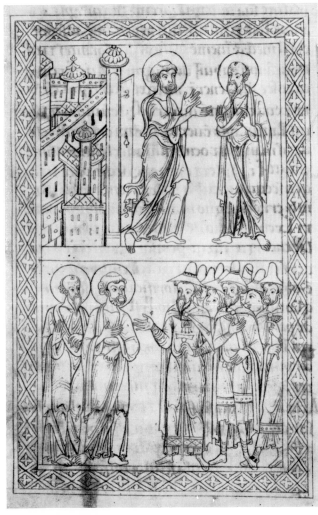

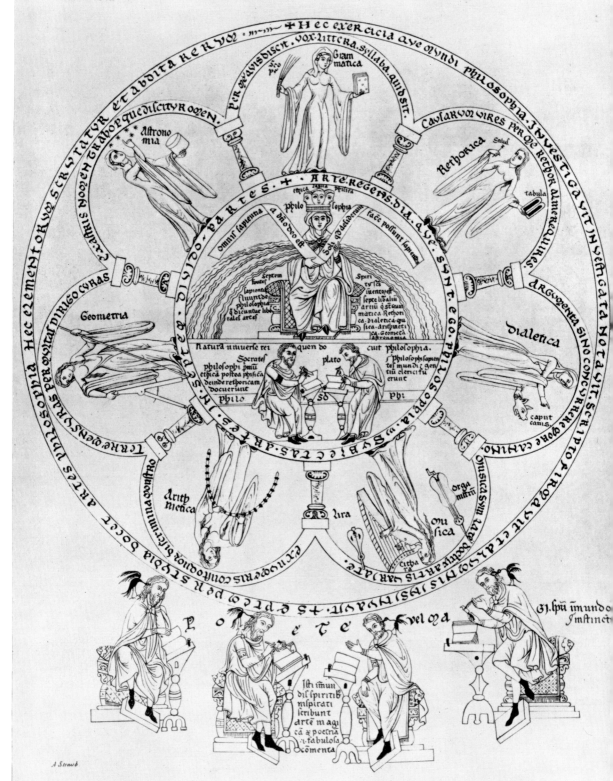

A Straub

198. Mont-Sainte-Odile (nineteenth-century copy): Philosophy and the Liberal Arts, from the *Hortus Deliciarum*. 1167/95

199. Clairvaux: Nuns ascending the Ladder of Virtue, from a *Speculum Virginum*. Late twelfth century. *Troyes, Bibliothèque Municipale*

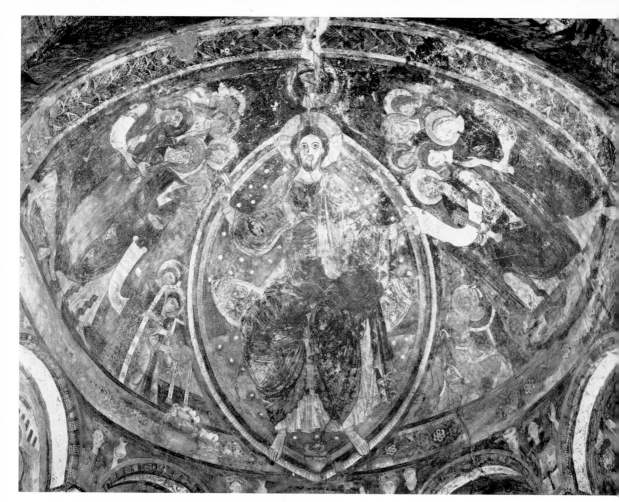

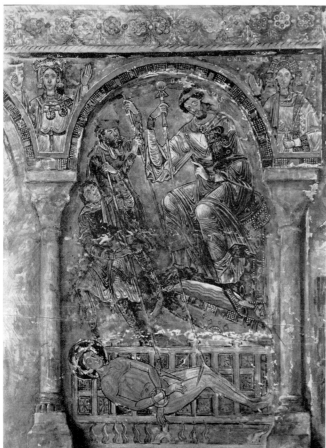

200. Berzé-la-Ville, priory, upper chapel, apse, Majesty. Wall-painting. 1100/40(?)

201. Berzé-la-Ville, priory, upper chapel, apse, Martyrdom of St Laurence. Wall-painting. 1100/40(?)

202. Cluny: Pentecost, from the Cluny Lectionary. Early twelfth century(?). *Paris, Bibliothèque Nationale*

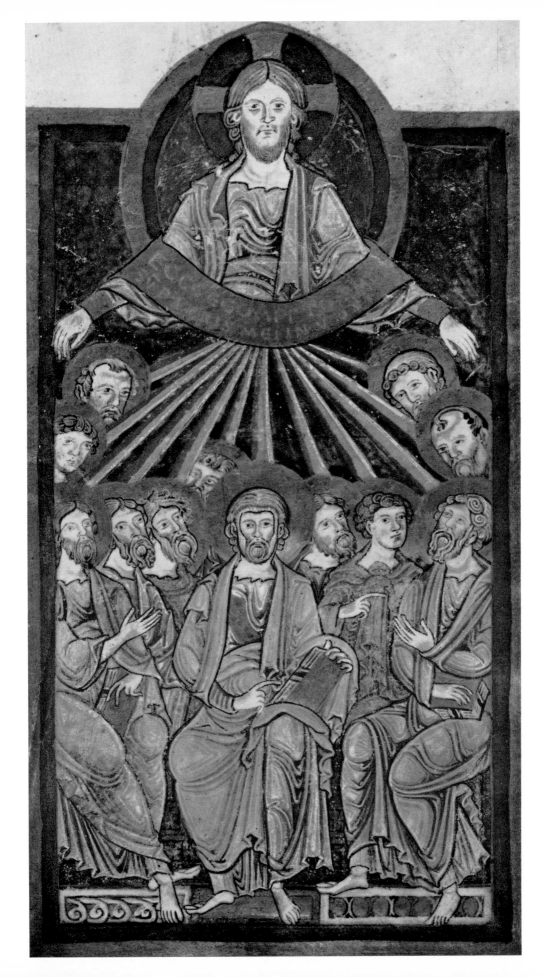

203. Cluny(?): Gómez presenting his book to Gotiscalc, from St Ildefonsus's *De Virginitate*. Twelfth century, first quarter. *Parma, Biblioteca Palatina*

204. Cîteaux: Tree of Jesse, from the Cîteaux Lectionary. 1120/50. *Dijon, Bibliothèque Municipale*

205. Cîteaux: Tree of Jesse, from a Commentary of St Jerome. Twelfth century, second quarter. *Dijon, Bibliothèque Municipale*

206. Cîteaux: Saint, from the Cîteaux Lectionary. 1120/50. *Dijon, Bibliothèque Municipale*

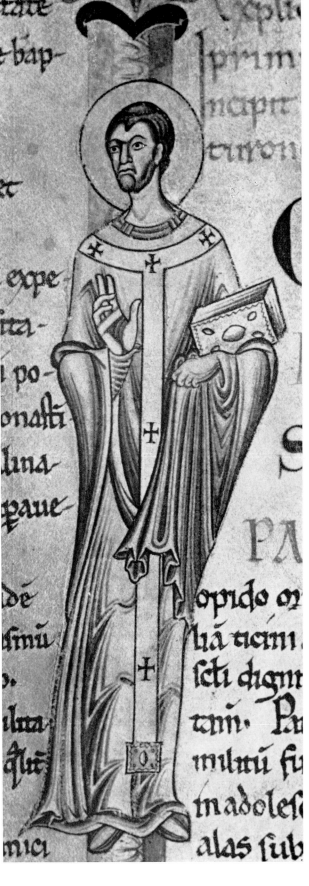

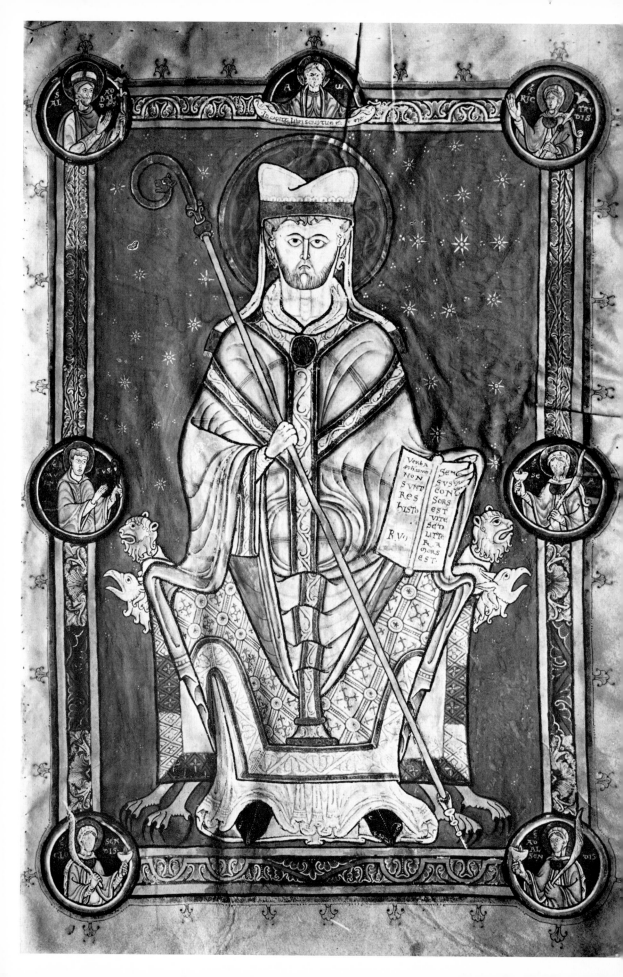

207. Marchiennes: St Augustine,
from a Commentary of St
Augustine. 1130/60. *Douai,
Bibliothèque Municipale*

208. Saint-Amand: St Gregory,
from the *Letters of St Gregory*.
Twelfth century, second half.
Paris, Bibliothèque Nationale

209. Saint-Amand: Two Saints,
from a *Life of St Amand*. Mid
twelfth century. *Valenciennes,
Bibliothèque Municipale*

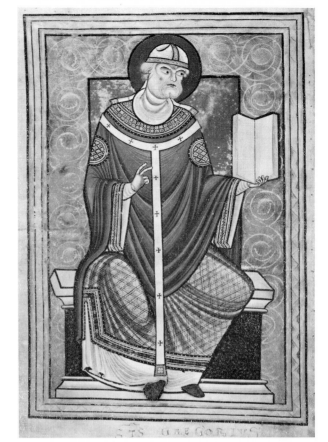

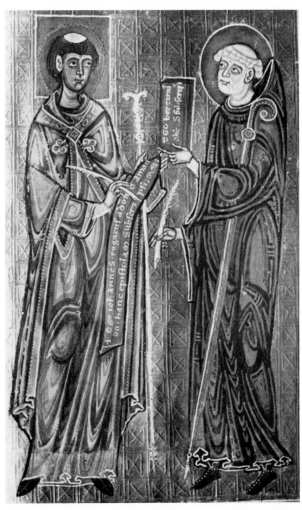

210. Saint-Amand: Crucifixion, from a Sacramentary. Mid twelfth century. *Valenciennes, Bibliothèque Municipale*

211. Liessies: St John, from the Wedric Gospels. 1146. *Avesnes, Société Archéologique*

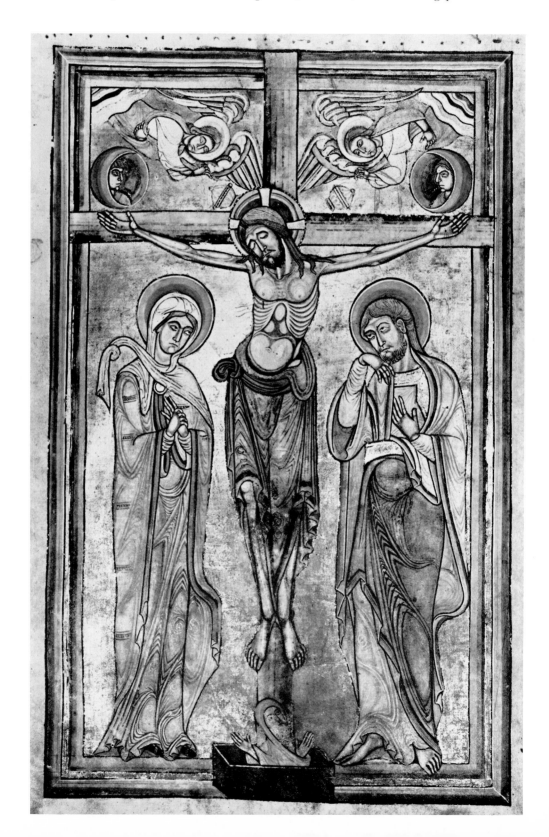

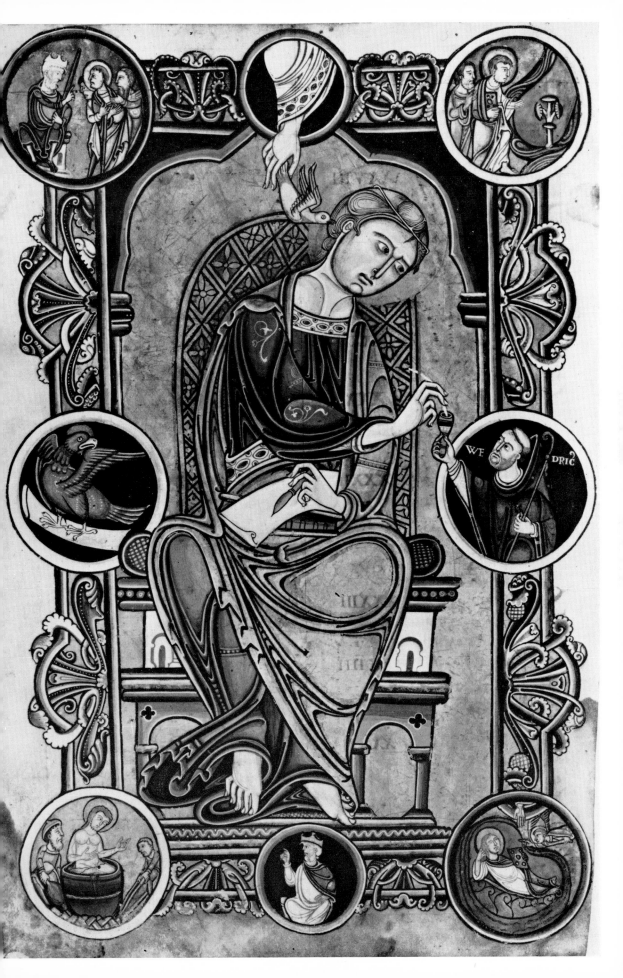

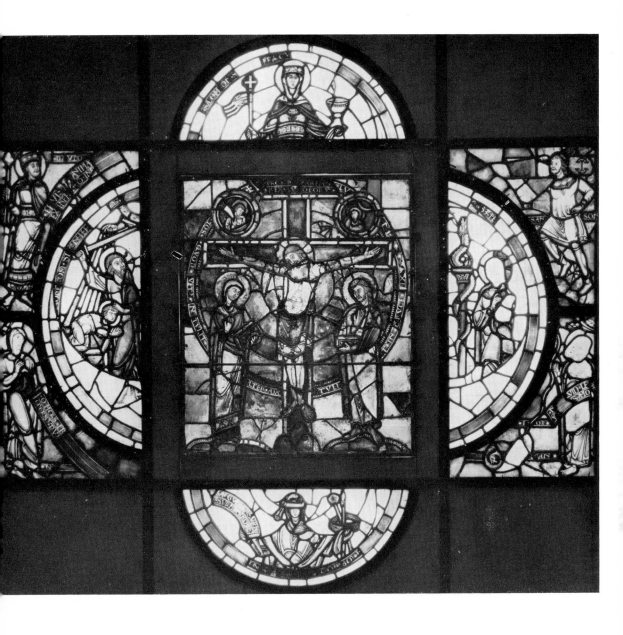

212. Le Mans Cathedral, Ascension. Stained glass. *c.* 1158

213. Crucifixion, with Church and Synagogue, from the cathedral. Stained glass. Twelfth century, third quarter. *Châlons-sur-Marne, Musée des Monuments Français*

214. Saint-Chef, Chapel of St George, Heavenly Jerusalem. Wall-painting. Late eleventh or early twelfth century

215. Saint-Savin-sur-Gartempe, crypt, Martyrdom of St Savin and St Cyprian. Wall-painting. Early twelfth century(?)

216. Saint-Savin-sur-Gartempe, porch, St Michael attacking the Rebel Angels. Wall-painting. Early twelfth century(?)

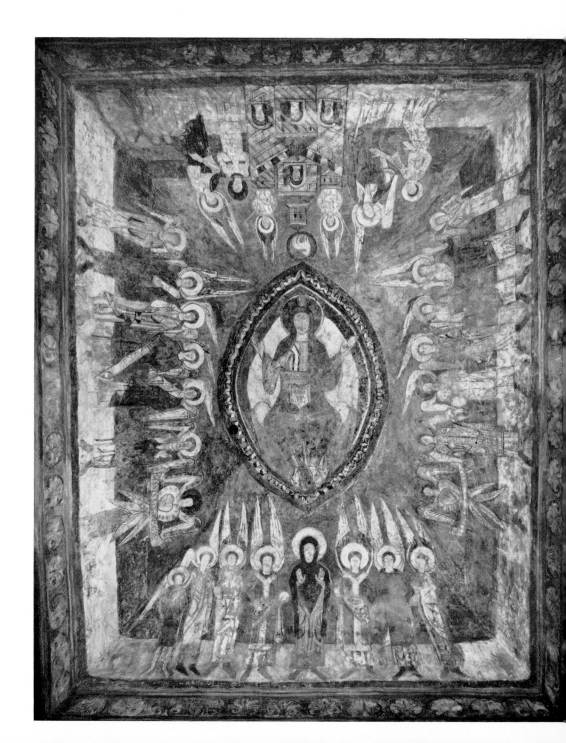

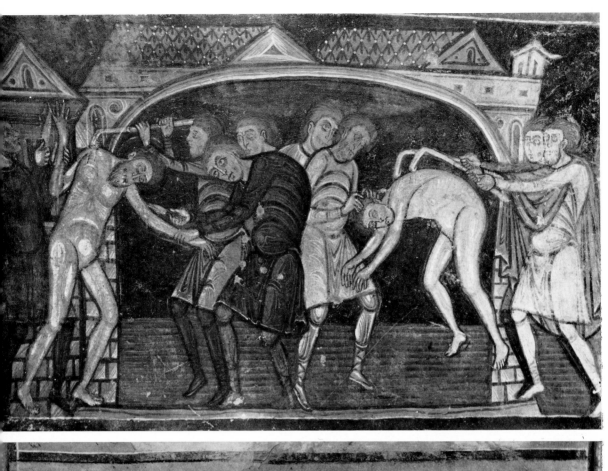

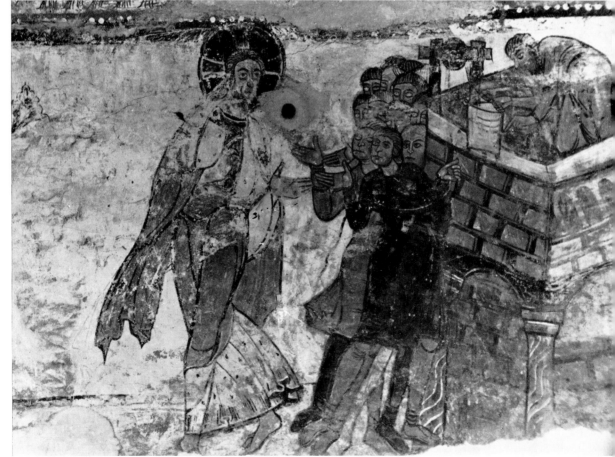

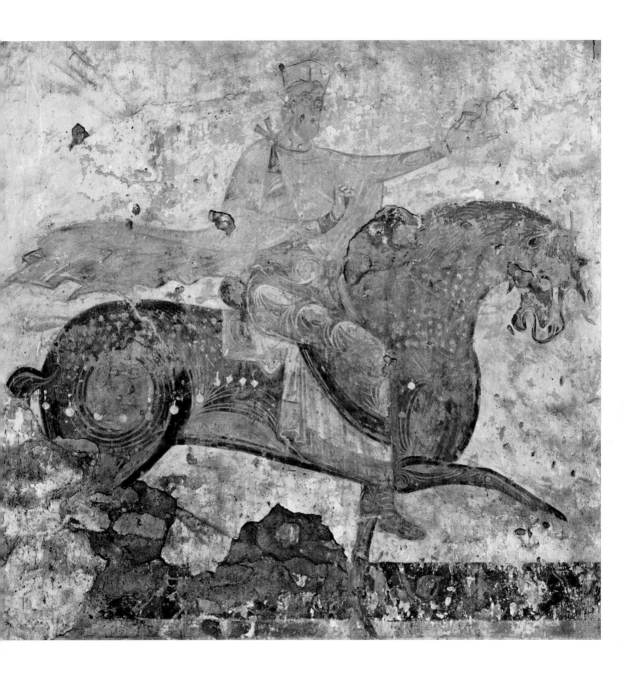

217. Saint-Savin-sur-Gartempe, nave vault, God commanding Noah to build the Ark. Wall-painting. Early twelfth century(?)

218. Saint-Savin-sur-Gartempe, nave vault, Tower of Babel. Wall-painting. Early twelfth century(?)

219. Poitiers, baptistery of Saint-Jean, Emperor on Horseback. Wall-painting. Twelfth century, first half

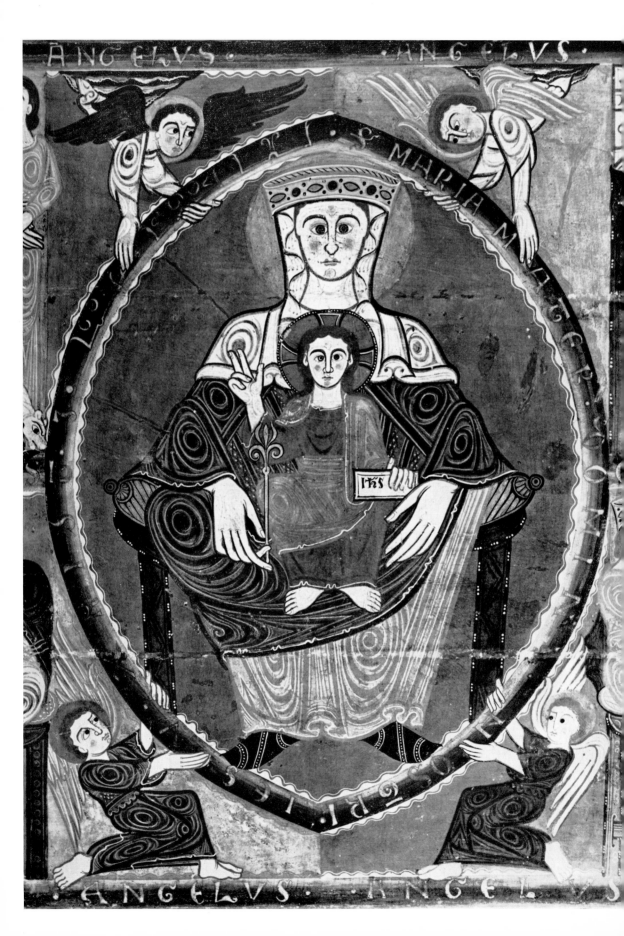

220. Virgin and Child, from an altar-frontal. Twelfth century, first half. *Vich, Museo Arqueológico Artistico Episcopal*

221. Altar-frontal, from the Seo de Urgel. Mid twelfth century. *Barcelona, Museo de Arte de Cataluña*

222. Majesty, from San Clemente de Tahull. Wall-painting. 1123/50. *Barcelona, Museo de Arte de Cataluña*

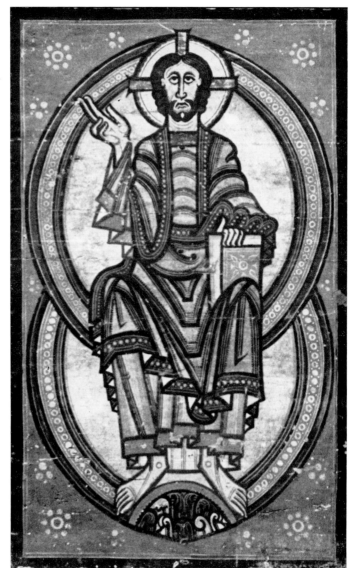

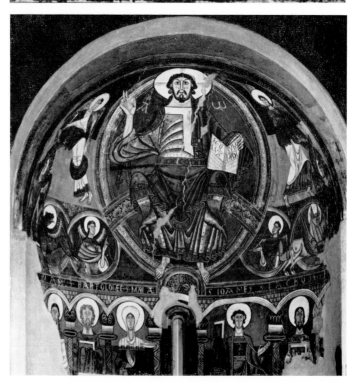

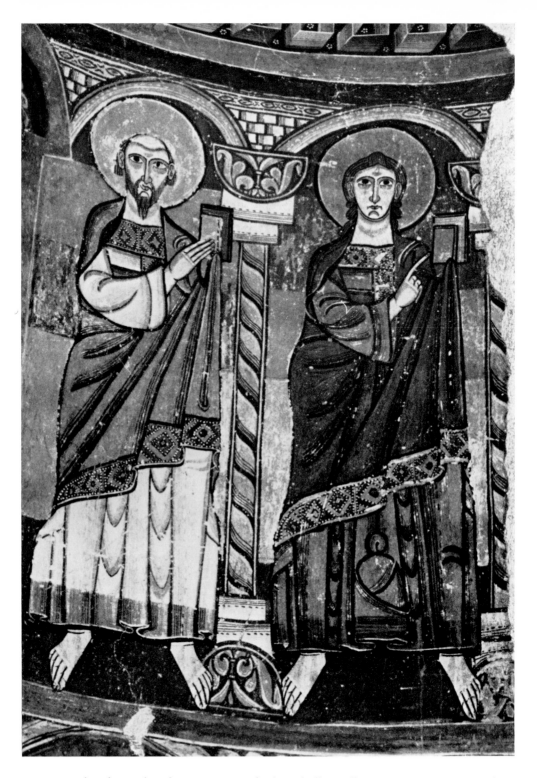

223. St Paul and St John, from Santa María de Tahull. Wall-painting. 1120/50. *Barcelona, Museo de Arte de Cataluña*

224. Virgin and Child, from Santa María de Tahull. Wall-painting. 1120/50. *Barcelona, Museo de Arte de Cataluña*

225. Santa María de Barbará, apse, Three Magi. Wall-painting. Late twelfth or early thirteenth century

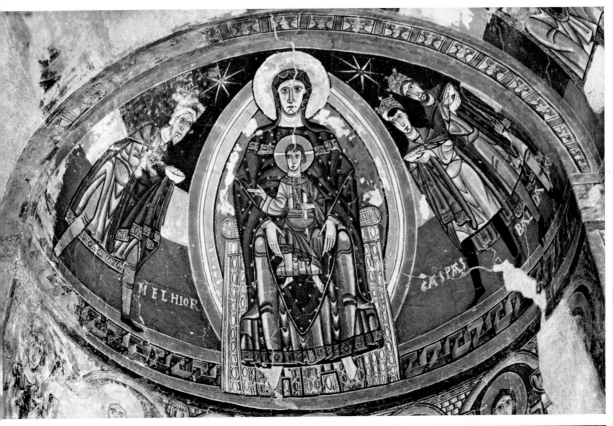

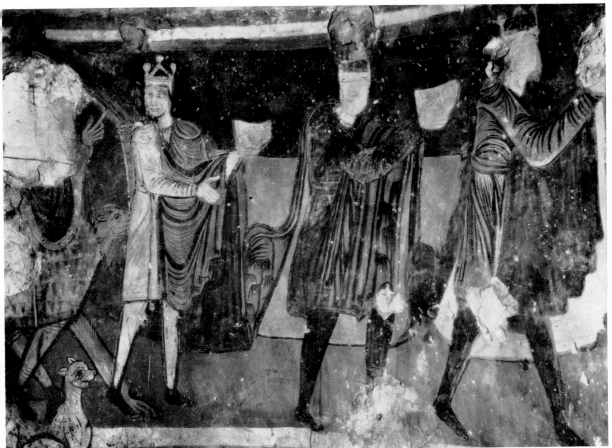

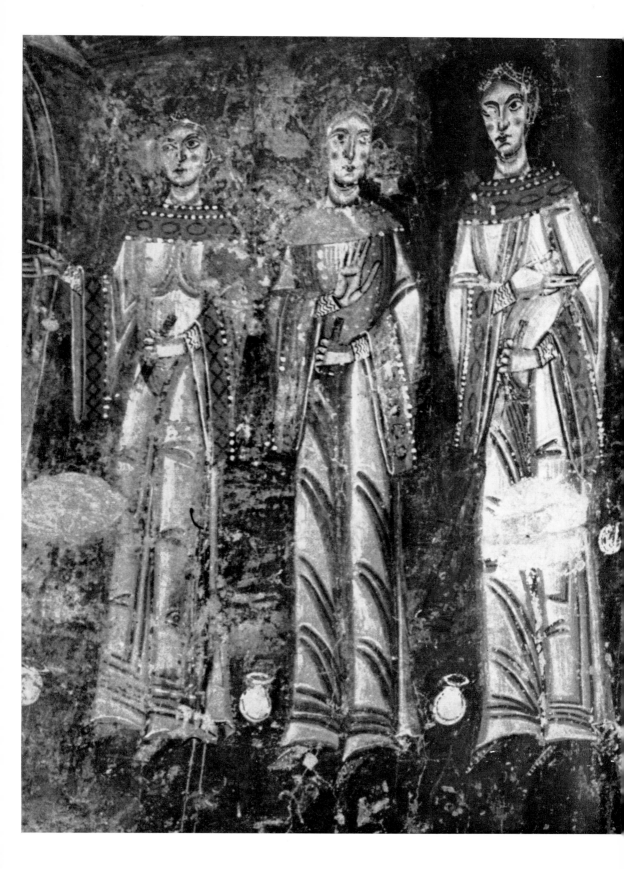

226. San Quirce de Pedret, right apse, The Foolish Virgins. Wall-painting. Twelfth century, first half

227. St John the Baptist and St Paul, from San Pedro del Burgal. Wall-painting. Twelfth century, second half. *Barcelona, Museo de Arte de Cataluña*

228. St John the Evangelist and St Paul, from the Castello de Orcau. Wall-painting. Twelfth century, second half. *Barcelona, Museo de Arte de Cataluña*

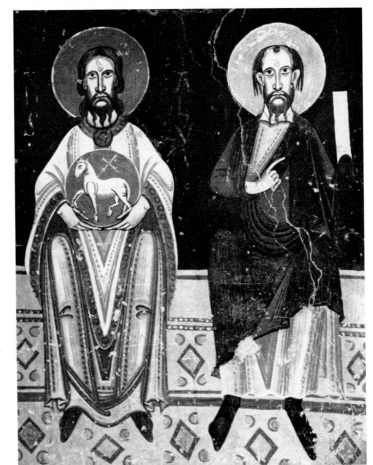

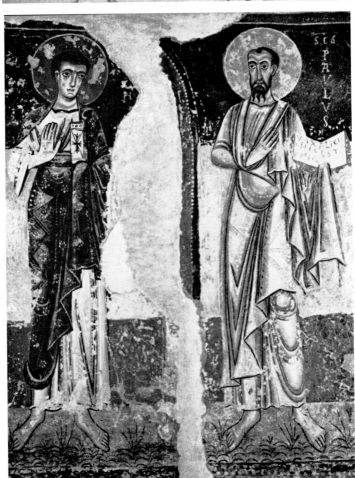

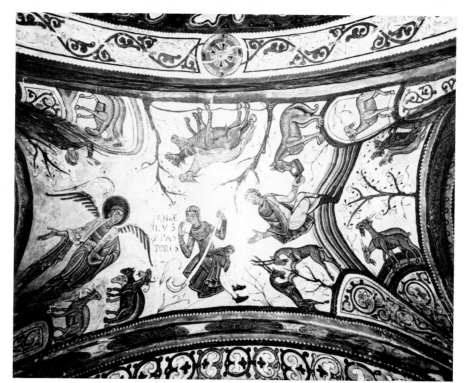

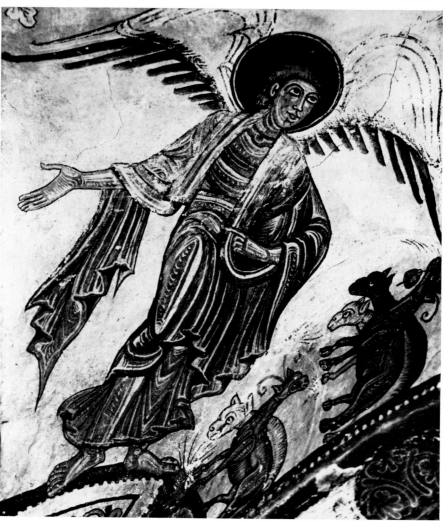

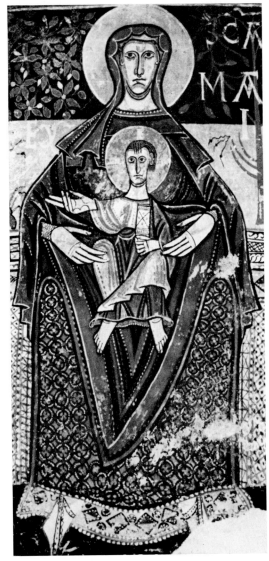

229. León, San Isidro, Panteon de los Reyes, Annunciation to the Shepherds. Wall-painting. 1157/88

230. León, San Isidro, Panteon de los Reyes, Angel from the Annunciation to the Shepherds. Wall-painting. 1157/88

231. The Three Marys at the Tomb, from San Baudel de Berlanga. Wall-painting. Twelfth century, second half. *Boston, Museum of Fine Arts*

232. Virgin and Child, from San Pedro de Sorpe. Wall-painting. Twelfth century, second half. *Barcelona, Museo de Arte de Cataluña*

233. Majesty, from Santa María del Mur. Wall-painting. Late twelfth century. *Boston, Museum of Fine Arts*

234. Altar-frontal, from Hix. Mid twelfth century, *Barcelona, Museo de Arte de Cataluña*

235. Altar-frontal, from Vich. Late twelfth century. *Barcelona, Museo de Arte de Cataluña, Espoña Collection*

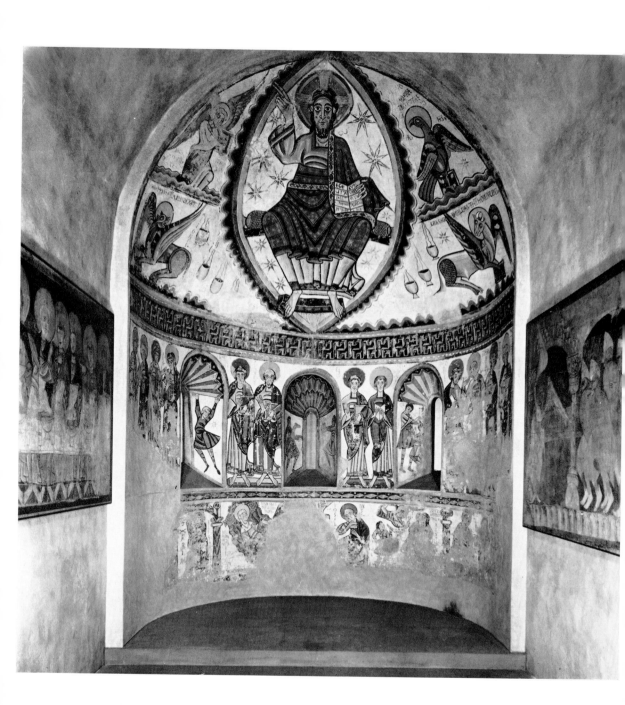

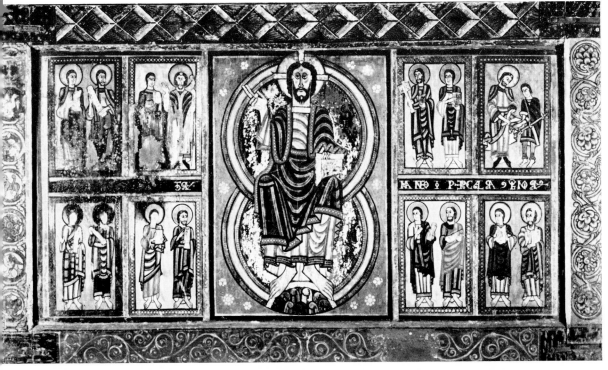

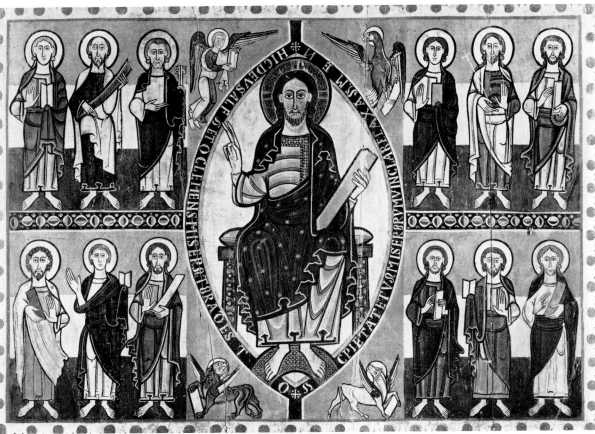

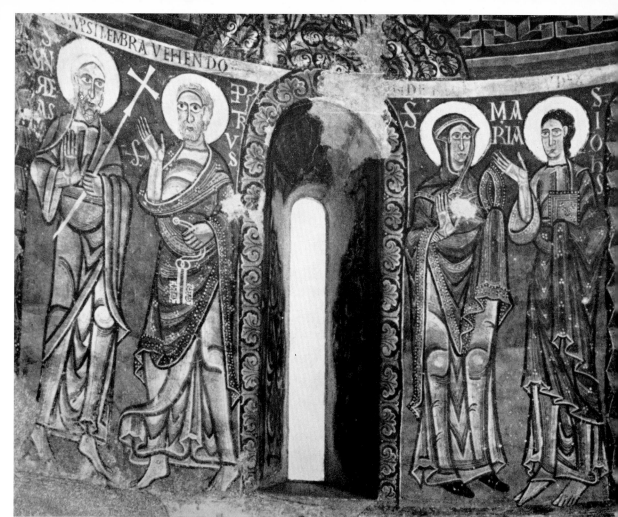

236. Virgin and Apostles, from San Pedro de Seo de Urgel. Twelfth century, second half. *Barcelona, Museo de Arte de Cataluña*

237. Saint-André-au-Bois: Illustration from a Bible. Late twelfth century. *Boulogne-sur-Mer, Bibliothèque Municipale*

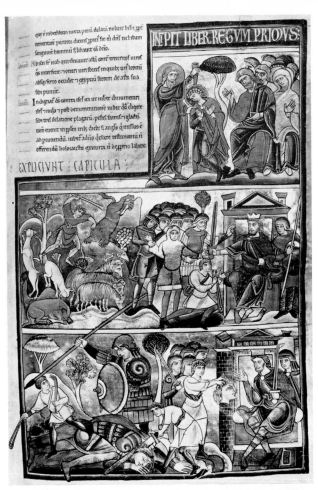

238. Souvigny: Scenes from the life of David, from the Souvigny Bible. Late twelfth century. *Moulins, Bibliothèque Municipale*

239. Saint-Amand: Illustration from the third *Life of St Amand*. 1170/1200. *Valenciennes, Bibliothèque Municipale*

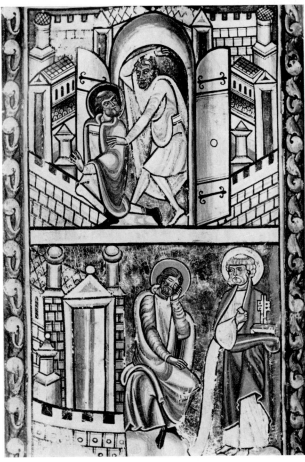

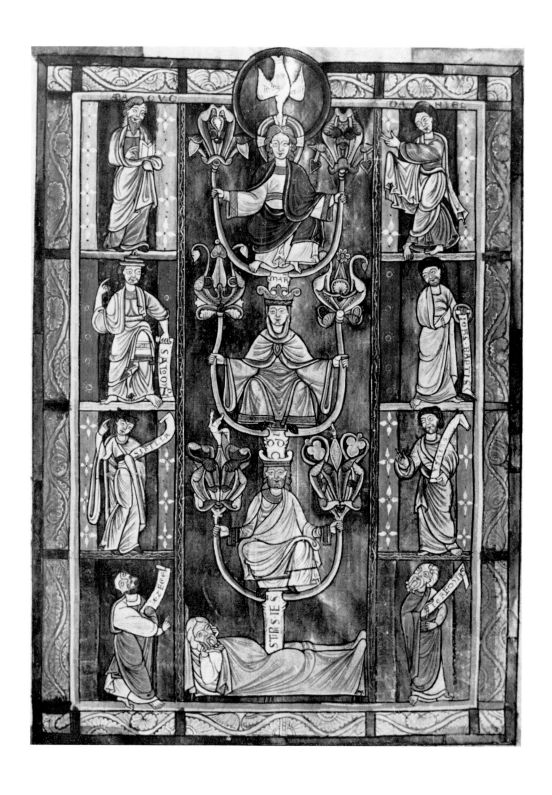

240. Anchin: Tree of Jesse, from a *Hrabanus Maurus*. Late twelfth century. *Douai, Bibliothèque Municipale*

INDEX

Numbers in *italics* refer to plates. References to the notes are given to the page on which the note occurs, followed by the number of the note. Thus 212⁵⁶ indicates page 212, note 56. Only those notes are indexed which contain matter to which there is no obvious reference from the text, and which do not contain purely bibliographical material. Libraries and museums are indexed with the name of the town in capitals. If a library or museum is situated in a town which is also referred to for other purposes, it appears separately after the general entry for the town.